# THE ROBERT GORE RIFKIND COLLECTION

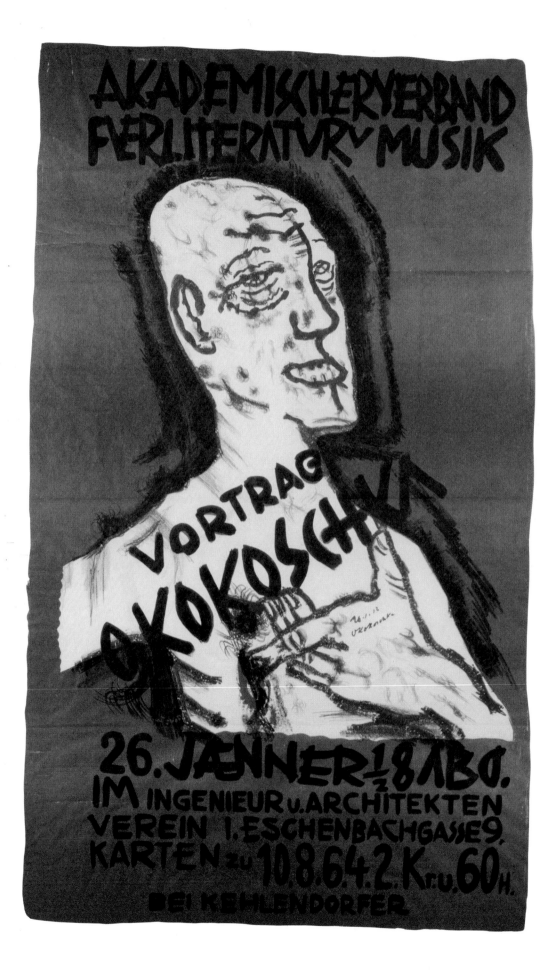

# THE ROBERT GORE RIFKIND COLLECTION

**Prints
Drawings
Illustrated Books
Periodicals
Posters**

# GERMAN EXPRESSIONIST ART

BY
ORREL P. REED JR.

**Frederick S. Wight Art Gallery
University of California, Los Angeles**

First edition

*GERMAN EXPRESSIONIST ART. The Robert Gore Rifkind Collection*

*Copyright © 1977 by Robert Gore Rifkind*

*Published by the Frederick S. Wight Art Gallery*
*University of California, Los Angeles*

*Distributed by Alan Wofsy Fine Arts*
*San Francisco*

*Printed in the United States of America*

An exhibition has been organized by O. P. Reed Jr, as guest curator, based upon this book.

The exhibition has been supported by a grant from The National Endowment for the Arts Washington, D. C. a federal agency created by Act of Congress, 1963.

Exhibition Dates:
*Frederick S. Wight Art Gallery*
*University of California, Los Angeles*
*March 1 – April 17, 1977*

*Front Cover: E. L. Kirchner. Eispalast-Tänze. handcolored woodcut, 1912, catalogue number 77.*

*Frontispiece: Oskar Kokoschka. Selbstbildnis, Hand auf der Brust. color lithograph poster, 1911, catalogue number 186.*

*Back Cover: E. L. Kirchner. Schleudertanz. woodcut, 1912, catalogue number 245.*

*New Orleans Museum of Art*
*New Orleans*
*June 16 – August 6, 1978*

*City Art Museum of St. Louis*
*St. Louis*
*September 14 – October 29, 1978*

*Library of Congress catalog card number: 77-7172*

*ISBN   0-915346-27-3*
*ISBN   0-915346-28-1 paperback*

*Busch-Reisinger Museum*
*Harvard University, Cambridge*
*November 15, 1978 – January 13, 1979*

# ERRATA AND CORRECTIONS

| Page | As Printed | Correction |
|---|---|---|
| iv. | City Art Museum of St. Louis | St. Louis Art Museum |
| x. | Dr. Walter Hüder | Walter Huder |
| 1. | Bohemian | bohemian |
| 6. | placement of figures | massing of figures |
| | BathSheba | Bath-Sheba |
| | g.5,g.6,etc. | G.5,G.6,etc. |
| 8. | 36 x 28 cm., (1f) | 1f+60+1 |
| 10. | StaufferBern | Stauffer-Bern |
| 16. | Osterreichs | Österreichs |
| | Wien (Klinger Beethoven | Wien Klinger Beethoven. |
| 18. | ,but later | ,and later |
| 25. | 1872 | into a beginning entity in January, 1871 and bureaucratic reforms after 1872. |
| 28. | li | Li |
| 30. | Axel Gallen-Kallela | Axel Gallén-Kallela |
| 33. | After Bleyl saw | After Bleyl had seen |
| 35. | Oskar | Oscar |
| 40. | Woocut | Woodcut |
| 43. | Krefeld | Crefeld |
| 45. | French, the Swiss | French, and the Swiss |
| 50. | quick calligraphy | rapid calligraphy |
| 51. | green watercolor | yellow-green watercolor |
| 52. | Paul Knorr Berlin | Paul Knorr, Berlin |
| 56. | doll become brightening | dolls become frightening |
| 57. | von Frau Eucken, Bremen Jena Woman's Club | von Frau Eucken, Jena Bremen Women's Club |
| 59. | single plan | single plane |
| 60. | shows that 1916 | shows beginning 1916 |
| 61. | earliest time in Dresden | earliest time in Berlin |
| 64. | January 16, 1913 | January 16, 1912 |
| 66. | Kirchner to 1916 | Kirchner to 1924 |
| | 1924? 26 | 1924/26 |
| 67. | eye, experience | eye experience |
| 69. | although | although most of the |
| 72. | tonality with aquatint. | tonality with aquatint in later prints. |
| | with type | with type, printed in 1912 |
| 75. | Mutter of 1918 | Mutter of 1916 |
| 77. | state eagle, | state eagle, based on his pre-Weimar design. |
| 78. | lack of seriousness | lack of modern seriousness |
| | later symbolism | latent symbolism |
| | Like the Japanese | Unlike the Japanese |
| 83. | The print is a | The print holds |
| | 35 W40-78,86,L.35 | delete repeats after 35. Insert: Published by Julius Bard, Berlin, 1911. |
| 88. | working from crayon | working with crayon |
| | men are feminine | men are feminine-like |
| | both serious | both seriousness |
| 90. | not sympathized with | not now sympathized with |
| | evolves again | evolves mostly again |
| | M. Peckstein | M. Pechstein |
| 94. | Fechter 621 | Fechter 121 |
| | in etched | in an etched |
| 96. | nudity is natural | nudity is open |
| 98. | red 39.7 | red, 39.7 (add commas after all colors) |
| 99. | eye omnivision | eye of omnivision |
| 100. | lines encountered | lines countered |
| 105. | Roethel Book 5,54 | Roethel Book 5,R.54 |
| 110. | built out of | build out of |
| | bass oboe | bassoon |
| 114. | Aurelie | Aurelie |
| | Color woodcut | color linocut |
| 115. | Peters 8ii | delete |
| 142. | of the sanitarium | of the military convalescent sanitarium |
| 150. | for Schiele means | for schielen means |
| 151. | Kallir 162 | Kallir 1/b/2 |
| | Kallir 82 | Kallir 8a |
| 152. | 203.Secession (49th Exhibition of the Secession) 49 Ausstellung | 203. Secession 49 Ausstellung (49th exhibition etc.) |
| 154. | This great woman, this great humanitarian, | This woman, this impressive humanitarian, |
| 156. | one mark. | one half mark, the same admission as for the Volksbühne. |
| 169. | gouche | gouache |
| 176. | type:schrift | type: Deutsch schrift |
| 178. | 205,206,209 | 205,206,208,209 |
| 179. | 230,231,233 | 230,231,232,233 |
| | night. A mere racing | night. Later a mere racing |
| 182. | Cologne; First Sonderbund | Düsseldorf: First Sonderbund |
| 192. | in Düsseldorf before certain | in Düsseldorf during 1909, 1910,1911, before certain |
| 203. | editor in Dresden | editor in Leipzig. |
| 204. | Die Aktion in 1912 | Die Aktion in 1911 as a literary/political journal, and added the word art to the title in 1912 |
| 211. | Die Bücherkiste 1920/3 | 1920/1921-3 |
| 213. | He printed 65 issues | He printed 35 issues |
| | find out a friend | locate a friend |
| 215. | emphasis on Rhineland | emphasis was mainly on Rhineland |
| 219. | Bilderhefte | add: 1920-21, 4° |
| 231. | ideals until 1921 | ideals until 1922 |
| 233. | the socialist revolution in | the communist takeover of the socialist revolution |
| | 1 issue, II double issues | 10 issues, one double issue |
| 237. | There were two issues after the two issues | two first issues after the two first issues |
| | Meidner's apocalyptic visions | Meidner's cataclysmic visions |
| 247. | Das Tribunal. (1-7) seven parts | (1-7) Four parts in one issue |
| 257. | Der Almanach | add: 188 pp. |
| 258. | Die Neue Dichtung | add: 157+32pp. |
| 265. | as a use of the day of | as a meaning of the day of |
| 276. | In 1933 Gustav Wolf | In 1923 Gustav Wolf |
| 283. | Joined the Blaue Reiter in 1911 | joined in 1912 |
| 289. | Meseck. numbered 1-p | numbered I-V |
| 325. | self industrialist | self-made industrialist |
| 326. | death has entered | Death has entered |
| 346. | 412, Mother and Child | Add: drawing for plate VIII of Schoenberg's Pierrot Lunaire Suite. Galgenlied, 1915. Söhn 16. Richter Edition. |
| 352. | Deutschland, Deutschland | Add: Bodoni-Antiqua Script |
| 366. | Feininger | |
| | Deitscher Arkiv | Deutscher Archiv |
| | Grossmann | |
| | Garphische | Graphische |
| 370. | Schmidt-Rottluff | |
| | Werkseit | Werk seit |

# TABLE OF CONTENTS

For
Joshua Gore Rifkind
and
Adam, Karen and Electra Reed

## FOREWORD

This book-catalog has been published on the occasion of the exhibition of selections from The Robert Gore Rifkind Collection at the Frederick S. Wight Art Gallery, University of California, Los Angeles, shown subsequently at the New Orleans Museum of Art, the St. Louis Art Museum and the Busch-Reisinger Museum, Harvard University.

As is often true with the development of exhibitions, the beginnings of this project rest upon discussions held between three and four years ago among the collector, his dealer-adviser, Mr. O.P. Reed, Dr. E. Maurice Bloch (Director of the Grunwald Center for the Graphic Arts, UCLA) and myself. At that time, I think it is fair to say, no one of us could have imagined the developments that would take place, prior to our realization of the exhibition, in the thinking of the collector, in the development of the collection and in our evolving concept of the show. Mr. Rifkind was a serious collector, taking German language lessons in order to help himself relate to the spirit of his collection, and buying with enthusiasm. In subsequent years he has tended to devote ever more time and energy to his collection, making even more important purchases, traveling often to museums and auctions in Europe and America with increasing zeal and frequency. The result has been the formation of one of the great German Expressionist print and book collections in the world.

In a sense it is fair to comment that the collection has come to possess its collector as much as the reverse is true. During the last three years we have learned to know German Expressionist scholars, editors and translators, secretarial assistants and curatorial personnel who have joined Mr. Rifkind's staff for differing periods in the development of this ever-growing, ever-changing project, which has had at least half a dozen titles over the period of gestation. Most importantly, we have come to know the collector's passion for the excellent and the rare, and we have all come to value the exhibition and its catalog as a reflection of scholarship that should lend insight and meaning to a period that is frequently misunderstood.

I want to express the University's gratitude to Robert Gore Rifkind for his wish to share his remarkable collection with us and with our sister institutions through the form of a traveling show. Since the works are lived with both in the collector's home and office, the loan is a sacrifice that we truly appreciate. I must also acknowledge Mr. Rifkind's more than generous contributions to the funding of the catalog.

I am anxious to salute Mr. Orrel P. Reed, the guest curator for the exhibition. At one point in our early negotiations, Mr. Rifkind suggested that he might have to ask O.P. Reed to take a holiday from his private dealership to become the official curator and author of the catalog essays and entries. Before long this unorthodox arrangement had been undertaken and it has proved to be crucial to the selection of works for exhibition and the catalog's production. Mr. Reed's reputation as a dealer of distinction is well known among leading collectors. It is not so well known that his passion for the German Expressionist period has led him to become a remarkably broad-ranged scholar in the period, relating social issues, politics, philosophy and the historical crises of the time to all of the cultural expressions. O.P. Reed's text opens avenues of research that should provide opportunities for a later generation of humanist scholars.

We are honored that three distinguished American museums are participating with us and we wish to thank Mr. James Nowell Wood, Director of the St. Louis Art Museum; Mr. E. John Bullard, Director of the New Orleans Museum of Art; and Professor Seymour Slive, Director of the Busch-Reisinger Museum, Harvard University for their cooperation and support.

It is my pleasure to express our thanks for efforts on behalf of the exhibition by Consul-General Wilhelm Fabricius of the Federal Republic of Germany. We want also to thank Ms. Karen Reed, of Mr. Rifkind's staff, for unusual service in connection with the production of the catalog and its demanding proofreading chores. A special expression of gratitude is due to Professor Jack Carter of the Gallery staff, for his design of the catalog and installation of the exhibition under severe restrictions of time.

We are pleased to record that this exhibition was organized with the aid of a grant from the National Endowment for the Arts in Washington, D.C., a federal agency.

Gerald Nordland
Director
Frederick S. Wight Art Gallery
University of California
Los Angeles

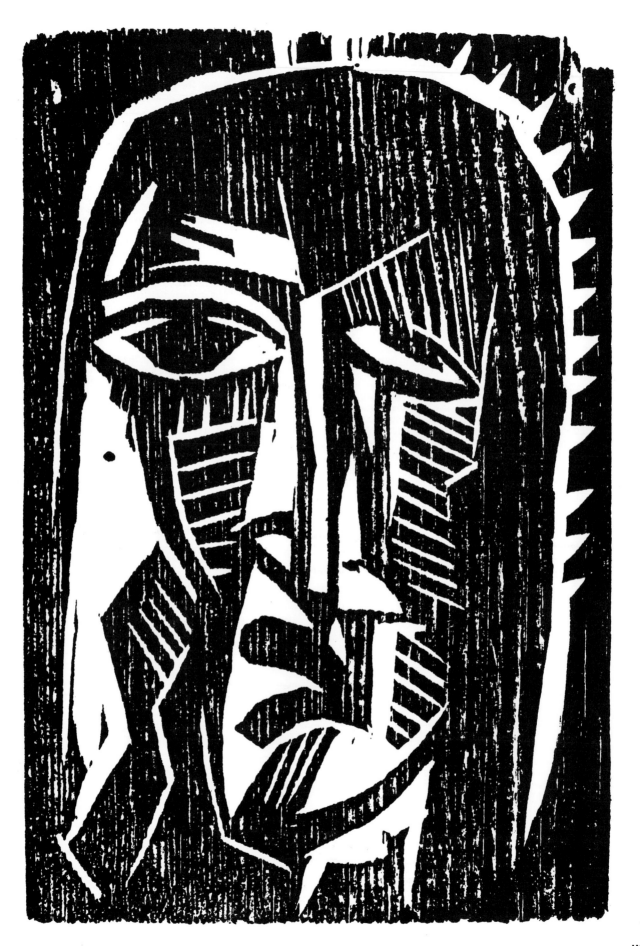

## COLLECTOR'S NOTE

### I

In November 1970, O. P. Reed, Jr., purchased for me my first German Expressionist print, an early Nolde self-portrait. Thus began a six-year art odyssey which was to take us ten times to Germany and criss-crossing the United States. During this six years, we ate, drank, smoked, slept, debated and fought German Expressionism; not just the art, but the poetry, the plays, the films, the politics, the economics. We ate it over rushed sandwiches at the Stuttgart Museum coffee shop and with beluga caviar and 1961 L'Montrachet served by tuxedo-clad waiters at Hamburg's Ehmke Restaurant. We drank it with Mosel on the terrace of the Drei Koenige by the Rhine River, and with German gin in our hotel rooms late at night. We got it into our pores in the sauna at the Bristol Kempinski and while drinking Finnish vodka with the shames of the Orthodox synagogue in Berlin. It was pounded into us in train rides from Zurich to Bern, from Bern to Basel and in the tedium of day after day of Swiss and German auctions. We smoked it over big, black cigars in the lounge of the Atlantic Hotel and fought about it when we were over-tired and could not get taxis in the rain or a ferry on the upper Alster.

O. P. is a wiry, intense man with a dry wit and a sponge-like memory. For him, our odyssey was the culmination of German Expressionist studies begun as a student at Yale in the early 40's and pursued for the next thirty years. For me, it was an intellectual and emotional adventure into a hitherto unknown world.

We explored that world relentlessly. No one and no place was too remote from our curiosity and our acquisitiveness.

On our first trip to Hamburg, I went to Jenischpark, in the suburb of Klein Flottbek where Ernst Barlach Haus is located, and announced that I was there to see the Director. The receptionist firmly explained that the Director was busy, the Director did not see people without an appointment. Having spent forty minutes on the train and walked two miles through the mud to get there, I was in no mood to be put off. With equal firmness, I said that I would wait. Ninety minutes later, a lithe blonde with a beauty mark on her left cheek, came to the waiting room and asked what I wanted. I repeated my insistence upon seeing the Director. She told me to follow her through a hall to a small office, where she sat down at a desk. "Now," she said, "tell me why you want to see me." I was talking to the Director! For five hours, we walked through her lovely Museum, examining every wood carving and bronze. Frau Dr. Isa Lohmann-Siems, the great Barlach authority, became convinced that I was sincere in my desire to study and collect Barlach, and has guided me ever since. We have also become good friends.

In Bern, O. P. introduced me to Herr Hans Bolliger, a solid, studious, bespectacled man in his late 50's, with a vivacious young wife. He invited us to come to Zurich, and, thereafter, we made an annual pilgrimage, always trying to be the first visitors of the season and preferably on a Sunday when no one else would be present. We would sit in Herr Bolliger's apartment for eight hour days, going through everything he had, the good book dealer trying to protect his personal copies from our clutches. Each evening we would ascend the spiral staircase from his library, groggy but happy with our new purchases, Herr Bolliger and his wife gazing over the shambles of his once beautifully organized library.

O. P. introduced me to an art publisher and dealer named Ralph Jentsch, a serious young man of 30, with a cherubic face and a good-looking, bright Israeli girlfriend. He sold primarily by catalogue, since he lived in the relatively remote twelfth century town of Esslingen, about twenty miles outside of Stuttgart. After dealing with dealer Jentsch for a few years via long distance, we decided we had best go to the source. By this time, Dr. Ida Rigby, a willowy, brunette, blue-eyed German Expressionist art historian out of Berkeley, the proud product of Professors Herschel Chipp and Peter Selz, had joined our cause, and the three of us descended on Mr. Jentsch's gallery-residence in Esslingen. To our amazement and delight, he had German Expressionist books we had heard of but never seen, books we

had seen but never been able to buy, and books which we had never heard of! For the next two days, the three of us went through Mr. Jentsch's collection, book by book. When it became apparent that we were not going to leave, he gave us lunch, then dinner, then rooms in his house, then breakfast the next morning. We left poor Mr. Jentsch the next day shaking his head and muttering that it would take days to get our order together and shipped, much less put his gallery in shape.

I took my first trip to Berlin where O. P. introduced me to Frau Florian Karsch, a jolly lady with kind eyes, who, with her husband, owned the famous Galerie Nierendorf. The storm started quietly with lunch at the Berlin Hilton. O.P. said that he had to run down to Munich that afternoon to bid at an auction for me and asked Frau Karsch if she would show me and Dr. Rigby her gallery. Frau Karsch said she would be glad to, not realizing that she was soon to be in the eye of the storm.

Six hours later, a harried Frau Karsch said the gallery was about to close. But we had just begun to fight. Another hour, we implored? Well, alright, one more hour. Two hours later, Frau Karsch announced she was faint from hunger and really had to eat. We struck a bargain; I would take her to dinner at Hardy an der Oper if we could return afterwards.

We returned to the gallery and worked with Frau Karsch's staff until 1:00 a.m. At last, these Californians with the incredible stamina were about to leave! Frau Karsch, I know it's late, but one more favor? I understand you and Herr Karsch have a brilliant personal German Expressionist collection at your home. Could I possibly see it? At one o'clock in the morning! After all, I don't get to Berlin everyday. The gracious Frau Karsch agreed and took us to her home. We drank scotch 'till three in the morning while looking at her treasures. Later, she wrote that it took her staff a week to recover from the onslaught.

One of the German Expressionist scholars I had admired from afar was Dr. Martin Urban, Director of the Nolde Institute in the remote village of Seebüll. Unsuccessfully, we tried to obtain an appointment with Dr. Urban. O.P. and I were dining with Dr. Lohmann-Siems at the Jacob Restaurant, high above the Elbe River. I told her about my problems in meeting Dr. Urban. She said she would call him, one museum director to another. She put through a call to his residence. No, he really could not see me at this time. But, Mr. Rifkind has come 9000 miles from California to see you. Well, tell him I will see him tomorrow, but not for more than ten minutes. I returned to the Vier Jahreszeiten Hotel and had the night concierge order a limousine and driver. The driver showed up promptly the next morning with a long Mercedes, and we drove 180 kilometers an hour up the almost deserted Autobahn towards the Danish border. After driving over three hours, we reached the narrow northerly-most tip of Germany, which divides the North Sea and the Baltic Sea and touches Denmark. The winds were strong and cold and the country desolate. We understood and knew Nolde better already!

Arriving at the Nolde Institute, we were greeted by a tall, handsome, graying Martin Urban. He began the conversation by saying that when Nolde had lived there the place was entirely surrounded by water twelve months of the year and could only be reached by boat; what a pity, he sighed, that was not now the case. Perspicacious person that I am, it became clear that Dr. Urban was not in the mood for chit-chat.

"Dr. Urban," I said, "thank you for seeing us. I realize we have only ten minutes and, therefore, I will ask you only one question. Please tell me what you consider to be Nolde's ten greatest prints." Two and a half hours later, Dr. Urban finished his answer over a leisurely cup of tea. He had shown us through the archives, let us view Nolde's personal collection of primitive art and see the paint cans and palettes that Nolde took into the fields when he worked. In between, we received a brilliant dissertation on Nolde's graphic art. O.P. and I took the long drive back to Hamburg feeling that this had been one of our greatest days. Later, Dr. Urban gave us advice on potential Nolde acquisitions. I think he feels better now that some of Nolde's work is safely cared for and loved in Southern California.

Of all the museum directors we met, none was more gracious than Dr. Gerhard Wietek, Director of the Altonaer Museum in Hamburg. Catering to our tight schedule, he met us early on a Sunday morning, opened the Museum and conducted us on a three hour tour. How many American museum directors would do the same!

In 1975, Dr. Wilhelm Friedrich Arntz, the famous septuagenarian German Expressionist scholar and book collector, met me for dinner at the Dolder Grand Hotel at the top of the mountains overlooking Lake Zurich. We quaffed '69 Meursault and '59 Bonne Mares and ate a six course meal (Dr. Arntz, gray moustache twitching and eyes twinkling, opined that the "meal was definitely deluxe, not the trade edition."). Afterwards, we went back to the room and drank scotch and talked and talked and talked about German Expressionist art books. Dr. Arntz reminisced about his five decades of collecting. There was no book I had or could mention that he did not know and to which he did not add to my own knowledge. It made one very humble. Since then, Dr. Arntz has generously advised and helped fill gaps in my own Collection.

And so it went, our lovely German Expressionist odyssey; cajoling dealers into letting us see galley proofs of their catalogues prior to publication so that we would miss nothing; talking museum directors into opening their museums on "closed" days and letting us go into their basements and backrooms; prevailing upon art historians to permit us to peruse their archives; making photocopies; taking pictures; constantly talking to scholars, dealers, historians, critics and collectors; making notes on everything; and buying, buying, buying!

It has all been very exciting, very tiring, very rewarding and very stimulating. This book, and the exhibition which it accompanies, is an effort to share with Americans the results of our German Expressionist odyssey and to enable the reader and the viewer to partake of O.P. Reed's vast knowledge and my exuberance and pleasure.

## II

From what I have said above, it is obvious that O.P. Reed, Jr. has been the architect of my Collection. In addition, he has devoted the last two years to writing the present book, for which I believe all German Expressionist collectors, scholars and dealers will be most grateful to him, as am I.

The very first German Expressionist "book" in my Collection is a 1957 catalogue with a brief article on Ernst Ludwig Kirchner. I was impressed by the article and have kept it for the past twenty years. The author? Gerald Nordland! Therefore, it seems altogether fitting that Dr. Nordland, now Director of the Frederick S. Wight Art Gallery at U.C.L.A., should have mounted the present show. His knowledge and enthusiasm for the material and this book, as well as the Exhibition, has been constantly stimulating and encouraging. Dr. Maurice Bloch, Director of the Grunwald Center for the Graphic Arts at U.C.L.A., has been both helpful and instructive in his comments. Professor Jack Carter, also of U.C.L.A., physically mounted the exhibition and was responsible for the splendid overall layout and design of this book.

Frau Dr. Isa Lohmann-Siems, Director of Barlach Haus in Hamburg, and Dr. Ida Katherine Rigby, Assistant Professor of Art History at San Diego State University, both have generously contributed articles to this book and their knowledge of German Expressionism to me. I commissioned the late Kate Steinitz to do the special translations of Kandinsky's poems. It is my useless regret that she cannot see the fruits of our labor.

Completing our "team" is Assistant Curator Karen Reed, who spent endless hours doing not only her own work, but cheerfully helping all of the rest of us with ours; the aforementioned Ralph Jentsch of Esslingen, who devotedly read final manuscript and made literally hundreds of valuable suggestions; our translator, Louise Weingarten; our copy editor, Ruth Hoover; and our photographer, John Thomson. Particular thanks to my own secretary, Mrs. Eileen Vincent, who, in addition to her regular duties, has typed pounds of art correspondence, placed innumerable calls and acted as part-time assistant cu-

rator and travel agent for O.P. and me.

In addition to the above persons, I have had a great deal of help, guidance and encouragement on both the Collection and the Exhibition from many people. Among them, I should like particularly to thank Dr. Wilhelm Friedrich Arntz of Haag; D. Thomas Bergen of London; Hans Bolliger of Zurich; John Bullard, Director of the New Orleans Museum of Art; Dr. Dorothea Carus of New York; Camilla Cazalet of London; Professor Herschel Chipp of Berkeley; Arthur Cohen of New York; James Demetrion, Director of The Des Moines Art Center; The Hon. Wilhelm Fabricius, Consul General of the Federal Republic of Germany; Christa Gaehde of Arlington; Eleanor Garvey of The Houghton Library, Harvard; Dean Gordon Gilkey of The University of Oregon; Evelyn Hagenbeck of Hamburg; Barbara Haskell of The Whitney Museum, New York; Catherine Hodgkinson of London; Elizabeth Hofer of Berlin; Dr. Walter Hüder and his assistant Frau Bräuer of Archiv des Akademie des Künste, Berlin; Dr. Naomi Jackson-Groves of Ottawa; Mr. & Mrs. Florian Karsch of Berlin; Morton D. May of St. Louis; Ernst Nolte of Hamburg; Marilyn Pink of Los Angeles; Dr. Leopold Reidemeister and his assistant Frau Seidel of the Brücke Museum, Berlin; Dr. Ernst Scheyer, Senior Curator Emeritus of The Detroit Art Institute; Henry J. Seldis of Los Angeles; Professor Peter Selz of Berkeley; Dr. Seymour Slive, Director of the Fogg Art Museum, Harvard; Moise Steeg of New Orleans; Dr. Martin Urban, Director of The Nolde Institute, Seebüll; Katalin Walterskirchen, Curator of the Kunsthalle, Bern; Dr. Gerhard Wietek, Director of the Altonaer Museum, Hamburg; and, James Wood, Director of the City Art Museum of St. Louis. Appreciation is also expressed to L. Clarice Davis, Ellen Landis, Kathryn Misch, Claudia Rylands and Judith Springer, all of whom did valuable work for the Collection.

My final and most affectionate thanks to my family and my law partners, who have lived with my obsession for the last six years.

Robert Gore Rifkind
Beverly Hills
February, 1977

## AUTHOR'S REMARKS

This is not a complete history of German Expressionism. My intentions were to supplement existing surveys of the field, fill in gaps and extend some interests into new directions. Nor is this a complete list of Mr. Rifkind's Collection, but selections of about 500 items from a total of almost six thousand.

Special thanks must be given to Ida Rigby for her scholarly essays. Dr. Rigby has researched and written fine and compact treatments of both chapters.

Emphasis has not been placed on only those artists who have been promoted by commercial and curatorial ideas of quality and value. One of the major intentions of the German Expressionist artists was to disregard divisions between so-called "fine artists" and "craftsmen". I have followed this method.

I am completely responsible for the final form of each translation. Exact and literal translations were made first. I edited these for an American audience. Original punctuation was used if possible. My final form emphasizes factual information more than exact meter and rhyme.

I cannot begin to thank Bob Rifkind. The woodcut on the cover can suggest some appreciation and symbolism. Robert Gore Rifkind is a humanist. His collection is much more than a picture gallery for walls. It is truly a Zeit im Bild, An Image of an Era.

Orrel P. Reed Jr.
Malibu, California

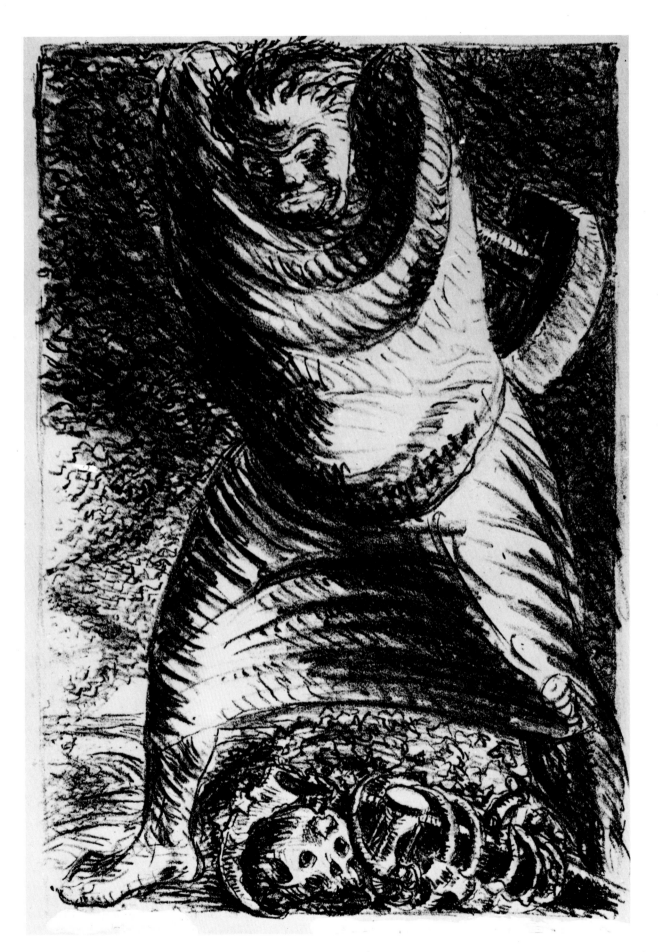

# INTRODUCTION TO GERMAN EXPRESSIONISM

Essences are sometimes artificial distillations from some personal bias. To capture the background of Imperial Germany immediately preceding the beginnings of German Expressionism takes special skills: the sensitivities of the social historian; the humor of the social satirist; the patience of the social philosopher; the detailing of the social statistician plus enough sadness and tears.

Imperial Germany was a complicated structure of loose federation, still disunited because of regional differences and sectional egotisms which are sometimes traced back to early tribal groupings. The north German disliked the south German. The Rhinelander seemed crude to the urbane man of business from Hamburg. Ruling this boiling mixture was the Kaiser, who lived in a world of false pride and falser power. He was a dedicated horseman who used a saddle behind his desk instead of a chair. His taste in almost anything was abominable. Unfortunately this ruler dreamed his dreams of glory and conquest without consulting reality; the divisionism between regionalism and imperialism; the nationalistic reactions of other nations.

The intellectual citizen of Germany, a man of real dreams and imaginations, was far from the center of political power, and had been since the social revolution of 1848. Most intellectuals were professors, artists, educated sons of wealth, writers for certain periodicals, rather overworked editors and the normal Bohemian type who frequented coffee houses.

An intention ingrained in the educational system kept these intellectuals from engaging in public affairs, and most of them turned from nationalism to a cultural internationalism. Though always keeping the idea of the people, the Volk, as a background for social changes, Imperial rhetoric kept the Volk in position and fought social change unless as a reactionary diversion. German kaisers tended to treat their subjects like children; German intellectuals treated their readers on their level of complexity. It is not surprising that most Germans mistrusted the intellectual-artist. Imperial rhetoric was prepared to be understood on low levels for the barely educated. Intellectuals became more and more isolated into peer groups.

These close relations among intellectuals developed a special language taken from their classical training, which in this case meant Goethe and Greece. Later these two G's were combined with the great F, Freud. A dash of Bergson, Nietzsche and international socialism made a strange brew. This idiom differed from the Imperial mixture: thirst for foreign colonies, rapid industrialization and above all a belief in German superiority as a moral imperative. Inevitably, these opposing developments met in frequent encounter.

The impulses collided with a tremendous explosion during World War I, but there always was some freedom under Imperial Germany.

In Expressionism, the inner vision, the passion of personal seeing, the ecstatic intuition are to provide the fundamental sources from which this form takes its concreteness. It is expressionism made fundamental. This is the main link between the artists of this time. The expression is transformed by each personal psyche, by political and social thrusts of individuals. Being set in time, it partakes of everyday events, scandal and victory, national aims and visions of utopia; these are some of the developments interacting into the normalcy of the period from 1905 (or thereabouts) until about 1925, the era of German Expressionism's decline.

In and out of the kinesis move many men and women. Some reveal more expressionism than Expressionism. We must remember that the remnants of German Romanticism were prolonged in the nationalistic education, universal to the citizens. *Der Sturm,* the title of an influential periodical, was also part of the name for a period—"Sturm und Drang": the historical connotation is contained therein.

It is important to distinguish between the two words, as many artists, most modern artists, are expressionists, though not Expressionists. One of the difficulties in the literature about German Expressionism is that scholars tend to group all the creative individuals during this period of twenty years into one heading, Expressionism. We must call it a German movement, and define each artist according to each way of looking at art and life. Certain of the earlier artists were working in late Romanticism, changed to a form like Expressionism: for example Corinth and Slevogt lived through the entire era.

Some foreign artists also brought influences from their native countries, influences that were crucial to the history of German Expressionism. These were absorbed, just as French, Belgian, British and American writings and art were absorbed by the younger creators. Though we call it Germanic, there was nothing specifically German about it. Art is a largely universal impulse partaking of human, not national particles, though propagandists, some among the artists, wrote as though this were so. Without the input of Russian mysticism German Expressionism would not have divided into abstraction, a search for the spiritual clarity and stillness of fixed space. Without the developments in western science at the beginning of the century, German Expressionism would, probably, not have had the freedom of thought, the complete freedom from religious discipline and the fetters of a universalized philosophy, so much sought in the land of Weltanschauung and social discipline. Indeed, many of the thinkers saw fragmented reality as the vision of existence, a lack of unity in formerly held classical dogmatism, man lost in layers of personalized sense data, each individualized, each alone in the vastness of space. This sense of aloneness is a key in the movement.

Movements are groupings of similar minded persons. These were attempts to find some solace in companionship, to find human thought and human spirit that provided some bulwark against the newly seen universal iciness of existence. Instead of searching for God after a profound loneliness was experienced, the German Expressionist artist, forsaking the lesson of Kierkegaard, looked inwardly for the vision of ecstasy, shared the use of the newly discovered irrational unconscious, the parable of existence as described later by Wittgenstein, the relative interchange of space and time as with Einstein, the emphasis on individual sense data as shown in one tendency of European philosophy through Hume, Kant, Nietzsche, Schopenhauer and Mach. This is description after the fact. It is broad generalization using historical information not apparent to the artists. They lived in the flux not above it.

What distinguishes German artists of this double generation, early and later, is the literate expressiveness of their heritage to later generations. Barlach, seemingly a monolith, continued throughout his entire life to clarify and describe. Kafka, man of neurotic inner conflict, wrote clear descriptions of his personal interplay of theme and influence in letters to his friends. Werfel, Nolde and Kirchner, Klee and Kokoschka, Kandinsky and Marc, had this ability to think in terms of descriptive language as well as plastic art.

It was a time of creative expression in the essay form and letters too, an age of intelligence and high literacy among the artists. This also disproves one criticism of formalism as a retraction from life. All these artists were living intensely, thinking, working at a feverish pitch, analyzing, describing, making idea into form. They were abstracting from life, not from a void. They were using inner compulsions, passions for formal and distorted reality, as an image of their age. None were hermetic. Even the isolated ones such as Nolde, exhibited, corresponded, knew what was happening in the art world, and reacted to the events of the time. They read the modern poetry and saw the new drama. Even in seeming isolation, inner life was sensitive to outer life, mostly critical, showing reaction, never drawing on itself alone.

It was a time of intense mental activity, nervous energy, but also political awareness. It was a time of sensationalism too, for the new literate audience was ready for diversion by exposed scandal and corruption. It was a time of muckraking. Leisure, formerly the property of the aristocracy, became a goal of the middle class. And the artists of German Expressionism were mostly from the middle class, not refined in manner or overly

intellectual. It was a rising and ambitious class. Ideas were considered universal. Walt Whitman, Bergson, Dostoyevsky, Shakespeare, Plato and Aristotle, Jefferson, and many others formed the kernel of influences.

From German thought came the ever-in-mind Goethe, Novalis, Schiller, Nietzsche, Schopenhauer and, especially, the Bible of Martin Luther, the founder of the modern German language. The film was becoming popular. It had an influence on language and presentation, for this was the silent film of exaggeration and symbolism that had to fit intervals and titles between action and description.

There was a fascination with the idea of speed and this entered the language through a search for poetic shorthand. It brought, too, impatience. Science had shown possibilities that were still far away. Religion was thought of in terms of language and tradition, not especially of ritual. It was a time of anti-theism. The expression of this inner torment took two paths: one was toward redemption of the world; the other was the opposite of idealism, the presentation of insane realism, of the macabre materialism of unplanned technology, of a realization of the pedantry of naturalistic and psychological description.

There is a connection between literary figures and illustrators in a collection such as this. It is logical for the collector to acquire the books about and by the writers as well as the artists. More than the formalism of the French modern painters, the German Expressionists were never far from the subject. Rather than going directly to abstraction, as came later at the Bauhaus, these painters and draftsmen used social methodology rather than intellectual motivation, and were part of a movement that was united in spirit if not individualism. Expressionism was a side front moving forward in a mass rather than a singular advance.

The coffee houses of Vienna, Berlin, Munich, Cologne, Dresden and other cities were the meeting places. The publishers also were central for discussions and work for artists in and out of the main arenas. Exhibitions were also the forums for exchanging diverse views. The group represented a small and castigated collection, and their followers and collectors and dealers were small in number until the period after World War I, when German Expressionism became more accepted by certain parts of German Society.

The teaching community was against modern art. The class of royalty was more interested in its hunting and social posturing. The legal profession too was very much against the new thinking. There were exceptions – Gustav Schiefler was a judge, but most legal cases against artists were not favorably decided.

Yet there was real excitement in the air. New exhibitions and new publications aroused speculation and comment, sold well to the minority of collectors. New ideas spread fast throughout the artistic community. Periodicals had the most recent diversions quickly dissected and analyzed. Spreading from the coffee houses, poems became famous overnight. The public loved sensationalism. Even the newspapers, written for the commercial middle class, gave fuel to this spreading fire of individual talent and new expression. Plays, such as those produced by Max Reinhardt, were performed to raves and growls of rage. Reaction was split, though very evident. Audiences, in the German tradition, attended performances of misunderstood or unintelligible speeches with quiet attention. Even the Emperor,

with his hatred for the new, allowed wild schemes and gloomy absurdities to be staged. It was an age with an interest in the morbid, the murderous, the pathological, the neurotic, in disaster and conflict. It was truly the Jüngster Tag, the day of judgment. Every aspect of society was judged, rejected or complimented, and exposed to creative light.

Honest books about German Expressionism apologize for the use of oversimplification and simplistic definitions. I do so now. Extensive treatments of all the movements are available and the bibliography provides a basis for deeper study. For the exhibition I must show logical and practical progressions of material, as collected. This book cannot be a real history of German art of this period. It is a cross section of the best examples that could be assembled.

As important as what a person is for, is what a person is against. Temperament, physical and mental health, censorship, wartime service, growing Nationalism, Communism, Fascism, Socialism, revolution and disaster are only some of the diversions that help splinter the walls of our neat cubbyholes. War and peace, especially, changed the direction of this art. These created strong separations, inclined movements outward and away from the initial thrust. Ideas glance off the unexpected obstacles into unexpected areas of investigation, social and aesthetic, the rational and irrational.

War caused immense havoc among the German Expressionists as it did among all the European community. Confidence gained after the long peace of the later nineteenth century was smashed into horror against the trenches of Verdun. Some artists and poets had seen an apocalyptic vision of this future that was contained in pessimism and gloom. All were afraid of the future as well as hopeful.

The introduction to the first section describes the predecessors of German Expressionism. For purposes of clarity, the exhibition and catalogue are divided into periods of highest creativity. Expressionist playwrights called such sections stations. These sequential stations are facets of a time, not entire gemstones.

Criticisms of a foreign work, whether in language or art, tend to stress certain elements of history, reputation, influences and trends, social outflow, biography or other common themes. Values innate in a work must be emphasized too. This means an investigation of content and form. A single impression comes from a single work and this draws attention to the total work.

We know that many German words are not translatable, as there are no equivalents that may match the emphasis and description of special German words. In a work of art, too, much of the intent is also personal and untranslatable. When the artist explains his intentions we find, too, barriers by personal interpretations, special wordings and historical meanings.

Thus, we would like to have the works speak as much as possible in the art forms of the creators. We place form and content before the audience, not purely subjective meanderings. Criticism and value judgments will be attempted within the historical context. We will relate one to the other as content within intent as we read it. Wittgenstein sought, finally, a reality in language through parable; and the art and poetry, rhetorical writing and drama of German Expressionism as assembled in this fine collection will illustrate this exactly.

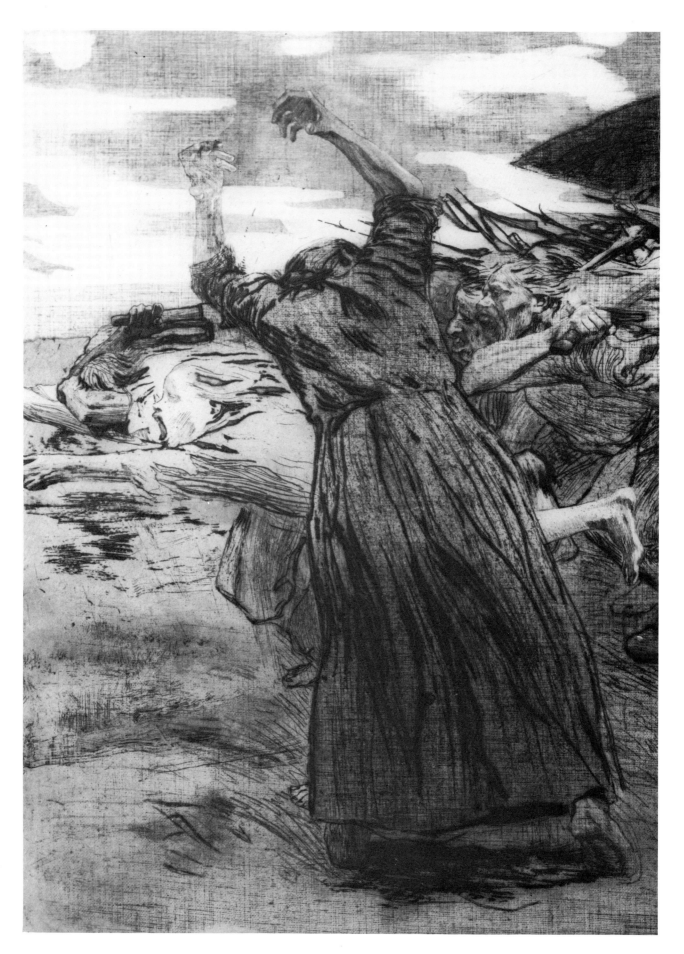

## LIST OF ARTISTS

### GERMAN NEO-IMPRESSIONISTS
Max Beckmann (to 1914)
Lovis Corinth 1858-1925
Max Liebermann 1847-1935
Hans Meid 1883-
Max Slevogt 1868-1932
Lesser Ury 1861-1931

### SCHOLLE (MUNICH) JUGEND ART JOURNAL
Benno Becker 1860-
Max Eichler 1872-
Fritz Erler 1868-1940
Eric Erler-Samaden 1870-1946
Max Feldbauer 1869-1948
Walter Georgi 1871-1924
Hugo Frhr.von Haberman 1849-1929
Adolf Hengeler 1863-
Angelo Jank 1868-1940
Max Klinger 1857-1920 (assoc.)
Adolf Münzer 1870-1952
Walter Püttner 1872-1953
Leo Putz 1869-1940

### NEU DACHAU
Ludwig Dill 1848-1940
Wilhelm Dürr 1857-1900
Adolf Hoelzel 1853-1934
Arthur Langhammer 1854-1901
Toni Stadler 1850-1917

### MUNICH (Important Independent)
Franz von Stuck 1863-1928

### WORPSWEDE (In Order of Appearance at the art colony)
Fritz Mackensen 1866-1953
Otto Modersohn 1865-1943
Hans am Ende 1864-1918
Fritz Overbeck 1869-1909
Carl Vinnen 1863-1922
Heinrich Vogeler 1872-1942
Hertha Stahlschmidt-Mackensen 1884-1949
Hermine Rother-Overbeck 1889-1937
Emmy Meyer 1866-1940
Paula Becker-Modersohn 1876-1907
Bernard Hoetger 1874-1949
Clara Westhoff-Rilke 1878-1954
Walter Bertelsmann 1877-1963
Udo Peters 1883-1964
Georg Tappert 1880-1957
Walter Müller 1901-1975
Hans Saebens 1895-1969
Willy Dammasch 1887-
Fred Ehlers 1891
Karl Jakob Hirsch 1892-1952
Alfred Kollmar 1886-1937
Carl Emil Uphoff 1885-1971
Otto Tetjus Tügel 1892-1974
Bram van Velde 1895-
Albert Schiestl-Arding 1885-1937
Helmut Heinken 1920-1968
Friedrich Meckseper 1936-
Pit Morell 1939-

### GERMAN SOCIAL REALISTS AND NATURALISTS
Theodor Alt 1846-1937
Louis Eysen 1843-1899
Käthe Kollwitz 1867-1945
Albert Lang 1847-1933
Wilhelm Leibl 1844-1900
Johann Sperl 1840-1914
Hans Thoma 1839-1924
Wilhelm Trübner 1851-1917

## JUGENDSTIL, REALISM, AND IMPRESSIONISM

An art movement has a beginning that is also a continuity; the new influence may also be the ending of another era, or the two may overlap into the future. Flux is a complicated event, and influences can be objective or subjective.

The history of German art and literature is interrupted periodically by times of emptiness and lack of skills. It ranged into nationalistic arrogance, sometimes being mere servile imitation and at other times demanding free expression. These elements do not seem to coincide always with other European cultural movements; the peaks of German art do not coincide either. The late 19th century was such a time, not a height, but a bleak and uncreative emptiness.

Art Nouveau, called so in French-speaking countries, has been gradually accepted as the overall title to this idealistic period. In Munich it was called Jugendstil. In Vienna the terms used were Secessionstil and Jugendstil. The ideas probably coagulated (about 1897) in England under the impetus of the crafts movement's attempt to bring back earlier craftsmanship which had been lost during the Industrial Revolution. It was an attempt to improve human life through art as an antimaterialistic movement, partly with the creative use of the new machinery of industry.

Art Nouveau straddles one of the ridges of modern art. It marks the beginning of a new period characterized by a search for original forms. This is its forward reach. In its fear of materialism, its use of art for art's sake, the vision was retrogressive and romantic. Its preciousness was not a social consciousness.

In Germany, the name "Jugend" was a deliberate choice: youth. It defined a strength and faith and inspiration among newly born seers. The periodical, *Jugend,* was the champion of these artists. "Jugend" meant both a faith in the new and rejection. Rejection was represented by traditional form, as used in classical or medieval models. Ornament was to be restudied for rhythm and reason.

Josef Hoffmann was the dominating practitioner of the Secession thinkers. Joining two others, Kolo Moser and Fritz Wärndorfer, he founded the Wiener Werkstätte in 1903. The workshop grew, and flourished in many countries. A program, published in 1905, lists over one hundred workers making designs for over thirty-seven masters and master craftsmen.

Kolo Moser was the first master designer for this workshop. Moser gave the Austrian school a linearity which differentiated the work from the more naturally derived designs of Munich Jugendstil. One abstracted from flat, mathematical progressions; one was reducing natural objects to schematic simplifications.

This Austrian world of art overflowed with ideas. It closed a circle with the intellectual of Vienna. The psychologically analyzed plays of Arthur Schnitzler, the wit and charm of Peter Altenberg, Idealistic philosophy as represented by Ernst Mach, von Hofmannsthal's pure and lyrical early poetry all make up influences on Jugendstil. Robert Musil scans this dying age of the Austrian monarchy. Karl Kraus writes savage criticism, lyric poetry and deep satire. The new cinema, the deep cross-fertilization among artists of many nationalities in this center of twin kingdoms gives a microcosm of intelligence and energy.

The greatest designers of Jugendstil were in Vienna, though some offshoots worked in or near Munich. Yet the influences on later German Expressionist artists came from the posters and illustrated books by these artists of Munich and Vienna, but published by great houses in Berlin, Leipzig and Jena.

The legacy of Jugendstil was paramount. It reinforced the view of art as on one plane rather than a view of three dimensional hills and mountains. Japanese and Persian influences had been used in the new modern art, Art Nouveau, breaking the hold of Grecian and Roman Ornamentation, which formerly represented the height of European culture. The emphasis on graphic art also gave the younger man a free hand in these mediums. The use of pure color, linearity, stark black and white patterning, personal ornamentation, repetition, a new sense of scale, study

of varying line, the baroque curve and rectangular simplicity all made an impact on the German Expressionists.

It was in the book design and poster design of the Jugendstil that the influence was unsurpassed. These were seen all over Germany in magazines of art, the theater, in the schools and most other areas in which these young artists were tasting change.

The Expressionists put their faith in art and literature as other men worshipped dogma. For most, the visions were more important than the planning. Fortunately, the freedom of the artist to do his work was the heritage from the past, the victory of the individual in an authoritarian society.

Cross-fertilization caused by the travels of peripatetic artists and publishers made the movements understood almost immediately all over Europe. We must remember that the fine books of this period were the products mostly of small firms. During some of the award giving for fine book design, the small presses would have taken all honors; however only a portion of the yearly awards were given to these publishers. Commercialism was not forgotten.

The earlier Jugendstil design was a kind of stylized ornament which was graceful and calligraphic. The later artists of the Wiener Werkstätte changed this oriental-based stylization to a more formal, elemental theme of repetition and parallelism. Geometry became more important than symbolism through the display art of architect-trained designers. The ruler and T square dominated.

The Impressionist painters and printmakers of Germany were, of course, somewhat dependent on rhetorical provisions from France. German Impressionist painters represented a kind of internationalism as opposed to the growing nationalism fostered by the government and allied with the Realist school, with a few notable exceptions. Popular literature' was also naturalistic and nationalistic. The Impressionists were cosmopolitan men well traveled and fluent in many languages, very interested in recent international developments in the science of light and color.

Most of the realist printmakers and painters presented a dual role beyond nationalism. They emphasized social ideas as well as naturalistic drawing. Art became part of the thrust for social justice. This major development occurred in the late nineteenth century, a time of Marx and Engels, the rise of unionism and the belief in man's ability to solve social and physical problems through scientific analysis; and it carried through the entire development of twentieth century art in Germany.

We have three themes for Expressionism in Germany: Idealism or human happiness through art; Impressionism or the use of new scientific theories of vision to see nature in a new way; Realism showing that man could be improved. All were primarily idealistic in art, though their counterparts in literature were not always so.

Foreign influences entered through these three major filters. They were given interpretation through selective sensitivities among the leading creative minds.

What was the legacy of Jugendstil, Impressionism and Realism for the German Expressionists?

Realism became an opponent, a cause to be against. Inner search for personal symbolism, personal calligraphy took the place of social propaganda, though this stream continued, too, as a reinforcement to the personal approach. The Expressionists held to the idea of human improvement, to the idea of art as a force in the improvement of the human race.

Impressionism was a bedfellow with Expressionism for some time, though family quarrels were common. Max Liebermann and Lovis Corinth helped many young painters; most were under thirty. Impressionist graphics had influence. Line had become the basis of light vibration instead of color. Line had been studied in varied ways. Atmosphere and depth were made real with wavering, unrealistic contours. The young Expressionists, with their idea of rebirth (literally as in the case with the Brücke men) restudied these elements.

## MAX BECKMANN

**1. Verkauf der Gefangenen** *(Selling of the Prisoners)*
Brown ink drawing, ca. 1909 (dated by Dr. Ernst Scheyer)
10.8 x 12.6 cm, signed and dated in pencil

The twenty-five-year-old artist had no sympathy with the German avant-garde in this year of 1909. He was more interested in reducing the atmospheric effects to a singular stylization within the impressionist language. He was aggressive with detail and somewhat sentimental in attitude.

Beckmann had studied great crowds of writhing figures. There were themes taken from his admiration of Delacroix. This crowded sketch is possibly a scene from the *Destruction of Messina,* painted also this same year of 1909; now in the collection of Morton May, St. Louis.

Beckmann keeps an open feeling with his Rembrandtesque placement of light on the grouped figures. He is studying the placement of figures, not details. The theme of endurance is another major one for the young artist. He shows the dejected figures as they react to the event. He becomes the stage director more than the formal designer.

**2. David und Bathsheba** *(David and Bath-Sheba)*

Lithograph, 1911, Gallwitz 14
31.5 x 25 cm., signed and numbered
Verlag J. B. Neumann
Editions: 3 impressions on parchment, 20 impressions on japan, 40 impressions on Bütten

Beckmann had studied subjects from the New Testament in 1911. His other literary interests were the Old Testament and Goethe's *Faust.*

His BathSheba is an impersonal nude, squat and white. King David is a mere spot on the upper rooftop. The design is based on two white areas circled by deep blacks, with darks threaded through the composition.

**3. Sechs Lithographien zum neuen Testament** *(Six Lithographs to the New Testament)*

Six Lithographs in a portfolio, 1911.
3/1. Christus in der Wüste *(Christ in the Desert)* g.5
3/2. Die Taufe *(The Baptism)* g.6
3/3. Christus und die Sünderin *(Christ and the Adulteress)* g.7
3/4. Die Bergpredigt *(The Sermon on the Mount)* g.8
3/5. Abendmahl *(The Lord's Supper)* g.9
3/6. Die Würfler unter dem Kreuz *(The Dice Players Under the Cross)* g.10
Berlin-Steglitz: Verlag E.W. Tieffenbach, 1911
Printed by Birkholz, Berlin
Portfolio with cardboard cover: 59.8 x 43 cm
Prints: 58 x 41.5 cm (sheet)
Title page and 6 prints, each signed, on heavy laid japan paper dedicated on title page by Beckmann, Christmas 1912.
Gallwitz 5-10

From his Secessionist comrades, Beckmann learned sensitivity, strength in technique, and imagination.

Beckmann had spent some time in Paris and Florence, gaining knowledge of monumentality and mastery of space from such masters as Signorelli and Piero della Francesca. After returning to Berlin in 1905, Beckmann fell under the influence of Lovis Corinth, who was still a Naturalist-Impressionist.

The drawings for the Bible are quick and brutal. Characters are oriental, almost Russian types. The Christ figure is not a weakling, but a man of dignity and discipline. Beckmann tried for a sonorous black, varieties of effects with the crayon scratched overtones or a blunt twisting of heavy shading. A certain fierceness, a sure brutality pervades the illustrations. Beckmann tried to hold down the overstated gestures. But these New Testament drawings presented wordy scenes of dialogue through gesture and symbolic pose, unlike the naturalistic drawings of other Secessionists.

2.

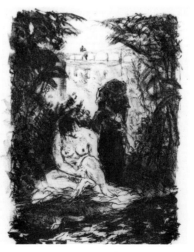

3/1.

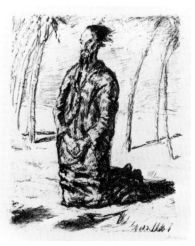

1.

**4. Aus einem Totenhaus Das Bad** *(From the House of the Dead—The Bath)*

Sieben originallithographien von Max Beckmann
from: *Kunst und Künstler, Jahr XI, Nr. VI* (March 1913)  p. 280-296
Berlin: Verlag Bruno Cassirer
Gallwitz 28 (1-7)
Page size: 32 x 25 cm.

Beckmann illustrated an episode in *House of the Dead* by Dostoyevsky. The chapter describes two bath houses in the penal camp: one for hire and the other for poor Volk. The men are nude but shackled. Their barbarity, humanity, and humor while bathing is described by the sympathetic author.

This early and prewar Beckmann still is engaging in a great dialogue with the past. His admiration for that other miller's son, Rembrandt van Rijn, is apparent in the sketchy use of line crayon, the quick shaping, the full light and shade. There is little originality or modern feeling beyond the impression of the scenes.

His studies with the Norwegian painter, Frithjof Smith, had developed his facility with charcoal as the basis of painting, with sketching as the view into the nature he loved in this early confident and still optimistic stage. Beckmann felt a love of the object itself, the warm sheen of skin and appeal of the material. Even a later Beckmann never sought the spiritual in itself, but portrayed the object-ness of the subject as a mystery in black space.

## LOVIS CORINTH

**5. Das Buch Judith** *(The Book of Judith)*

Bücher der Bibel in der Übersetzung von Martin Luther *(Book of the Bible in the Translation of Martin Luther)*
Zweites Werk der Pan-Presse
Berlin: Pan-Presse. 1910
Pan-Presse directed by Paul Cassirer
2nd work of the Pan-Presse
Edition: 250 examples, 60 numbered examples on japan paper, each print signed and colophon signed by the artist
46.5 x 37 cm.
Unpaginated
Printed by Imberg & Lefson, Berlin
With original color lithographs by Lovis Corinth (vignettes and full-page illustrations.)

The eight full page, signed color lithographs by Corinth made for this book are the early, non-expressionist examples of his style. It was his second illustrated book: his first was finished in 1894. Fifteen other lithographs are interspersed through Luther's text.

This is Corinth the Mannerist, the student of oriental costume, the theatrical artist, the painter of drama on canvas and paper.

The story is one of apocrypha, not included in most Jewish and

**6. Selbstbildnis** *(Self portrait )*

Lithograph, 1914
Schwarz L.161b, second state
1/5, signed and inscribed in pencil
Editions: 1st state - a few examples, 2nd state - 5 examples, 3rd state - 25 examples on japan and van Geldern paper
21.5 x 26.8 cm.

Corinth found himself fascinating, though not as a primarily egotistic vision. There is always something of the demonic, the Germanic interest in violent emotion underlying the placid reality of direct observation. Corinth's fantasy always intrudes.

His crayon is treated as is the diamond point in drypoint. He bears down heavily for emphasis and keeps the line linear not tonal. In this way Corinth keeps his vision open and directed through the medium, as his talents are not forced into a study of dark and light. There is always expressive fervor, too, which marks his difference from the French. He is too bound up in himself. The emphasis here is on observation of various expressions of his face used for the accomplished rendering. The decorative is not used, but non-aesthetic fleshiness. This is German demonic, a meeting of vitalism with nature.

Protestant canons of the Old Testament. It appeared in pre-Christian Greek versions for Greek-speaking Christians as well as the Latin version of the Roman Catholic Church. Luther translated from the latter canon.

The heroine of the book of Judith kills the commander of the Assyrian forces, Holofernes. The subject of devotion to duty, to one's community, was an important theme in German literature. Friedrich Hebbel's play on this theme had been performed. Corinth attempts to combine the sixteenth century folk imagination of Luther with the compelling story of a heroic woman. She is tender and fierce, using sexuality and overcoming the enemy general by temptation. There is little more than seeing in the illustrations; there is little feeling. The works are strong and unsentimental, with fine dramatic awareness, a sense of humor at man's weaknesses. Corinth here is the traditional German artist, following the line of Cranach, Dürer, Melanchthon, and Luther in their profound interest in the revolutionary and nationalistic battle for emergent German arts and letters.

One can also compare Corinth's version with the exquisite illustrations of the nineties. His creatures are of this world, not dematerialized designs. There is fleshiness and earthiness, not flat aestheticism. Nevertheless, it is a costume play, a cultural charade.

4.

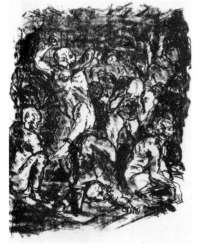

5.

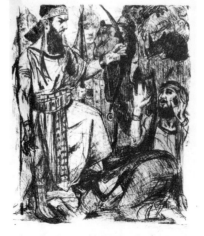

6.

## MAX LIEBERMANN

**7. Das graphische Werk von Max Liebermann** *(The Graphic Work of Max Liebermann)* von Gustav Schiefler

Berlin: Verlag Bruno Cassirer, 1907
26 x 20 cm., (1f) 75pp (3pp)
Etching printed by Carl Sabo, Berlin
Book printed by W. Drugulin, Leipzig
Edition: 300 numbered examples, 1-10 on handmade Bütten paper, with one original etching, 11-300 on "Subtonicpapier" with one original etching
Size of etching: 9.8 x 14.7 cm.

Max Liebermann was the great master of the Secession. He was a sane vigorous artist, exceptionally intelligent and witty. He had no French taste, instead was deliberate in his vision and saw into his impressions with diabolical dexterity and cleverness.

The etching for the early oeuvre catalogue by Schiefler is typical of his maturing and nervous line in etching. Made on the spot in a market in Amsterdam, it readily conveys sense of immediacy. Although the etching is from a series of sketches for a painting, Liebermann uses the etching as a functional medium, not as a substitute for drawing. There is outgoing mood transcribed, complexity by linear vibration, a deep space, and repeated motives giving visual transitions (7).

**8. Grosses Selbstbildnis, stehend und zeichnend** *(Large Self Portrait, Standing and Drawing)*

Lithograph, 1912
Schiefler 135 b
38.1 x 30.4 cm.
Edition: 50 examples, signed in pencil

We can see in this self-portrait by Max Liebermann his feeling for captured mood, for humanistic strength. It is a naturalistic world. There is no literary sentimentality. The lithograph shows his darktoned and objective realism. But by 1912, Liebermann had begun to use omission rather than an all-complex Impressionism.

**9. Bassompierre** *(Bassompierre)*

von Goethe
Mit drei originallithographien von Max Liebermann
Four page excerpt from: *Kunst und Künstler*
Jahr XV, 1917, Pp. 463-466
Berlin: Verlag Bruno Cassirer
Page size: 29.5 x 24.3 cm.

*Bassompierre* is one of two short stories Goethe wrote for a collection of Boccaccio-like tales collected in the book *Unterhaltung deutscher Ausgwanderter*. It is a slight tale of sinister and mysterious forces taken from Bassompierre's memoirs.

Liebermann's sketches for the scenes are quick and exact. The lithos for Goethe's story are developments after Liebermann had perfected his techniques in etching and drypoint. His first lithograph, a study, was done in 1896; a second was done for *Pan*. He did only one other until after 1900. But by 1917 he had purified his great draftsmanship.

Using wit and style, Liebermann exaggerates doom and sadness, with tongue in cheek and irony. Even in literal illustrations, he catches momentary impressions of life with his quick animation and articulation of space. His contours are tight. His line is the major force in the lithographs. He tries to project his intellectual trend toward common people, i.e., socialism, rather than the stiffness of Imperial pose.

## MAX SLEVOGT

**10. Sindbad der Seefahrer** *(Sindbad the Sailor)*

33 original lithographien von Max Slevogt
Berlin:
Bruno Cassirer, 1908
33 lithographs with illustrated cover design
36 x 28 cm, (1f)
(60pp (1f)
Edition: 300 signed and numbered examples
Signed by artist on justification page

Bruno Cassirer, the publisher of this portfolio, was a publisher as well as an art dealer; he was probably known more for the former profession.

Max Slevogt's *Sindbad* for the *Pan* workshop was a sensation in 1908. *Leatherstocking Tales* followed a year later. Slevogt was the perfect vehicle for the new development in Germany. He had proficiency with drawing for a creative use of the relatively new artistic medium of lithography. *Sindbad* was Slevogt's third illustrated book. The *Achilles von Homer* had been made for Langen in Munich one year earlier and *Ali Baba* in 1903.

*Sindbad* begins with fanciful initials before the first chapter. These are more than abstractions from the shapes of letters, but miniature scenes. Later chapter headings have small rectangular scenes. The lithographic technique is based on silhouettes, with dark shadows marking black calligraphy in outline. There is a sense of seriousness, a mood of dark mystery to the illustrations. Characters are not the slim hawkfeatured Arabs one might expect, but heavy Germanic types.

All the lithographs are fresh, have spontaneity, and strong power through contrast—perhaps too much strength to compete with the text.

**11. Aquarelle zu Mozarts Zauberflöte** *(Watercolors for Mozart's Magic Flute)*

Fünfzehn Faksimiles nach Aquarellen und ein Faksimile nach einem farbigen Steindruck
Text by Wichert
Designed by E. R. Weiss
Druck XXV,
Marées Gesellschaft,
Munich, 1920
R. Piper Verlag,
Munich
Recorded editions: 300 in total. Ausgabe A: 65 examples on Van Gelder paper numbered I-LXV. Ausgabe B: 235 examples on Hadern Paper numbered 1-235.
A proof impression of the title page before color plates.
Lithograph,
28.5 x 24 cm. signed and numbered.
From an extra edition of this print in 100 impressions.

The magic play, *Zauberstücke*, had a devoted audience in Vienna. It was an offshot of the lavish Baroque drama; and offered a fairy world in which a common man experiences changes from his simple-minded ways.

The libretto of "The Magic Flute" was by Emanuel Johann Jakob Schikaneder (1751-1812) an actor, singer, and writer. He sang the part of Papageno during the original performance on September 30, 1791.

The complex allegory of humanitarianism through Masonic elements— both the author and Mozart were Masons—was built into sublime music by Mozart during the last year of his life.

Max Slevogt shows all the major participants: Sarastro the wise with his magic flute; the evil Queen of the Night with her passionate gesturing; dwarfs and maidens all before a stage, with prompter's box and candle covers.

This lithograph was hand colored and reproduced in facsimile in the Marées-Gesellschaft edition of 1920. A small edition of one hundred impressions was separately printed and sold at the Cassirer gallery in Berlin.

8

**7.**

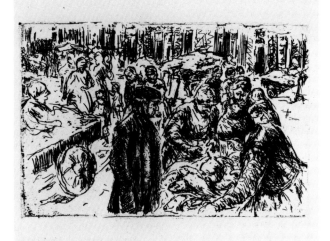

**10.**

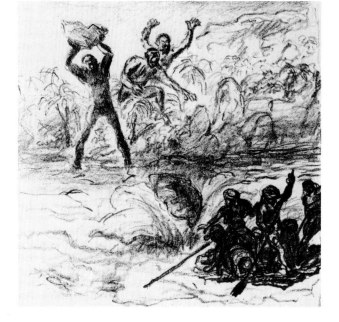

**8.**

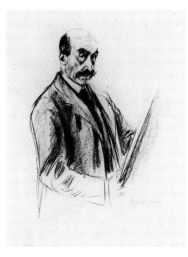

**11.**

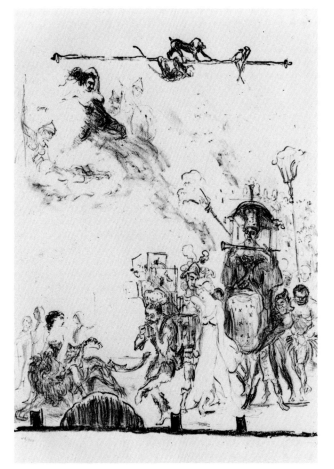

**9.**

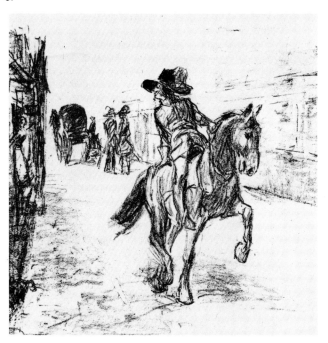

## KÄTHE KOLLWITZ

The earliest work of Käthe Kollwitz is based on her academic training under the great draftsman, Karl StaufferBern, the Swiss genius whose short life ended masterful developments in portrait etching. Through this extraordinary teacher, she first saw the works of Max Klinger, whose technique became a principle influence on the young woman.

After her marriage to Dr. Karl Kollwitz in 1891, the young artist and her new husband settled in Berlin, where the doctor specialized in care of the poor, an early form of socialized medicine. This background was her source of inspiration; and her early series, *The Weavers*, had some success at the Lehrter Bahnhof in Berlin. She was awarded a gold medal, but Kaiser Wilhelm II suppressed the honor.

### 12. Die Carmagnole *(The Carmagnole)*

Charcoal drawing, 1901
48 x 37.9 cm.,
Timm 177, Bittner Pl. 17
Signed in pencil,
preliminary drawing for Klipstein 49

### 13. Die Carmagnole *(The Carmagnole)*

Aquatint and etching, 1901
58.7 x 41 cm., Klipstein 49 VIII/VIII
Unsigned edition of E.A. Seeman, Leipzig

Both print and drawing were inspired by a reading of Charles Dicken's classic, *A Tale of Two Cities*.

The design is built around the drummer boy, who is beating out his message of revenge to the aroused women. The composition is also constructed in three layers: buildings rise in two masses; horizontal vibrations of reaching women; textures of cobblestone streets. Each plane is a change in texture.

In this drawing the quick draftsmanship is emphasized by verticality. In the later etching of the same year, the background houses become mysterious and closed forces. The black line of figures is changed in the print to become black and white, with the whites acting as zones of activity. The emphasis changes from humanity to environment. The gestures form a triangle pointing to the blade, instrument of death.

13.

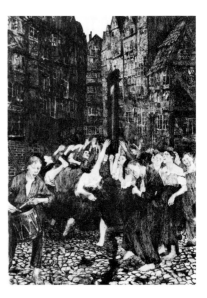

12.

14.

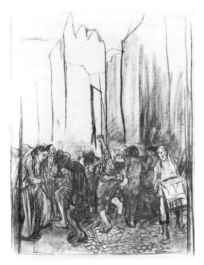

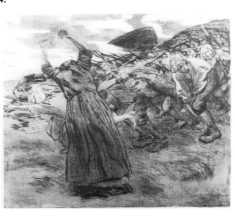

### 14. Losbruch *(Rebellion)*

Aquatint and etching, 1903
51 x 59.4 cm., Kl. 66 IX/XI
Leaf 5 of Bauernkrieg
On yellowish copperplate paper, signed in pencil.
Printed by O. Felsing, Berlin (Richter edition of 1921)

This is the fifth plate of a series, *Peasants' War*, published between 1903 and 1908. Though this plate is in the middle of the series, the artist conceived it first. It has the greatest image. The point of time is the explosion into revolt of the peasants. A great phalanx of people is streaming left towards an unseen enemy, a device common to Kollwitz.

This is a soft-ground etching in which texture is obtained by transferring the drawing through a rough material, probably linen in this case; and the ground is made of a soft wax mixed with grease, to transfer. As the plate had been aquatinted in advance, the textures gathered around the grouped dots from the resin. White areas were stopped from biting acid by a varnish.

There were seven changes in the plate until the artist finally considered the image perfected. Kollwitz worked back into etched areas after preliminary soft-ground texturing was applied. She toned down areas, emphasized light shapes, and textured by drawing, too. One reason for this technique is to achieve a less fragile surface than that of classical etching. The tonal range can be carried much further. Also, surface will not deteriorate as quickly with a large edition.

### 15. Brustbild einer Arbeiterfrau mit blauem Tuch *(Bust-length Portrait of a Working Woman in a Blue Shawl)*

Color lithograph, 1903
On ivory japan paper, signed in pencil
35.2 x 23.8 cm., Klipstein 68 II/III

This lithograph is one of a few proofs of the second state. The second state is rare. It was made with a brilliant blue ink that was changed later to a duller color. The ivory-colored Japan paper lends a softness to the printing. It is absorbent and slightly fragile for printing.

Careful use of the crayon in various strengths and widths places a tonal range over the surface. The background and bust are drawn in brown, using complex shading at the edges, though at first glance the tonality seems overall. Edges are the key to this lithograph. A bright blue is printed over the brown, to set dark areas; some are very dark. Another dark blue is carefully drawn with a fine crayon point to make up the finer detail of the shading and light pattern. A thin edge of pure light places the range into white. The edge of the face and side of the nose are picked out to throw these areas into powerful display, turning the form and articulating a sense of power to the face. Shading is directed around forms on the inner surfaces. The brooding face of the favored Slavic type is cast in a shade of beauty and dignity.

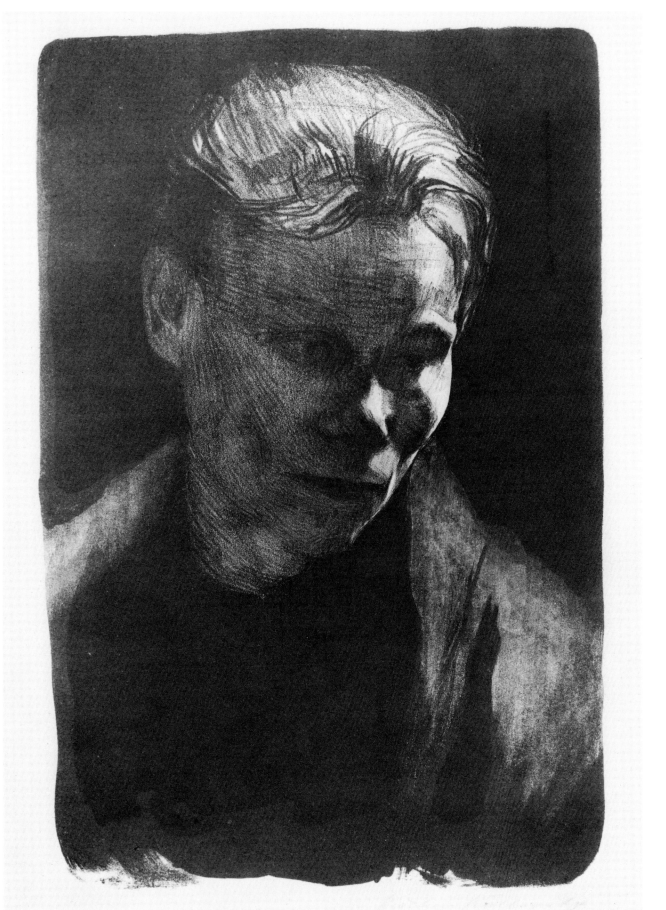

**16.** Halbfigur einer Frau mit verschränkten Armen *(Bust-length Portrait of a Woman with Folded Arms)*

Pastel and crayon drawing, 1904
On violet-grey paper, signed in chalk
60 x 40 cm.
Related to Klipstein 85

Back-lit figures are studied many times in this early period of the artist's life. The technique is classical. Kollwitz uses the violet-grey paper as her middle range and establishes dark with black chalk. Yellow and white pastel mark the light-thrown forms, which round the shapes naturally, allowing the back tone to work undrawn.

From this naturalistic approach, Kollwitz works into an emphasis that is not realistic. Hair, cast shadow of neck, outline of left hand and underarm are over-darkened to create a rhythm of line. Both light and dark areas are patterned by drawing, not from observation alone. The loosely held pose is transferred to the paper with an easy intention.

Economy of means in the hands of a skilled artist can provide a sense of reality, creative realism, without showing struggle in its attainment.

16.

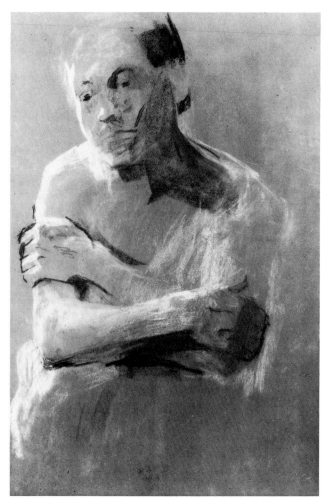

17.

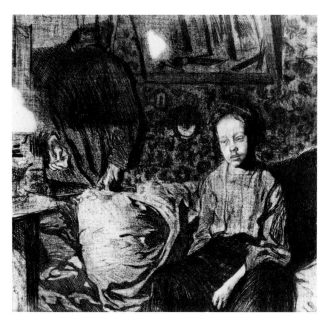

**17.** Junges Paar *(Young Pair)*

Etching and aquatint, 1904
29.7 x 31.8 cm, signed in pencil, Kl. 73 IIIb/V
Numbered 5/50
On yellowish copperplate paper
Printed by O. Felsing, Berlin (published by Richter, 1920, edition of 50 signed and numbered prints)

Literary subjects are paramount in these early works, The subject for this etching was taken from a three-act play, *Jugend*, published in 1893 by the dramatist, Max Halbe (1865-1944). Halbe was a follower of the naturalist tradition of Ibsen, and also a specialist in social problems of the German eastern regions, which was a major center for Kollwitz's character studies of facial types.

The patterning of the design was probably influenced by the French, Vuillard in particular. Such details as the brightest lights appearing reflected are Kollwitz's personal touches of mood. They set the tone as a dark image in the pain-filled room. Experience with the printer Felsing had given this artist a wide range of strict tonality. The design of cloth folds, diagonal breaks and off-centered placement of whites gives a deep luminosity to the crossed forms. Every aspect of the design is drawn for mood. The slanting picture on the far wall, the folded hands, the slump of the female figure and resignation of the man all move in and out of space in the stillness of sadness.

## 19. Männliche Figuren *(Studies of Men)*

Crayon drawing with charcoal, 1908
44.8 x 57.4 cm.
Signed and dated
A study for Klipstein 98

This drawing was made as a preliminary study for one of the figures in the preceding print, Die Gefangenen. It is the fifth head from the left. The clothed figure is drawn from a live model. Each person in the group was studied and placed carefully. Many of the faces are from the same model, an academic method. Even the smallest detail was worked out before the plate was etched.

But these are not individuals as symbols, but masses in revolt. They were the nameless, not the individualistic. They were from a time grown fluid in memory, four hundred years before, from history books made real. The actual Peasants' War had ended in complete defeat and massacre of the people. For two hundred years they became people without protection.

19.

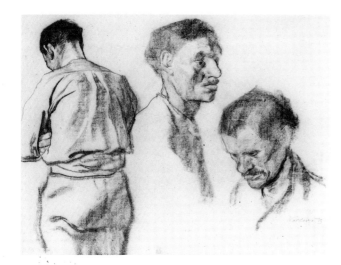

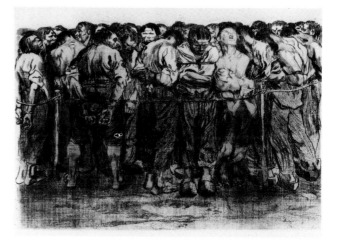

18.

## 18. Die Gefangenen *(Prisoners)*

Aquatint and etching, 1908
32.7 x 42.3 cm, Kl. 98 V/VIII
On white copperplate paper, signed in pencil
Leaf 7 of Bauernkrieg series
Before the reprinting of 1921

Though not completed until five years and thirty-two prints later, this scene of prisoners closed the cycle of Kollwitz's interpretation of the *Peasants' War*, which was emotional, not from literary influences.

A depiction of bound men and women could be treated either with realism or not. Kollwitz chose a mixture of both. The subjects are ape-like, Slavic faces over powerful bodies. There is little intelligence in the faces, but, just as Kirchner looked at calligraphy for expression, Kollwitz found hers in the skillfully-drawn lines which block out the forms. Complexity seems apparent, a close survey shows detail is mostly in the over-texture from the soft ground. The actual drawing is perfectly functional for the medium; and deep lines for ink plus a full range of values set well for a large edition. There is no romantic imagery here, but bold masses, patterning and sculptured movement.

# LIST OF ARTISTS
# ART NOUVEAU

**SIMPLI-JUGEND: MUNICH ILLUSTRATORS**
Walther Caspari 1869-1913
Franz Christophe 1875-
Marcello Dudovich 1878-
Reinhold Max Eichler 1872-1947
Walter Georgi 1871-1924
Richard Grimm 1873-
Olaf Gulbransson 1873-1958
Thomas Theodor Heine 1867-1958
Karl Klimsch 1867-
Bruno Paul 1874-
Peter Pietzsch 1872-
Ferdinand von Reznicek 1868-1909
Carl Schmidt-Helmbrechts 1872-1936
Eduard Thöny 1888-1950
Albert Weisgerber 1878-1915
Erich Wilke 1879-1936
Rudolf Wilke 1873-1908

**JUGENDSTIL MUNICH**
Karl Bauer 1868-1942
Otto Bauriedl 1881-
Peter Behrens 1868-1940
August Braun 1876-
Lovis Corinth 1858-1925
Julius Diez 1870-1957
Otto Eckmann 1865-1902
Fritz H. Ehmcke 1878-
August Endell 1871-1925
Fritz Endell 1873-1955
Raimund Geiger 1889-
Hermann Haas 1878-1935
Fritz Hegenbart 1864-?
Julius Hess 1878-1957
Ludwig Hohlwein 1874-1949
Eugen Kirchner 1865-1938
Ernst Neumann 1871-1954
Hans Neumann 1873-?
Adelbert Niemeyer 1867-1932
Hermann Obrist 1863-1927
Berhard Pankok 1872-1943
Emil Preetorius 1883-?
Richard Riemerschmid 1868-1957
Walter von Ruckteschell 1882-1941
Alexander von Salzmann 1870-?
Hans Schmithals 1878-?
Karl Strathmann 1866-1939
Carl Thiemann 1881-?
Hans Unger 1872-1936

**VIENNA SECESSION**
Ferdinand Andri 1871-1961
Gustav Klimt 1862-1918
Rudolf Jettmar 1869-1939
Friedrich König 1857-1941
Max Kurzweil 1867-1916
Wilhelm List 1864-1918
Elena Luksch-Makowsky 1878-
Karl Moll 1861-1945
Koloman Moser 1868-1918
Felicien von Myrbach 1853-1940
Josef Maria Olbrich 1867-1908
Emil Orlik 1870-1932
Alfred Roller 1864-1935
Ernst Stoehr 1860-1917

**WIENER WERKSTÄTTE**
Carl Otto Czeschka 1878-1960
Albert Paris Gütersloh 1887-
Joset Hoffman 1870-1956
Gustav Klimt 1862-1918
Oskar Kokoschka 1886-
Berthold Loeffler 1874-1960
Koloman Moser 1868-1918

## JUGENDSTIL IN VIENNA

The renaissance of Art Nouveau, Jugendstil, in Vienna was not directly a product of painters. Vienna is an atmosphere, an attitude, a fancy and a habit much more than a way of seeing.

Living was the art of the Viennese, who tried to be modern and up-to-date, but were without a strong prejudice against the old. Adolf Loos, with his rational criticism, was an exception. The other Viennese, and this included most of the population from the nobility through the middle and lower classes, preferred over-crowded rooms, stuffy atmosphere, and many possessions piled together as if to exhibit their material riches to the world.

It is probable that color was the single most important aspect of Jugendstil in regard to the Viennese public. The new use of architecture, the British philosophies of art, William Morris, Mackintosh, the Pre-Raphaelites, Ruskin et al, permeated the arts and crafts education through teacher and pupil.

Existing in a city that did not support painters, Jugendstil was promoted in conjunction with literature and the stage, through the publicity poster and the space for living. Color and color alone appealed to the people. It had immediate emotional appeal without much intellectual involvement, for most Viennese did not respect deep thought: it was too serious. The real atmosphere of Imperial Vienna was frivolity amid deep poverty and prejudice. This is also why magic was important in early Jugendstil in Vienna, for it was already there, and when Kokoschka wrote about magic in his play *Murderer, Hope of Women*, the challenge seemed invalid only to conservatives.

To be non-conformist was to be normal in the level of society of which we speak. Most of the artists and writers seemed youthful in appearance, boyish. They were a verbal generation. It was a society of gesture, of emphasis by the hand and body. Postures which seem mannered to us were not unreal to the contemporary viewer. The most radical minds, most of them the truly original artists and poets, left the city for other places. To the Viennese intellectual there were limits to permissible originality, and to intellectuals like Albert Ehrenstein and Georg Trakl, Germany seemed a richer ground.

Karl Kraus was the spokesman for criticism of language. Among the periodicals in Vienna, *Der Anbruch, The Rescue, Daimon, The Pamphlet* provided inspirations. Berthold Viertel gave expression to the new times in his stage productions, and Richard Strauss had already promoted the exotic and energetic in his early operas.

No internal schisms separated Jugenstil and Viennese Expressionism. The two overlapped with Gustav Klimt living through most of the double development, and being in turn leader and listener.

## JUGENDSTIL POSTERS, VIENNA AND GERMANY

The advertising poster has been a tool of the business world in most civilizations. The art poster is a child of color lithography. The Viennese were responsible for many of the technical advances which made this possible. It was in France that the art poster first reached a high level. But to the Austrians, the British were always a major influence. The work of Mackintosh, the earlier Frederick Walker, Beardsley, Hassall, Nicholson, Pride, and the rest were immediate influences on the young Secession artists of Vienna, with all their Anglophile enthusiasm.

The complete Art Nouveau poster probably originated in Holland, France, and Belgium simultaneously.

New ideas were exciting to the Viennese, too. The "Seven Book Club" was founded in 1895 to promote book illustration, and became a focus for modern theories of design. The *Ver Sacrum* magazine appeared in 1898, listing the principles of cooperation between the arts and crafts. A new method of free drawing had been instituted in Viennese art schools as early as 1873. The works of Walter Crane had been translated before 1900. The search for new styles was in full bloom.

Henry van de Velde was the principle theoretician of Jugendstil. Although he designed only one poster in 1897, titled Tropon, his position as director of the Kunstgewerbliche Seminar in Weimar made him a major influence on young designers.

The design school at Krefeld also exerted a major influence on the principles of Jugendstil design as a result of the classes in fabric design run by Jan Thorn-Prikker.

20.

## OTTO FISCHER

20. Die alte Stadt *(The Old Town)*

Color lithograph poster, 1896
Wember 310
Printed by Kunstanstalt Wilhelm Hoffmann, Dresden
65 x 94.5 cm.

Otto Fischer, who was born in 1870 and died in 1947, was a painter, graphic artist, poster designer and teacher at the Dresden Academy for Arts and Crafts. His poster for the Crafts exhibition of 1896 has many elements of the old tradition combined with the openness and simplicity of the new movements. He is more the master of handicrafts than of formal design as a Jugendstil artist. The color is subdued and balanced without harshness.

## JAN TOOROP

21. Het Hooge Land/Beek Bergen

Color lithograph poster, 1896
Printed by S. Lankhout & Co., Den Haag
Wember 758, Int. Plakate 148
88.4 x 65.5 cm. (image)

The sentimental symbolism of Jan Toorop appealed to Jugendstil artists. The frame and picture became a unit, fused completely. His title, with orange tones, also gave emphasis to his symbolism. The flame leaves and the complex hair of his women were always important. The ghost-like attitudes found in his art stand out from the abstracted naturalism of other Dutchmen. He had exhibited with Cezanne, Van Gogh, and Redon. But his graphic work was more in the style of Jugendstil than were his Post-Impressionist paintings. The mystical side had appeared as early as 1891.

This poster is a strange and fantastic work. The figurative elements add meaning to the mood: workmen and tools of similar size, the slender woman and gnomes huddled in supplication, the similarity of border, type, and lettering. The symmetrical structure is crowded with motifs. Every element is refined and printed in ethereal colors.

## GUSTAV KLIMT

23. I. Kunstausstellung der Vereinigung bildender Künstler Osterreichs Secession (First Exhibition of the Association of Austrian Artists Secession)

Color lithograph poster, 1898
Printed by A. Berger, Vienna
First Version
94 x 68 cm.

The complicated allegory shown in this poster by Gustav Klimt represents Theseus preparing to kill the Minotaur. It also publicizes the Secession magazine, Ver Sacrum. Perhaps the artist was showing the battle between the old artists' organization, Künstlerhaus, and the opposition, Secession. This was the first poster by the new group.

This is the first version of the poster with a naked Theseus. The government censors made the printer cover the genitals of the hero in published versions (a small tree was superimposed). The minotaur theme, so taken up later by Picasso, was common to Klimt and Franz von Stuck in Munich. The neoclassic represented part of Germanic revival of a lost heritage.

## ALFRED ROLLER

25. Klinger Beethoven. XIV. Ausstellung der Vereinigung bildender Künstler Österreichs Secession Wien (Klinger Beethoven. Fourteenth Exhibition of Associated Artists of the Austrian Secession Vienna)
Color lithograph poster, 1902
Printed by A. Berger, Vienna
185 x 59.2 cm. (image)

Alfred Roller, like Kokoschka, was Bohemian, born in 1864. But he lived his early life in Vienna and died there in 1935. At the time of this poster, Roller was a teacher at the Crafts school associated with Josef Hoffmann and Kolo Moser. Roller was later a famous designer for the stage, having to his credit many collab-

## HENRY VAN DE VELDE

22. Tropon (Tropon)

Color lithograph poster, 1897
Wember 777 B
Printed as a poster for Pan magazine by Leutert and Schneider, Dresden, Pan IV, I
30.8 x 20.2 cm. (image)

This is one of the major posters of the Jugendstil movement. It has elements from the Symbolist movement, and is an example of the turn to a more fixed image which combines creative typography in the image instead of an applied addition.

Henry van de Velde was a painter, architect, interior designer and teacher. He was born in Antwerp in 1863 and died in Zurich in 1957. His essays, titled Les Formules, laid down the cardinal principles of Jugendstil. His basic idea was that art should serve a social purpose: art should influence the life of a whole population, not be the toy of the influential and wealthy.

The revival of iconography was very important to these designers. Van de Velde's egg shapes are almost complete abstractions worked into a planar rhythm. The silhouettes are expressive; a repetition of shape carries the forms to compel attention. The work has its own reality by means of this single element of design, which unites both lettering and form. The color is completely original, based on the arrangement of colors next to one another on a personal color wheel. The shapes of the title letters are echoed in each abstracted form reaching into the vertical, and the entire design is tied together with elegant curves.

For Tropon, a food manufacturer, van de Velde designed the complete line of boxes, cans, cartons and some window displays.

## JULIUS DIEZ

24. VIII. Internationale Kunstausstellung Muenchen 1901 (Eighth International Art Exhibition, Munich 1901)

Color lithograph poster, 1901
Printed by Meisenbach Riffarth & Co., Munich
74.5 x 78.3 cm. (image)

Julius Diez was born in Nürnberg in 1870 and died in Munich in 1957. His primary activity took place in the latter city, for he studied, taught, and was the second president of the Secession there.

The German Jugendstil springs out of natural forms more than the Viennese variety. It is less rectangular or repetitive. Diez is a product of this side of the movement. He is formal, balancing his forms from the center. He is influenced by the leading artist in Munich then, Franz von Stuck. The pedestals seem taken from the actual home of Stuck. The central emblem of leathery flowers has the feeling of two-dimensional ornament as developed by Obrist. The plant shapes seem over-magnified.

The shimmering gold is applied in heavy, almost foil-like, layer. It vibrates against the brilliant blue as the two balance and penetrate space.

orations with Gustav Mahler, including impressive opera design for Tristan, Fidelio, Don Giovanni, The Magic Flute and others.

The poster considered here is based on designs Roller made for a ceramic mural in mosaics for the Braitfelder Kirche, but never used. The subject was the Sermon on the Mount. The design is constructed of masses holding repetitive spaces. Roller was anxious to eliminate conventional distractions such as emotional symbolism; thus the vertical is emphasized and the reversed-L-shape covers up the type. The round shapes are possibly taken from the passion fruit, with five lines; the robe has Egyptian eye-motifs.

**21.**

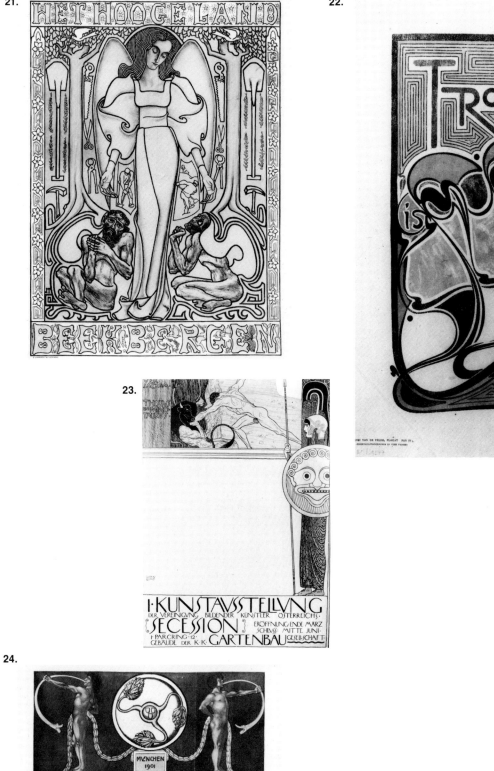

**22.**

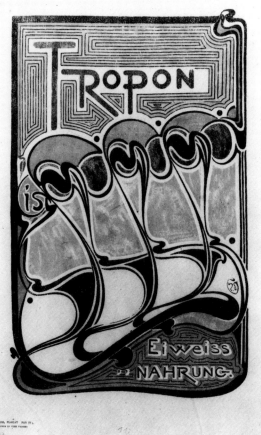

**23.**

**25.**

**24.**

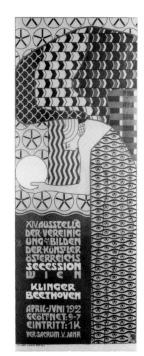

## GUSTAV KLIMT

**26. Secession. XVIII. Ausstellung d. Vereinigung bildender Künstler Oesterreichs Wien** *(Secession Eighteenth Exhibition of Associated Artists of Austria, Vienna)*

Lithograph poster, 1903
Printed by A. Berger, Vienna
96.5 x 68.5 cm. (image)

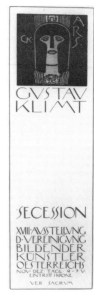

The eighteenth exhibition of the Secession was devoted to the work of Gustav Klimt. The poster and catalogue cover reproduced Klimt's design called *ARS,* based on a classical head, and has been used by the Secession as their logo up to the present day. It is a simple poster, even for the ideals of the Secession. The elegant type is placed for clarity and balance under the rectangle.

Klimt saw the traditional forms of classical art as a precondition for the development of modern forms of art.

In order to balance the heavy rectangle above, Klimt uses an optical brilliance between carefully lettered lines at the bottom. Letters vary in width as vibration is altered.

## JOHAN THORN-PRIKKER

**27. Holländische Kunstausstellung in Krefeld** *(Dutch Art Exhibition in Krefeld)*

Color lithograph poster, 1903
Printed by S. Lankhout & Co., Den Haag
Wember 751
85.6 x 121 cm. (image)

Johan Thorn-Prikker was born in Holland in 1868, trained there at the Academie voor Beelender Kunsten den Haag, but associated while still in Holland with van de Velde, for whom he did murals in the house the architect designed for Dr. Leuring.

Van de Velde organized this exhibition of Dutch artists in Krefeld, at the Kaiser Wilhelm Museum in 1903. Thorn-Prikker was hired as a teacher there the next year.

The design of the poster is kaleidoscopic, with images repeated on each side around the type. The two bars of design are inverted too. The poster is light in color and heavy in design. Balance is made with green emphasis on the central squares which break the complete repetition of design. In spite of the flat concept, Thorn-Prikker is able to give compactness, unity, and brilliance of color in a generous monumentality.

## LEOPOLD FORSTNER

**28. Karlsbad Posthof** *(Karlsbad Postoffice)*

Exposition des Beaux Arts
Color lithograph poster, 1906
Printed by A. Berger, Vienna
95 x 63 cm.

The Austrian painter Leopold Forstner was the product of a double education: at the Crafts School in Vienna and at the Munich Academy under Herterich. He became a fine craftsman in mosaics later in 1906, founding the Wiener Mosaikwerkstätte, later working at Stokerau. His mosaics for Otto Wagner's second villa are remarkable achievements.

The poster shows the result of his study in Munich. Rather than an abstracted linearism, Forstner uses the more Germanic curves and circles. He uses a postage stamp edge to emphasize the post office location.

29.

30.

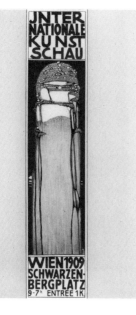

31.

## RUDOLF KALVACH

**29.** Kunstschau *(Art Show)*

Color lithograph poster, 1908
Printed by A. Berger, Vienna
87 x 45.8 cm. (sheet)

The young students of Berthold Löffler had a room exclusively for posters. Kalvach and Kokoschka were included. Other teachers were shown alongside students, accomplished men such as Forstner, Lang, Wimmer, and Moser. Kalvach's work was equal to any. The influence of his teacher is strong in the outlined form and black type which fits exactly against the design. The shapes of the type are repeated in the fir trees and the triangular forms of the kneeling figure. It is a simple but effective design.

Kalvach stayed at the Crafts School, later studying enamel work under Adele von Stuck.

## OSKAR KOKOSCHKA

**30.** Kunstschau (Baumwollpflückerin) *(Art Show/Woman Picking Cotton)*

Color lithograph poster for the Kunstschau, Vienna, Summer 1908
6-color lithograph
Wingler/Welz 30; Arntz 11
Printed by Albert Berger, Vienna
Published by Internationale Kunstschau, Vienna
Paper size: 94 x 62.5 cm.

Beginning in 1905, the Vienna Secession had been polarized into two groups: the Carl Moll group of painters, and the Klimt group which included designers and architects. The architect Josef Hoffmann, with the help of collaborators, erected a prefabricated building in an open space for the new Klimt group. During the summers of 1908 and 1909, this group and their associates of the Wiener Werkstätte and the Vienna Arts and Crafts school exhibited contemporary art.

Kokoschka's poster was made under the direction of his teacher, Berthold Löffler. Kokoschka's technique is similar to other students of Löffler, such as Rudolf Kalvach's fine designs for the same room. There is more innocence in Kokoschka's poster of the standing girl. Both use an angular vine form; colors are similar. Kalvach's poster is slightly larger. It has no leading between the lines of letters and uses a completely sans serif typeface.

The influence of Georges Minne on Kokoschka's work cannot be overlooked. Minne, a relatively unknown designer and sculptor, had a wide ranging effect on modern art. He influenced Maillol as well as the Viennese. His *La Princesse Maleine* by Maeterlinck (1889) and the *Serres Chaudes,* also by the Flemish writer (1889) are masterpieces of early Jugendstil. Kokoschka uses languid gestures taken from Minne's bronzes.

## BERTHOLD LÖFFLER

**31.** Internationale Kunstschau Wien 1909 *(International Art Show Vienna)*

Color lithograph poster, 1909
Printed by A. Berger, Vienna
90 x 45.5 cm. (sheet)

The Bohemian-born Löffler (1874) was closely associated with the Vienna Arts and Crafts School all his artistic life. He was also associated with the workshop.

The poster of 1909 is based on a ceramic figure. The primary colors are used often on both realistic putto and floral abstractions. The viewer sees the designed center first and later moves to the upper and lower sections of type. One reads the poster upwards, contrary to the usual. The center seems to turn in space. The use of crayon is untypical, but lends a lightness to the central portion. The colored top of the central form emphasizes the main title, separating the two with a white irregularity under the headlike shape.

**JULIUS DIEZ**

32. Ausstellung München 1910
Meisterwerke muhammedanischer Kunst/Musik-Feste
*(Masterworks of Mohammedan Art, Music Festivals)*

Color lithograph poster, 1910
Printed by Kunstanstalt Graphia, Munich
111.4 x 72 cm. (sheet)

This later work by the Munich artist and teacher at the Crafts School was done for a concert series in association with an exhibition of Mohammedan art. The design is taken from the elements and designs which make up Oriental carpets, though Diez's boldness is more in the tradition of his city.

He uses a square-faced type which relates well with the rectangular design. The mosque shape also centers the middle portion above the crescent moons of Mohammed's basic symbol. It is a powerful abstraction, a Persian rug exemplified in the animals and floral designs which bound the center. It expresses the essence of Near Eastern art filtered through Munich Jugendstil.

32.

**LOUIS OPPENHEIM**

33. Die Kornfranck-Tante *(The Kornfranck Auntie)*

Color lithograph poster,
ca. 1910
Kornfranck Gesellschaft mit beschränkter Haftung, Berlin
70.5 x 47.5 cm. (image)

This designer was a commercial artist in Berlin. He did a few posters on assignment for Berlitz studios, a fine fashion show of autumn clothing *(Wenn die Blätter fallen),* a poster for a shoe store and this symbol for a savings association.

It is interesting to compare a regular commercial poster of high quality with those made by Jugendstil artists. There is no real interplay of type and design in this poster. Color is used to attract, not intermesh ideas. It is based on commercial ideas more than the modern idiom.

33.

**KOLO MOSER**

34. Frommes Kalender *(Fromme's Calendar)*

Color lithograph poster, ca. 1904
Printed by A. Berger, Vienna
94.3 x 63 cm. (image)

This is a calendar poster representing the best of early Jugendstil before geometrical progressions took hold in Viennese poster design. The symbolism, simple floral designs, classical features of the woman, use of profile, stylized simplification of nature and use of white positive lines against a deep negative surface are balanced between figure and space. The poster has a complete architectural quality. The The school of Symbolists is shown by the hourglass and snake swallowing its own tail to make a holder.

Though examples are rare at present, the poster was used for decades to announce the *Frommes Kalendar* each year. It was a ubiquitous thing until historical criticism discovered a lyrical beauty.

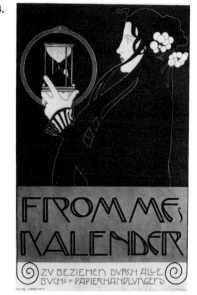

34.

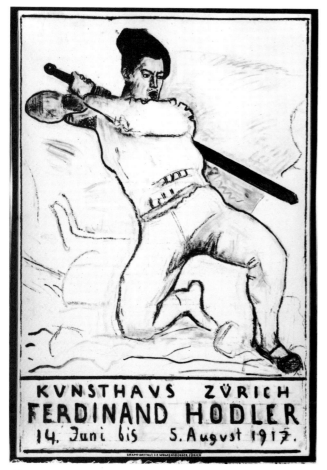

35.

## 36. Almanach der Wiener Werkstätte *(Almanac of the Vienna Workshop)*

**Vienna & Leipzig: Verlag Brüder Rosenbaum, undated [1908]**
**Edited by Max Mell**
**Book design by Josef Hoffmann**
**(2pp) 126 pp**
**Book: 16.5 x 13.5 cm.**
**Page: 16 x 12.9 cm.**

The Wiener Werkstätte was founded in 1903 by Josef Hoffmann, Koloman Moser and the industrialist, Fritz Waerndorfer. It was to be a center of craftsmanship, which would unite all creative efforts for the fine craftsman. It remained a force in world design from 1903 until October, 1932. The first group program, a small elongated brochure, was published in 1905, and there were more than thirty-seven masters and craftsman signing their names to the products of the workshop. In addition there were over one hundred workers providing assistance. The Wiener Keramik workshop was an associated enterprise run under the direction of Michael Powolny and Berthold Löffler. The Wiener Werkstätte always had two artistic directors, with a business manager to keep records and to provide commercial advice. The different departments were divided into modules, and each room of each module was painted in an appropriate color. All items, from stationery to periodicals, were designed according to the high standards of the group.

This almanac was edited by Max Mell, playwright, poet and an associate of the workshop. There were many associates with the Secession outside Austria as well: some of these colleagues sponsored the workshop. Mell had been a Christian Symbolist poet in the tradition of late Romanticism. He chose similar poets for this almanac, beginning with the best known Austrian, Hugo von Hofmannsthal. Max Brod, prodigy from Prague, also sent a short poem. Peter Altenberg, cafe frequenter and talented humorist, sent a touching episode based on his close look at Vienna and its inhabitants. Hoffmann's cover is complex, a mixture of geometrical and naturalistic abstraction, stamped in brown on an ochre cloth. Works of art are printed on a shiny paper and inserted. The result is rather precious, as the off-white text pages clash with the paper on which the illustrations are printed. An attempt is made to unify opposite pages by a device of outlining the boundaries in a dotted extension held together by a green line. The pictures are not illustrative but are examples of work by the master artists connected with the workshop or their close associates, such as Kokoschka or Mestrovic.

This almanac was not meant as an outline of workshop principles, but as a statement of unity with the other writers of sympathetic principles. The combination of English and Scottish design and also a geometric severity is still apparent in the pocket book size.

## FERDINAND HODLER

**35. Ausstellung im Kunsthaus Zürich** *(Exhibition in the Kunsthaus, Zurich)*

Color lithograph poster, 1917
Numbered example, #964 (lower left)
Internationale Plakate 160
132 x 91.5 cm. (sheet)

The great one-man show honoring Hodler, who was weak and sick in 1917, was held at the art museum in Zurich.

In 1903 Hodler had spent six weeks in Vienna, where he became close to Klimt and the other artists of the Secession. Thirty-one paintings were exhibited in 1904 at the XIX. Secession exhibition and helped establish Hodler's European reputation. He did another original poster, called Liegender Jüngling in Blumenwiese (96 x 64 cm) for this show. The Jugendstil soon took up Hodler's conception of man as proceeding through a series of gradations in history, exempt from real change. His essay on "Parallelism" of 1897, was very important. In it he said: "Physical shapes are brought into linear relief from one another. Numerous perpendicular lines create an effect of being like one mark." Form and repeated interval are the major themes the Viennese artists took from this great Swiss painter.

36.

**37.** Ver Sacrum. Mittheilungen der Vereinigung bildender Künstler Österreichs *(Sacred Spring)*

1901, Heft 1 (IV. Jahr, Januar), Verlag Gerlach and Schenk, Wien
Printed by Adolf Holzhausen, Wien
Photographs by Graphische Union, Wien
Covers: 26 x 24.4 cm., page size: 25 x 24 cm.
(2)26pp(1f.) paper covers
(Ver Sacrum: Jan-Dec., 1898 (1. Jahrgang, Heft 1-12) as second example)
Began January, 1898 to 1903
First year editors: W. Schölermann, Hermann Bahr
Second year: H. König, K. Moser, J. Olbrich, A. Roller, Fr. Zweybruck, Verlag E. A. Seemann, Leipzig.

The Vienna Secession split from the older exhibiting society, Künstlerhausgenossenschaft, known as "Künstlerhaus".

The final break came in May, 1897, when eighteen members resigned and the Vienna Secession began its independent role. The new organization had no strict program, but included graphic designers and typographers, as well as painters and sculptors.

As an important venture in modern concepts of layout and design, the Vienna Secession brought out its own periodical, called *Ver Sacrum* (Sacred Spring). The first issue in January, 1898, was a success. All issues were based on a unifying principle of coordination between the balance of the art and the printed page. New type designs were created, the best materials were used and collaboration by the best poets and writers of the day was obtained. Mostly, the artists devoted their talents gratuitously, lavishing a remarkable amount of time and attention in their contributions.

*Ver Sacrum* was the only German language journal run entirely by artists. The title probably originated from a poem by Ludwig Uhland (1787-1862). The literary contents were kept at a high level, with the help of the poet and man of letters, Hermann Bahr.

After 1900 the journal issued twenty-four numbers a year instead of twelve. The number of separate issues in an edition was never documented, but by 1900 there were 300 subscribers. By 1904 there were 600 subscribers. Special editions for founders were printed on larger, folio-size paper (about 55 x 50 cm).

The issue of 1901 begins the new year with a calendar issue. It divides each day of the month four ways into Catholic, Protestant, Greek Orthodox, and Jewish religious days. Gold ink is used with alternating brown-black and blue-black. Borders are designed around the theme of each month: April is rain; May is roses; October is the grape festival. Reproduction is crude, but the heavy inks carry out a primitive strength. All the advertisements were designed to fit the shape; the square format is characteristic of and original with the Vienna Secession.

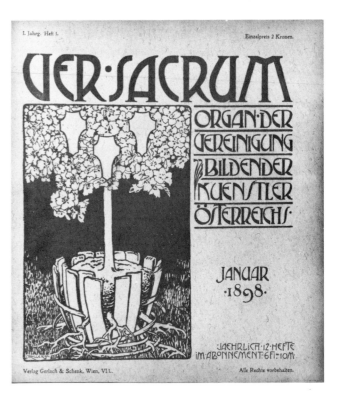

37.

38.

**38.** Avalun. Ein Jahrbuch neuer deutscher lyrischer Wortkunst *(Avalun/A Yearbook of the New German Lyric Art of Words)*

Verlag Avalun, Munich, 1901
Herausgegeben von Richard Scheid
Book size: 32.2 x 21 cm., page size: 31.5 x 20 cm.
160 pp, unnumbered, with 14 (eleven full page) graphics by Georg Braunmueller, Hans Heise, Ernst Neumann
Editions: 300 numbered examples

The Jugendstil in Munich developed less geometrical characteristics than in Vienna. The Arts and Crafts School in this capital of Bavaria based most abstracted patterning on natural objects, and taught simplification, not basic movement. Students worked from still lifes and landscape, reducing the objects to simple shape and line, flat tone and some half-tone.

This privately printed yearbook, Avalun, is fairly typical of Jugendstil design in Munich. The separate sections are printed as a folio size in nine parts, each folded as pages and bound together into a book. The prints, in this case color woodcuts and color lithographs, were printed on blank pages after type: some have color from the type pages carried into the design to give continuity.

The Munich school of poetry in 1901, at least the contemporary writers printed in this yearbook, were Symbolists. They wrote in traditional meters, using personal references and inner experiences as symbols which grew into the more subjective kind of Expressionism. There are interesting examples by a young Rainer Maria Rilke, a young publisher named Reinhardt Piper, and a young designer named E. R. Weiss.

Avalun exhibits a fine balance between the dark brown ink and the warm ivory handmade paper, coupled with the use of sans serif type, one of the earliest examples of this common modern publishing practice.

## CARL OTTO CZESCHKA

39. Die Nibelungen dem deutschen Volke *(The Nibelungen Legend for the German People)*

Narrated by Franz Keim
Verlag Gerlach & Wiedling, Wein, u.d. (1905)
Gerlach's Jugend Bücherei, Band 22
Printed by Christoph Reiszer's Söhne
Book design and illustrations by Carl Otto Czeschka
67 pp (1), Book size: 15.2 x 14 cm., Page size: 14.8 x 13.3 cm.

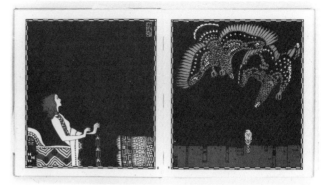

39.

The *Nibelungenlied* also became a focus for the fight of folk historians against liberal principles. Goethe disagreed and spoke for internationalism. In later years, the folk view became mystical, explaining the remote past by appealing to the creative forces of the Volk. Hegel, too, thought the tradition to be a static one. However, Hebbel wrote the outstanding version in 1855-1862 and turned the legend into a Christian message. Of course, Wagner used some of the tales in his *Ring of the Nibelungen* 1848-1874. Through Wagner the legend became an impressive German folk tradition, and settled in reactionary circles as inspiration.

Carl Otto Czeschka was born in Vienna, 1878. He studied at the Vienna Academy, was a teacher at the Vienna Kunstgewerbeschule, and a member of the Klimt group, a founding member of the Wiener Werkstätte. Most of his work was in book design, illustrations, and bindings. He later taught for many years at the Arts and Crafts school in Hamburg, also taught jewelry making in silver.

Josef Sattler was born in Schrobenhausen, Upper Bavaria, in 1867. He studied in Munich, taught at Strassburg (1881-1895), worked in Berlin, and returned to Strassburg until 1918 when he settled in Munich.

Sattler was an illustrator for *Pan* and *Simplicissimus.* He was the outstanding designer chosen to illustrate the great German version of the Nibelungenlied for the World Fair in Paris, in 1900. He did not finish the designs for editing until four years later. All the paper was handmade with specal watermarks giving the title on each page. Line blocks were made from full-scale drawings. Blind stamp designs were used for many pages (A blind stamp is printed as a stamp without ink to indent the paper with the design). A special typeface was designed. Special metallic inks were created. Three experts were hired to examine every page for flaws and only perfect specimens were used in binding. Every text page has at least three colors. Color variations were not obtained by using screens, but each tint was mixed and printed separately. The illustrations are designed closely with the text spacing, border width, and length. It is, all in all, the kind of special control and complete perfection in the style of the time which could never be repeated.

In contrast, the Czeschka version was printed for children, an example of the philosophy from the Wiener Werkstätte that everything used by man should be made by craftsmen with taste and love for their products. Gerlach's *Book Series for Children* was started in 1900 with Löffler's *Aus des Knaben Wunderhorn* as the best of the early books.

Czeschka is not less modest in the small size of his version. He works straight through the book from cover, end papers, illustrations, titles, to text design and binding. Though inexpensive paper was used and a small size, Czeschka creates a monumental book with exciting illustrations using many colors, metallic inks, and offset compositions which make this small book one of the most successful design solutions in the history of book illustration. This book is a complete expression of Viennese Jugendstil philosophy, with fine line drawing, abstract ornament, contrast of dark and light areas, static gesture and a wonderful repetition of motifs.

## JOSEF SATTLER

40. Die Nibelunge *(The Nibelungen Legend)*

Verlag J. A. Stargardt, Berlin, 1898-1904
Printed and bound at Werkstätten der Reichsdruckerei, Berlin
Special paper by J. W. Zanders, Bergisch-Gladbach
Type, illustrations and vignettes by Josef Sattler
Text taken from edition of Karl Lachmann, based on High German version, Handschrift A, Munich
Editions: 194 examples: a.–30 on japan; b.–4 on parchment; c.–160 on handmade Bütten

The *Nibelungen (Niebelungen) Lied,* or *Song of the Nibelungen,* is a heroic epic written in Middle High German dialect, a widespread Teutonic Saga with fragments in the northern Eddas. It tells of a war between the Huns (Etzel) and the Burgundians. It mixes real events with a misty and confused tradition of ancient folk heroes. Modern research identifies Siegfried with Segeric, son of the Burgundian king Sigimund; Brunhilda was Brunichildis. The Eddas preserved more of the original Franco-Burgundian identity. The *Nibelungenlied* also had influences from unconnected Christian legends.

For the Romantics, especially Novalis, the Middle Ages were a universal period, the probable fountainhead of German national culture. Siegfried is taken out of his Scandinavian role of the Eddas and made a Netherlander. Friedrich von Schlegel demanded that the epic be the basis of a German Iliad, a chief classic for the German school curriculum. The modern versions were translated by von der Hagen and August Leume in 1814.

40.

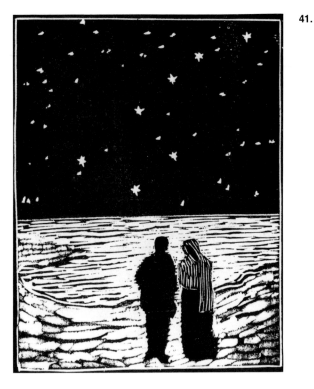

41.

**41. Bei sinkendem Licht/Dialog** (*By Diminishing Light/ Dialogues*)

Hans Bethge
Leipzig: Verlag von H. Seemann, 1903
Unknown total edition. Including 10 examples on thick Bütten, 5 examples on japan paper with parchment binding
Special edition signed by the author and artist
Printed By E. Haberland, Leipzig
102 pp 3(f)
Book 16.2 x 12.6 cm.
Page 15.7 x 12 cm.
Book design and five full page woodcuts by E. R. Weiss, 1903

The five Romantic dialogues are short stories in narrative form. All have introductory descriptions of the time of day and location. All are complete forms with development and ending of action during the ending of daylight while the sun sinks: the title is *By Diminishing Light.*

E. R. Weiss designed a woodcut for the beginning of each of the five sections.

Weiss's book design is less static than other German books of this time. He opens up the pages with clarity of line, a minimum of extraneous ornament, functional use of illustrations and superb use of titles balanced by an abstract design on opposing pages.

Weiss tackled the Jugendstil definitions in a different manner from his contemporaries. He avoided much ornamentation and was more individualistic. He thought as a sculptor when he designed in wood. Weiss studied type design from such old masters as Unger of the eighteenth century. He developed a new typeface, "Weiss Fraktur", changing a heavy early gothic typeface into one light and open, with wide and curving rhythm.

He left his mark on German book design throughout all his changes in concept, following the variations in German art through the war years and into the later twentieth century. His long series of pocket books for the Insel Verlag are some of the best designs ever made for inexpensive editions. What gave his books special taste was his wide knowledge of different forms, his complete training in drawing and painting, his literate intelligence, and ability to design for a book, without imposing his ideas on it.

## MELCHIOR LECHTER

**42. Huldigungen** *(Tributes)*

Lothar Treuge
Berlin: Blaetter fuer die Kunst, 1908
Edition: 210 examples. Nr. 1-10 on Imperial japan paper, bound in parchment. Nr. 11-210 on yellow (indischem) paper, bound in rough japan Bütten
Printed by Otto von Holten, Berlin
#199/210
70 pp (unnumbered)
Book: 33.2 x 25.3 cm.
Page: 32.3 x 24 cm.
With composition, title page, frontispiece, vignettes, and borders designed by Melchior Lechter

Stefan George was to German Symbolist poetry what Hugo von Hofmannsthal was to the Austrian movement. He formed a publishing house for his own imprints and finally expanded by publishing the works of his followers.

Melchior Lechter was a close friend to George. He was born in 1865, studied both glass painting and academic art. His major influences were from Pre-Raphaelite philosophy and the medieval revivalism of William Morris. In accordance with George's theories of revolt against realism, Lechter uses a controlled harmonious border system of classical columns throughout the book.

Lothar Treuge's prose is a homage (Huldigungen) to the works of various poets, writers and artists who were especially important to the George circle. Shakespeare, the Mona Lisa, Goya, Velazquez, Thais, Ophelia, Iphigenie, show the background which moved this group toward an aesthetic ideal.

Lechter, too, does not design for the middle classes, but for an aristocratic following, with an esoteric symbolism and monumental austerity which is somewhat dull. The placement of the border is equidistant, with attempted balance by low-set blocks of type. The use of serif type in the title page and sans serif in the text seems unrelated to the classical background of the text.

42.

## HENRY VAN DE VELDE

**44.  ecce homo** *(Behold the Man)*

Friedrich Nietzsche
Insel-Verlag, Leipzig, 1908
Printed by Friedrich Richter, Leipzig
Title, binding and ornaments designed by Henry van de Velde
154 pp (2f), Book size: 25 x 19.5 cm., page size: 24.2 x 18.8 cm.
Editions: 1250 examples. a. 150 on japan, numbered. b. 1100 on Bütten.

The last document from the degenerating mind of the genius Friedrich Nietzsche is a note about this book: *"Ecce* must go forward."* The manuscript was a pathetic attempt to sum up the intentions and actual accomplishments of this sensitive universalist. His message of individualism had been misunderstood by the German nationalists: his hatred of provincialism had been turned into a statement of power drive. His real distrust of Imperialism had been used as a vehicle for realpolitik. Nietzsche's hatred of bourgeois civilizations, attempted displacement by an appeal for higher consciousness through heroic morality, was perverted by his sister, executor of the estate, into justification of national and racial superiority through the cult of the superman. Nietzsche was neither a racist nor a conventional middle class moralist. He was a dreamer about the future, foreseeing a time of higher development for humanity, and was a critic of his time.

Henry van de Velde, the designer of this book, was born in 1863, in Belgium. He was a painter, architect, teacher, and writer. Van de Velde had an early interest in the unifying principles of Jugendstil, Japanese prints, the paintings of Van Gogh, Bernard's symbolism, the entire book reformation under William Morris in England. He was invited to head the Folkwang Museum in Hagen/Westf. from 1898-1902. Later he joined the group around Count Harry Kessler in Weimar, was director of the Weimar School of Arts and Crafts. His was the primary influence of the bold and dramatic style of Jugendstil art, which later combined with a geometrical principle.

Van de Velde's design for *ecce homo* has no real historicism. He works from the skeleton of the design, the dynamic and abstract idiom. The title is based on a free interplay of curved lines and empty spaces, arranged with elegant simplicity. There is a merging of Art Nouveau illustrative ornament and abstract balance of lettering into an appealing whole, which retains a functional two-dimensionality.

44.

43.

## WALTER TIEMANN

**43.  Marpessa** *(Marpessa)*
Stephan Phillips
Deutsche Umdichtung von Gustav Noll
Leipzig: Insel-Verlag. 1904
Edition: 300 numbered examples
Printed by W. Drugulin, Leipzig
#14
Parchment cover with gold stamping
With title, initial and binding designed by Walter Tiemann
Book: 16 x 12.3 cm.
Page: 15.7 x 11.9 cm.
41 pp (3 pp)

Walter Tiemann was born in 1876, a generation forever influenced by the change of Germany into an entity in 1872. Nationalism brought rapid growth in industry and technology. One offshoot of a new rising class of wealthy middle-class merchants was a growth in appreciation of fine books. Tiemann, together with Poeschel, Klingspor, Ehmcke, and Weiss, became sources of great typographic design, giving this generation a principle of serious commitment to freedom in book design. This principle was based on British models, Morris, Cobden-Sanderson and the rest of the Romantic revivalists in Great Britain.

In this book, *Marpessa*, Tiemann uses major forms from the great Kelmscott Press *Chaucer* of 1896, one of the most influential of Morris's imprints. The floral borders in British Art Nouveau were a reaction against the complicated decadence which had gone before; German Jugendstil was outgoing, experimenting with filled space and bulging, irregular shapes. In Germany the designs were created not only by architects, as in most other countries, but also by trained book designers, who were familiar with typefaces, the problems of legibility and spatial variations as a craft. But our criticisms are minor if we look at the easy legibility of the lines, the balance of color emphasis, the placement of type blocks. The small size is used for clarity, not mere reduction. The type designer's understanding has cleared away some of the medieval complexity which makes Morris's books difficult to read, but the elegance of French models is lacking.

## OSKAR KOKOSCHKA

**45. Wiener Werkstätte** *(Vienna Workshop)*

*Postcards for the Wiener Werkstätte*
15 color lithograph postcards after tempera designs by
Kokoschka
1906-1908
Wingler/Welz 3-17 (not in Arntz)
Published by the Wiener Werkstätte, Wien
13 postcards in Rifkind Collection
Edition sizes unknown

45/1. Reiter und Segelschiff *(Rider and Sailboat)* Postcard Nr.
55; W/W 3, 12.3 x 8.1 cm.
45/2. Blumengarten *(Flower Garden)* Postcard Nr. 64; W/W 4,
9.3 x 7.6 cm.
45/3. Jäger und Tiere *(Hunter and Animals)* Postcard Nr. 72;
W/W 5, 12.4 x 8.4 cm. (not in exhibition)
45/4. Flötenspieler und Fledermäuse *(Fluteplayer and Bats)*
Postcard Nr. 73; W/W 6, 13 x 8 cm.
45/5. Biedermeierdame and Wiese *(Biedermeier Lady in
Meadow)* Postcard Nr. 76; W/W 7, 12.2 x 8.4 cm.
45/6. Mädchen mit Lamm, von Räubern bedroht *(Girl with
Lamb, Threatened by Robbers)* Postcard Nr. 77; W/W 8, 13 x 8 cm.
45/7. Musikanten *(Musicians)* Postcard Nr. 78; W/W 9, 13.4 x 8.7 cm.
45/8. Mädchen mit Schaf auf Bergwiese *(Girl with Lamb on a
Mountain Meadow)* Postcard Nr. 79; W/W 10, 13.2 x 8.2 cm.
45/9. Sennerin und Kuh *(Dairy Maid and Cow)* Postcard Nr. 80;
W/W 11, 13.2 x 8.5 cm.
45/10. Drei Hirten, Hund und Schafe *(Three Shepherds, Dog
and Lambs)* Postcard Nr. 116; W/W 12, 13.4 x 8.5 cm.
45/11. Mutter mit drei Kindern *(Mother with Three Children)*
Postcard Nr. 117; W/W 13, 13.1 x 7.8 cm. (image w/o text)
45/12. Drei Mädchen, Lamm and Paradiesvögel *(Three Girls,
Lamb, and Birds of Paradise—Merry Easter)* Postcard Nr. 147;
W/W 14, 12.5 x 8.1 cm.
45/13. Mädchen am Fenster *(Girl at the Window)* Postcard Nr.
152; W/W 15, 13.4 x 8.7 cm.
45/14. Die Heiligen Drei Könige *(The Three Kings)* Postcard Nr.
155; W/W 16, 13.5 x 8.5 cm. (not in exhibition)
45/15. Mädchen auf Wiese vor einem Dorf *(Girl on a Meadow in
Front of a Village)* Postcard Nr. 157; W/W 17, 12.8 x 7.9 cm.

The Wiener Werkstätte made and sold many craft items. These
included writing paper, almanacs, postcards, thirty reproduc-
tions, posters, and many objects of applied art. Among the
postcards, Moritz Jung and Rudolf Kalvach did 45 humorous
cards for the series. Egon Schiele did three (Nrs. 288, 289, 290).
The postcards were very popular and brought needed
revenues for the workshop.

For his postcard designs, the young artist-student Kokoschka
drew upon his family heritage, for his father was a skilled
goldsmith until that craft was supplanted by the production
line. The young Kokoschka took form from toys, from the out-
lined shapes of magic lanterns and from Bohemian peasant
symbolism. As a child, he had been fascinated by fairy tales
told by a neighbor woman; the symbols had been reinforced by
the sudden death of this woman. From his mother, daughter
of a forester, he heard tales of mountain ghosts and peasant
superstitions.

He spent time in the department of ethnography at the Natural
History Museum on Maria-Theresa-Platz and had been impressed
by weapons, textiles, tapestries, and the like. The strange poses
found in his art are probably taken from the work of Georges
Minne, for this Belgian sculptor was one of the earliest influences
on the young painter. The forms are chaste and two-dimen-
sional, but Kokoschka uses color both to make space recede
and to spring forward. The beginning of a use of tension appears
in the line compositions, a method which the painter developed
further in his later illustrations.

45/6.

45/7.

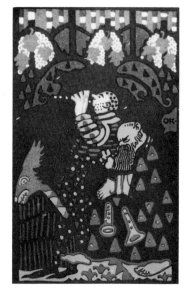

45/13.

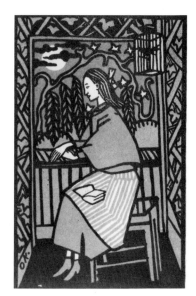

## OSKAR KOKOSCHKA

**46. Die träumenden Knaben** *(The Dreaming Boys)*

Written and illustrated by Oskar Kokoschka
8 color illustrations
Wien: Wiener Werkstätte, 1908
Edition: 500 examples (probable edition)
After few sales, remaindered to Kurt Wolff Verlag, 1917
Issued in 275 examples.
1906-1908
Printed by Berger and Chwala, Vienna, 1908
#35/275
Book: 24 x 29.4 cm.
Page: 24.3 x 29.8 cm.
10 sheets with printing on only one side of each page.

The publishing of small but well-designed children's books had begun in Vienna before 1900. The greatest of these was Czeschka's *Die Nibelungen* of 1905. Czeschka was one of Kokoschka's teachers at the Kunstgewerbeschule. The project for Die träumenden Knaben probably started as a school work in 1906, but was taken over by the independent workshop and published two years later.

Kokoschka was a scholarship student from 1905 until his departure in 1909. In 1907, the young artist had been asked to join the group of craftsmen and artists with the Wiener Werkstätte and was given important jobs by its founder, Josef Hoffmann. The youngster did designs for postcards and fans, and printing and mural design, and also worked on the Cabaret Fledermaus. He performed his puppet play there.

Studies for this book show Kokoschka's interest in gesture, which he varied and elongated according to his needs. Feet and hands are detailed more than in other works: in fact, these are greater centers of interest than foliage or clothing. They usually remain uncolored, a mannerism of the late Japanese Ukiyo-e art (1820-1840). The closest illustrations to these were the early ones by Georges Minne for Maeterlinck's *Serres Chaudes* of 1889. Minne's Gothic gestures outline discussion and sleep. Another major influence frequently pointed out was the illustrations by Wilhelm Laage in *Ver Sacrum* IV (1901).

Kokoschka felt more realism in this visionary world, a feeling which never left him. His work contrasts with the arabesque line which made up much of this Viennese Jugendstil. It was not the art of mechanical movement, but had the Baroque, Danube background of an empire without singular influence in the world. He shows himself as a man of mysticism with a humanistic bent of ironical skepticism.

The poems seem obscure, but were applauded at a reading as curtain raiser for a performance of his play, *Burning Bush,* in Heidelberg, 1920.

Kokoschka's world in these fariy tales is an instantaneous transformation of vision into the stillness, the boiling hot, and icy cold he described in his autobiography. In the poems, women are weak creatures; fish are omnipotent; the Danube flows around islands and peninsulas. Compartments of linear design capsule the squared spaces. Primary colors, often against a black background, seem medieval, not part of the industrial today. Flat effects resemble cave drawings. It is another childhood outside time. Men lean on one another for support as in Arab communities.

Die träumenden Knaben was not an immediate success. Kokoschka became known as a "Bürgerschreck," as a horror to the citizen. A newspaper invented for him a name infamous later: degenerate artist (Entartete Künstler).

There is little eroticism in this book. Nudity is expressed in openness and stillness. There are love gardens cast in black outline within areas of pure color resembling stained glass windows.

The peasant theme probably came from the great pageant in homage to Francis Joseph's ascension to the throne, celebrating the sixtieth year of his reign. The Emperor was seen as a folk hero.

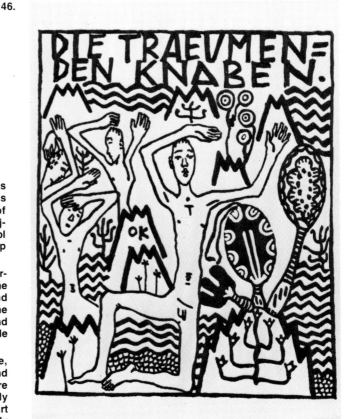

The Dreaming Boys

**OSKAR KOKOSCHKA** *(Excerpts)*

red little fish, red
knife you dead with the three-edged knife
tear you apart with my fingers
to end the silent circling

red little fish, red
my little knife is red
my little fingers are red
in the bowl sinks the little fish dead

and I fell down and dreamed
many pockets has fate
I wait at a Peruvian stone tree
its many-fingered leaf-arms grasp like fearful arms and fingers of thin
yellow figures
which move in the star-flowering shrubs unnoticeable like blind ones
without a light stripe
moving away in the dark air of falling star-flowers lures the silent animals
blood racers
who slink away in fours and fives out of the green
breathing sea-forests
where it rains quietly
waves roll over the forests
and walk through the rootless
redblooming
numberless air-twigs
which like hair in ocean water sucking dip in
out of there wind the green waves
and the terrible ocean of the immeasurable depths and man-eating fish
grips the overflowing galley (up there on the masts swing cages with little blue birds) pulls on the iron chains and dances with her into the typhoons, where water columns go like ghost-snakes on the screaming ocean.

46/2. I hear the calls of the sailors
who want to go to the land of the speaking birds
the sails swing to and fro
cold air moved them and turned the sails
the ship landed
softly go in rhythm
in stops, comprehensible
and then again drowned out the procession walking from the
ships
sneakers in brown wool dresses wind through and naked
skinny girls give bird
nuts and coral strands for souvenirs to the nights of dark
tendernesses
and I fell and dreamed the sick night

why do you sleep
you blue-clad men
under the branches of the dark walnut trees in the moonlight?

you mild women
what smells in your red coats
in the bodies the expectation of interlaced limbs since yester-
day and before?
do you feel the exciting warmth of the trembling mild air—
I am the roaming werewolf—

when the evening bell sounds
I sneak into your gardens
into your pastures
I break into your peaceful kraal

my fenced-in body
my body enhanced with blood and paint
crawls into your tabernacles
swarms through your villages
crawls into your souls
festers in your bodies

out of the loneliest quiet
before your awakening screams my howling

46/2.

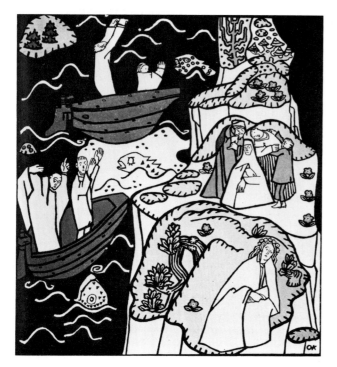

46/3. I consume you
men
women
half-awake, listening children
the raving loving werewolf in you
and I fell down and dreamed of strong uncheckable changes

Hurray
out of the yellow standing water
in which you live like coral reefs

hurray
you wax-colored ones, with the dough masks
and the beards of red sponge

a wind blows into the forgotten town
in the locked rooms of which hang singing people as if in
birdcages

hurray
you fearful large community
my weak boys'-song and my prayer of the innocent does not
protect your vices anymore

it is dreaming within me and my dreams are like the north
where snow-mountains hide ancient fairy tales
through my brains go my thoughts and make me grow
like stones grow
nobody knows about it and realizes
anxious hours I dream sobbing and flinching like children
who get up into puberty
not the events of childhood go through me and not those of
manhood
but the boyishness
a halting wanting
the unfounded shame before the growing
and the becoming a stripling
the flowing over and being alone
I recognized myself and my body
and I fell down and dreamed love

first I was the dancer of the kings
on the thousand-step garden I danced the desires of the sexes
I danced the thin spring bushes
before you maiden li (your name tinkles like silver sheets)
    yet out of the hangings of the vermillion flowers
    and sulphur-yellow-stars stepped
out of the herb garden
I knew you already and waited for you
    in the blue evenings on my sliver counterpane
out of the confusing bird-forests of the north
    and from the seas of the red fish of the south
I felt you here
felt the gesture of the angled twistings of your young body
    and understood the dark words of your skin
    and the childish joints hung with glass beads
and before you I fled into the gardens
up from step to step
to the thousandth the last one in my shy
music
music
juggler, my body
bell-rattler
drum-beater

away you scarecrow of my sinful restriction
bright fires lie on the dwarf-forests
soon I jump to earth in flowing garb
    and like a high, singular note the longing
    stands behind me on the gardens
and I dreamed

my body is like a tongue-damp tree
in lost fountains life runs up and down
    and urges to spill
the night wondrous
nameless

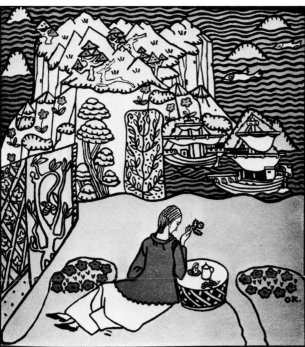

46/3

**47. Ex Libris: Frau Emma Bacher** *(Bookplate for Frau Emma Bacher)*

Medium Unknown, ca. 1909
7.5 x 5.8 cm. (image)
Signed in pencil
Edition unknown

Kokoschka took any job he could in order to supplement his scholarship to the Arts and Crafts school. He did a bookplate for Lorenz Kellner in 1906. He had worked on costumes for the Austrian Emperor's jubilee procession in 1908; all fall within the framework of his Jugendstil period. This bookplate was probably made for Frau Emma Bacher, wife of the academic painter, Rudolf Bacher, friend of Klimt. There are three variations known today, as well as studies for bookplates for the Fürst and Binder families, so this income must have been important to the poor young artist.

The design is compact and bounded by borders top and bottom. The tusche ink drawing is in a private collection, so the actual bookplate must have been printed by photographic means because the image is not reversed.

47.

KÜNSTLERGRUPPE BRÜCKE

## DIE BRÜCKE

With faith that
a new generation
of creative as well as
perceptive people will
develop, we call
together all young people,
and, as youth which
carries the future
in itself, we want to
gain for ourselves
the freedom of development
and liberation from the
old establishment. Everyone
belongs to us who
directly and undivergently
tries to express
that which impels
them to create.

## LIST OF BRÜCKE ARTISTS AND ASSOCIATES

Cuno Amiet 1868-1961
Fritz Bleyl 1880-1966
Axel Gallen-Kallela 1865-1931
Erich Heckel 1883-1970
Ernst Ludwig Kirchner 1880-1938
Otto Mueller 1874-1930
Emil Nolde 1867-1956
Franz Nölken 1884-1918
Max Pechstein 1881-1955
Karl Schmidt-Rottluff 1884-1976
Kees Van Dongen (Associate) 1877-1968

The manifesto above speaks for all German Expressionists in its message of liberation from the establishment and faith in the future. But the open heart can be a wound as well as a message of faith. Such tendencies are too broad for exact definition and could represent the message from romantic youth in the past as well.

Die Brücke was an organization of idealistic young men caught up in the international movement of youth, particularly students. This idea of freedom and spiritual togetherness was common to universities, to special groups in art and other disciplines.

Although Jugendstil was to some extent a group association, these young students looked for individualism. Being German, they had to find this in an organization, which could unite for strength against the uncaring outside world. Painting had become a higher value than architecture for these young men in their scale of world development, as seen in Dresden early in this century.

Their effort was different from the general idealism; thousands of young students had intentions and ambitions, which were discarded later at some mature age. The Brücke painters, even after dissolution of the group, sustained their idealism until World War I, and, to some extent, even later with relaxation of strong political action during that European era of horror at the vast slaughter. Rejection of politics for some meant withdrawing participation, but not loss of liberal or idealistic goals.

The Brücke painters were also rooted in the past with their dependence on the human figure, as basis of all classical training. Their impetus was towards renovation of art and rejuvenation of self, earlier the basis of Goethe's and Schiller's classicism. Though struggling for a linear style, a two-dimensional con-

cept, they never lost the strong linear perspective common to abstracted real form. Perhaps the psychological rejection of reality by a Kandinsky was not possible for these young Germans, with their long history of humanistic romanticism, worship of independent man which was traceable back to the time of Luther. This was the major difference between these provincial men and the French and Russian visioneers, who had impulses toward pattern and decorative abstraction.

The Brücke painters are not to be negated. They brought an original power of expression, a drenching by strong emotion common to no other art movement. They patterned emotion not decoration, contrasting their world of force and brilliance with a rejected real world. Theirs was an audacious, original, emotional contribution. Somehow, they climbed from the depths of provincialism and isolation up the ladder away from primitivism.

A lack of background shows most in their earlier work, for technique then is poor and style is weak in comparison with contemporary work in other countries or other parts of Germany. This soon passed as a frenzy of work developed technical virtuosity common to all Brücke painters; and intelligent rationalization produced a great leap in conceptual strength. What most provincial artists never gained in a lifetime was achieved by these young men in a few years.

Their prints and illustrated books differ in these principles from other craft-trained artists. They fought for originality. They did not copy from some simplistic tradition. They demanded to be seen and screamed through their work.

Although all worked within similar principles, no one resembled another under close scrutiny. All had different traits of personality, of changing and developing design concepts. Vision was directed towards the radiation of power, not the beautiful: it was power by personal development, not destruction per se. Their powerful visions could not be ignored. Opposing academic tradition, they reached for explosions on the edge of rational control. They did not create visions of perfectly placed nature: nature was seen as part of an irrational reality.

Young men, mostly town-provincial, fed early on books, with little experience in seeing and doing art. These amateur sketchers moved to Dresden for professional training in a more scientific art, that of architecture.

From small towns, they were fairly rude in speech even for a citizen of Dresden to encounter. Unsure in society, proud of being in a large city, wide open to strange sights and sounds, the new students gathered against outsiders for mutual support into small groups. They were awkward and gawkish in tight new clothing.

Their provincialism ended soon in study and unification in Dresden's atmosphere of internationalism and social change.

## BRÜCKE: THE EDUCATION OF A MOVEMENT

Kunstgewerbeschule Teachings: drawing, crafts, type forms, book composition, bookbinding, woodcut, lithograph, use of materials. Architecture Schools: mechanical drawing, life class, landscape class, engineering.

All of the college-technical schools had fine libraries in which students could browse through the latest European periodicals about architecture, painting and the crafts. These schools were probably the most progressive educational institutions in Germany, as the traditional art schools taught realism and had just begun to introduce Impressionism into the curriculum. The technical schools were already involved in an organized movement, that of Jugendstil. There was less experimentation in the art academies. The crafts schools were the centers of new ideas for German students of art.

These changes had taken place in the early twentieth century, and by the time the Brücke men were enrolled, there was little reaction against new principles of unification. National influences were also changed. The art academies were nationalistic: the crafts colleges were international in intent. Scottish, Belgian, American, Japanese, German plus folk and primitive art had already been investigated by the Jugendstil artists.

First year drawing teachers had students copy reproductions by illustrators in the comic weeklies, then do copies after Romantic German painters. Freehand drawing was emphasized. Plaster casts were also copied but less so than in the academies, where exact reproduction of form and shading was emphasized.

The Jugendstil idea was introduced early. It became the groundwork for the young students of architecture. Classes in Jugendstil ornament followed. The earliest development was linear and ornamental. Color was taught as a separate program. Mass was studied as utility, not aesthetic formation. This was important because the tradition of applied color passed directly into the new woodcut. Color and value were considered independent. Line could easily be regarded in terms of black and white. Color could be regarded as a separate emotional force.

Community was an important word in the student language of the period. They were a close-knit group. Most of the students read novels and magazines together, which broadened the primarily literary impetus of the Brücke.

Architectural training taught cleanliness with technique and care with drawing. The hand was carefully trained for precise movements. This meant spare movements, direct intention, not foggy outlines. In Fritz Schumacher, the young Brücke students had an inspired teacher. He advised in the field with freehand sketching and in the classroom. He counseled them when they decided to organize as a group. He developed their work habits, talked about Jugendstil ideas, discussed the practicality of architecture as against a life in painting, taught them the use of materials, and showed them the social background of new building in Europe and America. He became a real friend as well as their teacher.

The great Dresden exhibition in 1904, of the Viennese school opened their eyes to practical application of what they had studied. The great designers of *Ver Sacrum* were presented, along with furniture and books from their collaborators.

Unlike the work of the academic students, that of the crafts college students showed less French influence. This was an important part of the modern movement, but only part of a complexity. What was more important than the formal influence of French art was the emotional, literary background. Symbolist poets and Symbolist painters seemed united in the thoughts of these young Germans. Students were already reacting against the realism of the middle classes, and anti-intellectual intentions were striking and new. French art had not yet been compartmentalized. The emotional appeal of Van Gogh and Gauguin was still subjective.

This attitude appears again and again in the letters of the Brücke painters, and reinforces the formal influence which was filtered through their own understanding of the Jugendstil.

Architecture became too isolated a profession and was rejected by all except Fritz Bleyl. Combinations of emotion and form proved to be major interests, rather than utility and planning.

This background is very important to the education of the Brücke painters. We doubt if their development would have been similar if training had been in the conservative academies. Over seventy-five percent of the artists whose work appears in this catalogue were educated in whole or in part in a Kunstgewerbeschule.

It became impossible for these painters to remain either provincial or specifically nationalistic. All the world was their territory and all the inner mind their influence. They became sensitized towards originality. They were not steeped in an old tradition, but were educated to reach for the new, expecting a future which was not just a small addition to the old.

## CUNO AMIET

**48. Giovanni Giacometti beim Lesen** *(Giovanni Giacometti Reading)*

Woodcut, 1907
Printed in yellow ochre on simulated japan paper
Signed in pencil
Mandach 25; Bolliger-Kornfeld 6
53.4 x 38.7 cm. (sheet)
Plate 1 of Jahresmappe II, 1907

A product of the Jugendstil school combined with Symbolism, this older Swiss painter brought both these influences to the young painters in Dresden. He was asked to participate in the portfolio after he had shown a group of works in the Galerie Arnold, Dresden. He also brought the thoughts of the great monumentalist, Hodler, with concentrated form in outlined masses. Amiet had also been influenced by direct contact with Gauguin's thinking, through work alongside Bernard and Seguin at Pont-Aven, in Brittany.

Amiet never became personally close to the young painters, but they admired his philosophy of art, his use of massed color planes. Giovanni Giacometti, the subject of this woodcut, was the father of Alberto Giacometti, the modern sculptor, and was a well-known landscape painter of the time. The thin, winding lines are Jugendstil methods, but the balanced and centralized head compels a mood of meditation more in line with Symbolist methods. We don't know if this print was made especially for the portfolio or taken out of the exhibition.

48.

49.

## AXEL GALLÉN-KALLELA
### (Akseli Valdemar Gallén-Kallela)

**49. Mädchen und Tod im Walde** *(Girl and Death in the Woods)*

Woodcut, 1895
Printed in dark brown on simulated japan paper
Signed and dated in blue pencil
Bolliger-Kornfeld 7
16.5 x 11.7 cm., trimmed to the borders
Ex-Collection: Hans Bolliger, Zurich
Plate 2 of Jahresmappe II, 1907

The older Finn was a well known Jugendstil painter with an international schooling. He had exhibited as early as 1888 in Paris. After Gallén-Kallela returned to Finland in 1890, he entered a period of romantic-nationalistic art, using the themes of northern sagas and legends. There was an expressionist development in this artist as a result of the earlier work with *Pan* and Count Harry Kessler's group of Jugendstil illustrators.

Never a true member of the Brücke group, Gallén-Kallela was asked to submit a print for the portfolio. He sent this earlier work of 1895. The subject was dear to German Romantic thinkers. Schubert had written a quartet around the theme. The woodcut is Jugendstil in form and contains all the elements desired by the publishers of *Pan* rather than exhibiting direct Expressionism.

Gallén-Kallela was a leader of Finnish art, probably invited as such for this portfolio. He represented the romantic trend in northern art. Death is small and appears behind a snake. The print was influenced by grief at the death of his daughter, Mariatta in 1895.

It was important for the development of the young and developing Brücke painters in Dresden to have these outside influences, which led them away from provincialism. It shows their desire for wider scope in their thinking, their good intentions and expanding taste. The link through Gallén-Kallela with Hodler was very important to Heckel and Pechstein. Nolde must have been impressed with the Finn. Both artists brought a manneristic intention far beyond local painting in Dresden: a use of distortion that was in opposition to classical thinking, a direct link with the great painters of the earlier generation, Gauguin, Munch, and Van Gogh. The young painters learned to use only essential elements and combine these with the fantasy of inner impulse.

<div style="text-align: right">51.</div>

## ERICH HECKEL

Heckel's earliest woodcut is dated 1903, before those of most of the other Brücke people. Our first example is numbered 26 in the oeuvre catalogue. As with Kirchner, this artist designed most early woodcuts in a simple stamp-like style. There were no half-tones. The edges are sharp. A definite style does not appear until about 1906.

51.  Vor Sonnenaufgang *(Before Sunrise)*

Color woodcut, 1904
Printed in dark green and light grey-green
Signed and titled in pencil, an inscribed proof
Part of the artist's inscription: "Die 2 Bäume sollen dunkler werden" (the two trees to be made darker)
Approximates Dube 26 b/b (state unlisted in Dube), before monogram
8.2 x 15 cm.

This woodcut is typical of early work, though carried somewhat beyond a flat style by the color plates. Three tree shapes, very Art Nouveau, are varied in an interesting manner from simple left to complicated right. The diagonal shapes from the sky counter an upward thrust from the horizontal ground line. It is a two-plate composition with depth provided by the color. Curvatures are in the Jugendstil woodcut style, though the major simplicity is architectural in concept. Outlines vary according to the liquidity of the ink, and are somewhat accidental but provide an uneven outline that softens the edges in a graphic way. Verticality from the wood grains gives internal patterning. Simplicity is powerful in this minor work. The creative use of color provides an emotional over-effect that is sensitive and moody. Notations in pencil are the artist's own messages to himself about changes in the later states.

<div style="text-align: center">50.</div>

## FRITZ BLEYL

50.  Hockende mit Hut *(Crouching Woman with Hat)*

Carbon pencil drawing, ca. 1906
Verso: Estate stamp
44.6 x 34.5 cm.
Ex-Collection: Galerie Nierendorf, Berlin

Hilmar Friedrich Wilhelm Bleyl was born on October 8, 1880, which places him in the main group of young Expressionist artists. His earliest work is naturalistic—sketches of castles and landscapes with impressionistic quality. He was educated in the Technical College, Dresden, a classmate of Kirchner. From an honored teacher, Fritz Schumacher, Bleyl learned the use of high perspective and some interest in the application of Jugendstil to architectural drawing. He had a fine coordination between hand and eye, probably the best natural sense of draftsmanship of all the young men, but his main ambitions were in the field of architecture, not painting. His woodcuts are fine studies in contour and massed form, though all are rather naturalistic rather than containments for inner feeling. It is nature as seen through a controlling eye, not by fantastic inner directives. Bleyl brought to the Brücke group an interest in stained glass painting. He designed three such works in 1906, all in a Jugendstil tradition. Studies from nature in watercolor were developed into linear outline and hardened into a form similar to the non-graduated medium of woodcut.

This 1906 drawing, probably made in a study group with the other young artists, is fresh and spontaneous. After Bleyl saw an exhibition of works by Van Gogh in November, 1905, he had changed his line into a kind of Japanese verticality.

This sketch is lit from above, casting heavy shadows and outlining contentrated form, using a naturalistic formation of dark and light in massive planes. Impression and gesture are paramount in this work. There is little symbolism. It is a study of light and shade.

## 52. Sambo

Color woodcut, 1905
Printed in black and ochre
Signed and dated in pencil, titled
Dube 56 b/b, a proof
15.6 x 10.8 cm.

52.

Sambo is a print from the middle period of Heckel's early development. It is from a series of twenty-one heads. Most have grotesque dimensions. The subjects are formed from Heckel's readings: they show, or at least one recognizes as subjects, Nietzsche, Poe, Dostoyevsky. Whatever the subjects, they seem lost in contrasty woodcutting.

The ochre-tone plate, pale under the black block, is effective. Lines are not skillfully cut—a slip shows at the bottom left. Theatrical and realistic, the semi-abstracted features seem unimpressive. There is more uncut wood than in the early Kirchners. The drawing technique, perhaps, is more relaxed.

53/2.

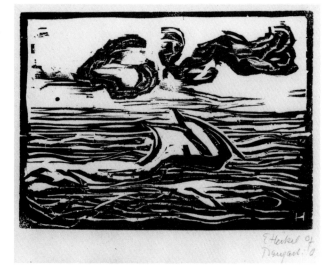

## 53. Segelboot *(Sailboat)*

Woodcut, 1907
Dube 143 IB/II; Bolliger-Kornfeld 10 (titled there: Segelschiff auf hoher See)
Signed in pencil, inscribed: "Dangast i.O."
First state as it appeared in Jahresmappe III, 1908
15.5 x 21.8 cm.
Plate 1 of Jahresmappe III, 1908

The woodcut is a fairly maturing work of the more skillful Heckel. The chisel is used well and cuts are made where necessary, not as the tool would move in a direction with or against the grain of the wood. It is a studied picture of movement and counterforce, of tossing sea and sky, living sky. All is transformed by the steam-like clouds which swirl and turn over the ship as though forming over an island. Use of woodgrain is here applied to edges in the sky, though over-inked to make a harsh, contrasty impression. Everything is designed to make the ship seem to leap forward and move against the elements. The impression is heavily printed, probably with heavy pressure on wet paper.

53.

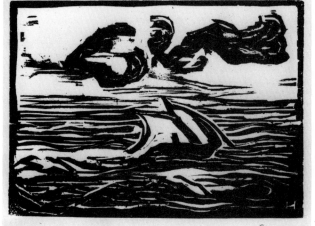

## 53/2. Segelboot *(Sailboat)*

Woodcut, 1907 (printed ca. 1920)
Dube 143 II/II as reworked after 1919
Signed and inscribed: "Dangast: O."(?)
15.5 x 21.8 cm.

The second state of Segelboot may or may not be an improvement. Heckel changes the entire mood of the print. More of the clouds are cut away, areas between the waves are wide and open. The entire effect is more calligraphic. Mood changes from somber wildness, a fight for survival, to shimmering sunlight and smooth journey.

It is interesting to compare a similar subject in a different medium, Heckel's Segelboot of 1910. This lithograph exposes the rounded corners of the limestone, not the square form of the wood block. Stillness succeeds action. There are peaceful reflections instead of massed, rounded forms. Perpendicular design counterbalances the composition. This concept is truer to Heckel's temperament, one of quietness, of a literary, intelligent, and patient man. Made by a twenty-seven-year-old artist, this print has some of Heckel's poetic feelings. It is the expression of a lyrical person.

**54. Die Ballade vom Zuchthaus zu Reading** *(The Ballad of Reading Gaol)*

von Oskar Wilde
mit Holzschnitten von E. Heckel
11 Woodcuts plus a title page woodcut by the artist, 1907.
In the original gray cardboard folder, loose plates, all plates signed by the artist, and some plates titled or listing the appropriate lines of poetry in German
Dube 120-131, small edition of unknown size (One of the two known complete copies. The other is in the Volkwang Museum, Essen)
40 x 23.5 cm. (folder)

Oskar Wilde (1856-1900) was sentenced at Old Bailey in May 1895 to two years of hard labor. In 1898 he published this powerful ballad about the experience.

Wilde represented a new elite devoted to pure form and symbolic expression. "I treated art as a supreme reality and life as a mere mode of fiction." The basic creed from this poem appealed to the young Germans. It spoke of hedonism and suffering. It reversed Wilde's snobbery, showed his social thinking and belief in cleavage between art and material life. The poet's sentence was also seen as the imposition of authority by a bourgeois and violent British public against a defiant artist.

Wilde's libretto for the opera Salome had been orchestrated by Richard Strauss and first performed in Dresden in December 1905. It was the sensation of the German music season because of the barbarism, cruelty and wild stage designs, and reinforced interest in Wilde.

Heckel's woodcuts are fairly direct illustrations of certain lines. On some of the impressions he had written the line sources near the lower margins:

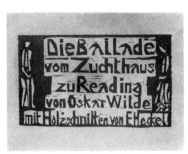

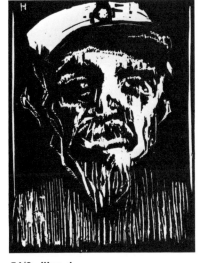

**54/2. Illus. 1.**
He Walked amongst the Trial Men
In a suit of shabby gray;
A cricket cap was on his head
And his step was light and gay;...

**54/3. Illus. 2.**
Yet each man kills the thing he loves,
By each let this be heard,...

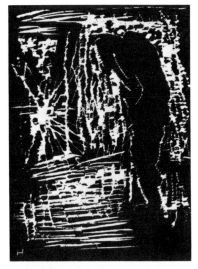

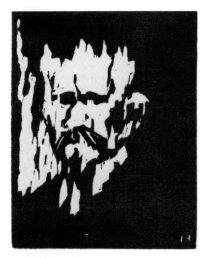

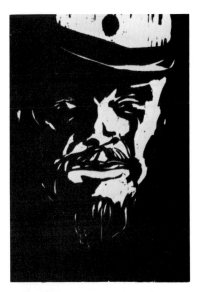

**54/4. Illus. 3.**
He does not wake at dawn to see
Dread figures throng his room,...

**54/5. Illus. 4.**
Titled by Heckel "The Judge";
no apparent verse connection

**54/6. Illus. 5.**
And twice a day he smoked his pipe,
And drank his quart of beer:
His soul was resolute, and held
No hiding place for fear;...

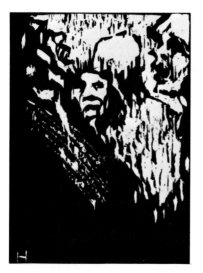

54/7. Illus. 6.
We did not care: we knew we were
The Devil's Own Brigade:
And shaven head and feet of lead
Make a merry masquerade.

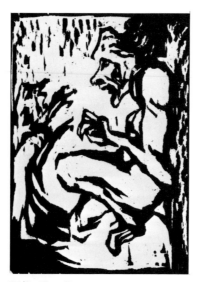

54/8. Illus. 7.
That night the empty corridors
Were full of forms of Fear,
And up and down the iron town
Stole feet we could not hear,...

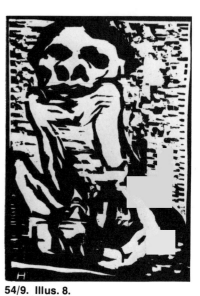

54/9. Illus. 8.
With yawning mouth the yellow hole
Gaped for a living thing;
The very mud cried out for blood
To the thirsty asphalt ring:
And we knew that ere one dawn grew fair
Some prisoner had to swing...

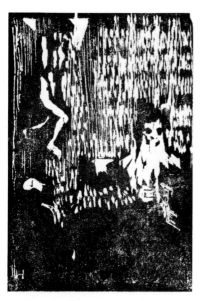

54/10. Illus. 9.
And as one sees most fearful things
In the crystal of a dream,
We saw the greasy hempen rope
Hooked to the blackened beam,
And heard the prayer the hangman's snare
Strangled into a scream.

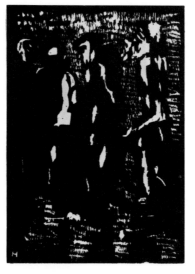

54/11. Illus. 10.
Like ape or clown, in monstrous garb
With crooked arrows starred,
Silently we went round·and round
The slippery asphalt yard;...

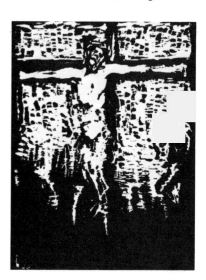

54/12. Illus. 11.
And there, till Christ called forth the dead,
In silence let him lie:
No need to waste the foolish tear,
Or heave the windy sigh:...

This was a time of reading and study for Heckel. He illustrated few books, so this manuscript must have been very important to his intellectual development. We know of his earlier portraits of Nietzsche and Dostoyevsky, perhaps also of Poe and Stirner.

His prints of morbid subjects, the growing skill with technique, the interchange, both intellectual and artistic, between the communal Brücke members made the period exciting. Nolde had influenced some of these woodcuts. Kirchner certainly also was an influence. But the scratching technique seems all Heckel. The prints are bathed in darkness, contrast sharply in black and white, made as spots without reference to any typography, but all personal reactions to the power of the verse.

The general mood is still romantic in origin, with exaggerated emotional overtones: the spiritual lassitude of the subjects in straightforward portraits contrasts the gothic attitudes of the free subjects. It is a prison full of ghosts and eerie sounds, stillness and horror, loneliness and fear of the future. Each print is an experiment in technique: soft edges, hard edges, scratched edges, sanded and criss-crossed.

**55. Plakat der Eröffnungsausstellung der Kunsthandlung C.G. Oncken im Lappan, Oldenburg** *(Poster for Opening Exhibition of the Art Gallery of C.G. Oncken in Lappan, Oldenburg)*

Woodcut, 1909
Dube 172, Bolliger-Kornfeld 54 (titled there: "Lapan Kunstausstellung")
Unsigned, on brownish paper
84 x 59.8 cm.

This exhibition poster uses two different blocks, one for scene and one for lettering. Heckel gives impressive strength to the scene of a light-filled townscape. The wood chisel effect is apparent on the outline and right building. There is little symbolism, but mainly direct perception. The tower on the left is probably an ancient city gate. Lettering at the bottom is designed to balance with the weight of the upper lines. This is a scene without much human feeling, unposed and related by plane, not poetry to human life. There is a highly restrained and highly stylized sense of peace in the ancient street. (It was designed for an exhibition of the art dealer, C. G. Oncken, Lappan, Oldenburg.)

55.

56.

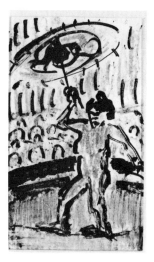

**56. Postcard of Clown**

Watercolor, undated (1909 on postal cancellation)
13.9 x 8.8 cm.

Translation of the postcard text:

"Dr. Rosa Schapire here is a tight-rope walker from the Kramer Fair. Karl (Schmidt-Rottluff) told Italian short stories, some of them are nice to read, especially while we are sitting on the warm banks of the lake during rain outside. My best, E.H."

Dr. Rosa Schapire, living in Hamburg, was an associate of Die Brücke. She promoted their work, helped sell individual pieces, wrote articles in Expressionist periodicals about some of the artists in Dresden. Her sensitivity to their aspirations was apparent from her earliest contact with them.

**57. Liegendes Kind** *(Reclining Child)*

Drypoint, 1910
Signed and dated ("12") in pencil, inscribed, on copperplate paper
Dube 79 A/B, a proof before the edition of 10 on japan and 30 on Bütten
12.9 x 19.2 cm.

One of the masterpieces of early Expressionism, this impression is a very fine example of printing and conception. Emphasis is on simplicity, careful arrangement rather than passionate statement. It is rather unemotional but intellectually direct. Placement of the face balances and counters the long horizontal division into thirds. Sharp, fine patterns are repeated and inverted with diagonal gracefulness. The unfinished plate was not burnished for printing, but scratched all over with minute lines, perhaps with fine sandpaper. This carries some of the tone, which Heckel carefully left on some areas and wiped clean on others such as the knee, face, and cloth. The rounded abstraction of the face with elongated body seems motivated from Etruscan art. The figure shows a sense of loneliness, flowing grace, adolescent awkwardness, some feeling of decadence and melancholy—a complicated conception indeed. The peculiar attributes of drypoint are used superbly with thin and thick lines, quick change of direction, sketchy feeling bounded by the emphasis of the burr forms creating linear vibrations.

57.

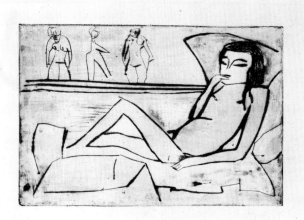

## ERICH HECKEL

**59.  Strasse am Hafen** *(Street by the Harbor)*

Drypoint, 1910
Signed and dated in pencil, on heavy vellum
Dube 91; Bolliger-Kornfeld 24 (titled there: Strasse mit
Fussgängern (Hamburger Hafen) *(Street with Pedestrians —
Hamburg Harbor)*
*17 x 20 cm.*
*Plate 3 of Jahresmappe VI, 1911*

Strasse am Hafen, a drypoint with small etching, uses the thick
burr effect for the tree trunks, left figures, and roofs, relating
darks in a triangular pattern.

Interesting fan-like shading turns inward on the trees, with ver-
tical shading on the figures. The plane of the street is tilted. A
house grows out of the top of a tree. A small sense of perspec-
tive is maintained by the horizon line and bridge, but dropping
arcs repeat downward forces and make the picture seem to
leap out of the plane with a peculiar sense of inner movement.

58.

59.

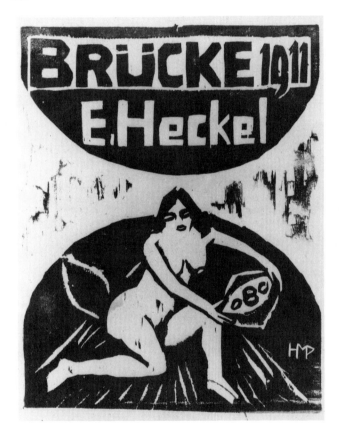

## DIE BRÜCKE JAHRESMAPPE 1911
## MAX PECHSTEIN

**58.  Umschlag: Kniender Akt mit Schale (Cover:** *Kneeling Nude
with Bowl)*

Woodcut, 1911
Printed on blue cover stock, unsigned
Not in Fechter; Bolliger-Kornfeld 21
37.5 x 30.5 cm.
Cover of Jahresmappe VI, 1911

**60.  Stehendes Kind** *(Standing Child)*

Color woodcut, 1910
Printed in red, green and black
Signed and dated ("11") in pencil, on heavy vellum
Dube 204 b2/b; Bolliger-Kornfeld 22, titled there: *Fränzi
stehend  (Fränzi Standing)*
*37.7 x 27.6 cm.*
*Plate 1 of Jahresmappe VI, 1911*

Fränzi Standing, a major work of 1910-1911, is the first of the
color woodcut masterpieces. Heckel begins to confine his
forms into closed boxes. The top is very heavy. A thoughtful
expression is on the girl's face. There is great restraint in the
use of line, simple but strong. The vertically placed figure is
massed right of center, countered by to curving hills in a grace-
ful and decorative manner. The abstraction is primitivistic. The
mood is poetic and restrained. Graceful, flowing lines are typi-
cal of this period. The subject seems a world-weary adolescent
with overlarge head, underdeveloped body.

Three colors are superbly used in bars one above another. The
main block was probably cut up into three sections on a jigsaw,
inked separately, and then put together for printing in one oper-
ation. This was a method Heckel may have borrowed from Munch
This color woodcut represents an example of great restraint,
perfect conception in a fine impression of German Expression-
ism at its best. It shows the poetic side of the movement.

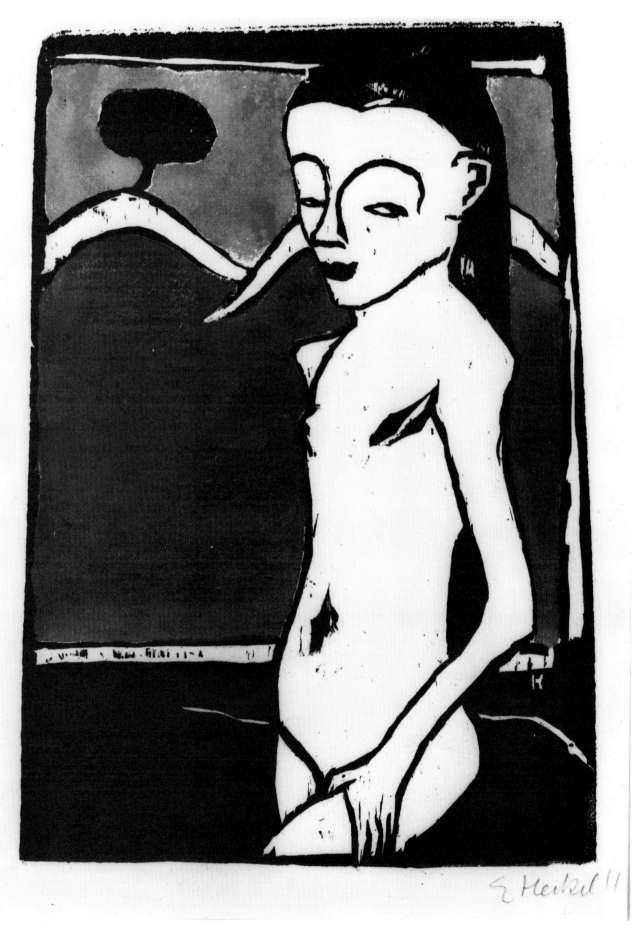

**61. Pantomime von W.S. Guttmann** *(Pantomime by W.S. Guttmann)*

Woocut, 1912
Unsigned
Dube 232 IV/IV, with text
8.5 x 11 cm. (woodcut only)

This woodcut was reused for the opening announcement of an exhibition, at the Goldschmidt-Wallerstein gallery of new work by Erich Heckel and Otto Mueller in 1912.

61.

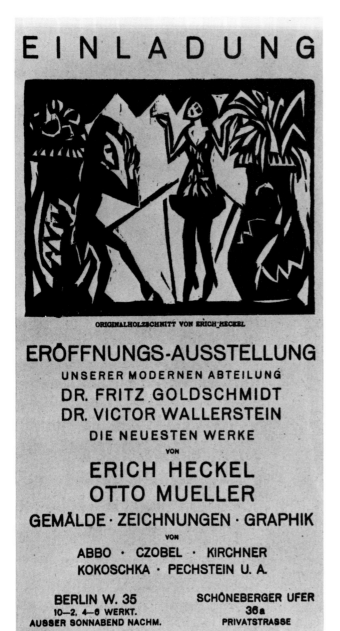

**62. Der Mord der Akulka von Dostojewski** *(The Murder of Akulka by Dostoyevsky)*

Woodcut, 1912
Signed in pencil
Dube 237 (titled there: "Titelblatt: Der Mord der Akulka")
Title page for The Murder of Akulka by Dostoyevsky
15.5 x 11 cm.

A woodcut illustrating a story by Dostoyevsky. The animal element in man was a major theme of the Expressionist poets. Taken from the naturalist writers of the earlier century, this idea was transformed by the new interest in psychology. The "id" seems to contain this elemental lack of morality and repression. Dostoyevsky described an inner conflict, an individual struggle of life and the death wish, which seemed very appealing to the young German thinkers. Heckel shows us a savage murder, a demented man cutting the throat of a young girl he has overpowered. We do not know if the idea was Heckel's or supplied by some publisher, but Heckel made some sketches based on Dostoyevsky's writings during this time, especially for the House of the Dead and The Idiot. The fragility of life, the melancholy tragedy of mankind was expressed by that writer's inner torment. It was a complex message of inner guilt and of innocence murdered by uncontrolled emotion. Dostoyevsky described his fellow prisoners in the House of the Dead in some detail, and they seem to have ratified his basic needs.

The two figures are shown in a spear-like forest of pines, all repeated triangles which lend an effect of danger and rage. The heavy overweight of the man's lower body dominates the center, a giant almost kneeling to slash his victim's throat. The man holds his victim by the hair to expose a vulnerable curve of the throat. Most of the fearful effect is provided by the abstraction, for the figure seems puppet-like in the expressionist device of a stage. Gesture is made in exaggerated poses. The surrounding darks also intensify this effect.

**63. Zwei Männer am Tisch** *(Two Men at a Table)*

Woodcut, 1913
Signed in pencil, on laid paper
Dube 250 I/II
23.5 x 26 cm.

This woodcut of 1913 is also an illustration for Dostoyevsky's The Idiot. It is a flat and angular print, designed for the white areas, spaces around forms, almost a design of negative space. There is little inner articulation except in the representation of Christ, now turned sideways, and in the faces of the men. Silhouette is little broken. There is a quality of vibration, a sense of quiet articulated into action by the stark contrasts. Everything is closely confined by the blacks. Lethargy and tension are combined. It is a bold concept in an irregular format. Inner feelings are shown by the violent design rather than by pose or expressions.

62.

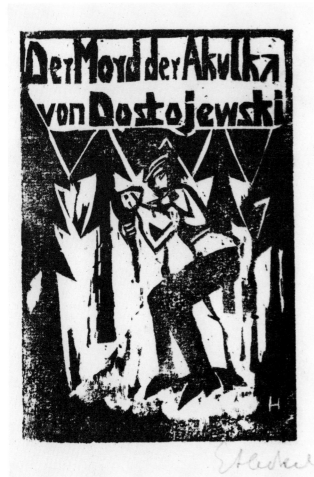

63.

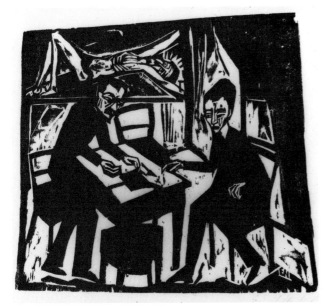

## 64. Handstand *(Handstand)*

Lithograph, 1916
Signed and dated in pencil, on wove japan, from the edition of 25
Dube 230 I/III
27.9 x 19.6 cm.
As issued in *Die Schaffenden; eine Zeitschrift in Mappenform.*
Edited by Paul Westheim
Weimar, Kiepenheuer Verlag. 1919/20
1. Jahrgang, 1. Mappe, #2
Edition: 25 impressions on japan and 100 impressions on Bütten

Heckel's friendship with Franz Marc after 1912 had produced a more powerful form of expression. He had studied the curves and interplay of line that came from Marc's interest in Cubism-Futurism. The prints after this time have more poetic content and dramatic intent. The forms become more elongated.

The lithograph was made in 1916 and used later for the periodical *Die Schaffenden*, which published about 100 original prints a year for subscribers.

Handstand is different from the paintings of the war period. Heckel had done religious murals in Ostend and a number of landscapes, some portraits of comrades, and new studies of bathing men on the Flemish beaches. From these studies come the distortions and use of movement in the lithograph. There are specific placements of horizontal and vertical emphasis, and a kind of double image of acrobat and shadow, which is used in the paintings. The masks on the curtain are an echo of the Brücke period in Berlin.

64.

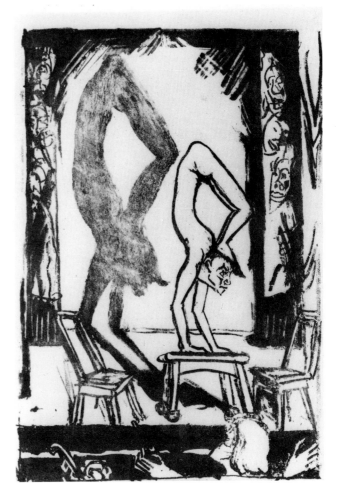

## 65. Der Narr *(The Fool)*

Woodcut, 1917
Signed and dated in pencil
Dube 309 IIB/IV
35.8 x 27.2 cm.
As published in Bauhaus Drucke; Neue Europäische Graphik 5te Mappe; Deutsche Künstler, Staatliches Bauhaus in Weimar, Müller Co. Verlag, Potsdam. 1921. 110 examples. Titled: Männliche Halbfigur *(Male Half Length Figure)*

Heckel was stationed at Ostend, Belgium, during part of the war, especially in 1917. He met Max Beckmann, Permecke, and Ensor there. The subject also of the earliest painting of the year was taken from his readings: "Roquairol" after a character in The Titan by Jean Paul, a German Romantic writer. This was not a prolific period for Heckel, who had also suffered depression and mental agony because of his work with wounded soldiers.

The Fool is a bold composition, of a rather mournful clown, not a figure of action. He seems introverted. There is some resemblance to the self-portrait, but the pursed lips are smaller, and the combination of some of Heckel's features with parts from the seven other portraits of that year make this a universal figure. All seven studies had been studies of sadness and stillness, with a rather shocked attention. In the past, the figure of the fool had provided a symbol to ridicule society; now, again, it seemed fitting for the incipient feeling in the country and among artists that the war was foolish and moving towards defeat.

The composition is straightforward and uneventful, a concentration more on theme than theory.

**65.**

**66.**

## 66. Der Spaziergang *(The Stroll)*

Woodcut, 1919
Signed and dated ("20") in pencil, on Bütten
Dube 317 I/II
46 x 32.6 cm

Heckel had returned to Berlin after the war. He took part in certain Workers' Councils for Art. He was involved with the revolution and plans for a new future.

At first glance, this woodcut of a stroll seems full of the earlier violence, with angular cuts, small in length, which break up the faces and hand. Yet, we can see a quieter mood, and the harsh shading fits into areas as tonal action not outside the intended mood. The theme is lyrical, with an older man teaching an attentive young person. The special articulation of the areas is a last use of these complicated strokes, which Heckel originated in the war portraits during the period in the hospital. Then he was driven by nervous energy, and the sadness and reaction to the horrors around him. Now his intention is to produce brilliance and vibration of surface to create a glow in the texture. Cutting away the surface in this manner also gives a quality of age to the middle-aged features.

**67.**

**67. Plakat der I. Ausstellung neuzeitlicher deutscher Kunst, Krefeld 1920** *(Poster for the First Exhibition of Contemporary German Art, Krefeld, 1920)*

Woodcut, 1920
Signed and dated in pencil
Dube 324
63.6 x 45.2 cm.

This large woodcut was based on an earlier Männerbildnis (called by some a self portrait) of 1919.

It is cleverly introduced among the type and space. The pensive mood of 1919 is kept exactly. The design is in the new manner and also more open and elongated. Slightly enlarging the size of the earlier portrait allowed some changes in details. There are pain lines added around the eyes and the brow is more emphasized by diagonal lines. It is a moodier face. (By 1920, the German revolution had been beaten back by reactionary elements in the new socialistic government and there was a withdrawing of artists and writers from the earlier feeling of hope and revival.) It shows a man watching with patience, a tired man.

The motifs within the upper type are an interesting addition, as the designs are both creative within each space and allow the heavy script to emphasize.

**68.**

**68. Inhaltsverzeichnis der Erich Heckel-Mappe des Verlages J.B. Neumann, Berlin** *(Table of Contents of the Erich Heckel Portfolio of the J.B. Neumann Publishing House, Berlin)*

Woodcut, 1921
Signed and dated in pencil
Dube 329 B/B, from the edition of 40 examples, printed by Voigt, with his signature
32.4 x 21.8 cm.

Again, we can see Heckel's use of type and design together in this table of contents for the Neumann portfolio. The prints are taken from the years 1913 through 1921, a cross section, as was J.B. Neumann's way in these issues. The woodcuts in the portfolio have mostly quiet subjects, landscapes, bathers, and portraits. There is a unity of feeling.

The table of contents is centered, with animated abstractions over and under the type. The page is very full, with no large areas of black and white. The upper frieze is built around dancing figures.

In the lower section one can find an animal, hands, and a bent figure. One must depend on the idea of continuity of design for the first cover is heavy and black with white type cut in the background. Then one can open to this black on white design as contrast. This gives a pleasing change as the portfolio is opened.

**69.** Katalog der Ausstellung "Erich Heckel" in der Kunsthütte Chemnitz *(Catalogue of the Exhibition "Erich Heckel" in the Art House Chemnitz)*

Printed by Buchdruckerei Adam, Chemnitz. 1931
16 pp, 17 illustrations
21.4 x 16.4 cm.
End papers are original woodcuts, as are the covers
1.  Faltumschlag *(Folding Cover)*. Color woodcut, 1930. Printed in yellowish brown and black. Dube 346, two blocks; end papers and cover cut in one block. 16.9 x 91.7 cm.
2.  Vorsatzblatt *(Title Page)*. Woodcut, 1930. Dube 347. 17.1 x 28.1 cm.

Heckel had planned this catalogue in a careful manner. The method of combining end papers and cover woodcuts was solved by cutting all on one long block and cutting another for the ochre color. Rather than have exact registration, the artist kept color areas inside black lines; and careless printing by a commercial firm could not destroy his intentions.

The late style is heavy, rather stiff and more in keeping with his later concept of outline and flat tone as in the paintings. He uses a lively primitive series of designs for the covers, breaks up the type with inserts of abstract shapes, which help animate an otherwise expressionless series of whites. There is strength still, some sentimentality in the figures, and a skillful solution to the design problem.

71.

**69.**

**70.** Graphik der Gegenwart/Band I/Erich Heckel *(Graphics of the Present/Volume I/Erich Heckel)*

Berlin: Euphorion Verlag. 1931
Printed by Poeschel & Trepte
Unpaginated (54 pp), 48 illustrations
24 x 16 cm.

Five original woodcuts:

70/1.  Umschlag *(Cover)*
Color woodcut, 1930
Printed in blue and black
Dube 348
20 x 28 cm.

70/2.  Zirkus *(Circus)*
Color woodcut, 1930
Printed in red and blue
Dube 349; front end paper
23.9 x 31.2 cm.

70/3.  Tanzende Matrosen *(Dancing Sailors)*
Color woodcut
Printed in red and blue
Dube 350; rear end paper
23.8 x 31.2 cm.

70/4.  Vignette *(Boy Holding Initials)*
Woodcut, 1930
Dube 351
3.8 x 4.3 cm.

70/5.  Stadion *(Stadium)*
Woodcut, 1930
Dube 352
19 x 11.3 cm.

Various projects had attempted to present graphic art of the present. Klinkhardt and Biermann had begun their series (adding prefix of German later). Die neue Kunsthandlung in Berlin had an earlier and minor series. The major publisher in Berlin, Euphorion Verlag, began its series with this picture book about Heckel. Unlike the others, there was no critical text.

Heckel designed original woodcuts for the book. He repeated his late style, with open forms and flat color between lines. Some overlap changes the red and blue into a dark for emphasis. He shows himself on the cover with a chisel in his hand.

The less profound Heckel has become dominant. The great social issues are no longer illustrated. He reverts to early circus sketches and a gay sailors' dance. The woodcut showing a scene in a stadium (a swimming stadium) has a very static quality, unlike Heckel's angularity.

**70/2.**

## E. L. KIRCHNER

The themes of Kirchner's early period were remembered fantasies of childhood; the anxieties of a child moved five times in ten years from city to town to city. Early woodcuts tend to be sarcastic, caricatures, simplified from interest in the watermark and trademark designs from various factories of his father's supervision at mills making paper. There is an apparent interest in simple and bold linear patterns. This was developed in special studies under Obrist and von Debschitz, but was mainly due to the teaching of Hugo Steiner-Prag, the teacher-illustrator in Munich. This mixture of Jugendstil abstraction and academic life drawing made a lasting impression on the aspiring artist.

His first catalogued woodcut was made in 1904, though Grohmann lists one in 1902. The Phalanx exhibition in 1903-1904 also seems to have influenced the young artist. Brücke material dates after 1905, when Kirchner graduated as an architect from the Technische Hochschule in Dresden. His relationship with Bleyl probably started in 1902, when both were students. Though Kirchner mentions interest in late medieval German woodcuts, that of Dürer in particular, there is no apparent modification seen in the earlier woodcuts, though a great influence is apparent from the French, the Swiss Vallatton especially.

Kirchner's early woodcuts show a monumentality rather than artistic realization, an architect's patterning rather than a painter's eye. The impressions seem more like stamps. They do not have the joined surface of complex lines so typical of professional woodcutters, for webbed lines carry heavier pressure for larger editions. White is designed into black without the complex relationship of massed areas of certain later masterpieces. Light and shade are also emphasized, making these early attempts heavy. The chiaroscuro is primitive, cameo-like.

### 71. Eisenbahn and Brücke (Railway and Bridge)

Crayon and charcoal drawing, 1903
Signed and dated in brown pencil
35.5 x 26 cm.

Our first example is dated 1903. But it may be backdated, a common practice by this artist to make his earlier work seem more precocious, as the signature seems to be that of 1908. The calligraphy also appears to be later. Nevertheless, the considerations, the free use of line, the massed color and the original shorthand form creative and manneristic integrity. A full swing of curves thrusts through the center ground and accents the motion of the horse and cart, moving the mass on the bridge with skill. Counterthrusts from right to left are fine opposites. Already Kirchner has thought out an original method of jotting down his quick reactions to a scene, a defined emotional response with minimal abstraction.

### 72. Stehender Mädchenakt (Nude Model Standing)

Woodcut, 1905
Signed in pencil; on verso, stamp from Kunstverein Jena
Dube 53; not in Schiefler
12 x 3.8 cm

This impression has the heavy early style combining Jugendstil curves with a frozen and impassionate effect of stillness. It is a curious unit of simple design combined with rather unskillful woodcutting. The linear simplicity reduces emotional overtones. It reads well in contrast, but is a figure study without emotional message, a style which became the basis for Kirchner's later work. The year 1905 was a time of great progress by this artist, barely two years after his first woodcut.

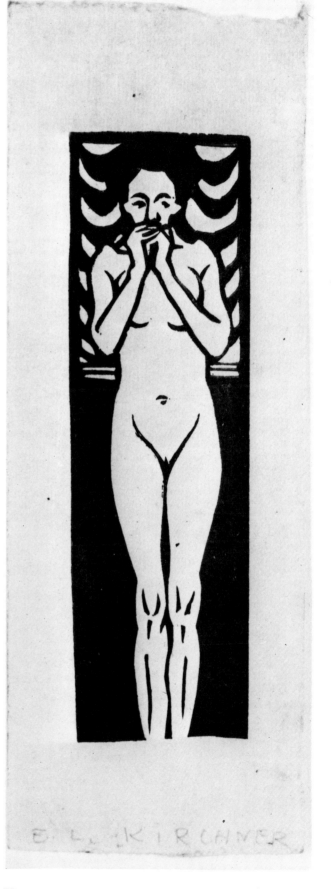

72.

### 73. Gehöft mit Bäumen *(Farm with Trees)*

Woodcut, 1906
Signed in pencil, marked "Grunddruck"
Dube 70; Schiefler 50
12.5 x 12.3 cm.

During his twenty-sixth year, Kirchner produced many fine woodcuts, Gehöft mit Bäumen is an exercise in sharpness, as though the artist were feeling out the repetition of triangular shapes repeated throughout the picture surface. Dark areas no longer have integrity, but are pierced into movement to vibrate the optical surface and create intensity. Linear perspective is used, though as movement for the eye not as reality. Form intermingles with form, a new use of design not common with the Jugendstil practices, though some of the earlier artists used this in color areas. This penetration of surface becomes a signature for the later Kirchner. In this woodcut, calligraphy is perfectly functional to the medium.

73.

### 75. Paar *(Couple)*

Pencil drawing, ca. 1906
Unsigned
43.5 x 33 cm.
From the estate of Curt Valentin, New York

As part of the new liberation, Kirchner studied the erotic in many aspects. Most of the erotic prints were made as lithographs. He painted sexual themes on the walls of the Berlin studio he shared wth Erna. Though his calligraphy is now advanced, Kirchner places the two figures carefully on the paper. He works in his familiar diagonal movement towards the upper left border, and articulates the balance by scribbles in the lower right. The figures are not drawn as separate beings, but intermixed as a symbol of unity. An intimate episode is documented with Kirchner's shorthand made real; for the drawing, though abstracted in line, seems maintained by the centrifugal force of the two-dimensional surface. There is some late impressionist optical objectivity. Yet none of the line coverage is in perspective relationships.

74.

### 74. Mädchenakt *(Female Nude)*

One-color woodcut, 1906
Printed in rose
Signed in pencil, marked "Handdruck", stamped verso: "EK", on heavyweight oatmeal paper
Dube 89; Schiefler 41
24.3 x 24.1 cm.
From the personal collection of Kirchner's wife

Mädchenakt of 1906 shows thought in the use of the heavy oatmeal-like paper for the simple design. Using his favorite thrust of left to right, the artist has achieved balance with curves and large white areas, pierced with simple curvilinear lines. Though some influence from Vallotton is still apparent, the woodcut possesses an irrational proportion that is original. Kirchner's use of inner line, rather than any expression from the model, creates excitement. Barely pronounced muscle structure is shown by lowering the surface as was done in Japanese prints. This woodcut begins to show Kirchner's mature style.

Various attempts to texture the surfaces of inner masses are less successful. Probably influenced by his study of Pointillism, he complicates the integrity of the balance in an unnecessary way.

Printed in a rose red, on thick oatmeal paper, the woodcut creates its own surface excitement by accidental changes of tone as the color is absorbed.

75.

76.

### 76. Stilleben *(Still Life)*

Color woodcut, 1907
Printed in yellow, grey-green and rose
Signed and dated in pencil, a proof on heavy vellum paper
Dube 112; Schiefler 43; Bolliger-Kornfeld 11 (titled there:
Stilleben mit Krug und Rosen *(Still Life with Jug and Roses)*
20.2 x 16.8 cm.
Plate 2 of Jahresmappe III, 1908

A traditional German still life had dark objects and bright cloth.
Kirchner uses, instead, objects which lend themselves to a
combination of line and flat tone. The wood shapes of the block
become the basis of angular pattern. Rather than use exact and
close-fitting color shapes, Kirchner designs so that the print-
ing can vary, yet retain a sense of the real. Colors intersect and
parallel, instead of fitting as a jigsaw puzzle.

There is still some of the cameo effect found in the early prints.
The cameo had been the major collecting object of nineteenth
century German art history. Combined with engravings after
paintings, cameos were the source of inspiration. Great collec-
tions were far apart and the books showing reproductions were
more readily available. Goethe speaks of this kind of collecting
frequently, and participated in it.

In this still life, the shadows are made into angular concentra-
tions, simplified and made into calligraphy. The use of large,
flat color areas is new for Kirchner, but he displays some native
skill for this difficult use of transparent and opaque printing.
The darks are correctly joined with the border to tie the design
together.

The color woodcut was more common in the period of 1908.
Kirchner had seen the great Jugendstil exhibition in Dresden,
in which the drawings and prints of the Vienna Secession had
been combined with the fine furniture and crafts objects. Some
of Munch's earlier woodcuts had been shown as well as those
of Gauguin. The design tendency in this color print seems more
closely related to the Jugendstil woodcuts from Vienna.

It is not surprising that after these clear colors in the woodcut
medium, Kirchner began to simplify the surfaces of his can-
vases, and use a thinner coating of oil paint. He had been paint-
ing with heavy impasto, dragged and spotted in combinations •
influenced by Van Gogh.

Kirchner's architectural training is still lurking behind this par-
ticular print, as well as the patterning from Hugo Steiner-Prag.
But the clear color is a step toward linear freedom. His drawing
style too is changing. We also detect a faint recollection from
the crafts school library, for the closest commercial illustration
to this print is the work by William Nicholson in *London Types*,
William Heinemann, London, 1898.

**77. Kirchhof und Kirche (Burg auf Fehmarn)** *(Churchyard and Church or Fortress at Fehmarn)*

Woodcut, 1908
Signed in pencil, on imitation japan paper
Dube 136; Schiefler 139, second state
50.5 x 37.8 cm.

The woodcut, Kirchhof und Kirche of 1908, indicates a development away from the studies of the diagonal. Here we find emphasis on the vertical. Three major forms are silhouetted with little interior definition except for some markings on the central tower. The horizontal lines are scratched as though from a drypoint needle. This is a quickly made and impatiently cut print. It is powerful and points to a developing personality.

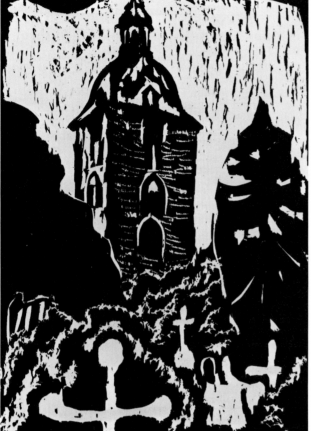

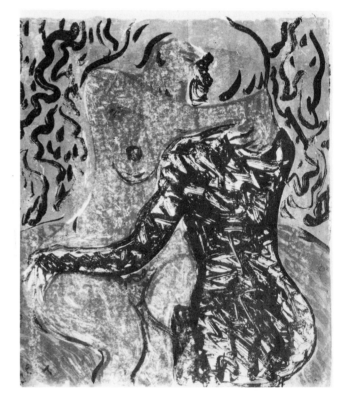

78.

**78. Liebesszene** *(Love Scene)*

Color lithograph, 1908
Printed in yellow, orange and grey-green
Unsigned
Dube 73/2; Schiefler 75
32.5 x 30 cm.
Ex-collection: Brother of the artist

The color lithograph of 1908, Liebesszene, displays Kirchner's use of a tone medium. The black and white illustration can show little of the careful drawing, but does show an interlapping of tone.

Color is used in a very functional manner. The intermixing of straight tone is differentiated by massed color areas. Three colors, a warm orange-red and a light yellowish-green and a warm gray, are overprinted on the under-gray to vary the tint and tone. This design is skillfully adapted to the use of color.

Kirchner's shorthand here is perfected. Curving movement is balanced by massed shapes. Motion, perhaps even shock, is conveyed by balance of the clinging figures. A strange texture, taken from the technique of oil painting but here an improvement, covers the near figure giving it heavier weight.

## DIE BRÜCKE: JAHRESMAPPE V, 1910

**ERICH HECKEL:**

79. Umschlag der Jahresmappe V "E. L. Kirchner" *(Cover of the 5th Year Portfolio, "E. L. Kirchner")*

Woodcut, 1910
Printed on yellow cover stock
Dube 181; Bolliger-Kornfeld 17 (titled there: *"Kniende Akte"*)
29.9 x 40 cm.

The cover by Heckel is a decorative stage-set with the man having features resembling Kirchner's. The crouching figures of a man and girl are formed in the letter "K" twice. This motif is repeated in the triangles.

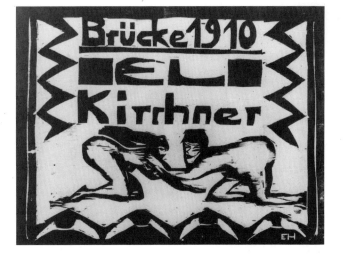

79.

80.

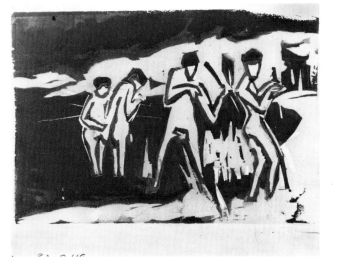

**KIRCHNER:**

80. Mit Schilf werfende Badende *(Bathers Tossing Reeds)*

Color woodcut, 1910
Printed in light green, red-orange and black
Signed in pencil, on heavy vellum paper
Dube 160; Schiefler 121b; Bolliger-Kornfeld 18
20 x 29 cm.
Plate I of Jahresmappe V, 1910

This fine three-color work was made from drawings done near Moritzburg, where the young painters went with their models to live freely, study from the nude in natural surroundings, and escape from police control. Each man posed when other models were unavailable.

The nudes are playing in a lake with reeds. The artist made quick sketches in pencil, crayon and watercolor. There is unusual animation to the playful figures. Nudity seems natural and unashamed. The design form is based on weighted sides right and a sweeping curve from the left, while the lake reeds give verticality.

81. Tänzerin mit gehobenem Rock *(Dancer with Raised Skirt)*

Woodcut, 1909
Signed in pencil, on heavy vellum paper
Dube 141 II/III; Schiefler, 126b; Bolliger-Kornfeld 19
24.7 x 33.5 cm.
Plate 2 of Jahresmappe V, 1910

The dancer has a smiling countenance. She is made static. The design is bold and flat, with some suggestion of movement by use of abstracted figures in the background which counteract the diagonal. There are many quick sketches for this kind of subject, but the woodcut is a fine example of high Brücke design in its inner mood, shown by brilliant contrast of large areas, the violent action, the simplicity of abstraction, the rude stamp of flat surfaces, studied line variations and symbolism of a freely moving, uninhibited figure.

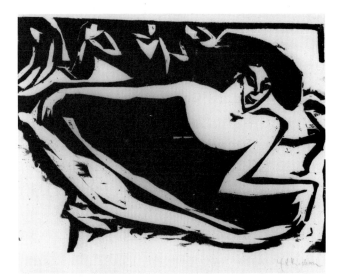

81.

**82. Drei Badende an den Moritzburger Seen** *(Three Bathers at the Moritzburg Lakes)*

Drypoint, 1909
Signed, on heavy vellum paper
Dube 69; Schiefler 52, Bolliger-Kornfeld 20
18 x 20.2 cm.
Plate 3 of Jahresmappe V, 1910

The Moritzburg Lakes, with many islands and warm climate, were the favorite vacation and study areas for Pechstein, Kirchner and Heckel from 1907 until 1910. Kirchner did a number of etchings in this locale, studying line and movement. Most have more action than this quiet group by a lake.

Here, Kirchner uses economy of means in his study of line to show animation by suggestion. He continued the study of quick calligraphy in all mediums. The style is spontaneous, quickly drawn, without raising the drypoint tool much out of the wax resist. The lines are heavily gouged to make a strong outline. The three figures are almost continuously joined by sweeping lines, with a few quick suggestions of reeds and overhead shore.

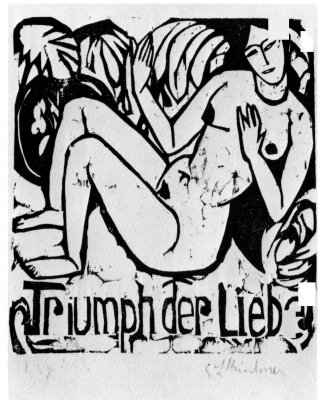

82.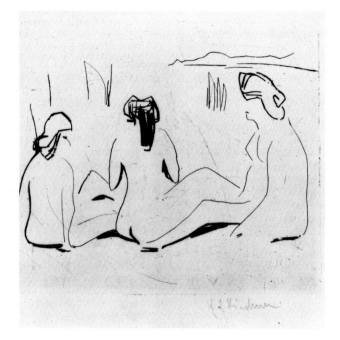

83.

83. **Triumph der Liebe** *(Triumph of Love)*

Woodcut, 1911
Signed in pencil, marked "Eigendruck," on verso are stamps of the Botho Graef Collection and the Entartete Kunst Exhibition.
Dube 186 II/II; Schiefler 165 second state before the reprint of 1918.
24.7 x 23.5 cm.

Triumph der Liebe, woodcut of 1911, is one of two prints made for a projected series based on Petrarch. It was finally completed in 1918. This mature work combines French balance of black and white areas with the primitivism from the Pacific and African sources. Love becomes exotic in a tropical paradise with banana leaves.

Kirchner's calligraphy is at its height. Line has been closely studied and varied according to the emphasis needed. Fat and lean line, horizontality of the title and placement of the head in upper right, with repeated shape, all add up to an exciting concept of expressionistic inner movement from the print, not the model. There is stillness in the posture, but repeated rhythm in arcs translates into beats of centers of interest. Here, the web of lines is more in the ancient Germanic tradition. It seems a complicated maturity, with much kept out, left out, and much thought out. Enough basic simplicity in the woodcut creates a great sense of power and original sense of reality.

### 84. Eispalast-Tänze *(Dances at the Ice Palace)*

Hand-colored woodcut, 1912
Hand-colored in yellow-green watercolor
Signed in pencil
Dube 196 I/II; Schiefler 179
33.1 x 23.4 cm.
Later used as a title page for *Zeit im Bild*

This is a proof of the first state made without the outer border of later impressions. The small monogram in the area under the letter D is also uncut. The hand-coloring in green watercolor is known by Schiefler in only one copy. The description in Dube mentions the added monogram, but this impression also has been trimmed at the base and lines are thinner in later editions. Because of the thumbprint, lower left, it is also possible that the border was added later as an insert around this first block. This impression shows the full outer margin because the edge was firmly held there while the printing was done. The lower border has faintly inscribed lines for later recutting.

Kirchner made six other woodcuts of cabarets or shows during this time. In lithography and etching Kirchner used other subjects. The woodcut was the medium for frivolity and entertainment. The metropolitan psyche of Berlin seems to bring out Kirchner's use of depth studies within varying perspective points. The circle encloses sharp forms which have strong interplay. The special distortion has a form-reason in this year of 1912. It creates a sense of plastic movement, of excitement and fragmentation. The letters of the title are worked in with an echo of the lower shapes to make a sculpturesque whole.

Unlike the French, German Impressionists did not study the fluidity of the dance patterns. Kirchner carries on this tradition in Eispalast-Tänze, with a static angularity, though he was to study the linear flow of human movements carefully in the later years. This woodcut is designed as a circular illusion with audience and dancers combined. The two v's at the bottom echo the sharpness of the lettering. Covering the lettering will show the necessity of these two forms.

Kirchner made two states. The entire print, as finally designed for the periodical *Zeit im Bild* had a thick outer border. In this proof of the first state, Kirchner has covered the border and concentrated on the central areas. The printing seems to have varied considerably in each impression. The kind of paper, whether moistened or not, the pressure of the printing element, the consistency of the ink, how the paper is held on the block, and indeed, the patience of the printer would all vary the impressions. This impression is printed flat and loses much of the detail around the edges. There are lowered areas which, too, do not pick up on this heavy paper. Other impressions of this woodcut show more inner detail.

Kirchner is designing without the usual perspective, but raising the central portion and emphasizing the spectators by making them solidly dark. Seven major letter forms are mirrored by seven figure forms at the base.

Berlin was a city of night life. It was said that Berliners, not tourists, made up the major audiences. Vaudeville palaces catered to the multitudes. From the clothing of the audience, we can see that this was a revue rather than a vaudeville. Though they later became a spectacle of nakedness in the twenties, these middle-class revues offered comics earlier, brilliant dance numbers and imaginative costumes. Kirchner captures some of the intimacy of this escapism by the German middle class. Kirchner also did another title page for the periodical *Zeit im Bild*; Müggelsee, (Dube 210).

84.

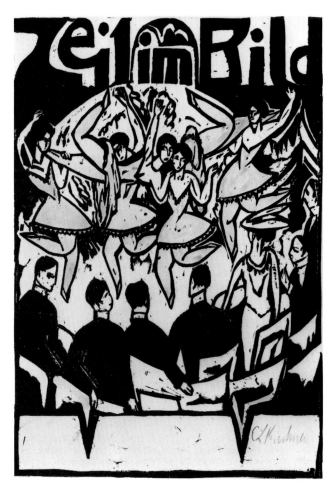

**85. Das Stiftsfräulein und der Tod** *(The Retired Spinster and Death)*

**Alfred Döblin**
16 page brochure, unbound, with 5 woodcuts, 1912
Published by Verlag A. R. Meyer, Berlin, 1913
Lyrische Flugblätter #8
Printed by Paul Knorr Berlin—Wilmersdorf
Dube 199-203; Schiefler 184-188
18 x 23.5 cm.

Meyer, the always financially troubled publisher, tried to publish a series of inexpensive works of new poetry and creative writing. Other titles in the series were by Gottfried Benn, Lasker-Schüler, Wedekind, etc. The only illustrated book of the series is this one by Dr. Döblin. Meyer and Döblin were close associates with the Sturm circle. They frequented the cafes and bars which were the meeting places of young writers. Meyer always had two jobs to help pay for the publishing efforts. Döblin worked on periodicals and did free-lance work for newspapers and any other odd writing jobs. Meyer founded nightly gatherings, called "Paris" after the center of European culture, where young intellectuals met and discussed Hegel, Dostoyevsky, new poetry, stage productions, newspaper articles and such. They were the young visionaries working for a creative tomorrow.

The book is about an old woman in a retirement home. In Germany, one could pay a lump sum for room and board for the final years of life. A Stift is such a place.

She sits and dreams in the first illustration. Her possessions are shown. They are pitiful and few.

She sits day by day dreaming. Her girlish ways try to appease Death. Her letters begin with an address to her master, Death; and the words seem those of a young girl toward a lover. The second illustration is described: "In the early morning she stood in the park...I must die, I must die...She walked into the water with loud screams...She banged her scrawny hands upon the water...fled back into the house." The third illustrated part is again accurately taken: "She really put on her finery for these walks. The other ladies could never find the person for whom she dressed. They thought she had desires for lustful sins." Illustration four is a fight with death, part erotic, part tragic: "Awakened in the dark by loud steps in her room...With one sweep, Death dropped next to her on the bed. She fought. Like a yoke, Death beat her shoulders with his flat hand. The clenched fist dropped onto her breasts, onto the stomach, the stomach and again on the stomach."

Kirchner passed through a transitional stage with these illustrations. He had studied both Japanese prints and the reproductions of Ajanta cave paintings. This was a heavier style, a developed handwriting using foliage curves and triangles. He keeps to the story in the first illustration, but in the others uses the idea of age becoming young when confronted by Death. The old woman becomes free and young in the second illustration. Unwrinkled and strong, she bathes under the moon. The next page is pointed and emotional by use of vertical emphasis and major diagonals to separate the lonely old woman and others who mock her. Kirchner cannot illustrate the last illustration with much feeling. The words are terrifying and cruel; the woodcut is forced and without pathos. Distortion seems irregular for the subject of a woman fighting death in an erotic-physical struggle with a heart attack.

**86. Chronik der Künstler-Gruppe Brücke** *(Chronicle of the Bridge Artists' Group)*

Bolliger-Kornfeld 62/1-4; Perkins 127
Folio with title woodcut and 6 woodcut vignettes, 1913
67 x 51 cm.

2 woodcuts each by Kirchner, Schmidt-Rottluff, and Heckel (less cover):

Karl Schmidt-Rottluff:
86/1. Kopf *(Head)*, woodcut, 1913, Schapire 101, 9 x 7 cm.
86/2. Kopf *(Head)*, woodcut, 1913, Schapire 102, 9 x 7 cm.

Ernst Ludwig Kirchner:
86/3. Zwei nackte Frauen *(Two Naked Women)*, woodcut, 1913, Dube 711 A/B; Schiefler 216, 9 x 7.2 cm.
86/4. Zirkusszene *(Circus Scene)*, woodcut, 1913, Dube 712 A/B; Schiefler 217, 9 x 6.9 cm.

Erich Heckel:
86/5. Sitzender Mann *(Sitting Man)*, woodcut, 1912, Dube 238 I/II, 9 x 7 cm.
86/6. Akt am Stein *(Nude on a Rock)*, woodcut, 1912, Dube 239, 9 x 7 cm.
(Missing title woodcut by Kirchner)

The last Jahresmappe portfolio of Die Brücke was published in 1912. Kirchner had planned a great survey of the group as an afterword, because there were personality conflicts between members; Pechstein had left.

The planning had begun in 1912, when Heckel began his illustration at that time. Kirchner used the summing up as a personal statement, rather than joint effort. His editing of the facts brought immediate opposition by the others and the Brücke group dissolved thereafter.

Kirchner planned variations. In Munich there is a pasted-up copy with photographs and essays. Our copy does not contain the title page but includes the complete text of the first draft.

85.

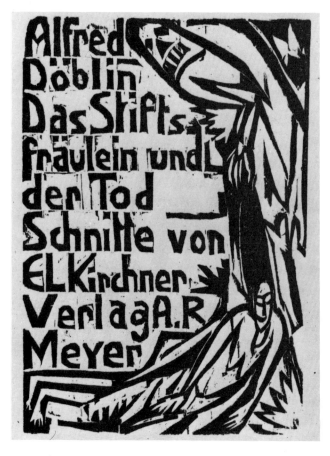

86/1.

zum Mitglied von "Brücke" ernannt. Ihm folgte 1905 Nolde. Seine phantastische Eigenart gab eine neue Note in "Brücke", er bereicherte unsere Ausstellungen durch die interessante Technik seiner Radierung und lernte die unseres Holzschnittes kennen. Auf seine Einladung ging Schmidt-Rottluff zu ihm nach Alsen. Später gingen Schmidt-Rottluff und Heckel nach Dangast. Die harte Luft der Nordsee brachte besonders bei Schmidt-Rottluff einen monumentalen Impressionismus hervor. Währenddessen führte Kirchner in Dresden die geschlossene Komposition weiter; er fand im ethnographischen Museum in der Negerplastik und den Balkenschnitzereien der Südsee eine Parallele zu seinem eigenen Schaffen. Das Bestreben, von der akademischen Sterilität frei zu werden, führte Pechstein zu "Brücke". Kirchner und Pechstein gingen zusammen nach Gollverode, um gemeinsam zu arbeiten. Im Salon Richter in Dresden fand die Ausstellung der "Brücke" mit den neuen Mitgliedern statt. Die Ausstellung machte einen grossen Eindruck auf die jungen Künstler in Dresden. Heckel und Kirchner versuchten die neue Malerei mit dem Raum in Einklang zu bringen. Kirchner stattete seine Räume mit Wandmalereien und Batiks aus, an denen Heckel mitarbeitete. 1907 trat Nolde aus "Brücke" aus. Heckel und Kirchner gingen an die Moritzburger Seen, um den Akt im Freien zu studieren. Schmidt-Rottluff arbeitete in Dangast an der Vollendung seines Farbenrhythmus. Heckel ging nach Italien und brachte die Anregung der etruskischen Kunst. Pechstein ging in dekorativen Aufträgen nach Berlin. Er versuchte die neue Malerei in die Sezession zu bringen. Kirchner fand in Dresden den Handdruck

86/2.

86/3.

Im Jahre 1902 lernten sich die Maler Bleyl und Kirchner in Dresden kennen. Durch seinen Bruder, einen Freund von Kirchner, kam Heckel hinzu. Heckel brachte Schmidt-Rottluff mit, den er von Chemnitz her kannte. In Kirchners Atelier kam man zum Arbeiten zusammen. Man hatte hier die Möglichkeit, den Akt, die Grundlage aller bildenden Kunst, in freier Natürlichkeit zu studieren. Aus dem Zeichnen auf dieser Grundlage ergab sich das allen gemeinsame Gefühl, aus dem Leben die Anregung zum Schaffen zu nehmen und sich dem Erlebnis unterzuordnen. In einem Buch "Odi profanum" zeichneten und schrieben die einzelnen nebeneinander ihre Ideen nieder und verglichen dadurch ihre Eigenart. So wuchsen sie ganz von selbst zu einer Gruppe zusammen, die den Namen "Brücke" erhielt. Einer regte den andern an. Kirchner brachte den Holzschnitt aus Süddeutschland mit, den er, durch die alten Schnitte in Nürnberg angeregt, wieder aufgenommen hatte. Heckel schnitzte wieder Holzfiguren; Kirchner bereicherte diese Technik in den seinen durch die Bemalung und suchte in Stein und Zinnguss den Rhythmus der geschlossenen Form. Schmidt-Rottluff machte die ersten Lithos auf dem Stein. Die erste Ausstellung der Gruppe fand in eigenen Räumen in Dresden statt; sie fand keine Anerkennung. Dresden gab aber durch die landschaftliche Reize und seine alte Kultur viele Anregung. Hier fand "Brücke" auch die ersten kunstgeschichtlichen Stützpunkte in Cranach, Beham und andern deutschen Meistern des Mittelalters. Bei Gelegenheit einer Ausstellung von Amiet in Dresden wurde dieser

86/4.

86/5.

der Lithographie. Bleyl, der sich der Lehrtätigkeit zugewandt hatte, trat aus "Brücke" 1909 aus. Pechstein ging nach Dangast zu Heckel. Im selben Jahre kamen beide zu Kirchner nach Moritzburg, um an den Seen Akt zu malen. 1910 wurde durch die Zurückweisung der jüngeren deutschen Maler in der alten Sezession die Gründung der "Neuen Sezession" hervorgerufen. Um die Stellung Pechsteins in der neuen Sezession zu stützen, wurden Heckel, Kirchner und Schmidt-Rottluff auch dort Mitglieder. In der ersten Ausstellung der N.S. lernten sie Mueller kennen. In seinem Atelier fanden sie die Cranachsche Venus, die sie selbst sehr schätzten, wieder. Die sinnliche Harmonie seines Lebens mit dem Werk machte Mueller zu einem selbstverständlichen Mitglied von "Brücke". Er brachte uns den Reiz der Leimfarbe. Um die Bestrebungen von "Brücke" rein zu erhalten, traten die Mitglieder der "Brücke" aus der neuen Sezession aus. Sie gaben sich gegenseitig das Versprechen, nur gemeinsam in der "Sezession" in Berlin auszustellen. Es folgte eine Ausstellung der "Brücke" in sämtlichen Räumen des Kunstsalons Gurlitt. Pechstein brach das Vertrauen der Gruppe, wurde Mitglied der Sezession und wurde ausgeschlossen. Der Sonderbund lud "Brücke" 1912 zu seiner Cölner Ausstellung ein und übertrug Heckel und Kirchner die Ausmalung der darin befindlichen Kapelle. Die Mehrzahl der Mitglieder der "Brücke" ist jetzt in Berlin. "Brücke" hat auch hier ihren internen Charakter beibehalten. Innerlich zusammengewachsen, strahlt sie die neuen Arbeitswerte auf das moderne Kunstschaffen in Deutschland aus. Unbeeinflusst durch die heutigen Strömungen, Kubismus, Futurismus usw., kämpft sie für eine menschliche Kultur, die der Boden einer wirklichen Kunst ist. Diesen Bestrebungen verdankt "Brücke" ihre heutige Stellung im Kunstleben. E. L. Kirchner.

86/6.

Chronik der Künstler-Gruppe Brücke *(Chronicle of the Artists' group Brücke)*

## TRANSLATION

In 1902 the painters Bleyl and Kirchner met in Dresden. Heckel was invited to join them through his brother, a friend of Kirchner's. Heckel brought along Schmidt-Rottluff, whom he knew from Chemnitz. In Kirchner's studio they got together to work. There they had the opportunity to study the nude human body, the basis of "building art," in free naturalness. From this kind of drawing originated their common feeling to take the stimulation to work from life and to subjugate themselves to experience. In a book, "Odi profanum" they each drew and wrote their ideas down for the others and in this way compared their originality. So they grew together in a group all by itself, which received the name "Brücke." Each stimulated the others. Kirchner brought the woodcut from South Germany, which he had taken up again, stimulated by old cuts in Nuremberg. Heckel carved wooden figures again. Kirchner enriched this technique of his by painting them, and looked into stone and found the rhythm of enclosed form. Schmidt-Rottluff made the first lithograph on stone. The first exhibition of the group took place in their own rooms in Dresden; it did not find recognition. But Dresden gave them many inspirations through its scenic beauty and old culture. Here the "Brücke" also found the first historical art footholds in Cranach, Beham, and other German masters of the Middle Ages. At the occasion of an exhibition by Amiet in Dresden he was named a member of "Die Brücke." He was followed by Nolde in 1905. His fantastic originality put a new note to "Die Brücke;" he enriched our exhibitions with the interesting technique of his etchings, and got acquainted with ours in woodcuts. At his invitation, Schmidt-Rottluff went to him at Alsen. Later Schmidt-Rottluff and Heckel went to Dangast. The hard air of the North Sea brought out (especially in Schmidt-Rottluff) a monumental impressionism. At the same time, in Dresden, Kirchner continued the closed composition; he found in the ethnographic museum parallels with his own work in negro sculpture and pole carvings of the South Seas. Striving to free himself from academic sterility, Pechstein was led to "Die Brücke." Kirchner and Pechstein went together to Gollverode to work together. The exhibition of "Die Brücke," including the new members, took place in the Salon Richter in Dresden. The exhibition made a big impression on the younger painters in Dresden. Heckel and Kirchner tried to bring the new art into harmony with the room. Kirchner finished his rooms with murals and batiks, with the cooperation of Heckel. In 1907 Nolde left "Die Brücke." Heckel and Kirchner went to the Moritzburg lakes to study the naked figure in the open air. Schmidt-Rottluff worked in Dangast on his color rhythms. Heckel went to Italy and discovered the stimulation of Etruscan art. Pechstein followed his order for decorations to Berlin: he tried to bring the new art to the Secession. Kirchner made hand-printed lithographs in Dresden. Bleyl, who had turned toward teaching, left "Die Brücke" in 1909. Pechstein went to visit Heckel in Dangast. That same year, both of them visited Kirchner in Moritzburg to paint nudes at the lake. In 1910 after rejection of the younger German artists by the "old Secession," the "new Secession" was founded. In order to support the position of Pechstein in the "new Secession" Heckel, Kirchner, and Schmidt-Rottluff also became members there. In the first exhibition of the "new Secession" they met Mueller. In his studio they found again the Cranach "Venus" which they appreciated very much. The sensual harmony of his work made Mueller a natural member of "Die Brücke." He brought us the charm of watercolor. In order to keep the strivings of the "Brücke" pure, the members left the Secession. They promised each other to exhibit only together in the "Berlin Secession." There followed an exhibition of "Die Brücke" in the rooms of the art salon Gurlitt. Pechstein broke the trust of the group and became a member of the Secession, and was excluded. The "Sonderbund" invited "Die Brücke" in 1912 to its Cologne exhibition; and invited Heckel and Kirchner to decorate the chapel which was located in the building. The majority of "Die Brücke" are now in Berlin. "Brücke" has kept its internal character there. Grown together from within, it radiates the new working values on the modern creation of art in Germany. Uninfluenced by today's currents of Cubism, Futurism, etc., it fought for the human culture, which is the basis of real art. "Die Brücke" has to thank these efforts for its present position in the life of art.
                                                        —E.L. Kirchner

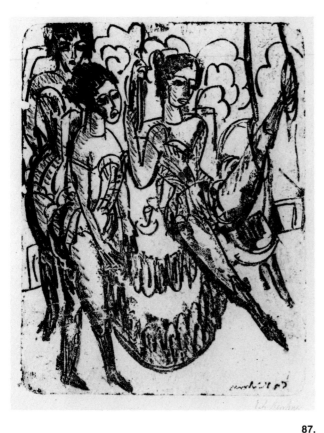

**87.**

**88.**

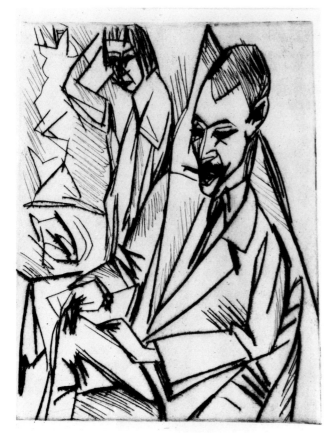

**87. Drei Akrobatinnen an Ringen** *(Three Acrobats in the Ring)*

Lithograph, 1912
Signed by Frau Kirchner, on verso is estate stamp and number
Editions: unknown, but probably exists in only one or two copies.
Dube 215 II/II; Schiefler 179
26.7 x 21.5 cm.
Designed especially for the Brückechronik

The last days of the Brücke organization were strange ones for this artist. He had planned to sum up all the activities of the Brücke effort in a chronicle called Chronik K. G. Brücke by Kirchner.

Schiefler states this print was inscribed by the artist: "drawn for a publication." The cataloguers, Annamarie and Wolf-Dieter Dube, have described this print as designed for inclusion in the chronicle. As Schiefler's information came from a very sick artist, proof may be difficult. The artist's companion and later wife, Erna, was with him when the print was made in 1912; and there may be actuality in the description.

After the members of the Brücke left their close association with each other, Kirchner became embittered, continued the special chronicle in his mind for some years, and made up at least two portfolios of his intentions. The special edition in the print room of the Zentralinstitut für Kunstgeschichte in Munich is described by Peter Selz. In addition to the copy in Munich, one exists at the Kestner Museum, Hannover. The copy in Munich has a woodcut made in 1915, so this more complicated copy was probably assembled later as a vision of what could have been. Kirchner made this copy into a real history with photographs and an inaccurate table of contents.

The lithograph is a scene from the circus or cabaret, probably the latter. It combines his rounded calligraphy with the late Berlin style of sharp, pointed compostion. All extremities are unarticulated. The corrections for the second state, some shading on the arms, are done with nervous energy, as though this print were an exercise in swiftness. There are some interesting techniques with a rag and liquid tusch in the areas between forms. The preparation of the stone was not accomplished with skill, the tones begin to block up even in a few impressions. The edge of the stone is not filed and prints with a bite on the paper. The paper and stone were very wet and print with a slight blur, which adds to the charm of this impression, and makes it unique, almost a monotype for no other impression would match this one exactly.

This is the only catalogued print that was designated and especially designed for the chronicle.

**88. Gewecke und Erna** *(Self Portrait and Erna)*

Etching and drypoint, 1913
Unsigned, on the heavy vellum paper of proofs
Dube 169; Schiefler 140
25 x 20.8 cm.

The etching of 1913, Gewecke und Erna, is a self-portrait with the artist's companion in the background. The pyramid design emphasizes Kirchner, makes the figure seem to be in a Gothic confinement.

Developing another kind of shorthand for this new medium, a linear method, he uses less of the common diagonal thrust across the surface. Kirchner kept to the vertical and horizontal with etching plates. Drawing with an etching point is free and not restricted by the punch of a chisel against a heavily resisting surface, as with a woodcut. Lines can turn quickly, jump and skip. Kirchner has developed a curious scribbled technique, quickly noted down. The lines have a force in themselves, vibrating the outlines of an impassive figure. This created atmosphere comes alive with the linear oscillations. The poses, too, are Gothic in feeling. Form is again made functional to the schematic inner movement. This is a print of variation in line.

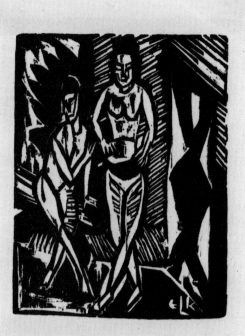

Eröffnung der L. Kirchner-Ausstellung ♦ Sonntag, den 15. Februar mittags 12 Uhr Einleitender Vortrag von Professor B. Graef

89.

## 89. Zwei nackte Frauen *(Two Nude Woman)*

Woodcut, 1913
On verso, stamp of Kunstverein Jena
Dube 711 B/B; Schiefler 216, with text
9 x 7.2 cm.
Used as advertisement for Kirchner's exhibition at Kunstverein Jena, 15 February, 1914

*Zwei nackte Frauen* of 1913 is a small woodcut showing the configurations of the later artist. Slashes relate to the decorative use in mature primitive statuary. A central figure anchors the design and is counterbalanced by one bent figure (left) and a complicated triangular shadow (right), which is perhaps a mirror image of the central figure. These three areas are broken into separate pillars by linear shading, which changes direction at the edges of each major shape. Simple details, such as feet and hands, allow the major change in directions to work without interruption. The print has planes like a three-sided post, with each plane a visual entity; and all is held together by the white areas. The woodcut was used as an announcment for Kirchner's exhibition in Jena, February 1914.

90.

## 90. Lesende Frau *(Reading Woman)*

Woodcut, 1913
Signed in pencil, on verso is estate stamp, marked state II
Dube 218 III/III; Schiefler 195, third state
28.2 x 23.3 cm.

Here, the whole surface is textured and interrelated, with flesh moving into foliage and planes differentiated by overlap. The theme and variation are curves and straight lines approximately equal in area. Classical rules are completely disregarded by now; one of these major laws was never to balance white and black exactly. Verticality is created by the inward turning sides of the black. Emotional effects are controlled, easily conveyed by texturing surfaces. Kirchner uses sharpness—to Klee this meant danger—in the cactus-like or spear-like spikes. We see a strange nightmarish glow in a forbidden garden. Less planar than usual, the surface is an interwoven spiky web.

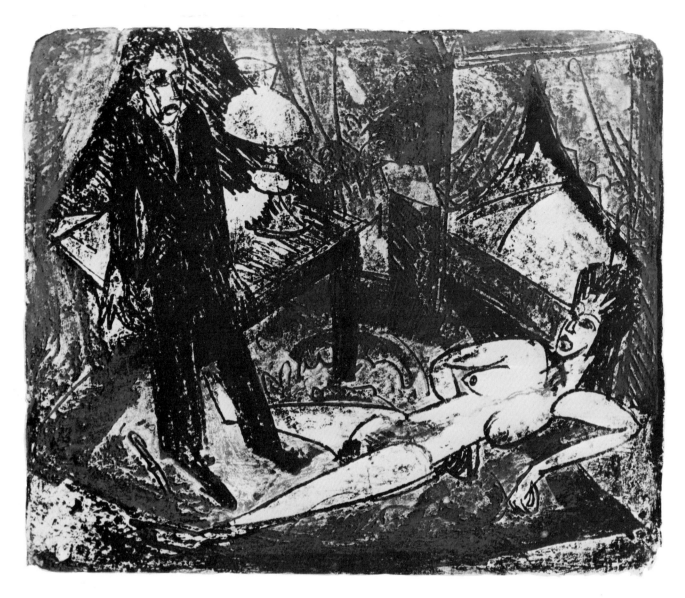

91.

## 91. Der Mörder *(The Murder)*

Color lithograph, 1914
Printed in red and black
Signed and dated
Dube 253 bII/bII; Schiefler 238, second state
on heavy smooth cardboard
50.4 x 39 cm.
First illustration (of three) for Zola's La Bète Humaine

Der Mörder is one of the masterpieces of modern art. In theme and technique it culminates a time in art which was lost forever during the next five years of violent world war. Here brutality is subjective and innocent, not the impersonal and murderous mass slaughter of the trenches. The scene is like a puppet theater, The figures are rounded into impassivity. Horror and disgust are emphasized by the color scheme of blood-red and black emptiness. Even dolls become brightening with the addition of some emotional overtones or realistic wounds.

This is one of three illustrations to Zola's La Bète Humaine. Two other works show a violent train crash and a solitary man wandering down an empty street, a tunnel of overpowering arcs—murder, accident, loneliness. All were somewhat innocent conceptions for what was to come—starvation, disfigurement and brutality on a mass scale.

This was a time of uncertainty in Kirchner's life. Other themes of this period were erotic prints, distorted landscapes, portraits with emphasized grotesqueness, and a return to the destruction of inner areas without large shapes. The etchings of 1914 have frenzied scratchings, very nervous delineations.

The paintings of 1914 show a study of rectilinear compostions. The artist uses the same method in this print, combined with a strongly realistic blood-red. The composition has an excitingly brutal and monumental thrust downwards. Light is placed for emphasis, a dream-like quality from the stage, as though from spotlights. There is a fixed, rigid stoppage to the action, as though in horror. The drawing, too, is brutal, and the crayon is almost smashed into the stone. The stone was under-etched in preparation for printing and few impressions could be taken from the rapidly decaying surface as the tonal areas blocked up with ink. The changing surface also produced the clotting effect, the blotched quality of drying blood. Kirchner printed this impression himself on a hard, almost bristol board (cardboard). Using a flat red and a shining, varnish filled black, he achieves a gain in depth, shading and drama.

Here the individual has meaning, has choices, seems to be considering his drastic act of murder. It is not the work of an animal, but of the animal portion of man.

**92. Strassenszene, nach dem Regen** *(Street Scene, After Rain)*
Woodcut, 1914
Unsigned, verso is estate stamp, II Druckerschienes, #54,323
Dube 236; Schiefler 223, only state
27.3 x 25.4 cm.

The apparent search for psychological tension of the earlier woodcuts produced more and more detail. Personal factors were emphasized in the portraits and carried into a consistent graphic composition.

Returning to Berlin in 1913, Kirchner turned to the excitement of the large city. His compositions changed to triangular forms. The figures are more generalized. His studies turned to work with special two dimensions using mixed perspective points. There is a harshness in the cruel faces and arched domes in the background. There is less austerity but great breadth of expression in this time before the war. Later that summer of 1914, Kirchner went back to the island at Fehmarn and immersed himself in landscape work without the pressures of city life. The anxiety of stress is apparent in this woodcut. It portrays a mood of enclosed cruelty and isolation in the busy atmosphere of a city street.

92.

**93. Katalog der Ausstellung von Kleidern aus der Stickstube von Frau Eucken, Bremen** *(Catalogue of Exhibition of Dresses from the Boutique of Mrs. Eucken, Bremen)*

Two color woodcuts and one woodcut vignette, 1916
Unknown edition (Only 2 copies known to the author)
Printed by G. Neuehahn, Universitätsbuchdruckerei, Jena
Unnumbered pages with heavy covers (4pp.)
28 x 22 cm.

The three woodcuts:

93/1. Dube 731: Titelholzschnitt, 17.1 x 11.2 cm., 3 blocks (black, blue, brown) *(title page)*

93/2. Dube 732 II: Dame mit Hund, 16.5 x 11.5 cm., 3 blocks (black, green, orange) *(Woman with a Dog)*

93/3. Dube 733: Vignette, 10.8 x 7.8 cm.

This small catalogue was made for the wife of Kirchner's friend, Dr. Rudolf Eucken, professor at the university and Nobel Prize Laureate. The vignette on the back cover is the letterhead and special identification of Irene Eucken, the owner of the small dress shop which held a benefit exhibition of women's clothing for the Jena Women's Club (founded in 1908). The exhibition included wear for all day, from morning coats, elegant street dresses, a fantasy jacket to evening dresses.

Kirchner chose a heavy pink cover paper to set off his woodcut in red-brown, black and deep blue. The rather somber style is inelegant and moody. Kirchner's drawing of a woman is heavy and provincial looking; obviously the artist was no clothes designer. Yellow paper was chosen inside to set off the warmer colors of the second illustration; and here, green over yellow, orange and black presents an upper-class lady with her greyhound. She is gloved and holding a fan. The style is late Berlin, and the elongated figure similar in elongation to late Utamaro. Japanese perspective is horizontally maintained with tipped angles and shallow penetration of the space.

The foreword by Frau Eucken is an appeal to artists. "We desperately need the cooperation of creative artists. They must give us new form and color, they must teach us to use highly developed handicrafts in fashion so that really wearable models for dresses will be developed." German fashions had attempted to develop self-reliance from the French couturiers.

93/1.

**94. Träumender Mann** *(Dreaming Man)*

Color woodcut, 1916
Printed in green and blue
Signed in pencil, marked "Versuchsdruck," on verso signed
again, "Berlin Kunstbibliothek, Balka, Prof. Saint Sine, 1916"
Dube 281, variation 1; not in Schiefler
18 x 12.9 cm.

This print is still dominated by triangles and arches, but they
are kept within larger forms, or used as atmospheric excite-
ment in the interiors. The reality of the subject is destroyed by
abstraction. The man seems to vanish in the background and
one's net of vision is caught by the upper structures.
Heightened sensitivity is expressed by the facial distortion of
the dreamer. The mood is melancholy.

This woodcut was made after Kirchner's discharge from the
army for mental and physical breakdown. He had returned to
Berlin for treatment, and later went to Königstein in Taunus for
further treatment. It was a period of terrible mental and physical
suffering. This print shows a comic atmosphere, too, as though
Kirchner were swinging from ridicule at the dreaming man to
crude cutting because of problems with his hands and some
paralysis. It is a picture of a man at peace, with features broken
into wrinkles of diagonal lines.

The color adds verticality, giving the picture plane some depth;
and the green isolates the man in his blue outlines.

95/1.

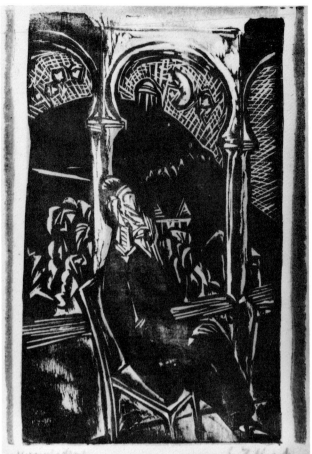

94.

**95/1. Titelholzschnitt des Kataloges der Ausstellung
E. L. Kirchner, Galerie Schames, Frankfurt** *(Title Woodcut of
the Catalogue of the Exhibition E. L. Kirchner, Galerie
Schames, Frankfurt)*

Woodcut, 1916
Dube 734 I/II, with text; not in Schiefler
15.6 x 10.5 cm.

**95/2. Vignette des Kataloges der Ausstellung E. L. Kirchner,
Galerie Schames, Frankfurt** *(Vignette of the Catalogue of the
Exhibition E. L. Kirchner, Galerie Schames, Frankfurt)*

Woodcut, 1916
Dube 735; not in Schiefler
12.4 x 8.4 cm.

Kirchner did not do much work in the period between 1915 and
1917. He was in army camps and later in various sanitariums.
During many months of 1916 he was a guest of Dr. Gräf in the
Taunus region.

The exhibition at the Schames gallery in Frankfurt was his third
one-man show; the others in Hagen and Jena had been less im-
portant than this one in a large art center.

For the catalogue, Kirchner designed two woodcuts, using the
wilder style of the war period. The V-shapes point away from
Gothic soaring, though the man's fingers point upward in
seemingly helpless gesturing. A house is upside down, as
though a cataclysmic explosion had taken place. The cover is
not a calm work. The vignette, too, is a spastic, convulsive wood-
cut with an imprisoned head captured in a contracted environ-
ment. In both Kirchner adds distortion to the human scale.

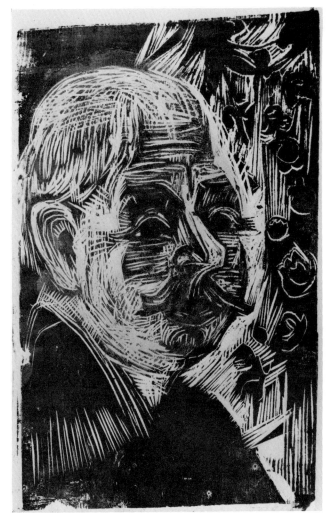

**97. Bildnis Dr. Spengler** *(Portrait of Dr. Spengler)*
Color woodcut, 1919
Printed in yellow and black
Signed in pencil, marked "Eigendruck," dedicated to
Nele van de Velde
Dube 404b; Schiefler 384
48.5 x 31.3 cm.

Dr. Lucius Spengler was the father-in-law of Eberhard Griseback, Kirchner's friend, and Director of the Jena Art Association. He met Dr. Spengler in 1916 during a ten day stay at Davos in Switzerland. The dedication is made to Nele, daughter of Henry van de Velde, whom Kirchner seems to have met in 1917 at Davos.

The later portraits were affected somewhat by Kirchner's study of his earlier work for oeuvre catalogues. He had to look closely at photographs, which concentrated the designs into compact form. The work became more completed as he was able to criticize the distortions and see what he thought the work lacked.

The portrait of Dr. Spengler is quickly cut with mostly straight-pushed incisions. The portraits of this period have outlines and cutaway inner surfaces, with most excitement in the surface interior of the face. They are placed directly centered. There is little psychological penetration, but mostly impassive expressions of wide-eyed sitters. There is a childlike simplicity to these faces including this one, too.

Kirchner was grateful to Dr. Spengler for his care, and shows this in the quietism of the portrait set in a field of flowers. Kirchner wrote many letters to Dr. Spengler's wife.

In one letter he mentions: "The yellow color is not quiet."

Kirchner also made a print of Dr. Spengler's daughter, Edith. Dr. Spengler, a heart and lung specialist, helped Kirchner in 1917 and referred him for further care after the examination showed other physical diminishment.

96.

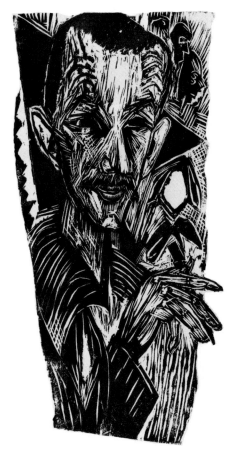

97.

**96. Der Theosoph** *(The Theosopher)*
Woodcut, 1917/18
Signed in pencil, marked "II" and "Eigendruck"
Dube 317; Schiefler 293
51.7 x 25.5 cm.
(Probable portrait of Rudolf Steiner)

The paralyzed artist was taken to a sanitarium near Davos in Kreuzlingen in 1917. He was very ill and not expected to recover his artistic faculties. Will power gave the artist incentive to work, which in turn expressed his desire to live. Painting was out of the question because of the trouble with his hands, but a loose form of woodcutting and much sketching were possible. Kirchner had also been struck by an automobile in February 1917, and this accident resulted in a loss of musuclar power in his painting arm. He had signed over a power-of-attorney to Erna, and made a list of graphic works for Schiefler to use in an oeuvre catalogue. Many of the dates were mistakes, though there was also a morbid distrust caused by the psychological upheaval from mental agitation.

All his anguish is seen in this woodcut of the *Theosopher*. The cutting is wavering and overcut in the background. The hands move in large sweeps, actually breaking the surface of the print into a single plan broken by the triangle behind the head. Mental agony seems to flow from the face. A massive skull dominates. Planes disintegrate; yet this portrait, done at Kreuzlingen Sanitorium, is human and soft at the same time.

Kirchner writes of having a nurse help him print these woodcuts because he could not handle the effort alone.

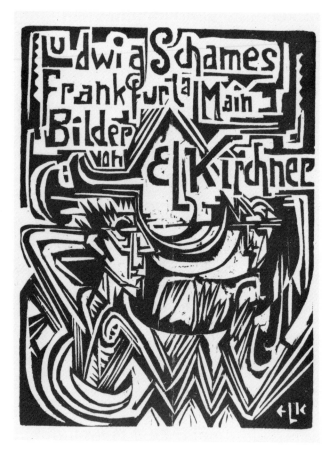

98.

**98. Ludwig Schames/Frankfurt a/Main/Bilder von E. L. Kirchner**
*(Ludwig Schames/Frankfurt a/Main/Pictures by E. L. Kirchner)*

**With one original woodcut on cover (Dube 736 IA/II:** *Titelblatt*,
**1919, 16.7 x 13 cm.**
**Unpaginated (44 pp), 11 illustrations**
**Exhibition from March 1919**
**Introduction by Botho Gräf**
**With a yellow paper cover**
**28.5 x 22.5 cm.**

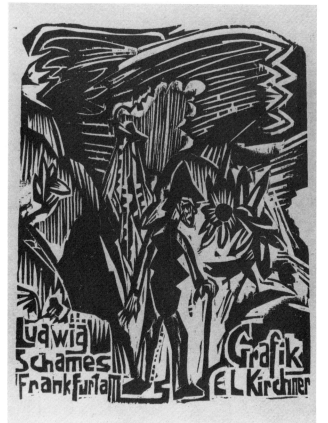

99.

**99. Ludwig Schames/Frankfurt aM/Grafik/E. L. Kirchner**
*(Ludwig Schames/Frankfurt aM/Graphics/E. L. Kirchner)*

**With one original woodcut on cover (Dube 737:** *Titelblatt*, **1919,**
**18 x 14.6 cm.) (10/1)**
**46 pp, 32 illustrations**
**Exhibition of 1920**
**Poetry by K. Th. Bluth**
**Essay by E. Grisebach**
**With a blue-grey paper cover**
**28.5 x 22.5 cm.**

Schames gave Kirchner one-man shows that 1916 and annu-
ally from 1918 until 1922. This gave the artist a reputation in
Germany, also brought him his first collectors such as Dr. Carl
Hagemann and Mrs. Rosi Fischer. The catalogues are made the
same size in all the exhibitions, though dimensions were liberal
for an exhibition catalogue. Both catalogues are divided into
sections by different exhibition rooms or different mediums. In
the first catalogue, an essay by the recently deceased friend
and close advisor of the artist, Botho Gräf, is included as a tri-
bute. Kirchner writes introductions to the sections. He de-
scribes the background of his art as being in dreams, life and
unending love.

The catalogue of 1920 is one of graphic art. Included is an illus-
tration of the great woodcut of Ludwig Schames (p. 6). There is
also another woodcut: Titelblatt für K. Th. Bluth "Hymnus"
(Dube 748 I/II, 1919, 17 x 10.5 cm.)

The savage restlessness of the 1919 cover is oppressive not
joyful, for this was a continuation of Kirchner's most difficult
period. A man is lost in swirling waves with a woman almost
disappearing into margin lines. The gratitude to Botho isn't ap-
parent here, but instead we see Kirchner's imagery of sightless,
eyes and lost ability to move in the quicksand of nervousness.
This savage and uncontrolled restlessness is apparent in the
design of type. It is intermixed so thoroughly that it is almost
lost. Inventiveness is carried too far into the black, which de-
stroys most of the planes. Lines are thick and austere.

The cover of 1920 shows the artist walking with a stick. He also
shows his dangling and useless right hand. But there is a sense
of recovery in the luxurious sunflower, the majesty of mountain
cloud formations and stillness of the Alpine valleys. The type is
integrated at the bottom in better relationship with the varying
lines. Kirchner has begun, again, to work in larger shapes,
although the masses are detailed with long, sweeping lines.

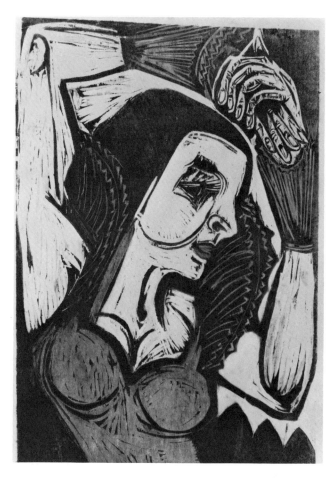

**100.**

### 101. Badende in Felsen *(Bathers in Rocks)*

Woodcut, 1921
Unsigned, dated and marked "I. Zustand"
Dube 452 I/II; Schiefler 443
70.5 x 39.8 cm.

This is a print from a series of eight nudes, five shown outdoors. Most are studies in circles within shortened form. From an edge, Kirchner articulates the direction of the lines away from and parallel to the edge. A form is isolated or absorbed by the background in this manner in order to make an area important or not, and the circles, such as the breasts and small spring, tend to capture the eye in supplementary actions. The print is also a masterpiece of light and silhouette, with the large planes in the background kept in shadow and the figures lit from within. There is more interpenetration between people and nature than in his more violent early woodcuts. The twist of torso in the figures is also a late mannerism.

**101.**

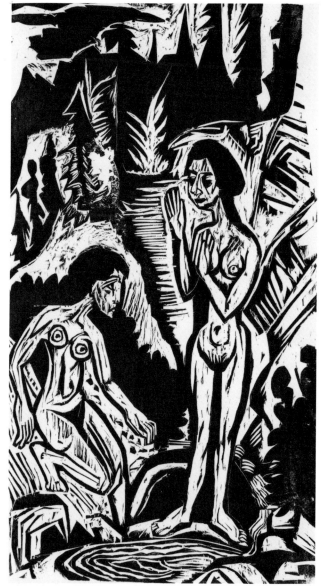

### 100. Plakat Nina Hard *(Poster of Nina Hard)*

Color woodcut, 1921
Printed in blue, black and red
Unsigned
Dube 718; Schiefler 445; second edition without text, a state unlisted in Dube or Schiefler
55.9 x 40 cm.

This poster was designed for a recital by the dancer, Nina Hard, in September, 1921, in Zurich. The color woodcut was made in two parts, with the text in the lower-fifth section. Later, the upper section was reduced in size by the artist and a few impressions were taken.

There are thirty-five woodcuts made during this year of 1921. Most have less interior detail and more concentration on outline. Many have a low point of view, as in this poster.

Nina Hard visited Kirchner in 1921. He painted three oil paintings including one of a reclining nude. The artist mentions the visit to Nele van de Velde on October 7, 1921. The strange wrist cuffs and zigzags on the side of the head are blocked out in separate colors. There is also a print of a Spanish dancer of this year with similar exaggerated posturing of the arms.

From his earliest time in Dresden, after meeting Erna's sister, Gerda, a professional dancer, Kirchner drew and painted dancers.

61

102. Ludwig Schames/Frankfurt a/M./Ausstellung von neuen Gemaelden und Grafik von E. L. Kirchner 1916-1921 (Schweizer Arbeit von E. L. Kirchner) *(Ludwig Schames/Frankfurt a/M. Exhibition of New Paintings and Graphics by E. L. Kirchner 1916-1921/Swiss Work by E. L. Kirchner)*

16 pp, 11 illustrations
Exhibition of 1922
With an orange paper cover

The illustrations include four original woodcuts:

102/1. Umschlagholzschnitt des Kataloges der Ausstellung Schweizer Arbeit, Galerie Schames, Frankfurt *(cover woodcut)*, 1921, Dube 738 II/II, 13 x 23.5 cm.

102/2. Kopf vor Landscaft mit Figuren *(Head Before a Landscape with Figures)*, 1921, Dube 739 II/II, 8 x 7.7 cm.

102/3. Selbstbildnis mit Blume in der Hand *(Self Portrait with Flower in Hand)*, 1920, Dube 428 II/II, 15 x 9 cm.

102/4. Wiese *(Meadow)*, 1921, Dube 757 B/B, 6.8 x 9.2 cm., first used in Davoser Blätter, 50. Jg., 1921, #17, p. 2

Kirchner shows himself naked in his art, but is reticent in his writing. He introduces the Swiss catalogue with an essay written under the pseudonym of L. de Marsalle, which he used also in *Genius*. His inner self-consciousness led to this disguise.

These criticisms of his own work offer some insight and have been used by critics for most accurate analyses. He speaks of the devil in his early color and also the clear air of the mountains which influenced the later use of thin color. Hand-in-hand go proportion and drawn form; and all of this is not really taken from nature but from the inner spirit of the artist. By this spirit was the new form born. The paintings were made with blood and nerves. He wants a starkness and nakedness in this fertile work period. He wants to rein in the fantasies from earlier intentions and use only the smallest of these. This is a statement both of intention and disgust with the experience of the early past. He has moved into the outside world of vision, and away from the uncontrolled inner impulse of ecstatic intent. Paul Westheim reviewing this exhibition in the periodical, *Das Kunstblatt*, saw new power and softer, more painterly techniques.

In the cover woodcut, Kirchner spans his early and late time. He uses a dishevelled nude on the left; himself double-faced in both directions in the center; a nude Erna standing in the midst of mountains and animals on the right. On the left is darkness; on the right is clear light and static peace.

At the death of the art dealer Ludwig Schames, Kirchner wrote this memorial statement for Alfred Flechtheim's periodical, *Der Querschnitt*, 1922, p. 156:

IN MEMORIAM LUDWIG SCHAMES
Born October 8, 1852 in Frankfurt on the Main
Died March 7, 1922 in the same city
This was the Art Dealer
LUDWIG SCHAMES
The fine, selfless friend of art and artist. In the noblest way he made it possible for me and many others to create and to live. We are losing with him the humane being who singularly, like a good father, was a faithful friend, a refined, understanding promoter of the art of our time.

—E. L. Kirchner

102/3.

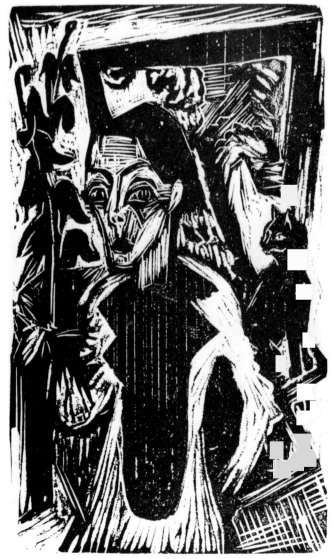

**103. Neben der Heerstrasse** *(Near the High Road)*
Erzählungen von Jacob Bosshart *(Stories by Jacob Bosshart)*

24 woodcuts by Kirchner, 1922; Dube 808-831
Leipzig and Zurich, Verlag von Grethlein und Co., 1923
Editions: 120 numbered examples, signed by the publisher as preliminary examples, hand bound by Thomas Knaur; regular edition unknown
Printed by E. Haberland, Leipzig
435 pp (5pp)
19.2 x 13 cm.

**103/2. Schutzumschlag** *(Book Jacket)*

Proof for Bosshart, Neben der Heerstrasse
Color woodcut, 1922
Printed in violet and black
Unsigned proof on red-brown cover stock
Dube 808, fourth state, variation 3; not in Schiefler
19.9 x 30.4 cm.

Before Kirchner had moved to his final house on the Wildboden, near Davos, he had rented a farm house on the Langmatte by Frauenkirch in Switzerland. The late expressionist style was developed here.

Inner forms are made from verticals, following form in direction rather than contour. Kirchner's studies of the dance are placed in forced and posed gestures. The calligraphy seems closer to the wood grain. Emphasis is on the vertical and horizontal contrasts, provides a calmer mood, and seems a flat style when compared with the excited concepts of the earlier time in Berlin. The side-turned heads and opposed bodies are Egyptian-like, a mannerism of the period, closer to those of his friend Otto Mueller.

103.  103/2.

**104.  Umbra Vitae** *(Shadows of Life)*

**Nachgelassene Gedichte** *(Posthumous Poems)* Georg Heym
47 woodcuts by Kirchner; Dube 758-807
Munich, Kurt Wolff Verlag, 1924
Editions: 510 examples, all numbered. Nr. A 1-10 on japan
paper, bound in leather, with one extra print: Dem Dichter
Georg Heym, *(The Poet George Heym)* etching, 1923, Dube 461
VII/VII, 14.6 x 9.2 cm. Nr. B 11-510 without this extra print, on
dark yellow laid paper.
Printed by Spamersche Buchdruckerei, Leipzig
Type: Fette Steinschrift; printed in dark brown ink
Covers printed in green, black and chrome yellow
(8 pp) 62 pp (1 f)
23 x 15.5 cm.

The woodcuts were printed directly from the blocks in this
small book. Kirchner designed the entire book from binding to
end papers, so we can see the artist's entire intention. Kirchner
had been interested in the Silesian's poetry since the days
in Berlin.

An early hero to the young Expressionist painters and poets,
Georg Heym had written of his roaring visions with unique use
of poetic imagery. The poems were printed in *Die Aktion*, and
issued in special editions on grey paper, which were passed
from hand to hand among frequenters of the literary cafes.
Heym loved explosions of color, hated sterile optimism, and
hated writing that was music for the masses.

He used the image of a colossal cyclops to show the single vis-
ion of war behind civilization, a careless and inhuman figure of
hatred ready to shatter humanity. It seemed a new direction in
the use of new language after the Symbolists, the melancholy
of von Hofmannsthal and the stoic resignation, however mov-
ing, in Rilke. Heym put action and passion into words for yearn-
ing young thinkers.

The first publication of *Shadows of Life (Umbra Vitae)* was by
the new publisher, Ernst Rowohlt, Leipzig, in May, 1912. The
poet had drowned on January 16, 1913; and never inspected his
second book by Rowohlt, Der Dieb, a collection of short novels.
His collected works were not published until 1960, although the
complete poems were issued by Arche in 1947.

The suggestion to use Kirchner was made by the publisher's
associate and then neighbor of the artist, Hans Mardersteig,
who had designed the Wolff books until after the war. Kirchner
used the first edition of 1912 and added woodcuts for headings
and endings of the poems, plus one full page with text cut in the
picture (p. 14). He used a previously made woodcut of 1905
after the table of contents.

Kirchner set up a rhythm with good margins and a heavy type
for the headlines, allowing some to carry over the text edges.
He adapted his woodcut line to the heaviness of the typeface a
roman style which seemed to fit the prophetic poetry. The linear
movement of the woodcuts is varied from page to page: here
vertical, there horizontal in emphasis. Vibrating colors con-
front the eye with some violence as the cover is opened to the
end papers. Kirchner and his wife appear nude in melancholy
attitude while opposite are strange faces in an enclosed form.
The final end papers have a different double picture of the artist
and his wife sitting, while two dancers gesture and move.

Most of these illustrations were made for the book, not taken
partially from earlier times. They seem direct visualizations of
the poetry. Page 3 has the title "War" and a vision of destruc-
tion is presented. Kirchner's stylization is also varied with
some full-contrast designs and linear conformations. The irra-
tional message of the poetry, probably influenced by
Baudelaire, is made personal by Kirchner. His illustrations
show explosions, violent action in a confused landscape.
Baudelaire had not experienced such a dire event as the Great
War, and Kirchner imposes the new feeling of suffering and
stammering uncertainty about the future.

## UMBRA VITAE
Georg Heym

Parallel crowds stand in the streets
And see great signs of the zodiac,
Where fire-nosed comets
Sneak threateningly around pointed towers

And all roofs are massed with astrologers.
Who thrust big pipes into the sky,
And magicians,
Growing from ground holes,
Slope in darkness,
Conjuring a constellation.

Suicides go into the night in great hordes,
Searching for their lost being,
Bowing to the South, West, East and North,
Sweeping dust with their arm-brooms.

They are like dust, which remains awhile.
Hair already fallen away.
They jump,
That they can die,
And in haste,
And lie with their leader in fields,

Still sometimes jerking. And the field animals
Surround blindly and thrust their horns
Into the bellies. They stretch all limbs,
Buried under sage and thorn.

The oceans stop. In the waves
Ships hang mouldy and sullen,
Dispersed,
And no current moves,
And judgment of heaven is closed.

Kurt Wolff Verlag München

Georg Heym
UMBRA VITAE

Alle Landschaften haben

Sich mit Blau erfüllt
Alle Büsche und Bäume des Stromes
Der weit in den Norden schwillt

Leichte Geschwäder Wolken
Weisse Segel dicht
Die Gestade des Himmels dahinter
Zergehen in Wind und Licht

Wenn die Abende sinken
Und wir schlafen ein,
Gehen die Träume die schönen
Mit leichten Füssen herein

Cymbeln lassen sie klingen
In den Händen licht
Manche flüstern und halten
Kerzen vor ihr Gesicht

Mit den fahrenden Schiffen
Sind wir vorübergeschweift,
Die wir ewig herunter
Durch glänzende Winter gestreift.
Ferner kamen wir immer
Und tanzten im insligen Meer,
Weit ging die Flut uns vorbei,
Und Himmel war schallend und leer.

Sage die Stadt,
Wo ich nicht saß im Tor,
Ging dein Fuß da hindurch,
Der die Locke ich schor?
Unter dem sterbenden Abend
Das suchende Licht
Hielt ich, wer kam da hinab,
Ach, ewig in fremdes Gesicht.

105. Die Graphik Ernst Ludwig Kirchners bis 1924 von Gustav Schiefler; Band I bis 1916 *(The Graphics of Ernst Ludwig Kirchner to 1916 by Gustav Schiefler; Volume I to 1916)*

1 multiple color cover woodcut, 4 multiple color, and 48 single color woodcuts (Dube 139, 157, 175, 212, 214, 215, 217, 232, 233, 354, 401, 487, 725, 958, 859 - 899

Berlin-Charlottenburg, Euphorion Verlag, 1924/26
Edition: 620 numbered examples. Nrs. 1-70 on handmade Bütten paper with three extra prints, all signed: 1. Männerkopf (Selbstbildnis) *(Head of a Man (Self-Portrait))*, woodcut,1926, Dube 550 II/II, 16.5 x 10.7 cm. 2. Nachtdame *(Night Woman)*, lithograph, 1922, Dube 420 II/II, 15.2 x 9 cm. 3. Der Tanz zwischen den Frauen *(The Dance Between the Women)*, drypoint, 1919, Dube 289 V/V, 15.3 x 8.7 cm.
Nrs. 71-620 without the extra prints
Printed by Otto von Holten, Berlin
Type: Römische Antiqua
358 pp
26 x 16 cm.

105/2. Titelblatt ("Die Graphik Ernst Ludwig Kirchners bis 1924 von Gustav Schiefler; Band I bis 1916") *(Title Page) ("The Graphics of Ernst Ludwig Kirchner to 1924 by Gustav Schiefler; Volume I to 1916")*

Color woodcut, 1924
Printed in violet and black
Unsigned proof on ivory japan paper
Dube 861 III/III, the final woodcut in a color variation; not in Schiefler
15.8 x 10 cm.

105/3. Titelblatt (Verworfen) ("Gustav Schiefler; Verzeichnis des Graphischen Werkes Ernst Ludwig Kirchners bis 191()") *(Title Page) (Rejected) ("Gustav Schiefler; Catalogue of the Graphic Works of Ernst Ludwig Kirchner to 191()")*

Woodcut, before 1918
Signed in pencil, on blotting paper
Dube 860 I/III, a proof; not in Schiefler
15 x 9 ch.
The rejected former title.

105/4. Einband ("Das graphische Werk von Ernst Ludwig Kirchner") *(Book Jacket) ("The Graphic Work of Ernst Ludwig Kirchner")*

Color woodcut from three blocks (Red-orange, blue and black), 1924
Unsigned, marked "Eigendruck" (Self-printed), on butcher paper
Dube 859, the final state as printed for the editions; not in Schiefler
27 x 32 cm.

105/5. Liegendes nacktes Mädchen mit Katze *(Reclining Naked Young Woman with Cat)*

Color woodcuts, 1924?26
Dube 878 A/B and B/B
A. Printed in dark orange and blue, 6.3 x 9.3 cm.
B. Printed in light orange and purple, 5.6 x 9.3
The larger proof is the cover of a brochure advertising Schiefler's catalogue
The smaller proof is for an introductory page before the section about lithography, Volume I of Schiefler's catalogue

105/4.

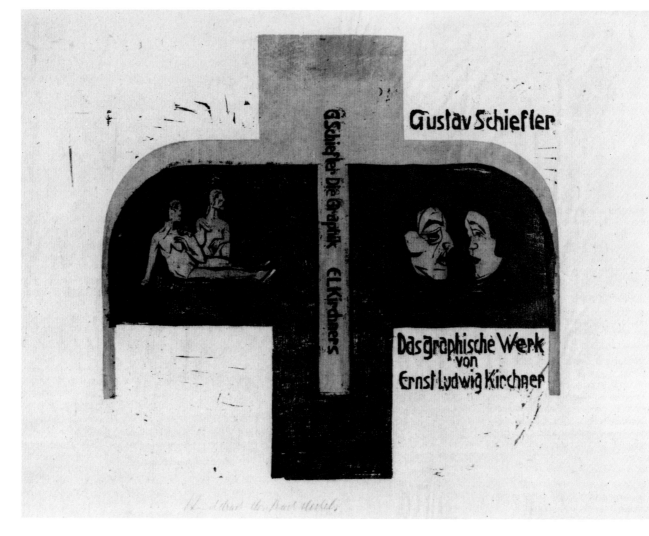

105/3.

105/2.

Gustav Schiefler explains the intentions of the artist in two prefaces. In the first he tells how he promised to do the oeuvre catalogue in 1917, while Schiefler was in Hamburg. Over a thousand prints were sent for his inspection. There was a problem with exact dating as Kirchner was ill and his companion Erna did not know the dates of works made before she met the artist.

The second preface goes into some detail, because Kirchner had written articles critical of his own work under the pseudonym, L. de Marsalle. Schiefler was thus able to draw from Kirchner's own words. The original articles appeared in *Genius* (II/2, 1920, p. 216-234; II/2, 1921, p. 251-263).

Kirchner's intentions are complex and difficult to describe in the imprecise German he used. He thought the secrets of life are in the events of everyday existence. They would never be bloodless allegories. Even the transcendental takes place in the artist, he sees the basic hieroglyph of compression and integration. The transformation exists only in the spectator, the artist has become one with it. It is not like Egyptian art, a stereotyped schematic design, but is a constantly changing design. "The artist creates newly, by his every eye, experience which is filled with the secrets of creation."

Kirchner uses himself and his newly married Erna on the cover in profile and sitting nude together (105/4). The inside pages contain a wide cross section of his work from the earliest

woodcuts, which are reprinted, to special woodcuts for the book. The other prints in lithography and etching are reproduced. Some drawings are also reproduced as line blocks.

The range of styles is described in the second preface. Schiefler uses some detail to show how Kirchner can change an expression on a face by working on a black background or white background. The expression of lips, smiling, can be a grimace or happiness by change of thick or thin contour. Eyes can be wild or gentle by modifying an abstracted iris. Grotesque or angular form can create a mood of transformation in this world of hieroglyphs. Each section of mediums in each of the two volumes has an original color woodcut prefacing the section.

The two proofs for the title page show the artist's original intention to make a humorous woodcut, as he is begging the lawyer to be careful (105/3). The actual title was changed. In the selected title page the artist is a proud man, while the lawyer is bent over a portrait (105/2).

The prospectus for the Schiefler catalogue (105/5A) shows two variations of the introductory color woodcut to the section on lithography (105/5B). It was reduced in size when used. The size variation was caused by a different positioning of the purple color. This well printed, tasteful and well designed prospectus was inserted in certain fine periodicals and mailed to prospective collectors.

**106.** Die Graphik Ernst Ludwig Kirchners von Gustav Schiefler;
Band II 1917-1927 *(The Graphics of Ernst Ludwig Kirchner;
Book II 1917-1927)*

1 multiple color cover woodcut, 6 multiple color woodcuts, and
55 single color woodcuts (Dube 549, 558, 591, 736, 78, 810, 822,
823, 826, 830, 859, 900-952)
Berlin-Charlottenburg, Euphorion Verlag. 1927/31
Edition: 620 numbered examples. Nrs. 1-70 on handmade
Butten paper with three extra prints, all signed: A. Frau und
Mann *(Woman and Man),* woodcut, 1927, Dube 591 IV/IV,
16.4 x 9.7 cm. B. Unknown lithograph. C. Unknown drypoint.
Printed by Spamerschen Buchdruckerei, Leipzig
Type: Römische Antiqua
536 pp
25.5 x 66 cm.

106.

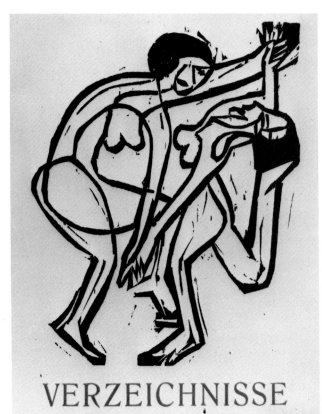

107. W. Grohmann; Kirchner-Zeichnungen; 100 Tafeln und zahlreiche Holzschnitte im Text *(W. Grohmann; Kirchner Drawings; 100 Plates and Numerous Woodcuts in the Text)*

3 cover woodcuts, 2 color woodcuts and 14 woodcuts printed in black (Dube 355, 832-849)
Dresden, Verlag Ernst Arnold, 1925
Arnolds Graphische Bücher, Zweite Folge, Band 6
Editions: 2225 numbered examples. 25 bound in leather, with an original drawing. 200 bound in half parchment, with an original print: Weiblicher Akt vor einem Schrank *(Female Nude Before a Wardrobe)*, woodcut, 1916, Dube 287 II/II, 18.4 x 15.6 cm. 2000 bound in dark yellow linen, without original print or drawing.
Printed by Johannes Pässler, Dresden
Reproductions made by Römmler und Jonas, Dresden
Type: Monotype Grotesk
39 pp, 100 numbered plates (8 pp)
26.5 x 20.5 cm.

insame, schöpferisch veranlagte Menschen lieben es, in irgendeiner Schaffensform dauernd dem Sinn ihres Lebens und ihrer Arbeit verbunden zu sein, und es ist offensichtlich, daß im Umkreis der Bildenden Kunst die Zeichnung alle Möglichkeiten einer nicht endenden Auseinandersetzung mit sich und der Wirklichkeit enthält. Weniger die Zeichnung, die eine bloße Übung des Handgelenks oder des wissenschaftlich

107/2.

107/1.

The drawings show twenty-five years of work, although the woodcuts made for this book show the technical tendencies of the twenties, with rounded forms, simpler interior spaces, a new linear rhythm taken from Kirchner's study of optics. The flat patterns and simplified profiles are used as repetition of shapes throughout, and subjects are taken from his immediate interests, including his reading.

Page 28 has a murder scene, Murder of Amelia, also used in a painting. These literary intentions mark the real end of Kirchner's Expressionism, for he had turned towards symbolism as a last gasp of emotional intentions before moving on into intense studies of optical effects and interpenetrations of space by linear overlap. Intellect, not emotion, became Kirchner's driving force as he withdrew from the world of society. Naked is how he always shows himself and his wife, Erna. They are outlined on the cover (107/1); they are on the title page in strange attitude. Kirchner stands nude as part of the great E, which marks the beginning sentences (107/2). He kisses the naked feet of Erna in an early illustration, holds her hand later in consolation. The thin-skinned painter shows his inner nature uncovered.

**108. Das Werk Ernst Ludwig Kirchners von W. Grohmann**
*(The Work of Ernst Ludwig Kirchner by W. Grohmann)*

1 two-color and 5 one-color woodcuts (Dube 852, 853, 855-858)
Munich, Kurt Wolff Verlag. 1926
Edition: 850 numbered examples. 50 bound in leather, with two
extra prints: 1. Sitzende Bäuerin *(Sitting Farmer's Wife)*,
drypoint, 1922, Dube 410 III/III, printed by O. Felsing,
Charlottenburg, 18.6 x 17 cm. 2. Gerichtsszene aus Shaws
"Heiliger Johanna" *(Trial Scene from Shaw's Saint Joan)*, color
woodcut, 1925, Dube 533 III/III, printed by Officina Bodoni,
Montagnola di Lugano, 18 x 19.2 cm. 800 bound in dark blue
linen, without the extra prints.
Printed by Spamerschen Buchdruckerei, Leipzig
Type: Fette Grotesk (Monotype #15)
59 pp (3 pp), 100 numbered plates
27 x 27.4 cm.

The six original woodcuts include a tondo, a round shape,
which represents an earlier phase and is not similar in concep-
tion to the others (Paar vor Spiegel *(Pair Before a Mirror)*, Dube
858 II/II). The design of the other introductory rectangles is
spread out to fit the wider format of this book. Grohmann's in-
troduction takes a cross section of the best drawings, oils,
sculpture and prints from 1900 until the time of publication. The
essay, which includes the later intentions of the artist, takes us
beyond the Expressionism of the German periods. The late
woodcuts included those in the style of a synthetic Cubism,
which Kirchner developed. There is a new humor, a meandering
of form, a study of motion in figure and surrounding lines.
There is still a sense of alienation in the isolation of the figures
in open areas, but the effect is more lyrical than the earlier
subjects.

## KARL SCHMIDT-ROTTLUFF

The art of Karl Schmidt-Rottluff begins in complexity, bound
with thick surfaces and bright color. It moves into a monumen-
tal Impressionism simplifying the outline and mass, until a
dynamic Brücke style is evolved. From 1910 until 1912, surface
is studied and simplified apart from texture. A Cubist-plastic
improvisation moves in about 1912-1915. The artist also begins
a long study of volume and objective space. After 1918, a strong
religious element enters, and remains firm through the 1920s.
Schmidt-Rottluff begins to study flat, tonal design too. Later
zone designs are studied against volume. The last works move
into more naturalistic organizations of form. After World War II
this artist returns to zone design. All this is paralleled in
printmaking.

## BRÜCKE, PORTFOLIO OF 1909

The Brücke Portfolio of 1909 was devoted to the work of Karl
Schmidt-Rottluff. This artist made three prints for the contents,
and Kirchner did a cover showing a portrait of the artist.

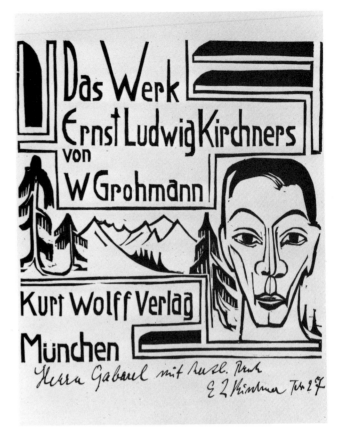

108.

110.

**KARL SCHMIDT-ROTTLUFF**

**111.  Bildnis H (Heckel)** *(Portrait of H (Heckel)*

Lithograph, 1909
Signed in pencil, on heavy vellum
Schapire 56; Bolliger-Kornfeld 14 (Titled there: Bildnis Erich
Heckel *(Portrait of Erich Heckel)*
Printed by the Brücke press
39.7 x 32.3 cm.
Plate 1 of Jahresmappe IV, 1909

111.

**112.  Berliner Strasse in Dresden** *(Berlin Street in Dresden)*

Lithograph, 1909
Signed in pencil, on heavy vellum
Schapire 57; Bolliger-Kornfeld 15
Printed by the Brücke press
40 x 33.8 cm.
Plate 2 of Jahresmappe IV, 1909

112.

**ERNST LUDWIG KIRCHNER**

**110.  Umschlag der IV. Jahresmappe der Künstlergruppe
Brücke** *(Cover of Jahresmappe IV of the Brücke Artists' Group)*

Woodcut, 1909
Printed in red
Unsigned, on heavy vellum
Dube 706; not in Schiefler; Bolliger-Kornfeld 13 (Titled there:
Umschlag: Porträt Schmidt-Rottluff *(Cover: Portrait of
Schmidt-Rottluff)*)
39.8 x 30 cm.
Cover of Jahresmappe IV, 1909

113.

### 113. Altdresdner Häuser *(Houses in Old Dresden)*

Etching, 1909
Signed in pencil, on yellowish vellum
Schapire 9; Bolliger-Kornfeld 16
Printed by Carl Sabo
13.6 x 18.6 cm.
Plate 3 of Jahresmappe IV, 1909

The artist is still moving in and out of the Impressionist style. The cover by Kirchner is more expressionistic in character than the contents by Schmidt-Rottluff. It shows the young artist with a short beard, a symbol of independence also worn by his friend Heckel, though with less Oriental-looking effect.

Schmidt-Rottluff is said to have introduced the art of lithography to his friends in Dresden. Though he had previous knowledge of lithography, this publication of the medium by the Brücke workshop is over-etched and prints harshly. His two examples show much lack of technical knowledge, for these self-printed examples lose some of the rich tonality of ink touch by improper preparation of the stone.

Both the lithographs are calligraphic, with emphasis on a high perspective, taken from lessons by his teacher at the Hochschule. The up curve is central to each. Both become linear, though the portrait is intentionally so. Berliner Strasse was where the Brücke artists resided at this time, in a former butcher's shop in the workers' quarter, converted into a studio by Heckel and the rest. In both portraits, Kirchner's as well as Schmidt-Rottluff's, the mood is somber and inward, but enthusiastic in structure and line. Lithography seemed the freest medium for the young painters, trained as they were in freehand sketching, a basic method of teaching in the architectural department of the technical college.

Etching proved more difficult, especially after the young artists studied the work of Rembrandt. The etching of old houses may have been drawn from the rear of the converted shop, because there is a watercolor of that subject, which seems to be a view from the backyard. Here Schmidt-Rottluff uses a reed pen to cut through a hard wax ground before the acid bath. There are skips and dotted portions also reminiscent of Van Gogh in the late reed pen drawings from around Arles. Because etching seems the least capable of expressing inner tensions, this early linear style from Rembrandt was turned into a more massive interpretation by addition of tonality with aquatint, which better served the purposes of these emotional artists. Even here the lines are heavier in accent than most Impressionist etchers would attempt. Woodcut was the most mobile and needed the least amount of equipment, so a more rapid development occurred in that medium.

### 114. Der Neue Club *(The New Club)*
### Neopathetisches Cabaret *(Neo-Pathetic Cabaret)*

Woodcut, 1911
Unsigned, with type
Schapire Gebrauchsblätter 16
4.7 x 16.8 cm.

The club was organized in 1909 by Dr. Kurt Hiller as a reaction against another group in Berlin, the Free Academic Society. The atmosphere was very highbrow, and the club moved to various locations. This particular program was carried out at an architectural center, later meetings were held in a casino and a cabaret. The club was also described as "neo-aristocratic." "Der neue Club" met evenings, and to begin with was not active in politics, though later very active. About eight evenings were held to promote the work of the new poets in Berlin.

This evening of April 3, 1912, a meeting was held to read from the work of the recently drowned poet, Georg Heym. His death came as a shock, for he was one of the leaders of the early Expressionist movement. The opening reading was delivered by the young poet Robert Jentsch, killed later in World War I. He read from the ecstatic poetry and letters of Hölderlin. Hölderlin had also died young, and was considered an influential thinker by these young Berliners. In addition to Heym's work, six piano pieces by Arnold Schönberg were performed. Other young poets read from works of the early Expressionist poets.

Schmidt-Rottluff had an early interest in typography and graphic design. Though largely self-taught, he had a kind of clearheadedness and the strong will of the eastern German from Saxony. His lettering carried the Brücke originality further into freer exaggerations, skillfully drawn and quickly cut.

The Brücke artists were in Berlin at this time. Schmidt-Rottluff was illustrating articles for *Der Sturm*, to which Dr. Hiller also contributed. Perhaps Walden, publisher of *Der Sturm*, or his wife at that time, Else Lasker-Schüler, introduced the young artist to the intellectual circle of "Der neue Club."

114.

### 115. Zwei Köpfe or Köpfe I *(Two Heads)*

Woodcut, 1911
Schapire 66, printed by the artist
Signed in pencil, from the collection of Schmidt-Rottluff's
biographer, Rosa Schapire, Hamburg
On smooth white paper
50 x 39.2 cm.

The double portrait presents a problem of double interest. In
this case, Schmidt-Rottluff borrows from Gauguin via Edvard
Munch for his solution. The great unity in this design is the
wood grain. Munch had used sexual tension as a unifying ele-
ment, but there is none of this in the 1911 woodcut by
Schmidt-Rottluff. Even the identity is hidden, for we cannot be
sure of the sex of the models. Yet the wood grain ties the dark
half with the white half, and facial details weave through the
center.

The flat forms, the verticality, the size of the block, the impas-
sive poses, side borders, rather rectangular stylization, and
half division between light and dark all mark this as a Brücke
print. Schmidt-Rottluff was not interested in the Jugendstil
swirls of Munch and the others. Tendrils are in the functional
material only. It is too early for the primitive character of his
later abstraction. There is still a rational grasp of the obsession
with surface, a coarseness in these bystanders of the painter's
young days.

What is also interesting in this early woodcut is the cleanli-
ness, the lack of museum antiquity. Though the inner content
is without emotion, even rather prosaic, the imagery is subor-
dinated to analysis, and to a non-specific emotional content.
The two faces do not melt together.

115.

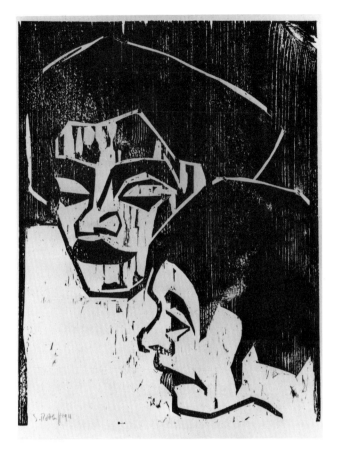

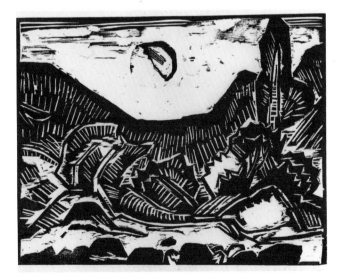

116.

### 116. Bucht im Mondschein *(Bay in Moonlight)*

Woodcut, 1914
Schapire 160, printed by Imberg and Lefson
Edition of 25-30 examples
Signed in pencil
39.8 x 49.8 cm.

The bay is lit white by a glowing moon, almost disappearing
into brilliance, at a time that was a lost period of European
civilization as these artists knew it. A ghastly landscape with
light picked out, as lines creating an inner excitement, unifies
the horizontal mass of darkness. This wild landscape, possibly
near Memel, shows anti-impressionist abstraction. There is a
concept of non-decorum, a consciousness of life through the
interweaving of things growing and the atmospheric mood
from primitive emotions.

Schmidt-Rottluff had spent the summer in Holstein waiting for
his class to be called into service. He entered the army in the
spring of 1915.

### 117. Mutter *(Mother)*

Woodcut, 1916
Schapire 194, printed by Voigt
As published in J. B. Neumann-Mappe, 1919, edition of 75
examples
Signed in pencil
41.2 x 32.4 cm.

This strong woodcut forms part of a portfolio published by J. B. Neumann in Berlin. Neumann wanted a salable portfolio so he chose woodcuts made over various years from 1914 to 1918, the year of actual publication.

This is the great period of architectural-like figures and massive heads. Of the eight listed woodcuts of 1916, one is a landscape and the rest are heads. The great sculptural forms are cut broadly into planes by diagonal lines.

The overproportioned subject leaps into immensity like the head of a giantess. Eyes are slits as in Slavic lands. This woodcut was probably done from memory while the artist was in military service. It seems a thing of the imagination, modeled from the subjective mind. Form is simplified into as few planes as is desirable. There is some Cubistic concept, with the use of cone, sphere, and cylinder combined with the linear punctuations of primitive art. There are no paintings listed for 1916, so the artist probably kept to this portable medium, which lent itself to the mental and physical restrictions of military duty and impersonality.

The symbolism is personal, but gives a meaning of mother earth, strong and unforgiving. It is a serious interpretation of life.

117.

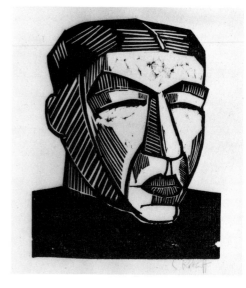

### 118. Das Spiel Christa vom Schmerz der Schönheit des Weibes *(The Play "Christine" about the Pain of the Beauty of the Woman)*

Schmidt-Rottluff and Alfred Brust
In *Der Rote Hahn* series, Doppelband 29/30. Berlin-Wilmersdorf: Verlag der Wochenschrift "Die Aktion" (Franz Pfemfert), 1918
45 + 2 pages
21.5 x 13.5 cm.
Containing 9 original woodcuts by Schmidt-Rottluff (Schapire 219-227)

The author Alfred Brust (1891-1934) was a German playwright, novelist and essayist. This was his first published book, a discovery by Pfemfert. Later the author published in *Genius, Die rote Erde* and *Menschen*.

Brust's work is a mixture of religious and mystical elements. He carried the sexual themes of August Strindberg and Frank Wedekind into the new generation of idealized standardizations, which were not complete studies of individuals. Brust uses these general names—father, son, woman, daughter. Combining grief and beauty is typical of his theories of idea-drama, as in the title of this play.

The mystical-religious theme fell in with the religious thoughts of Karl Schmidt-Rottluff during this time of reappraisal. His was a non-dogmatic kind of religion, based on humanity rather than history. In keeping with this concentrated mood, the woodcuts are small, chosen for the surface, of either smooth or rough wood, weathered and sanded. Schmidt-Rottluff has softened his Germanic masculinity somewhat and his style is more pronounced in this period after the impact of the war.

The style is a greater simplification of plastic form, an intensification of the small world within the confines of a woodcut's black and white. It becomes an inner world of threatening and forgiving symbolism. African sources are internalized into a high emotional intensity. The foreign element is no mere tool for curiosity but makes a conscious metaphysical statement in abstract context. It is still an elementary part of the modern struggle for form.

The quickly cut woodcuts are all stylistically different. They show a passionate will to create, an art of energy. The book is assembled without much care. Woodcuts are printed irregularly, slipped out of position and with varying margins.

Other inexpensive series, such as those by the Insel press, show remarkable control. The publisher of *Der Rote Hahn*, Franz Pfemfert, had no overall designer, but had his books designed by some typesetter at an obscure job print shop, perhaps the lowest bidder. For Pfemfert, politics was becoming more important than art. The rebirth of German society was primary to aesthetic considerations.

118.

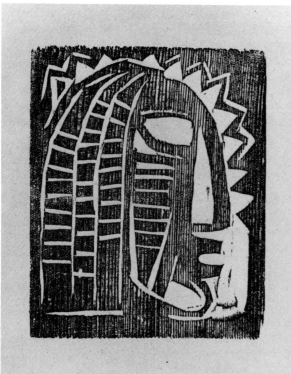

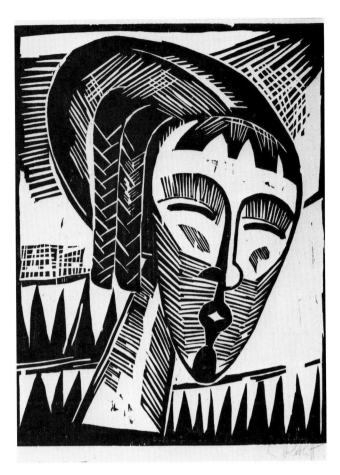

### 119. Mädchen aus Kowno *(Girl from Kowno)*

Woodcut, 1919
Schapire 209
Edition for the J.B. Neumann Portfolio, Berlin, 1919,
75 examples, printed by Fritz Voigt
Signed in pencil
49.5 x 39 cm.

This is another woodcut from the Neumann Portfolio. He was doing a portfolio for Kurt Wolff in Munich at the same time. Schmidt-Rottluff's experience as a postal clerk in Poland and Russia during the war provided notebooks of drawings, themes for later work, and some woodcuts done in the field.

There is a peasant quality about the hanging braids. The slit eyes of the eastern Slavic type are repeated. Motifs become more ornamental in this work. To Worringer this newer ornamentality meant a deeper spiritual quality. This woodcut was probably adapted from a sketch made during the war, while the artist served in Kowno. We know he travelled there, then went to Wilna and other parts of the eastern front.

After the war, when this work was cut, Russia had become part of the socialist symbolism of the brotherhood against democracy, relating to reaction. The earlier Russia of mysticism and immense space had evolved a new idea which appealed to the ultra-left intellectual. Part of this postwar change meant a more objective subject matter, as in this portrait, for early subjectivity became an unsympathetic thing to the new critics.

Schmidt-Rottluff also experimented with a changing concept of form with triangles dominant. There is a beginning flatness and tonality in zones, a return to centralizing of the face, and more ornamental, less sculptural planes. Most of the stylization came from African figures, possibly Baule and Dan (both Ivory Coast).

### 120. Inhaltsverzeichnis für die Neumann-Mappe *(Table of Contents for the J. B. Neumann Portfolio)*

Woodcut, 1919
Schapire Gebrauchsblätter 43
Signed in pencil
Edition of 75 examples
49.7 x 39.4 cm.

This title page of the Neumann Portfolio represented the artist with all his concepts and subject matter: Melancholie of 1913, Drei am Tisch of 1914, Katze of 1915, Mutter of 1918, Die heilig. 3 Könige of 1917. Influences apparent in these ten prints range through Dostoyevsky, Biblical stories, a fishing scene, moody landscapes, army service, and interest in ecstatic light. Many of these prints appeared also in German journals such as *Die Aktion* and *Die rote Erde*. Influences can be observed in styles from Africa, the Western Pacific, and glass painting, though all have been smoothed out into gesture rather than as copies of proportion or detailing. The two figures hold a curtain containing the list of prints. The strange audience is based on the contents and includes a wide-eyed cat. A nude man and nude woman appear before the grotesque audience of the artist's creations.

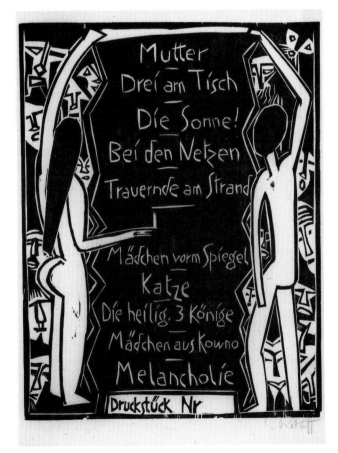

**121.  Christus** *(Christ)*

Woodcut, 1919
Schapire 208, printed by the artist, proof before editions
Signed in pencil
Editions: Portfolio for Kurt Wolff, Munich, 75 examples in the edition printed by W. Drugulin, Leipzig
50.1 x 39.1 cm.

Religion was a favorite theme of the postwar artists. It resulted in stress from supernaturalism before the rise of radical socialism. The whole idea of high and outgoing Christianity came from Tolstoi, defined as service to mankind. Some of the Expressionists carried this idea into the late 1920s as a reaction against suffering and the psychosis of revolution.

Religion seemed to be a breakthrough for the young Schmidt-Rottluff. It was not so much a theme as a sketch of a possible world. His theology was not that of dogma, but mystical and ecstatic. It was a direct Protestant relationship with the divine. He tried to give the old symbols new meanings for a renewed mankind. So we find these illustrations are not true illustrations of church tradition but direct expressions. This Christ speaks through defined gestures, through the expressive drawing and form, through exaggeration. One eye is closed in pain and the other is open in wisdom. The title asks "Has Christ not appeared to you?" On the forehead is the date 1918, end of the Great War and representing the end of old suffering and the beginning of the new era. The closed lips have the fullness of a person who has enjoyed life. A serious and somber mood pervades the print. The breakup of form into rude cubes and blocks emphasizes the brutality of the expression, as though Christ had been ground down by chisel and sandstone.

122.

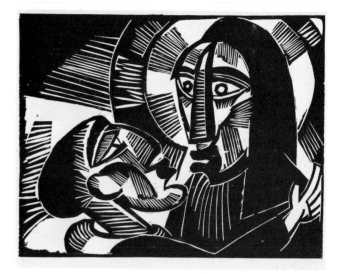

123.

121.

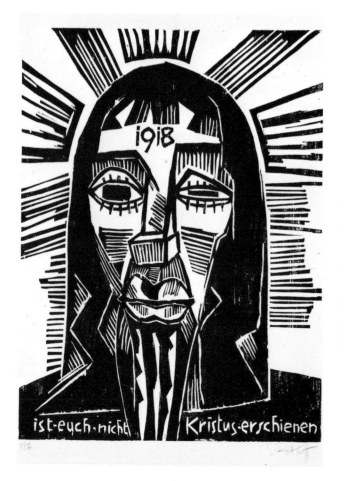

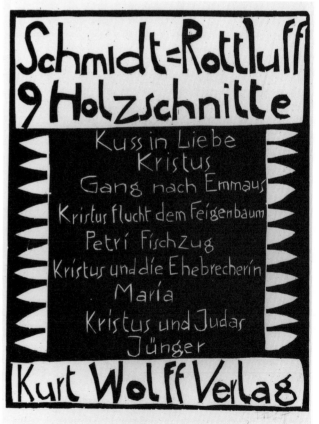

**122. Christus und Judas** *(Christ and Judas)*

Woodcut, 1918
Schapire 218, printed by W. Drugulin, Leipzig
In the Kurt Wolff Portfolio, 1918, 75 examples
Signed in pencil
39.7 x 50 cm.

In this woodcut, Gothic verticality is interrupted by circles. Christ is bewildered, knowing of his fate before the lip-pursed Judas. Both seem brutalized by the future, just as the young painters were pulverized by the war. Christ is centered in an explosion of light, reinforcing universal allegories about the tragedy of man. Both figures are made ethereal by angular lines intersecting the circular shapes. The artist has used sure and deep incisions without halftones to space the blacks within white depth.

**123. Titelblatt zur Holzschnittmappe im Kurt Wolff Verlag**
*(Title Page for the Portfolio Published by the Kurt Wolff Press)*

Woodcut, 1919
Schapire Gebrauchsblätter 30, printed by W. Drugulin, Leipzig
Signed in pencil
Edition of 75 examples
50 x 39.8 cm.

The effective title page is designed over and under a black square, which is used for negative space. Borders are triangles, enlivening the margins and lessening the tension of pure black, using pure abstraction to carry through the sense of the primitive which is used in the illustrations. The type is designed in free and rounded verticality, yet functional to the woodcut medium. By this time Schmidt-Rottluff was experienced with typography, and capable of creative and exceptional use of this vehicle. The white-on-black type of the major concern, the list of contents, is carried through from the first page.

124.

**124. Reichswappen** *(The German Coat of Arms)*

Woodcut, 1919
Schapire 262
Signed in pencil
50 x 39.8 cm.

The revolution of November 1918 brought hope to most of the German painters and writers. It seemed a social-aesthetic turning, a change in basic concepts more in line with dreams of earlier creative men. Schmidt-Rottluff joined the "Arbeitsrat für Kunst," described as a "people's council for art" based on the Russian Soviet. Creative people in Berlin drew up programs to remake humanity. Schmidt-Rottluff carried his wide interest in all the creative arts into this political battle. He designed pamphlets, did layouts and lettering, and helped design an ideal city with César Klein. For some time the Weimar Republic saw the artist, especially the Expressionist artist, as a leader of the change. Edwin Redslob was appointed State Commissioner of Art and was asked to establish standards in all designs for the young government.

Schmidt-Rottluff was given the commission for designing one of the government emblems, the state eagle.

This proof is a preliminary study. The motif is not aggressive nor especially symbolic of strength or cruelty as was the old imperial bird. This is a flattened bird, with little traditional impact, a thing of small wings and parrot-like head. This bird seemed a mockery of German fierceness to the Nazis, who covered up all in existence as soon as they came to power.

125.

## EMIL NOLDE

### 126. Akt *(Nude Model)*

Aquatint, 1906
19.75 x 14.75 cm., Schiefler-Mosel 34, second state, Bolliger/K. 8
Editions: 7 examples of first state, without work on foreground.
66 examples printed for Brücke Jahresmappe 1907 (of these about 20 were used). A numbered edition of 20 examples on Bütten paper.

The Brücke Jahresmappe II, of 1907 was intended to show some of the artists other than the original founders. Nolde and Schmidt-Rottluff had joined later as had the outside men, Cuno Amiet and Axel Gallén-Kallela.

The Rifkind Collection has all these prints with the exception of the Schmidt-Rottluff lithograph, Holbein Platz in Dresden. (Schapire 8)

Though complete aquatint was used by Munch and Kollwitz, neither artist had attempted a fluid technique using the resin dust as suspended in a fluid of alcohol. Nolde must have had superb advice. Although he was a stubborn thinker, he was never afraid of technical experts such as Sabo and Felsing.

The figure, appearing in relief above the background, is given horizontal contour by over-etching, probably by using iron-perchloride, which lowers the entire surface. Each brush stroke is apparent, for the brush leaves a thin surface of resined aquatint, which after heating is fastened to the printing surface of the metal and becomes acid proof. Nolde went back into the plate with a resist, such as asphaltum, to block out the white areas.

The furious and rapid drawing is typical of this time in Nolde's life. Like the Japanese, Nolde believed in certainty rather than study: the inner creative force could be released by innate, personal drawing, and this would, somehow, enable him to reach into the center of universal conceptions.

After their studies in sedate architectural directions, the young Brücke painters were impressed by the direct action of this somewhat older painter from the marshlands of the north.. There was an immediate change in the work of Heckel and Kirchner.

### 125. Titel: Kündung/Eine Zeitschrift für Kunst *(Title for the Periodical Kündung/A Periodical for Art)*

Woodcut, 1920, printed with an orange background
Schapire, Gebrauchsblätter 52-53, a proof of Schapire 52
Signed in pencil, and marked "Orig. Holzschnitt"
30.8 x 32.8 cm.

Though Schmidt-Rottluff did some work for the periodicals in Berlin, notably *Die Aktion* and *Der Sturm,* he sent most work to Hamburg for his biographer and friend Dr. Rosa Schapire. Dr. Schapire and Dr. Wilhelm Niemeyer, art historian and docent of the cultural history department at the Arts and Crafts school, collaborated on this journal, which intended to show the best poetry and thinking from the Hamburg area. Dr. Schapire had already tried to edit a couple of monthly issues of the other journal in Hamburg, *Die rote Erde.*

The seven issues of *Kündung,* all that were published, had this cover by Schmidt-Rottluff. It had a differently colored background for each issue. The design is late Expressionist with the major design simplified at center, and white on black lettering surrounding the title. The design of the lettering is free and varies in thickness. The periodical was supposed to be a very deluxe work, and, fittingly, this woodcut is printed on thick, handmade paper. There is a lack of seriousness in the contents of the periodical, but the cover is a strong announcement in major contrast, so it seems a trumpet of modernism, not an egoistic solution.

From Traum des Bösun *(Dream of Evil)* (About Nolde)
By Georg Trakl

From pale masks the spirit of evil watches.
A square darkens into grey and melancholy.
A whisper showers from islands themselves.

Nolde's first etchings appear earlier than most of the Brücke artists, about 1899. They were already caricature-like and moody. Grotesqueries appear, violent action, exaggerated poses, much of the later symbolism from a far northern area of strange—even to the Germans—introverted peoples. He also did some softer portraits of young women, showing an early contrast to the inner turbulence so noted for Nolde. It seems a fairly peaceful interlude for this artist.

By 1906, Nolde had returned to the scenes of rough peasant subjects, combining these with some traditional landscapes. Nolde had been mostly self-taught. Some early direction by his friend, Max Wittner, had introduced him to the literature of humanism, of Hamsun, Strindberg, Gorki, and Jacobsen. Nolde was not oriented to the normal background of a German intellectual, and his education had gaps which affected his prejudices and biases. He learned from the theater, books and periodicals. Nolde was one of the generation of naturalistic writers, and there is always a split personality apparent in his work.

**126.**

**127. Tischgesellschaft** *(Dinner Party)*

Aquatint and etching, 1906
Schiefler-Mosel 38 iv
Unsigned, as issued in *Der Zeitschrift für bildende Kunst,* 1907,
N.F. XIX, Heft 2, on Bütten paper
15.1 x 19 cm.

This work is an early attempt to show rude common German
workers in one of the endless discussions at a table in a back
street tavern. It is similar to some of the early Kollwitz scenes
from Germinal. Nolde gives a troll-like concept to the figures.
The lines are drawn with a primitive immediacy. The scene is
probably in Soest, where Nolde worked. The stylistic approach
is still impressionistic, with hard outlines and light and shade
maintained. It is a kind of drama.

**127.**

**128. Düsterer Männerkopf** *(Head of a Man in Darkness)*

Color Lithograph, 1907
Schiefler-Mosel 17 iii, printed in 1915
A two-color proof in yellow-brown and black-brown
Editions: State 1—few examples. 2—100 examples, 20 of which
are numbered. 3—few proofs and 34 examples, of which 20 are
numbered.
Signed in pencil, on Bütten paper
43.1 x 33 cm.

Nolde's first lithographs date from the Brücke period in Dres-
den, 1906. This portrait of 1907 is typical, with skillful drawing,
rather academic in concept, not using the full tonality possible
in this medium, and rather woodcut-like. It is a very direct
medium, without room for mistakes by a learning painter.

The portrait is subtitled "Darkness". It relates to the early
woodcuts of the same time, which also have chiaroscuro
effects of light areas picked out of solid backgrounds. This
is a two-color proof mentioned in the oeuvre catalogue. Later
impressions have more articulation around the face and a
richer, detailed background.

This example of a rare impression has simplicity and force
within the depth of focus. Nolde studied the white edges with
more effect than the other Brücke painters at the time. They are
complicated contours, varied and softened according to the
change of plane.

**128.**

**129. Propheten Kopf** *(Head of a Prophet)*

Ink drawing, 1912
Signed in pencil, on rice paper
Dated by Dr. Urban, director of the Stiftung Ada und Emil Nolde, Seebüll.
41 x 30 cm.

An ink drawing made in 1912 from a series of heads of prophets, according to Dr. Urban, Director of the Nolde Museum.

It is very much like Japanese drawing, using the finer lines of studied Chinese calligraphy, but with heavier, more weighted brushwork. The drawing was made on an absorbent paper, a japan type. The shorthand is not all a Japanese style, but Nolde's own, with a thrusting touch, lift of loaded brush to turn a line here, blot or tear an end of a line there. Thick lines are used without much sweep of the wrist. The model was probably Hans, who was used for many religious paintings and prints. He was a man with a low forehead, deep-set eyes and low brows. If we could count the lines as in an Oriental calligraph there would be just 26. It is a very simple and very powerful notation. There is no attempt to make calligraphy reality as in Rembrandt or Kirchner. It has a rather lined and brutal directness of drawing.

129.

130.

**130. Der Prophet** *(The Prophet)*

Woodcut, 1912
Schiefler-Mosel 110
Signed in pencil, on brownish oatmeal paper
31.7 x 20.9 cm., edition of approx. 20 examples

A major revival of religious subjects is apparent in Nolde's life after a serious illness while the artist was in the isolated village of Rüttbull, with its windswept, cruel climate of contrasting cold and humidity. It was an illness probably from tainted water.

This woodcut is strong in concept, studied for vertical linearity. It relates to Nolde's use of the mask, which appears in 1911. The face is awesome, not in the least literary. The subject is a prophet of action, not words. He is a man of strong opinion, not Christian charity. He glances powerfully outward. The technique is one of negative direction from black to white, removing areas that do not print, the reverse of the ink drawing. Nolde worked, as he wrote, in a kind of direct, detached concentration. We know from the drawings however, that he did not work as spontaneously as he described, for there are many studies for the later heads.

## 131. Tänzerin *(Female Dancer)*

Color lithograph, 1913
Schiefler-Mosel 56 (Five Stones)
Signed in pencil, on japan paper, 53 x 69 cm.
A variation of the grey-violet foreground not mentioned in catalogues (Dr. Urban). Numbered by the artist's wife.
From the edition of 35 examples, without the full violet color; probably misnumbered as part of the edition
Printed by Westphalen.

This lithograph is one of the major masterpieces of German Expressionism. It is the culmination of Nolde's early style, made before his trip to the Far East. It shows Nolde's interest in the frenzy of the modern dance, for he studied postures and attitudes early. The pose is theatrical, revealing his early interest in the stage. It shows his development of quick drawing, studied gesture made by design and designed for balance. Here, too, is the early interest in primitive ritual as a source for exciting and sinuous patterns. Vibrating blacks, dots of nipples, rich red-ochre color against a grey-violet, the writhing shapes echoed in the background, all illustrate the artist's sensuous reaction to the subject matter. The triangular shape of the legs is countered by the pubic triangle. The arms and flowing hair lend a horizontal line of force. Nakedness is exposed with truth and power. Yet there is a sense of inhumanity, which is not satirical or humorous in the least. The whole composition is forced toward us by the curving horizon line which rises to its highest at the center under the dancer. Nolde shows versatility and some sophistication in this culmination of his early period. It is not the work of a peasant ignoramus from an introverted wasteland.

131.

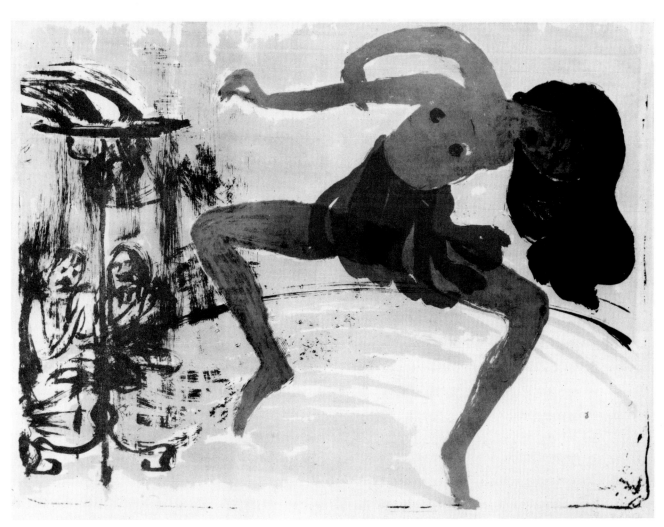

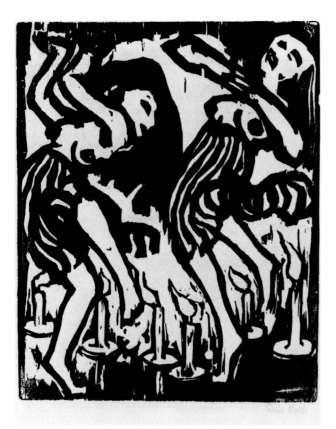

**132.**

## 133. Lichter Kopf or Heller Kopf *(Luminous Head)*

Woodcut, 1917
Schiefler-Mosel 148 iv, fourth state of 13 impressions, known edition is 21 including proofs
Signed in pencil, on yellowish paper
30.8 x 24 cm.

This was an important year of study, for Nolde worked in portrait heads about fifteen times, studying calligraphy, tilting profiles, using strange expressions on the faces, cutting heavily down in the wood.

Placed directly in the center of the rectangle, this portrait of a blond woman has some color notation by values in the cheeks, forehead, and chin: all representative of northern complexions with red cheeks from contrasting heat and cold. Otherwise the dark areas have little meaning. They add a ruddy glow to this shining "bright head," Nolde's secondary title. It is noteworthy that Nolde followed Jawlensky's career closely, and this portrait has much of the Russian artist's mood of cross-form and impassive, peaceful gaze.

At this period Nolde had finally settled permanently at Utenwarf; this woodcut was probably made in isolation, and represents some of the mood of the northern landscape too. There is an inner movement, as though the artist had looked at shimmering water and building cloud masses. The face almost seems constructed of airy clouds.

**133.**

## 132. Kerzentänzerinnen *(Candle Dancers)*

Woodcut, 1917
Schiefler-Mosel 127 v
Signed in pencil
From an edition of 13 examples; known edition is 21 including proofs
29 x 24.3 cm.

This woodcut was made after a trip to the exotic East. It is based on a similar subject used in a painting made before the trip. It is interesting to see his change in concept. The early painting is a study in rich color. The figures are not well articulated from the background. Form is not directed in contrasting movement, but seems part of nature.

This print has a new stylization, a heroic grotesqueness. There are no costumes from the Far East represented, but the poses are more mannered and made essences of primitivism, not an attempted travelogue. Broken and decorative rhythms pile upward toward the familiar arc, now on top. Brutish expressions show, and primitive strength is in the dancing figures. They are the subjective reactions of this repressed artist from a Protestant northland. He had passed through actual communication with primitive man: it was no longer a dream or imagination. The picture seems to dance and flicker in the candlelight. It vibrates forward and backward as the ritual dance drums wild emotions within the picture plane.

### 134. Wikinger *(Vikings)*

Etching and aquatint, 1922
Schiefler-Mosel 212 ii
From an edition of approximately 18, of which 6 are in this state
Signed in pencil, inscribed "II" (state), on Bütten paper
32.4 x 25 cm.

A skillful etching with some aquatint in various degrees of strength, its technique shows some of the freehand skill Nolde had developed from the watercolor medium, a mature skill with fine collaboration between tone and line. Innocence and experience meet in this saga-inspired subject matter, a kind of entity Nolde used more and more from 1918 onwards. It may have been a primitivistic return to older religions after rejection of nationalistic Christianity following the war. This is an epic print, glowing with inner light. It is earthy, heavy, and dramatic.

The print is a mythological tale contrasting old and young, with graduated transitions of tone and verticality. There is a fine sense of patience and nobility in the young man.

134.

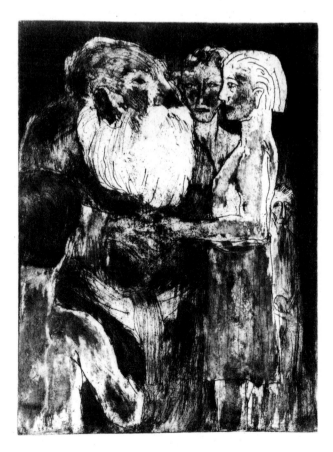

135/2.

### 135. Das graphische Werk Emil Noldes bis 1910 von Gustav Schiefler im Verlag von Julius Bard, Berlin 1911 *(The Graphic Work until 1910)*

Editions: 435 total examples. A–I-X on kaiserliche (Imperial) japan paper. B–11-35. Both A and B editions have an additional original etching: Joseph und seine Brüder, 1910, *Joseph and His Brothers)* Schiefler-Mosel 150, printed by the Pan-Presse, 14.9 x 10.8 cm. C–36-435 on Bütten paper
4 + 139 + 1 pages, Schiefler-Mosel 41-48, 50, 53-58, 60-62, 66-70, 72-76, 86, 96, 167, 35 W40–78, 86, L. 35
25.7 x 19.6 cm.
With 26 original woodcut vignettes and two original prints: as Frontispiece: "Ägypterin I *(Egyptian I),* woodcut, 1910, Schiefler-Mosel 86, 15.3 x 10.5 cm. (135/2). After page 32: Die Pflüger *(The Plowman),* lithograph, 1911, Schiefler-Mosel 35, printed by W. Gente, Hamburg, 15.2 x 11 cm. (135/3).

135.

135/3.

GUSTAV SCHIEFLER: Introduction to Das graphische Werk von Emil Nolde, vol. II, excerpts:

Nolde's development has occurred without a break. The creations of his fantasy (if we wish to use a metaphor) spout like a fruit bud on upward-reaching branches of a tree, spontaneous and matter of fact. In spite of the sureness and firmness with which Nolde dominates the drawing and knows how to build the composition with means of few pregnant lines, his style is predominantly painterly. He sees the world not in lines but colors. But in this he is still a child of his time, the past impressionistic time, for color must serve him less with depth as the planar surface effect. Yes, he was one of the leaders on the way to this sudden change.

The group of large color lithographs is proof of the coloristic attitude of Nolde. Although his first lithographs were made on transfer paper, he worked in 1911 with Gente in Hamburg directly on the stone. Only now the charm of the material opened to him, allowed him to get out of his mind and onto the stone what he had thought as color-planes. During the early summer in Flensburg of 1913, he turned his longing into reality. He developed a new kind of intoxication for handling brush and print. He let go with means of always new variations and combinations of plates and colors in his joy for coloristic finesse. Next to it were prints of almost bleak strength.

The tendency towards the painterly also dominates his etchings. Certainly, there are impressions on which we see outlines with delicately etched lines. But one is always under the impression that these would only satisfy the artist if these were given coloristic nuances by tone-etching. The artist's joy in experimentation makes him try other means to achieve tonal effects. Once he bought rough, unsurfaced copper plates, which were meant to cover the keels of ships. The surface resembles that of mezzotint. He tried iron plates, which had again different effects. The greater hardness of iron brought a certain coldness to the tone, but welcome to the astringent sense of the artist.

Even in the woodcuts, which can be called the most drawing-like because of the sharp outlines of the planes, his will towards the painterly triumphs, as in the earliest impressions, which used blind stamping to achieve a play of light and shade in accord with the painterly effect he desired. Later and frequently the broad spots and coarse lines of the drawings are more and more dissolved so there develops an oddly "swimming" movement in the impression, which can give the illusion of colors. We may mention the Candle Dancers here.

When the first part of this catalogue came out, Nolde had already presented a large part of his religious paintings, foremost the Last Supper and Pentecost pictures. The introduction of these topics also circled into the graphic art. Later, wider room was taken by the fantastic presentations. What seems represented in the oil paintings as curbed and tame, as masque compositions and still lives, is allowed full freedom in the graphics. It is a strange entangling of pure play for composition and invention of deep seriousness and bitter mockery. A fine humor passes, understandable only to one who has a sense of humor himself. An atmosphere of fairy tales comes over us ... Our experiences are changed into the droll by self irony. Wild, grotesque scenes appear. We appreciate less themes of beautiful, naked women throwing themselves into the waves. Humor, jest, seriousness and satire hold each other's hands and perform a dance of creatures of a thinking, forming spirit, sometimes running or somersaulting.

136. Gustav Schiefler Das graphische Werk von Emil Nolde 1910-1925 *(The Graphic Work* – 1910-1925)

Berlin: Euphorion Verlag, 1927
Editions: 520 total examples. A – I-XII on japan paper. B – 13-75 on handmade Bütten paper, both A and B editions have the color lithographs signed, plus one extra etching: Mädchenbildnis, 1924, Schiefler-Mosel 230, printed by O. Felsing, 15.2 x 10.8 cm. C – 76-520 on Bütten paper. 1 + 172 + 4 pgs, Schiefler-Mosel 40, 51, 59, 63, 65, 71, 78, 95, 158-162, 168-183, 188-189, 191, 71, 77 25.7 x 19.6 cm.
With 33 original woodcut vignettes and two color lithographs: page 68: Ältere Herren *(Old Men),* Schiefler-Mosel 71 (136/4). page 76: Fabelwesen *(Fabulous Beast),* Schiefler-Mosel 77 (136/5). (see proofs).
And two full-page original woodcuts: as Frontispiece: Mann und junges Mädchen *(Man and Young Woman)* 1925, Schiefler-Mosel 188, 17.6 x 12.8 cm. after page 102: Nachbarsleute, *(Neighbors),* 1925, Schiefler-Mosel 189, 15.2 x 10.8 cm.

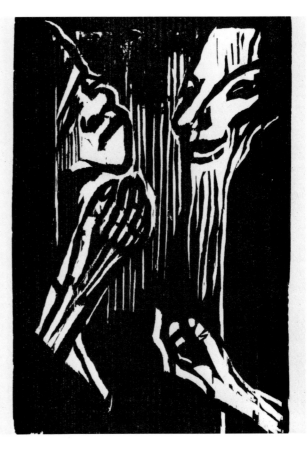

The fantasy of imagination carries on the leprechaunlike activity also in the portraits. Portraits in the exact sense of naturalistic likeness hardly ever appear. Otherwise the subjective presentation of the artist outweighs so much more, that we can speak of characteristic paraphrases of single traits which interested Nolde especially. Themes are varied as though in different keys. The model is left for the type. On the same face, the artist can portray humor or seriousness of tragic humor.

Nolde did few landscapes in later years. Nothing is romantic. Everywhere he uses the simple forms of the north-German flatland. He speaks of the natural feeling for the home. His origins were the farmer cultures of north Friesland, the west coast. All of Nolde's art—in the best sense of the world—is rooted in his native soil. This means it is not rooted in common narrowmindedness, but in a locally bound soul, yet still relates to the great world. So he possesses the strength to grow beyond the narrow home territory into the great German fatherland, beyond that into the German orientated communities of neighbor peoples. Also his earth fantasy belongs to this earth boundedness. The great simple powers of nature rule: the ocean, the storm, the long winter nights and short summer, the glittering sunlight over vast marshy lowlands. This is more mysterious than the "merry south".

His creations live, the figures of ghosts, the "little folk", nightmares and nightriders, mermaids. The shudder of fear and laughing humor is interwoven into the legends and fairy tales which discuss them.

Perhaps we have gotten lost too much in the subjective. As important as it is, it is really important because it has found a pure, artistic expression. It is a quite personal expression, but forces recognition beyond the self, makes one happy. We must and want to leave it up to the future to place Emil Nolde into art thought as a whole. He belongs to those who showed the way, who found the level of the valley when Impressionism seemed to have reached a dead end.

136/1.

136/2.

136/3.

Schiefler Proofs

136/1. Vier Fische *(Four Fish)*
Woodcut, 1924
Schiefler-Mosel 170, proof
5.1 x 10.7 cm.

136/2. Zwei blühende Kakteen *(Two Blooming Cactus Plants)*
Woodcut, 1924
Schiefler-Mosel 169, proof
5.4 x 10.7 cm.

136/3. Zwei Pflanzen *(Two Plants)*
Woodcut, 1924
Schiefler-Mosel 178, proof
4.5 x 10.7 cm.

Three proofs printed on one page and signed in pencil, are illustrations for Schiefler's catalogue, volume two, pages 43, 97, 80.

Nolde personified nature, especially flowers and plants. To him, they seemed to set the stage of yearly cycles. These small end pieces were designed to be printed along with the type for Schiefler's catalogue of Nolde's graphic work. They relate also to some ceramic plates Nolde painted, bright-colored ceramic reliefs. Tropical leaves, carp and bass, exotic cactus plants show the artist's reflections from his travels and experience with nature. They are highly personal reactions from the sea, desert and tropics, all places which fascinated the artist. It is a spontaneous expression balanced for the page.

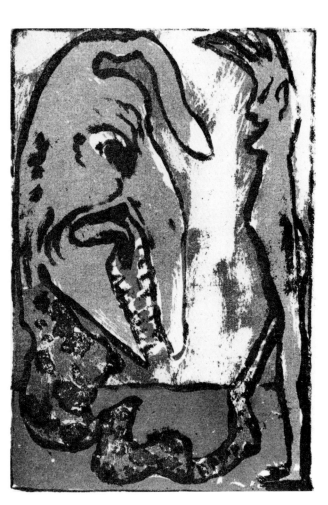

136/5.

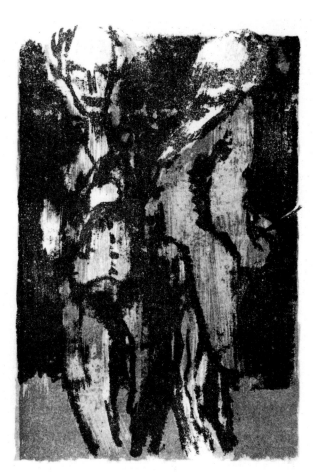

136/4.

136/4. Ältere Herren *(Old Men)*
Color lithograph, 1926
Schiefler-Mosel 71 ii, proof edition of 28 examples, used after page 68, printed by Westphalen
16.3 x 11.2 cm.

136/5. Fabelwesen *(Fabulous Beasts)*
Color lithograph, 1926
Schiefler-Mosel 77 ii, proof edition of 28 examples, used after page 76, printed by Westphalen
16.3 x 11.2 cm.

Both are proofs for volume two of Schiefler's catalogue, pages 69, 77.

These were not used next to type but inserted as illustrations. Thus a full depth of contrast could be used, not a flat surface. Age and youth again, a recurring theme. Both are grotesque. The older man seems pompous while the youth seems floating off the top of the picture in an over-weighted crown of baldness.

The other illustration represents a devil and a dragon growing together at the foot or one growing out of the other; transformation and discussion. Neither seems of classical clarity but grown out of misty and primeval memory. Anecdote and allegory are the main themes of this artist: A response to life, though strange and naive, that was combined with the invisible reality of legend and myth, continuing nineteenth century pseudo-volk history.

# OTTO MUELLER

Mueller had already worked in lithography as an apprenticed student, and his first catalogued work was done around 1895. An etching of 1903 is also mentioned.

**137. Knabe zwischen Blattpflanzen (Knabe im Schilf)** *(Seated Boy Between Leafy Plants (Boy in Reeds))*

Woodcut, 1912
Karsch 2 iiA, printed after 1946, with monogram
Unsigned edition of about 400 examples, printed by Eugen Meyerhofer
28 x 37.5 cm.

This is a later impression after the surface had been sandpapered to remove scratches and planar imperfections. Blattpflanzen, ornamental plants raised for their beautiful foliage, stand on each side of the boy. The technique is like that of bas-relief, with white areas cut away leaving a plain surface. It is a lyrical and decorative conception, with the typical slim male figure. Simplicity is the route to design. It is primitive in sophistication. By using the same line for figure and background, Mueller makes the figure live in the same world of nature as the two plants. Contour, as in a relief, is paramount . . The earlier state has larger features and seems more ghostly.

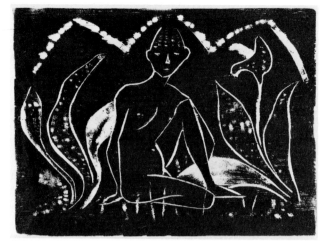

137.

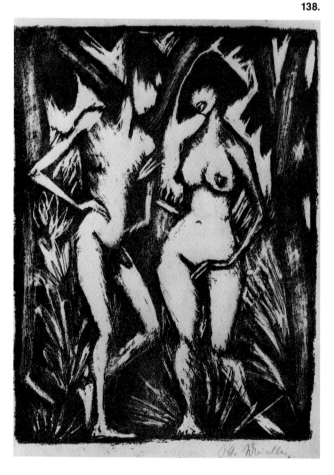

138.

**138. Adam und Eva** *(Adam and Eve)*

Lithograph, 1920-23
Karsch 122 ii, second state
Signed in pencil
Edition of 50 examples on ivory blotting paper
43.7 x 33.8 cm.

This is a lithograph from the series of nudes in this period. The relief technique continues, for the black frontal ground is scraped away with a sharp instrument, working from crayon into black and back into the whites to uncover the plain stone. It gives interesting edges from the diagonal scraping. The movement depends on the use of these tools for straight lines, for the shading and radiating away from centers.

The peculiar proportions of the figures are Mueller's own, with heavy-bodied women topped by thick necks and smallish heads. The men are feminine and tense at the same time. The relationship of man and woman is the theme throughout the working career of this artist. Here the pair is in a forest relating directly to nature, nude and unashamed, natural people, though the woman has a slight gesture of concealment with her hand. The two are like startled animals in a wild place.

The painting of this same subject of 1922 is flat and tempera-like in contours. The faunlike head of the man is carried into the painting, but the woman becomes stronger and more dominant. Emphasis is carried to the woman as it is for the man here. The trace of the erotic is always in Mueller's portrait and figure studies. He has been described as a program painter without a program. Rhythm is centralized and countermoves the eye to and fro. It is a private world, a world of gypsies and natural uncivilized people. Mueller had suffered a lung inflammation in 1917 and never fully recovered his health, so this is a vision of hope. These are not beautiful people in a perfect world but vital humans of impulse and simplicity.

**139. Polnische Familie or Judenfamilie, Polen** *(Polish Family or Jewish Family, Poland)*

Lithograph, 1920/21, colored in crayon by the artist
Karsch 114 iia, second state, a proof between states a/b
Editions: A—60 examples on etching paper, signed. B—25 examples on japan paper, hand-colored and signed. C—100 examples on Bütten paper (only monogrammed).
Signed in pencil, printed by the artist
26 x 18.8 cm.

A very rare state of this lithograph known in few examples, its subject is obviously a holy one, possibly the Holy Family of Mary, Joseph, and the Christ child, for the adolescent form of the woman wears a halo. Polish Jews are models. The costume is usual with the top hat (schtramel), and long black coat (kittel), of Polish sects. There is a charm to the young woman with her feet pointing together, an awkwardness contrasting with the nonchalant man. It is both serious and mockery, unspoiled people and ghetto background, beauty in motherhood and repellent place. It follows the trend towards subjective religious ideas of the Brücke artists after World War I.

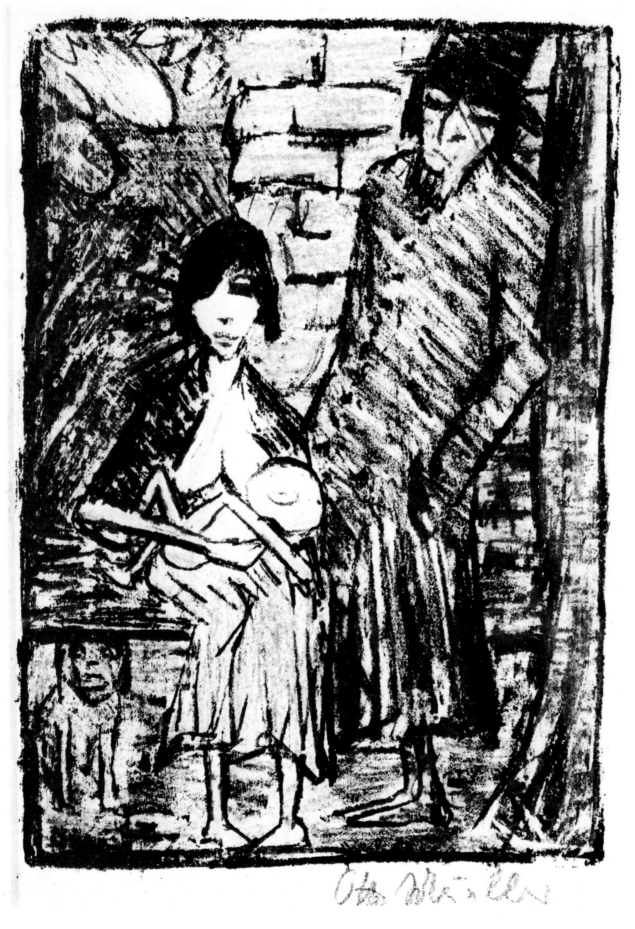

**140. Zigeunerfamilie am Planwagen** *(Gypsy Family by a Covered Wagon)*

Color lithograph, 1926/27
Karsch 167 iii, third or finished state with color plates
Edition of 60 examples on gray-brown machine made paper,
printed by Lange at the Breslau Academy
Signed in yellow pencil
69.7 x 50.3 cm.

Otto Mueller summed up his feelings about the wandering gypsies of Hungary and Poland in a series of nine color lithographs. Most have four or five color stones.

The gypsy family poses before its horse-drawn wagon. The people are not sympathized with, but are rather rude, unsocial, and perhaps mocking beings. The woman has typical slant eyes and pointed head. The child poses as for a photograph. The design is formed around a massed lower form and outlined against a yellow sky, countered by a red hat on the woman. Three colors are first printed, black and red and yellow, then overprinted with a thin brown. The effect gives an interweaving of color over and under the massed forms. It is an exotic group of a now disappeared culture. Life was hard and never settled. There is a mixture of laughter and melancholy, combined with monumental force. It seems the art of an overly sensitive man, a man limited in theme and intention, but certainly an experimenter in the mediums he skillfully developed. It is also obvious he could create what he intended, for his varied and inventive use of the printing mediums gave him a wide choice in any field of expression. Here he brushed in the massed forms, picked away with a sharp point to excite the eye in internal details, shaded away edges to make sharp breaks, experimented with the different steps in the use of color plates and printed an edition of 60 examples all alike, as he intended. It was done in Breslau, where Mueller taught.

In late 1929, Mueller made his last journey to visit his beloved gypsies in Budapest and Bulgaria, and immediately upon his return he became very ill. He had visited Bulgaria and Budapest almost every year since 1924. Mueller was a reader of literature all his life, though he did not write his philosophy of painting or life, except through letters to friends or to his three wives. There is a literary action to his graphics, stories in the form and positioning of subjects. He takes nineteenth century German art into the twentieth century through technique and style.

140.

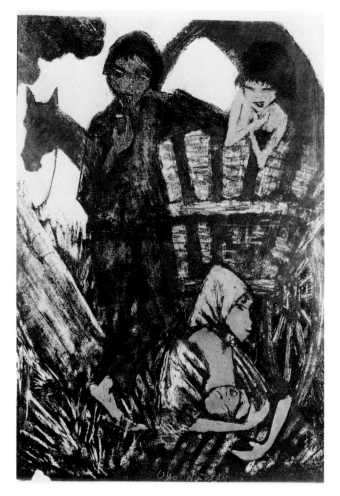

## MAX PECHSTEIN

The earliest etchings date from about 1908, the first litho from 1906, but three years earlier, Pechstein had tried his hand at woodcuts, a few heads, maidens, Indian scenes, nudes, portraits of his friends Heckel, Schmidt-Rottluff, and Kirchner.

The early etchings are impressionistic, linear scenes with atmosphere and light. His first woodcuts are typically stamplike and flat. Lithographic techniques are the most interesting, because of an early influence from Munch and Gauguin, and the artist used from these sources enclosed and rounded shapes with flowing, intercrossing patterns weaving through the horizontal plane. The woodcuts are crude, unfunctional to the medium, an attitude that evolves again after the war. There is some humor and skillful caricature.

One searches out the early work for a sense of development, but there is little divergence from the symbolistic stance. Kirchner's influence through the work done on Brücke catalogues, in which Pechstein reproduced some of Kirchner's paintings, marked a development in woodcutting techniques. After this time, Pechstein's graphic art approaches a new vision, becoming somewhat angular, more representative than most of the other Brücke painters, but strong and vital.

141. Postcard: Zirkus Pferd *(Circus Horse)*
Watercolor, 1910
13.9 x 8.8 cm.

Contents of Postcard:
"I thank you cordially for the cards. This writing between us I hope will not become a habit.
Greetings, M. Peckstein."

A 1910 postcard to Rosa Schapire in Hamburg from Pechstein in Wilmersdorf/Berlin.

The scene is probably one of the circus performances in the Hippodrome, and related to many paintings by this artist and Heckel. These were artistic sources for Picasso as well as Pechstein, Kirchner as well as Matisse. The quick notation in ink and water color is an accurate, playful and skillful notation for his friend. Pechstein's Rome prize gave him an early introduction to Etruscan art, and there may be some influence in this small drawing, with its strong, sensuous color, robust contours and widely spaced white areas.

**142. Frau auf dem Sofa** *(Woman on a Sofa)*

Aquatint, 1910
Not in Fechter (similar to Fechter 11 and 12, 1908)
Signed in pencil
On heavy wove paper. 19.9 x 19.9 cm.

An interesting technical solution is made here to a usual scene for a Brücke artist. Pechstein uses heavy lines with dark edging and clear center. The choice of light wax ground picked out with a quill pen allowed use of perchloride of iron, which etches straight down, not undercutting the edges as with nitric acid. A deep etch made broad and deep lines, but these had to be marked with a drypoint to hold ink, probably along each edge. The signature and hair are picked out dot by dot with a broad pen. The effect is rather heavy along the lines and pleasing in function. It is a real technical originality for this artist. The drawing becomes heavy and distorted, more like a woodcut, but strong in statement.

## KÜNSTLERGRUPPE "BRÜCKE"
## VII. JAHRESMAPPE, 1912

Cover by Otto Mueller (not shown)
3 plates by Pechstein

**143. Russisches Ballett I** *(Russian Ballet I)*

Etching and aquatint, 1912
Signed in pencil
Fechter 65; Bolliger-Kornfeld 26
On smooth vellum paper
Plate 1 of Jahresmappe VII, 1912
30 x 25 cm.

Quite a straight illustration, not overly creative, this work was typical of this decoratively trained painter. The scene of orgy and abandonment probably came from one of the Ballet Russe presentations in Berlin. Russian music, theater, literature and psychic philosophies were very appealing to the young German intellectuals. It is a painter's expression, not that of a print-maker. The picture is finished to each edge. Planes are set in the foreground. There is a static quality reminiscent of the stage. This violent scene does not draw in the observer, but remains set apart from empathy by ornamental abstraction.

143.

142.

141.

91

**144. Tanzende und Badende an Waldteich** *(Dancers and Bathers by a Forest Pond)*

Colored lithograph, hand colored
Bolliger-Kornfeld 27; not in Fechter
Signed, dated, numbered in pencil (#23)
Plate 2 of Jahresmappe VII, 1912
43 x 32.8 cm.

Here Pechstein draws a wooded spring, probably taken from drawings made in Moritzburg, but the influence is all French, Matisse in particular: The Le Luxe I of 1907 with flat figures dancing in an outdoor scene. The circular group is outlined by a circular pond. The composition is forced into compression and seems rather overcontrolled. It is decorative rather than forceful. The people have little real life, not creative community, but seem figures on a flat mural.

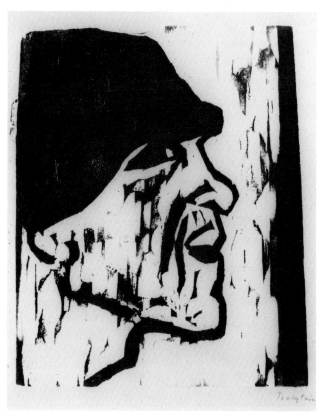

145.

144.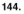

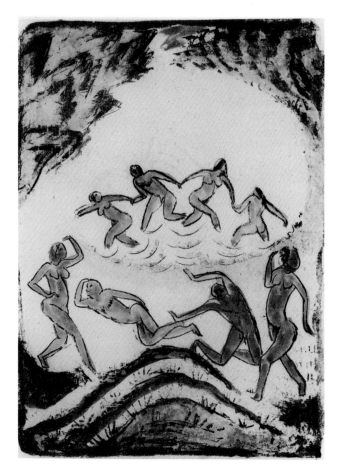

**145. Fischerkopf VII** *(Head of a Fisherman VII)*

Woodcut, 1911
Signed, dated and numbered in pencil (#7)
Fechter 79, Bolliger-Kornfeld 28, plate 3 from Jahresmappe VII, 1912
An earlier edition of 20 impressions on japan paper was made for the portfolio, Fischerkopf, (11 woodcuts, 1911)
30.4 x 24.1 cm.

This portrait ties together the trilogy of Pechstein's interests during this period: cultural influence from Russia, French modern art, and the simple fisherman of Nidden on the Baltic coast, who seems to express the struggle for life between his family and the sea. The profile is Nolde-like, functional for the medium of wood grain and chisel. It has none of the emotional power of the other Brücke artists, but this was not the Pechstein method.

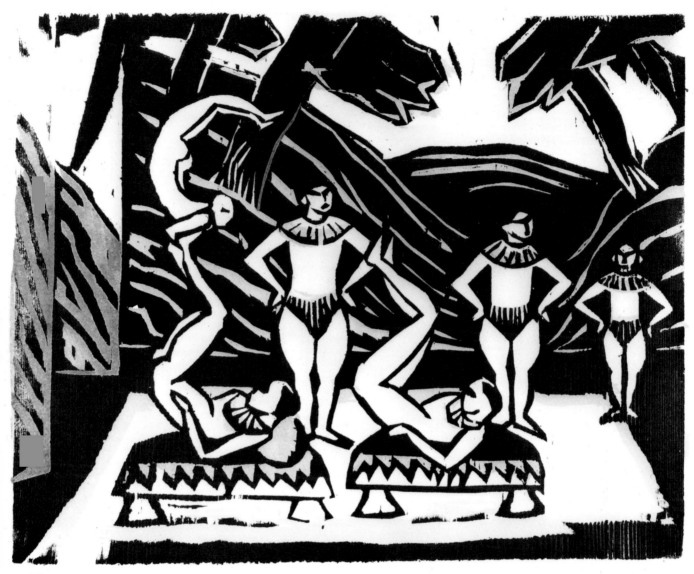

146.

146. **Akrobaten III** *(Acrobats III)*

**Colored woodcut (colored with stencils), 1912**
**Fechter 89**
**21.5 x 27 cm.**
**From** *Die Schaffenden.* **Ed. by Paul Westheim. Kiepenheuer**
**Verlag, Weimar. Jahrgang I, Mappe I, Nr. 6. From the edition of**
**25 examples on japan paper. Regular edition was 100 examples**
**on Bütten, signed in pencil**

The woodcut is handcolored through two stencils. It was made
for subscribers to a publication called *Die Schaffenden,* from
editor Paul Westheim, who made up portfolios of about 100 dif-
ferent artists a year in editions from 100 in later portfolios to 125
in the first year, 1918. He had more enthusiasm than feeling for

commercial possibilities. Pechstein took an earlier woodcut
and had it reissued for the set in 1919. The portfolios had little
value until the 1960s when the individual prints began to bring
fair prices. This woodcut is less tense than other Brücke prints,
with a frontal view and low horizon. Done after his honeymoon
in 1911, this print repeats an early interest in mosaic-like effects
relating to trips to Italy and Ravenna in particular. Flat forms
with added diagonal sweeps command the major areas, coun-
tered by stage flats left, which give depth. Perception was made
ornamental, less Expressionistic than Impressionistic. Nega-
tive space is used as in mosaic work. Color blocks by stencil
give emphasis to mass with red bringing out the plane of the
foreground and blue used to separate the action. The stark
white background allows the irregular upper forms to contrast
in strength.

**147. Eibedul**

Woodcut, handcolored, 1917
Signed and dated in pencil
Fechter 621
24.2 x 20.2 cm.

The woodcut is in square format which is consistent with the verticality theme, probably taken from a statue of the Sepic river, New Guinea. It doesn't seem to be from African sources. The tree is a variation of a yew, famous in British archery. Strong diagonal intersections move the eyes in an agitated, menacing and primitive motion as befits the glare of the bearded man. The stylization is simple, forceful. The subject was made as one of a series of religious subjects after the war.

Pechstein exhibits his relationship with craftsmanship showing that no boundary exists between art and craft. The woodcut is not French, and not especially decorative in mannerisms, but Germanic with its interplay of jutting and receding planes. The curious perspective points up to the sky. Pechstein, too, had suffered nervous troubles from the war. His memory had failed. His intellectuality is returning during this period. The decorative pales before the monumental in this time of rebirth for the artist.

**148. Bildnis Dr. Freundlich** *(Portrait of Dr. Freundlich)*

Woodcut, 1918
Signed in pencil
Fechter 142
On grey copperplate paper
36 x 23 cm.

The period after Pechstein's discharge from the army was a difficult one of adjustment. He had not painted since 1914. Masses of works about the prewar trip to Palau were studied and remembered. From 1917 until 1921 Pechstein worked on a great series of portraits in all mediums culminating in the portfolio of 1919, *Ten Heads,* in woodcut. It seems as though the artist had to look closely at the human face after inhuman experiences. He had already worked out some of the war experiences in etched series, the great battle of the Somme, of 1918. These had strong angular motifs. His South Sea episode also culminated in the Palau series of lithographs of 1918.

The woodcut of Dr. Freundlich was the second to a lithograph of the same subject, made the same year. The woodcut shows us a slightly tilted head squinting left, a pensive mood. There are strong lines of suffering. Lines are cut surely and boldly with emphasis on some deformation by elongation to intensify the high forehead. Some edges are softened by scratching as if by an impatient artist. The facial plane has a quickened vibration of form broken by counter lines. The rhythmic pattern speaks of unquiet turbulence and an inner, emotive sadness, with less violence than in some of the other Expressionists.

It is true that Pechstein has been widely criticized for his Frenchified background. It also is true that the paintings are less expressionistic, more traditional than other Brücke painters; but the graphic arts need less linear enclosure, less dependence on color areas, perhaps Pechstein's major lack.

The prints are less sentimental due to the innate character of the craft. Because of his schooling in decorative arts, Pechstein was drawn more to French decorative concepts, especially to Matisse. In painting the structural qualities are weaker than in French composition. But in graphic art he used the simplified mediums with great sensitivity.

147.

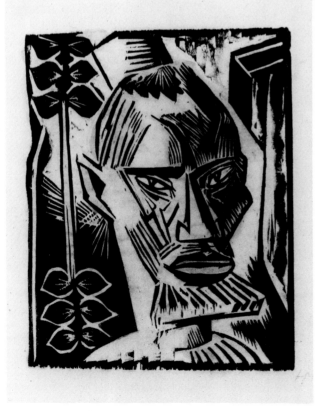

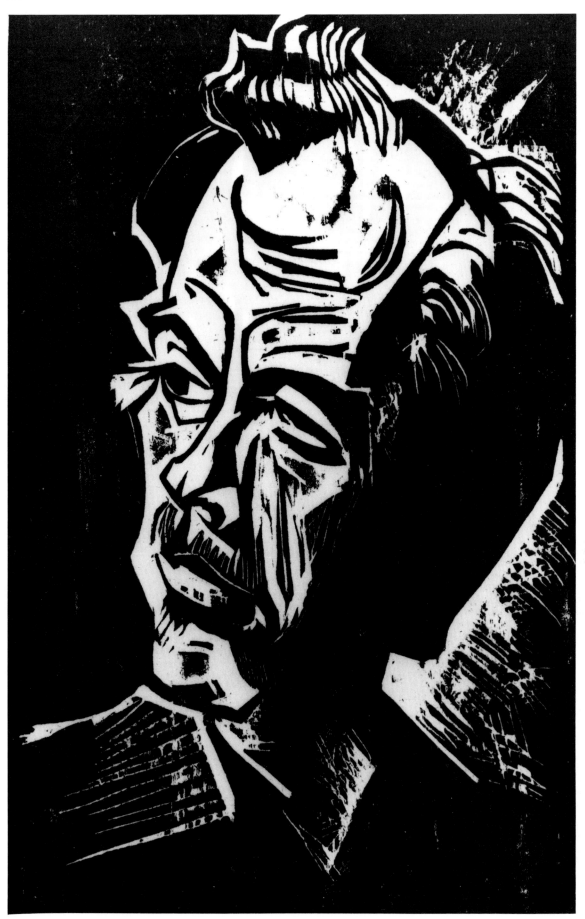

149.

149. Letter

Addressed to Rosa Schapire, Hamburg
Letter: 25.4 x 22.8 cm. (1918)

Contents of Letter:

My esteemed Rosa Schapire, please accept my best thanks for
your present news. I have asked Gurlitt (the art dealer) to look
for replacements for these two drawing sheets. Now I must tell
you that of the sheet *Mother and Child*, probably no impres-
sions are available any more. At the time I made only five impres-
sions, as in general I make few impressions of my graphics, at
the most ten impressions (lithographs): then I grind off the
stone. With woodcuts it is something else, also with etchings. I
regret very much that I could not send you some newer
graphics, but hope in the future that I can provide more of a
supply. To be honest I did not count on selling anything, and
now you see me pleasantly surprised. Once more my thanks
and best greetings. Your devoted, Pechstein. P.S. Since it gives
you pleasure I sent you a sketch for a painting on the reverse.
Is it alright?

Max Pechstein was one of the most popular of all Expression-
ist painters, yet in his letter to Dr. Rosa Schapire he writes about
his surprise that anyone would buy his prints. He also de-
scribed his lack of editions for lithographs, ten impressions at
most before the stone is erased, and tells of better success with
woodcuts and etchings.

The drawing on the back of the letter was a study for a painting,
which used only the mother and child: Mutter und Kind, 1918.

Dr. Schapire was a close friend to all the Brücke painters, espe-
cially Schmidt-Rottluff; and she promoted and sold all their
work. Fritz Gurlitt in Berlin also promoted the new civilian after
his discharge from the army in 1917, because of a nervous con-
dition which made him unable to paint. By 1918, he had begun to
review the mass of sketches made in Palau, and these began a
new phase of rather stiff angularity. The watercolor in the letter
retains the freedom of the original, unstudied drawings in the
South Seas, but the painting from it is less genuine. In any case
the letter is a valuable document of this self-conscious painter,
half bold and half decorative.

150. Reisebilder Italien Sudsee. 50 Federzeichnungen auf
Stein von Max Pechstein *(Travel Book to Italy and the South
Seas with 50 Drawings on Stone by Max Pechstein)*

XV. Werk der Pan-Presse, verlegt bei Paul Cassirer, Berlin, 1919
28 x 36.7 cm., not in Fechter, 112 pp unnumbered
Hand lithographed introduction by the artist
810 numbered examples: A—I-X Museum Ausgabe.B—1-50-on
japan paper, handcolored, bound in green leather. C—51-800 on
Bütten paper, bound in linen, signed only on justification page.
Introduction by the artist, all typography is a hand-lettered
script by the artist. 2 sections: Italien und Südsee.

The travel book of sketches was made from sketchbooks done
during various journeys to Italy and the South Seas.

In Italy, Pechstein lived in a little fishing village between Genoa
and Spexia, called Monterosso al Mare. Pechstein and his wife
left Germany April, 1914, for Palau near New Guinea, a German
colony since 1899. By October, the war had disrupted their stay
on the islands.

They had journeyed to Italy in 1911 and 1913. Pechstein went
back to Italy many times in the later period. The Italian drawings
are based on models from Cezanne and van Gogh, with easy
flow of line, an almost primitive statement of essentials. There
is little conjunction between the freshness of the drawing and
inner expression. There is little excitement from the scenes.
There is more vigorous life in the drawings of fishermen, which
exhibit a playfulness to the action.

Italy to Pechstein meant fishermen, and activities from net
mending to rowing in a rough sea are shown. Later scenes show
the simple men at play, rolling balls and playing cards.

The separate section about Palau is introduced by a scene of
the harbor. Palau was administrated by a small group of German
dignitaries who lived separated from the natives. The German
dream of colonization had failed and most German expatriates
lived in the United States, not in the African or Pacific colonies.

Pechstein and his wife lived with the natives on a small island
away from the capital. In the Marquesas, Gauguin had found re-
juvenation among the true natives. On Palau, the Germans ran
the chain of islands like a military reservation, with strict rules
for everyone; and the native was kept in his place. Pechstein
had expected to find similarities to his own vital German energy
and sensuality among the natives. He found instead vegetation
that was overwhelming, brilliant sunlight and intense color-
ing. He was most impressed by the complete integration of the
natives in a self-sufficient life in perfect sympathy with the
oceanic nature.

The sketches are based on a Palau diary which the artist kept.
He contrasts the heavy seas of Italy with the placid calm of
Pacific Island shores. Exaggerated gestures of Italian fisher-
men in violent struggle with nature contrast in the South Pacific
without the nervousness of European civilization. The natives
sit, lie down, gather in groups unclothed, and appear in an easy
rhythm of line. The foliage and landscape fall into easy decora-
tive patterns. Repetition is used as it is in natile paintings. All
is happiness and smiles. Nudity is natural and free. Dignity is
also natural.

150.

150.

### 151. Holzschnitte 1919 *(Woodcuts 1919)*

Woodcut, 1920
Fechter (Nachtrag) 160
Verso: signature of the publisher, example #v/xx, special edition
Title page for the Fritz Gurlitt portfolio which had an edition of 95 examples: A: I-IV with 11 woodcuts. B: V-XX with 9 woodcuts. C: 1-75 with 8 woodcuts

The woodcut cover comes from a portfolio published by Fritz Gurlitt. There are eleven varied heads, rather arbitrary subjects gathered by the publisher to promote Pechstein's work. Some of these subjects include an orator, a princess, children's heads, a cellist, a sick girl, etc. All the portraits have the full blown angularity of mature German Expressionism, not of Frenchified decoration. All glow with the power of inner expression described as the central spirit of Expressionism. There is an inner violence, perhaps, in the placement of darks against major white areas, but none are overdone or overdesigned.

The statue seems based on some magic statuette from the Cameroon area, probably Mambila. This is shown in "attack impulse" by the round plastic form of the eye in strong outline, the savage row of teeth combine in a major statement of vitality. It is consistent in design. The lettering is interwoven, dark on light and light on dark.

151.

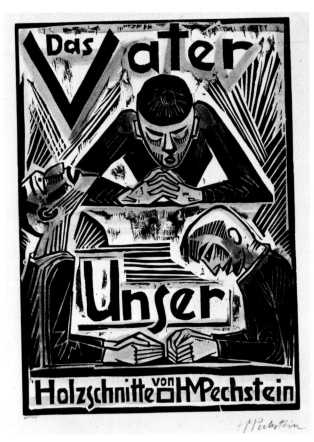

152/1.

152/5.

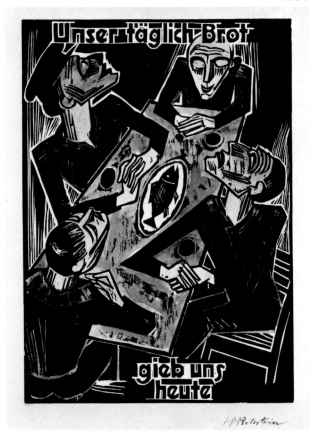

**152. Das Vaterunser** *(The Lord's Prayer)*

12 woodcuts, 1921
Portfolio 62 x 143 cm., sheets 59.5 x 41 cm., not in Fechter.
Signed by artist and printer, Fritz Voigt, in pencil
Editions: 50 handcolored. 200 black and white only
Printed by Manus Offizin (F. Voigt) for Propyläen Verlag, Berlin
Portfolio bound by H. Söchting (R. Ulber) after a rough sketch by the artist
Reference and translation from: The New Scofield Reference Bible, Oxford University Press, New York, 1969 revised from 1909 edition

**152/1. Title Sheet**
Das Vaterunser, Holzschnitte von H. M. Pechstein
Ochre, blue, red 39.7 x 29.6 cm.

**152/2.** Vaterunser/Der Du bist/im Himmel *(Our Father, which art in Heaven)*
blue, ochre, yellow, red 39.8 x 29.8 cm.

**152/3.** Geheiliget werde/Dein Name *(Hallowed be Thy Name)*
yellow, blue, green 39.9 x 29.7 cm.

**152/4.** Dein Reich komme/Dein Wille geschehe/Wie im Himmel also auch auf Erden *(Thine Kingdom come, Thine will be done, on earth as it is in Heaven)*
blue, red, yellow, ochre 39.9 x 29.6 cm.

**152/5.** Unser täglich Brot/gieb uns heute *(Give us this day our daily bread)*
red, blue, ochre 40 x 29.6 cm.

**152/6.** und vergieb/uns/unsere Schuld *(and forgive us our debt)*
blue, green, yellow, ochre 39.8 x 29.8 cm.

**152/7.** Wie wir vergeben/unsern/schuldigern *(as we forgive our debtors)*
blue, ochre, aqua 39.8 x 29.5 cm.

**152/8.** und/führe/uns nicht/in Versuchung *(and lead us not into temptation)*
pink, orange, yellow, blue, ochre 39.9 x 29.5 cm.

**152/9.** Sondern erlöse uns von dem Übel *(But deliver us from evil)*
blue, yellow, ochre, aqua 39.7 x 29.8 cm.

**152/10.** Denn Dein/ist das Reich *(for Thine is the Kingdom)*
ochre, blue, aqua, red 39.8 x 29.6 cm.

**152/11.** Und die Kraft/und/Die Herrlichkeit *(and the power, and the glory)*
blue, yellow, ochre, aqua 40 x 29.8 cm.

**152/12.** von Ewigkeit/zu Ewigkeit/Amen *(for ever and ever, Amen)*
red, yellow, blue 39.9 x 29.6 cm.

Matthew 6:9-13 and Luke 11:1-4 describe the instruction in praying. The Lord's Prayer is Christ's personal instruction about prayer (Luke); and in praying (Matthew). Pechstein uses Matthew in full with Martin Luther's translation.

We must look to the set of Revelations by Dürer, Die Apocalypse, 1498, for some of the tradition behind this interpretation of the Lord's Prayer as an apocalyptic vision by Pechstein. The end of the world did seem at hand or a beginning of a new world after suffering and warfare.

Critics have called this portfolio ornamental and secondary, but if we consider this group of woodcuts within the intentions of the artist, it has validity and originality whatever its place in traditional modern art history as new form. Both Dürer and Pechstein had brought Italian influences back from trips to the southlands. Dürer brought optical functioning of lines into a new form, away from Gothic stiffness. Pechstein returns to early concepts of stiffness and open spaces, loses some of his curvatures and bold, special inward spirals. The

pictures are self-contained with lettering worked into the design, as in the majority of the thirteenth and fourteenth century manuscripts. Like Dürer, Pechstein achieved concentration and dramatization by condensing the message into paragraphs for each illustration. The blockbook Apocalypse relates also with its hand printed episodes in strict Gothic angularity. One seems to find the raw material for the major inspiration from Dürer's series of fourteen woodcuts.

OUR FATHER WHO ART IN HEAVEN, pl. 2, Rev. 14. "His head and his hair were white like wool...and his eyes were like a flame of fire." With much from the Old Testament, we have rather a strong and self-wise God with the third eye omnivision. The flaming wheel of Ezekiel. The combined totem God of stone and living word. An explosion of blasts in small cold forms. God somewhat as a mechanical man with an elbow of inserted circle. Heaven depicted.

HALLOWED BE THY NAME, pl. 3. Anxious angels or fallen sinners in purgatory wildly gesture to an external light coming through the center of the design. Shift of locale back to below heaven. Sense of sin and expectation of divine judgment apparent in the gestures for forgiveness. Suffering and torment in angularity and expression.

THY KINGDOM COME, THY WILL BE DONE ON EARTH AS IT IS IN HEAVEN, pl. 4. Simple fishermen or workers give thanks. Back to earth. New day, new earth, Lam 3:23. Rev. 1:7, "Behold He cometh with clouds and every eye shall see Him." An earth scene of bursting sunlight and new day, symbol of the new society.

GIVE US THIS DAY OUR DAILY BREAD, pl. 5. Earth scene with four men giving blessing. Perhaps with a potato each and a fish on the central platter. Famine in Germany this time and simple thanksgiving for any good stuffs available.

AND FORGIVE US OUR DEBTS, pl. 6. God, a fleece-covered beard, with light lines of super-vision coming from His eyes, blesses the sinners. Obvious confession by the sinners is taking place, based on forgiveness from the grace of God.

AS WE FORGIVE OUR DEBTORS, pl. 7. Simple and touching strength of concept showing forgiveness. This was a major theme in both books of the Bible, from Genesis to Rev. 12.

AND LEAD US NOT INTO TEMPTATION, pl. 8. Adam and Eve, or, perhaps, man and woman fighting in front of a savage sculpture and overseen by a serpent and fox, both symbols of sin. The design is mainly jagged with a curve from the serpent's body to weaving blacks through the composition. The shading is linear, and placed as much for curve as for form and as another purpose of eye directing.

BUT DELIVER US FROM EVIL, pl. 9. Sick or dead persons on a couch. Two mourners establish gestures, built out of darkness. The half sun lightens the sick or dead bodies. Proportions are elongated. Inner tensions are simple and the entire effect depends on the division of dark and light achieved by a band in the center.

FOR THINE IS THE KINGDOM, pl. 10. Rather grotesque and over sentimentalized family group praying. Background of fish and birds and beasts fits Christian mythology. Again, use of a central white area penetrated by black figures and woven into the rest by top and bottom borders.

AND THE POWER AND THE GLORY, pl. 11. Various symbols of Free Masonry (triangle and eye), Trinity (three faces), five hands and a fox as symbol of sin. The animation is busy, complicated and overdone. (Foxes are from Lam 5:18.)

FROM FOREVER TO FOREVER, AMEN, pl. 12. The hands beat drums, symbol from medieval passion plays. Musical emphasis of drumbeat on words. One can imagine rhythmic pounding. Silhouetted hands against the sound waves are directed in opposite directions.

The set of woodcuts has great variety in designed images. Most are diagonal compositions pointing towards the top, heaven. There is some humor as in Plate 2, with God as a mechanical monster. Pechstein seems to dislike dogmatism. He ranges freely, using some caricature, which was derided by critics.

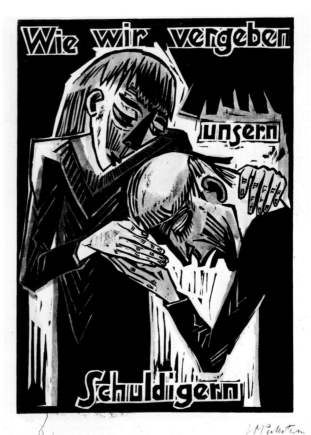

152/7.

152/10.

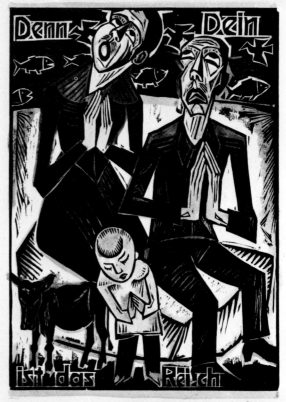

99

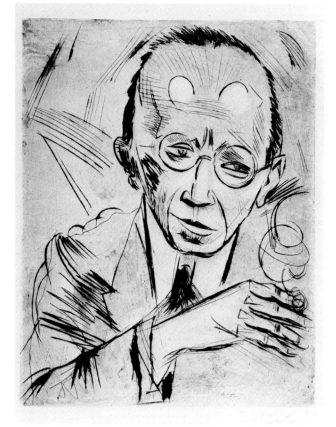

**153. Bildnis Paul Fechter** *(Portrait of Paul Fechter)*

Drypoint, 1921/22
Signed in pencil
Not in Fechter
On van Gelder paper
From the edition of 150 examples as published in Kreis graphischer Sammler und Künstler, Leipzig
39.7 x 31.7 cm.

The quickly drawn drypoint is a portrait of Pechstein's friend and the cataloguer of his prints. Technique is used in slashing straight lines built around small circles and curves. Emphasis is built up by deep gouges with the diamond point to make a rich burr in necessary areas of emphasis. The curious forehead shines with two half moons of outlined white, humorous representations of a devil's horns, cleverness. Distortion pulls the face towards the left in a meeting of lines, encountered by the smoke from a finger-held cigar.

154.

**154. Fischerkopf** *(Head of a Fisherman)*

Woodcut, 1922
Signed in pencil
Not in Fechter
Edition of 20
On cream wove paper
40 x 29.7 cm.

As one of the leaders of the attempted alliance between art and socialist society, Pechstein took an active part in the forceful idealism of 1918-1919. He soon saw the violent overthrow of the socialist leftwing groups by the middle socialists in power, became more realistic in work and concept; and even accepted membership in the official Prussian Academy of Arts in 1922. Rebellion was lost: acceptance was desired. Pechstein lost his spontaneity, which never again is apparent in his work.

This woodcut suggests his inner depression and stoic acceptance of fate. The cut is well composed and designed with some force, but it is more decorative than powerful. "Tired, conquered, small the earthworm falls into bed." He never again shows the harmony with nature, which values peace and stillness as a strong experience.

155. Das weisse Weib und drei Eingeborene *(The White Woman and Three Savages)*

Drypoint, 1922
Signed in pencil
Not in Fechter
Plate from: Yali und sein weisses Weib, Verlag Fritz Gurlitt, *(Yali and his White Woman)*
Berlin, 1923
Text by Willi Seidel
220 examples
Die neuen Bilderbücher, Fünfte Reihe, #4
23.8 x 18 cm.

This adventure story of a young blond woman stranded on an island in the South Seas was first published in 1914 by the author Willi Seidel (1887-1934) for the Insel Press in Leipzig, (Inselbücherei 133). Pechstein took up the story in 1922/1923 as it fitted in his memories of the visit to Palau.

In his Palau diary Pechstein writes: "A new day. Silent like one has seldom seen. Did I dream? No. Dream and pure was the night. The awakening and the beginning of day was full of harmony. Human beings are bare and unified with the air, trees and world." Fritz Gurlitt Almanach 1919.

The white woman married Yali, a savage chieftain. There is a touch of Hermann Melville with Rousseauean romanticism in this escape for the war weary artist. The illustrations have some vitality as a kind of transfusion. Yali's wife takes the lead in this dance and is not a submissive European dame.

Pechstein worked for Fritz Gurlitt on a number of fine illustrated books in the 1920s. Always Pechstein's strength lay in his quick perception which he was able to express with easy flexibility. He had a less serious nature. He adapted to anything that seemed new.

## DER BLAUE REITER: INTRODUCTION

The Blue Rider group had no unified philosophy of art, except a unity for the modern. They consisted of Germans, Russians, one American born in St. Louis, Dutch and French associates, a musician from Vienna named Arnold Schoenberg. The group embraced other kinds of art such as Gothic, Romanesque, primitive, children's, folk and Egyptian sculpture. Most of these illustrated Wilhelm Worringer's theories of abstraction against an empathy of realism. Worringer's sister, Emmy, promoted the group.

What is a Blue Rider? It is a like-minded group working with inspiration in the developing concepts of the modern. It was direction. It contained a tinge of the mystical, more so than other expressionist movements. It tended towards the more abstract as a universal source for elementary symbolism. Some members believed in a nature-pantheism. Most of them were less politically minded than other Expressionist groups. Each artist was a strong element on his or her own, rather than one atom making up part of an atomic universe. Women were included, as they were not in the usual German organizations.

Unlike the Brücke, this group split from other earlier organizations which had become reactionary in their eyes, in the diversions of German art politics. Kandinsky and Marc were the guiding geniuses, though sympathetic and non-dictatorial ones. Much of this tolerant direction took place both in infrequent meetings and by extensive correspondence. Some members never actually lived in Munich during the first years of exhibitions.

The Blue Rider was the most international-minded of all German art unities, and was also the most intellectual. The thinking of Kandinsky was venerated by young painters, who called him a prophet of a modern renaissance.

The idea of the Blue Rider came out of the publication of their almanac in 1912. Kandinsky and Marc called themselves editors, not presidents or leaders. The exhibitions were loose associations, with some changing names. The men were great friends, not acquainted by some art ceremony of unity.

Kandinsky and Marc were studying "fully spiritualized and de-materialized inwardness of feeling." Both believed in the birth of a new spiritual epoch after nineteenth century materialism. Kandinsky speaks of a future spiritual religion based on the symbols of art. Marc found a poetic phrase, "the mystical inner construction," which became a touchstone for all the group.

Just as creative German artists were outside reactionary society, a Russian such as Kandinsky was involved early against bureaucratic abuses. All the Blue Rider artists moved easily in intellectual and emotional directions that were not purely materialistic. From Nietzsche came the major concern for the individual alone. Self realization was the fundamental effort. All the Blue Riders were very concerned with the reactions of the art viewer; growth was directed to this person as the most important drive, whether the art viewer disagreed or not. This also meant an abandoning of old values. They felt that the most spiritual men were the strongest; and in this case "spiritual" meant more than religious doctrine. Their great joy was in self conquest, searching into universal depths for something similar and undistorted. The radical search for truth itself, as an undogmatic and unprejudicial adventure, was the goal of their free and inquiring art.

There was no similarity of background as with the Brücke artists, who were trained in crafts schools. The Blue Riders had the entire, ideal world of European cultural history behind them. All also maintained a belief in rejection of ordinary reality as empirical knowledge. Theirs became a search for a synthesis of culture.

The factual histories of these artists have already been written by Selz, Bernard Myers and Lothar Günther Buchheim. Individual monographs listed in the bibliography will show stylistic trends; and this has been somewhat extended in the individual descriptions which follow. But their relationship with illustration has not been outlined before.

From the first, the Blue Riders thought in terms of their own development. This is not to say they were less interested in literature or drama than the other art groups, but most of their concentration is on the illustration of their own ideas, not those of a writer outside the movement.

The major development came with the publication of the Blaue Reiter Almanach in 1912. Kandinsky had already illustrated his own Xylographies and Poems Without Words, but these were in the earliest tradition of Russian Jugendstil. The almanac was the first programmatic publication. None of the illustrations were made for specific sections of prose or poetry. Kandinsky always tended to include prints or reproductions he considered sympathetic rather than exact illustrations of specific ideas. In his later books, too, he followed this plan.

German, Czech, French and Russian periodicals used many of the prints from the Blue Riders. Six of Kandinsky's early woodcuts appeared in early editions of Der Sturm, the 1912-1913 issues. Reproductions of his works were used in many other periodicals, though the major ones were in Dada publications, the Dada 2 and Cabaret Voltaire pamphlets.

Franz Marc sent many woodcuts to Walden in Berlin, and they were printed in Der Sturm. Fifteen original woodcuts by Marc appeared in this periodical between 1912 and 1916. Others appeared in Genius I, Das hohe Ufer 2 and other publications, but after Marc's death in the war. Many posthumous impressions were printed as his wife, Maria, promoted his memory; and his friends kept his reputation alive whenever possible.

August Macke sent two linoleum cuts to Walden during the 1912-1913 period of the Blue Rider exhibition at Der Sturm Gallery. Gabriele Münter had five woodcuts printed in this Berlin periodical. Eighteen woodcuts by Campendonk were used in Der Sturm, as this artist became close to Walden and retained his friendship after others had left.

We have described the theories of the Blue Rider group as antimaterialistic, but they also depended on rational explanation. The ideas were based on the idea of a central source in all mankind which could be tapped. Marc was extremely intelligent, very literate and expressive within his basic pantheism. Because Kandinsky wrote in German, which was not his mother tongue, his ideas were less intelligible: word theory was combined with art theory in long philosophizing. He was attempting to define the indefinable in new combinations of foreign words, using a language notorious for its inexactness. Yet Kandinsky's combinations of words and pictures gave a synthesis far more original and beautiful than his contemporaries could produce. His book of woodcuts, Klänge, is one of the classic monuments of modern illustration.

## LIST OF BLAUE REITER ARTISTS AND ASSOCIATES

Albert Bloch 1882-1961
David Burljuk 1882-1967
Wladimir Burljuk 1886-1917
Heinrich Campendonk 1889-1957
Robert Delaunay 1885-1941
Elizabeth Epstein (dates unknown)
Eugen von Kahler 1882-1911
Wassily Kandinsky 1866-1944
August Macke 1887-1914
Franz Marc 1880-1914
Gabriele Münter 1877-1962
Jean Bloe Niestle 1884-1942
Arnold Schoenberg 1874-1951
Close Associate: Paul Klee 1879-1940

NEUE KÜNSTLERVEREINIGUNG MÜNCHEN
Paul Baum 1859-1932
Wladimir von Bechtejeff 1878-1971
Erma Barrera-Bossi 1909-
Adolf Erbslöh 1881-1947
Pierre Girieud 1874-1940
Karl Hofer 1878-1955
Alexej von Jawlensky 1864-1941
Wassily Kandinsky 1866-1944
Alexander Kanoldt 1881-1939
Moyssey Kogan 1879-1942
Alfred Kubin 1877-1959
Gabriele Münter 1877-1962
Marianne von Werefkin 1870-1938

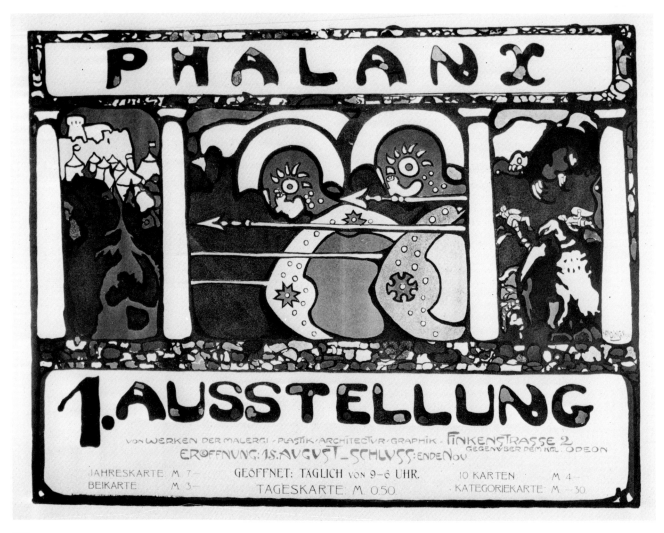

156.

## WASSILY KANDINSKY

**156. Plakat für die erste Ausstellung der "Phalanx"** *(Poster for the 1st Exhibition of the "Phalanx")*

Color lithograph after a design by Kandinsky, 1901
4 stones printed on an offset press, light green, green, blue and black, on satin-surface paper, edition unknown
Unsigned
Chipp p. 9. Dumont V-2; Roethel Anhang V-2, p. 414
Printer: Kastner und Lossen, Munich
52 x 67 cm.

Kandinsky formed the Phalanx artists' club in 1901 with a friend, Waldemar Hecker. They first issued an announcement on September 19, Kunst für Alle, listing the new name and inviting young artists to participate. The first exhibition was held in a small room where a woman sold admission tickets and the attendant named Baron was a stately negro, described as dark-colored. The opening on August 17, 1901 was reviewed by a relatively friendly press in easygoing Munich. Of all the exhibitors, only Kandinsky became well known.

The poster is based on Jugendstil themes, especially the floral style of Munich. There is some folk art background too from Kandinsky's interest in Russian folk art. Two Roman lancers are centered in a pillared division marking three spaces. On the left is a scene of forest and high town, of tents dominated by a medieval castle. The right scene has an abstracted battlefield, with fallen knights in armor.

Kandinsky always thought of white as a separate color. He uses white in a creative way, first dominating and then submissive in force. The lettering is broken intentionally by color carried from the central areas, which tie the design together.

There were eleven Phalanx exhibitions in all, extending into 1904. Kandinsky also planned a school to be associated with the group: the prospectus lists Hohenzollernstrasse 6 as the location. The school closed after one year, but Kandinsky kept some of the pupils as private students. One of these, from 1902 onwards, was Gabriele Münter.

This is a remarkably well preserved example of the poster. The blues are bright and new looking. One can see the variations in the basic color, from deep cobalt to a warmer tone. Kandinsky was not entirely a beginner as a designer of posters, for he had already done a commercial poster for the firm of Abrikosov, a chocolate factory, in Moscow.

158.

## 158. Xylographies *(Pictures in Wood)*

6 heliogravures
In portfolio with text (with 2 illustrations)
Roethel Book 5, 54, 55, 59, 60, 65, 66, 70, 71
Edition des Tendances Nouvelles, Organe Officiel de L'Union Internationale des Beaux Arts et des Lettres, Paris
Edition of 1909 with introduction by Gerome-Maësse (Four of the woodcuts appeared in the periodical Tendances Nouvelles, 1906-1907)
Edition of 1000 copies
32.5 x 32.5 cm.

These woodcuts made in 1907, were printed from the original blocks as well as from heliogravure reproductions. Some appeared in periodicals such as Der Sturm and Tendances Nouvelles. Another appeared in the prospectus for the portfolio: it was machine printed from the blocks.

Kandinsky paid for all production costs, and realized most of the small profits. His friend Gerome-Maësse eulogized the artist with an explanation of Kandinsky's inner emotions, "...into his innermost being he draws from the visual elements of his subjects, as though from a dream. He animates them with rhythms, he possesses the secret of complex associations in shapes, in signs, and in the luminous spots which animate the surface of Erebus; primitive representations that serve the subtle."—From the "Introduction."

The published set was reproduced by heliogravure, a relief process using photographic transfer of the image to prepared, type-high, zinc-covered wood blocks. The reproductions are the same size as the originals.

Xylographies as a title tells the medium and lack of derivation. Plate 1 is Flute, a fairyland picture taken from old Russian motifs in folk art. "Church," "Clouds," "Woman in a Wood," "Birds," "Landscape with Figures" and a Phoenix, and the last plate called Hill, Tree, Clouds and Figure, make up the remaining titles.

The techniques are simple and magical. Careful brush drawings are cut in brushlike forms with the knife exactly transferring the original human touch. Outline is used or not in the intermixing of space and figures. Negative and positive shapes mix on black backgrounds. Blocks are sometimes divided exactly into half black and half white.

Though all these prints seem simple and primitive, they are very sophisticated in design and cleverly worked into tone. Each print is built from a different basic shape. Each print is made to vibrate at a different rate of sensation; and all are united by a Russian fairy tale mood of peace and romance.

## 157. Gebirgssee *(Mountain Lake)*
Woodcut, 1903, proof impression
Roethel 15, first state,
Unsigned, with Russian title
Plate 4 in "Gedichte ohne Worte", Moscow, 1903
("Stikhl
bez slov")
8.6 x 14.6 cm.

Kandinsky was in Moscow on the 18th and 19th of October 1903. He was attempting to have a book of woodcuts published by the Stroganoff publishing house. It was published later, after the painter had returned to Munich. Four of the plates appeared in the French periodical, Tendances Novelles, in 1906-1907. There were fourteen woodcuts in the first edition. Later editions had no Russian title.

This is a proof of the first edition probably printed by the artist.

This is a full Jugendstil design, with black masses as large forms without interruption. The tension between near and far planes is moody and emotional. The white forms are clear cut, highly stylized and vertically opposed to the darks. The white border within a black border increases the brilliance. It is said that Kandinsky used a black mirror to explore the major contrasts. The pattern is realistic, yet masterful in its simplified use of edges against the tonality. The early prints already show rhythmic impressions and a quiet symbolism.

157.

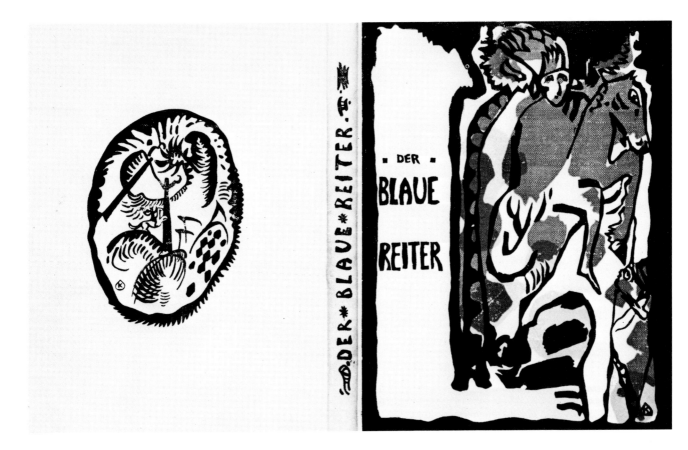

160.

### 159. Der Spiegel *(The Mirror)*

Color linocut, 1907
Roethel 49
Signed in pencil, on smooth japan paper
Inscribed: "Spiegel (Holzschnitt)" in pencil lower left,
Ex-collection: (as mentioned in Roethel) Mrs. R. S. Benjamin
32.1 x 15.9 cm.

Truly fine impressions of Kandinsky's color linocuts are very rare. This superb impression shows all the artist's intention, as the color is fresh and unfaded. Though the print has "woodcut" marked on it, the records of the artist mention it as a linoleum-cut. An alternate title, *Poem in the House* is also listed.

Throughout this year of 1907 Kandinsky had been experimenting with color prints. Some have little black, and massed color areas. Der Spiegel marks a culmination of all the earlier styles. Apparent space seems to flow back and forth, uninterrupted by divisions.

Kandinsky had worked in tempera, using both Russian and European themes, experiments with high and low horizons. He had visited Paris, where, incidentally, he had been close to a nervous breakdown, seen the prints of Matisse and Gauguin.

This color linocut is illustrative in theme and Pre-Raphaelite in stylization; but Kandinsky's original contribution is the sense of movement and the rich placement of color areas which take the place of white. White is used rather sparingly and tied to borders, with flower forms in the center ground. A scintillation of spots and enlargement of clouds is all reflected in the mirror.

The woodcut series of 1907 had a number of medieval subjects painted after scenes either in opera or from the common pageants in Southern Germany. The actual cutting was probably done at Sevres, France. This subject resembles a character in an opera by Glinka or Rimsky-Korsakov.

### 160. Der Blaue Reiter *(The Blue Rider)*

Herausgeber: Kandinsky and Franz Marc
Erste Auflage: (First Edition) München: R. Piper & Co. Verlag, May 1912
142 illustrations (4 handcolored), 8 vignettes, 3 musical pieces, color cover design by Kandinsky, 4 initial letters and one vignette designed by Marc, 3 initial letters designed by Hans Arp, 2 color reproductions hors texte.
Editions: 1260 examples. A: Museum Ausgabe: 10 copies with original watercolor or drawing by Kandinsky or Marc. Includes: Kandinsky, Bogenschutze, color woodcut, 1908-09, R. 79 ii, 16.4 x 15.2 cm.; Marc, Fabeltiere, color woodcut, 1912, L. 8263, 14.3 x 21.4 cm. B: Luxus edition: 50 copies without drawings but including the two original color woodcuts. C: Regular edition: 1200 examples bound in linen and paper.
142 pp, Roethel 141      Roethel book section #10
29.5 x 23 cm.

Zweite Auflage *(Second Edition)*: Summer 1914
Half sheet added for two new prefaces by Marc and Kandinsky.
Dedication to Tschudi moved to right-hand side.
New plate for Rousseau self-portrait, and Marc replaced color plate of horses with a new subject (also horses).
Edition: 1100 examples
(12 pp) 140 pp.

The background to the important almanac is outlined in scholarly fashion by Klaus Lankheit (Der Blaue Reiter Almanach, Viking Press, N.Y., 1974. Documents of Modern Art series). We can repeat some of the basic facts and expand some of the background material.

The Blaue Reiter organization, which lasted a bare two years, grew out of the NKVM (Neue Künstlerverein) which tried to unite individual trends in the modern groups that critics had divided into categories. The breakup of the NKVM in December, 1911, led to the first exhibition of the new Blaue Reiter in the same gallery, Thannhauser. The almanac was planned earlier, announced with the exhibition, and they were intended to go together. Kandinsky had conceived the idea of the almanac as early as Spring, 1911. By September, 1911, the outline and table of contents was complete and most articles begun. Macke joined the two editors at this time.

Marc had known the publisher Piper since 1909, when he drew two covers for art books. Kandinsky had furnished Jugendstil woodcuts for Piper's short-lived graphics sales room. Piper had also published Kandinsky's earlier book, at the time of the exhibition.

Piper demanded a guarantee against costs (3000 marks was needed) and the artists signed as guarantee-intenders (original word). The wealthy industrialist, Bernhard Koehler, the uncle of Macke's wife, finally guaranteed the amount for the painters, who had nowhere near this sum.

The philosophy behind this almanac is one of the most important concepts of the twentieth century art scene. It was not original, but a summing up through the filter of Kandinsky's immense intellect and background, and through the sensitive and literate intelligence of Marc. Their immediate predecessors were French. The central ideas range from Arthur Rimbaud through Baudelaire. In A Season in Hell, Rimbaud wrote: "I invented the color of vowels, A black, E white, I red, O blue, U green." (From "Delerium II, Alchemy of the Word"). Goethe's color symbolism had taken a side direction through French symbolism. Baudelaire notes in the introduction to the second edition of Flowers of Evil "…how poetry borders on music by a prosody, the roots of which go deeper into the human soul than is indicated by any classical theory."

The ultimate form of the almanac appeared in the middle of May, 1912. It had fourteen large articles interspersed with shorter notes and quotes. The exhibitions were already travelling and had already been shown in Berlin.

To Klaus Lankheit the title Blue Rider meant the following: Rider had a common European meaning of noble mindedness; blue meant spiritual fulfillment. This art was concerned with the most profound matters. A renewal must be more than formal, a complete rebirth of the old thinking, all thinking.

Marc and Kandinsky produced the almanac to state these intentions. They meant to create symbols for their own time, symbols which belong on the altars of a future spiritual religion, symbols behind which the technical heritage cannot be seen. To them, modern science works in a negative way. They reached for truth into past art which remains genuine in all times, regardless of exterior, contemporary conventions. These works of art are pathfinders if they contain the inner state of truthful minds.

The first articles are about the "savages" of Russia and Europe. From Oscar Wilde came the idea of art as a living correlation of man. Burljuk gives seven differences in concept between the old and new relationship with form. Macke relates the primitive [pathfinders] to modern art. Both suggest, as does the article by Arnold Schönberg, that there must be an innermost essence of the world which the artist in all mediums can find in tension, though it may be obscure and incomprehensible. For Schönberg, music exists apart from verbal ideas.

For Kandinsky, art is the materialization of this inner content. He divides this materialization into white as fertilizing ray, black as the veiling of spirit. In this opposition, black is fear of clarity, fear of freedom and fear of spoken spirit. The most important question relating to form is whether or not it has grown out of inner necessity. All art is basically internal, and equal in inner content if all show the disintegration of materialism; all build from the spiritual and intellectual life of the 20th century.

Kandinsky expounds these ideas fullest in his essay about stage composition. He proposes that each art has its own external language, but the innermost cores of all are identical. The soul vibration of every work of art will vibrate identical sound reactions from the audience. A specific sound or color in one art can be identical with the specific sound or color in another art. They can reinforce or harmonize with each other to create an especially strong reaction in the viewer. But there can be no universal method. Each art can be developed as an externally independent thing. For example, a voice can be pure and yet without words or meaning of words; therefore the content is primary, not the form.

The almanac included music which had texts by the Symbolist poets of the time, such as Stefan George, Maeterlinck, and Mombert. The music was that of Arnold Schönberg, his pupil Alban Berg, and colleague Anton von Webern. All were founders of modern music schools through new tone systems, serial, and Expressionist music.

In the preface to the second edition in 1914, Marc and Kandinsky describe the spread of the movement through a "stronger and more compact current" than in the beginning. They had offered the themes in their publication, which reached a wider audience than the exhibitions. These intentions would be fulfilled in another world, on a side road away from progress as an idea, away from the methodical development of science. Though the almanac is spontaneously made and is fragmentary, the main articles are the philosophical backbone of the Blue Rider group. This "ray to the future" was an attempted synthesis of culture as the major idea for the future.

Kandinsky and Marc as editors of the group wrote the introduction to the first exhibition: "We choose for this small exhibition not a precise or special form of propaganda, but we wish to illustrate how the various artists' inner intentions may be variously completed by the variety of forms represented."

The exhibition was expected to show the change in art, away from the displacement of the center for embellishment of outer nature in art, and the intense turn toward inner nature. Forty-three works were in this first exhibition. Only seven were for sale, and the others were borrowed or lent by the artists and collectors. The range of styles went from the primitivism of Rousseau to the abstract improvisation of Kandinsky. Delauney showed the great cubist masterpiece, The Tower, which was purchased by Koehler. Albert Bloch and Münter had six works apiece. Delauney had four paintings and a drawing. The Rousseaus came from Kandinsky's private collection. This exhibition later went on the road to various cities. From Munich, the show went to Cologne, where Worringer's sister provided exhibition space at her art club. Then the exhibition went to Berlin, where Walden showed it at the Sturm rooms, but included additional works by Kokoschka and Framm, and works called "Expressionist" which were French, as the term then meant only modern art. Later, this first Blue Rider show went to Bremen, Hagen, and Frankfurt. Thus, the artists had some publicity, and were widely seen, though reviews were mostly scathing.

The second exhibition at the Goltz gallery was held on the second floor, before the new exhibition rooms were ready downstairs. This show had only watercolors, drawings, and graphics. There were 315 items listed in the catalogue. A Swiss group was invited, including Arp, Gimmi, Helbig, Klee, and Lüthy. From the Sturm circle came Mörgner, Tappert, and Melzer. Various Russian and French painters, most of whom resided at the time in Munich, made up the remaining group. There were also eight Russian folk art reprints to represent the old but honest inner expressions.

**161.** Über das Geistige in der Kunst, insbesondere in der Malerei *(On the Spiritual in Art, Especially in Painting)*

8 illustrations and 10 original woodcuts by the artist. R. Piper, München, 1912, with cover illustration by Kandinsky
12 + 104 pages, edition of 1000 (Printed late 1911)
Printer: M. Müller und Sohn
20.5 x 17.5 cm., Roethel 82 (cover) 83, 84, 85, 86, 87, 88, 89, 90, 91, 92, Book 8.

There is some problem tracing the printing. Our copy has a cover from the third printing and a title page from the second. The other copy has both cover and title page from the third edition.
Second edition has 12 + 125 pages, (1912) April printing 1000
Third edition has 12 + 125 pages, (1912) fall printing 1000
23.5 x 19 cm. in soft cover (can be accounted for by binding cuts of margin design)
22.8 x 17.8 hardbound half linen

The first edition has a different colored cover: dark green. Second and later, a brighter green design. Both editions are on wove paper.

161.

**KANDINSKY**

**ÜBER DAS GEISTIGE IN DER KUNST**

DRITTE AUFLAGE

The three editions of one year totalled three thousand, speaking of importance in the mind of someone, probably the artist, for Piper, the publisher, did not pay for more than half the costs. Kandinsky paid the other half when the book was published. Piper paid for the second and third editions.

The book had been refused earlier by another publisher, who said financial success would be impossible.

The woodcuts are taken from current ideas of the time with Kandinsky. They are not direct illustrations of material in the text. Some come from studies for glass paintings. Some come from older woodcuts. The dedication is to Kandinsky's older sister, Elizabeth Tichejeff.

This is a most important book about an artist's ideas. It is the last phase of abstraction before the leap into non-objective painting. It is both the summing up of Kandinsky's ideas about art and the relationship of the artist's spiritual growth to his intentions.

The book is divided into two sections: the first is about the spiritual background on which all art rests; and the second part concerns the formal conditions of practice, methods, painting as it is made.

1911 was the year of Kandinsky's first non-objective oil-painting. Thus, these ideas in the book do not include the final step. Kandinsky argues for analogies between music and painting, though he writes that he does not paint music, but similar emotional associations in the inner consciousness. He sums up the book by dividing art into three parts: impressions, improvisations, and compositions. The last category would include complete abstraction. He also stresses the inner necessity of the creative artists as the most basic need for creative art. He asks for an age of conscious composition, a gradual discovery of the evolving structures in this new spiritual realm. He ties this all together with the artist's personality in his time, the historical makeup of art, and the inner "spiritual" spring (probably meaning the fresh approach of all creative individuals), which allows us to discover similarities in all genuine works of art no matter when made. The woodcuts used as illustrations are all from nature. These riders, landscapes, medieval scenes and models are taken beyond general recognition by extreme simplification of form and designed movement. Space is articulated by width of line variables and compression of spaces. Balance is achieved by strength of mass only. In most, perspective is ignored, but the forms are related to some basic form, such as a triangle or circle.

In the manuscript, he wrote about the imprecise as keeping the artist away from the purely human. This was his first fear of non-objective art, as he thought it would not relate to human activities, but later Kandinsky realized that the spiritual basis of genuine art was purely human and universal.

Letter from Kandinsky, signed, to Merle Armitage, included with the copy of the book. Written in French, translation in English below:

28 May 1939
Neuilly s/Seine (Seine)
135, Bd. de la Seine
France

Dear friend,

I thank you for your very kind letter and consequently for the brochure which gave me much pleasure. It is not easy for me to read in English, but I have understood well the contents of your brochure. I always regret knowing so little of the English language. I was flattered by your words on my art which "has been the one clear star in the art firmament" according to you. Also your brochure externally is very pretty—the lay-out of pages, typography, paper etc. I would like very much to apply the word "appetizing."

Permit me to point out to you a small passage which is not completely exact in my opinion. You say on page 16: "Braque, Miro, Leger, Kandinsky, and others, have been painting abstractions since the War." As far as I know, before the war there were only two painters who have done this type of painting other than myself, Delaunay. My purely abstract water colors date back to 1910, the first paintings to 1911. And as far as I am concerned these works were not experiments without consequence as they were for the painters that you name with myself, but a development completely organic is consequently that which endures for almost thirty years.

But if I work in this way consequently, that does not mean that I do it by "principle." No, I do it because I find the abstract means (I prefer to say concrete ones) the strongest, the clearest and the most expressive for me. This is my most natural language.

When I had the courage to begin this new path, there was no one by whom I could take as an example. And truly, I had the world completely against me. It is for that perhaps that I am a little too exact and demand a perfect exactitude of the accounts of the "birth" of concrete art. If my demand for exactitude is exaggerated, it is concrete painting which has accustomed me especially to an irreproachable exactitude. Yes, without this meticulous exactitude concrete painting becomes empty and without content. Pardon me please for this little "philosophy"— I speak to you as a friend, and therefore with complete frankness. Do you intend to come to Paris this summer? It would be a very keen pleasure to see you again.

Sincerely,
Kandinsky

162.* Klänge *(Musical Sounds)*

München; R. Piper and Co. Verlag, 1913
38 poems in prose, 12 color woodcuts, 44 black and white woodcuts
Unnumbered paging (116)
Printer: Poeschel und Trepte, Leipzig
Color woodcuts; printer: F. Bruckmann AG, München
Editions: 345 examples. A: 15 for the artist. B: 30 review or complimentary copies. C: 300 examples, signed and numbered. Undetermined number of proofs from various blocks. Most are on paper 29.1 x 29 cm., Roethel 85, 95-140, 142-146, Book 9.
Bound in purple half-linen with crimson cardboard. Covers are covered with pasted japan paper having a stamped vignette designed by the artist
27.7 x 27.2 cm.

This important book went through long preparation. A version in Russian exists, but only in dummy form. This published version displaced illustrations to other poems, seemingly to prove the cuts were decorative rather than direct illustrations of words in the poems.

Again, Kandinsky paid for half the publication costs and was given a commission of fifty percent of the retail price. A number of extra unsigned copies were printed, and Roethel mentions an additional forty-five for the artist's use, for friends and review copies. The final contract was signed on September 28, 1912.

All thirty-eight poems are in prose. Kandinsky left few actual titles for the Klänge woodcuts, mostly the earliest ones. The interesting advertising brochure issued by the publisher Piper lists books previously published by Kandinsky.* It contains an introduction to Klänge which describes the artist's intentions. "The book is to be called Sounds. I do not want to create anything but sounds. But they built out of themselves. That is the description of the contents, the inner contents. This is the foundation, the ground on which it grew, partly by itself, partly thanks to the cold hand of the calculating gardener. This (my) hand was not cold, though, and never stole the right hour; also in calculation, the hour came by itself."

On the reverse of the announcement is a proof impression of one of the woodcuts.

As is typical of Kandinsky's illustrated books, the artist does not exactly illustrate the text. He presents a cross section of his stylistic development from 1907 until the time of publication, 1913. There are orient-derived subjects, Russian folk-scenes, free compositions and non-objective designs. Many of the subjects were used in behind-glass paintings, watercolors and oil paintings. Horses and riders, and religious themes make up the bulk of Kandinsky's interest. It is interesting to note his many themes and ideas together in one book. Though he had already made the first non-objective watercolor in 1910, he still uses all the earlier themes and compounds his development, not simplifies it.

This first poem is narrative. The next, an abstract is titled *To See*. It describes a color as action, hanging brown, a white crack in a white crack in a white crack.

Then we move into musical sounds not natural ones. Kandinsky calls the instrument a fagott, which is a kind of bass oboe. The "apathetic" sound turns the landscape green. It makes a tree grow a "glaringly" yellow crown. The bass oboe interrelates with the changes and tries to describe these natural changes into musical ones, low, nasal tensions.

*prospectus from R. Piper for Klänge

# FAGOTT

**Ganz große Häuser stürzten plötzlich. Kleine Häuser blieben ruhig stehen.**
**Eine dicke harte eiförmige Orangewolke hing plötzlich über der Stadt. Sie schien an der spitzen Spitze des hohen hageren Rathausturmes zu hängen und strahlte violett aus.**

162/4.

### 162/4. Fagott *(Bassoon)*

Very big houses tumbled suddenly down. Small houses remained standing quietly.

A thick and hard eggshaped orange-cloud hung suddenly over the city, as if hanging on the pointed top of the high and slender tower of the City Hall, radiating violet.

A tree, dry and bare, stretched its long quivering, jittering branches into the deep sky. The tree was all black, like a hole in the white paper. The four little leaves kept quivering quite a while. But the wind was calm.

But when the storm came up and many a thick walled building fell down, the thin branches remained without motion. The small leaves became stiff: as if cast from iron.

A cluster of crows flew through the air over the city in a straight line.

And suddenly again it was all quiet.

The orange cloud disappeared. The sky changed into a sharp blue. The city into yellow to make you weep. And through the silence only one sound was ringing: The beat of horseshoes and one knew that a white horse was wandering all alone through the empty streets. This sound lasted long, very, very long. And one did not know exactly when it stopped. Who knows when silence is born?

By the long stretched, expanded, rather inexpressive, apathetic tune of a Bassoon, a long, long while moving in the depth of emptiness, everything slowly became green. At first deep and somewhat dirty. Then lighter, colder, more poisonous, still lighter, colder, more poisonous. The buildings grew high up, becoming narrower. All bent towards a certain point to the right, perhaps toward the morning. One could perceive a strive towards the morning.

And still lighter, still colder, still more poisonous green–the sky, the houses, the pavement and the people who were marching on it. They marched continuously without interruption, slowly, steadily looking forward, always alone. The bare tree accordingly grew a large exuberant crown. This crown high up had a compact form, sausage-like swelling above. Only this crown was glaring yellow, no heart could stand it. How good that none of the people walking below had seen this crown.

Only the Bassoon tried to describe this colour. It rose higher, became glaring and nasal in the tension of its tune. How good that the Bassoon was not able to reach this tune.

### 162/3. Sehen (To See)

Blue, blue rose, rose up and fell.
Pointed and thin whistled and squeezed itself in, but did not pierce through
At all edges it droned.
Thick brown remained hanging, as if for all eternity.
As if, as if.
Wider, wider spread your arms.
Wider. Wider.
And your face you should cover with red cloth.
And perhaps it is not yet shifted, only you are shifted.
A white crack after a white crack.
And after this white crack again a white crack,
And within this white crack a white crack. Within each crack another white crack. Within each crack another white crack.
It is not right that you don't see the dark turbulence.
In the turbulence, that's where it is just sitting.
That's where everything begins
It has cracked.

162/3.

### 162/8. Wasser (Water)

On the yellow sand a small, thin, red man was walking. He slipped again and again as if walking on slippery ice. However, it was yellow sand of the limitless plain. From time to time he said: "Water...blue water". And did not know himself why he said it.

A rider dressed in a green frock with folds was racing on a yellow horse frantically fast.

The green rider drew his thick, white bow, turned round in the saddle and shot the red man with the arrow. The arrow whistled as if crying and was going to force himself into the heart of the red man. At the last instant the red man grabbed it with his hand and threw it aside.

The green rider smiled, bent down to the neck of the yellow horse and disappeared in the distance.

The red man had grown taller and his step had become more firm.
"Blue water" he said.
He walked on and the sand formed dunes and hard gray hills. The farther he went the more hard, the more gray and high became the hills until finally the region of the rocks began. And he had to force himself through the rocks, as he could not stand still nor look around.
As he passed a very high peak, he noticed the white man squatting as he was going to let a gray rock fall down on him. He could not turn back. He had to pass the narrow road and he did. Just when he walked across the high peak the man on top with panting effort gave the last blow. And the rock fell upon the red man. He caught it with his left shoulder and threw it over his back.
The white man above smiled and nodded his head friendly.
The red man became still taller.
"Water, Water," he said.
The road between the rocks became wider until finally again came dunes, flat and still more flat until they were no longer there.
But again only a plain.

162/8.

WASSER

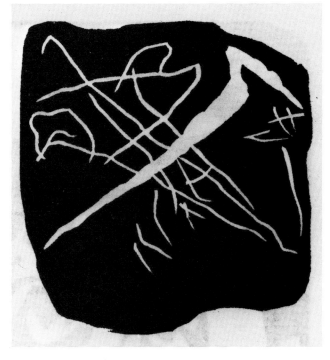

162/6. Käfig *(Cage)*                                          162/6.

Torn it was. I took it with both hands and joined both ends.
Something grew all around. Close around me. But nothing was
visible.
I thought myself there was nothing. But I was not able to get
onward. I was like a fly under the glass globe of a cheese plate.
Nothing visible, but insurmountable. It was ever so empty.
All alone, a tree was standing in front of me, a little tree, in fact.
The leaves green like verdigris; tight like iron and just as hard.
Small red apples shining like blood were hanging on the
branches.

This was all.                                                 162/5.

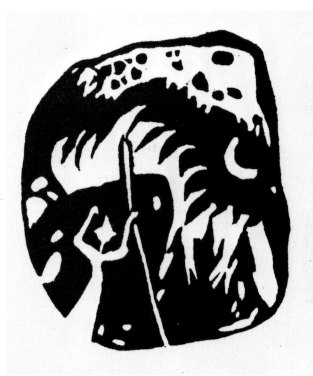

162/5. Vorfrühling *(Early Spring)*

A gentleman lifted his hat in the street. I saw black-white hair,
steadily fixed with pomade, right and left of the part.
Another gentleman lifted his hat. I saw a big rose-colored
greasy baldness with a blueish highlight. Both gentlemen
looked at each other; they showed one another their crooked
greyish yellowish teeth with fillings.

Kandinsky moves next into description of a landscape: "disappearing and lying, long black pipes."

He moves again to seeing, a scene of gentlemen raising their hats, but looks at details in the action such as "bluish highlights and yellowish teeth."

He describes physical sensations: "Eating a giant cloud and finding the taste dry." This image is opposed to a burning house, hot. The medieval symbols of earth, air, fire and water are alternated throughout the poem.

His major images unite all sensations. Sound and feeling combine with action. Physical exertion contrasts with distant movement in the landscape.

The poems appear to be prose pictures blending the elements Kandinsky wished united in his "universal" art. Place becomes anyplace. Sounds become personalized. Colors become symbols of inner tension. Rhythms become divisions as in music. Heavy words oppose short words. There is theme and variation just as in the improvisations. Ordinary rational meaning is used in some of the poems. Others suggest imaginings from word-thoughts, not exactly stream of consciousness writing. Kandinsky believed that certain colors and sounds caused similar echos in the subconscious mind.

Many of the poems are short and fit his description of direct impressions from nature. Others are more thought out and can be described as symphonic, complex developments with many themes, variation and development sections.

They can also be divided into the artist's own categories of direct impressions from nature, spontaneous writing and his reasoned complex studies based on the two earlier means. These categories are also carried out by certain themes which move throughout the book and seem emphasized points. Colors are such themes, trees and animals, too. Everything is given a keyed color. Roses sing. Music is specific as to its instruments. Enigmatic actions show the irrational in man. Trees are watered with colored inks, "which tickle the Turk with his watering can."

"Everything Dead shook." Not only the stars, the moon, the woods, the flowers about which poems had been written, but also a cigarette-butt lying in an ashtray; a patient white pants button lying in the street, looking out of a puddle of water; a pliable piece of tree bark, which is dragged in the strong teeth of an ant through the high grass towards unknown and important purposes; a calendar leaf for which a certain hand is reaching, and forcibly tears it from the warm fellowship of the other pages which are still remaining together in the pad. "Everything showed me its face, its most inner being, the secret soul, which more often is quiet than speaks." Thus every resting as well as every moving point (line) became equally alive and "opened up his soul to me." That was enough for me to "grasp" in my whole being, with all my senses the potentialities and the existence of art, which today in contrast to the "objective" is called "abstract" art. **From his autobiography "Rückblick 1901-13", Berlin, 1913.

All translations by Kate Steinitz.

# GABRIELE MÜNTER

Gabriele Münter's mother was German, though brought up in Tennessee and the young artist visited relatives in Texas during the 1890s. She read and had sympathy with American ideals, and influenced Kandinsky by her democratic messages. From the first she tried to break with the naturalistic art tradition of her youth. Study with Kandinsky at the Phalanx school brought her into contact with his ideas; and she became his companion until 1914.

Münter developed a talent for using color. She worked with primitive motifs early. She learned about abstraction from the stimulation of Kandinsky's genius. She was also an early inspiration for him, because Münter was an unselfish and serious emotional force. Her intense sensitivity and wide interest in fresh approaches to the problems of art in the early twentieth century made her important to the modern movement. Her discovery of the glass painters of Murnau probably directed Kandinsky into beauties of color unknown in other mediums.

Gabriele Münter was a natural painter. She usually worked directly from a visual perception which was peculiarly her own. She could easily simplify yet remain uncomplicated.

163. Aurelie *(Aurelie)*

Color woodcut, 1906
Helms 4
Unsigned
10 examples known
18.2 x 16.7 cm.

*Aurelie* is one of the painter's series of portraits which make up an oeuvre remarkable for the German Expressionist era. This 1906 portrait is quite naturalistic, though simplified and kept to the contrast of light and shade without halftones. It seems impressionistic as capturing a moment of facial mood. It has the life of nature, unlike the stillness of later Expressionism. The impression has been taken from a linoleum surface; and used functionally for this medium with chisel deeply used for undetailed edges. The three colors are printed soft and flat. There is an element of the real in this face alive with life and will.

163.

164.

164. Neujahrswunsch *(New Years Greetings)*

Color woodcut, 1909
Helms 36
Signed in pencil
About 24 examples known to Helms
Offered in Der Sturm with 5 impressions mentioned there
8.6 x 12 cm.

This woodcut forms part of an intense interest by Gabriele Münter in children's subjects from 1907 until 1911. Toys and dolls are most of the major themes. Paralleling her interest in simplified outline and color placed as flat areas, like impasto in the paintings, is the use of transparent color overlap of the three colors to create extra tints. Yellow over blue shapes makes a green. Red over yellow extends the range to orange. The charming simplicity of this still life seems both naive and conventional at the same time; and it reflects the artist's own simplicity and strength of character.

# DER STURM
### WOCHENSCHRIFT FÜR KULTUR UND DIE KÜNSTE
##### HERAUSGEBER: HERWARTH WALDEN

## Ständige Ausstellungen
Berlin W. 10 / Königin Augusta-Straße 51

## Elfte Ausstellung
# G. Münter

**165. Blumengiessen** *(Watering plants)*

Woodcut, 1912
Helms 40
Unsigned, verso: Münter Nachlass stamp
22 x 19.8 cm.

One of five proofs announcing Gabriele Münter's one-man show at Der Sturm Galerie, Berlin, 1913. The woodcut also appeared in the periodical Der Sturm: #138/199, p. 231 (December, 1912).

Münter's development stayed her own even under the strong influence of her daily companion, Kandinsky. Her work shows a gentle sense of humor, and an interest in the dynamic events of life which the Russian, perhaps, disregarded for intellectual investigations. Münter had a natural sense of composition.

This simplistic domestic scene, with a woman watering a plant and two children climbing steps, blends the two tones to add drama by diagonal movement in the tree and slanting plant. There is a dreamy sense of stillness, a lyrical sensitivity.

This impression was taken from an earlier woodcut prepared for the poster announcing Münter's one-man show in Berlin, in January, 1913.

166.

## AUGUST MACKE

**166. Begrüssung** *(Salutation)*

Linocut, 1912
Peters 8/ii
On heavy etching paper
Proof before break in the block
23.9 x 19.3 cm.

August Macke is considered an artist from the Rhineland, for he was born in Meschede on the Rhine, educated in Düsseldorf, part time under the great book designer, Fritz Ehmcke. His two early journeys to Paris in 1907 and 1908, provided an interest in pure color. He was described as a humorous man, prolific sketcher of studies for later works, musically receptive, and living in the present with a great sense of the curious. He had good fortune early to be recognized and cherished by the great collector, Bernard Koehler. "Understanding the language of form is to get close to comprehending its secret," he wrote. He studied the relationships of forms from a sense of the inconceivable to be made in concrete works.

This linocut may have been made for the October 1912 issue of Der Sturm. A few of Macke's prints and drawings were in the exhibition of the Blaue Reiter artists at the Sturm gallery.

This is a proof of the first state before a small break in the wood block, caused by changes in temperature.

Macke works for a vitality of surface, by making predominating whites vibrate in the left thrusting movement. The tension is balanced by the smaller horseman, appearing on the same plane as the three figures. Tension is also given by opposing the rough outline to smooth outline, which separates the harmony and moves the edges in and out.

167.

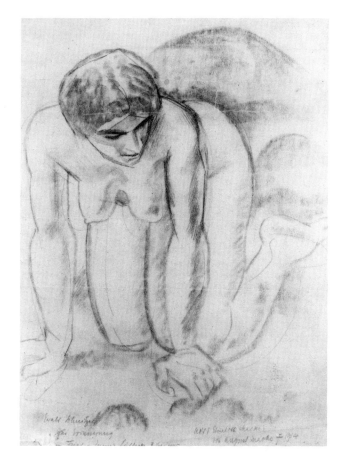

168.

**167. Drei Akte** *(Three Nudes)*

Linocut, 1913
Uncatalogued
Signed in pencil by Elizabeth Erdmann-Macke, and numbered:
"No. 5 Nachlass August Macke"
The first printing may have appeared in Der Sturm, March 1913
though Goltz in Munich was Macke's principle dealer for
graphics.
The print also appeared in Das Kunstblatt, regular edition,
April, 1918
11.5 x 8.5 cm.

The abstraction in this linocut of three posing models is more
mechanical, with little variation in line, as though the artist had
been studying edges. The mood is established by jagged out-
line, which resembles that of a spotlight and intensifies the
inner crosses on the posteriors of the end girls. Such a vignette
floats unless anchored, and Macke uses a psychological an-
chor with the left jagged edge. The linocut is a study of balance
between decorative abstraction and structural integrity. The
print looks backward to Ehmcke and the decorative schooling
in book design, and forward to the abstract works of 1913. None
of the Sturm linocuts by Macke were offered in a Sturm edition
as was the case with the prints of Münter, Marc, Pechstein, and
others.

**168. Akt** *(Nude)*

Charcoal drawing, 1914
On charcoal paper
Signed by Elizabeth Macke
63.5 x 48.2 cm.

Elizabeth Macke, wife of the artist, posed for this study. The
drawing was at one time owned by the concert pianist, Emma
Lubbecke, at whose home Macke spent many evenings, for it
was a center for musicians such as Paul Hindemith, writers and
painters.

The drawings of 1913-1914 range from cubistic landscapes to
simplifed and flattened form studies. Again and again, Macke
uses a rhythm from a central round pillar to create the sense of
solidity. The head is balanced by round masses over and to the
right of the figure. Muscle structure is little noticed, but round
and sculptural flesh is modelled only for vertical emphasis.
Perhaps a side glance at Matisse can be directed, by the careful
placement of the figure on the paper, with the lines moving and
forming to balance the space.

117

# FRANZ MARC

The prints of Franz Marc offer some problems with editions. Many were printed in Der Sturm about the time of the Blue Rider exhibition in 1912. Walden, publisher of Der Sturm, also issued small editions of Marc's woodcuts in the 1912-1913 period. They were frequently advertised for sale then. The price was 40 marks each. The editions are listed as 10 to 15. Eleven of the prints appeared in the periodical: eight of the woodcuts were made in special handprinted editions for Walden's gallery.

### 169. Katze hinter einem Baum *(Cat behind a Tree)*

Pencil drawing, (1910-1911)
Unsigned
Related to Lankheit 146, Kinderbild.
From sketchbook XXIII, p. 20
17 x 11 cm.

Marc made a number of studies of cats for a poster. It was meant to promote an exhibition at Brakl's Modern Gallery, Munich, in 1910. This early work is not yet touched by Cubism or Futurism, and is less abstract. The composition is studied for original placement of the subject not force lines or action lines. Edges of forms are cut off as in Japanese prints, while far and near images merge.

This drawing is taken from one of Marc's sketchbooks, the 23rd. A related painting was made in 1910-1911. Cat and tree are intermingled in the painter's understanding of the interplay of life throughout all nature. The major form of the tree naturally dominates the composition, with the cat forming a cross through it. No real search for form behind reality, as in the later Marc, is exhibited here. The viewer is related to an actual scene, though his vision is carefully directed by design. Stopped action can be seen, nature at rest, little show treatment beyond the slight variation of line: there is organic rhythm, which Marc described as "being in all things."

169.

### Briefe aus dem Feld *(Letters from the Battle Front)*

Berlin: Rembrandt Verlag, 1941.
page 150: Marc's last letter to his wife; 4, iii, 16 (March 4, 1916)

L, Imagine: Today I received a letter from my landlord in Maxstadt which contained your birthday letter! The woman had found it, in spite of my searching, in one of the cartons. I was already a little ashamed but also doubly pleased to have it now after all: You write so nicely in it, yes, this year I shall return to my undamaged and dear home, to you and to my work. In the unlimited horror, the pictures of destruction in which I now live, this thought of returning home has a halo, which cannot be described in lovely enough terms. Take care of this my home and yourself, your soul, and your body and all that belongs to me, is mine!

At the moment we camp with the squadron on a totally devastated castle estate, over which the former French front line passed. As a bed I have overturned a rabbit's cage, removed the grating and filled it with hay and put this in a room that is still rain proof. Of course I have plenty of blankets and pillows with it, so my sleeping goes well. Don't worry, I shall get through it, also, as far as my health is concerned, I feel alright and take good care of myself. Thanks many times for the dear birthday letter!

(Marc was killed at 4 P.M. of the same day.)

### 170. Geburt der Pferde *(Birth of Horses)*

Color woodcut, 1913 (4 colors)
Unsigned
Lankheit 840
21.5 x 14.5 cm.

Kandinsky and Marc had planned a series of illustrations for the Bible. Klee was invited and wrote about this in his diary. Kokoschka, Pechstein, and Schmidt-Rottluff later carried out some of the ideas. The Blue Rider Bible was to be issued in 1916 by Piper. Marc designed a number of woodcuts with this theme (Lankheit 840-841-842-843) but he was killed in the war, and Kandinsky lost interest in the project with the death of his close collaborator.

Else Lasker-Schüler had described Marc as a young patrician of biblical times, and: "Even the wild animals turn into plants in his tropical hands." He was not just an animal painter, though, but worked for a synthesis of animal in nature, a pantheism of all life on earth.

The *Birth of Horses* was to be for the Book of Genesis. There is a complex design of part Cubism and part Futurism, all the planes and speed being filtered through Marc's intensity and changing into vital comment rather than formal statement. The animals are kept as an organic part of the whole not as simple nature identities. Marc tried to see the visual image through the horse's eyes. He called this "the surfacing of the image in another place." He tried to break the surface "skin" to get inside the essence, the "truth". Images become transparent and merge with natural surroundings, all becoming one.

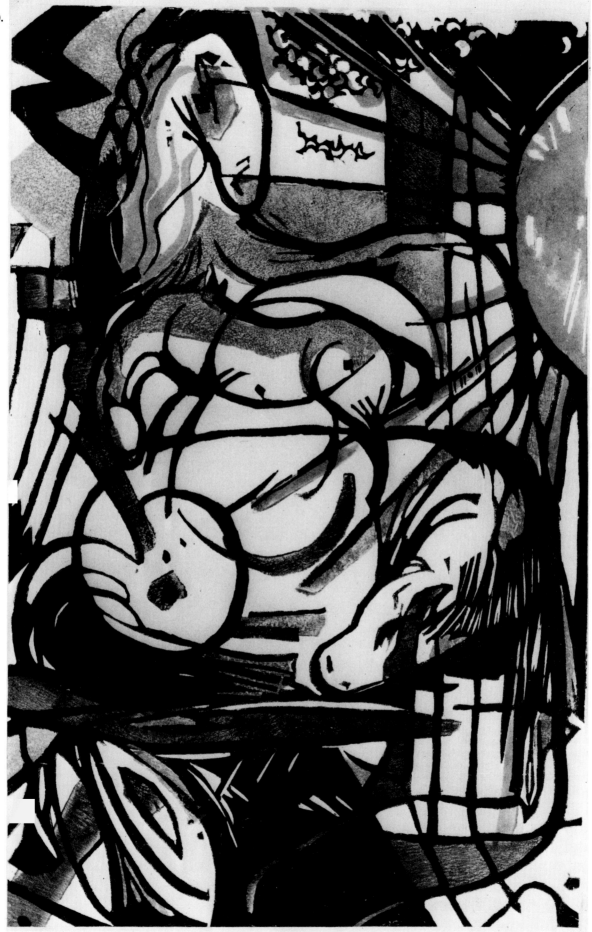

## HEINRICH CAMPENDONK

Heinrich Campendonk was born in Krefeld, center for the German Arts and Crafts Institute, the greatest school for creative fabric design and stained glass. Campendonk studied there with Jan Thorn-Prikker, the great Dutch designer in ecstatic Art Nouveau. The limitations of this craft influenced his later styles. Campendonk returned to the stained-glass field in 1926-27 and did important works in glass until 1957, the year of his death.

Glass design is a rigid medium, relating the mass of transparency to hard outlines. There is a tendency to color within areas and vary the outline by thin and thick supporting lines. It is a "hard edge" medium.

Campendonk was a controlled artist, as one can tell from the carefully inscribed writing of his letters. But he had also been trained by Thorn-Prikker in freedom of expression, in semi-abstract symbolism which he never left, except in some completely abstract stained-glass windows designed later in his life.

Invited to Sindelsdorf, Bavaria, by Franz Marc in 1911, Campendonk was fascinated by peasant votive painting done behind glass, as had been Kandinsky, Marc, and Münter. The hard edges and simple ornamentation appealed to his background and related to his early training. Most of his nature techniques were developed from this behind-the-glass technique. Children's art, too, influenced his reach for simplicity and symbolism, as children see in symbols rather than copied reality. The meeting in Bavaria with Marc, Kandinsky, and an enthusiastic Macke, and subsequent discussions and inspirations were the "most marvelous" of Campendonk's early experiences.

Marc introduced Campendonk to the craft of woodcutting. He also sent some of these earliest woodcuts to Walden, who printed the first ones of 1912 in Der Sturm. Of the first 19 works, 16 appeared in the periodical. After this, Campendonk's woodcuts appeared in Das Kunstblatt, Das Holzschnittbuch, Deutsche Graphiker der Gegenwart, Die Schaffenden, and other books and periodicals.

171.

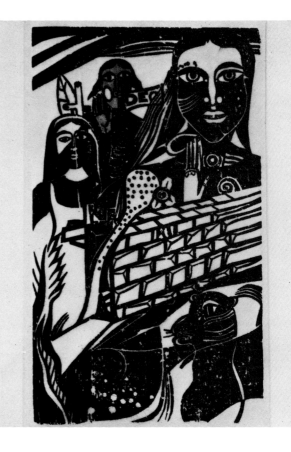

**171. Deo** *(Deo)*
Woodcut, hand-colored in blue and green
December 1920/21
Kohlhammer 50, Engels 50
On japan paper
33 x 20 cm.

There had been an influence from Franz Marc from the first woodcuts in 1912. An ecstatic Cubism, complicated structure and symbolism from nature had provided the balance between Campendonk's primitivism and the Expressionist stylization. After 1918, the style becomes simpler, with puppet-like humans placed in a balanced tonality between black and white. White lines are used over black shapes, black lines used over white shapes. Figures are cut off arbitrarily by the edges. Faces look straight out. There is little feeling for the wood medium, and little perspective except by overlap of forms. Animals and humans are universalized in symbolic abstraction: none are exact types; people stand without social unity and are isolated but near. He shows us a mysterious, personal world of peaceful quietism. It is a world of man-like marionettes.

172. Heinrich Campendonk by Walter Schürmeyer

Frankfurt a.M.: Verlag Zinglers Kabinett, 1920
Printed by C. Naumanns Druckerei, Frankfurt a.M.
Type: "Bernhard-Antiqua"
Reproductions (Kupfer-Autotypien) printed by Bauersche
Giesserei, Frankfurt a.M.
28.5 x 22 cm.
4 + 8 pgs + 11 sheets of plates (printed on one side)
With two original unsigned woodcuts and thirteen reproductions (one on the cover)

Two original woodcuts in the catalogue:
172/1. Frau mit Blume *(Woman with a Flower)*
(1918), Engels 32
Woodcut printed in dark brown ink
On Bütten
Facing title page
17.8 x 12.1 cm.

172/2. Am Tisch sitzende Frau mit Katze und Fisch *(Woman at a Table, with Cat and Fish)*
1919, Engels 42
Woodcut printed in dark brown ink
On Bütten
Facing page 4
17.7 x 15.5 cm.

The *Woman with a Flower* has a curious abstraction that is undiminished by outside influences such as political thinking or personal tragedies. It is an idealized form set in a timeless space. The sweep into space provided by diagonal lines goes only into a depth without distance, ending in a flat, window-like cutaway. All details are stylized according to the simplest lines and masses. The central figure is most important in the scheme of things; later comes the nude and strange cow-horse of the upper right. The magic, the tension, the movement are compelling and real to a sensitive observer.

The *Woman Sitting at a Table with a Cat and Fish* is simplified into a rising and at the same time receding central pillar. The relationship between the woman and the gigantic cat is static, though the symbolic and compositional relationship is echoed in square forms which make up the areas around the cat, the table, picture behind the woman and the abstracted shapes in the upper middle portion. Again, there is the impassivity of the central figure, with staring eyes and frozen motion. The picture plane is tilted into the distance, from the leaning table up to the white and black windows into space.

From the time of Goethe's later years, the marionette had been a symbol of German passivity. Many great dramatists used this theme, making the wood figures more or less real. There was the sense of magic as a part of life, of inert forms being given rational life, of the division between the chosen and the automatic will. This theme was elaborated by later romantics into the supernatural, into the golem-figure and the hypnotized subject without will.

172/2.

## LIST OF INDEPENDENT ARTISTS

Ernst Barlach 1870-1938
Lyonel Feininger 1871-1956
Otto Gleichmann 1887-1963
Karl Hofer 1878-1955
Richard Janthur 1883-1950
Alexej von Jawlensky 1864-1941
Paul Klee 1879-1940
Oskar Kokoschka 1888-
Käthe Kollwitz 1867-1945
Alfred Kubin 1877-1959
Wilhelm Lehmbruck 1881-1919
Ludwig Meidner 1884-1966
Paula Modersohn-Becker 1867-1907
Wilhelm Morgner 1891-1917
Max Oppenheimer 1885-1954
Christian Rohlfs 1849-1933
Egon Schiele 1890-1918
Arthur Segal 1875-1944
Jacob Steinhardt 1884-1968
Georg Tappert 1880-1957

## EARLY INDEPENDENTS

Relationships among the independent artists are difficult to establish because they, too, grouped and ungrouped, tended toward different directions in politics, mysticism and formal attitudes. All worked with the publishers of periodicals, as this was the major and traditional means of publicity for German artists. Most were interested in literature, as we have seen; German art depended on literary sources for intellectual development.

As the Expressionist time-period progressed there was a drawing together of artists and writers in the coffee houses and cabarets of Munich, Frankfurt, Dresden, Vienna, Prague, Berlin, Cologne and Hamburg. Writers of poetry were also art critics. Men of the theater wrote about their friends in art. Specialized publishers and general publishers with special publications, such as those for Jewish works, drew together the best illustrators. Though some professional illustrators retained traditional methods, the very large German reading public also bought modern works by the new artists. There was room for many styles and traditions in one commercial market.

Many of the artists in Berlin gathered around Walden and Pfemfert in the circles of Der Sturm and Die Aktion. Except for Kandinsky, the German Expressionist artists worked within a humanistic tradition based on the human being and nature. It was only later that formalistic tendencies became paramount, and this in a decidedly left-wing direction.

At the time, Kandinsky was developing his theories of pure abstraction, Meidner was making very abstract woodcuts for Der Sturm. Meidner, Steinhardt, and Janthur were organizing the group known as Die Pathetiker, representing a social attitude of empathy. Kokoschka was working in his psychological methods without basic theory, but using instinct from a sensitive reaction to subject. Klee was settled in Munich and developing towards the most original depth of insignt in art. The elegant Jawlensky was focusing on the human head in all its pronouncements and variations.

They met in the periodicals. They wrote to each other, and exhibited together. Some were not social people. Barlach corresponded from isolation. Kubin wrote, illustrated and dreamed in his Austrian castle. But all were thoroughly engaged in art as the most vital activity of life.

As two-dimensional graphic art was basic to the independent Expressionist, direct impressions from nature were not necessary. Spontaneous expression was desired and developed. The inner character of nature, the spontaneous improvisation caused by the creative inner impulse was major. Even a social minded artist such as Käthe Kollwitz began a development away from the realism of her youth; and this added strong feeling to her art. Rohlfs lost the influence of van Gogh and the late Impressionists, and moved into a Germanic depth of morbid feeling.

Closer relationships with periodicals developed after the war. Independent artists were used more than others in such publications as Der Bildermann, Das Kunstblatt, Zeit-Echo, Dada and many others during this fertile period for small magazines. Another basic reason for the linear development of each artist was the wide latitude allowed by publishers. Reactionary publishers did not use the Expressionists.

Later the periodicals became political within narrower intentions and the artists tended to gather around the centers of their particular political interests. Yet the quality remained very high, with even far left-wing magazines using original art for covers and inside illustrations.

By this time, graphic art in Germany was complicated by explosions of inflation and social depression, of class warfare and political focus. Thirst of the soul was supplanted by more elementary needs. There was a tremendous activity, as though from some weaving machine out of control, and quality was spun into small units of minor value in a decaying future.

## DIE PATHETIKER
Steinhardt, Janthur, Meidner

In the spring of 1912, three young painters, Ludwig Meidner, Jacob Steinhardt, and Richard Janthur, established a group called Die Pathetiker to exhibit together. It was meant as a protest against the lack of social pathos among the Impressionists. The themes of the first exhibition were to be an "affront to unpathetic people."

A provincial town provided the background for Steinhardt's knowledge of the world. The population was mostly Polish, the Jewish community very small. Zerpow, in the eastern Posen district of Germany, was isolated.

The young dreamer was sent to Berlin for education about 1896, an unsuccessful accomplishment according to the artist. But then his drawings were submitted to Max Liebermann, Corinth, and Trübner, all of whom affirmed his talent to a group of city fathers who had agreed to finance the young painter if he proved deserving. Steinhardt studied one year at the Arts and Crafts school, Berlin, and two years with Corinth, an artist the young student idolized. Paris, Italy, friendships with writers and sculptors provided a cultural background.

On his return, Steinhardt met and became the close friend of Ludwig Meidner. Most of their activity took place in the circle of the Neo-Pathetiker Cafe. From this association with the cafe emerged a joint effort, the periodical Das Neue Pathos (1913-1914). Janthur was primarily an illustrator. He, like the others, was mystically inclined. His illustrations were inspired by such interests as: sagas such as Gilgamesch; Indian religion such as Pantscha Tantra; animal life as in the Jungle Book of Kipling; and Persian and Chinese love poems. He seemed to have few early political attitudes.

Janthur described himself (Gurlitt, 1921)* as a "coarse fellow, full of hope and agony." He continued: "We played in the dirt and experienced super things...blue became red and cold became hot. Our excitement became our knowledge." Janthur is a minor figure in the group and in the German Expressionist movement.

Ludwig Meidner was the Expressionist painter best described as an artist of inner explosion. A small man, he compensated with energy and eager intelligence. He was the son of a traditional business man, owner of a textile firm. His mother had some interest in art. His beloved grandfather, perhaps, furnished inspiration for an unconventional approach to life, for this semi-revolutionary appears again and again in Meidner's work. Meidner always retained the Silesian earthiness. His schooling and travels took him to the Breslau Academy and to Paris, where he befriended Modigliani. Many years of near starvation and privation after his return to Berlin in 1907 have been described as turning an unconventional man into an eccentric. He became demonic in his attitude toward work, sometimes drawing for days without sleep, using any material at hand—burnt matches, tallow and wrapping paper, following the flicker of a candle with his drawing board. Intense poverty produced the realization that art was everything for him. The normal pleasures of middle class life, which he experienced later, were stripped from this inner core. From this center came the inspiration, the strange dreams of explosion and religion, the denial of gravity and structure as we see it. Apocalyptic visions were also current with the work of his friend Martin Buber. They were fostered by the poets in the Sturm circle, which Meidner frequented. These ideas were a comment upon the social situation more than a view of the future, less a prediction of the coming war than a look at the changing social situation in Germany. Meidner, perhaps, had too much imagination, was too versatile, lacked discipline for his expression of dream and vision.

*Das Graphische Jahr Fritz Gurlitt
Berlin: Fritz Gurlitt, 1921, p. 70

## LUDWIG MEIDNER
173. Selbstbildnis *(Self-portrait)*

Ink and pencil drawing, 1916
Signed in ink
44 x 35 cm.
Illustrated in Grochowiak, Ludwig Meidner, pg. 22

Smudges of pencil, erased and redone, are visible in this self portrait under the sure line from a scroll pen. The portrait has the shape of force, not sorrow. The drawing is not tricky but involved with the exaggerated brow and diminished neck, yet without pathological distortion. The flat plane of the central face is turned somewhat into the picture, which brings the eyes into direct stare. There is some echo of Kokoschka in the parallel shading, though the lines are closer together. Peter Selz quotes Paul Westheim as calling the portraits "frequently a battlefield of rage."* There is more pathos than rage in this drawing. It is a sad, proud man, sure of his hand and eye.

*Selz, Peter; German Expressionist Ptg, LA, 1957, p. 282

173.

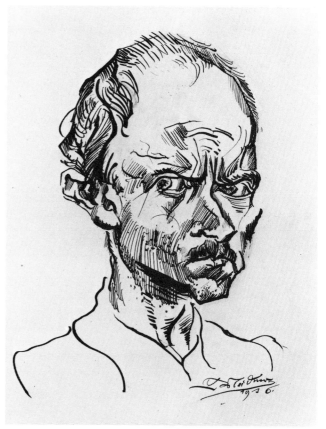

**174. Portrait of Alfred Wolfenstein**
Drypoint, ca. 1920/22
Signed in pencil
19.6 x 17.7 cm.

This is a dynamic portrait of a dynamic poet, Alfred Wolfenstein. The writer was born in Halle, 1888. The extent of his works is not large. His first book was published in 1914. His general attitude towards life was nihilistic. He saw the new paradise among mankind, not from religion. Meidner's interest in this young poet came during the war, when Wolfenstein and Franz Werfel wrote of future utopian epochs, a biblical, messianic message. Wolfenstein's credo was expressed in Menschheitsdämmerung, 1920: "Mankind was formed when man was formed, had spoken. It is rooted on earth."

Meidner shows us the man who has spoken. The technique is built up of short strokes, gathered around areas to open the form and lend a feeling of impatience and rustle to the face. The direct technique of drypoint shows little variation in line, demonstrates the artist working at speed, cutting up space without linear outline. This method brings out the emotional impact of the poet's studied gaze. The clear theme of inner wisdom is made dissonant in the grass-like use of line. It is an ecstatic landscape of facial movement.

174.

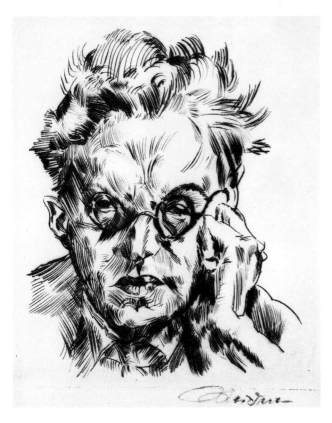

**ALFRED WOLFENSTEIN**
Menschheitsdämmerung, pg. 19
*Dammed Youth*
Flee from home, flee through streets
Unknown to you and every location
Only like the fast sky a high
Foreign noise without words!

How good is loneliness, and mixed
And none mixed there; who touches me
Fails of intimacy dumb and close
To my heart, hated they wallow.

There is no home. There is the limit
Not plump love, only fighting and barter
Ah, the street flows proudly out,
combining with others in a giant chase.

Ah, it sprints by, abrupt and horseless
And perks black, the mush of the crowd
And houses flutter, whipped into it
By light, ringing bells, hissing and screaming.

Stones move in false calm
Hacked by the pounding of the army, the shoes,
The pale heads glitter wounded
By the quick glow of the lamps

Faces here are strange as animals
With eyes like ice pressings
And self seeing eyes
Faces here are stopped by nothing.

My head disperses. You godless one,
Dehumanized one. My heart escapes me,
Without a home, without a destination
You street, yes stun me: Stun!

175. Porträt des Dichter Theodor Däubler *(Portrait of the Poet Theodor Däubler)*
Drypoint, 1910
Signed in pencil
17.8 x 14 cm

The strong portrait of this early poet of Expressionism shows the profile cutting the air in a pose of strength. This friend of Barlach was a great internationalist, propagandist for Expressionist art, creator of new forms in writing. His background was multilingual, including German and Italian. A free-lance correspondent for papers in Berlin during 1916-1918, Däubler had immense influence among the painters. He was described as the most important middle figure between the artists and the writers.

The portrait is fairly straightforward. The poet seems heroic in pose. He was a fat man of gigantic height in actuality. Both Meidner and Däubler were associated at this time with the periodical Die Aktion. Both were frequenters of the Romanisches Cafe in Berlin. Däubler, called the Dante of the Northern Lights after the title of his first great poem and his interest in classical Italian writing, seems frozen in thought. There are few fireworks in this portrait, but it shows the searcher, the strong personality, the careworn poet.

## THEODOR DÄUBLER
Northern Lights
(Second part, Müller Verlag, Leipzig, 1910, p. 561)
The eyes are only longing, only the mouth is owned:
Only dream-storms appear and the day is a kiss:
Being is cloudiness, God alone is lightning;
I myself am fire, since I must remain believable.

Glances are longing, the breath has mystical exhaltation:
And truth, mysterious things, sway the word into song.
The unheard is frightened away, in amber-like smoke:
The soul hears itself, it sees the strangeness.

Away with masterpieces! Without hope or eagerness,
Free the spirit for me. Back to wind and speech!
My anthem is song, sound of the time in me.
My call is weight and storm: My dark ground a gorge.

176. Die Feuerprobe *(Ordeal by Fire)*
Roman von Ernst Weiss
Berlin: Verlag Die Schmiede. 1923
Edition: 675 examples
A—Nrs. I-XXV
B—Nrs. XXVI-C
C—Nrs. 1-575
First edition of the Officina Fabri
Printed by Poeschel & Trepte, Leipzig
Etchings printed by van Hoboken, Berlin (handprinted)
35.5 x 25 cm.
115 + 1 pgs
With five full-page original etchings by Ludwig Meidner

The author was Bohemian born (1884-1949). He was a doctor of medicine; and wrote descriptions of the decadence of modern civilization.

The Feuerprobe is in nine parts, each narrating a subjective experience. Most of the thematic intention is directed toward oppressive relationships between man and the city.

Meidner's illustrations are also generalized, without much individuality. They do not relate to the text, but are placed in random fashion. They add little to the words. The subjects stand away from us, having no empathy because of arrangement or personality. There is little of the exploding Meidner in these late etchings. The line mastery of the emotion-charged young artist has been lost. Meidner still followed the drawing tradition of van Gogh, with his swinging line, open shading and broken outlines. The draftsmanship is weaker in the late works, as though Meidner had lost some of his urgency and accumulated restlessness. The emotive impact is diminished. He had begun the journey back into tight form which made up the last intentions of his working life, a path back to the effects of Corinth.

## JACOB STEINHARDT
**177. Bildnis eines Mannes** *(Portrait of a Man-probably Georg Fuchs)*
Dark gray chalk and graphite drawing, 1913
Monogrammed lower left, "JST, 13"
36.8 x 26.8 cm.

Steinhardt was interested in portrait drawing from the beginning. He did a portrait of his friend, Meidner, in 1909. His heads of 1913 are influenced by new articles recognizing the "Expressionist" El Greco. The elongation is upwards, the tonality is full, with a rubbed graphite establishing a middle range. The soft middle tones allow emphasis with sharper black lines. The line itself is obviously nervous and quickly drawn, though skillfully placed. This drawing seems a working sketch. It has studied details in the face, especially the nose and eyes. These elements have been charged with emotion and a sense of apprehension. External reality is not studied, there are no color notes by tone or value, but form is an entity in itself. The Pathetikers sought form and expression through dramatic action in the massed tones and swinging line. They tried to introduce dramatic content back into art. Though relatively realistic, this portrait does not fall outside the intent of Expressionism. It represents, too, the less ecstatic side, the end of Romantic perfectibility and decadence.

177.

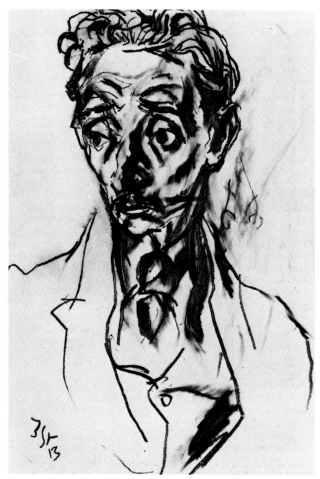

176.

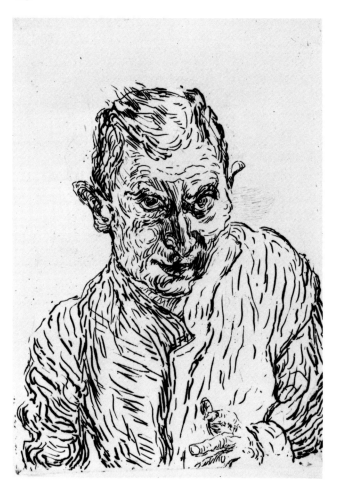

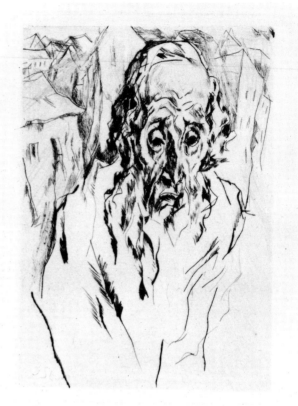

178.

179.

**178. Älterer Mann** *(Elderly Man)*
Etching (drypoint), 1913
Signed in pencil
11.5 x 8.4 cm.
The etching technique is used in a tentative way at the beginning of this plate. Slight lines are used to build up the composition. The penetration of space is flat. Later, drypoint is worked over the first lines, rounding shapes and setting the background apart in lighter tonality. Further work of direct drypoint establishes dark patterns, rich and velvety, which carry the diagonal pattern from lower left to upper right. Distorted perspective emphasizes the sense of weary moodiness. There is a slight Cubist movement of form within the dark areas, which vibrates the surface in and out. The old man seems to carry the buildings on his shoulders.

Many of the works during 1913 were studies for biblical subjects. Their characters came from the streets of Berlin. Steinhardt had been working on the subject of Job (Hiob), used as a symbol of suffering humanity. The wrinkled face of his old man contrasts against the hard outlines of the buildings; the rustle of life is in the face and not in the city. This is an internalized portrait, with technique used to strengthen the emotional appeal.

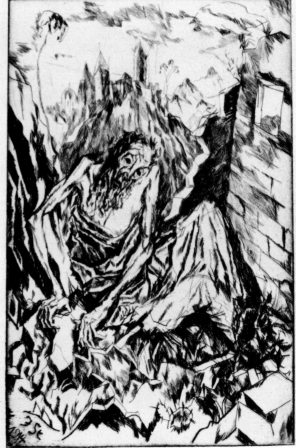

**180.** Neun Holzschnitte zu ausgewählten Versen aus dem Buche Jeschu ben Elieser ben Sirah *(Nine Woodcuts to Selected Verses from the book Jesu ben Elieser ben Sirah)*

With a preface by Arnold Zweig
Berlin: Soncino-Gesellschaft, 1929
Edition: 900 examples
Printed by Aldus, Berlin
Ninth publication of *The Friends of Jewish Books*
Text printed in Hebraic and German fraktur
German translation by Rudolf Smend
Book: 28 x 19.5 cm.
Woodcuts: 15.9 x 12.5 cm.
Unpaginated (4 + 24 + 4 pgs)

In 1915, the young soldier-artist spent much time in the Jewish communities in Lithuania. For the first time, the young Jew saw traditional life, with the ritual provisions of these time-old spiritual people. The minor Jewish traditions he had experienced as a boy found inspiration. This empathy helped form the painter Steinhardt.

The Soncino Gesellschaft was founded in 1924, taking inspiration from the classical Jewish families of Soncino, and later other Italian cities, who printed the first Talmud in 1484. Typography and language were intended to conform to these early inspirations.

The manuscript for this book was found in handwritten form in a synagogue in Cairo. It is an ethical pronouncement concerning the drift of literary-philosophical thought in the late Jewish epoch.

For the illustrations, Steinhardt uses a linear technique, cutting line in black backgrounds and reversing the line of drawing. Memories of Lithuania appear in houses and subjects. He penetrates into the spiritual landscape of mankind. Life and death appear as living examples in the panorama. Skeletons argue, dogs defecate, spirits appear, men get drunk, artists work in their studios, snakes fall from the mouth of a demon, symbols appear from dreams and superstitions. The last illustration sums the philosophy of life in this small book: a nursing mother holds a child in the sunlight and the text tells: "The sun shines from God on high over the mother sitting in the throne of her house."

There is little of the Cubist tradition in the inner forms. There is also little direct illustration of the text. The ancient book is brought into the then contemporary world, which was the intention of the Society of Soncino.

180.

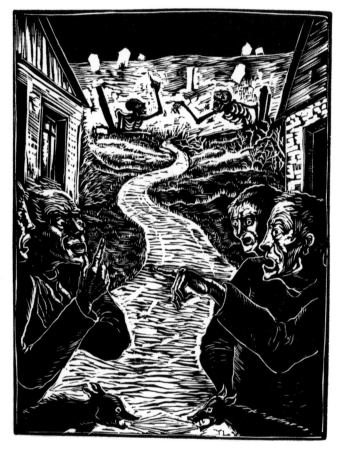

**179.** Jesaias *(Isaiah)*
Drypoint, 1914
Signed and dated in pencil
16.2 x 10.8 cm.

The Bible had always been an inspiration for the young artist of this time. The Pathetiker technique of jagged, broken line is used fully. Perspective is tilted away from the central figure toward both sides.

"And it shall come to pass in the last days, that the mountain of the Lord's house shall be established at the top of the mountain." Earlier, Isaiah had written of visions of sinful nations, wrong sacrifices and invasion of the Holy Land. He is the prophet of writing prophets, the messenger whose name means "Salvation of the Lord."

Steinhardt uses this symbolism at the beginning of the great war. Isaiah also sets forth the predictions of a great messiah.

The technique, again, is used to break up the surface into triangular articulations, which surround the sitting prophet, circle the sides, and point towards the sky. The city on top of the mountain is the final center of interest. The various surfaces, flesh, rocks, sky, cactus, all seemed cubed.

## RICHARD JANTHUR

181. Wintermärchen *(The Winter's Tale)*

Lithograph, 1918
30 x 20 cm., signed, on japan paper from presubscription edition of Shakespeare Visionen, R. Piper, Munich.

Janthur uses the rough and spread edges of an old bristle brush, dipped in liquid tusche, to draw his free expression of massed scenes from Shakespeare's drama. As in medieval painting, he combines events and times outside a logical series. The design is complicated enough to approach chaos. Perhaps he was most impressed by this sensual play, lost himself in variations, all combined without unity.

The German cult for Shakespeare was introduced by Lessing and Herder, although Hamlet had been first performed as early as 1777 in Dresden.

Shakespeare's play of circa 1611 has a theme of jealousy and revenge, with opposing action echoed in comedy. The high and mighty are opposed by the low and lusty. Similar to most of the late plays, The Winter's Tale is a comedy of tragic blunders and a tragicomedy. The vulgarity in Autolycus's broadside ballads was translated into the vulgar German of Hans Sachs for the tradition-minded Germans, searching for an early history for their new nation.

The idyllic ending finished a round of lost and finding. What must these Germans have made of such lines as these in Autolycus's song:

"The lark, the Tirra-Lirra chants, with hey! with hey! The thrush and the jay, are summer songs for me and my aunts, while we lie tumbling in the hay." (iv, ii, 9-12)

Janthur shows us none of this lusty headiness, the fleshy mood of the play. Instead the artist makes a complication of this and that, all nonspecific.

181.

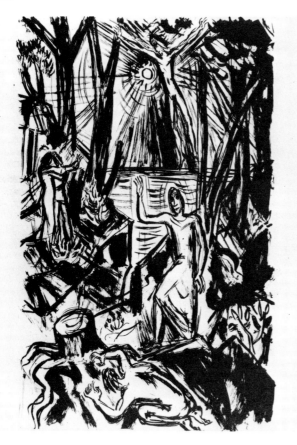

182. Des Capitain Lemuel Gullivers Reise in das Land derer Houyhnhnms *(Of Captain Lemuel Gulliver's Journey in the Land of the Houyhnhnms)*

Jonathan Swift
Berlin: Fritz Gurlitt. 1919
Die neuen Bilderbücher, Zweite Folge
Edition: 150 examples
Nrs. 1-5 bound in parchment
Nrs. 6-46 bound in half parchment
Nrs. 47-150 bound in half linen (regular edition)
Printed by Otto von Holten, Berlin
43 x 35.4 cm.
2 + 62 + 2 pgs
11 full-page, signed lithographs; 26 unsigned lithographs including borders and capitals.

A famous artist during the early Twentieth Century, Richard Janthur is now in complete eclipse. He was mainly an illustrator, friend of the Sturm circle, a worker for Die Aktion. His interest was in the Volk tradition of saga and legend, though not the nationalistic side as were the right-wing propagandists for Blood and Soil.

Janthur designed all the capitals and borders for the text, and achieved a pleasing balance.

Most satire of the Eighteenth Century takes two basic forms. These were formulated in ancient Rome. Laughter at people and events comes from Horace. Juvenal brought to satire the intense dislike of man for his vices and vanities. Swift sought to anger the world, not amuse it, though his Gulliver's Travels was edited into a comic book for children.

Germans were amused by Chapter II, which compares Houyhnhnm language with German, although Swift makes fun of Emperor Charles V's snobbishness about High German being such an elevated method of speaking: the emperor would only use this form if he could speak to his prize horse.

The Germans found lessons in these battles between reason and passion. It had been a traditional theme in Romanticism and early Expressionism.

Swift and Janthur place man somewhere between the angel and the beast, and modern man found the individual was a composition of these elements. In fact, the Expressionist poets used the word "Tier" (beast) as a symbol of the unconscious, the uncontrolled and raging imagination. For a rationalistic Swift, man sought to brake his vicious tendencies, tried to avoid pain by seeking less pleasure. Man could control the beast by reason.

Richard Janthur combines an essentially linear style with realistic illustration in the traditional method of German illustration. His elegant calligraphy is the modern addition. It takes the drawing out of the realm of caricature. It makes action less exaggerated and more apart for quiet relationship with the two dimensional page. There is balance by simplicity when horses are important for the picture, and a more complex violence to the compositional scheme when the Yahoos appear with their uncontrolled passions.

Janthur's technique is tusche drawing with a brush. His draftsmanship is direct, without correction. Janthur's hand is not sure enough for high skill. Variation of line is lacking. The picture plane is very deep, not two-dimensional for the page, a window into space. The horizon line tends to be high, which weights the bottom of the page for easy entrance from the text.

Richard Janthur is, perhaps, more humanistic in his art than most other Expressionist illustrators. He is concerned with the human being in nature, a charming human being of graciousness and obviousness. In Swift's Gulliver's Travels there is an apotheosis of nature in connection with harmony and proportion. This abnormality is a ghostliness. The elemental monumentality of Swift's epic is lost in Janthur's lyrical mildness. The illustrations, which are from the Volk tradition, appear timeless and inexact.

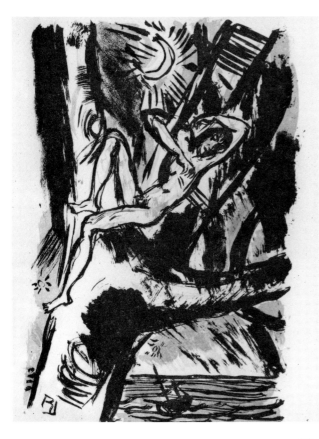

183.

182.

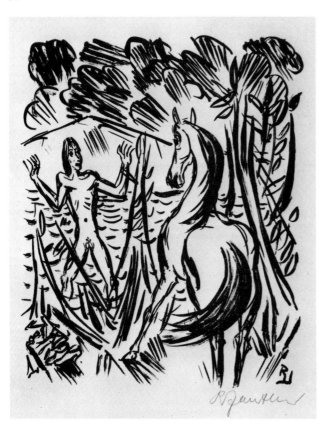

183. Das Leben und die ganz ungemeinen Begebenheiten des weltberühmten Engelländers Robinson Crusoe *(The Life and the Complete Extraordinary Adventures of the World-famous Englishman Robinson Crusoe)*

By Daniel Defoe
Leipzig: Insel-Verlag. 1922
Edition: 800 examples in parchment and half-parchment bindings
Printed by the Bibliographische Institute, Leipzig
Lithographs printed by H.F. Jütte, Leipzig
2 + 104 + 4 pages
With 31 illustrations and cover vignette by Richard Janthur
(Illustrations are original two-color + black lithographs)

Probably made on thin and transparent transfer paper, these lithographs show some of the limitations of this method. A drawing transfers easily when line is used, but soft edges tend to lose dimension. It is also difficult to hold a tone that is less dark than the complete area. Color can be mixed with extenders and blended to make any tint, but the control of these color plates was not extensive and design was lost in a careless overlap.

This late book design is a far cry from the early and elegant books produced by this press. The wonderful pages of Don Quixote, designed by Czeschka (1908), the van de Velde books, Kessler's Odysee (1910), Rilke's Duineser Elegien of 1923, and the great Insel almanacs from 1900 to 1960 are fully controlled in design and originality.

Each Insel book is a work of taste. These, too, are laid out to be read, which is the first presumption of a reader. The Verlag had opened in 1899 with the publication of the Insel periodical. Later that year the first book was published. Two Insel portfolios came out the next year: Hugo von Hofmannsthal's Der Kaiser und Die Hexe, and five etchings by Hans Thoma.

The Ernst Ludwig-Presse, the Janus-Presse, and Koch's work were all represented by the Insel-Verlag. Almost all important book designers worked for the press, including Mathey, Weiss, Koch, Vogeler, Kleukens, Ehmcke, Heine, Preetorius, Behmer, Slevogt, Tiemann, Mueller, Reiner, Gill, Craig, Maillol and Masereel.

The Insel title pages were not as important as with some other publishers. They produced mainly library-type volumes, well printed and well bound. Any sharp originality was kept to a minimum after the first years.

The bindings and end papers of the Insel-Verlag could be a study in themselves. Utmost originality was desired and obtained by the use of dotted wallpaper, vines and fields, vegetation and abstraction, crystals, all cheerful or forceful according to the contents of a particular book.

It was a collaboration between tasteful publishers and the best designers Germany had produced. Most of the refinement was in the use of type. Low-priced books were also produced without losing the complete design of the expensive volumes.

Janthur based his work on his personality, combining a knowledge of the unconscious with outward appearance. The style is thus harmonic, but instinctive rather than intellectual. Form development is lacking, as the unconscious tends to repeat personal muscular tendencies. The lyrical idyl of Crusoe becomes a cave of jungle darkness instead of a kind of enchantment.

There is a kind of mental exaltation in the drawings. There is also an attempt at metaphysical cohesiveness, but these cosmic events seem lost in the gloom and complexity of the poor printing of the color lithographs. The sense of energy remains.

## OSKAR KOKOSCHKA

"The Wild Man"—this was the description of the young Kokoschka.

Britain and America sent some influence through Kokoschka's training at the Kunstgewerbeschule,"the Arts and Crafts School." The American-trained architect, Adolf Loos, and the school, with its British influenced arts and crafts movement from Ruskin and Morris were both struggling against a complacent and decor-loving middle class, not the art movement of Impressionism. This was a major difference with other modern movements of the time. It was a time of shocks.

Klimt had provided an erotic change. Munch had shown the relationships between the sexes: Otto Weininger and Freud had forever changed the idea of reality. Kokoschka absorbed all these ideas within his eager talent. He was never a passive observer. He understood the primitive and hidden drives, the sense of moral collapse, the art of accusation and exposure through his revolutionary idealism. Kokoschka was intensely involved.

Kokoschka was the painter of action, the lover of paint and the touch of brush and swish of paste-like color on the rough canvas. He was a virtuoso of the turning stroke and rapid massing of color areas. He painted from little inner vision, but worked as the subject developed within his range of color and mood. The eye was the principle means for development. Visionary experience comes from transference of sight to art. Just as his poetry was spoken language, his art was visual language. His temperament was spontaneous, disruptive.

In most cases, Kokoschka did not treat his graphic work as preliminary steps to painting, as did so many of the Expressionists. His graphic art has more relationship with the poems and dramas. There are less adjustments, less pressure and counter pressure. The graphic art seems to confront directly the single problem. The graphic language had to be explored in itself, and the language of meaning also had to be settled.

184. Mörder, Hoffnung der Frauen *(Murder (or Assassin) the Hope of Women)*

Der Sturm, Nummer 20, Jahrgang 1, 1910, Berlin/Donnerstag, 14. Juli 1910
38 x 28 cm., edited and published by Herwarth Walden, Verlag Der Sturm, Berlin, 4 pg.

The collaboration between Walden and Kokoschka began by way of an introduction from Adolf Loos, Walden's friend and Kokoschka's mentor. Kokoschka was experienced, ready for entry into the art world of Berlin, and very poor and ambitious. He also had a recommendation from Karl Kraus, whose periodical, Die Fackel, was distributed in Berlin by Walden.

This drama was Kokoschka's third attempt after a puppet play at the Fledermaus Cabaret and a short play for the Kunstschau. The play, for which this illustration was more a documentation of Kokoschka's inner transformation than exact portraits from the performance, was done during the student's last year. The play was performed on July 4, 1909. It depicted a struggle in the young painter's mind between death and sexual longings.

Woman represents and desires hope. She is a virgin. "O the singing of time, flowers never seen." She is branded. "Hot iron into her red flesh." She stabs the man while in terrible pain. He is placed in a coffin, which had been lowered by ropes from the heights of the stage, placed inside the tower by an old man, and lit by blue light. The woman becomes lascivious, probes his wound through the bars. The hero sees this as a cycle of creation, a repetition of time repeating time. The woman thinks she has tamed the wild beast. He rises. She writhes, convulsing her thighs and muscles. He stands upright and touches her with his fingers. She screams and collapses. He walks through the crowd, "killing them like mosquitoes."

In Kokoschka's adolescent world woman cannot affect man by her gentleness. He reverses the story of Eden. Though woman is the temptress, man rejects the sexual necessities, the hope, and is the ultimate creator of the Fall.

This short play, really an interlude, was written for the students at the Crafts college. Kokoshka costumed the young actors in scraps of cloth, rags and material taken from the art rooms. He painted their faces with the expressions of smile and frown. He painted lines on exposed legs and arms, showing sinews and muscles, resembling Maori and Pacific tattooing, and some of these lines protruded into the costumes.

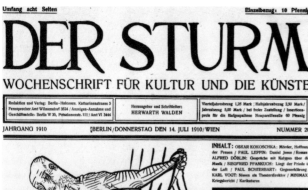

Zeichnung von Oskar Kokoschka zu dem Drama Mörder, Hoffnung der Frauen

184.

The leading actress, Ilona Ritscher, dressed in red. The hero was played by Ernst Reinhold, later a famous actor-producer. The dialogue was impromptu, written from a boiling unconscious, and set down on scraps of paper just before the performance.

It is important to remember that Kokoschka had described this play as expressing his attitude towards the world; it was made because he couldn't afford the actual theater performances.

It is also important to remember that Kokoschka rejected cosmic or Freudian influences. Nor does a moral or didactic reason come from his intentions, though we must also remember that the writer was intelligent and a witty young man, reading and experiencing all the things of Vienna, all the influences that appear intended or not, so his disclaimer is less important. This interlude is related to medieval plays of the travelling theater. It was a play for acting, not reading.

This play was to flow with pitch changes, variations of rhythm, and movements of facial expression. The actors performed with much excitement.

Kokoschka writes about this time, of his fear of sex, and of woman. He read Bachofen on matriarchy. He was studying Greek ideas. He saw humanity as a proving ground for heroes and martyrs, the theme of this play. He saw life as a place of continuous danger.

Woman is described as hope. Yet she is drawn to the inhumanity by passion, tries to kill passion with a knife stab.

The theme is cyclical, with the man bringing a wound and suffering a wound on a wound. Man has no loss of innocence. The ending is a vision of terrible inhumanity, just as the entrance of the hero in the beginning is a premonition of disaster. The cycle is of nature meeting innocence, being wounded by it, but ending unchanged.

The unconscious forces in the young man are apparent. One sees also the Austrian Jugendstil ideas of warriors and peasants, tower and torches, dramatic exclamation and chorus. The Greek studies of the young Kokoschka gave the main flow of drama, the interplay of chorus and character. However, the Greek device of a God's interference in man's ambitions is changed to an image of woman as force aginst primeval nature in man, finding her abilities to sensitize and gentle are powerless against this male force, whether creative or not.

The small orchestra was made up of drums, bagpipes, clarinets, and cymbals. It made a great noise, which brought neighboring troops to a wall overlooking the garden. At the close of the performance the actors crashed their torches onto the floor and earth with a tremendous shower of sparks and wild screaming. A riot occurred. Police had to be called.

The drawings were also issued in an edition of one hundred examples on finer paper by Walden in 1916 (five reproductions). The play was printed in Kokoschka's collected works by Kurt Wolff in 1913; in Book 41 of Wolff's Der Jüngste Tag series in 1917, by Paul Cassirer in Vier Dramen of 1919; and set to music by Paul Hindemith in 1921.

**186. Selbstbildnis, Hand auf der Brust** *(Self Portrait with Hand on his Chest)*

Color lithograph, 1911, published 1912
Printed in blue and red
Wingler/Welz 33
Published by Akademischer Verband für Literatur
und Musik, Wien 1912
*(Poster for a lecture by Kokoschka)*
Signed and dated: "26.1.12"
90.5 x 55 cm.

Kokoschka was introduced to Walden, proprietor of the periodical Der Sturm, in 1910, just as the older man was beginning his magazine. The artist collaborated with the busy editor by providing illustrations, bringing in coffee, correcting proof.

Kokoschka shows himself with shaven head and finger pointing to a wound in his right breast. His real face in these posters is grimacing, with wrinkles under his eyes, furrowed brow, and skull-like in the clenched teeth. The hard outline is Jugendstil-influenced. Kokoschka mentions later that a Russian bayonet went through his lung in exactly the same place as the wound in the drawing.

The print reveals how Kokoschka saw himself for the public. He did not show the quiet and intelligent artist others described, but a white-faced sculpture, looking drugged and suffering.

The lecture, advertised in the second poster, was called "On the Nature of Visions". Kokoschka lost the script, but later rewrote the text from memory while convalescing after the war wound in 1917.

The poster for the lecture shows his eclecticism, which was abundant, but much according to the taste of the times. His later dislike of the elegance of the Jugendstil movement promoted this inner search for essence away from the mannered linearity. He keeps ornamentation in the facial area and underarm. Kokoschka wanted to find elementary expression in this portrait. He searches through the line, and applies color later to reemphasize the emotional power. The pose is a classical form of the "ecce homo" gesture.

The identical poses differ by background into fierce and fiercer events for the eye. The 1912 poster for the lecture is the other redone, with changes of detail and seems, perhaps, less effective and more complicated. The Sturm poster of 1910, has less typography overlapping the image and seems more alive.

**185. Selbstbildnis (Sturmplakat)** *(Self Portrait on a Sturm Poster)*

Color lithograph, 1910
Printed in rose, blue and black
Wingler/Welz 32
Printed by Arnold Weyland, Berlin
Published by Der Sturm, Berlin
67.3 x 44.7 cm.

185.

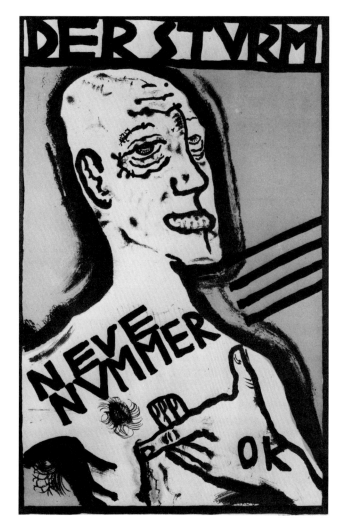

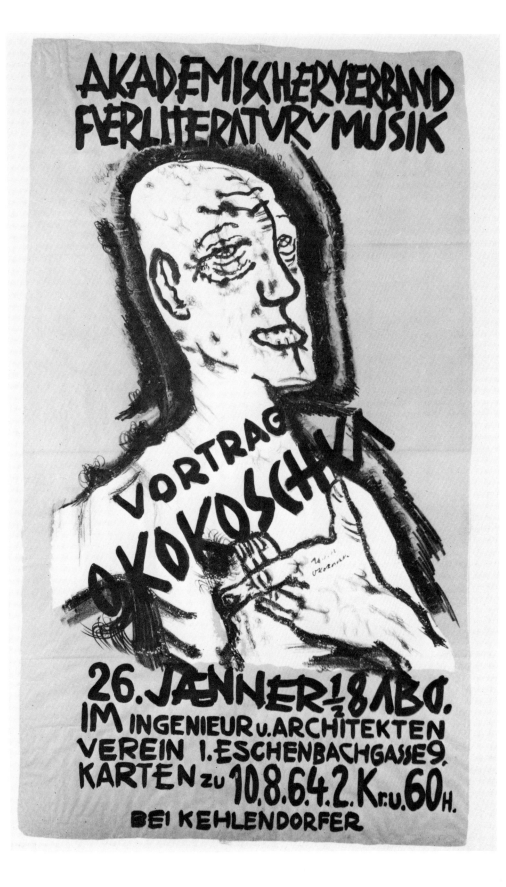

**187. Die Chinesische Mauer** *(The Chinese Wall)*

8 lithographs, 1913; published 1914, Portfolio edition
Leipzig: Kurt Wolff Verlag
Printed by Poeschel & Trepte, Leipzig
Editions: 200 examples in the book edition
         30 examples on japan in the portfolio edition
Wingler/Welz 35-42
Each sheet signed in pencil
Lithographs titled as follows:
1. Der Mord *(The Murder)* (W/W 35)
2. Aristoteles und Phyllis (W/W 36) *(Aristotle and Phylis)*
3. Frau mit Kind und Tod *(Woman with Child and Death)* (W/W 37)
4. Am Spinnrad *(At the Spinning-Wheel)* (W/W 38)
5. Die Christliche Liebe *(Christian Love)* (W/W 39)
6. Welb, von Mann begehrt *(Woman, by Man desired)* (W/W 40)
7. Lauscher *(Eavesdropper)* (W/W 41)
8. Die Eindringlinge *(The Invaders)* (W/W 42)

Karl Kraus and Kokoschka

Karl Kraus must be considered at some length as a critic of society and major influence on the artists of his time.

The Chinese Wall can be considered as one summational attitude toward the role of woman in the society of Habsburg, Austria. Essays in Die Fackel, Kraus's periodical, were collected every few years and published in book form, with the title taken from the major essay—in this case "The Chinese Wall", which appeared as the last essay. Inspired by a newspaper account from New York—a Chinese man had killed his white mistress—Kraus had spent many hours writing about the relationship between Eastern man and Western woman. To Kraus, the Chinese had a naturalness which had been lost in Europe. The Chinese were aware of woman's sensuality, while Western man wanted to diminish the sensual nature and "make woman conscious of the universe." In the West, morality had weakened the strong. "We have built our nest in a crater, which we believed to be extinct."

Kraus describes the murder as a monumental event. He thinks it should awaken a Western world that is inwardly satisfied. He thinks scientific progress assures all cringing spirits that it can control nature. Nature has been driven out of man by the invention of morality. Woman has become something between an interest and an erotic farce. A reaction by woman against her greatest tragedy, unattractiveness, resulted in the wish for social politics. Kraus admires the woman of greatly heightened sexuality, not woman as liberated human.

Kraus was convinced there was a relationship between the relatively primitive state of Chinese technology and the Chinese gain in imagination. He saw Chinese attitudes toward sex as an elemental force, not the Christian culture of curiosity. To the Chinese, Kraus writes, "it was not amazing that nature had created two sexes."

Man has sexual urges; woman is sexuality itself. Woman was thus rationally unaccountable for her conduct. But woman was also the source of all irrationality and chaos, the fountainhead of art. Kraus did not consider the rational nature of man as the basis for art. Woman provided a sense of fantasy, which was the foundation of all creative acts. Fantasy was the eternal female.

Kraus was essentially a hater of modern civilization—"you electrical scum."

Karl Kraus
Poem by Georg Trakl from Der Brenner,
1912-1913, page 840

White high priest of truth,
Crystalline voice, an icy breath lives in this God,
Angry alchemist,
Whose blue armor clanks under the flaming cloak.

Plate 4.

Plate 6.

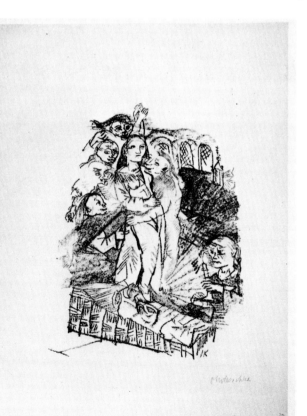

## Kokoschka's illustrations for The Chinese Wall

Kokoschka's lithograph illustrations are from the transitional time after his work for the Sturm journal in Berlin. He was in a happy period, poor but active in social and artist circles, with some reputation already, and a new love affair. Berlin was in a twilight zone, between set characteristics and new developments. Berliners expressed a faith in the ideology of technology. Kokschka with his background in Imperial Vienna, had none of this view of success. In this portfolio, he showed his other impulses, which reacted with Western Lebensraum.

In Plate 1, Death the Leveller shows vanity of pride and ambition, as he steps from a grave to light the view with his torch.

In Plate 2, Aristotle is ridden by his dominating wife, a legend from early medieval times, not Greek. The Western wife becomes a driving force, not the passive helper of Eastern tradition. Karl Kraus thought modern woman a thing of charming feeblemindedness. He thought such dominating arrogance was a product of mediocrity, indeed partly a product of the machine. He considered such intrusion in the affairs of man as degrading. Aristotle had taught his wife about the universe and now paid the price.

Plate 3: Progress assures all creeping spirits that it controls nature. The machine, though it made life difficult, still was cherished as though it had made life worth suffering. Both birth and death have the same face in the complete cycle of life. Woman creates life and destroys the present.

In Plate 4, a worn and depleted man sits before a spinning woman. Both are nude. For Kraus, man's greatest loss might be in the realm of the imagination. Woman also talked her way past the sensualist experience into a shallow present between her main functions as an erotic machine. Western woman was bored, except by the exotic.

Plate 5 shows a primitive life before the degradation of the technical intrusion. Greek-like costumes are worn in a garden of love. The woman resembles Alma Mahler. The child seems Kokoschka. The relationship between an older woman and a young man.

Plate 6: Woman was desired by the yellow race only for her sensual qualities.

Plate 7: Death is the eavesdropper on all intimate occasions. He adds motions of grotesqueness and, perhaps, a bottle of incense. Death sees love as an improbable interlude.

In Plate 8, the intruders are spectres of destruction when man "will see millions die but not be able to envision a single death." Progress had invented mortality, with machines holding the world together by hysteria and mere material conveniences. The intruders bring destruction through the invention of only comfortable works. Unity, as found among the invaders, was a shallow surface, never a thing of the creative. The artist's life had fidelity in its lack of stability, self-preservation by self-rejection.

Plate 7.

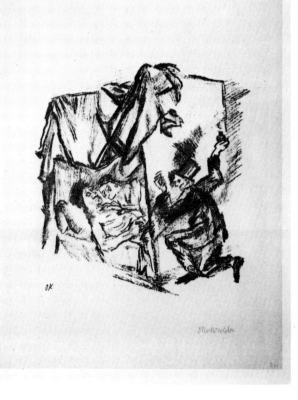

188. Allos Makar *(Happiness is Different)*

5 lithographs, 1914; published 1915 in Zeit-Echo, Heft 20
Munich, Graphic Verlag G.m.b.H., 1915
Printed by C. Wolff and Sohn, Munich
Unsigned, printed in grey ink
Paper size: 24.1 x 16 cm.

The lithographs:
1. Männlicher und weiblicher Akt, sitzend (Das Weib hält den Kopf des Mannes) *(Sitting Man and Woman/The Woman Holds the Head of the Man)*, Wingler/Welz 69; Arntz 46, 17.3 x 11.6 cm. page 297
2. Der Mann, im Schosse des Weibes liegend *(The Man Lying in the Lap of the Woman)*, Wingler/Welz 70; Arntz 47, 15.3 x14.8 cm. page 299
3. Der Mann im Boot *(The Man in a Boat)*, Wingler/Welz 71; Arntz 48, 14.4 x 19.1 cm. page 303
4. Sonne über einem vogelähnlichen Paar *(Sun over a Bird-Winged Couple)*, Wingler/Welz 72; Arntz 49, 18 x 15.1 cm. page 305
5. Mann und Weib mit Schlange *(Man and Woman with a Serpent)* Wingler/Welz 73; Arntz 50, 15.5 x 16.5 cm. page 308
Kokoschka's relationship with Alma Mahler became difficult, and he returned home after his mother had threatened Alma. The goddess of love, the inexpressible mystery, had become destructive. He described the separation as intolerable anguish.

He saw that happiness is different from the turmoil of the mind which thought and emotion had torn apart. He wrote a poem to free himself from his obsession with Alma Mahler. The title is made up of an anagram of their two names, Alma and Oskar. Allos Makar means "happiness is different" in Greek.

Translation:
*Allos*
From a fog world, how I am twisted miraculously,
Looking for her, a little white bird named me Allos.
Allos which I never faced. Because she changed in a
Moment into my being, as through a back door.
Ears suffer. Eyes tried to see her!
I am the poor summer night, which disappeared
And cries from a chasm in the earth.
Which weaves and spins a net before your eyes,
Gold curled, catches the heroes. Pulled by danger.
Gird your love nest more mysteriously,
Pretensions of seeming resistance all around,
Force the bird-catcher to fall into your net love-excited.
You are not
Like a scaled, feathered animal or naked spirit!

You are not, cannot be
Everything that holds itself to earth,
Divides the lonely air,
Looks for warmth in others!
In the pleasantness of the clear sun-sheafs,
Which embrace the world hot and strong,
Unlock the womb of figures, the nightly ones,
Which magically stops your net from fleeing change.

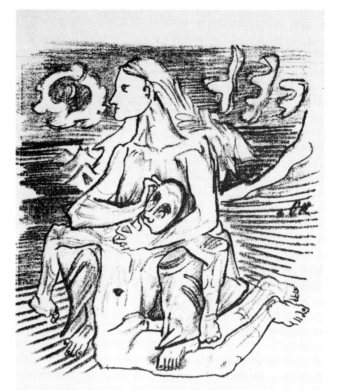

188/2.

188/4.

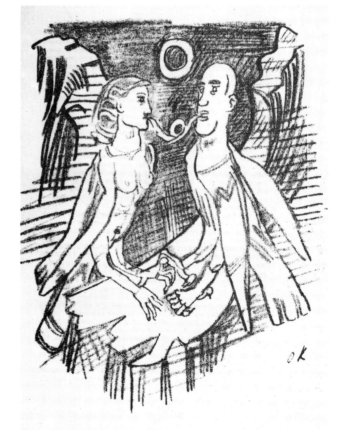

*Makar* 189/4.

I come from far away
Through foam spaces
In which the mother threw her child.
Debatable, concerned day and night,
Uncertainty, the awakened one comes here.
Sun and moon do not directly help together.
Mild, the climbing one went further traveling,
And in the fog-north he became a woman's husband.
His eye became blind in the chain-forging
Female's service.

Melancholy without reason after winter,
Longing follows wing-sick.
A fire burns immensely for both.
It consists of myself. She is overcome by sleep.
His love twisted hands flee from the nightmare!
The wind flees home.
Who turns the mirror for the dream I have interpreted:
Inclinations cry simply for itself!
Reveal the refugee
By lengthening a moonbeam,
And tell the sun to burn softer.
Makar rises in the wind and
Allos clings to fathomless depths.
Raise yourselves floating ghost ships, mast and anchor.

*Allos-Makar*

A deceiving calm encircles the ribs,
The heart storms with urges, inside by itself,
Returns to things past.
White earth of the winter sun.
The same hurt, dust made, shadow play,
Churns over the quietly imagined.
A powerlessness enters into the restlessness.
The heart pounds thunderingly, fearful to be alone.
Accidentally from below, there came
The screaming of birds aloft, roughly.
A little man and a little woman choke a snake.
Each is fearful of the others advantage,
Each loses strength to the other.
Weariness winds out of the screaming beaks.
Let mistakes drop, crushed by struggle,
I took them, read them, bent in the dust.
Laughing
The deceiving lips.
"Different is happy."

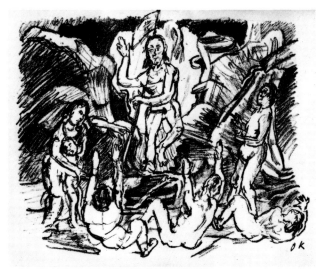

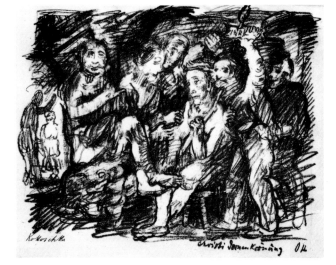

189/2.

189/1.

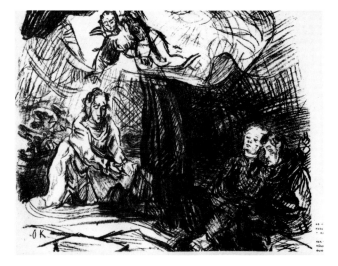

## 189. Die Passion *(The Passion)*

Six lithographs, 1916
Printed by M. W. Lassally, Berlin; Paul Cassirer Verlag, Berlin
As appearing in Der Bildermann, paper size: 35 x 28 cm.
1.  Christus am Ölberg *(Christ on the Mount of Olives)*
26.8 x 31.5 cm., W/W 78, A. 54; Heft 7, 5 Juli 1916, p. 6
2.  Christi Dornenkrönung *(Christ crowned with thorns)*
25.6 x 30.9 cm., W/W 79, A. 56; Heft 9, 5 August 1916, p. 6
3.  Christus am Kreuz *(Christ on the cross)*
26.7 x 31.5 cm., W/W 80, A. 57; Heft 12, 20 September, 1916, p. 6
4.  Auferstehung *(Christ rising or Resurrection)*
25.2 x 30 cm., W/W 81, A. 58; Heft 14, 20 Oktober, 1916, p. 6
5.  Der Judaskuss (Gefangennahme Christi) *(The Judas Kiss or the Capture of Christ)*
24.2 x 28.5 cm., W/W 82, A. 55; Heft 16, 20 November, 1916, p. 6
6.  Das Abendmahl *(Last Supper)*
21 x 26.8 cm., W/W 83, A. 53; Heft 17, 5 Dezember 1916, front page

A separate printing of 50 examples on Van Gelder Zonen paper was made for Paul Cassirer with larger paper size.

Der Bildermann was a war journal, but the wounded Kokoschka shows a religious pacifism after his early enthusiasm for the war effort and change of scene. Suffering is his theme here. His non-political stance was also unusual for the period. The designs for Der Bildermann are full stage scenes, like some Christmas spectacle, with light and shade in Baroque fullness, as if arranged under overhead lights. His intentions grow less Jugendstil and more molded in space. His technique is that of pure crayon.

**190.** O Ewigkeit-Du Donnerwort (Bachkantate) *(O Eternity-Thou Thundering Word)*

1914, lithographs, published 1916/1917-1918
Fritz Gurlitt, Berlin, Wingler/Welz 56-68
Editions:
A Prepublication edition 25 examples on Van-Gelder Zonen each lithograph signed, 66.5 x 31 cm.
Regular edition (1917) first lithograph signed, rest monogrammed, edition 100, 64 x 44 cm., on Bütten paper, in portfolio
B second edition of 1918
13 plates, 56.2 x 46.5 cm., edition unknown, in portfolio
C third edition of 1918
all bound as a book, 55.2 x 41 cm.
pre-publication edition of 1-25 on Holland paper and each lithograph signed
26-125 on Bütten paper, Justification page signed only
Printed by Gustav Ascher, Berlin
There is a small edition of all eleven plates printed in a red-brown ink as OKA-Drucke.

The text of the cantata can be interpreted as both a passionate or peaceful message. Eternity is a thundering idea. Belief in eternal damnation allows a position of fear to be taken. The dialogue form, with reiterated quavers of the music, has question and answer for the end of the world: "Schalle, Knalle, letzter Schlag." *(Sound, Explode, final Beat)*

Kokoschka's interpretation is dominated by a fear of eternity. There is much of the early Jugendstil romanticism in the linear drawing and massed inner design within the figures. The technique uses full tones, little real abstraction and emphasis on the literary message. As much of the graphic material is semi-autobiographical, we can see Kokoschka's face in the man and the image of Alma Mahler in the woman.

In plate four, man is resigned and melancholy before the gravestone, with imposed skull and crossbones. The flying owl can be both a symbol of Satan and an attribute of Christ (Luke 1, 79): "To give light to them that sit in darkness and in the shadow of death, to guide our feet into the way of peace."

Man holds his heart: woman leads the way. Hope and fear are the principle themes of this print. Kokoschka also uses the device of a web, similar to a spider's web, with dual function of unity and motion. It unites the themes. "O Schwerer Gang zum letzten Kampf und Streite." *(O Heavy March to the Last Struggle and Quarrel)*

The music in D Major was written to be performed on the 24th Sunday after Trinity. It was first performed at Leipzig in 1732, while Bach was the cantor there.

The first illustration was taken from Revelations. The reference is to a thundering voice: "and I heard a voice from heaven, as the voice of many waters, and as the voice of a great thunder." (Revelations, 14, 2) The major idea behind this chapter was to warn against spiritual indifference and to elicit courage under persecution. The dragon is described in Revelations 13, 1.

We do not know where Bach found the actual verses, and the poet and source are still unknown.

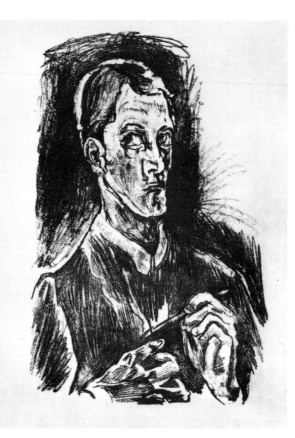

Plate 1.

Plate 7.

Plate 4.

Plate 8.

Verses as marked by the artist on drawings for the set:

Plate 1:
A Self-Portrait

Plate 2:
From the Book of Revelations 13, 1
"Oh eternity-Oh thundering word
Free me from my mortality."

Plate 3:
"Oh eternity, you thundering word
Oh sword, the drills through the soul."

Plate 4:
"The Hope and the Fear"
"A weary road of struggle and resistance,
My Savior is at hand.
The death rattle, the last agony overtakes and
Invades my heart, tortures these limbs."

Plate 5:
"Hope"
"Lord, I wait for thy salvation.
I wait for thy salvation. I wait for thy salvation."
"I show no advance sorrow
When I examine my past.
The fright which makes my heart tremble
Glues my tongue to my palate."

Plate 6:
"The Hope"
"I lay this body before God as a low sacrifice,
The fire of affliction may fiercely blaze,
But then, it purifies me to God's praise."

Plate 7:
"The Fear"
"Death is dreaded by Mankind's nature
It shatters hope,
Almost tears it from the body,
The voice of the Holy Ghost:
'Blessed are the dead.'"

Plate 8:
"The Fear"
"My last rest terrifies me."
"The Hope"
"The hand of the Savior will protect me."
"Both"
"My faith diminishes lower."
"The Hope"
"My Jesus helps me with the burden."

Plate 9:
(Recitativ/Arioso) "The Fear"
"Blessed is death at mans' dying,
From now on."

Plate 10:
"The Fear"
"Now then!
Should I from now on blessed be;
Hope again is one with me!
My body wants no fear in sleep's repose
Where spirit can put joy in each glance."

Plate 11:
"Choral"
"It is sufficient, Lord, when it pleases thee,
So span me out as you will.
My Jesus comes: now goodnight O world!
I travel to the house of heaven,
I journey there in peace,
My great misery remains behind.
That is sufficient, that is sufficient."

**191. Lob des hohen Verstandes** *(In Praise of High Intellect)*

Victor von Dirsztay
With six original lithographs and title vignette by Kokoschka
Leipzig: Kurt Wolff Verlag. 1917, Wingler/Welz 104-109
Lithos printed in the Kunstanstalt Jütte, Leipzig
Text printed by Poeschel & Trepte, Leipzig
34.2 x 26 cm.
1 + 28 + 8 pgs
edition unknown

The enigmatic essay by a wellborn von Dirsztay was illustrated by Kokoschka during his period of recovery in Dresden. The artist met many friends there, including Alfred Ehrenstein, Käthe Richter, and Walter Hasenclever, all of whom he drew.

Von Dirsztay had been a close friend during the early days in Vienna. The author was the son of nouveaux-riches from Hungary, a typically proud and lofty-minded young Viennese, rejecting his gross relatives, a nervous perpetual scratcher, a "Rigoletto", as Kokoschka called him. A creature straight out of a romatic novelette by Arthur Schnitzler, von Dirsztay eventually killed himself.

In Dresden at this time, Kokoschka lived in a boarding house called the Rockfortress, on the grounds of the sanitarium, the White Stag. His mental state was depressed. He wrote of having visions, of seeing other men with blood on their hands, of resisting revolution. He had trouble coordinating his hands.

The tusche drawings for this book are unstudied and quickly done. A suicide, a badly drawn phoenix, the contemplation of a skull, woman commanding man to act as an animal, one man grovelling before another, and an avenging angel make up the illustrations for this uninspired book. It is a continuation of previously drawn themes, over-emphasized by postwar shock. The philosophical background of Viennese attitudes through the critic, Karl Kraus still dominate, though the Austrian, von Dirsztay, had a more lyrical approach to womanhood. Kokoschka vacillated between pain and energy.

He was unforgettably touched by performances of his plays during this time in Dresden and rapidly grew in self-esteem.

192.

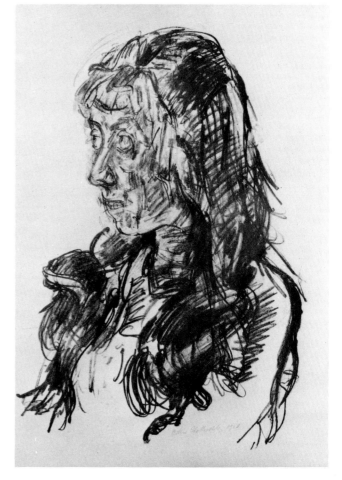

191.

142

**192. Corona I** *(Corona I)*

Lithograph, 1918; published in 1919
Wingler/Welz 126
Signed and dated in pencil
Editions: 25 examples on japan paper
          50 examples on Zanders-Bütten
Printed by Pan-Presse, Berlin
Published by Paul Cassirer, Berlin
55.7 x 40.3 cm.

At least one preliminary drawing in black crayon exists which relates well with the technique of the lithograph. This is unusual, for Kokoschka liked to draw directly, using his eyes to pierce the complex psychological aspects of the human face. He had made over 160 drawings for a painting of his doll, "the silent woman". That human-sized toy had meant a great deal to the recovering artist.

Corona as a lithograph, shows the face turned more towards the side, marking the apprehension and alertness. Her wide-open eyes search the distance.

The technique uses all variations of the crayon. Kokoschka rapidly works in the tonal areas with the side of the crayon, sharpens the end for emphasized thin lines and works over and over the hair and breast with nervous energy. The face is blocked out in short strokes, giving the portrait a nervous aspect which seems to fit the model.

When critics speak of Kokoschka's instinct for the psychological dimension of each model, this is what they mean, and the artist has used the broken technique to bring out this movement, nervous energy and captured mood of the model. The portrait is alive and set in time. It is not universalized, it is personalized. It is wrinkled time, caught in the folds of the instant.

The model, Corona Steven, lived in Dresden. She died in 1957.

193.

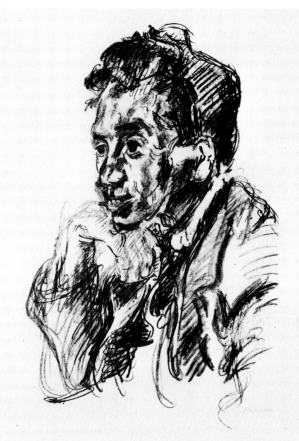

**193. Walter Hasenclever, Brustbild nach links** *(Walter Hasenclever, Bust Portrait toward the Left)*

Lithograph, 1918
Wingler/Welz 118
Signed in pencil
Editions: 25 impresions on japan
          50 impressions on Bütten
Printed by Pan-Presse, Berlin
Published by Paul Cassirer, Berlin
62.1 x 42.3 cm.

This lithograph was made during the period in Dresden while Kokoschka was recovering from war wounds. There is some recovery of powers of draftsmanship. The linear work of early influences is changed for a more baroque roundness. There is some reclaimed self-confidence in his use of crayon, though part of the head is distorted and the hands are less well articulated than earlier work, when Kokoschka had always drawn extremities with loving care.

Hasenclever was the genius of the Expressionist theater, a member of the circle in Prague which included Brod and Kafka. His strong themes, especially the idea of division between age groups and within the family, formed the basis of the new direction in the theater.

Hasenclever was born in 1890 and died a suicide in 1940, while imprisoned in a French concentration camp at Les Milles. His stark prose expressed perfectly the biting concentration of the new German language as used in a rhetorical theater. Characters became types without real names but only general descriptions: mother, father, son. These dramas were really manifestos, new attempts at a psychological legend. They also reflected the political tragedy of the pre and postwar eras.

Kokoschka has caught the face of this intense poet, a man of burning eyes, flattened nose, of charming gestures; the sparkling nervousness, the "eternal youth". He was the poet of lamentation and speech of salvation. By dissecting society at the family roots, he represented the new attempt for timeless values. It was humanistic, though a new view of humanity. The dominating German father figure was attacked unsuccessfully, for it still exists through indolence and thoughtlessness. The white-hot prose moved one generation, but after dazzling performances is lost now. Erwin von Busse produced the Hasenclever play, Der Sohn, on the 22nd of November, 1918, at the Deutsche Theater, Berlin. It was the beginning of the new theater.

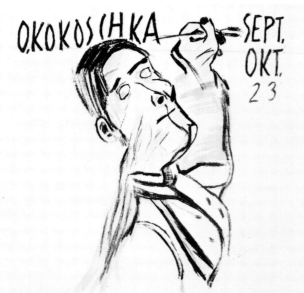

194.

194. **Selbstbildnis von zwei Seiten als Maler** *(Self Portrait from Two Sides as a Painter)*

Color lithograph Poster, 1923
W/W 164, Printed by J. E. Wolfensberger, Zurich
Published by Kunstsalon Wolfsberg, Zurich
Image: 125.2 x 88.2 cm.
Paper size: 127.2 x 88.2 cm.

Most of Kokoschka's self-portraits are melancholy. His Austrian gaiety he left for his social communication. In this strange self-portrait of the later years, the artist reverts to his use of a profile and full face in simultaneous form, first seen in the drawings for Mörder, Hoffnung der Frauen. His use of the split forms is never carried with the full heroics of a Picasso, and it seems less schematic in Kokoschka. The years of 1922-1923 were times of great progress in the watercolor medium. The use of clear color is perfected, as an end of the Dresden Expressionism. After this time Kokoschka made many journeys, devoting himself to the landscapes and views of cities.

*About Kokoschka*
by Albert Ehrenstein

You are one of light,
At sunrise of the red sun,
What black stillness lurks in darkness,
Moves from you towards the turning clouds.
Stillness balances on the edge of decay,
Chaos measures the mountain's precipice.
Lower life is pregnant,
Love is greedy and not pregnant,
The creation gives you only work,
Floating in the lights of powerful storms
Breath pure and shielding the ether.

From: Zeit Echo, Heft 20, 1915, page 298

## KARL HOFER

Hofer was an energetic, prolific artist who as an individual was inaccessible. His was a brittle, frequently dogmatic, aloof manner, and his works often communicate the same unengaging qualities. Hofer's congenital antimodernism led him to perceive himself as the upholder of eternal verities against an age which could inspire only a vacuous formalism. His conservatism was rooted in a classical humanism inspired by the late Goethe. Hofer's was a social critique; he inveighed against the dominance of science rather than symbol, and denounced the avant-garde, especially nonobjective art, as the reflection of the soulless premises of contemporary life.

In the late 1890s Hofer was an unqualified romantic who sketched brooding, nocturnal images. He was soon caught up in the early twentieth century German striving to articulate a new German style, but even in his youth, Hofer turned to traditions for solutions. Instead of building on the discoveries of van Gogh and Gauguin as did the Brücke, he turned to the Deutsch-Römer. It was Hans von Marées, Conrad Fiedler, and Adolf von Hildebrand who set the limits within which his oeuvre would evolve.

He therefore moved to Rome in 1903 and remained there until 1908. In Rome, Hofer abandoned the romantic excesses of his youth and developed a classical style. His forms became heavier and more sculptural, his colors matte and dull. His artistic life was a perpetual conflict between the romantic and the classical modes, a not uncommon German dilemma. The suppressed romantic surfaced sporadically, but Hofer's essential formative impulse was classical.

In 1908, concerned that his work was becoming too sculptural, Hofer moved to Paris. Even there he chose to identify with the past. He copied El Greco, Delacroix, and the Impressionists, but shunned Matisse and Picasso. Cezanne he absorbed into a conservative structure derived from Marées. His palette, however, brightened, his brush work became more fluid, and he painted romantic themes.

Hofer remained in touch with the German avant-garde. In 1909 he was briefly a member of the Neue Künstlervereinigung, München, and knew Franz Marc and August Macke. In 1913 on his return to Berlin, he exhibited at the Herbstsalon and held a successful one-man show at Cassirer's in 1914. The critical response was most favorable. August 1914 caught him vacationing in France where he was interned until 1917 when he was released to neutral Zurich. In 1918 he returned to Berlin an Expressionist.

By 1920, however, the classical Hofer reasserted itself and he began constructing the strictly delimited, tightly structured, airless spaces which have come to be associated with his name. He sought "pure being," and it was the achievement of this denatured image which made much of his work unengaging. Hofer strove to evoke a serene world immune to the exigencies of everyday existence. The vague undercurrent of melancholy which suffuses his works was perhaps the recognition that the the search for immutables in form and space, as in life, was in vain. The 1920s brought increasing recognition at home as well as abroad. From 1925 he exhibited regularly at the Carnegie Internationals, and in 1928 was invited to serve on the jury.

By 1928 externals began to forcibly intrude into Hofer's world and his classical structure accommodated disquieting, expressionist communications. The expressionist and the classicist always coexisted in an uneasy equilibrium in Hofer's oeuvre and after 1928 the former became more evident. His essential humanism led Hofer to liken the artist to a seismograph, sensitive to fluctuating psychological pressures of the times. In this relationship with disquieting times lay the source of Hofer's Expressionism.

Essay by Ida Katherine Rigby

195.

195. Zwei schlafende Mädchen *(Two Sleeping Young Women)*
Pencil drawing, ca. 1922/23
Initialed in pencil
36.8 x 43.2 cm.

The early etchings and woodcuts are derivative, influenced by Munch, Böcklin, and others. Hofer used massed forms of dark against white figures. Later (Rathenau 3, 4, 5, 6, 7) he reverts to a childish realism taken from Ludwig von Hofmann and Wilhelm Leibl. There is little personal style, though in some (Rathenau 29, 31, 32) the energy of the later Hofer is already compelling. From 1903 until 1924, there were no more etchings at all. The five early lithographs resemble the mystical symbolism of Redon, especially Rathenau 4, a tree growing around a face resembling Ibsen's. This is all until the illustration for Shakespeare Visionen of 1917-1918; and one wonders if Hofer became uncertain in these media where there is no margin for error. By 1919, when he took up graphic techniques again, Hofer had perfected his style, and was a strong and sure artist with maturity and confidence. His experience had been partially formed through travel and study in Italy and the Indian subcontinent.

Karl Hofer had some relationship with German Expressionism, familiarized himself with the dialogues about volkism, civilization and community, inner visions and social developments of his time. But his major interest in structure was a dramatic contrast. Hofer's emotional content is expressionistic, but related by form and content more to El Greco and the late expressionistic watercolors of Cezanne. Hofer is never as spontaneous as the Brücke painters; and he adds more remoteness and classi-

cal modelling to his subjects than the Blaue Reiter painters.

The careful drawing for the *Two Sleeping Young Women* would be foreign to most of the other Expressionists. It has none of the linear activism of the postwar realists. It has none of the political overtones of these later activists. The style seems to be that of 1922-1923, and this is suggested by the vertical shading of the hair (see Liebespaar, lithograph, Rathenau 23).

The theme of interwined women was repeated by Hofer. This variation in drawing has a peacefulness, none of the protective gesturing of other and similar oils and drawings. Interlocked bodies provide a fine study in angularity and spacial volume. Dr. Ida Rigby calls these compositional rather than thematic considerations. She suggests a central interest in the formal impulse rather than in a deep erotic meaning. Hofer was a closed and reserved man. He had a methodical and totally determined personality. Bernard Myers comments on the "powerful erotic outlook" of Hofer. There is a frank and powerful interest in the carnal, but a reserved and poetic one.

Hofer held to his individual and human approach, which he thought (with Goethe) determines the incommensurable. He rejected both formalism and playfulness. He fiercely fought the internal and external simplifications which relate the forms of nature to a universal understanding. "If you want to recognize the invisible, look exactly into the visible." This was a middle ground for modern art: it needed denaturing. Hofer found this in his search for pure being, which had to be abstract as a perfection of types. Hofer's never-ending search found major accomplishments in passive and time-frozen figures.

Karl Hofer
*What is German Art?*
In Omnibus. Almanach für das Jahr 1932 (Verlag der Galerie
Flechtheim, Berlin und Düsseldorf, p. 53-54)

When before the war an obscure German painter published a
pamphlet against French art and its influence in Germany, he
experienced an energetic defense by the closed ranks of the
best German artists and the German public interested in the arts.
If such a publication appeared today, though to be discussed
seriously it would have to originate not from stupid chauvinism
but from truly German "volk" opinion, it would not encounter a
solid front of resistance. On the contrary, it would find approval
everywhere, even the sensible French would agree, since now
one is not interested in how the German paints French, but in
how he paints German.

There has been a change within several decades.

For the few German artists of my generation (who like me got
into the sharpest opposition to the ruling naturalistic-
impressionistic art with their first creations) there was around
the turn of the century no school, no teacher, and, above all, no
living tradition which could have transferred even the most
primitive elements of the new formative arts. One had to hoe the
ground oneself, where the beginner today finds ripe fruits. So it
is understandable that my generation and the one following
found guidance and stimulation from the great French art, from
van Gogh, and from Munch. Without these forerunners the
German art of the present is unthinkable. The German artist
was not imitating strange elements, but rediscovering creative
elements which are common to all great art of all nations and all
times. These elements were forceful in our old German art, and
came to light again, isolated in single personalities like Runge
and Marées, whose traditions were never interrupted in France.

So it was not farfetched that one looked outside for things
which were not to be found at home, and went where the mas-
ters were. Of course there were also artists, recognized today,
who stayed at home and, not sure of their own natures, paid
homage to the ruling Impressionism, though this had not been
born in Germany either.

Since we have now learned the abc's of artistic creation and
can discuss them, it is a natural demand that we speak German
in art.

Now, what is German? This question is not to be answered by
ignorant narrow-mindedness. It needs the understanding of
the informed who can distinguish between superficial imitation
of foreign art and transposing universal values into one's own
language.

It is impossible to divest ourselves of all that we have taken in
terms of morals, ways, language, culture and art forms from
other peoples, and which we consider justifiably as thoroughly
German. We can be proud of what we have made of these. We
are today the only nation whose art as a whole can stand up
next to the French. Not through an attempt to present our na-
ture in national specialties, but on the higher plateau of univer-
sal forms in art.

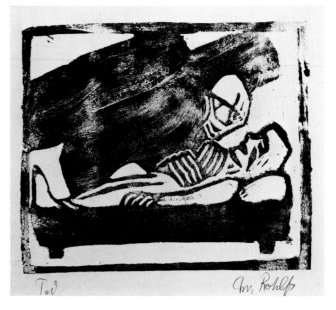

196.

Karl Hofer
*Answer to the inquiry about "A New Naturalism"*
Das Kunstblatt. Heft 9, 1922, page 405-406

It is not difficult to create nature-like illusionistic images with
the utensils of painters and sculptors. It is just as easy to create
self-creative abstract images with the same patient material.

It is difficult or better to present the inner expression in a uni-
versal and understood language of the shapes of nature. It is
not through chance or exaggeration but through an under-
standing simplicity, which contains everything, or by giving all,
which is adoration, not copying as fools believe.–Ways of
south and north, orient and occident.

"If you want to recognize the invisible, look closely at the visible."
(Talmud)

From the center of the fine arts, whose narrowness the roaming
ones do not perceive, looking into the heights and the depths!
Vertical. An inability to do this drives them into the distance,
into the lowlands of sensualism or at outweighing intellect
beyond that, into its opposite pole, horizontally into the fields
of literature (earlier), nowadays into the fields of music, meta-
physics and science in general.

On the other hand, we know certain regions of the fine arts ex-
perience a helpless description of nature, program music and
tone painting.

Peripheral appearances are always interesting and exciting
(the odium of the new, a puzzle)

There might be a way of honoring Cubism as a kind of contra-
position in painting, and giving it a special place. Maybe as a
diagonal (force) which must diminish into nothing, or turn back
as a thing severed in formalism or as a toy. For the European
artist of our time, the individual human is decisive. The great
anonymous labor out of the need of the masses creates the
technique. Everything else remains busy-bodying and silly
babbling.

There is also the problem whether Naturalism and Verism can
be explained as natural reactions. A work is not great because
of, but in spite of, the school to which it belongs. The rest, which
does not fit into the definitions, the incommensurable, of which
Goethe speaks, begins where the word ends, and ends where
the word begins: The Human.

## CHRISTIAN ROHLFS
196. Der Tod *(Death)*

Woodcut printed in blue-black, ca. 1912/13
Signed and titled in pencil
Vogt 64
20.3 x 24.1 cm.

Christian Rohlfs was born in 1849, before most of the other Expressionists. Perhaps allowed to become an artist because of an accident on the family farm in northern Germany, he developed his precocious talent for drawing. His training was along strict academic lines, which meant careful study of antique casts, realistic life drawing and little intellectual education. Later Rohlfs decided it was necessary to make a self-effort towards intellectual betterment. Rohlfs was a fairly conservative painter until a great personal crisis at the age of fifty.

Appointed artist in residence at the Folkwang Museum, Hagen, Rohlf's crisis was influenced and overwhelmed by the fine collection of modern and primitive art, classical and modern applied arts assembled by the great collector, Karl Ernst Osthaus, for his personal art museum. The changes in Rohlfs' symbolism can be traced to this time. He also met the Brücke and Blaue Reiter painters after 1904-05. Der Tod dates from this period, after the emotional change in value relationships.

Rohlfs was an isolated individual who liked solitude and study. His minute investigation of the small world around him kept influences limited to this eastern city of Hagen. He had experienced thirty years of brooding and personal development. His move into the realm of modern art came at maturity, when he had searched and found something of peace and concentration. He began to compact subjects into symbols, using the simplified abbreviation from his northern background of rhythmic peasant life and closeness to nature. There the circle of life and earth was always close. Death was not a mystery.

The symbolism for this woodcut is taken from gravestones and medieval sculpture, but mostly from simplified folk art. These simple people emphasized the baseness of flesh, of vanity and earthly ambitions. The cold blue color lends a mood of stillness and desolation.

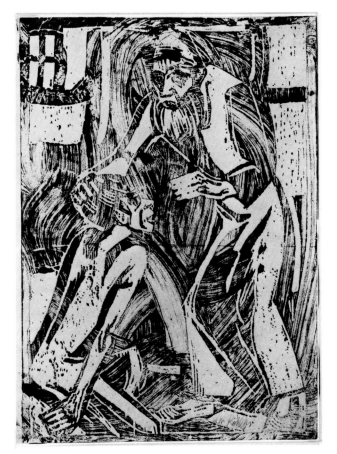

197.

197. Rückkehr des verlorenen Sohnes *(Return of the Prodigal Son)*

Woodcut in black ink on brownish paper, ca. 1916
Signed in pencil
Vogt 99
49.5 x 36.5 cm.

All his mature life, Rohlfs was impatient with conventional methods. They seemed to interfere with his nervous energies and the inner creative image of what he saw.

In this woodcut, the block was not inked with a roller, but brushed with a heavy pigment, full-bodied, which allowed the artist to retain his brush strokes in the final impression. The separated brush strokes are united to animate the flat surfaces of the dark uncut areas. Circular movements round the upper design and curve left toward the lower edge. This general sweep of detailing adds much animation to the surface, though it is controlled as a wood grain is not. The interruptions by white, cutaway surface patterns create the actual balance rather than the darks. The integrity of the darks is reversed into a kind of action line above the symbolism which makes the comforting motions of the father more alive.

The theme of the return of the prodigal son was a favorite for this artist, and was used again and again. It was one method of returning to biblical themes and removing himself from the present.

198.

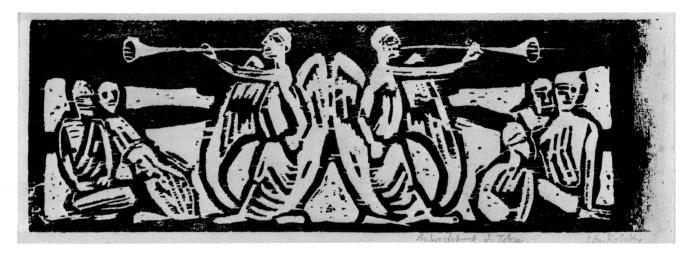

198. Auferstehung *(Resurrection)*

Woodcut printed in black, ca. 1917
Signed and titled in pencil
Vogt 105
13 x 39.6 cm.

In the northern area of Schleswig-Holstein, Rohlfs' birthplace, myth and grotesqueness combine with common introspection. Bravery in adversity was common. New religions, new political movements all came from this land of isolated thinkers and dreamers. It is a land of mysticism.

Christian Rohlfs was not afraid of new approaches either. He used both vigorous lines and great lightness of effect.

This is a print made by an artist horrified by war, though over-age and unfit for military service. His emphasis turned to paramount religious symbols. He led a life of further isolation after some social movement before the war.

The format is formalized and made unreal. Central, trumpeting angels sound the resurrection to paired persons alongside. These pairs hold each other for comfort. There were other prints in this death series and this may be the least gruesome. It is a work of end and beginning, a symbol of war's aftermath and the breakdown of European society. Rohlfs, like many of the Expressionists, goes back to the eternal, his center of greatest power.

199. Tod mit Sarg (Tod als Sargträger) *(Death with a Coffin or Death as Casketbearer)*

Woodcut printed in brown ink, mounted by the artist on yellowish paper, ca. 1917
Signed and titled in pencil
Vogt 104
21.5 x 15 cm.

This brown image from a woodblock is small but strong. All the structure in the death image is refined to a few lines, much like the medieval popular image before flesh was added for such symbols in Baroque times. The abstraction separates the spectator from reality, but careful articulation of the image by the artist gives life to the grotesque humor. It shows we might imagine death through centuries of symbolism, but not experience. The inner mind is usually violent and imaginative before the symbol.

An amused Death carries a coffin. He waits for the next rider. The coffin is carried lightly on one shoulder. Rohlfs has picked out certain bone structures to counter the dark mass of the coffin, but arranged to lead the eye up into the mysterious dark mass which touches two sides of the dark border. The arched leaf formations and simplified fingers disappear into the window of the white heat of anxiety. Only inner emotion captures the eye with simple line made symbolic, made terrifying, made moving.

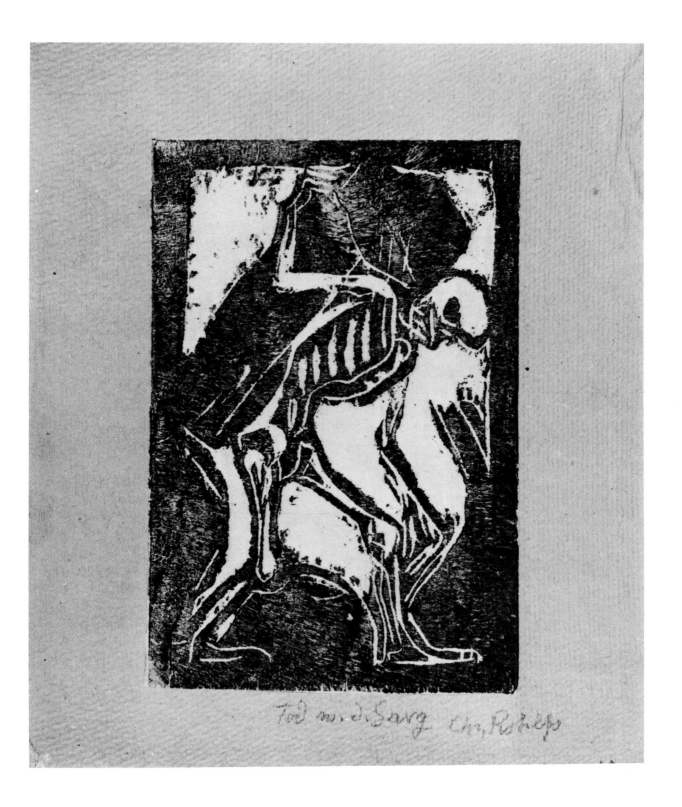

Tod im d Sarg Chr. Rohlfs

**199.**

# EGON SCHIELE

**200. Shaw oder die Ironie besser als Shakespeare Conference, Vorlesung Dr. Egon Friedell, Vortragender** *(Shaw or Irony Better Than Shakespeare Conference, Lecture Dr. Egon Friedell, Speaker)*

Poster, two-color process print (reproduction), 1910
23.0 x 13.4 cm.

The great series of self-portraits culminated in this grimacing face, which was adapted from the Nude Facing Front, a pencil and gouache of 1910. Distance became a kind of symbol for writers and painters who were engaged in social criticism. Karl Kraus had made the expression into a long dialogue of linguistic criticism. This poster was used for Dr. Friedell's lecture, and later for an announcement of a modern concert. Even later it was the cover of a short-lived magazine called Der Ruf, which had a total of five issues in two parts (late 1912 to early 1913). Schiele's plate was used for the third issue of November, 1912.

To a German audience, George Bernard Shaw's criticism of Shakespeare was at best a novelty, and at worst an egotistic mistake. Though Shaw based his criticisms on socialist theory, the prominent scholar Dr. Egon Friedell introduced Shaw's ideas for discussion by the conference in all Teutonic seriousness.

Facial emotion made up Schiele's group of self-portraits, but the translation for reproduction strengthened the decorative shading and made the image violent. The full-length figure was cut off at the top of the head and just under the chin. Focus was put in the center on the white eyes and white teeth. These malicious eyeballs create a sense of energy. The mouth seems a center of stress for Schiele. It is an intimate glance as though through a one-way mirror into a private act. It was also a personal joke, for Schiele means "squint" in German.

Not drawn from life this design shows concentration on pattern and edging. It is compressed in the borders and does not have the grand sweep of a draftsman sitting with pad on knee noting linear complexities from nature. It has become a decorative exaggeration.

200.

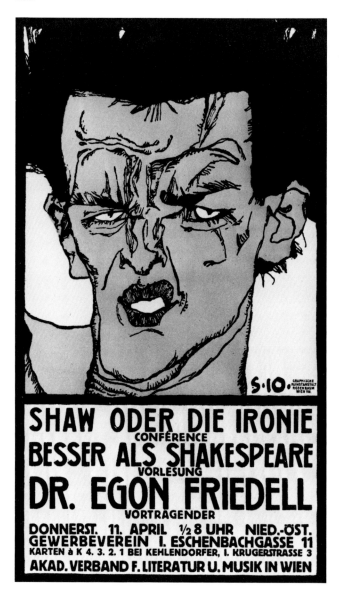

**201.** Männlicher Akt (Selbstbildnis) *(Male Nude or Self-portrait)*
Ink and Brush Lithograph, 1912
From the portfolio Sema, 15 Originalsteinzeichnungen
Delphin-Verlag, Munich, 1912
Edition of 215 numbered copies
Nrs. I-XV on heavy japan paper
Nrs. 16-215 on yellowish vellum paper
42 x 21.5 cm.
Stone effaced, Kallir 162

Schiele was invited to join the Sema group in 1911. These artists were based in Munich. Schiele sent two transfer lithographs, one of which was used in the portfolio.

Transfer lithographs are drawn with regular lithographic tusche and crayon on a specially prepared paper. The finished drawing is placed face downwards on prepared limestone and rolled through the press under pressure. The image is thus transferred by pressure to the stone. It is then treated in a normal preparation for printing: dusted, etched, and rolled up for printing.

By 1912, the twenty-two year old artist was finishing a long series of self-portraits, much as the young Rembrandt had done. Most facial expressions were studied as well as physical gestures, which matured into a style. The progressive studies began to develop into emotionally charged, thinly fleshed presences, which assumed the realities of Schiele's nervous intentions.

This first print is done in the regular technique Schiele had developed for his drawing, using tusche ink instead of watercolor, and brush instead of chalk. The darks are heavy handed, without the delicate inner variations of ink, for tusche merely covers the surface with wax and does not vary in transparency as watercolor does. Since the printing was done without Schiele's control, his intentions were probably not fully carried out.

Schiele's Expressionism here becomes fully developed. His self engrossment at this time emphasizes the body with arms cut off at the elbows. The frowning face tips forward. He presents a brutalized version of the mirror image, which he seems to have preferred. Jugendstil line is broken into sections by carefully placed shading, which moves contours forward and backward in rhythmic interrelationships. The work seems a tormented man in an isolated, self-conscious pose.

201.

202.

**202.** Bildnis Arthur Roessler *(Portrait of Arthur Roessler)*
Drypoint, 1914
Signed and dated by Schiele; signed by Arthur Roessler
24.2 x 32 cm.
Before steel facing,
Kallir 82

Roessler had given Schiele money to buy tools and plates for this new technique. Fritz Gurlitt had expressed an interest in the prints, and a graphic artist named Robert Philippi provided some instruction in etching and drypoint methods. Schiele's first etching was a small plate depicting a man's head. It was cleanly wiped without tone. The second etching was a small self-portrait. It had some surface scratches, possibly from mishandling. The third etching was done in the Jugendstil style, with abstract cross-hatching and loose swirls. Perhaps the artist had seen the possibilities of a scratched tone from his earlier accidents, for the next print had an all-over tone made by drawing sandpaper in parallel motions over the entire surface leaving a textured tone. He continued this technique in the next two works.

The last dry-point on copper is the portrait of Arthur Roessler. It has a very textured surface.

This portrait has gone through three editions. The first probably had about thirty-five to forty impressions. The second, made after 1921, had eighty impressions pulled from a steel- faced plate (in this process the copper is coated with a thin steel surface by electroplating). A third edition was pulled in an edition of eighty-five in 1969.

About 1910 a small group of friends had begun to promote the young painter. Arthur Roessler and his wife, Ida, gave the painter many opportunities, opened up their vast library, and engaged him in constant dialogues, which removed some of his loneliness. Roessler was an influential man, an art critic for the left socialist newspaper Arbeiter Zeitung, which had a large following among intellectuals and trade unionists. Schiele and Roessler carried on their friendship and lengthy correspondence all through Schiele's brief life.

Roessler was a man of expressive gestures. Photos show his posing stance, which Schiele copied from his own photographs. The preliminary drawing for the drypoint (in the City Historical Museum, Vienna) has more realism. It is an outline in perspective without much inner emotion. In the print, Schiele did not understand how to translate faint lines or light tones into the calligraphy of drypoint. Instead he uses perpendicular shading against the line to soften the outline, and he abstracts the eyes.

The drawing probably was transferred by tracing, as the beautiful draftsmanship of Schiele's freehand style is lacking. Attention is on details in the line, not on the sweep of delicacy found in the drawing. The blocked-in square shading is heavy, defeating the horizontal movement.

**203.** Secession *(49th Exhibition of the Secession)*
49 Ausstellung
Lithographed poster in three colors (red, yellow, black)
1918
After the oil painting "The Friends" (K. 15)
Size with text: 63.5 x 48 cm.
Printed by Albert Berger, Vienna
Kallir 15
Unknown edition

This use of lithography is an interesting technique, one that modern graphic artists have rediscovered. A painting is photographed; this is transferred to a stone. Color separations are then drawn by the artist directly on the first proofs. These are made into plates and printed over the reproduction. The resulting final impressions are a combination of reproductive and original methods, placing the poster in a category of marginal prints. We can assume that Schiele would have made a master block without photographic transfer if he had been willing to take the time.

The poster was designed for an exhibition at the Secession building in Vienna. It was Schiele's first great one-man show, and signaled beginning financial success. Schiele had a building to himself, showing nineteen large paintings and twenty-nine drawings. His associates showed in another room. He had commissions, offers of other exhibitions, and a new garden house. His wife Edith was expecting her first child. By the end of the exhibition in May, 1918, Schiele was planning monumental paintings. But by November, both Egon Schiele and his pregnant wife were dead of influenza.

The subjects of this poster have been analyzed by various experts. Several persons have been identified. The empty chair is supposed to symbolize the recently dead Klimt as a titled drawing for it exists. The person heading the table is perhaps Schiele. Others might be of the "Neukunstgruppe," with whom Schiele had shown at the Kaisergarten on the Prater, in 1917: Paris von Gütersloh, Faistauer, Harta, Nowak, Kars. Schiele also saw this as a "Last Supper", for he had begun preparation for a huge canvas. However we interpret the symbolism, as a composition the theme is an extension of Schiele's earlier works around the monkish theme, which he had taken from Klimt. The group seems quiet, secluded, men with cropped hair, long gowns, intently absorbed in paper, drawing, and reading. In Viennese thought, the artist was a frontrunner in the race towards progress, though a less obtrusive influence than the linguistic propagandists in this verbal society. As medieval monkish orders kept alive the traditions of the humanities, so too this modern order of painters keeps alive the tradition of Secession or advancement into the modern age.

203.

## KÄTHE KOLLWITZ

**204.** Sieben Holzschnitte zum Krieg *(Seven Woodcuts About War)*
7 woodcuts in folio covers, 1922-1923
Dresden: Emil Richter, 1924
Editions: Ausgabe A—100 impressions on japan paper, paper size: 66 x 47 cm. Each woodcut signed. In folio covers of yellowish vellum on which is printed plate 4 ("Die Witwe I"); with table of contents printed on the inner side of the front cover. Folio size: 67 x 48.3 cm.
Ausgabe B—100 impressions on yellowish vellum, paper size: 54/55 x 45/47 cm. Woodcuts unsigned, no folio covers or title page.
Ausgabe C—200 impressions from a zinc plate (reproductions) on yellowish vellum, paper size: 68 x 49 cm. Unsigned and unnumbered, frequently stamped with facsimile stamp in lower left. Later edition in 1949, all blind-stamped.

The seven woodcuts in order of appearance:
Plate I: Das Opfer (The Offering), 1922-23, Klipstein 177, 37 x 40 cm.
Plate II: Die Freiwilligen (The Volunteers), 1922-23, Klipstein 178, 35 x 49 cm.
Plate III: Die Eltern (The Parents), 1923, Klipstein 179, 35 x 42 cm.
Plate IV: Die Witwe I (The Widow I), 1922-23, Klipstein 180, 37 x 21.5-22 cm.
Plate V: Die Witwe II (The Widow II), 1922-23, Klipstein 181, 30.5 x 53 cm.
Plate VI: Die Mütter (The Mothers), 1922-23, Klipstein 182, 34 x 40 cm.
Plate VII: Das Volk (The People), 1922-23, Klipstein 183, 36 x 30 cm.

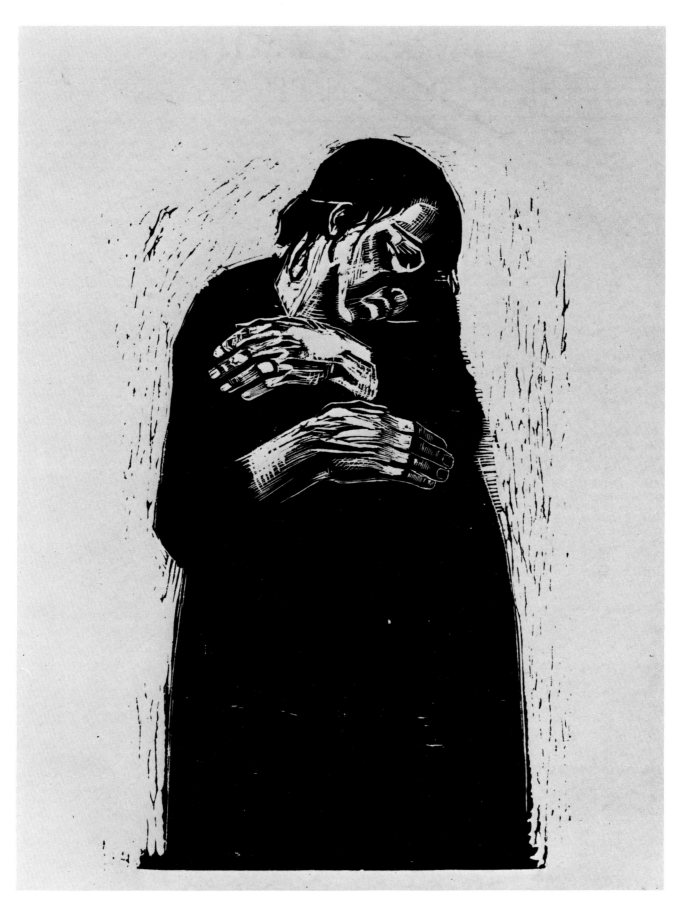

**Plate IV.**

Begun as etchings, the technique later became the woodcut, after the influence of Ernst Barlach, a close friend, on her conception for the 1919 memorial for Karl Liebknecht, in this stronger form. The stark, intense woodcut technique finally satisfied the artist. The series was finished late in 1923 and published the following year. There had been a full year of changes and variations on the seven subjects.

Kollwitz described the theme as not subjective but representing mankind's "suffering during those unspeakable years." It is a work of deep pain and anguish. The opposite of a super patriot, her never-forgotten tragedy was the death of her son, Peter, on October 22, 1914, on the Belgian front.

Though Goethe probably was the most influencial writer in her life, Kollwitz also read works of the then modern writers: Dostoyevsky, Zola, Gerhart Hauptmann, Hugo von Hofmannsthal, Gorki. The expressionist themes of later life are not the balanced humanism of the Weimar scholar. Kollwitz shows us beauty as a spectrum of entire human life, not in personal proportions nor naturalistic perfections. She drew her vitality from the lives of common people.

War as a theme can take various courses. Callot reduced figures to small animations in a stage-like landscape, with action appearing distant from us. This was a deterministic outlook: the participants have no control of their destiny.

Goya shows victim and oppressor. Gruesome realism is cast in a minimum landscape without details, and with an emphasis on the cruelty of man to man. Such sadism and pain are almost impossible to view. It is a reinforced naturalism for propaganda purposes.

Kollwitz shows us only victims. The leaders never appear. These subjects are common people caught in a common tragedy.

The series has a rhythm of three horizontal prints interrupted by a vertical pillar, with horizontal movement stopped by a black rectangle in the final print. The artist has varied from white outline to inner motion, from horizontal movement to white on black. Delicate lines are used for some details while brute force from a broad chisel creates a contrast of brilliant starkness.

The intellectual content is deterministic, not from free will. Birth places the child in the flow of tragedy, the floating soldier follows Death as a drummer. Variations of this theme include parents, widows, protecting mothers and common people. Volk, here, has a deeper meaning than "common people," for in German history of the nineteenth and twentieth centuries, the word "Volk" meant an entire historical unity, a continuity of culture. The destruction and pain were meant for the past as well as the future. Again, actual historical detailing is not used, but stylized, rather medieval cloaks and gowns place the action in a generalized area of history. The plates themselves are full of the inner tension of the Expressionist movement, though the forms are rather sculptural and massed more than the modern would allow.

The technique is woodcut, cut on pearwood, a fine-grained material with a slightly oily surface. It allows fine cuts or holds wide areas without splitting away at the edges. It compresses well under the printing press.

The first two plates set the theme: *The Offering* and *The Volunteers.* Germany had entered the war in a mood of self-denial for the fatherland threatened by outsiders. Government-controlled propaganda made this seem apparent, although the leaders were forced into war by indecision and, mostly, incompetence. Every patriotic mother expected to offer her son. The volunteers were carried away by this message of giving, of self-sacrifice, but Kollwitz shows them in somnambulation, ecstatic movement, uncontrolled in column following a figure of Death beating on a drum. They moved towards destruction, unable to hold back. Their necks are bared to the knife.

The tragedy is brought home in the next plate, which has dramatic outline and scratched inner lines, sketched quickly with a sharp point. The kneeling couple is formed in a massed expression of sorrow. Faces are hidden and mood is reinforced by angular line and related to historical, religious poses.

The next plate, *Widow I,* is more carefully cut as a vertical column, with some silhouetting by use of a lowered surface. The pose is Egyptian, with head at a right angle to the body, a reader in *The Book of the Dead.*

*Widow II* is either a suicide or a woman fainted after hearing of death. Studies began early for this pose, taken somewhat from Holbein's painting of the dead Christ. The body is cast into light and shade by horizontal sweeps of white line, graceful and fearful lines, stopped by the pitiful feet and the frozen head. The child's body forms an arc under the long curve.

*Mothers* is the next title, also made into a sculpture. The details were studied in many drawings. The form had special appeal for Kollwitz, these massed people protecting children with their bodies. The people are simple mothers driven into rigid and unseeing compression by the white distance of real evil, which arouses their protective instincts.

The last plate is called *The People.* It here shows anguish, calm protection, fear, passive sadness, and indescribable horror in the face of the child.

This great woman, this great humanitarian, has cut her record of experience with great artistic power.

Plate I.

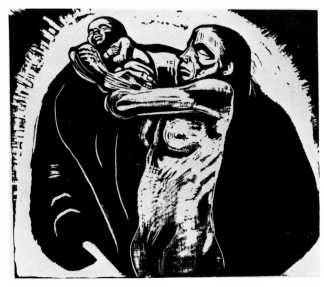

Plate II.

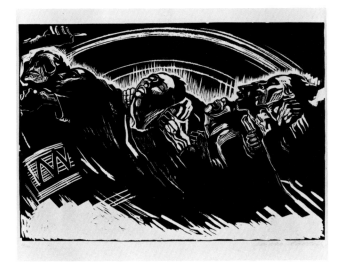

154

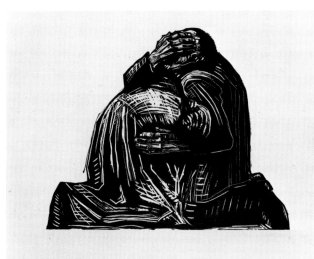

**Plate III.**

**Plate V.**

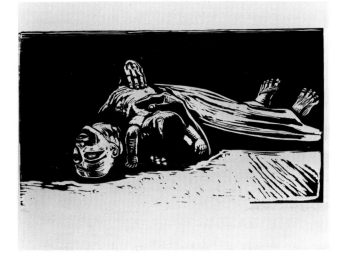

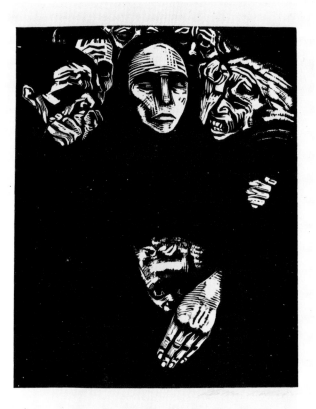

**Plate VII.**

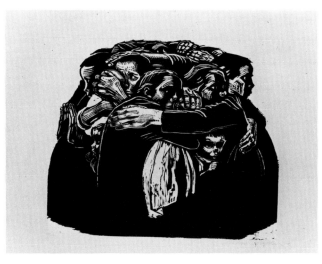

**Plate VI.**

**205. Selbstbildnis** *(Self-portrait)*
Lithograph, 1924 – Kl. 198a
Japan paper – 29 x 22.5 cm.,
signed in pencil
ed. 25 for deluxe edition of Kreis graphischer Künstler und Sammler, Leipzig.

This large lithograph has been cleaned of all extra detail. It concentrates on the expressive features only. The artist has gone through great personal tragedy, as well as defeat for her ideas about social progress. She had seen the starvation in Germany, Austria and Russia which killed millions. 1924 was a year of strikes and struggle. Yet it was a very productive year for Kollwitz. But this searching and penetrating self-portrait stands out among all the work done then and among all the other self-portraits. It is the most alive. It is the most concentrated, powerfully and simply drawn, perhaps accusing.

The technique is all crayon, virtuosity with the medium. The side and pointed end of the crayon are used as needed to set the exact tones for the drawing. It has no look of peace and inner contentment. There are no corrections for mistakes.

205.

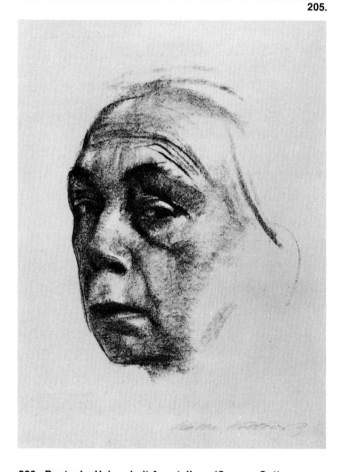

**206. Deutsche Heimarbeit Ausstellung** *(German Cottage Industry Exhibition)*
Kl. 209 II
34.3 x 42.7 (68.5 x 46.5)
lithograph poster, 1925
signed in pencil

206.

The later Kollwitz had foregone her advocation of revolution, especially the varieties of retaliation with guns. She described herself as an evolutionary. She never lost her desire to give revolutionary messages. This poster of German Home Work was shown by the Society for Social Reform, Berlin. There was a charge for admission of one Mark. The message of resignation is formed in one-half of her work. The other half shows the energy of life, with laughter and the simple pleasures of the common people.

**207. Maria und Elisabeth** *(Maria and Elizabeth)*
woodcut, 1928
36.1 x 34.8, Kl. 234, Va
signed in pencil on japan paper, unknown edition.
Published by Euphorion Verlag, Berlin

This is Kollwitz's only apparent biblical subject. Elizabeth, on the left, is pregnant with John the Baptist, while Mary, on the right, contains Jesus.
Luke: 1:39: "And Mary arose in those days...into a city of Judah.
And entered into the house of Zacharias, and greeted Elizabeth.
. . .
And why is it granted to me that the mother of my Lord should come to me?
. . .
And His Mercy is on them that fear Him from generation to generation.
. . .
He hath put down the mighty from their seats, and exalted them of low degree.
He hath filled the hungry with good things; and the right He hath sent empty away"

This is the message of common goodness which is told so simply in this woodcut.

The technique is simple. Edges are lightly cut. There are no sharp outlines, but edges are softened by sandpapering. Most of the cuts are made with a small chisel, which follows the direction of the woodgrain in the block. The two figures are placed against a roundish pillar as though in bas-relief. The horizontal shading gives a peaceful balance to the curves. The three woodcuts of this subject have an interesting change from white and black, through pure line to this soft, maternal meeting in darkness.

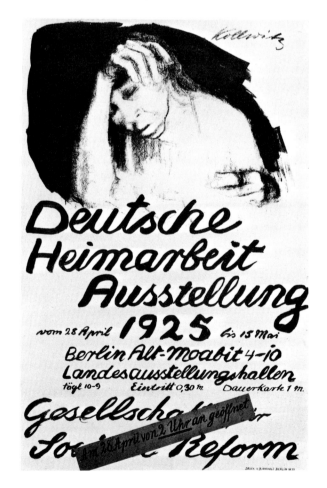

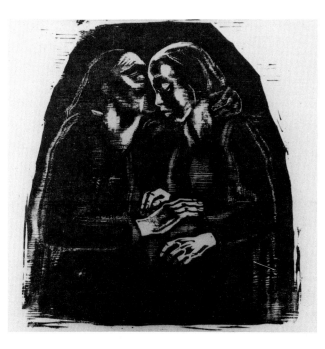

207.

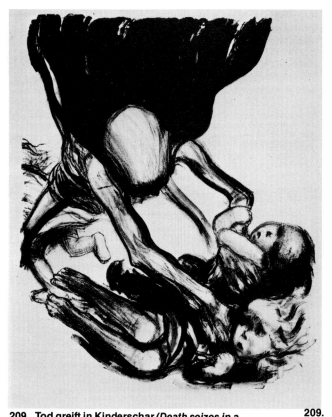

209. Tod greift in Kinderschar *(Death seizes in a Multitude of Children)*

lithograph 1934
50 x 42 cm., KL. 258, unsigned
plate 3 from series: Tod *(Death)*

209.

208. Selbstbildnis *(Self-Portrait)*

lithograph, 1934
20.8 x 18.7 KL. 252 b
proof before edition (of 80 impressions)
signed and dedicated in pencil

208.

In 1928, Kollwitz had been appointed a servant of the German civil service, as instructor of advanced drawing at the Prussian Academy of Arts, Berlin. She had also received public honors, including the Prussian award of highest standing, "pour le mèrite." She had suffered through illnesses in 1930.

The struggles for political power between the Nazi and Communist forces had come to a head in street battles, which the police used to crush the leftist workers. The Nazis had come to power in some of the German states and quickly moved against modern art works. She lent her name and work to a series of revolutionary sponsored exhibitions. She had finished the memorial to her son Peter and to all dead soldiers.

She had worked on other sculptures, including the life-sized self-portrait from 1926 to 1936. The pose is similar to that on this lithograph. Her beloved husband, Karl, developed cataracts in both eyes and remained a constant worry to her during this period.

The drawing in this lithograph is concentrated on the face. The details are cast in gloomy shadow. The eyebrows are less ridged than in the sculpture of the face, and the eyes are softer and less defined.

Kollwitz had been forced to resign in 1933 from the Prussian Academy by the Nazi Minister for Education, Bernhard Rust. The terrible atmosphere in Germany was impossible to escape. She had her grandchildren, her work, friends and heritage all in Germany. With the final move to a small studio in a building rented to artists, she worked on sculpture. At home, she worked on graphics. All this time of grief and weariness seems to flow from the face, although masked in intent awareness.

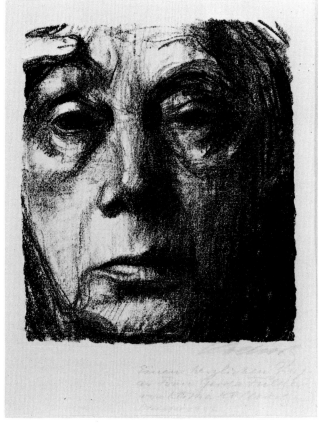

210. Tod im Wasser *(Death in Water)*
lithograph 1934-1935
46.5 x 38.4 cm., KL. 262,
signed in pencil on brownish Bütten paper
Plate 7 from series: Tod *(Death)*

The Death Series was begun by the old artist, after experiments with the theme throughout her life. The coming of death was real to her inner imagination. This is an especially German attitude, for none of the subjects flinch while confronting death. The series was completed in 1937.

The subjects range from terror to bargaining. The series begins with Death comforting a mother of two children by holding her hand. Death supports a girl in his comforting arms. Death seizes children in a play group. A terrified woman hears Death talking in her ear. A poor person folds into Death on the street. A person embraces Death, the friend, in joy. The dead float in a column of water. Death's hand summons an old woman by slight touch.

Our two examples show Death taking children and Death in water. There is no religious basis. Death taking children seems to predict death from the air. Death by water seems to show that the atmosphere is a stifling doom among the intellectuals in the Third Reich. It is the only depiction of dead persons in the series, rather than the approach of the reaper. Death is loving, kind, tender, terrible in his fury.

The series begins the end of Kollwitz's life in art, for she completed three more minor works before her death. From 1938 to 1942, the artist worked on two more lithographs and sculpture. Her grandson had been killed as her son had lost his life in World War I. The bony hand of Death hovered over her work and life.

210.

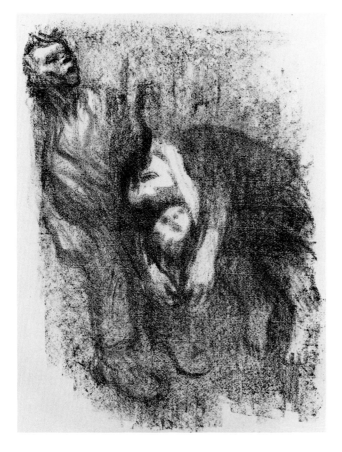

## ALEXEJ VON JAWLENSKY

211. Köpfe *(Heads)*
6 Lithographien
Verlegt vom Nassauischen Kunstverein. Neues Museum, Wiesbaden, 1922
Editions: Pre publication edition of 20 on kaiserlich japan paper numbered 1-20
regular edition on Bütten paper of 80 numbered 21-100
Each plate is signed and numbered
Portfolio: 55 x 45.5, dark blue paper covered cardboard, gold ink
Plates in mats: (Mats 54 x 44 cm.) paper 47.4 x 33 cm.

These lithographs are an exercise in simplicity based on a counted number of lines which make up a front view face. The treatment is varied by introducing force-lines pulling from various directions, which articulate the balance in certain methods, which must then be counter-balanced by centers of interest. The points of reference relate to the center of force.

A) has a complete front view with rectangular lines animated by slight curves and balanced by top diagonals of the hair line. The right eye line breaks complete horizontal balance. Fourteen strokes are used. The drawing is not quickly done, but examination of each line shows careful and slow motion of the controlling hand holding the tusche pencil. The lines are placed with careful judgment for each.

B) A straight forward view with open eyes and introduction of a curved brow and two dots left. The eyes are open. This makes sixteen strokes and two dots for eighteen marks. Jawlensky later went back to fewer strokes. There is less sense of repose in this face. It has little of the usual lyrical quality the artist successfully achieved most often by minimal means.

C) The center of force is now directed from the top over the nose. Gravitational force, but from inner intentions only, pulls the lower face into more complexity, with a need to balance the three lines of the hair. Two dots center the eye off-center. Thirteen lines plus two dots make up this drawing.

D) The face is tilted right on the neck column. Rather than having features pulled by the force, the whole head is drawn towards the right. The two dots are the method of framing. The rectangular beginning is lost in the necessity of method. Twelve lines plus two dots are the basic materials.

E) The next to last print is a design of struggle as the force lines pull up and right, while the side retains some of the verticality. The face plane is bent in half. The eyes face opposite; thirteen strokes are apparent.

F) Full force left pulls the face into a grotesque angle. This is the strongest exertion in the series. The face becomes a circular variation. Fourteen strokes are used, with no dots to break the flow of line.

The artist has used this theme of variation to change the symbolic attitudes of the faces. Mood changes, from stillness to struggle, to near classical beauty, to a general mood expressing inner thought.

Jawlensky made few prints: A series of six lithographs, nude subjects, made in 1912. Then the one etching of 1923, plus these six heads of 1922. Jawlensky shows a life based on the struggle against formlessness. His paintings and prints show great breadth of variation on this theme, using reduction as a means of expression. Jawlensky was not a theoretical intellectual, but an instinctive designer of immense talent. He settled early on a central axis for his work, frontal and monumental. The search for synthesis in his art meant a language of abstract life made universal by perfected line, balanced form and related harmony.

**211 A.**

**211 B.**

**211 C.**

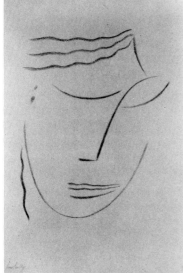

**211 D.**

**211 E.**

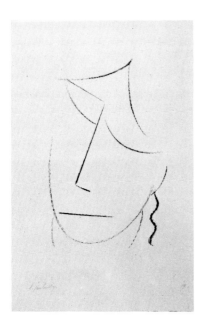

**211 F.**

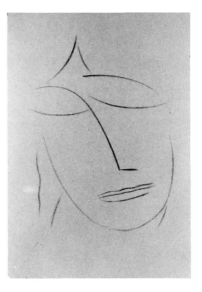

## WILHELM MORGNER

Wilhelm Morgner was an adventurous soul, moving in and out of various movements, always nervously seeking strong and intuitive expression.

He was a man from Soest. This meant rooting his art in the soil. This art was contemporary, not medieval-inspired. "The outdoors furnished immediate inspiration, not inner tradition. The sun, moon, and stars are seen as symbols of light. The earth moves as a complex unity of motion, not dead stability."* The triangle, taken from the form of mountains is his principle shape. Morgner, though he seems analytical and Cubistic, was not so. As a visionary, he used whatever seemed applicable. Van Gogh's drawings, perhaps, had the major influence on him, for many of the drawings and paintings seem blown up from Vincent's reed-pen drawing technique. He also used the pen techniques of Rembrandt, though more open and loose.

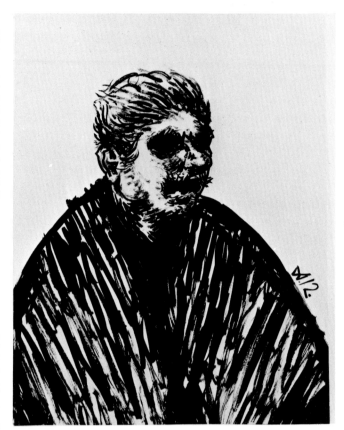

212.

212.  Selbstbildnis *(Self-portrait)*

India ink drawing, 1912
Monogrammed and dated
Verso: Tappert estate stamp #504
61 x 48 cm.

Morgner's self portraits remind one of his personal approach. They are the most intimate view of himself. The artist sees himself in many ways: earlier as a slow peasant, later as earthy burgher, as a man of the mountains in sackcloth. Here he presents himself as an old, careworn, totally inward apparition. The eyes and mouth are black slashes. The nose is a bulb of prominent grotesqueness. Lines are heavy to fit the mood. It is a timeless face set in the premonition of doom. It is a face without redemption, of the blackest humor, a powerful image of self-criticism. Later, during the war he wrote to Georg Tappert:

I prefer now not to hear of the art problem.
I do not include myself in this category of artists now, because I am at this moment,
Grave-digger
that is
death burier of Prussia
in Serbia.*

This sensitive man had spent 1916 as a grave inspector and grave digger in Macedonia. Morgner disappeared during a battle on the Western Front in 1917, as completely as though he had never existed.

213.  Männliches Porträt *(Portrait of a Man)*

Ink drawing, 1913. Monogrammed and dated on dun-colored drawing paper, 25.2 x 18.5 cm.

With Der Sturm, Morgner had been employed as an illustrator. His work was mainly with linocuts. He had developed a linear technique made up of curves and angled lines, most of the same width, white-spaced equally. This portrait carries the linocut technique into ink drawing. In a letter to Tappert he states:
"to become harsh and rugged
like the Serbian mountains
and wonderful like the sun
with chasm of earth and
songs of the water—like
trembling of the stars."*
The portrait is an honest look at himself, perhaps too critical.
"The chasm frightens the soul if it looks to the right, the left or backwards, the salvation is in front of us.
Each sunbeam is a beautiful sound in color and all of you people can lick my fanny, if you please." *
He tried to be free of the impression, but put instead a sensuous expression in the formation of his drawing.

*Däubler, Theodor; Deutsche Graphik des Westens, Feuer Verlag, Weimar 1922, p. 59

160

**214. Selbstbildnis mit hoher Mütze** *(Self-Portrait With a High Hat)*
Linocut, undated. From an edition of 50 examples
Verso: Nachlass Wilhelm Morgner, Frau Morgner 36 x 23.5 cm.

The woodcut is used for a close look again at the artist's face in a high cap, a stern look, hiding harsh thoughts.
"I am curious to see how Modersohn gets along with the people from Soest. I did learn one thing, however.
These people are not going to see a single picture of mine. I did mean to give a speech. Now I am laughing about it. I did not say anything. I shall go into the loneliness of the countryside or into the loneliness of the big city.
I shall change into the spirit."*

This is the accomplished graphic artist, almost too accomplished; his calligraphy is traditional, stopped linearity. Movement points towards the top center. Hair and eyebrows seem textured like wood. Each line is ended with care. Face and background become one, though given artifical depth by the change in direction of the sweep over the cap.
"I grin about everything that is called human being. Most of all, I have to laugh at myself, for I am crazy enough to bring forth these people. It is better if I were to throw lava and ashes into their heads. I am annoyed that I have not been able to tame the organism."

*(ref.: Letters to Georg Tappert
Künstlerbekenntnisse,
By Paul Westheim, Propyläen, Berlin, 1926.)

213.

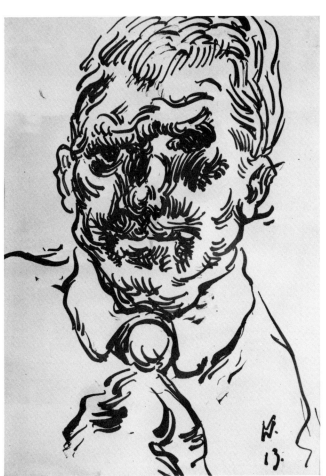

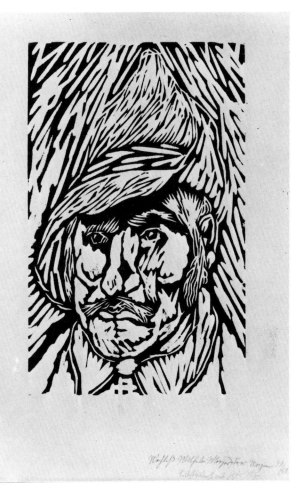

214.

161

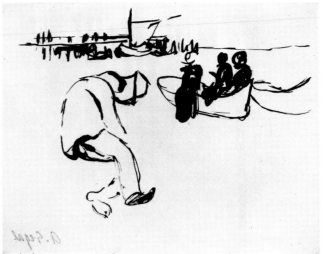

**216. Am Strand** *(At the Beach)*
Ink drawing, 1912
Signed on verso in ink
21.6 x 28 cm.

**ARTHUR SEGAL**
**215. Die Sonne** *(The Sun)*
Ink drawing, 1910
26 x 22.2 cm.

217.

orig Handbruck                                                        A. Segal · 1916

**218.**

**219.**

**218. Die Flucht nach Ägypten** *(The Flight into Egypt)*
Ink drawing with touches of white, 1917,
21.6 x 28 cm.

**218/2.** Woodcut of the same, 1917
Signed and inscribed in pencil,
21 x 28 cm.

**219. Vom Strande** *(From the Beach)*
8 Woodcuts bound into a pamphlet, 1919
With text by Rudolf Leonhard on the back of the last woodcut
Berlin-Wilmersdorf: A. R. Meyer
Erstes der graphischen eine Mark-Flugblätter
Edition: 1000 examples printed by Paul Knorr,
Berlin-Wilmersdorf, 1913. Unknown number in the later edition
28 x 34 cm.
8 sheets.

Arthur Segal was born in Jassy, Roumania, in 1875. He appears in Berlin about 1895. He joins the Neue Secession and shows with them in 1910 and five paintings afterwards. He is very much under the influence of van Gogh. He never changes from the spiritual-religious influence of the great Dutchman. Segal is a member of the Aktion circle and thus excluded from exhibitions by Walden in the Der Sturm galleries, although his earliest illustrations appear in Der Sturm (1911-1912). Perhaps Walden never forgave Segal's desertion to his rival, although two of the woodcuts from the series Vom Strande appear in Walden's journal.

Segal later becomes very close to Alfred Richard Meyer and his small publishing ventures. Segal's illustrations appear in Meyer's Die Bücherei Maiandros, and he publishes the first edition of Vom Strande with Knorr, Meyer's early outlet.

To escape the war, Segal moved to Ascona, Switzerland. There he became very close friends with Arp and Jawlensky. Arp introduced Segal into Dada circles, and he exhibited with some of the group. A woodcut by Segal appears in Dada 3.

Segal returned to Berlin in 1920 and joined the Novembergruppe. He had given up printing in 1919 for an interest in mystical Cubism. He believed in a theory of equal importance in a work, called the style "optical equi-balance." The desire for balance and harmony continued until his death in London in 1944.

Segal's interest in chromatic color studies interested the Dada circle. Ball, Huelsenbeck, and Klee were friendly, and invited him to show in Club Voltaire. Segal did a portrait of his friend Raoul Hausmann.

The drawings and woodcuts illustrate Segal's early and late styles. The drawings of sun and beach are in the Brücke style, co-existing with the Van Gogh style of his painting.

The woodcut and drawing, called Die Flucht nach Ägypten, have the beginning of later compartmentalization. Later these sections are divided into equal portions and given red, green and yellow colors, which mix in the eye to become "spectralisms."

There was something in the quiet painter which appealed to the more violent activists. He concentrated always on the human, calling it the "godlike matter in us." He taught equilibrium and quiet as the basis of economic reality, for the human organism should "not accommodate itself to the economic but should be restored by it."*

**217. Dorf im Tessin** *(The Village in Tessin)*
Woodcut, 1916. Signed, dated, and inscribed in pen. 12 x 20 cm.

*From the Catalogue: Kunst Salon Wolfsberg, 1919, p 3-4.

## GEORG TAPPERT

Because of his life-long teaching career, Georg Tappert was more influential than known as an artist by the art public. There was also a political career through the periodicals, "action through art" as the Expressionists attempted it. He had separated these subjective and objective existences.

Tappert was born in Berlin in 1880, but much of his early art life revolved around the Karlsruhe academy, where he studied until 1903. He worked for a few years again in Berlin, had his first one-man show at the Paul Cassirer gallery in 1906 and did some illustrations which appear now as immature and badly drawn. In 1906 Tappert joined the artist colony at Worpswede, where he began a school of art. His most famous student there was Wilhelm Morgner.

In 1910 he moved back to Berlin, helped found the Neue Sezession group, and began another school of modern art with his friend Moritz Melzer. Tappert invited the Brücke painters to show with the Neue Sezession group. In 1912 Tappert was invited to exhibit in the second Blaue Reiter exhibition in Munich. He also took part in the great Cologne Sonderbund exhibition in 1912.

As an illustrator for periodicals, Tappert first worked for Der Sturm in 1912. He moved to the Aktion circle in 1914 and cut some woodcuts for that periodical. As the war became more politicized, Tappert moved into the arena of leftist action with Die Schöne Rarität, Menschen, and others. In 1918 Tappert was one of the organizers of the Novembergruppe and edited the Arbeitsrat für Kunst, that statement of intent by the Novembergruppe. He did the Däubler portfolio for Galerie Flechtheim, published in 1920.

Georg Tappert was also influential in the Deutsche Werkbund during the twenties. He helped keep the crafts movement alive. Appointed a teacher at the art academy in Berlin in 1919, he kept an important position there until 1937. After 1945 Tappert undertook the reconstruction of art training at the academy and the connected college of art education.

Though overpraised during his lifetime in reality, Tappert is a minor talent in art. His activities in art propaganda, philosophy of art and education made him a leading figure of the time. He was a skillful and intelligent writer, but a mediocre painter.

220. Der Nachtwandler *(The Sleepwalker)*
by Theodor Däubler
With 8 woodcuts by Georg Tappert (1918) Düsseldorf: Galerie Flechtheim, Spring 1920 Edition: 136 examples Nr. I-VI artist's edition on japan paper, each print signed and numbered by the artist, portfolio signed by artist and author
Nr. 1-30: printed by the Pan-Presse on japan paper, each print signed and numbered by the artist, portfolio signed by artist and author
Nr. 31-130: printed by the Pan-Presse on etching paper, signed and numbered by the artist, portfolio signed by artist only Mappe IV, Galerie Flechtheim
Portfolio: 48 x 38.3 cm.
Prints (sheets): 42.5 x 21.5 cm.
8 woodcuts + title page and 1 page text

The illustrations for Däubler's poem are among Tappert's best work. He tended to be a poor draftsman, with little sense of proportion but a good sense of design. It is in the more abstract works that his proficiencies bloom.

The six verses of the poem have alternative rhythms in a classical style. The images in the poem alternate between dream and night symbolism.

Tappert uses a kind of Futurism to create the sense of motion in space. There is none of the free and pure sense of visual language which could echo Däubler's use of verses. There are three woodcuts built in cloud complications without a border. The other five have black borders and are established as scenes within a frame work. One is titled: "Für Lilith." The Images are complex: Merry-go-round, cabaret, dreaming maiden, lust, multiple madonnas floating and rising. Most of the imagery is loaded corner to corner into the framework of the blocks. A wild complexity is indicated by the visual patterns, but a personal one for the artist and not directly illustrative of Däubler's sad and meandering poetry.

220/1.

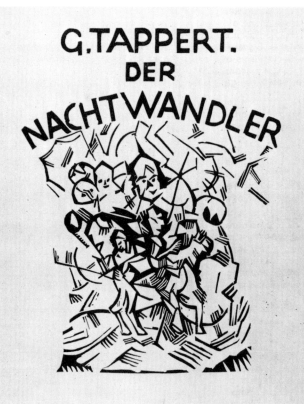

## PAUL KLEE

221. Potsdamer Platz oder die Nächte des neuen Messias
Ekstatische Visionen *(Potsdam Place
or After the New Messiah's Ecstatic Vision)*
Curt Corrinth, with 10 reproduced lithographs by Paul Klee
München: Georg Müller Verlag. 1920. Edition: 500 examples,
bound in half-leather. 21 x 14 cm.
2 + 90 pgs

222. Kandide oder die beste Welt. Eine Erzählung *(Candide or
The Story of the Possible World)*

Voltaire
With 26 reproduced ink drawings by Paul Klee. Munich: Kurt
Wolff. 1920 Printed by Spamersche Buchdruckerei, Leipzig,
July 1920, 25 x 19 cm., 90 + 2 pgs.

The Candide drawings were made during 1918-1919. In 1917
Klee had received a letter from the Georg Müller Verlag in Munich,
which was intending to publish this book. He mentions this
once in his diaries, but does not consider it important enough
for further discussion. Klee was reading classics while serving
in the German army, attached to an airfield, as private first class
and paymaster.

The ecstatic vision by Corrinth was written in 1919. He was
born in 1894 and followed the late romantic prose of middle-of-
the-road Expressionists. During the war he tended towards
religious ecstatic prose, though later he favored neo-realism,
with a novel about a bordello and certain works published dur-
ing the Nazi era.

Klee made drawings for the book, titling each after study of the
prose. He worked in his various styles of the period, angular
combinations of intermingled male and female forms and the
calligraphy of abstract meaning through shape. Berlin and the
Potsdam Square seem complicated and busy to Klee, combin-
ing his studies of movement within shapes with architectural
structuring, from principle not life. His symbolism is still per-
sonal, not thought out into scheme as it was later.

The drawings for Voltaire were studied quite early in Klee's
career. He mentions Voltaire in notations entered in his diary
during 1911, writing about his uncertainties and the break-
through when the weather turned beautiful in May. Klee's friend
Alfred Mayer took the drawings to Georg Müller, who already
had a book illustrated by Chodowiecki after Voltaire. Then
Franz Marc took the drawings to Piper. The set was considered
by Verlag der Weissen Blätter, then later published by the firm
of Kurt Wolff, newly moved to Munich.

Klee had made "his first offensive against painting" in 1910. He
had become bored with nature, began to cultivate a freer use of
line. Klee felt surer, writing that "the inner struggle in my art is
abating." He studied optical distortion of perspective through a
glass. Light and dark were studied for symbolism in line. The
Candide drawings are one phase, using the direction of line as
contour and the opposite as emotional stimulus. Bodies are
elongated, have small heads and extremities, and are
positioned into the gestures of actors. The scribbled line takes
on some realism as smoke, but not as successful emotional in-
terplay. Mannered gestures, too, do not illustrate the cool criti-
cism of Voltaire. Klee's use of wildly grotesque faces do illus-
trate the barbarity of the subject matter. Most of Klee's illustra-
tions are used as chapter headings. He animates the page tops
with the letter or number-like positioning of his figures, ar-
ranged in complex calligraphy. The use of fine, complicated,
scribbled line works well with the type face in the book, a
square and thin Unger-Fractur.

221.                                                    222.

Dreißigstes Kapitel

Schlußszene

So rechte Lust hatte freilich Kandide eben nicht, Kunegunde zu heiraten, indes hatte er
sein Wort einmal gegeben, Kunegunde drang so heftig in ihn und der außerordentliche
Bauernstolz des Barons verdroß ihn so sehr, daß er den festen Entschluß faßte, die Heirat
zu vollziehen.  Vorher pflog er mit Panglos, Martin und Kakambo geheimen Rat.
Panglos verfertigte einen gar stattlichen Aufsatz, worin er bewies, daß dem Baron keine
Gerechtsame über seine Schwester zuständen, und daß sie nach allen Reichsgesetzen sich
Kandide konnte an die linke Hand trauen lassen. Martin stimmte dahin, daß der Baron
sollte ins Meer geworfen werden. Kakambo tat den Ausspruch: Man müsse ihn wiederum
dem Levantifahrer überantworten, eine Zeitlang an die Ruderbank schmieden und dann mit
dem besten Schiffe nach Rom an den Pater General schicken.

84

## LYONEL FEININGER

223. Das Tor *(The Gate)*
Etching and drypoint, 1912
Editions: 125 impressions for Die Schaffenden,
Edited by Paul Westheim, Weimar: Kiepenheuer Verlag, Year 1,
Portfolio 1 (1919). Nrs. 1-25: on heavy off-white vellum
Nrs. 26-125: on yellow Bütten. 27.2 x 20 cm., plate destroyed
Prasse E 52

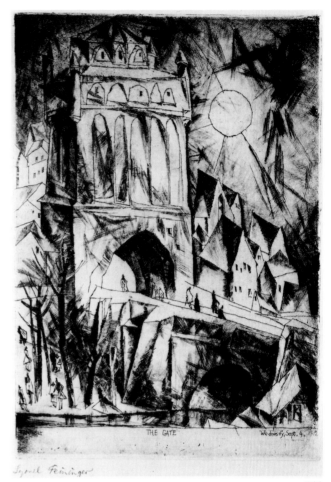

223.

Feininger had his first painter's studio in Berlin-Zehlendorf. He was trying to commit himself to a life as a painter, after successful years as an illustrator. The decision came, perhaps, from the trip to Paris with his companion and later wife, Julia, where he met the German painters, most of whom were early students of Matisse. He began to see that daring was the rule, recognized new possibilities in his own work.

The painting Green Bridge of 1909 introduced this subject, possibly from his remembered excitement as a child on a visit to New York. He loved height and angular projection. He searched for a new perspective. He introduced the Cubistic breakup of form, but it is a linear dissolution of form seemingly more planar than complete abstraction, as was the case with Braque and Picasso. There was a beginning harmonious relationship with nature, which was carried later into elegant regularity.

The subject of this etching has never been properly identified and may be a complex mixture of earlier influences, both subjective and objective. The design is carefully studied, with a turning point on the bottom right base and a sweep into the open gate, followed by a circular direction around the tower. This is done both by line and drypoint shading. Some of this must have come from Feininger's contact with exhibitors at the Salon des Independents.

He contributed six paintings in 1911. He had become friendly with Delaunay and others. But the relationship of volume and space within the object had not been Feininger's purpose. He wanted a time sequence, and a mixed perspective in space. He also wanted an intensified emotion made through strong contrast, and a sense of speed, movement and balance.

Feininger used this subject again in 1920, though the new woodcut reversed the image and simplified it into long ray-like motions. Both works develop the rhythmic progression of similar forms placed side by side, and the echo of similar shapes into the background. Actual substance is not made individual, but light interweaves through stone and sky. Feininger uses all these themes: rhythm, form, mixed perspective, and expressive contrast.

Feininger was invited to join the Brücke in 1912, but declined.

224.

225.

### 225. Alt-Timmendorf (Old Timmendorf)

Watercolor, 1923
Signed and titled, marked: "Sonnt. d. 8. April. 1923."
On heavy watercolor paper, stretched on a board with
pins 26.6 x 33 cm.

Feininger spent 1923 in Erfurt, formerly part of Thuringia, and now part of the German Democratic Republic. He had a workroom in the Anger Museum. He had visited Kandinsky in Timmendorf the year before, where the Russian was staying with Walter Gropius's mother. So, this watercolor was apparently made from sketches, not on the spot in that old part of the city.

It was a happy time with his friends, as Gropius had joined them. Feininger did little painting in Timmendorf, but spent much of his time sketching the heavy cloud formations over the flat landscape. He filled sketch pads with drawings of buildings and color notations.

This fine watercolor was a studio piece, but it brings his previous ideas together into an active luminosity. The medium with transparent pigments allowed the painter to keep clear and brilliant tints in his watercolor washes. The 51 year old painter has escaped most of his earlier Cubism, into a nervous and jagged fantasy. The town cross is seen on the right of the picture, and buildings are designed in an upward thrust along the central horizon. Feininger tried to keep a fluid hesitancy to the drawing, so the achievement appears accidental, though the control is skillful and apparent. The outlines of the buildings are designed to appear tentative in space, and structures seem to flow in and out of one another. There is a strange other worldliness to this painting.

The humans appear as humorous details, not stylized forms of naturalism. There seems a similarity with Gothic shorthand. The choice of colors, too, seems close to that of Gothic manuscripts. The hardness of the angularity marks this painting as anti-romantic.

The northern part of Germany along the Baltic coast became a favorite vacation spot for Feininger, where he raced model boats with his sons, heard music in the old churches, and made many sketches, which were later turned into important paintings.

During the vacations on the Baltic Sea, Feininger learned from nature to intermingle color. The harsh and clear light made outlines seem to shimmer and interplay. He lost absolute contours and learned to let the planes penetrate one another by letting colors overlap. This example has only few mixtures of color but most of the outlines are strengthened with ink.

### 224. Fischerboot im Regen (Fishing Boat in the Rain)

Etching on zinc, ca. 1917
Prasse E 61
Edition: Prasse lists 100 examples on heavy wove paper with printed title verso. The issue of Das Kunstblatt in which the print appears mentions an edition of 110 examples, with 100 of these open to subscribers. (This probably refers to an edition of 10 usually called "Museumsausgabe.")
Unsigned edition appeared in Das Kunstblatt
Weimar: Gustav Kiepenheuer Verlag
Year 1, Vol. 3 (March 1917)
Luxusausgabe. (Special edition)
11 x 13.9 cm.

This small etching on zinc is one of Feininger's most important prints, for it marks both a turning point and an ending. The style marks the change into pure linearity. There are only four more etchings, for Feininger takes up the woodcut as his principle graphic medium after 1917.

Zinc lends itself more to heavier line. It does not take the fine etched line as does copper. The acid tends to break down the sides of a zinc cavity. Feininger uses a wavering line not a straight stroke as a functional use of this metal.

Feininger began to experiment with a form of Cubism in 1912. He called his method "prism-ism." His early work had been concerned with the human figure, and now he turned to works about ships, water, and the villages of Thuringia and the Baltic Sea. He did not dissect the human body as he cut up space. The rhythmic proportions, the planes of light and dark, seem reflections in mirrors. He began to use line structurally instead of decoratively. His drawings of 1913 show Futurist investigations, but the early etchings, though approaching linearity, have line surrounded by form and not open and interpenetrating space. The paintings of 1914, too, have the openness.

It may have been the influence of Walden, when Feininger joined the Sturm circle, which gave him his first real recognition. Walden was excited by Feininger's work and promoted the exhibition of 1917 into a popular success, which attracted large crowds. It marked the end of Feininger's life as an unknown artist.

## WILHELM LEHMBRUCK

226. Männlicher Rückenakt mit gesenktem Kopf *(Back View of a Male Model with Bowed Head)*
Etching on zinc with an unpolished surface (back of a plate used for another etching), 1911. 20 examples on japan paper Petermann 19, second state 15.8 x 12 cm.

227.  Der Pilger *(The Pilgrim)*

Drypoint on zinc with an unpolished surface, 1912. 20 examples on japan paper, Petermann, 41, only state 20 x 15 cm.

World War I took another life with the suicide of Wilhelm Lehmbruck at the age of 38 in 1919. His later graphics show a progressive melancholy, self doubt, search among classics for some solution. His seven etchings in 1918 for the Macbeth play have this sense of doom, hatred of killing, and the senseless-ness of mass destruction.

His entire oeuvre in etching and lithography comes to 200 individual pieces: 180 etchings and the rest in lithography, mostly portraits.

Lehmbruck was a sculptor, trained in classical methods combining Parisian and German ideals. He was trained at the Arts and Crafts school in Düsseldorf, moved to Paris, worked there from 1910 to 1914, lived in Zurich from late 1917 to 1918, and died in Berlin after his return on March 25, 1919.

His graphics have been called a study of torsos. His four years in Paris had seen a change from the academic training of his youth. He had become friendly with Brancusi, Dunoyer de Segonzac, Derain, and Modigliani. All of these influences appear in his work.

The *Back View of a Man with Bent Head* of 1911 relates to six other etchings of a young male model. Here he studies form in outline. The large masses are placed one over another in bulky roundness. As was customary, no background was introduced. The back of a zinc plate was used, but unpolished and unbeveled. This print was offered in 1913 by Bruno Cassirer, Lehmbruck's dealer in Berlin.

*The Pilgrim* of 1912 is one of three studies of sitting models. It is again made on an unpolished surface, with more careful drypoint drawing. The pose is a study of mass opposed to the staff of the pilgrim.

"All art is measure." Lehmbruck's saying is fulfilled in his graphics. His search for the monumental in sculpture took the path of silhouette in prints. Intensity somehow glows from his prints. Proportion is not important, but the relationship of round form to round form, the subdivision of surface, is paramount. Action is not realized, but pensive melancholy is in the smooth echo of the contours. In almost every graphic work, verticality is used.

The two works have much of the introspective personality of the artist. They are, perhaps, minor things in the entire realm of German Expressionism, but they have a real style and a true vocabulary of personal energy.

226.

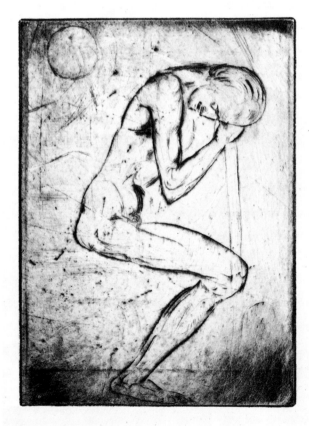

227.

228.

## OTTO GLEICHMANN

**228.** Tier *(Beast)*
Gouche, 1920. Signed and titled in ink. 16.1 x 14.5 cm. (image)
227 x 19.9 cm. (sheet)

Otto Gleichmann, born in Mainz in 1887, spent most of his life in Rhineland area, settling in Hannover.

His work is generally representative of the ecstatic school and changed little until much later in the 1950s. His is a primitivistic vision of life as seen from the primeval swamp. Form is violated by spots and irregularities. The Slavic face prevails again, at least the variety from the eastern regions, with slant eyes, large head, claw hands, and inward-looking eyes: a type of subhuman.

Gleichmann is also classified by H. von Wedderkop as a German graphic artist of the western area.

In a monograph, Theodor Däubler writes that this artist is uncommon, with original technical resources and expression.* As a visionary Gleichmann noticed the world did not become objective because seers saw ghosts, grotesque appearances or heard lunatic speech. Gleichmann describes all these things without humor. Däubler says that Gleichmann sees the world as a place being invaded by invisible rodents and we cannot protect outselves against the beasts. Gleichmann describes the common people as caterpillars with ape heads. There can only be room for the creative after mass migrations have taken place, after the greedy have devoured one another. Everything now is grim. Gleichmann does not draw caricatures. The ecstatic artist was a serious visionary.

Gleichmann drew with a wiggling line. Perspective is directed in a circular motion around the subject. Planes are irrational and provide an effect of madness. His color is gray or dull, of the earth and wounds.

Gleichmann was one of the prominent members of the Hannover Sezession, founded in 1917. He became a member of the opposition when the young painters in Hannover opposed Expressionism in the 1920s. He became committed to specific programs of first Dada, then Constructivism. Gleichmann remained true to his early promise as a visionary Expressionist.

*Theodor Däubler, Otto Gleichmann in Deutsche Graphik des Westens, Weimar; 1922, p 30-31.

## ERNST BARLACH'S BOOK ILLUSTRATION

The illustrated book is an extremely important area in Ernst Barlach's oeuvre, though not a large one. Ernst Barlach was doubly talented: as an artist forming his perceptions of existence and as a writer expressing his mental vision. A strong talent drove him in both fields. His illustrations for his own texts are a connecting link between the two forms of expression. We can perceive the artistic and spiritual concepts of his entire output.

Ernst Barlach was a sculptor as well as a graphic artist. He worked with color early but soon abandoned its sensual fascination entirely because his interest was concentrated in a precise expression of abstract mental insight conveyed by the symbol of the human figure.

As a sculptor Barlach was not only interested in form values. He fought most of all for the spiritual core of his sculptural creations. The form automatically resulted from the content. The battle for mental content within his sculptural works can be verified at every step of the artist's development and can be documented in his writings—dramas, essays and letters. It is not merely a matter of subjective art historical interpretation. One must not, however, use his written works carelessly as proof, since Ernst Barlach rarely interpreted or analyzed his own creations. His written expression in dramas or prose always remained picturesque, never analytical or explanatory. His figures are the keys to his perception of life and the world. As such, they are comparable to the logical conclusions of the philosopher. Barlach's life work is philosophy; it is an interpretation of existence. His medium for communicating his perceptions is not the sculptural thought, but the artistic form: he conveys a picture of existence.

In this great attempt to express an intellectual understanding of existence through art, Ernst Barlach's mental attitude is basically different from his contemporaries. In the history of art, most of their positions are to be understood entirely in terms of reactions within cultural and historical developments in the decade which preceded the first world war. His contemporaries wanted liberation from tradition in art, from the forces of prescribed form, from conventions of behavior in human relationships. They descried a new law and order in the liberation; they attempted to find elemental connections in the total formal structure of life to reveal the fundaments of existence. Many artists formulated these ideas in different kinds of "programs." It was certainly possible for several artists to group together in recognition of mutual goals, as was the case in the associations of the Brücke and the Blaue Reiter.

Much of the work of Ernst Barlach may appear related to these programs of Expressionism. But Barlach's outlook is so widespread that it cannot be formulated within the framework of a program which consists of an existential belief with its attendant future-directed tendency. Barlach's art has to be seen as a sequence of symbolic messages unconcerned with the overt existence of men. His work describes man's basic spiritual behavior in relation to the eternal, to God. The early work starts from a relationship to real life conditions, but this view is more and more sublimated. In maturity his work becomes a purely religious quest, on religious terms, for the ontological basis of existence.

Barlach was a loner, living and working as one. There is evidence in his work of the revolutionary spirit of his era (which marked the works of all the great artists of his time.) But with Barlach this does not emerge from his inner development. As an artist, he owes a lot to his time, but he is not a child of his time. And he leaves his mark on it.

We must modify the idea that his style remained the same from the trip to Russia in 1906 until the end of his life when we examine his entire oeuvre. Initial realism in the works just after the Russian journey becomes more and more sublimated, until his figures are transparently medial statements of supernatural powers. The Russian trip exposed the Expressionist Ernst Barlach who is familiar to us. His style was formed at this point in time, and from here it continued to develop.

In Güstrow, where Barlach finally settled in 1910, he created his real life's work, the wood and memorial sculptures. Here too he produced the endless concentrated drawings of visionary "anthropomorphic metaphors" that float ghost-like over the stage in his dramas, suspended between their reality and an intuitive supernatural law. Only talented and courageous directors dared present these difficult plays to contemporary audiences looking either for entertainment or their own experiences mirrored by psychological analysis. Barlach's drama met neither requirement. The world view in these dramas is philosophical, coming close to the thinking of the existentialists. His figures are marionettes, blind victims or self sacrificing individuals drawn into a gigantic power play.

Yet Barlach found a publisher and promoter in Paul Cassirer, who produced his dramas and took over the sale of his art. It was Cassirer who prompted Barlach to illustrate his own dramas. Through him arose the work Der Tote Tag (The Dead Day), with text and graphics portfolio. From this beginning a number of illustration series developed. They will be dealt with here in detail.

Essay by Isa Lohmann-Siems

229.

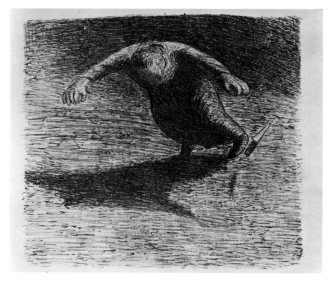

229.

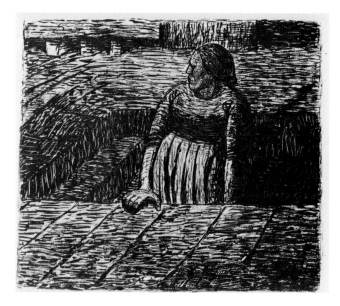

229. Der Tote Tag (The Dead Day)
Drama in fünf Akten von Ernst Barlach
27 lithographs in portfolio, with text in separate volume
Paul Cassirer, Berlin, 1912
X. Werk der Pan-Presse, Printed by Julius Sittenfeld, Berlin
Portfolio: 53 x 68.8 cm; text volume: 35 x 32.3 cm.
editions: 210 examples
A: I—LX on thick japan paper, 50.6 x 65 cm., all plates signed
B: I—150 on Holland paper without watermarks, 51.8 x 66.3 cm.
Colophon page signed only
Schult 16, 17, 18, 19, 20, 21, 22, 23, 24, 26, 27, 28, 29, 31, 33, 34, 35, 36, 37, 39, 40, 41, 42, 43, 44, 45, 46.
A separate "Volksedition" without the portfolio was published in 1912. It has no "X. Werk der Pan-Presse" on title page
A separate "Volksedition" was published in 1918 with reproduced lithographs.

The trolls and dwarfs of traditional German history differ according to the region, state or province in which they are described. Southern Germany provided happier symbols because of Catholic customs and easier release of the sense of sin through confession. To the people of the cold North, sin was inborn and largely unchangeable, an ever present reminder of mans' base nature, which could be only redeemed by a personal relationship with God. Protestant history had been a series of events about individualized conscience. In Northern Germany this was mixed with Scandinavian tradition, which was, perhaps, even more inhuman.

This Northern influence was filtered through the acute sensibilities of August Strindberg, became immediately acceptable to a German dramatist with a similar trend, and reached the young Barlach in full consistency.

Barlach used this omnipotent sense of sin in combination with the early part of the Parsifal legend in this first play. The hero is the son, one destined to serve God, a Göttersohn. Herzeloyde becomes the mother. The passing knights, who awaken the hero to his destiny, are combined into one symbol, the wandering blind man, Kule. But the legend of Parsifal is changed into a rustic tragedy, a drama of frustrated intentions and blocked destinies.

Barlach's play is obscure, highly charged with emotional speech, and designed around complete scenes which alternate humor and brutality. The characters move through the action, a few at a time, speak and group, inserting primal ideas and then move away.

Reality is cast aside in the first scene by the presence of an unseen household troll. Then other unseen dwarfs are mentioned. One later speaks, another appears, although dumb, with broom stick legs. These spirits have personalities. Some are always irritated by the actions of humans, and others are pathetic servants. This lends both a humorous and morbid significance to the story.

Barlach's lithographs are less charged with emotion than his drama. Studies in volume and plane show depth and confined space. Most of the simplification is a scuptural massing of form. Emotive additions are brought into the shading, which moves in a directional space as categorical restlessness. The bulky shapes are animated by the air around them, as though this atmosphere were alive with frenzied evil. Barlach's method of shading is functional to the particular play, and he did not apply it exactly to other lithographs during his lifetime.

In the play, Barlach is skillful in his characterizations. In the lithographs he is able to apply the sense of the quietness of a provincial farm, the primitive power and brutality which resounds in the peasant life of the North.

A brief outline of the play, Der Tote Tag:
The son has been kept in isolation from the world on an isolated farm. Kule, a blind man, arrives carrying a divine staff, which led him to the son. Kule is supposed to awaken the boy to his mission as the servant of God. Herzhorn, a mythical horse, is waiting outside to take the boy on his journey into salvation. The mother is in anguish, unable to let her son depart. She kills the horse. The following morning is dark, the dead day. Steissbart, an

irritable and unseen voice, torments the boy with earthly yearnings. The mother confesses her act of killing, then stabs herself. The son feels closer to his mother and takes the path of blood rather than the path of God. Kule loses his divine staff.

Barlach's message is his concern with the world of the spirit, which must discard the world of the physical. In the play, the effects of introversion in a primitive microcosm are emphasized and seem stronger than the emotional strength of divine destiny. Barlach interjects fate as a multiple path.

Barlach's reading in German and Scandinavian fairy tales, combined with the stories he learned from his mother, were applied to the manuscript. In Finno-Ugrian mythology, Ku (Kule) was a spirit of the waters, one apt to demand victims. The spirits Barlach describes are commonplace in these folk stories; and there are special activities connected with the barn, the barnyard, with the hearth, forest and field. Though German Christianity overcame the major gods of classical paganism, the small divinities remained, and still remain actual forces in the daily life of the peasants.

229.

230. Eine Steppenfahrt (A Journey to the Russian Steppes)
13 lithographs, 1912, Schult 49, 50, 51, 52, 53, 54, 55, 56, 57, 58, 59, 61, 62. As published in Kunst und Künstler, edited by Karl Scheffler, published by Bruno Cassirer, Berlin, printed by Offizin W. Drugulin, Leipzig. Jahrgang XI, 1912-1913, Heft 1, October 1912. 10 pp, numbered 3-12. 30.8 x 24.5 cm.

The last flourish of the Jugendstil period in Barlach's life came in his book Figurzeichnen (Figure Sketches), 1895, with flying figures in spiral attitudes.

Before his trip to Russia, Barlach had passed through the most painful part of his early life. He had suffered a nervous breakdown, had given up his teaching position at a ceramics institute and had returned to Berlin, where he waited for some miracle which would release him from his uncertainties.

The background of this indecision and questioning lay in the German development. During the late nineteenth century, German scholars were divided into many spheres of history and thought. Their search for historical bonds within the tradition of the new nation led them to classical training, western democracy, French logic, Oriental mysticism, Japanese and Chinese culture, and, foremost, to a belief in Slavic agrarianism, which appealed to the traditionalists.

In 1906 Barlach traveled to Russia with his brother Nikolaus to visit his other brother Hans, who was working at Kharkov in the Ukraine. Just as Rilke had a few years before, Barlach found a mighty force in Russia, a force unawakened and strong in potential. He felt a close relationship between the common people and religions, though it was a feeling for spiritual inner life rather than doctrinal experience.

Barlach, mostly self-taught through a random pattern of reading, was unsure of his own thoughts until the course to reality became the road to the Russian Steppes. There he found a sense of stability among the Russian peasants. There he thought he found a definite relationship between the Russian people and their God. This existed in a state of nature, not in the complexity of western civilization, which many German intellectuals did not trust.

The life force Ernst Barlach found in Russia was an energy which paralleled his inner exigence. He watched the seemingly simple people, with their solid figures, quiet repose, and form and content which were revealing. He found artistic regeneration through this image of a strange land. The conflict between a romantic ideal and realism somehow was extinguished. Barlach was able to invent his own originality and regeneration.

These Russian themes are the basis of his article in the Kunst und Künstler periodical. The entire journey had a duration of only two months; the description was published six years after, yet the effect is timeless and extended.

230.

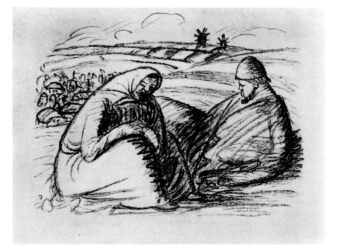

The lithographs, which frame the words, are mainly drawn from the German settlements and contrasted against the backwardness of the Russian peasants. Barlach shows country life, strange vehicles, geological formations, anthropomorphic hills and valleys against the background of the Steppes.

The apparent relationship of the hills and valleys with human forms is an intention. In the manuscript, Barlach mentions the land as seeming like "sleeping beings." He does not draw a parallel with mysticism in this definition, but uses the Russian images as counterparts to his concern for the primitive, for the primordial and massive sculpture he had already visualized in his mind. Real solidity of the human figure was the new, applicable concept. This had being in an apparent harmony between simple life and terrifying nature.

He understood what his friend Arthur Moeller van den Bruck had meant by young peoples. Barlach read his friend van den Bruck's editions of Dostoevsky, especially the introductions, which described the great mystic's knowledge of his people. It was a message of pessimism, which appealed to the young Barlach. Moeller later wrote about the Prussian spirit, and this too found ground in Barlach's thoughts; for the logical matter-of-factness of the northerners, the devotion to duty, the obedience to authority were all abhorrent to the sculptor. This produced an idealized picture of Germany and its older past. It meant an attempt to bring his German people close to self consciousness, and interpreted the spiritual and artistic possibilities of modernity. He saw how the naked human remains, after all the rhetoric has been scoured away. The human instincts have not been much modified, but human nature was immutable.

From Moeller and the Russian journey came the major idea that art renders religion superfluous by rendering everything in the universe full of faith.

The lithographs have some of this new feeling for isolation of the new found seer. The forms are still tentative in modelling, although the future Barlach appears in the massiveness of the reclining figures under rolling hills. Russian, Slavic features are not studies, but the simplified costumes, lack of clarity between figure and landscape, show Barlach's preoccupation with man as part of earth. There is little difference between outline in ground and flesh.

Barlach returned to Germany with a feeling of creative power. He began his massive abstractions and simplifications from this spiritual influence. The form of this change took place both in his written language and in his art. He applied it to his first drama, Der Tote Tag.

231.

230.

**231.  Der Kopf** *(The Head)*
Ein Gedicht von Reinhold von Walter, mit zehn Holzschnitten
von Ernst Barlach, Paul Cassirer, Berlin, 1919 *(A Poem by
Reinhold von Walter, with Ten Woodcuts by Ernst Barlach)*
7 + 36 + 6pp., two volumes, both in portfolio 35.7 x 25.5 cm.,
bound in red and brown covered cardboard, printed by
Spamerschen Buchdruckerei, Lelpzig
Editions: 211. A: A-K with extra suite on japan paper (Bremen)
B: 1-20 on Old-Stratford paper, with an extra suite on thin japan
paper, all plates signed, bound in leather by Ulber, Berlin
C: 21-200 on same paper, without extra suite of woodcuts,
bound in half leather, Colophon page signed by artist and
author, woodcuts printed from zinc plates, 32.1 x 24.7 cm.
16 Werk der Pan-Presse: Schult: 102, 103, 104, 105, 106, 107, 108,
109, 110, 111
Type: Koschen-Maximillian
Barlach Haus has an edition marked A−K of the two volume edi-
tion so the entire edition of the advance issue was 211. This was
probably a museum edition as was usual with luxury editions.

Barlach had a long friendship with the Baltic poet Reinhold von
Walter. The author later published a book about the artist, titled
Ernst Barlach, Furche-Kunstverlag, Berlin, 1929. The message of
this long philosophical work is overintellectualization of the world,
in which the "flesh and spirit" are divided. The scene was chosen
from aspects of the Russian revolution in Petrograd of 1918. The
beggars have arisen to become important citizens. Monstrous
dwarfs have terrible inner ideas of cold violence and rage. The
giant head of one becomes the master of the multitude.

"And under spread, that is the ground,
And over seemingly pale, that is the spirit."

The multitudes are victimized by this giant head, and react pas-
sively. His one-armed companion dreams with hollow eyes.

Pessimism permeates the poem. It ends with visions of insanity
and horror. The artist is asked to reveal clearly in his craft, not
through empty words, "you must learn to love the hand that
beats you."

The revolutionary qualities of the poem are illustrated by a very
sympathetic Barlach. Russian beggars had been one of his in-
terests since the Russian journey. The finest woodcuts of the
set are the Bettler majestät *(Beggar King)*, Die Peitsche *(The
Scourge)* and Untergang *(Ruin)*.

These are Barlach's first woodcuts to be made into a series. He
is already a master of the technique. He identifies with the pri-
vate mythology of the Nordic sagas, of dwarfs and gnomes.
This is fairly particular to his Northern imagination. Deforma-
tion was considered a sign of inner evil, of a wrong turning
away from spiritual paths. Misshapen forms meant more to Bar-
lach than mere symbols used to take a close look at contem-
porary culture through social criticism based on current art
trends. Man is always in the process of becoming something
else. The typical beggar and poor of the small towns of North-
ern Germany are seen in reality as cranky, queer people given
to lusts and fantastic imaginations.

231.

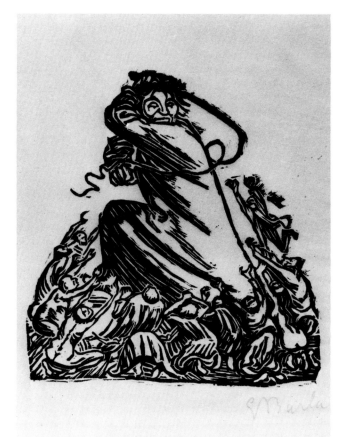

**232. Der arme Vetter** *(The Poor Cousin)*
Ein Buch mit 34 (38) lithographien von Ernst Barlach,
Paul Cassirer, Berlin, 1919, 2 volumes; text with 112 pp, 2
lithographs printed as reproductions from process plates, in
box 52 x 36.5 cm.
editions: 300 examples
A: 1-30 text on handmade Zanders paper 49.3 x 35 cm.
extra suite on yellowish paper without watermark
34.7 x 49 cm. all plates signed
B: 31-110 text on Holland paper, 49.3 x 41 cm., extra suite
on same yellowish paper, 40 x 49 cm., all plates signed
C: 111-300 text on Watteau paper 49.3 x 35 cm., extra suite
on same yellowish paper, 34.7 x 49 cm., colophon page
signed by printer and artist, extra suite unsigned.
text printed by Otto von Holten, Berlin
Lithographs printed by M.W. Lassally, Berlin
Ausgabe A bound in half parchment; Ausgabe B bound in
half linen
Schult: 113, 114, 115, 116, 117, 118, 119, 120, 121, 122, 123, 124, 125,
126, 127, 128, 129, 130, 121, 132, 133, 134, 135, 136, 137, 138, 139,
140, 141, 142, 143, 145, 146, 147, 149, 150, 151, 152

This play was conceived around 1907, first published as a text
by Cassirer in 1918, and published as a two volume set with lith-
ographs a year later. Barlach sticks to the text almost exactly,
and a person staging the play can use these illustrations as a
reference of the writer's intentions.

A short outline of the plot may be helpful in an understanding of
the lithographs:
On Easter Sunday, Hans Iver walks along the banks of the Elbe
in Hamburg seeking an escape from reality. He plans to shoot
himself on this day in the spirit of Resurrection. After complet-
ing this act, he is taken to a nearby inn. He had already met a
sympathetic girl, Lena Isenbar, who was there with Sieben-
mark, her fiance. The man is trying to become less materialist.
The girl feels Iver's suffering and longing for spiritual fulfill-
ment. The wounded youth is mocked by the guests, especially a
grotesque "Frau Venus,"—a male veterinarian. Lena tries to
bring Iver back into the world by compromise. Siebenmark tries
to buy Iver by his basic materialism (money). Iver rejects the
cash. He opens his wound and dies alone. The corpse is brought
into a barn, where Siebenmark gives Lena the choice of himself
or the dead youth. She chooses Iver, relating to his spiritual
message.

There are major exchanges about religion and life between the
major actors with mockery and guffaws from the crowd. In Iver
Barlach has given us a portrait of a split personality, with all the
symptoms of introverted nature, persecution complex, sen-
sationalist, absolutist. The sentimental German girl is placed
against this melodrama. She sees both the world of the spirit
and the world of materialism. But her fiance sees only the mate-
rial aspect. The interweaving of these three outlooks is the
basis of the play. Spirit finally overcomes the rational.

The interpretations by Barlach in the lithographs are very
bourgeois. Characters appear in the clothing of 1919. Later the
characters appear in more sculptural attitudes, but still later
they are placed in isolation against a dominating blackness.
There is a motion to the scenes that does not appear in any
other series, a flow of actors on a stage set.

232.

232.

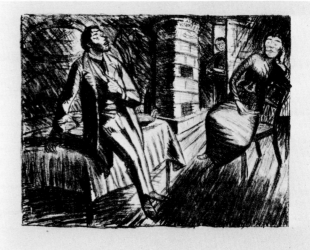

232.

174

**233. Die Wandlungen Gottes** *(Transformation of God)*
Sieben Holzschnitte von Ernst Barlach, 1920-1921
Paul Cassirer, Berlin, 1921 19. Werk der Pan-Presse
Editions: 121 in Vorzugsausgabe, Volksedition unknown
A: I-XI on old German Bütten paper, 30.8 x 45.7 cm., bound in parchment
B: 1-110 on imperial japan paper, 32.4 x 45.2 cm., bound in parchment
C: unknown edition printed from zinc plates by Paul Cassirer, Berlin, 1922, 32.3 x 44 cm., bound in grey cardboard.
unknown edition of these reproductions printed by Christian Kaiser, Munich, 1954
Schult: 164, 165, 166, 168, 169, 170, 171

Barlach uses the book of Genesis as a thematic hint. But his God is a complicated figure who gave His children His own attributes of joy and pain, sorrow and happiness. Barlach shows no joy or happiness except through a vision of gluttony. He presents a seven-fold panorama of a pensive God, a suffering God, an old God.

Die erste Tag *(The First Day)* "God said: Let there be light and there was light." Out of nothingness this unfolding figure emerged, casting forth beams from fingertips. (233/1).

Die Dome *(The Cathedrals)* of the second day: God divided waters unto waters. Barlach unfolds a great cityscape of Gothic cathedrals as the great ocean for humanity. (233/2).

The Gothic time was especially religious in German history. God flies in contemplation over the crowded past. The earth is also divided between the waters of faith and the waters of materialism in Barlach's eyes.

Der göttliche Bettler *(The Divine Beggar),* Third Day: Dry land is created. Brutality has appeared with the land. The ladder to heaven has broken steps filled with crushed animal-people. God rests heavily on crutches, sadly sees the future in pain and suffering. The crippled God is carrying the burden of mankind. The ladder previews the vision of Jacob.

Totentanz *(Dance of Death)* Fourth Day: Sun, moon, and stars become visible. Barlach takes from this theme the element of journey in life. From the Gothic time he combines the death dance, which symbolized the shortness and uncertainty of existence. With the months and days came the sense of rhythm of life through suffering and death. Though to the medieval man the Black Death of Plague was the theme of a Death Dance, to Barlach ever-aging existence places a limit on man's ambitions.

Gott Bauch *(God Belly)* Fifth Day: The creation of animal life— fish and fowl. An ecstatic harpist sings near an altar with rising fire. To the left a lone figure raises arms to heaven. The central figure shows God as a glutton. For this day saw the creation of food. The theme of the woodcut is food for the belly and for the earthbound spirit. Evil is predisposed by this grossness and need. Eating meant consumption by the rich of the poor as well as evil natural appetites. (233/5).

Die Felsen *(The Cliffs)* sixth day: the creation of living creatures with conscious souls. God, a Goethe like creature without a beard, contemplates the creation of animals and man. He is in the rocks before Eden. In this bleak landscape God thinks of man in his own image, perhaps pensively so. God-consciousness meant including all the bad parts of God as well as the Good. This plate sums up the previous variations.

Der Siebente Tag *(The Seventh Day)* God rests: We are reminded of Moses seeing the land of Israel. God is now very old and weakened, careworn, supplicating. God contemplates the land east of Eden. The day is sanctified by God's pause. (233/7).

233/1.

233/2.

233/5.

233/7.

**234. Der Findling** *(The Foundling)*
Ein Spiel in 3 Stücken mit Holzschnitten von Ernst Barlach
Paul Cassirer, Berlin, 1922, 34.7 x 26.5 cm., 78 pp, printed by
F. A. Lattmann, Goslar, type: schrift von Rudolf Koch.
Editions: 80 in Vorzugsausgabe, Volksedition unknown
A: 1- 80 on heavy Bütten paper (yellowish), with an extra suite
of 20 woodcuts printed by the Pan-Presse, Berlin.
plates: 34.7 x 26.6 cm., all plates signed. plates on thin
japan paper in extra suite. Parchment bound
B: Volksedition, paper bound, 31.8 x 24.4 cm., Text only,
unknown edition printed from zinc plates
Schult: 172, 173, 175, 176, 177, 178, 179, 180, 181, 182, 183, 184,
185, 186, 187, 188, 189, 190, 191, 192

The theme of this play is food in all forms, from ravenous eating
of the people by oppressors to actual starvation, from an engorg-
ing pestilence to hunger for a homeland. Symbolism is also
built around cannibalism. Man devours himself by eating his
own flesh (war).

The Foundling is a mystery play direct from medieval traditions
of a people's theater. The words are written in a passionate
prose with alternating rhymed and unrhymed verse for each
situation in the rapidly changing scenes.

This brief outline of the play will show the major events: A
stonebreaker kills the Red Emperor, who has come to him for
shelter. The Emperor previously had taken the land and food
from the common people. The imperial body is fed to straggling
refugees, among them a discarded foundling. The family of
Mother Kummer, including her daughter Elise, take refuge with
the horde. Later a puppet master's son, Thomas, joins the starv-
ing and ragged group. Both young people recognize similar
feelings of rejection for the greed surrounding them.

Thomas puts on a puppet show with his princess doll. He uses
the play within a play to express the poet within, for inspiration
and away from corruption and unbelief.

The Red Emperor had predicted the birth of a new savior before
he was killed. The stonebreaker reveals this to his starving
community around his fire. Elise takes up the foundling, a
strange and grotesque baby. In the child she sees a new hope.
"On the frightful form of this child I lay my hands, as on the
worst wound of the world. He shall be our first son."

The stonebreaker becomes a seer, and delivers a speech in
which he sees the world reversing itself from disorder to order.
Elise understands the words, holds up the newly restored, and
now beautiful child, and proves that compassionate love has
conquered the world.

Ernst Barlach had experienced what every German had ob-
served in the dark days of starvation and human misery after
the war. Germany had been blockaded, and inflation had made
food a priceless item in daily life.

This is Barlach's answer. He says to add love and care even to
the lowest forms of life whereever needed.

The woodcuts are made in simple designs directly from action
in the text. All facial characterizations show brutal faces and
worn bodies. The only exception is when the girl shows the
radiant child to the audience. Only she is straight and unbent:
the poor circling refugees are squat and crooked. The wood-
cuts seem a premonition of the future and a message from the
past. The play seems very contemporary.

The world in this play is replete with cruelty and calamity.
But the prose has a melancholy and enchanting beauty
which mutes the pitiful lives, and silences the grief of the home-
less people whom Barlach suffused with the odd and the
miraculous.

234.

234.

Du ~ ausgetriebener und durchtriebener Teufel, laß dich mit
Riechwaſſer taufen und geh ans Gericht, da riechen ſie vor dem
Waſſer nichts von deiner Raſſe. Packt euch Puppenpack!
Kaiſer, König, Knecht, Kümmeltürk und Krokodil.
Frommaul, Frechdachs, Filu, Hummelſchwanz, und Pfuſcherhahn
(ſteigt hinein und zieht Fratzen), beliebt nun auch mich zu begraben,
bin im Sarg und muß mein Ruheplätzchen haben.
Sonſt ſtell ich ein Stinken an, daß eure Naſen ſtaunen, und
ſpuk euch Stückchen vor, daß ihr ſpeit.
(Singt und zeigt auf Thomas und Eliſe):

Hähnchen hupft auf einem Beenchen,
Lenchen ſäugt ihr ſüßes Söhnchen,

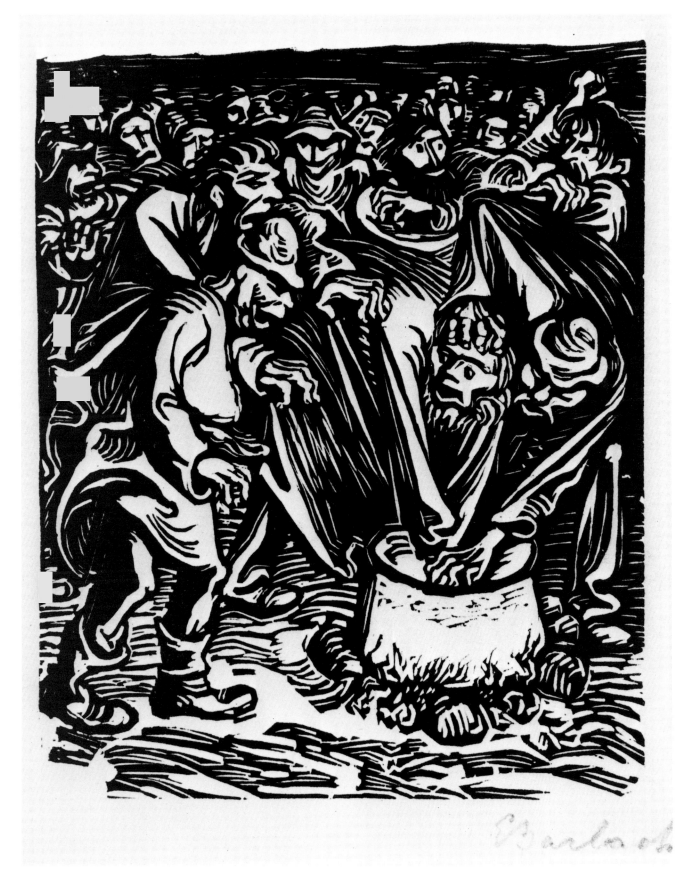

234.

235. Goethe. Walpurgisnacht (*All Hallows Eve*)
Mit 20 Holzschnitten von Ernst Barlach, Paul Cassirer, Berlin, 1923
49 pp., 25 x 33 cm. Text printed by Poeschel und Trepte, Leipzig.
Editions:
A. Vorzugsausgabe in 120 numbered examples, with an extra suite of woodcuts printed on thin japan paper, printed by the Pan-Presse, Berlin. All plates signed.
Bound in leather by Ulber, Berlin
B. Unknown Volksedition on Zanders Bütten paper, bound in grey cardboard, printed from zinc plates
(24.9 x 32.1 cm.)
Schult: 203, 204, 205, 206, 209, 210, 211, 212, 213, 214, 215, 216, 217, 218, 219, 220, 221, 222, 223

In the first part of Faust, Mephisto transports Faust to a witches Sabbath (Walpurgisnacht). Faust is shown crude sensuality and earthiness. This is the world of private emotion which makes up the first part of the book (Kleine Welt).

The witches' Sabbath was held on May first in the Harz mountains. Barlach takes this time period and illustrates it with his love of the grotesque and the fantastic. He was also interested because Goethe's text was taken not from the old versions of the medieval puppet play, but from much older European traditions. Goethe had used a true ancestor of the witch, the Druid, in his cantata of 1799, one year before this part was written. To Barlach, the Walpurgisnacht was Gothic.

The theory behind these woodcuts can be outlined from a few examples.

Plate 4, Das Irrlicht (*The Will-of-the-Wisp*) has the eery light of temptation for the weary traveller according to a folk tradition. It was a thing of the devil and a road to destruction.

Plate 6, Hexenreise (*Witch's Trip*): The specters are en route to their wild party on the mountain top. They ride on the wings of the wind song. "The witches ride to Brocken's top."

Plate 7, Die Hexe Baubo (*The Witch Baubo*): "Alone old Baubo is coming now. She rides upon a farrow sow." This old crone was Dementer's nurse, which Goethe uses as a thread to the classical second part of Faust. Baubo was known for indecent stories.

Plate 10, Reitender Urian (*The Mounted Urian*): This horseman was named as an unknown person (John Doe) or some one whose name was improper. The boisterous guests crowd around him. In the text, Urian comes after Baubo, but Barlach reverses the arrangement as a humorous application to the devil. The artist's full imagination to combine lobster claws, fish and goat parts in a complicated mixture of fleshy collage is directly from the tradition of Martin Schöngauer's St. Anthony.

Plate 15, Lilith: This female was Adam's first wife according to Rabbinical tradition (Genesis 1:27) Lilith proved unsatisfactory and Eve was created from Adam's rib. (Lilith also appears as a word in Isaiah 24:14) This first woman of Adam's was described in medieval legend as having beautiful hair, great power over infants, and causing destruction among young men.

Plate 17, Faust tanzend mit der Jungen (*Faust dancing with the Young Witch*), Goethe uses allusions to the young witch's breasts in the verse: "I beheld an apple tree, and there two apples shone." The witch replies:" Apples have been desired by man since first in Paradise they grew. I am happy to know that two in my garden grow."

Plate 19, Gretchen (called Marguerite later): The girl appears to Faust as a ghostly figure, which seems to have a thin line across its neck. It was the mark of the executioner's axe.

Barlach's technique in woodcut is fairly developed by this time. It resembles some of the carving on the statues in the Marienkirche at Ulm, with smooth and rounded faces on women, and angular, deeply undercut eye sockets. Barlach had used his knowledge of medieval symbolism to illustrate exactly Goethe's long story. Barlach applies little critical effort but enlarges the meaning of the words into visual strength. He expresses his own world view with a new assumption of the age of Faust.

Though Faust was first conceived as a legend of an alchemist, it is not considered only the drama of medieval man by Goethe. Barlach uses it in a wider context also during the difficult period after World War I. The play spans three thousand years, and includes scientific theory, philosophy and a rich description of human experience. Though Barlach does not clothe the characters as modern men, uses medieval costumes, he delves into the purposes and values of all human existence. Barlach's mocking woodcuts are very human.

235. Plate 17.

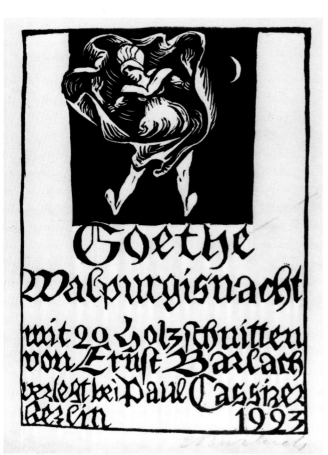

235.

235. Plate 10.

236. Goethe: Ausgewählte Gedichte *(Selected Poetry)*
Paul Cassirer, Berlin, 1924. Zweite Lieferung *(Second Offering)*
Ernst Barlach mit 31 (35) Lithographien.
Boxed, 39.5 x 29 cm. (15f)
60 pp., Unnumbered paging. Editions: 110 examples.
A: Museum Ausgabe: I – X, all plates signed, with extra suite on
B: 1-100 on Zanders Bütten, with extra suite on thin japan paper
all plates signed.
Schult: 227, 228, 229, 230, 231, 233, 234, 235, 236, 237, 238, 239,
240, 241, 242, 244, 245, 246, 247, 248, 249, 250, 251, 252, 253,
254, 255, 256, 257, 258, 259, 260, 261, 262

In contrast to the functional use of woodcut for the harsh and
stark words from Goethe's section of Faust, Walpurgisnacht,
Barlach uses the softer medium of lithography for the illustra-
tions of the early lyrical poetry. He is able to create scenes
within a reasonable appearing landscape. A sense of distance
is accomplished by plane as in woodcuts, but also by an at-
mospheric dimension and change of tonal values.

Titles of poems are given, then illustrated with some imagina-
tion, although Barlach remains fairly close to the meanings of
the words. This was important as Goethe's early poems were
considered as national treasures and memorized by every
German school child.

There is little development in the illustrations as there were in
the early to later styles of the poet. Goethe had passed from a
romanticism to classical severity. Barlach almost caricatures
the emotional stories.

The Erlkönig *(Erl King)*, for example, had been set to music by
Franz Schubert as a progressive development of more and
more excitement, by short phrases of music which increased in
speed as the final tragedy approached. Barlach is able to show
the idea of speed by exaggerating the horizontal lines of the
figures and background in the two views of the episode. A quiet
traveler with an apprehensive child rides through the specter-
filled night. A mere racing shadow of man and child against the
suggested form of the donkey, races with death along side as a
white image. (236/2).

Der Zauberlehrling *(The Sorcerer's Apprentice)* was also set to
music, but this time by Dukas. Barlach illustrates the frantic
accident, when the apprentice begins a magical action and
loses control, with a light touch and some humor.

Harzreise im Winter *(Journey to the Harz Mountains in Winter)*
is one of Goethe's most famous works. The beginning sense of
mission by the traveller is shown, and the other illustrations
show the lonely dejection of the character. This change came
from the poet's visit to an unhappy young man named Plessing,
who had been overly influenced by the romantic tragedy of
Goethe's Sorrows of the Young Werther. Brahm's alto Rhap-
sody was based on this poem.

Der König in Thule *(The King of Thule)* was taken from an
episode in Faust, part one. Gretchen sings the song, while she
is sitting in her bed chamber. The two illustrations have some
of the vibrant qualities of the actual words. Berlioz set these
words to music with extreme beauty in his musical version of
Faust. (236/3).

Barlach's illustrations were intended to be combined with the
text of each poem. Cassirer, the publisher, was unable to com-
plete his intention of illustrating the entire works of Goethe.
Only fifteen of the poems are matched with the illustra-
tions by Barlach. The other illustrations are given titles, but in-
cluded without the text as loose plates.

236/1.

236/2.

236/3.

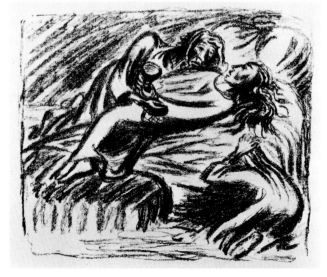

237. Schiller: An die Freude (*Ode to Joy*)
Paul Cassirer, Berlin, 1927, text printed by Jakob Hegner, Hellerau.
24 pp, Editions: 40 numbered examples in Vorzugsausgabe, unknown Volksedition
A: 1-40 on WZ or JWZanders paper, all woodcuts signed, parchment bound, 35.2 x 51.2 cm.
B: unnumbered Volksedition, bound in grey paper, woodcuts printed from zinc plates
(There may be a Museumausgabe of I-X)
Schult: 271, 272, 273, 274, 275, 276, 277, 278, 279

An die Freude, *(The Ode to Joy),* was Friedrich Schiller's great burst of happiness, written in Leipzig. The date, 1785, began a period of change for the poet. He had passed through an unhappy love affair in Mannheim earlier; and left for Leipzig, where two young couples provided for his material wants for two years until the final removal to Weimar.

The Ode combined cosmic images with an intention to raise human and spiritual joy high into universal realms. It was part of the poet's development toward a philosophy of instinctive right doing as opposed to Kant's morality of imperatives.

Schiller published the original version in his periodical, Die Thalia, which was issued from 1785 until 1793. Beethoven used the first three strophes and part of the chorus in the final movement of his ninth symphony. Schiller had begun with nine, but cut to eight strophes and choruses in the final version. Franz Schubert also set the Ode to music (D. 189). In 1927, an older Barlach gives a medieval clothing to Schiller's romantic poetry. Heaven is pictured as a place of height; and the title page has a feathered man gazing into streaming rays of joy, a section of the later illustration.

180

Barlach has worked with woodcuts in many conceptions. Here he articulates within areas, much like the work in the lithographs of his first play, Der Tote Tag. The outline is a plane rather than a line separation. Movement and direction of line within an area are the dimensions for movement not posture. Muscle structure is disregarded for apparent linear abstraction within the shape. The skillful artist makes each abstract form appear real and necessary in each location. Calligraphy is a mirror of necessity.

Few of the illustrations are representational as stages of a drama or picture plane. These are not stages for a spontaneous process, but mythical simulation. There is a floating quality to the figures, which are almost uprooted from earth.

The poetry of Schiller is full of images. Barlach introduces some of his own commentary, but also keeps to many of the poet's symbols of joy and the oppositions. Evil and good are contrasted. Lust and fulfillment are opposed. Earthly and heavenly love are exhibited as strong and double sides of the same likeness. There is a sly comment about a scholar, who is characterized as a grotesque, paper eating devil about to be attacked by a cool executioner. Joy is shown made real by wine and dream, by prayer and revelation, by toast and intimate discussion. Joy is not a simple feeling. Joy is finally pronounced by a seated God, with hands wide spread in benediction.

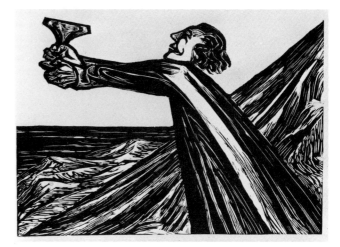

Plate 1:
Joy, fairest spark of God,
Daughter of Elysium,
We approach drunk with fire,
Heavenly, your sanctuary,
Your magic will bind us,
What custom sternly held apart,
All men will be brothers,
Beneath the softness of your wings.
Chorus:
Be embraced, millions!
By this kiss to all the world!
Brothers, High in the starry heavens
must a loving father dwell.

Plate 2:
When the great cast of dice occurs,
There is a friend of friends for thee,
Who has found a treasured wife,
Let him join our jubilation!
Yes-who has only one spirit
Can count on all around!
And he who denies it, then unseeing
Let him weep away from this alliance.
Chorus:
Who resides in this great circle,
Pay homage to sympathy!
Lead thee to the stars,
Where the unknown One is throned.

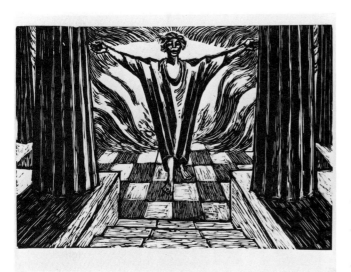

Plate 3:
All creatures drink joy
At the breast of nature,
All good, all bad
Follow her rosy trail.
She gave us kisses and the vine,
A friend, tested by death;
The worm was given voluptuousness,
And the cherub stands before God.
Chorus:
Kneel down, millions?
Do you sense the nearness, World?
Seek Him in the starry tent!
He must live above the stars.

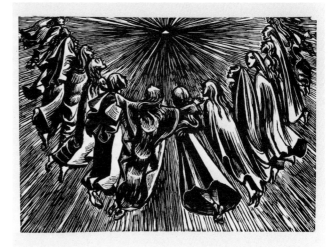

# EXHIBITIONS

## CHRONOLOGY OF EXHIBITIONS 1880-1914

| | | |
|---|---|---|
| 1880 Berlin: | Fritz Gurlitt opens his gallery | |
| 1888 | Gurlitt shows Liebermann | |
| 1889 | Gurlitt shows Lesser Ury | |
| 1892 | Group XI forms, shows at Schulte. Paul Hildebrandt shows Munch at Amsler & Ruthardt: Violent protest by academy professors | |
| 1893 | Fritz Gurlitt dies at age 39, gallery continues in family (Wolfgang) | |
| Munich: | Munich Secession opens first show | |
| 1894 Berlin: | Munch shows in Unter den Linden, private rooms. | |
| 1895 | Gurlitt shows Rohlfs. Berlin Kunsthalle shows British Pre-Raphaelites | |
| 1897 Munich: | Crystal Palace exhibition | |
| 1898 Berlin: | Bruno and Paul Cassirer open gallery | |
| Vienna: | Vienna Secession has opening exhibition; later in November, has second show at new quarters designed by Olbrich | |
| 1899 Berlin: | Berlin Secession begins | |
| Vienna: | Vienna Secession shows French art | |
| Munich: | Munich Secession has own headquarters | |
| 1900 Dresden: | Vienna Secession shows Japanese art and applied arts | |
| Berlin: | Munch shows at Wolffranns | |
| 1901 Munich: | First Phalanx exhibition | |
| Berlin: | Berlin Secession shows modern French art | |
| 1902 Dresden: | Munch shows at Richter-Holst | |
| Vienna: | Klinger's Beethoven at Vienna Secession | |
| Berlin: | Cassirer shows Kubin. Berlin Secession includes 72 Munchs | |
| 1903 Hamburg: | Munch at Cassirer and Commeter galleries | |
| Vienna: | Vienna Secession includes Marées, Hodler, Munch. | |
| 1904 | Miethke shows Beardsley, Secession shows Klimt | |
| Berlin: | Barlach shows at Mutz. Cassirer shows van Gogh | |
| 1905 Dresden: | Arnold shows Nolde | |
| Berlin: | Berlin Secession opens in permanent quarters. Munch has two shows at Cassirer | |
| Bremen: | Munch shows at Kunsthalle | |
| 1906 Berlin: | Schulte shows Russian art | |
| Bielefeld: | Fischer shows Munch | |
| Vienna: | Miethke shows Kubin | |
| Dresden/ Löbtau: | Brücke has first show in a glass showroom. | |
| Dresden: | Great crafts exhibition. Richter shows Munch | |
| Weimar: | Hofer shows for Count Kessler | |
| 1907 Dresden: | Richter shows Brücke, exhibition travels to Flensburg, Hamburg, Braunschweig, Leipzig, etc. | |
| Frankfurt: | Kandinsky shows at Katharinenhof | |
| Berlin: | Cassirer shows Munch, Cezanne, Matisse | |
| 1908 Bremen: | Memorial show for Becker-Modersohn | |
| Dresden: | Richter shows Brücke | |
| Vienna: | Kunstschau | |
| Munich: | Munch at Thannhauser | |
| Berlin: | Berlin Secession shows Brücke plus Barlach and Klee | |
| 1909 | Berlin Secession features Marées. | |
| Munich: | Brakl shows van Gogh. Thannhauser holds first Neue Künstlervereinigung exhibit | |
| Vienna: | Kunstschau. Pisco shows Schiele | |
| Dresden: | Richter shows Brücke | |
| Cologne: | First Sonderbund exhibition | |
| 1910 Düssel- dorf: | Sonderbund | |
| Dresden: | Arnold shows Brücke and Gauguin | |
| Munich: | Thannhauser shows Neue Künstlervereinigung, second show | |
| Berlin: | Neue Secession begins at Macht Galerie and has second exhibit there. Munch at J. B. Neumann | |
| 1911 Cologne: | Hodler show | |
| Berlin: | Munch at Kunstverein, Neue Secession's third exhibition | |
| Munich: | Thannhauser shows Blaue Reiter with Neue Künstlervereinigung. (Berlin Secession includes Munich groups) | |
| Düssel- dorf: | Tietz shows Brücke | |
| Bonn: | Cohen shows Ernst | |
| Hamburg: | Commeter shows Nolde and Schmidt-Rottluff | |
| Vienna: | Hagenbund | |
| 1912 Berlin: | Der Sturm gallery shows Blaue Reiter with French artists and Kokoschka. Later, shows Futurists, Kandinsky, Die Pathetiker. Gurlitt shows Brücke | |
| Cologne: | Gereon Club shows Blaue Reiter. Great Sonderbund exhibition | |
| Munich: | Goltz shows Blaue Reiter Macke shows at Thannhauser | |
| Bonn: | Macke shows at Cohen | |
| Bremen and Frankfurt: | Blaue Reiter shows | |
| Hagen: | Nolde shows Das Leben Christus at Folkwang Museum | |
| Chemnitz: | Brücke show | |
| 1913 Munich: | Goltz shows Schiele in expanded gallery | |
| Berlin: | Marc and Macke hang the Autumn Salon at Der Sturm gallery. Gurlitt shows Heckel, as does J. B. Neumann. Der Sturm shows Münter, Klee, Marc, Bloch, Cubists | |
| Vienna: | Miethke shows Schiele | |
| 1914 Düssel- dorf: | Flechtheim shows Munch, Barlach. Later Flechtheim shows the Rhineland Expressionists. | |
| Berlin: | Der Sturm organizes travelling shows for Blaue Reiter to visit Helsingfors, Trondheim, Göteborg. Cassirer shows Hofer and Beckmann. Gurlitt shows Otto Mueller. Der Sturm later shows Jawlensky, Macke, Klee, Kubin, Chagall, Futurists, Campendonk, Itten | |
| Hagen: | Folkwang Museum shows Schmidt-Rottluff | |
| Vienna: | Arnot shows Schiele | |

Ausstellungshaus am Kurfürstendamm 208/9

Berlin

## EXPRESSIONISM AND THE EXHIBITIONS

Germany had grouped into movements, as well as small or large centers for discussion and promotion in all fields. Periodicals and newspapers were known for definite viewpoints rather than unbiased reporting. Much of this compartmentalization was a result of the split between the intellectual classes and the centers of political control. With the advancement of Prussia to the control of government in Imperial Germany, there was no place for the thinkers and creators in policy or general affairs in the new capital of Berlin. Germany had always been a place of splinter groups, and this national tendency was carried to the extreme. Very few men had the courage or impulse to depart out of the defined social positioning that was rampant. Nietzsche was one exception, but he did not approve of the German political direction nor the Volkish and inward irrationalism of frustrated intellectuals.

The attitude of the public had been established in the late nineteenth century by official policies of the ruling classes as set forth in their newspapers and magazines. This was focused on realism, heroism and historicism, which was supposed to formulate a coming-together of German-speaking peoples through their cultural history. Thus the public did not accept the new art of the Expressionists; they ridiculed it. The growing disbelief of the younger artist in reality as his objective was discounted by critics such as Adolf von Hildebrand and official organizations of traditional artists.

The first great break with the traditionalists came in 1892 with the rejection of Munch's paintings by the official academy of art at an annual exhibition. The Verein Berliner Künstler kept intact. We exhibit a later catalogue to show the continuing conservative tone of naturalism and semi-Impressionism:

**238.** Der Verein Berliner Künstler *(The Union of Berlin Artists)* Katalog der grossen Berliner Kunstausstellung 1912 *(Catalogue of the Great Berlin Art Exhibition 1912)*
Berlin-Stuttgart-Leipzig: Union deutsche Verlagsgesellschaft
(5 pp) 160 pp text, 160 plates (39 pp advertising)
18.2 x 13 cm.
Grey linen covers with title stamped in gold
Includes work of Thoma, Trübner, Hoelzel, Zille, Kley, Gordon Craig.
Includes organizations from Munich and Düsseldorf, plus associations such as Freie Vereinigung für Graphik

This Verein Berliner Künstler was decimated when Max Liebermann led a group of painters away from the older group to exhibit as the Berlin Secession in 1899 and later. The art dealers Bruno and Paul Cassirer promoted these painters and their impressionist ideas. The catalogues of 1901, 1902, and 1904 were the third, fourth and fifth exhibitions before the group moved to permanent headquarters on the main boulevard in Berlin, the Kurfürstendamm. These exhibitions were held twice a year, in the spring and fall. In the fall show of 1908, the Secession exhibited the small group of graphics by the Brücke artists, most of whom were still in Dresden, though the overall policies of the Secession were directed towards Impressionism. Another exhibition reintroduced the work of Hans von Marées to the German public (1908), which brought his influence to young painters, such as Marc.

Liebermann had begun to turn his pupils and circle of artists away from literary painting. He combined a protest against this content with a liberal political outlook and put his mark on the contents of all the Secession exhibitions.

## BERLIN
239 Berliner Secession
**239/1.** Katalog der dritten Kunstausstellung der Berliner Secession *(Catalogue of the Third Art Exhibition of the Berlin Secession)*
Berlin: Bruno and Paul Cassirer, 1901
Printed by Imberg & Lefson, Berlin
66 pp text, 48 unnumbered plates (14 pp advertising)
15.7 x 11.7 cm.
Grey paper covers
Includes works by von Hofmann, Corinth, Forain, van Gogh (8 oils and 3 drawings), Kollwitz, Liebermann, Monet, Pissarro, Renoir, Rohlfs, Toulouse-Lautrec, Whistler, Zorn, Rodin
(Third Exhibition)

**239/2.** Katalog der fünften Kunstausstellung der Berliner Secession
Berlin: Paul Cassirer, 1902
Printed by Imberg & Lefson, Berlin
59 pp text (3 pp), 46 unnumbered plates (12 pp advertising)
15.8 x 11.6 cm.
Grey paper covers
Includes works by Corinth, Hodler, Kandinsky, Klinger, Kollwitz, Leistikow, Liebermann, Manet, Monet, Munch (drawings for the Frieze of Life, 24 oils, and 3 drawings), Orlik, Rohlfs, Sargent, Slevogt, Walser, Whistler, Zorn, Zuloaga, Minne, Rodin
This included the large one-man show of the works of Munch. The organization had become strong enough to have real and exclusive prerogatives. They began to introduce younger painters such as Kandinsky and Walser.
(Fifth Exhibition)

**239/3.** Katalog der neunten Kunstausstellung der Berliner Secession
Berlin: Paul Cassirer, 1904
Printed by Imberg & Lefson, Berlin
50 pp text, 48 unnumbered plates (14 pp advertising)
15.8 x 11.6 cm.
Grey paper covers
Includes works by Amiet, Carriere, Corinth, Gallén-Kallela, Hodler, von Hofmann, Jawlensky, Kandinsky, Liebermann, Maurer, Slevogt, Vallotton, Whistler, Zorn, Kolbe
(Ninth Exhibition)

**239/4.** Katalog der dreizehnten Ausstellung der Berliner Secession
Berlin: Verlag der Ausstellungshaus am Kurfürstendamm G.m.b.H., 1907
Printed by Imberg & Lefson
57 pp text (1 pp), 32 unnumbered plates (12 pp advertising)
15.8 x 11.6 cm.
Brown paper covers
Includes work by Amiet, Beckmann, Corinth, Courbet, van Gogh (10 works), Klein, Klinger, Liebermann (fine exhibition of 52 works), Munch, Nauen, Nolde, Purrmann, Puy, Segal, Slevogt, Maurice Sterne, Weiss, Zille, Barlach, Kolbe, Minne, Rodin
Nolde is shown for the first time, as is Barlach and Nauen. Purrmann and Segal were working in Paris, and were probably discovered by Cassirer during a journey to Paris.
(Thirteenth Exhibition)

**239/5.** Katalog der fünfzehnten Ausstellung der Berliner Secession
Berlin: Verlegt bei Paul Cassirer, Victoriastrasse 35, 1908
Printed by Imberg & Lefson, Berlin
71 pp text (1 pp), 40 unnumbered plates (28 pp advertising)
15.8 x 11.6 cm.
Blue paper covers, brown spine
Includes works by Beckmann, Bonnard, Cezanne, Corinth, Daumier, Denis, van Dongen, van Gogh, Hegenbarth, Hofer, Israels, Lang, Leibl (memorial exhibition of 55 works), Liebermann, Marquet, Maurer, Munch, Nauen, Slevogt, Vuillard, Weiss.
This exhibition included Barlach among its board members.
(Fifteenth Exhibition)

**239/6. Katalog der zwanzigsten Ausstellung der Berliner Secession**
Berlin: Verlag der Ausstellungshaus am Kürfurstendamm G.m.b.H., 1910
Printed by Imberg & Lefson, Berlin
71 pp text (1 pp), 48 unnumbered plates (32 pp advertising)
15.8 x 11.6 cm.
Blue paper covers with blue spine
Includes works by Amiet, Beckmann, Cezanne, Corinth, van Dongen, Feininger, G. Giacometti, Grossmann, Heckendorf, Hegenbarth, Hodler (including a drawing for the great Woodcutter), von Hofmann, Liebermann, Manet, Matisse, Meid, Moll, Monet, Munch, Nauen, Renoir, Slevogt, Stern, Walser, Weiss, Zorn (19 works)
Max Beckmann is now included on the board.
This is the first exhibit after the group split into the Neue Secession (see catalogue for that section). Cassirer is no longer the publisher.
(Twentieth Exhibition)

**239/7. Katalog der XXVI. Ausstellung der Berliner Secession**
Berlin: Verlag der Ausstellungshaus am Kurfürstendamm G.m.b.H., 1913
Printed by Imberg & Lefson, Berlin
78 pp text (1 pp), 48 unnumbered plates (18 pp advertising)
15.8 x 11.6 cm.
Blue paper covers, blue spine
Includes members who rejected the disagreement and kept within the membership of the Secession plus invited paintings from the Cassirer gallery and private collections.
Includes works by Meid, Oppenheimer, Purrmann, van Gogh, Slevogt, Walser, Cezanne, Pascin, Toulouse-Lautrec, Kokoschka, Barlach, Matisse, Lehmbruck, Grossmann, Heckendorf, Orlik, Moll, Schmidt-Rottluff, Derain, Segal, Pechstein, Kirchner, Heckel, van Dongen, Minne, Renoir, Seurat, Bonnard, Friesz, Sintenis, Marquet, Vlaminck
Barlach and Kollwitz are on the board.
(Twenty-Sixth Exhibition)

## LOVIS CORINTH

**240. Lebenswerk von Lovis Corinth. Ausstellung in der Secession, 1913** *(Exhibition of the Life Work of Lovis Corinth at the Secession, 1913)*
Color lithograph poster (After the painting of 1906, "Rudolf Rittner as Florian Geyer") (A Play by Gerhart Hauptmann, published in 1896)
71 x 94.8 cm.
Printed by Hollerbaum and Schmidt, Berlin.
Internationale Plakate 290
Ex. collection: Nürnberger Werbe-Arkivs

240.

## VIENNA

The Secession in Vienna was founded in 1897. Nineteen artists and designers organized as Die Vereinigung bildender Künstler Österreichs. Their periodical was first published in January, 1898. The first exhibition was in March, 1898, on premises of the Horticultural Society of Vienna. A poster for the exhibition was designed by Klimt. The new group's second exhibition was held in a new building designed by Josef Maria Olbrich and opened in November 1898. It was a success. The later exhibitions introduced the Impressionists, worked the old masters back into the stream of modern painting, included crafts and architecture.

**241/1. XIV. Ausstellung der Vereinigung bildender Künstler Österreichs Secession Wien**
**Klinger's Beethoven**
Wien: Ver Sacrum V. Jahr, April-Juni 1902
Printed by A. Holzhausen, Wien
85 pp text alternating with illustrations (13 pp advertising)
18.1 x 15.5 cm.
With original woodcuts by Andri, Jettmar, König, Kurzweil, Lenz, List, Elena Luksch-Makowsky, Moll, Moser, von Myrbach, Orlik, Stöhr
Max Klinger's *Beethoven* statue was at the center, with Minne sculpture introduced in side rooms (4 works)

This idea of using a center piece was a new one for the group. The three-nave arrangement allowed a viewer to see the central Klinger Beethoven from all sides. This catalogue was the first attempt to unify a book with an exhibition. The great murals by Roller, Böhm, and Andri were made for the exhibition and destroyed later. The Beethoven frieze by Klimt was saved, and finally purchased by the Austrian nation in 1972.

After the last great exhibition, the nineteenth of 1905, the organization split into two groups: the Klimt Gruppe which included architects and designers, and the Nur-Maler group ("Painters Only" group), with Engelhart as leader.

The Klinger statue had a balance between paganism and Christianity in the minds of the Jugendstil painters. His world of inner fantasy and grotesque imagination also appealed to them. What came into the stream of Austrian art was an interest in large shapes, deep interaction between mass and space and the use of dynamic line; though most of these influences came from the murals and designs around the statue. We will show some of these later exhibitions as examples of variety.

**241/2. XVI. Ausstellung der Vereinigung bildender Künstler Österreichs Secession Wien** *(16th Exhibition of the Union of Fine Artists of Austria, Secession, Vienna)*
Entwicklung des Impressionismus in Malerei und Plastik *(The Evolution of Impressionism in Painting and Sculpture)*
Wien: Januar-Februar 1903
42 pp text (18 pp advertising) (No illustrations)

Many sections, including: Old Masters with Tintoretto, El Greco, Goya, Velazquez, Delacroix, Daumier, Houdon (background). Main Impressionist section with Manet (9 works), Renoir (6 works), Degas (7 works), Cezanne (6 works), Pissarro (5 works), plus a section of near-Impressionists such as Whistler, Forain, Liebermann, Slevogt. Neo-Impressionists include Seurat, van Rysselberghe (7 works). The next section is a tasteful display of Japanese prints including Kiyonaga, Eishi, Eisho, Toyokuni, Utamaro, Hokusai, Hiroshige. This is followed by another section from the Impressionists: Toulouse-Lautrec (6 works), Vuillard (7 works), Bonnard (12 works), Denis (12 works), Vallotton (10 works), Redon (10 works), Gauguin, Valtat.

This was one of the greatest exhibitions ever held in Vienna. It included a very scholarly survey of the French impressionist school, some earlier influences on the nineteenth century modern movement, and the Japanese background to Jugendstil ornament. Japanese art had been given a complete show in the sixth exhibition in 1900.

**241/3. XVIII. Ausstellung der Vereinigung bildender Künstler Österreichs Secession Wien**
Wien: Nov.-Dez. 1903; Kollektiv Ausstellung Gustav Klimt
Printed by A. Holzhausen, Wien
16 pp text, 56 plates of oil paintings and drawings 72 pp total
24.7 x 23.5 cm.
Tan paper covers
80 works by Gustav Klimt in a one-man show in 9 rooms.
With Ver Sacrum logo by Klimt.
Catalogue and exhibition designed by Koloman Moser

This was the only exhibition by the Secession devoted to one painter. Many of Klimt's most important landscapes and portraits were exhibited. Only Karl Kraus seems to have found this show repulsive. This was the last great exhibition before some decline in standards.

242.

241/3.

241/2.

**242. II. Ausstellung der Vereinigung bildender Künstlerinnen Österreichs Hagenbund**
Wien: Sept.-Oct. 1911
Printed by C. Reisser's Söhne, Wien
42 pp text, 16 plates (4 pp advertising)
17 x 16.9 cm.

An interesting exhibition by Austrian women painters and foreign associates including Kollwitz, Mackintosh and Mme. Besnard.

By the wide selections in their shows, the Austrian Secessionists succeeded in bringing Austria into the international art scene. Minne was given great publicity as was the school of architects from Scotland; Mackintosh and the rest. Toorop, Munch, Hodler, and Rops were shown with great success. The Secessionists brought Oriental influence, through the Japanese print and sculpture. The most significant foreign artists from the Impressionist school were shown.

## DRESDEN

Modern German Expressionism was twofold in development: in Munich with the Blaue Reiter and in Dresden with the Brücke.

The Brücke had set a program as early as 1906. Nolde had exhibited at the Galerie Arnold as early as 1906, impressed the Brücke members and been asked to join. A first private exhibition organized in a lamp showroom, took place later in December 1906, and through January of 1907. This was the showroom of the manufacturer Seifert at Löbtau. The show was poorly attended and received only one review in a local paper, though it was by an important critic, Paul Fechter.

A second exhibition took place in Dresden, with Kandinsky included as a guest. The Salon Richter had an exhibition in the fall of 1907. The first great catalogue was published for the exhibition in the Galerie Arnold in Dresden in 1910. The exhibition travelled to the Grand Ducal Museum in Weimar before it opened in the rooms of the important Galerie Fritz Gurlitt in April, 1911. The catalogue was reprinted from most of the original blocks with some changes.

243. **K. G. Brücke** *(Catalogue of the Brücke Exhibition at Galerie Arnold)* Dresden, Schlossstrasse, September 1910
Printed by C. Rich, Gärtnersche Buchdruckerei; Heinrich Niescher, Dresden
38 pp (unnumbered)
23.2 x 18.5 cm.
Ochre colored paper covers
With 20 original woodcuts, in order of appearance:
243/1. Heckel, Titelholzschnitt *(Title Woodcut)*, Dube 177 I/II; Bolliger-Kornfeld 41/1, 17 x 11 cm.
243/2. Kirchner, Rudernde Samoanerin *(Rowing Samoan Woman)*, Dube 725 I/II; Bolliger-Kornfeld 41/2, 5.7 x 10.8 cm.
243/3. Kirchner, Mann und Frau *(Man and Woman)*, Dube 723; Bolliger-Kornfeld 41/3, 17 x 11 cm.
243/4. Kirchner, Badende (Badehaus) *(Bathers/Bathhouse)*, Dube 726; Bolliger-Kornfeld 41/4, 17.3 x 10.8 cm.
243/5. Pechstein, Sitzender Mann *(Seated Man)*, not in Fechter; Bolliger-Kornfeld 41/5, 17 x 11 cm.
243/6. Heckel, Fränzi, Dube 179 I/II; Bolliger-Kornfeld 41/6, 16.9 x 11 cm.
243/7. Kirchner, Sitzender Akt *(Seated Nude)*, Dube 722; Bolliger-Kornfeld 41/7, 17 x 11 cm.

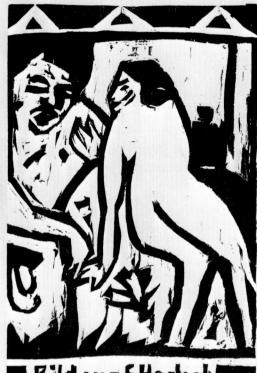

243/3.

243/8. Schmidt-Rottluff, Haus im Park *(House in the Park)*, Schapire 49; Bolliger-Kornfeld 41/8, 17.3 x 11 cm.
243/9. Schmidt-Rottluff, Schnitter *(Reaper)*, Schapie 50; Bolliger-Kornfeld 41/9, 17 x 11 cm.
243/10. Kirchner, Sandgräber am Tiber *(Trench Diggers at the Tiber)*, Dube 721; Bolliger-Kornfeld 41/10, 17 x 11 cm.
243/11. Pechstein, Artistin *(Artist)*, not in Fechter; Bolliger-Kornfeld 41/11, 17 x 11 cm.
243/12. Pechstein, Badende *(Bathers)*, not in Fechter; Bolliger-Kornfeld 41/12, 17 x 11. 2 cm.
243/13. Kirchner, Tanz *(Dance)*, Dube 724; Bolliger-Kornfeld 41/13, 11 x 17 cm.
243/14. Heckel, Müssige Weiber *(Idle Women)*, Dube 180 I/II; Bolliger-Kornfeld 41/14, 11 x 17 cm.
243/15. Heckel, Schlafender (Mann) *(Sleeper)*, Dube 178 I/II; Bolliger-Kornfeld 41/15, 17 x 11 cm.
243/16. Kirchner, Mitglieder *(Title of Associates)*, Dube 700; Bolliger-Kornfeld 41/16, 5 x 7.6 cm.
243/17. Kirchner, Passivmitgliederverzeichnis *(Membership List)*, Dube 701, 702, 703, 704; Bolliger-Kornfeld 41/17-20, each 17 x 10.5/10.8 cm.

243/8.

243/4.

243/6.

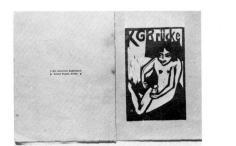

243/1.

243/13.

243/14.

This was the first great catalogue, after the Vienna Secession, which was completely designed by artists as a unity of ideas. Each artist made woodcuts after the paintings of his friends. Included in this exhibition were Amiet, Heckel, Kirchner, Pechstein, Schmidt-Rottluff, and the guest, Otto Mueller. Nolde had already broken from the group. Typography, a heavy primitive typeface, was carefully selected to match the optical weight of the woodcuts.

### DÜSSELDORF

244. K. Gr. "Brücke" in der Kunstausstellung im Hause Leonhard Tietz, Düsseldorf *(K. Gr. "Brücke" in the Art Exhibition at Haus Leonhard Tietz, Düsseldorf)*
Announcement: May—June 1911 Exhibition
Woodcut, 1911
On Cardboard
7.5 x 14 cm.

For an exhibition in Leonhard Tietz's gallery, in Düsseldorf, May-June 1911, the Brücke issued an invitation. The actual designer is unknown, but all the artists designed such material for various shows.

244.

## BERLIN

245. Ausstellung von Künstlergruppe Brücke im Kunstsalon Fritz Gurlitt, Berlin, 1912 *(Exhibition of the Brücke Artists' Group in the Fritz Gurlitt Art Salon, Berlin, 1912)*
8 pp text, 10 original woodcuts, insert of 6 illustrations (23.3 x 19 cm.)
26 x 19.8 cm.
Blue-grey paper covers with red and black title by Kirchner. This is a variation of the catalogue made for the Galerie Commeter in Hamburg, later in 1912. Two woodcuts were substituted. 10 original woodcuts on deckel edge handmade paper, in order of appearance:
245/1. Kirchner, Titelholzschnitt *(Title Woodcut)*, Dube 727; Bolliger-Kornfeld 42/1, 15.1 x 5.9 cm.
245/2. Heckel, Badende am Teich *(Bathers by a Pond)*, Dube 227 I/II; Bolliger-Kornfeld 42/2, 13.5 x 11 cm.
245/3. Heckel, Sich Waschende *(Woman Washing Herself)*, Dube 228; Bolliger-Kornfeld 42/3, 13.3 x 10.5 cm.
245/4. Kirchner, Schleudertanz *(Swing Dance)*, Dube 728; Bolliger-Kornfeld 42/5, 13 x 10.9 cm.
245/5. Kirchner, Toilette *(Dressing Table)*, Dube 730 II/II; Bolliger-Kornfeld 42/6, 12.9 x 10.8 cm.
245/6. Mueller, Drei sitzende Mädchen *(Three Seated Girls)*, Karsch 4; Bolliger-Kornfeld 42/8, 11.2 x 13.1 cm.
Mueller, Sitzendes Mädchen, *(Seated Girl)*, reproduction of a drawing.
245/7. Pechstein, Landschaft *(Landscape)*, not in Fechter; Bolliger-Kornfeld 43/6, 10.8 x 13.1 cm.
245/8. Pechstein, Schwermut *(Sadness)*, not in Fechter; Bolliger-Kornfeld 43/7, 13.3 x 11.1 cm.
245/9. Schmidt-Rottluff, Kämmende Frauen *(Women Combing Their Hair)*, Schapire 97; Bolliger-Kornfeld 42/9, 13.3 x 11.2 cm.
245/10. Schmidt-Rottluff, Sitzendes Mädchen *(Seated Girl)*, Schapire 98; Bolliger-Kornfeld 42/10, 13.3 x 11 cm.

After this exhibition, Pechstein left the group and was not included in the show at Galerie Commeter, Hamburg. His prints were dropped from the catalogue and graphics by Heckel and Schmidt-Rottluff were substituted.

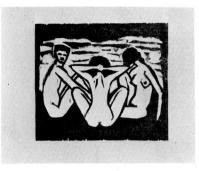

245/4.

245/6.

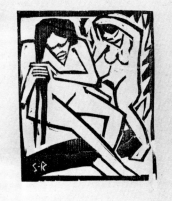

245/8.

245/1.

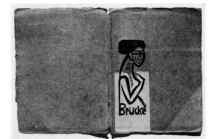

245/2.

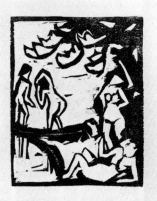

245/9.

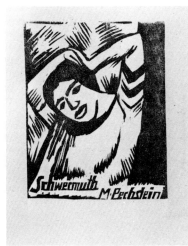

## MUNICH

The Blue Rider Group had grown out of previous organizations and was a continuance, not a beginning as was the Brücke. Munch's one-man show and earliest Secession exhibition was the first break. Kandinsky had organized the Phalanx group, and later helped form the Neue Künstlervereinigung.

246/1. Neue Künstlervereinigung München E. V. *(New Artists' Group, Munich)*
Turnus, 1910 (First Exhibition)
Printed by F. Bruckmann, Munich
10 pp text, 14 plates
16.3 x 12.8 cm.
Off-white paper covers with gold logo
Includes Kandinsky, Jawlensky, Hofer, Kubin, Kanoldt

246/2. Neue Künstlervereinigung München E. V.
Turnus, 1910/11 (Second Exhibition)
Printed by F. Bruckmann, Munich
47 pp text (1 pp), 25 plates (6 pp advertising)
16 x 12 cm.
Off-white paper covers with gold logo
Includes Kandinsky, Münter, Braque, the Burljuks, Derain, van Dongen, Le Fauconnier, Jawlensky, Kanoldt, Kogan, Kubin, Picasso, Rouault, Vlaminck

246/3. Neue Künstlervereinigung München E. V.
Turnus, 1911/12 (Third Exhibition)
Printed by F. Bruckmann, Munich
13 pp text (1 pp), 8 plates
15.8 x 12.2 cm.
Off-white paper covers, without gold logo
Includes Jawlensky, Kanoldt and Kogan. Does not include Kandinsky and Münter

The New Artists' Group was decimated by the departure of Kandinsky. The last catalogue is small and unimportant.

Kandinsky's relationship with the Brücke included participation in the second graphics exhibition in 1906-1907. He had split from the Munich Secession and joined a new artists' group in 1909. They held two important exhibitions before the group separated again. The second exhibition of the NKV in 1910-1911 was the most important, because it included many of the best young French painters, such as Braque, Derain, Picasso, Rouault, and Vlaminck. The five statements as introduction by Le Fauconnier, the Burljuks, Kandinsky, and Redon, who was not in the show, and an introduction to a catalogue from Paris by Rouault infuriated the stuffy public in Munich. But Cubism had been introduced to Munich through a wider survey than private dealers could accomplish.

Kanoldt and Erbslöh held aesthetic views different from Kandinsky, and the inevitable break came in 1911. This led to the formation of the Blaue Reiter exhibition and almanac one year later in 1912.

247/1.

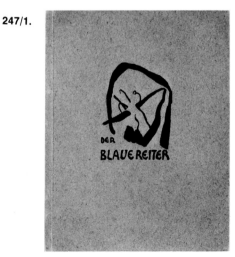

246/2.

247/1. Die erste Ausstellung der Redaktion der Blaue Reiter, 1911-12
*(The First Exhibition by the Editorial Staff of the Blue Rider, 1911-12)*
Exhibition opened December 18, 1911, in the same gallery as the Neue Künstlervereinigung, Moderne Galerie Thannhauser.
6 pp text, 13 plates
14.9 x 12 cm.
Grey paper covers with blue logo
Includes works by Rousseau, Bloch, D. Burljuk, Campendonk, Delaunay, Elizabeth Epstein, Kahler, Kandinsky, Macke, Marc, Münter, Niestle, Schoenberg

Marc and Macke had not been members of the split group. Marc was close to Thannhauser and probably influenced the selection of that gallery for the first exhibition. The name came from the title of the projected almanac. Kandinsky showed early non-objective paintings. Niestle, Macke and Campendonk were close friends of Marc. The American, Albert Bloch, born in St. Louis, was invited. During this period, Kandinsky published his ideas in *Concerning the Spiritual in Art;* and during the spring of 1912, the Blue Rider Almanac was published, both by Piper in Munich.

248/1.

In Berlin the reactionary forces had lost some control in earlier exhibitions, such as that of 1908-1909, though they regained control and excluded the younger modern painters in 1910. Pechstein and others formed into a "Salon des Refusés" in 1910.

248/1. Katalog der neuen Secession, Ausstellung von Werken Zurückgewiesener der Berliner Secession 1910 *(Catalogue of the New Secession, Exhibition of Works Refused by the Berlin Secession 1910)*
Berlin: Verlag der Gemälde-Galerie Maximilian Macht, 1910
15 pp text (1 pp), 17 plates (2 pp), (12 pp advertising)
18 x 12 cm.
Off-white paper covers with logo by Pechstein in red-brown.
Includes works by Heckel, Helbig, Klein, Kirchner, Melzer, Mueller, Pechstein, Richter-Berlin, Schmidt-Rottluff, Segal, Steinhardt, Tappert, Waske

Most of these were young painters around the literary publications, except for Pechstein and his close friends. Kirchner and Heckel showed the most advanced work. Most of the reaction in the press was negative. This exhibition occurred at the same time as the important Brücke show at Galerie Arnold.

248/2. Katalog der neuen Secession Berlin E.V.; III. Ausstellung; Gemälde

February-April, 1911 (Third Exhibition)
Berlin: William Baron Verlag, Augsburger-Strasse 24
23 pp text (1 pp), 13 plates (2 pp), (10 pp advertising)
17.7 x 12.3 cm.
Off-white paper covers with logo by Pechstein in green.
Includes works by Heckel, Kirchner, Klein, Melzer, Mueller, Nolde, Pechstein, Rohlfs, Schmidt-Rottluff, Segal, Tappert

248/3. Katalog der neuen Secession Berlin E.V.; IV. Ausstellung; Gemälde
18 November 1911-31 January 1912 (Fourth Exhibition)
Berlin: Verlag: Neue Secession, 1911
23 pp text (1 pp), 23 plates, (16 pp advertising)
17.7 x 11.8 cm.
Off-white paper covers with logo by Pechstein in red.
Mitglieder der neuen Künstlervereinigung München und neuen Secession.
Includes two sections: Munich and Berlin

Though the Munich group had broken into two parts, Kandinsky, Marc, Jawlensky, Kanoldt, and others are together here.

247/2. Die zweite Ausstellung der Redaktion der Blaue Reiter, Schwarz/Weiss, 1912 *(The Second Exhibition by the Editors of the Blue Rider, Black/White, 1912)*
Munich: Ausgestellt durch Hans Goltz, Kunsthandlung, Briennerstrasse 8, 1912
Exhibition held in the upstairs room of the bookstore owned by Hans Goltz, February 12, 1912.
16 pp text, 20 plates
14.9 x 12.5 cm.
White paper covers with blue logo
Includes works by Arp, Bloch, Braque, Delaunay, Derain, Maria Franck-Marc, de la Fresnaye, Gimmi, Gontcharova, Heckel, Helbig, Kandinsky, Kirchner, Klee, Larionov, Lotiron, Lüthy, Macke, Malevich, Marc, Morgner, Mueller, Münter, Nolde, Pechstein, Picasso, Russian folk prints, Tappert, Vera, Vlaminck, Kubin, Melzer

Kandinsky and Marc searched farther for participants in this second exhibition. They included the Russians living in Munich, members of the Swiss Moderne Bund, some of the circle around Walden in Berlin, young French painters and reprinted Russian folk prints. Kandinsky had been able to reciprocate for his inclusion in the earlier Brücke show in Dresden by inviting the Brücke members, including the departed Nolde. All the works in the second exhibition were on paper.

## DÜSSELDORF

The great Sonderbund organization held exhibitions in Düsseldorf before certain objections prevented further exhibitions there. A representative show is listed below.

249. Ausstellung des Sonderbundes westdeutscher Kunstfreunde und Künstler, Düsseldorf 1910 (*Exhibition of the Sonderbund of West German Art Friends and Artists, Düsseldorf 1910*)
16. Juli bis 9. Oktober im Städtischen Kunstpalast am Kaiser-Wilhelm-Park (Second Exhibition)
Düsseldorf: Verlag August Bagel, 1910
66 pp text (2 pp), 30 plates, (22 pp advertising)
15.6 x 11.6 cm.
Tan paper covers with two-color title in red oxide and black.
Includes works by Bonnard, Camoin, Cross, Denis, Derain, van Dongen, Friesz, Matisse, Hofer, Jawlensky, Kandinsky, Kanoldt, Kirchner, Klein, Liebermann, Maillol, Nauen¦ Nolde, Pascin, Pechstein, Picasso, Purrmann, Rohlfs, Schmidt-Rottluff, Signac, Vlaminck, Vuillard, Walser, Weiss

This was a major attempt at a survey of the best French and German art. It included the Rhinelander painters, those from Berlin, Munich, Paris. An explanation of the new color theories was published with the show.

After the 1910 Sonderbund exhibition, a great international exhibition was planned. The teachers at the Academy of Art in Düsseldorf, where the exhibition was planned, refused to allow it. The great Kunsthalle in Cologne was offered as a substitute, and a fund of 25,000 Marks was provided. Important citizens were selected as board members to insure the success of the exhibition.

249.

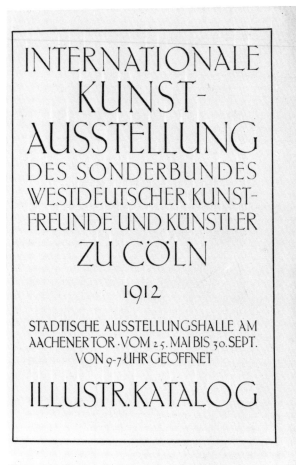

250/1.

## COLOGNE

**250/1.** Internationale Kunstausstellung des Sonderbundes westdeutscher Kunstfreunde und Künstler zu Cöln 1912
25. Mai bis 30. September
Printed by M. Dumont Schauberg, Cologne
Introduction by Dr. R. Reiche
(2 pp) 104 pp text, 65 plates (38 pp advertising)
15.7 x 11.2 cm.
Tan paper covers with logo in ochre and black

There were twenty-five galleries of paintings, a chapel decorated with a mural by Heckel and Kirchner (Madonna mit ornamentaler Bemalung) plus windows of stained glass by Jan Thorn-Prikker, four rooms of crafts from Die Gilde westdeutscher Bund für angewandte Kunst, showing batik, book covers, jewelry, silhouette drawings, silver, illustrations.

Includes works by van Gogh (108 oils and 17 drawings), Cezanne (24 oils, 2 watercolors), Gauguin (21 oils, 3 on paper), Cross (15 works), Picasso (16 works), Signac (18 works) as features. From France: Bonnard, Braque, Denis, Derain, Friesz, Laurencin, Matisse, Maillol, Marquet, Vlaminck, Vuillard. From Holland: van Dongen, Mondrian, Thorn-Prikker. From Switzerland: Amiet, Giacometti, Hodler. From Hungary: Bato, Pascin. From Norway: Munch was not included, but given a special room with 32 entries. From Austria: Kokoschka and Schiele. From Germany: von Bechtejeff, Becker-Modersohn, Bloch, Caspar, Erbslöh, Freundlich, Genin, Grossmann, Heckel, Hofer, Jansen, Jawlensky, Kandinsky, Kanoldt, Kirchner, Klee, C. Klein, Lehmbruck, Levy, Macke (both August and Helmuth), Marc, Melzer, Mense, Morgner, Mueller, Nauen, Nolde, Ophey, Pechstein, Purrmann, Richter-Berlin, Scharff, Schinnerer, Schmidt-Rottluff, Tappert, Weiss. Among the sculptors were included: Barlach, Freundlich, Hoetger, Kogan, Lehmbruck, Haller, Georges Minne (14 pieces), Maillol, de Fiori

It was truly an international show, excluding the New World: the Rhineland, Blaue Reiter, Brücke, Germans from Paris, the French artists, etc. Beckmann was the only important painter excluded. It was the last exhibition held by the Sonderbund. After this great exhibition the organization collapsed.

Published in conjunction with the international Sonderbund exhibition:

**250/2** Die neue Malerei *(The New Painting)*
Dr. Ludwig Coellen
Munich, E.W. Bonsels & Co., 1912
75 pp (1 pp)
24.3 x 16 cm.

Introduction, page 7-10:
Whoever was not aware of it could learn at the Cologne exhibition of the "Sonderbund" in the summer of 1912, at least the fact that painter-youths go their own and new ways. We were geared to Impressionism for a long time; Cezanne and van Gogh went along somewhat, and Hodler appeared as a single, towering individual who, however, demanded a different standard. What becomes apparent before our eyes today is that we are at both the beginning and the very end of the scheme. There is no longer the panorama of impressionistic mists; this is different, yes, a conscious and emphasized opposite to Impressionism as it is generally understood. These painters make programs and call themselves Expressionists, Cubists and Futurists. Whoever has a sense for art tries to learn this, tries to understand the intentions of the art and in this way to finally gain enriched enjoyment. The consequence and agreement of so many painters, the fighting energy with which they express themselves: We are given the assurance almost that a special way of looking works here, which is not accidental, but a law which art necessarily serves. When in art a principle becomes a habit (as Impressionism has become to us), and then disappears; when we are pushed towards a new attitude, then the most important thing is no longer to describe the greatness of the creation: It is necessary, first of all, to understand the law which is emerging.

The attitude of the public is fatal. It always is in such a case. When there is a break with tradition, ridicule and anger arise; and here a lot will be asked of the convention-prone. I am not even talking about van Gogh, but the obligation to take a dishevelled confusion of arbitrarily confined plane areas as a "woman with violin," and beyond Picasso they must watch with forebearance the wild gallop of the "Blaue Reiter." Why should they not laugh and scold here? Because art is a holy matter, which demands awe. Because van Gogh was a genius, who gave his life in the heated wrestling for a holy duty, gave his life to the very end of insanity. And because this crowd of artists gives testimony that they obey the same duty. Anyone can make up his own mind, but he must do it with deep consideration. It is not true that art is immediately understandable to everyone. It is easier to understand the teachings of science than to have maturity enough for the comprehension of art. For this you need long training and an orderly elevation of the mind. And, also, each work of art which has greatness needs to be conquered. It demands discovery. It is a multitude which is held to unity by the stream of life, and can only be grasped in its multiplicity. Then one feels happiness bringing warmth to this life. Simplicity in a work of art is no longer the usual, the easily understandable, the natural. The simple is a mysterious necessity with many facets. The many parts are each necessary for a complete organism, and in only this way is the work simple. Thus, each needs to be discovered by the use of strength and brains: The simple is the task which the work of art presents before us.

This principle of simplicity which forms the soul of the work of art, however, is at the same time a symbol of the spirit of the time. The spirit of art does not express itself in a general form, but is always stipulated by historical necessity. And with the dignified and honest attitude which we must take toward a complete view of the new painting, we are directed toward another law which manifests itself. Just as Impressionism expresses a spiritual law of our time, so this art desires to spring from at least an inflection of the same law— if not from a new one. If we can advance toward an understanding of this, we have gained the first basis for sufficient judgement, worthy of real education. We must say neither yes nor no before we have accomplished this effort of thinking. Certainly such an understanding of art has nothing to do with its enjoyment. It is an action which contains much philosophical sense and value, and is opposed to the direct experience of art. But it belongs, nevertheless, to conditions which make a judgement possible, and it is an invaluable means for a mental attitude which a visual comprehension of art demands.

The exhibition of the "Sonderbund" gave a comprehensive picture beyond the single appearance of the artist personalities. It was of special value, and raised this to an exceptional event. When I undertake this writing to search for the overall picture of the painterly expression of the time, it seems possible to uncover the relationships which connect the consciousness of our time with the painting of today. However, the intention of working in an instructive manner within the form of this pamphlet is in a sense confining: I must enter some things as mere theses, which require a deeper philosophical reasoning; but my desire is to say what is necessary to understand the new pictures.

## BERLIN

After the Sonderbund effort faded away, the avant-garde was carried especially into public view by Herwarth Walden in Berlin. He did not have the space for a huge exhibition, but chose the works carefully, with emphasis on Cubism, Futurism, and Expressionism as the leading modern movements. Herwarth Walden had travelled all over Europe, corresponded with painters in fifteen countries. The final choice was of 366 paintings. He included Russian peasant art, a couple of paintings of tigers by an Indian court painter, one Turkish work, four Japanese landscape prints and one Chinese landscape print.

251. Erster deutscher Herbstsalon, Berlin, 1913 (*The first German Autumn Salon, Berlin, 1913*)
Organized by Herwarth Walden
Berlin: Der Sturm
Printed by Wilhelm Rohr, Berlin
32 pp, 60 plates (4 pp advertising)
22 x 16.3 cm.
Purplish-blue paper covers with title in white. Includes works by Rousseau (22 works), Archipenko, Arp, Balla, Baumeister, von Bechtejeff, Bloch, Boccioni, D. and W. Burljuk, Campendonk, Carra, Chagall, Delaunay (21 works), Sonia Delaunay-Terk (26 works), Elisabeth Epstein, Ernst, Feininger, Filla, Gleizes, Marsden Hartley (he was living in Germany), van Heemskerck, Helbig, Jawlensky, Kandinsky, Klee (22 dwgs.), Kokoschka, Kubin (19 dwgs.), Larionov, Leger (10 works), Macke, Marc, Marcoussis, Mense, Metzinger, Mondrian, Münter, Picabia, Seehaus, Severini, Seewald, Steinhardt, von Werefkin.

Many of these pieces were major statements in the history of modern art, especially the Boccioni *Unique Forms in the Continuity of Space,* Marc's *Tower of Blue Horses,* Kandinsky's *Composition #6,* and Balla's *Dog on a Leash* (Eine Leine in Bewegung).

Walden also announces his "Club for Art" in which a member can spend twenty Marks and get: free subscription to Der Sturm, free entrance to Sturm gallery exhibitions, free entrance to the Autumn Salon (at another address), artist portfolio of the year (Kokoschka), and get half-price for all meetings of the Verein. If one paid for five years in addition, one would get five percent off works of art and books issued by Der Sturm.

Introduction by the Exhibitors (p. 27 of the catalogue):

Today we are not living in a time in which art is a helper of life. What originates today in real art seems rather a condensation of all powers which life is not able to absorb, to use up; it is the equation which abstractly thinking minds draw from life, desireless, purposeless, without fight.

At other times art is yeast which ferments the dough of the world. Such times are remote from today. Until they are fulfilled, the artist must keep at the same distance from official life.

This is the reason for our self-chosen seclusion from the offers the world brings us. We do not want to mix with it. Along with this "world" we count artists who are foreign to us, with whom cooperation seems impossible to us. Not for "political art" reasons, which are so talked about nowadays, but for purely artistic ones.

## MUNICH

The new Secession in Munich had one show before the war. It exhibited only German or Austrian artists. The international aspect was over until 1919. It showed mostly Munich painters and friends.

252. Neue Münchener Secession 1914 (*New Munich Secession 1914*)
Erste Ausstellung: 30. Mai bis 1. Oktober (*First Exhibition*)
Munich: Verlag des Graphik-Verlag, G.m.b.H.
Printed by R. Oldenbourg, Munich
29 pp text (3 pp), 30 plates (18 pp advertising)
16.3 x 11.9 cm.
White paper covers with four-color logo by Max Unold. Includes works by Beckmann, Caspar, Genin, Grossmann, Heckel, Heckendorf, Hofer, Jawlensky, Kanoldt, Kisling, Klee, Kokoschka(Windsbraut (*The Great Tempest*), which Kokoschka sold after war broke out to buy a horse), Kolbe, Nolde, Pascin, Pechstein, Purrmann, Scharff, Schinnerer, Seewald, Teutsch, Unold.

251.

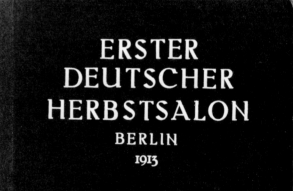

ERSTER DEUTSCHER HERBSTSALON
BERLIN
1913

DER STURM
LEITUNG: HERWARTH WALDEN

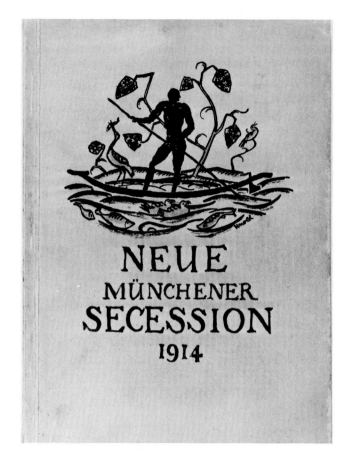

252.

After the Sonderbund exhibition and the Sturm Autumn Salon, another battle broke out in the Berlin Secession. The reactionary members stayed with Corinth as a side-Secession. Members with more modern views formed the Free Secession. The new honorary president was Liebermann, but the board had real power and was made up of such artists as Barlach, Beckmann, Lehmbruck, van de Velde, Walser, Weiss and Zille. Some of the older conservatives went along, serving on the board. Trübner, Slevogt, and August Kraus worked in sympathy with the more modern men. There were three exhibitions of the Free Secession in Berlin before the war.

253. Katalog der ersten Ausstellung der Freien
Secession, Berlin, 1914
*(Catalogue of the First Exhibition of the Free Secession,*
*Berlin, 1914)*
Berlin: Verlag der "Ausstellungshaus am Kurfürstendamm," G.m.b.H., 1914. III. Auflage; printed by Imberg & Lefson, using Haarlemer type. Bound by Lüderitz & Bauer, Berlin
72 pp text (23 illustrations in text), 48 plates (16 pp advertising)
17 x 11.8 cm.
White cardboard covers with green logo by E. R. Weiss.

Includes works by Beckmann, Bonnard, Carriere, Cassatt, Cezanne, Degas, Denis, Feininger, Gauguin, van Gogh, Heckel, Heckendorf, Hettner, Hodler, Hofer, Jansen, Janthur, Kirchner, Kisling, Laurencin, Levy, Liebermann, Macke, Manet, Marées, Meid, Meidner, Meseck, Moll, Monet, Morisot, Oppenheimer, Orlik, B. Pankok, Pascin, Pechstein, Pissarro, Purrmann, Renoir, Schmidt-Rottluff, Seewald, Segal, Sisley, Slevogt, Thoma, Vuillard, Waske, Weiss; sculpture by Barlach, de Fiori, Kolbe, Lehmbruck, Maillol, Marcks, Minne, Rodin, Sintenis.

Neither Kandinsky nor Marc joined. Kollwitz, Kubin, Matisse, Obrist, and Rohlfs were members but did not exhibit. The beloved French Impressionists were exhibited, as usual in any show in which the Cassirer group had a hand. There were no major works, except, possibly, Heckel's oil of Die Tote *(The Dead).*

253.

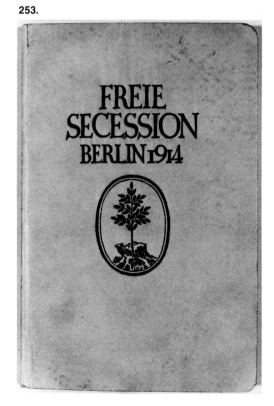

## MUNICH

Private galleries had group shows, theme shows, evenings for discussions, musical meetings, and dogmatic or simplistic extensions of the gallery activities. We can use Hans Goltz in Munich as an example. He had begun as a bookdealer and small-time publisher. To bring in extra clients he started a small upstairs art gallery, where the Blue Rider exhibition was shown. His later policies were devoted to the illustrators and native painters of Munich. Klee was treated in an extremely derogatory way, but exhibited there.

## RICHARD SEEWALD

254. Neue Kunst Hans Goltz *(New Art at Hans Goltz)*
handcolored lithograph poster, 1915
71.5 x 91.5 cm.
Signed by the artist, from his collection.
Jentsch P 2
This poster, designed for the New Year exhibition at the Goltz Galerie in Munich, is a rare example of the newly expanded gallery's tendencies in modern art. The works of Beeh, Grossmann, Klee, Purrmann, Seewald and others were exhibited in the old building in Briennerstrasse 8. Later the gallery moved again to large quarters near the Hotel Der Vier Jahreszeiten and the Opera.

255/1. Neue Kunst Hans Goltz *(New Art at Hans Goltz)*
Erste Gesamt-Ausstellung *(First Entire Exhibition);* undated (1912)
Introduction by Dr. Ernst Stählin
Printed by F. Bruckmann, Munich
24pp text, 19 plates (2 pp advertising)
15.1 x 12.5 cm.
White paper covers with title in green ink.
Includes works by Amiet, Cezanne, Derain, van Dongen, Elisabeth Epstein, Le Fauconnier, Gauguin, van Gogh, Heckel, Herbin, Jawlensky, Kandinsky (24 works), Kanoldt, Kirchner, Klee, Marc, Matisse, Münter, Picasso, Roussel, Utrillo, Vlaminck, von Werefkin.

Goltz took up the international exhibition with this next first show after the war. He had a small selection of graphics by Arp, Gauguin, Braque, Kandinsky, Kollwitz, Kubin, Marc, Munch, Pechstein, and Schiele.

255/2. Neue Kunst Hans Goltz—54. Ausstellung
Herbst 1919—V. Gesamtausstellung—September-Oktober *(Fifth Complete Exhibition)*
Printed by C. Wolff & Sohn, Munich
Introduction by Leopold Zahn
14 pp text, 23 plates (12 pp advertising)
15.2 x 12 cm.
Light orange paper covers with title in black.
Includes a protest from the Immermann-Bund in Düsseldorf against adverse criticism, against those who flaunt local tradition, against the kind of "small spirit" that caused the Sonderbund to flee from Düsseldorf to Cologne, and also against the Flechtheim gallery. In his introduction, Dr. Zahn calls this an attack on windmills.

Includes works by Bloch, Davringhausen, Derain, Eberz, Feininger, Felixmüller, Gleichmann, Grosz, Heckel, Kanoldt, Kirchner, Klee, Kokoschka, Lange, Meidner, Mense, Mueller, Nauen, Pechstein, Rohlfs, Scharff, Schrimpf, Seewald.

Again, these are not important works with the exception of an oil by Feininger, Ehringsdorf. The attacks by nationalistic groups are laughed aside, now in this time of wide acceptance for the Expressionists.

254.

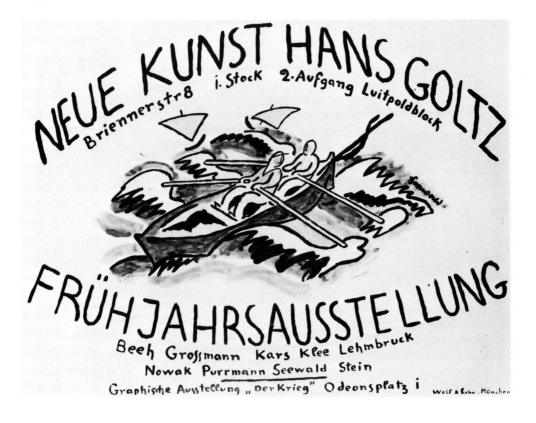

# DÜSSELDORF

Alfred Flechtheim in Düsseldorf opened an Expressionist show as his first venture after the war. He published a book to accompany the exhibition.

256. Galerie Alfred Flechtheim, Düsseldorf
Wiedereröffnung—Ostern 1919. I. Ausstellung—Expressionisten *(Reopening-Easter 1919–First Exhibition–Expressionists)*
Potsdam-Berlin: Gust. Kiepenheuer Verlag, 1919
88 pp mixed text and plates (60 plates), with two original woodcuts on yellow japan paper by Richard Schwarzkopf and Eberhard Viegener
23.5 x 16 cm.
Tan paper covers with title printed in black
Introduction by Herbert Eulenberg, articles by Walter Cohen, Wilhelm Hausenstein, Hans Müller-Schlosser, Wilhelm Uhde, Hermann von Wedderkop and Paul Westheim

This is more than an exhibition catalogue. It is a manifesto about the new politics, and especially revolution in Germany. A Herbert Eulenberg poem set the stage.
"Art and Revolution
the paths belong together
a painter and a poet
stand continually in flames."

It is not only in Berlin that the intellectuals had hope for a new day. The catalogue also has articles about the recently dead Macke, Seehaus, Lehmbruck. There is a statement attesting the formation of the radical group, Das junge Rheinland, organized on the 24th of February, 1919 with Christian Rohlfs as honorary leader. Most of the artists lived in the Rhineland area.

An excerpt from the Flechtheim catalogue, page 7-10, Die neue Kunst *(The New Art)* by Wilhelm Uhde (excerpts):
Impressionism was the last great expression of the French soul in art, which because of its composition, had as goal the qualitative formation of surface. It was not in its aim to shape the essence of things in the composition of organic painting or make people happy with it, but to capture the accidental view of appearance and the here and now of things which satisfy the eye.

As long as opinions of the time suited this tendency, Impressionism was the fact of European painting. But the minute a change in the soul of the time occurred, a deeper, more mysterious, more mystical need came up. An attempt was made to get away from an art form which began to seem superficial.

It was significant that it was a Dutchman, van Gogh, who made the first step away from surface art, liberated painting from the domination of the blinking eye, bound it together with human interest and transposed essential contents of its subject matter by the strength of a great feeling onto the new plane of reality. And that it was primarily Germans, who in their work, (under the pressure of a strong interest in the objective) worked out the characteristics (in the sense of humane, not optical). The name Expressionism, which bound these artists together (Kokoschka, Eberz, Lehmbruck, Nauen and others) expresses the fact that a new generation does not want art to be considered any longer as a matter for the eye and taste, but as a matter for individuals, that it is not out to make one happy with charm but to effect the entire range of human values, which it feels to be essential. It attempts to give the stylistic expression of all that moves the soul of the times. Its mission was negated and exhausted by the battle to negate Impressionism.

Thus, Uhde's article sees the end of Expressionism as early as 1919.

256.

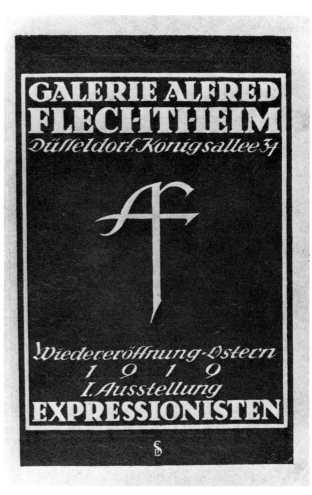

Der Querschnitt durch 1922, Galerie Alfred Flechtheim,
Düsseldorf, Berlin, Frankfurt, Köln, pp. 181-186.
Introduction to the Auction Catalogue of the
Remainder of the Gallery Flechtheim in June 1917

Around Christmas, 1913, Alfred Flechtheim opened an art
gallery in Düsseldorf. The introduction to the catalogue,
which caused a sensation at the time, started with:
"Finally I am in the position to fulfill an old desire of mine: To
occupy myself now exclusively with matters of art. My art
shop should help me do that." The middle-aged merchant,
who had been conspicuous for years in the art world as a
very temperamental buyer, was not lucky. He hardly had es-
caped the hated office and reached the goal of his wishes
when the war broke out. He and his coworkers left the gall-
ery, obeying the call of the fatherland in the first days of
August. His coworker (Hans Fehr) was killed in August 1914
in France and Flechtheim, finally, had to see that strangers
could not possibly run such a new enterprise. He was forced
to give up his business and to auction off the wares of his
house.

The auction may have been an odd event even in the pre-
liminary exhibition. It gave a concentrated picture of art life
in western Germany as it existed three years ago before the
outbreak of the war. Here we saw the hotly fought about, often
admired, and often ridiculed works of the newest trends of
German and foreign painting. The slogans like Impres-
sionism, Expressionism, Cubism, Futurism, words which
had been almost forgotten during the war, were pushed into
the foreground again. Picasso, as well as his German suc-
cessors, were represented, with Cezanne, Renoir, Redon,
Bonnard, Signac, Hodler, Munch, van Gogh, Gauguin next to
Nauen, Levy, Marc, Matisse, Derain, Braque, Laurencin, de
Vlaminck, de Fiori, Kokoschka, Leger, Pascin, Maillol, Minne
and Henri Rousseau. In short, the whole group of names
which moved the art world before the war suddenly came
into our view again. Although some of the young ones who
threw themselves so courageously into the artistic battle
have succumbed to death in the meantime in another war,
their works live on, works which were created up to the very
day the Galerie Flechtheim closed. It will be interesting to
watch how much acclaim this new art has kept or acquired
during the war in which it has naturally received less
attention.

Two apparently unrelated trends in art were brought together
in the Flechtheim collection. On one side stood the works of
the Dusseldorf art circle, to which Flechtheim had become
close through his stay in Düsseldorf. Almost all of this art
belongs to the last century. E. te Peerdt has the most impor-
tant place among the Düsseldorf painters, at least on ac-
count of numbers. A long series of his landscapes and
sketches gives this circle its character. Its most important
representatives are: Schadow, Lessing, Schirmer, Rethel,
both Aschenbachs, Bendemann, von Gebhardt, Deiker, oth-
ers. On the opposite side stood the newest of our artists,
who one reproaches for leaning toward French art. It is not
necessary anymore to reject the gross accusation that this
leaning has made bad Germans out of them. Everyone who
has made that reproach will remember with shame his hasty
anti-art comments in face of the deeds of these "Frenchl-
ings". Thus, the exhibition at the Galerie Flechtheim gave a
colorful, stimulating, lively total view of art by contrasting
side by side the old Düsseldorf masters and the timely ad-
vanced works of the newest artists. In this the auction had
another principle meaning: the introduction of young unre-
cognized artists on the art market. Everywhere, though es-
pecially in Germany, it is extremely hard for the young,
unknown artist  to earn even the basic necessities of liveli-
hood because he either does not have enough opportunities
to sell, or the opportunities which are available are unsuita-
ble. Only the exhibitions of the artists' associations remain
for the younger artists, with the exception of a few private art
galleries. In Berlin their number has not by any means in-
creased within the last few years, instead it has been more

and more reduced. The art associations arrange exhibitions once a year and can only accept a limited number of works by each artist. To come in contact with a real art patron in our times is almost impossible for the young artist. The lonelier the artist becomes, the more he devotes time and effort to art, the more he must suffer from the lack of possibilities of sale. The more adept, businesslike, but perhaps infinitely less serious artist will always harm him if the art market does not interfere protectively and pay attention to the young, unknown artist. The romantic idea of restoring the old relationship between the consignor and the artist as it was perhaps in the 14th and 15th centuries (by the 17th century, this relationship did not exist anymore) is unfruitful in our social life. And the artists would complain bitterly at the return of these old conditions. Those who know the history of art know how even the great artists, such as Dürer and Titian, and all the artists who were honored like princes, suffered interference from their patrons. Of course the relationship between artist and patron in the small states was more bearable since the patron was usually a prince who had known the artist since childhood. But no one has any idea today how to aid the young artists in our big cities. The task of discovering the artist is left to the art associations, the press, and the art business. The critic can only judge by what he sees in the exhibitions. And the exhibitions are so limited, that when they are over the young artist is again left to his fate, and no one cares for him. The conditions are such that even a very talented artist who has great success in the press is not able to receive even 50 to 100 Marks for a picture. Out of this another development arises. The young unknown artist knows that he will not sell a large part of his output. He plays a lottery with his pictures, with the assumption that he will sell two, three or at the most four pictures in one year. He asks for those pictures prices which are so high that he will be able to live on them if he concludes a deal. With these high prices he turns to the collector circles, in which the large sums are common. He thus cuts himself off from the possibility of reaching the public. He limits the number of purchasers to a very small wealthy circle, while there may be thousands who would buy his pictures if they knew how to do it.

The number of art dealers who arrange exhibitions is much too small to be of aid here. In addition, the public trusts the dealer only when he shows recognized, and thus expensive, pictures. The art dealer could not make a living off dealing in cheaper pictures and the public, which is not used to buying works of art, does not even dare to ask for the prices of the exhibited works.

Perhaps the public auction is a means to remedy the disaster among the young German artists. One can imagine that frequent auctions, not only of collections, but simply of pictures which young artists hand over to auction houses, could be opportunities for the broad masses of the public to buy works of art at low prices. The sensation of high prices will be lacking from these auctions, but this sensation is no more than an irrelevant and even deplorable feature. The idea of the auction is not to get higher prices; the idea of the auction is to find the real market value of a work and to stimulate large masses of people to purchase works of art. The auctions must contribute a real estimation of the artist. We all know that through associations, through all kinds of art dealing practices (though they don't play the biggest role in it) value estimations which are entirely wrong are being publicized. If auctions become customary, and if young artists will offer their works there will ensue a strong fight against bad art. The art lovers who will be attracted to these auctions will learn to rely on their own judgement, and will see that the educated art lover who takes the trouble to study works of art seriously will find the opportunity to discover the artist who is closest to his heart at a time when it is possible to acquire works for very little money. The connection between art lovers and artists will be created. The senselessly high prices of artists who can't sell their works will disappear. Instead hundreds of young, striving talents will

be offered the opportunity to make a living from their art without losing a large part of their time in hunting for connections and visits to associations.

It is impossible that one clique or party will get all the attention, as happens in exhibitions by the strong fights among artists. These auctions will be a hundred times more valuable to artists than even a jury-free exhibition. The outcome will perhaps show an improvement in another field. Initiates know that only a very minimal part of the art trade comes under the control of the entire population and the press. All the valid and invalid reproach directed at the art trade are based in the end on this not always clearly recognized lack. No book, no drama can become famous without being judged by the entire population. But with painting this is not the case. Many entirely valueless artists steal the breath from the valuable ones, take away their possibility of living and force them to a social fight for which the best artists are suited the least. There are pictures which are not worth the canvas they are painted on, which are auctioned off by manipulations for a price of thousands. In contrast, there are artists who cannot earn their daily bread, although their pictures are suited to be loved by thousands.

Auctions of this kind are a means of control for everyone. Not only for the artist, not only for the press, and the public, but also for the art dealer who is forced to stick to prices which these auctions show. It goes without saying that at auctions, the sale or lack of sale of a picture must be made public. There is no law for this yet, but absolute control, openness, and honesty should be achieved even without a law.

Thus, the strange situation into which an aspiring young art dealer like Alfred Flechtheim got himself leads to the discussion of a problem of the greatest importance for the life of art of our time, though the problem could not have been handled on this occasion in its full purity since this art dealer's stock did not consist only of pictures by young, living artists.

Paul Cassirer

For an example of German contemporary art as shown in the United States, we exhibit this catalogue of 1912-1913.

**NEW YORK**

257. Catalogue of an Exhibition of Contemporary German Graphic Art
New York: Berlin Photographic Company, 1912-1913
With an introduction by Martin Birnbaum
36 pp text with 2 plates and 1 photograph
20.2 x 14.5 cm.
Blue paper covers
Includes works by Barlach, Beckmann, Behmer, Corinth, Feininger, Geiger, Grossmann, Kandinsky, Klinger, Kollwitz, Lehmbruck, Liebermann, Marc, Pechstein, Richter-Berlin, Thoma, Vogeler

This is a fair representation of the better known graphic artists of this time. Munich and Berlin are represented. Der Sturm and Simplicissimus are represented. Most of the participants are from the Galerie Paul Cassirer.

TRAVELLING EXHIBITIONS

German exhibitions were sent all over the civilized world from Japan to North Africa. Herwarth Walden of Der Sturm was responsible for a number of these. Two examples of this activity follow.

**ZURICH**

258. Sturm-Ausstellung, Galerie Dada, Zürich (*Sturm Exhibition, Galerie Dada, Zurich*)
I Serie 17 März-7 April; II Serie, 9 April-30 April, 1917
12 pp, with 4 illustrations
White paper covers with portrait by Kokoschka, and pasted strips of paper covering title of another catalogue.
The exhibition opened at Galerie Corray in Basel early in February, 1917, then moved to the Galerie Dada in Zurich. Rather than make a new catalogue, the earlier one was adapted by the use of three paper strips with new names and dates. This was sufficient as the exhibition was unchanged. There is an introduction by L.H. Neitzel and Herwarth Walden. Included are the artists who were still faithful to Walden. These included Bloch, Bauer, Campendonk, Ernst, Feininger, van Heemskerck, Itten, Kandinsky, Klee, Kokoschka, Kubin, Mense, Muche, Münter, Schrimpf and Uhden.

A motto tells of the intentions: "Art is from the artist, and not growing out of the desires of the audience."

**COPENHAGEN**

259. "Der Sturm." Direktion: Herwarth Walden. International Kunst Ekspressionister og Kubister Malerier og Skulpturer (*"Der Sturm." Direction: Herwarth Walden. International Art—Expressionist and Cubist Painting and Sculpture*)
Georg Kleis, Copenhagen, 1918
Printed by J. Jorgensen and Co.
Text by Walden in German and Danish
20 pp (unnumbered), with 10 illustrations
24.4 x 16 cm.
Blue paper covers with logo of the Kleis gallery.
The exhibition started in Düsseldorf, traveled to Hamburg, Jena, Stettin, Breslau, went to Copenhagen in December, 1918.
Includes works by Bauer, Campendonk, Chagall (17 works), Gleizes, van Heemskerck, Jawlensky, Kandinsky, Klee (13 works), Leger, Marc, Metzinger, Muche, Münter, Picasso, Topp, Uhden, von Werefkin; with sculpture by Archipenko and Wauer

259.

„DER STURM"
DIREKTION: HERWARTH WALDEN
INTERNATIONAL KUNST
EKSPRESSIONISTER OG KUBISTER
MALERIER OG SKULPTURER

UDSTILLEDE
VESTERBROGADE 58

GEORG KLEIS
KØBENHAVN · MCMXVIII

There was much competition between art galleries in Berlin. Gurlitt and Cassirer combined to attack the exhibitions of Walden. They finally succeeded in removing most of the better artists from his stable of painters. In May, 1917, Walden showed his personal taste in this exhibition of his collection.

## BERLIN

260. Sammlung Walden (Walden Collection)
Gemälde/Zeichnungen/Plastiken
(Paintings/Drawings/Sculpture)
Berlin, Der Sturm
Berlin W/Potsdamer Strasse 134a
Sechstes Verzeichnis Mai 1917
16 pp, no illustrations
19.8 x 15.2 cm.
Yellow paper covers with logo by Jacoba van Heemskerck.
Includes works by Archipenko (7 works), Arp, Bauer, Bloch, Boccioni (4 works), Campendonk (13 works), Carra, Chagall (42 works), Delaunay, Derain, Ernst, Filla, Gleizes, van Heemskerck (32 works), Itten, Jawlensky, Kandinsky (9 works), Klee (10 works), Kokoschka (37 works including 4 drawings for Mörder, Hoffnung der Frauen), Leger, Macke, Marc (22 works), Mense, Metzinger, Morgner, Felixmüller, Münter (8 works), Pechstein, Picasso, Schrimpf, Severini.
This was a joint exhibition held with another showing the works of Albert Bloch and Harald Kaufmann.

SAMMLUNG WALDEN
Gemälde / Zeichnungen / Plastiken

Jacoba van Heemskerck

Berlin W / Potsdamer Straße 134a
Besichtigung: 4 Uhr / Montag / Donnerstag
Sechstes Verzeichnis Mai 1917

260.

261.

## MUNICH

By 1924, German museum curators had begun a study of modern art. The great exhibition in Munich during 1924 attempted a survey of the best painters of the past fifty years.

261. Deutsche Malerei in den letzten fünfzig Jahren—Ausstellung von Meisterwerken aus öffentlichem und privatem Besitz, 1924 (dM—German Painting in the Last Fifty Years-Exhibition of Masterpieces from Public and Private Estates, 1924)
Munich, Neue Staatsgalerie, Königsplatz
(XV pp) 48 pp text, 96 plates (30 pp advertising)
16.8 x 12.2 cm.
Yellow paper covers with the title in orange.

The catalogue extends from early nineteenth century to the modern age. The museum taste is conservative, with emphasis on figurative and naturalistic art. Though the Russians such as Kandinsky are excluded, Feininger is considered a German and included. The modern group includes Becker-Modersohn, Beckmann, Corinth, Feininger, Grossmann, Heckel, Kanoldt, Kirchner, Klee, Klinger, Kokoschka, Liebermann, Macke, Marc, Nauen, Nolde, B. Pankok, Pechstein, Purrmann, Rohlfs, Schmidt-Rottluff, Seewald, Slevogt. The only abstract work is by Marc, long dead. All of the politically oriented painters, such as Meidner, Felixmüller, Dix, plus those around the Bauhaus are excluded from this important survey.

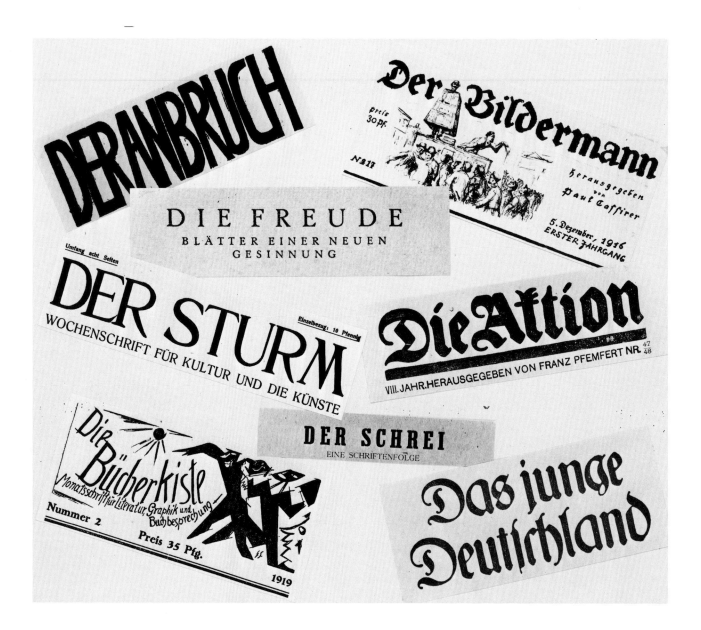

## MOST PUBLISHED AUTHORS OF EXPRESSIONISM

Listed in order of published material in periodicals. () = number of periodicals in which published.

Theodor Däubler, 1876-1934, (27) poet, essayist
Albert Ehrenstein, 1886-1950, (30) poet, writer
Kasimir Edschmid, 1890-1967, (19) poet, writer, editor
Rudolf Leonhard, 1889-1953, (32) poet, dramatist, writer
Max Brod, 1884-1968, (28) poet, writer, editor
Iwan Goll, 1891-1950, (23) writer
Alfred Wolfenstein, 1883-1945, (24) poet, writer, editor
Else Lasker-Schüler, 1869-1945, (18) poet
Johannes R. Becher, 1891-1958, (18) poet, writer
Paul Zech, 1881-1946, (21) poet, dramatist, editor
Gottfried Benn, 1886-1956, (10) poet, writer
Klabund (Alfred Henschke), 1890-1928, (24) poet, dramatist
Franz Werfel, 1890-1945, (26) poet, writer, dramatist
Max Herrmann-Neisse, 1886-1941, (28) poet, dramatist
Ernst Blass, 1880-1939, (14) poet, writer, editor
Franz Blei, 1871-1942, (17) writer, critic, editor
Kurt Bock, 1890, (19) editor, writer
Mynona (Salomo Friedländer), 1871-1946, (17) writer, poet, editor

Oskar Maria Graf, 1894-1967, (20) novelist, essayist
Kurt Hiller, 1885-1973, (20) writer, editor
Oskar Loerke, 1884-1941, (14) poet, essayist
Heinrich Mann, 1871-1950, (12) novelist, essayist
Alfred Richard Meyer, 1882-1956, (11) poet, publisher, writer
Otto Pick, 1887-1940, (14) poet, editor
Ludwig Rubiner, 1881-1920, (14) writer, dramatist, editor
Anton Schnack, 1892-, (19) poet
Ernst Weiss, 1884-1940, (15) writer, dramatist
René Schickele, 1883-1940, (15) poet, editor, writer

OTHER POETS
Ernst Stadler, 1883-1914
August Stramm, 1874-1914
Georg Trakl, 1887-1914

MAJOR DRAMATISTS
Reinhard Goering, 1887-1936
Walter Hasenclever, 1890-1940
Georg Kaiser, 1878-1945
Paul Kornfeld, 1889-1942
Carl Sternheim, 1878-1942
Reinhard Johannes Sorge, 1892-1916
Fritz von Unruh, 1885-1970

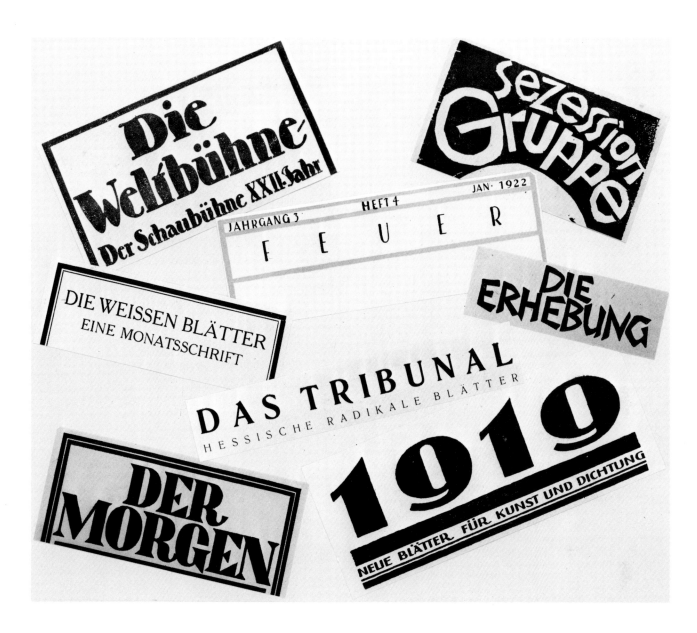

**IMPORTANT EDITORS**

Heinrich F. S. Bachmair, 1889-1960, *Die neue Kunst, Die neue Zeit*
Georg Biermann, 1880-1949, *Der Cicerone, Junge Kunst*
Ernst Blass, 1890-1939, *Die Argonauten*
Franz Blei, 1871-1942, *Der lose Vogel, Summa, Die Rettung, Hyperion*
Kurt Bock, 1890-, *Berliner Romantik*
Max Brod, 1884-1968, *Arkadia*
Friedrich Burschell, 1889-1970, *Neue Erde, Revolution*
Paul Cassirer, 1871-1926, *Der Bildermann, Pan, Kriegszeit*
Ludwig von Ficker, 1880-1967, *Der Brenner*
Alfred Flechtheim, 1878-1937, *Der Querschnitt*
Willy Haas, 1891-, *Herder-Blätter, Literarische Welt*
Wilhelm Herzog, 1884-1960, *Pan, Das Forum, März*
Wieland Herzfelde, 1896-, *Neue Jugend, Jedermann sein eigener Füssball, Die Pleite*
Kurt Hiller, 1885-1973, *Das Ziel, Tätiger Geist, Der Kondor*
Siegfried Jacobsohn, 1881-1926, *Die Weltbühne*
Heinrich Lautensack, 1881-1919, *Die Bücherei Maiandros*
Karl Lorenz, 1881-1961, *Die rote Erde*

Alfred Richard Meyer, 1882-1956, *Der Mistral, Der neue Frauenlob*
Carlo Mierendorff, 1897-1943, *Das Tribunal*
Erich Muhsam, 1878-1934, *Kain, Kain Kalender*
Carl von Ossietzky , 1889-1938, *Die Weltbühne*
Franz Pfemfert, 1879-1954, *Die Aktion*
Kurt Pinthus, 1886-, *Genius, Menschheitsdämmerung*
Wolf Przygode, 1895-1926, *Die Dichtung*
Anselm Ruest, 1878-1943, *Der Einzige*
Rosa Schapire, 1874-1954, *Die rote Erde, Kündung*
Karl Scheffler, 1869-1951, *Kunst und Künstler*
Rene Schickele, 1883-1940, *Die weissen Blätter*
Heiner Schilling, 1894-1955, *Menschen, Die neue Schaubühne*
Walter Serner, 1889-?, *Sirius*
Theodor Tagger, 1891-1958, *Marsyas*
Herwarth Walden, 1878-1941?, *Der Sturm*
Paul Westheim, 1886-1963, *Das Kunstblatt*
Josef Würth, 1900-1948, *Die Dachstube*
Hugo Zehder, 1881-1961, *Die neue Schaubühne, Neue Blätter, 1918, 1919, 1920, Die neue Bühne*

# THE PERIODICAL

The German periodical grew slowly in importance. Until the 17th century, calendars had provided historical information for the common people. Almanacs were used as vehicles of popular instruction for the lower classes. In 1811, over one million copies of Becker's almanac were sold.

In most German towns and cities, booksellers had wide varieties of books for a well-known clientele. Books were also sold from carts by book peddlers.

With the end of patronage by the church and nobility in the early nineteenth century, the public became the major patron of publishers. Advertisements, prospectuses, general and particularized bibliographies were well established by then. The rising middle class developed a desire for intellectual improvement. "Geschmack," personal taste, became one method of judging a person's culture and and good manners. By the middle of the nineteenth century, the priest and scholar were no longer the principal audience, and politicians, business men, and men about town were part of the reading public.

It was primarily this large new audience which made the expansion of periodicals possible. Diversion and variety were demanded. The nineteenth century had been one of reading-mad audiences. Newspapers, magazines and various other kinds of reading were developed fully. Book clubs and rental libraries were common. The variety of newspapers alone ranged from cheap serial newspapers to pseudophilosophical periodicals, from papers for the barely literate to rhetorical broadsides, or the new fiction. A larger and fairly well off middle class supported certain art and publishers, and the future looked promising for many artist-designers and their publishers.

The enforcement of compulsory education in Germany by the middle of the nineteenth century dethroned the book and made the periodical and newspaper the public's major reading matter. Though statistics promoted the idea of almost universal literacy in Germany, the reading public was semi-literate. In 1909 literacy among army recruits was given as 99.42 percent, but these tests were simple and used to insure a final outcome in high percentages.

Newspapers had a large following among the middle and lower classes. Except for specialized papers, they used a simpler language. They inculcated and maintained certain non-progressive ideas and standards which appealed to a bourgeoisie fond of material possessions. They raised the tone of public controversy, and easily accepted censorship. These qualities influenced early Expressionist periodicals for they had to compete with newspapers. Most periodicals combined a sensational layout, exalted language with higher ideals for a more snobbish and better educated audience.

By 1900, Germany had 3,278 newspapers. The Germans had become a newspaper reading public. In 1900 Berlin had forty-five dailies. Of these numerous kinds of periodicals and newspapers, some were fed articles directly from government agencies. Some types of publications were: liberal, radical, reactionary, nationalistic, internationalistic, German navy, stock exchange, Roman Catholic, Lutheran, independent, commercial, various cultural groups such as Polish and Scandinavian.

Yearbooks and bibliographies of the preceding year became popular. By 1910 there were over fifty major periodicals devoted solely to issuing information and criticism about literature. This number does not take into account periodicals published by literary societies, organizations, movements, learned bodies, etc. Each journal had its special audience and message.

The newspapers, especially the antigovernment ones, provided a circus-like spectacle for the public. There were almost daily scandals, murders, political corruptions and catastrophes reported, and frequently commented upon in the most exclusive journals. The reading public was rapidly edged toward sensationalism. Germans, then being more docile than individualistic, divided into parties. Extremism was common. Hatred for the machine or a new belief in technocracy became a battleground. Use of the quotation rather than the major thought became a rule of conversation. Most information about movements and attempted changes became impersonalized as much as today. Few people had seen the wild performances of Richard Strauss's Electra, but Germany read about the sensationalism, and felt shocked and insulted, but probably forgot it within a week because of the next assault by the press on a sensation-loving public.

The periodicals fought these cultural battles of record in more elevated prose, and among a smaller, more educated group.

Weekly serials became popular as well as the new illustrated weeklies. Most people got their basic ideas about illustration from these cheap tabloids. Most of these weeklies never tried to show both sides of a question, though some papers in Frankfurt and Berlin made the attempt. Political attitudes were more important and partisan to readers and publishers.

The reading public became unprecedented in size. In the eighteenth century the number of people who could read was equal to the number who did read. This was not so later if we consider only literate works.

The periodical was really a book in installments. Serials had provided the way. Difficult typefaces were gradually eliminated. Fraktur type, the difficult Gothic script, was gradually replaced by a legible roman face. A rebellion by scientists, as international collaborators, was the primary urge, though real change took place in our own time, with Hitler's elimination of the fraktur typeface as a "Jewish" invention.

Literary clubs had strong influences on the German literary and Expressionist periodicals. One of these clubs became the backbone of Expressionism. Kurt Hiller's "Neue Club" met at the "Neopathetiker Cabaret" to read provocative new poetry. Karl Kraus had organized meetings around his Die Fackel which had excited a German-speaking public. Clubs sprang up in Leipzig, Heidelberg, Munich, and Vienna, all filled with young enthusiasts. Publishers began to form new periodicals around these new ideas; Forum, Brenner, Neue Jugend, Sturm all held special meetings in the evening. Authors travelled all over Europe for these gatherings, and quickly spread new trends and ideas. In the past authors had been confined to specialized periodicals such as Simplicissimus and Jugend, März. One of the leading editors, Franz Pfemfert of Die Aktion, had edited such a political paper earlier, the Democrat.

Ambition and native pride provided the stimulation for legitimate periodicals that carried the new message. Herwarth Walden, after editing Morgen and Neuer Weg and Theater, brought out his own periodical in 1910. In Der Sturm he created one of the most important vehicles for Expressionist statements about all the arts. He used a modern format and added illustration a half year later. After 1912 most of the important painters in Europe sent works to be printed in Der Sturm.

Franz Pfemfert began his specialized periodical Die Aktion in 1912. It was the great rival of Der Sturm. Text and illustrations were combined from the first. His direction was more political. "Painters build Barricades: The Poet reaches into Politics."

These two major periodicals gave encouragement to writers outside Berlin. Far from the German capital they began their own magazines. Herder Blätter in Prague, Saturn in Heidelberg, Argonauten, Neue Kunst and Revolution appeared soon after.

The important Bücherei Maiandros and Das neue Pathos were brought out in Berlin. By 1914 there were over 15 different Expressionist magazines. Many did not survive one year, although it was not expensive to begin a new magazine during this time.

New publishers, too, sprang up to print the new authors. A.R.

Meyer, H.F.S. Bachmair, Hermann Meister, Kurt Wolff, and R. Piper were some of these adventurous entrepreneurs.

The common usage of the fraktur typeface was still evidenced in these magazines. Some kept to the old face, while others used a modern roman typeface. The new typography, necessarily, spread to other cities from the centers of printing such as Leipzig, Berlin and Dresden. Great typographers laid out Pan magazine for Cassirer and Count Harry Kessler; and here they were influenced by fine designs used by the French government printing office for the illustrated books of Bonnard and Vuillard.

Generally, prewar magazines were not designed by painters. With Der Sturm we have a collaboration. Max Oppenheimer laid out the title page with a clarity and openness adapted from British periodicals. British and German newspapers of this period were not models as editorials cluttered the first page.

The next year Richter-Berlin designed the title page of Die Aktion, using fraktur for the main titles, but a fine roman for the text and small capitals. There was an existing Pan-Germania tradition which assigned fraktur to volk tradition as it was supposed to have originated out of the medieval German script. Barlach usually insisted on this old style face in accord with his volk ideas.

More of the later periodicals were designed by artists. The Jugendstil works had combined art and typography in one title drawing and this became the inspiration for Schmidt-Rottluff, the most important designer and the one who had the greatest influence on the art of the Expressionist title page.

Hermann Meister in Heidelberg was a fine designer. His Saturn used fraktur, but with heavy woodcuts which gave a modern feeling to the page. Bachmair in Munich used a heavy red title and fraktur throughout, but with regular spacing of traditional typography. Only the most up to date designers used a French variety of roman. Das neue Pathos had an elegant hand-lettered script. Die Bücherei Maiandros used a heavy roman face with tasteful regularity.

We see now that the great originality and complete Expressionist flavor of the layouts for the Brücke catalogues of 1910—1911 had little immediate influence until after the war. The impact of war and revolution was needed before irregular spacing, varying margins, heavier roman faces and contrasty woodcuts would be combined. Rudolf Koch later adapted his theories to pure Expressionism with large woodcut leafs, cutting the image and type as one; but he also did simultaneous traditional layout.

The young amateur printers, as they do today, tended to use extremely tasteful layout and tradition, and favored artistic typefaces. This was the case with Joseph Würth in Darmstadt. Yet these attractive periodicals used a clarity of line, in the "British manner", a major change from traditional newspapers and periodicals, which were very difficult to read. Only scientific journals had accepted and used the cleaner expression. The roman typeface, too, became a standard for internationalism with Cassirer and others who had less native nationalism.

The terrible World War I extinguished most of the early Expressionist periodicals, but Der Sturm and Die Aktion carried on. Das Forum had been prohibited by censorship for pacifistic ideals. Der Sturm concentrated on abstract literature and art. Die Aktion expressed opposition by silence, but printed the programs and messages from the men in the trenches, and this message was antiwar. Die weissen Blätter had to take its message of pacifism to Switzerland, where it became the most effective antiwar journal.

For some time after the war new periodicals were prohibited by both censorship and paper shortages. Some new ones began as bookseller's brochures like Die schöne Rarität. Marsyas was entered as a bibliophilic work to escape censorship. Series of books were possible and Der Jüngste Tag and Sturmbücher began. Other publishers, such as Wolff,

Reiss and Müller published single works of writers and painters.

Radical typography was introduced by the Dada movement, a product of a rebellious new spirit. After 1918 in Germany the censorship was somewhat loosened and many new periodicals were begun. By the end of 1919 there were over forty-four.

Kurt Schwitters broke the mold in Hannover with his Merz publications. In Kiel and around Hamburg, Die schöne Rarität and Kündung were laid out by Schmidt-Rottluff, as stark and eccentric designs. In Dresden Felix Stiemer hired Felixmüller to design the title pages for Menschen. Influenced by the Brücke style of typography, the young artist combined an abstract figure with lettering. Text was kept to a more legible roman face. Excitement was very much desired in cover art; but clarity was desired for the message of new ideas, though the content was ecstatic and complex, and more in tune with an expressive typography.

Almanacs began to appear again. The formerly conservative Fritz Gurlitt Verlag hired Pechstein for a very original cover design for their first almanac. The artist combined type and design in primitivistic fashion not unlike Maori cloth.

Traditional designers were still used. Max Unold used a medieval technique for Zeit Echo, but with modern simplicity for the overall page. He also designed a cover for Münchner Blätter with somewhat more Expressionist simplicity and direction. Genius was laid out superbly by the master typographer, Hans Mardersteig.

In the 1920s German Expressionism had become both history and real influence. Its uncompromising attitude was partially destructive to the old design. Classical methods continued in traditional printing centers, but book design was never the same again. A new freedom had been given. The guilds and unions which had controlled the forms and methods of printing were mostly unlocked from control.

The humorous journals also participated in the modern development of line and tone. Daumier had been collected by many painters, especially his works for Charivari. Andre Gill had first created the oversize head which became a common feature of later modern distortion: sad man with the proportions of a baby. La Rire began in 1896. Simplicissimus was founded in 1896 and both had immediate influence. Newspapers had used caricaturists for many years. The cartoons of Toulouse-Lautrec, Forain, Hermann-Paul, T. T. Heine, Gulbransson, and Wilke all inspired through special social symbolism which was basic for the reader. Feininger began as a cartoonist for Lustige Blätter as did Grosz.

Abstract drawing, in an abbreviated form, can approach caricature. Both refine into essences of defined personality, and a core of meaning.

The cartoon looks for humorous or satirical statements by exaggerating certain features or mannerisms. The great caricaturist uses free line, calligraphic intensity and simplicity. This could also describe the abstract expressionist of figurative works. Sometimes with the later men, the major drawbacks of the style, the ease and abundance of variation, frequently met and overlapped.

Taste is a varying thing, eccentric sometimes, always marginal except in works of outstanding strength, dynamism and inspiration. Redon and Ensor frequently approach caricature. Picasso in many cases does. Beardsley was saved by his perversity, Klee by his musical sense of form. Propaganda could bring out the worst of these converging meanings, as with the lack of taste shown in Kriegszeit and Krieg und Kunst. Artists who could save by pathos instead showed bathos.

Caricature is mostly iconic. Aniconic tendencies prevail in modern art. Most were still based on art as "memoria rerum gestarium," an expression of feelings intended to arouse a similar response in the spectator through concrete technique. Aniconic meaning has long been the basis of both

Oriental art and certain mystical or non-natural tendencies in Western art, such as a similarity between the medieval Buddhist art of Japan and that of fourteenth century Italy. In the late 19th and early 20th centuries there are similarities and exact influences. Line and flat tone, abstract tonal arrangements, little atmospheric recession are some of these which spring from the Orient. The use of seemingly careless definitions of elements, arbitrary disarrangement of space, a sense of dynamic nature, the brilliance of white within dancing patterns of shapes all could be traced, at least partially, to oriental influences. The soft mergence and emergence of line suggesting change and movement within the outline of a form, this dissolving of sections of nature, which seems logical when performed by a master, the succinct suggestions, and calligraphy are misleadingly similar between East and West. The aim and techniques are as distant as age and distance. Oriental art may seem obscure, but it never severed from life or tradition.

The journals brought home the social message with a force that later political Expressionism never could accomplish. An example of social humor in Simplicissimus could be: "Is it not true that Leipzig has a half million inhabitants! No, fifty thousand, the others are workers." The sad children of Rudolf Wilke, the brutal citizens of Thöny, and Paul's stupefied and overworked women were part of the growing social awareness among the German middle class. Jugend provided an outlet for such young artists as Barlach, Geiger, von Hofmann, and others. The compact drawing, the earthy humor, the self-criticism within a fixed rectangular format spread social commentary throughout Germany. By 1910 the party of Social Democrats was at its prewar height, and much of its impact was propagandized by the magazines of satire. Popularizing of Jugendstil art through these journals awakened the audience for later variations, and this introduction was rapidly carried on by the later Expressionist publications.

**262. DIE AKTION** (The Action)
Wochenschrift für freiheitliche Politik und Literatur.
Undertitle after 1912, #14: Wochenschrift für Politik, Literatur und Kunst.
No undertitle after 1918, #45-46.
Edited by Franz Pfemfert.
Years 1-22.
Berlin, Verlag der Wochenschrift Die Aktion 1911-1932, 4° (30.5 x 23.3 cm)
Raabe 4, Perkins 164, Schlawe pp 85.
1911 45 issues (1-45)
1912 52 issues (1-52)1913 52 issues (1-52)
1914 41 issues, 9 double issues (1-52)
1915 28 issues, 24 double issues (1-52)
1916 27 issues, 25 double issues (1-52)
1917 27 issues, 25 double issues (1-52)
1918 26 double issues (1-52)
1919 29 issues, 21 double issues (1-52)
1920 26 double issues (1-52)
1921 25 double issues (1-52)
1922 24 double issues (1-48)
1923 19 double issues, 1 triple issue (1-52)
1924 14 issues, 10 double issues (1-24)
1925 12 issues, 11 double issues (1-24)
1926 9 issues, 2 double issues (1-12)
1927 3 issues, 2 double issues (1-6)
1928 6 issues, 5 double issues (1-12)
1929 3 double issues (1-8)
1930 1 triple issue (1-3)
1931 2 double issues (1-4)
1932 1 four part issue (1-4)

"I set up this journal against the face of the age." This was the message of Die Aktion until the social changes of the 1920s. It was an attempt to print the truth as Pfemfert saw it, as a purge and a statement of account for Germany. He was the total embodiment of the opposite side of war in Germany. He was not a gentle and kind man. He was violent towards those who defected from his ideas. He became an embittered man, uncompromising and lonely, but he always worked for mankind.

As an early editor, Pfemfert collected a group of friends who followed him to Die Aktion when he organized the new periodical in 1911. His friend Max Oppenheimer laid out the first title page. The first issue appeared on February 20, 1911.

Die Aktion was the most avant-garde periodical in all Germany. Most of the essays in the periodical were put in the framework of social criticism. Older and established writers and poets were proud to write for Pfemfert and to help their younger colleagues. Pfemfert also organized evenings of poetry readings to further the development of his poets.

The inner circle of Die Aktion was made up of the publisher and his Russian-born wife, Alexandra Ramm. They kept close to the writers Otten, Hiller, Carl Einstein, and Sternheim, as well as to the art dealers Paul Cassirer and J.B. Neumann. Pfemfert found moral support from the great publishers Wolff, Fischer, and Rowohlt.

The intellectual climate of Die Aktion always remained high. Yesterday's naturalism was opposed by today's policy of enlightenment. Phases of Die Aktion paralleled the ideas of Pfemfert: 1911-1914 was a period of collecting new talents, with interpenetration of poetry, literature, and art; during wartime, 1914-1918, the establishment and expansion of the Expressionist movement took place; 1918-1932 became the political time for the periodical. Pfemfert began to embrace a revolutionary communism. During this period, most of the original contributors left, though they continued the early message of Die Aktion elsewhere.

Every major contemporary writer appeared at some time in the periodical. Among the artists who were reproduced were Daumier, Derain, Dufy, Feininger, van Gogh, Grossmann, Kisling, C. Klein, Laurencin, Matisse, Meidner, Morgner, Nadelmann, Oppenheimer, Rops, Schiele, Schmidt-Rottluff, Segal, Tappert, Vogeler, Ensor, Grosz, Kokoschka, Marc, Modersohn-Becker, Vallotton, Toulouse-Lautrec, Kirchner.

No matter what commentators have said about Die Aktion, it was more than a political journal. Most numbers had literary essays, poetry and some drama. I have translated a few selections to show some of this range.

The first is a faintly humorous section from a play. The second is an Expressionist poem. The third exhibits some of the political rhetoric of the publisher.

DIE AKTION
8. Jahrgang, Heft 13/14, 1918

Joseph and Karel Capek

"Moon-Comedy" (From Rübezahls Garten, 1909)

(World submerged in night—darkness over fields and meadows. The moon strolls around between clouds like an uninterested pedestrian, walks over fields, forests and lunatic asylums, calling to the insane)

A melancholy Man: Oh, moon, Byron-moon, you are like an unhappy majesty on an ebony-wooden throne, like a tragic and pale king, who covers his face with mourning veils. How high you sail, dizzyingly high.

The Moon: (Ignores him)

A Girl: (Looking out of her window in her nightgown) How strange! Whenever I look at Luna, I must think strange sad things, of unknown love, hidden sorrow, unconscious striving in vain from the beginning...Cats climb the roof gable and drench their eyes in moonlight, to make those cat eyes flicker in the moonshine....

A Lunatic: Do you come again moon to spook, emotional

**WOCHENSCHRIFT FÜR POLITIK, LITERATUR, KUNST**
VIII. JAHR. HERAUSGEGEBEN VON FRANZ PFEMFERT NR. 31/32

INHALT: Karl Jakob Hirsch: Widmungsblatt für die AKTION (Titelblatt) / Wilhelm Schuler: Totenklage / Jean Paul: Zum fünften Jahr / Ludwig Börne: Unzeit-Gemäßes / Otto Freundlich: Dem toten Freunde Bols / Jan Wronicki: Holzschnitt / Georg von Charasoff: Die Marxsche Preisformel / Karel Teige: Federzeichnung / August Graf Zamoyski: Aktstudie / Paula Modersohn: Aktstudie / Christian Schad: Porträt / Rudolf Manasse: Politik / Oslo Koffler: Studie / Aus Bakunins Briefwechsel / Max Schwimmer: Federzeichnung / Herbert Saebel: Mondaufgang / Paul Boldt: Der Leib / Ludwig Bäumer: Irrenhausgarten / Georg Kulka: Segen / Erich Goldbaum: Holzschnitt / Wilhelm Klemm: Der Grübler / Julius Kaufmann (Straßburg): Friedenssehnsucht / Otokar Theer: Der Mittag des Paradieses / Edith Renyi: Bitteres Gebet / Oskar Schürer: Todesrausch / Jules Talbot Keller: Ein Brief an Carl Sternheim / Max Herrmann: Höllisches Bruder Wurm / F. P.: Ich schneide die Zeit aus; Kleiner Briefkasten (mit „Lyrik" von Herbert Eulenberg)

VERLAG · DIE AKTION · BERLIN-WILMERSDORF

HEFT **80** PFG.

262.

planet sick among the planets. Do you approach in order to awaken midnight madness within the unprotected! There are six kinds of lunar psychosis: Lunacy, dizziness, ghostly visions, oceantides, women's periods and the inspiration of the multitudes. Sickly seducer of virgins, you lewd one, you white mask, you fool, you sneak!

The Moon: (Ignores him)

(The lunatics climb up on window sills, drainpipes, fight gravity, hands outstretched with their eyes closed.)

Another Lunatic: My God, this terror. My God, this horror! I cannot stand to have the moon look at me. I cannot sleep.

(Black dogs, skinny watchers, lift their paws up to the moon, howl with desperation, depart like a fearful panic.)

The Commentator: Anaxagoras has said: "The moon is a stone." Ptolomaios has said: "The moon is a satellite." A mad one has said: "The moon is alive." Which one of the three is the biggest fool? Which is the best truth? Luna is a reflection as every magic is a reflection. Luna is a phantom of the sun... It is also the phantom sun of horror, which magnetizes the wide awake ones, puts them into bondage by lunar strands. I have misunderstood you, moon.

The Moon: (Ignores him and trots on between the clouds, like an uninterested pedestrian, moves over fields, forests, and lunatic asylums.)

Translated into the German from the Czech by Otto Pick
DIE AKTION
8. Jahrgang, Heft 1/2, 1918

**"Way into Light"**
by an Unnamed Author

Through this echoing meadow, reason
Drives crawling terror, comrades retreat
Between the walls of my madness, encompassing infinity
With their gestures
From the same consuming terror:
Shelter only from open eyes, there flickers sometimes the
Enormous scorner

And on the icy lips of Adam lasting millions of years,
There sometimes bloom  thoughts of eons.
We are shy in our loneliness during the day.
We are blinded by deceit from malicious goodness, and we
Desire
Through windows into the landscape. But when evenings
Fall,
Then our longing feeds everything disgraceful with death,
And the large stars of our gratitude awaken in the vision
Of the night. And from the heart of the world
We know to be one with the ray which God collects. And we
Know ourselves to be blameless of pain,
Flame with joy and weightless feeling.

DIE AKTION
9. Jahrgang, Heft 6/7, 1919
Dedicated to Franz Mehring

**"Franz Mehring"**
by Franz Pfemfert

"In 1914 when the patriotic plague broke out, when "fieldgray" and "dying" were the great fashion of these lunatics, when we saw the sorrow of the drafted forced warriors, the blooming season in business for the home-warriors, 1914, when we solitary ones who opposed the corpse making which was so honored by militarism, the way we are now so blood-honored under the dictatorship of the Noske creatures, at that time there were four names which gave the international proletariat the assurances that the German worker class was not the exclusive objection to the corrupt traitors: Lightships in the night of madness were the first proclamations of Rosa Luxemburg, Karl Liebknecht, Franz Mehring,* Clara Zetkin! And in the midst of the black-white-red-spotted hyenas, in the midst of these rapists of mankind, close to despair at times, I had the high fortune to call Rosa Luxemburg, Karl Liebknecht, Franz Mehring, Clara Zetkin close friends and companions in the struggle. As a consequence of the prisoners tortured in protective custody, with which the still unchecked German soldiery answered the fight against the exploiters and murders of the proletariat, our wise comrade Franz Mehring has now succumbed.

The pack of hounds barks joyfully. Rosa Luxemburg! Karl Liebknecht!! Franz Mehring!!!!! The pack shall soon whine for mercy! Arms may sink, hearts may break: Unbroken remain the weapons! For every murdered fighter, a legion arises!"

*Franz Mehring was one of the grand old men of German socialism. He was a contributor to Die Aktion in 1917-1918. In the period before the war he joined Rosa Luxemburg in opposition to the Imperial government. He belonged to the group of socialists called "Internationale Gruppe," which later became first the Spartakusbund and then the Communist Party of Germany. Mehring was very interested in the theater as a political vehicle for the working classes. He edited Die Volksbühne from 1892-1895. This now rare periodical was a social-democrat theater magazine, literary too, for the naturalism of the time, and issued announcements of political books and criticism.

Mehring was a prominent newspaper editor in Dresden. He also edited the literary estates of Engels and Marx (published in 1923 after his death).

263. **DER ANBRUCH** *(A New Beginning)*
Year 1 (1918)—13 issues, edited by Otto Schneider
Verlag Der Anbruch, Wien.
Year 2 (1919-1920) 8 issues, 4 double issues edited by Otto Schneider and J.B. Neumann, Berlin, Graphisches Kabinett J.B. Neumann.
Year 3, no issues
Year 4, (1921-1922) 8 issues, 7/8 double issue edited by Otto Schneider and J.B. Neumann, Berlin: Erich Reiss

J.B. Neumann commenced his art dealing in Vienna, but moved to Berlin in 1911. Flechtheim and Neumann worked in coordination to some extent. Neumann had been one of the earliest supporters of "Die Brücke." Many members were still described and illustrated in Der Anbruch, though by this time Kirchner had broken with the others and refused to participate. The second issue announced a Kirchner print that was never printed in later editions.

Articles are inside the two-sided sheet of folio size. They range from strident (Meidner) to lyrical poetry (Nadel), music (Mellings) to Christian volkism (Pannwitz).

There was some trouble during the war and only one issue was printed. It took about two years for the first scheduled year of publication. The work of many of the gallery's graphic artists were used on one side of the page with full-size woodcuts, sketches, and lithographs on verso.

Special editions were printed without text after the second year, usually of 150 numbered impressions.

The Austrian Expressionists participated wholeheartedly in Der Anbruch, which appeared as a war publication, with anti-war poetic texts and manifestos. Neumann also conducted lecture evenings.

Der Anbruch published an anthology of new poetry in 1919. Some of it expressed the general tone of the periodical: "It is not easy to show common community when the connection is benumbed. The paleness of death discolors the present more than ever, and covers a future in darkness. Decayed roots which are within the newborn, demand and promote its decomposition. This sign and stigma of our time promises coming power. Because it is history that has died in the present, this community has a right to existence. Searching for recognition in the base of decayed Vienna, this community arose around Der Anbruch, which warped like a ball in order to pull up a lazy and limping body, whose blood vessels are so important for the main organism."

Der Anbruch became a kind of broadside, opening to a full sheet which could be nailed to a wall.

DER ANBRUCH *(A New Beginning)*
II. Jahrgang No. 1 Januar 1919
An alle Künstler, Dichter, Musiker *(To All Artists, Poets, Musicians)*
by Ludwig Meidner (excerpt)
In order to avoid being ashamed before the vault of heaven we must finally get up and participate, so that a just order will be set up in state and society.

We artists and poets must join in the first rank.

There must be no more exploiters and exploited!

It can no longer be that an enormous majority have to live in the most deplorable, undignified, and disgraceful conditions, while those of a tiny minority become like animals at an overloaded table. We have to rule for socialism: to a universal and unresistable socialization of the means of production that gives every person work, spare time, bread, a home and the idea of a higher goal. Socialism must be our next creed.

It must save two: the poor from the shame of servitude, dullness, violence and hatred; the rich from merciless egotism, greed and hardness—forever.

We painters and poets are united with the poor by a holy solidarity! Have not many of us known misery and the shame of hunger and material dependency?! Do we stand much better and more securely than the proletariat in society?! Do we not depend like beggars on the whims of art collecting bourgeoisie!

If we happen to be still young and unknown, they throw us a hand-out or let us mutely rot.

When we do have a name, then they try to divert us from the pure goal with money and vain wishes. And when we have gone to our grave, then their snobbery covers our pure works with mountains of gold pieces. —Painters, poets, musicians, be ashamed of your dependency and cowardice, be-

come brothers of the ostracized, poorly paid serf with no rights!

We are not workers, no. Ecstasy, rapture, passion is our day's work. We are nimble and knowing and must, like directing flags, wave for our heavier brethren.

Painters, poets—who else is obliged to fight for the just cause but we?! In us the conscience of the world still pounds mightily. The voice of God in us again and again wakes our enraged fists.

Let us beware!

Again, tomorrow, won't the bourgeoisie wrench the power of the state into their own hands by riots, graft and unscrupulous voting practices? Won't this new Germany of the ruling bourgeoisie even more shamelessly exploit human working power, put down the poor still more brutally?

Won't it want to triumph in all spiritual things, still more arrogantly and impudently than was ever done by the Kaiser's Germany?!

It, with its rigged up cannons, barracks, and iron ships, ABC schools, policemen and false popes, was too fat and lazy and ignorant to do perilous damage in the field of the mind. Where, however, the despotic bourgeois appears—where he in the lofty realms of the spirit steps with his paw—there no grass will grow...

263.

EMIL NOLDE, FRAUENKOPF                    NACH DEM ORIGINALHOLZSCHNITT

## DIE ARGONAUTEN

### EINE MONATSSCHRIFT

HERAUSGEGEBEN

VON

ERNST BLASS

Erstes Heft

HEIDELBERG 1914

VERLAG VON RICHARD WEISSBACH

264.

**264. DIE ARGONAUTEN** *(The Members of Jason's expedition to recover the Golden Fleece)*

Eine Monatsschrift
Edited by Ernst Blass
Heidelberg, Richard Weissbach
1914/1921, Raabe 17, Schlawe p. 161 (Interrupted publication dates)

Folge 1,1914
| | | |
|---|---|---|
| Heft 1 Januar | pp. | 1-48 |
| 2 Februar | | 49-96 |
| 3 März | | 97-144 |
| 4 April | | 145-192 |
| 5 Mai | | 193-240 |
| 6 Juli | | 241-271 |

Folge 2,1915/1921
| | |
|---|---|
| 7 Herbst 1915 | 1-48 (Autumn) |
| 8 Herbst 1915 | 49-102 |
| 9 Dezember 1916 | 103-152 |
| 10/11 Dezember 1921 | 153-271 |

Of the first issue, a special edition was published as follows:
7 examples on Imperial Japan paper
25 examples on Strathmore paper
50 examples on old Strathmore paper and numbered.
22.5 x 14.7 cm.

A careful typography sets off the poems, interleaved with an unornamented title page. The printer was the excellent firm of Drugulin, in Leipzig.

The background was Heidelberg-Mannheim and the early Expressionist circles. There was some influence from Stefan George's ideas of communal endeavor. The philosophical prose really determines the publication.

The periodical came out in irregular intervals during the seven years of its existence, especially during the war. The editor, Ernst Blass, was known first for his youthful verses, having some fame as a German Verlaine. Blass was not a democrat, but an individualist. He fought both racism and mass appeal. He was known as a fighter, especially against the idea of Jewish subduedness. A writer of sincerity and strength, he kept lyrical poetry as his interest.

Die Argonauten preserved Blass's concept of literature. It did not join the movement of pathos, of social and mass betterment, the activists. He had George's concept of uncommitment, and also rejected bucolic elements.

The journal had a difficult time financially, though the publisher, young Richard Weissbach, managed to raise money among the academics and intellectuals of the area, who wanted a journal of high cultural value above and beyond their own special disciplines.

DIE ARGONAUTEN
Erstes Heft, 1914
*Dedication, by Ernst Blass*
Joyful passion drives us to lift the anchors at such a departure. At an hour when the darkness of the early day still stifles us, but already makes us happy, we shall leave the land behind for dearer air and cleaner dangers of the ocean won, which mortal and conquerable men need in order to withstand storms and adversities. Otherwise it is the affair of the gods. Lynkeus, the sharp-eyed one, was once the pilot of the Argonauts, but with the overwhelming lute playing Orpheus inspired the courage of the heroes. May the gods be protective of our ship, in which the singer as well as the reasonable speaker, the observer as well as the one feeling beauty, are united for a virtuous journey.

**265. DER BILDERMANN**
Steinzeichnungen fürs deutsche Volk
*(The Picture Man. Lithographs for the German People)*
Directed by Paul Cassirer
Edited by Leo Kestenberg
Berlin, Paul Cassirer, 1916, (April to December), 4,°
36.5 x 29 cm.
18 issues, successor to Kriegszeit (1-18)
Raabe 27, Perkins 167.

Each issue of Der Bildermann had about six pages with four full-page lithographs with print next to an illustrated poem, or two printed pages with texts of poetry. There was also a limited edition of seventy-five on large paper.

The periodical continued the policy of the gallery as a war effort. The thought was to mediate the time of war through artistic arenas. The lithograph seemed the art of their time. Folk songs and early Lieder of the nineteenth century were included among the drawings in Der Bildermann.

The director, Paul Cassirer, was a slightly left-wing radical in this time of conflicting political parties. He was not as left as the "Spartakists" led by Rosa Luxemburg, but in a liberal tradition followed by intellectuals and some professors. Cassirer's editor, Leo Kestenberg, was a noted musicologist.

The editorial policy changed dramatically. Early patriotic appeals, such as those made in the Kriegzeit diminished after the great losses of life in the early military campaigns. Heckel's contributions featured sad views. Barlach became less ambiguous with anti British and anti American hysteria. Kirchner and Jaeckel became more lyrical. The periodical began to speak softly against the war profiteering, and at the same time showed sympathy for displaced children. It was a confused statement, with no real stand.

Later issues continue this trend. Barlach became anti death. Ottomar Starke began a series of satirical sketches about life behind the lines. Kokoschka presented religious prints without any social message. This tendency preceded a change in attitude toward the war among the German people. One year later there were general strikes and antigovernment votes in the Reichstag.

Der Bildermann

preis 30 Pf.

herausgegeben von Paul Cassirer

№ 18

20. Dezember, 1916
ERSTER JAHRGANG

DONA NOBIS PACEM!

265/7.

Poets also changed their messages. They spoke of brotherhood and became esoteric, with Klabund translating Chinese verse.

The last issues in 1916 became out and out antiwar. Hasenclever wrote about international friends of mankind. Zweig told of a peace dove.

This periodical began publishing with patriotic tonality and ended with violent antiwar feeling. The people of the Secession had been strongly for the original declaration of war, but lost all illusions very soon.

Important Original Prints in Der Bildermann (This is not a complete list of prints):

1. BARLACH, Ernst    #1, April 5, Demut (Humility), Schult 75
2.    #4, May 20, Der Müde (The Weary One), title from Schult 76
3.    #11, Sept. 5, Aus einem neuzeitlichen Totentanz (From a Modern Dance of Death), Schult 78
4.    #13, Oct. 5, Wem Zeit wie Ewigkeit (Böhme), (To whom Time is Eternity) Schult 79
5.    #14, Oct. 20, Anno Domini MCMXVI Post Christum Natum (In the Year of Our Lord 1916 After the Birth of Christ), Schult 80
6.    # 16, Nov. 20, Selig sind die Barmherzigen (Blessed Are the Merciful), Schult 81
7.    #18, Dec. 20, Dona Nobis Pacem (Give Us Peace), Schult 82
8.    Song 4, Brüder (Brothers), printed from the stone with a poem by Christian Morgenstern, Schult 77

9. HECKEL, Erich    #3, May 5, Die Fahrt (The Ride), Dube 241 IIIB
10.    #4, May 20, In der Muschelstube (In the Shellfish Room), Dube 229 IB
11.    #8, July 20, Belgische Landschaft (Belgian Landscape), Dube 242 IIB, titled there "Flanderische Ebene"
12.    #15, Nov. 5, Bei Gent (At Ghent), Dube 238 IIB
13. KIRCHNER, Ernst Ludwig    #6, June 20, Landschaft im Taunus (Landscape in the Taunus), Dube 315 C, titled there "Bahnkurve Taunus"
14.    #9, Aug. 5, Bildnis Carl Sternheim (Portrait of Carl Sternheim), Dube 328 C
15.    #15, Nov. 5, Auf dem Kasernenhof (In the Barracks Courtyard), Dube 308 C, titled there "Zwei Reitende Artilleristen"
16. KOKOSCHKA, Oskar    #7, July 5, Verkündigung (Proclamation), Wingler/Welz 78
17.    #9, Aug. 5, Christi Dornenkrönung (Christ Crowned with Thorns), Wingler/Welz 79
18.    #12, Sept. 20, Kreuzigung (Crucifixion), Wingler/Welz 80
19.    #14, Oct. 20, Auferstehung (The Resurrection), Wingler/Welz 81
20.    #16, Nov. 20, Der Judaskuss (The Kiss of Judas), Wingler/Welz 82
21.    #17, Dec. 5, Der Abendmahl (The Lord's Supper), Wingler/Welz 83
22.    #18, Dec. 20, Rast auf der Flucht nach Ägypten (Rest on the Flight into Egypt), Wingler/Welz 84
23. KOLLWITZ, Käthe    #2, April 20, Mutter mit Kind auf dem Arm (Mother with Child in her Arms), Klipstein 132 II, poem printed with graphic in the stone
24. LIEBERMANN, Max    #10, Aug. 20, Untitled (By the Sea), see Schiefler 160 V or 220 B
25.    Supplement, Lieder des Bildermann (Songs of the Bildermann), Song 3, Berliner Pfingsten (Berlin Whitsun), see Schiefler 160 V or 220 B
26. MUELLER, Otto    #9, Aug. 5, Drei Figuren und gekreuzte Stämme (Three Figures and Intersected Trunks), Karsch 66

## 266. DIE BÜCHEREI MAIANDROS

(The Bookshop Maiandros)
Eine Zeitschrift von 60 zu 60 Tagen
Edited by Heinrich Lautensack, Alfred Richard Meyer, Anselm Ruest.
Paul Knorr Verlag
Berlin-Wilmersdorf, 1912-1914, 6 Books, 13 issues, 8°
Raabe 11
21.7 x 14.4 cm.

This was a literary publication which opened by introducing a new chapter from a forthcoming book by one of the authors in the circle. Most of these authors met in coffee houses and wine cellars for lively discussions. They formed close friendships, battled each others' theories, and worked with ferocious energy in this time of new ideas.

The periodical had additional pages of essays, texts, notices, proclamations, and declarations. It was a continuation of the circle of early Expressionism from the Neopathetisches Cabaret.

## DIE BUECHEREI MAIANDROS

eine Zeitschrift von 60 zu 60 Tagen

herausgegeben von

Heinrich Lautensack/Alfred Richard Meyer/Anselm Ruest

im Verlag von Paul Knorr/Berlin-Wilmersdorf

Das dritte Buch                    1. Februar 1913

### APOLLODOROS

Ueber Lyrik ein Dialog von Anselm Ruest

Sechs Holzschnitte von A. Segal

266.

Lautensack (a friend of Wedekind and Franz Blei) was one of the editors and represented the theater. Alfred Richard Meyer was the inspired writer and publisher in Berlin, using the name Munkepunke. Anselm Ruest was an anagram nom de plume for Ernst Samuel, a philospher, critic, and editor, who was once close to the Aktion group.

Their periodical was always in financial trouble, and came out in two-sheet issues on three different occasions. The themes were stated in each issue: "Ecstatic;" a lyrical anthology called "Mistral," "in memoriam Leon Deubel," etc.

Graphics were furnished by a group in Berlin made up of Beckmann, Meidner, and Arthur Segal.

A.R. Meyer, the other editor and a true enthusiast, furthered connections with French modernism and new trends in Expressionism, almost before anyone else. He talked, drank pale ale with his friends under clouds of tobacco smoke, organized meetings in a coachman's pub. But Meyer kept out of politics at this time. He lived and published in a frenzy of love for the new, finally went bankrupt, but continued his work for other publishers.

DIE BÜCHEREI MAIANDROS
Das IV. und V. Buch
1. Mai 1913
"Der Mistral.
Eine lyrische Anthologie" page 63-64

"Grand Ecart (Dance Song),"
by Frank Wedekind

Are the muscles all tensed up,
shoes and stockings in good shape,
then begin
in the middle,

from the Queen's front and rear!
Dance, as no woman has danced
Each buck's-leap, that you can!
Left leg,
fast leg—
The right must be even faster.
When the timpani crashes,
make a Grand Ecart!
With hips
high in the air
prepare
the somersault

When you left home
and arrived at the theater,
did you dream then,
of measuring the difference?
No, you dreamed
highly dramatic roles for yourself:
Claire, Sappho, Rhodope,
Salome at the worst.
Night after night with high kicking,
ovations,
which compensate...

### 267. DIE BÜCHERKISTE *(The Book Chest)*
Monatsschrift für Literatur, Graphik und Buchbesprechung
Edited by Leo Scherpenbach except for the last issue edited by Sylvia von Harden.
Bachmair & Co.
Munich, 1919-1921
Raabe 67, Schlawe p24
1919/6 issues/2 triple issues
1920/3 double issues
21.4 x 14.2 cm.

267.

Original-Holzschnitt                    Maria Uhden

Dieses Heft ist Maria Uhden gewidmet.

This was begun as a monthly magazine for literature, graphic art and book reviews. It went through many changes in policy as the German scene changed artistically and politically. These variations are traceable in the pages of this small and concentrated periodical of mediocre design.

The editor, Leo Scherpenbach, book seller in Munich, was also a small time publisher. The arena for meetings and discussions was the bohemian cafe called "Cafe Stefanie," where the tall and awkward Scherpenbach met his friends and contributors. The publisher, F.S. Bachmair, was also there as close friend. They managed to get out Die Bücherkiste for a period of two years.

Each issue gives a short bibliography about the two artists who did woodcuts for that month. The title design was made by Fritz Schaefler, a young friend of the publisher, handled by the Goltz Galerie in Munich; and a wild and chaotic artist typical of the Schwabing population. Each issue also contained a short list of exhibitions, new books, some middle-of-the-road poems, articles about political literature, mostly representing the southern regions of Germany and also including Switzerland. It was a kind of digest for the region.

There were only five complete issues. Some were combined in three parts per month, as Bachmair was in continuous financial difficulties.

The issue of 1920 becomes political, and the literary scan of south Germany becomes less concerned with art and literature. There is a short but important article about spiritual revolution. The last issue changed again into a partly Dada issue, with poems by Tristan Tzara and Hans Arp, with the woodcuts becoming less jagged and more political by Grosz and Masereel.

What a place the "Cafe Stephanie" must have been! It has the subname of "Cafe Megalomania." Reputations were made and degeneration took place equally as often. There were endless conversations amid the click of billiard balls and the ring of time clocks at the chess tables. "Tobacco smoke was so heavy there was little movement unless the front door was opened." F.S. Bachmair, the young publisher, constantly supported these long talk-sessions among the bohemians of Munich.

DIE BÜCHERKISTE
Nummer 1, März 1919, p. 44
*The Flesh Umbrella*
By Hans Arp
(Dada poetry)

in those days men did not paint themselves in perspective as blue grotto gondolas or leaning towers
the edelweiss tower with all the friezes of the world wound round it carried bath tubs
full of combed grass and hair on tongue buds of marble
and fir cones borrowed bird wings and snails and hermaphrodites groomed their lips
with fish scales before mirrors the stars sat on winding stairs with earrings the echos burst
from jellyfish with water quivers and whales with lighted chandeliers and trumpets
they furnished head huts and dancing floors for masons
out of sweet dew grass the glittering angels revolved on their hinges the glass owls
handed death to each other from beak to beak
the cross bow bolts of fur were hammered roses the hair of fishermen
were sailboats full of torture chambers the bondsmen lay foundations for morning noon
night adventures

Nummer 1, März 1919, p. 70
Soldaten *(Soldiers)*
By Ernst Toller

I cannot forget the faces of my comrades. They let themselves be led into factories, squeezed into parts of machines. Their souls had been choked by a four year long war and their eyes had been blinded. War vomited into their humane faces, expression died, ravished. One often sees a kind of smile springing up under the made-up masks on whores in dark harbor-inns and dirty bordellos. But the faces of my comrades are like rigid laughter—God! Brother! Men! Will they ever awaken?

268.

268. **DER CICERONE** (*A Guide for Sighteers*)
Published twice a month, 1909-1930
Covers by different artists each year
1921 (Bernhard Hoetger, was editor this year), directed by Georg Biermann, with other under editors, who changed every few years
Klinkhardt und Biermann, Leipzig
28 x 20.8 cm.

Dr. Georg Biermann was the overall director of this semi-monthly periodical. He had always been a partisan of the younger artist as attested by his long series Junge Kunst. Some of his other ventures were the Monatshefte für Kunstwissenschaft and Jahrbuch der jungen Kunst. He became general director of painting and crafts for the city of Cologne.

Der Cicerone, during its long life, served as one of the most important art periodicals in Germany. Biermann was a scholar and kept the level very high in this periodical. It was a magazine for artists, friends of art and collectors. Not only complete and thorough monographs were written but also articles about current exhibitions, problems in the art market, listings of all important current art exhibitions in Europe and reviews of important art books.

Der Cicerone is a valuable source for information about some of the obscure Expressionists, such as Lodewijk Schelfhout, Oskar Maria Graf, Oskar Moll and others. Each issue began with an important monograph about one artist or about a type of art such as Oceanic or African. Descriptions, some of the only available sources, of various galleries in Germany were also presented. Collectors were also featured.

Wedderkop wrote about Dada. Frank E. Washburn Freund wrote about American painters. Correspondents were hired all over the art world including New York. There were important articles about classical art too. Karl With wrote his significant monographs about the art of Asia. Some issues also listed complete auction prices of the period.

Der Cicerone was much more than a typical Expressionist periodical. Biermann's range of scholarly tastes were too wide to limit the scholarship in this way; he saw art as a long history, continuously developing in crafts and painting, sculpture and graphics. This periodical had many of the most important first articles about the young painters and their intentions. It remains a rich source for any scholar who specializes in German art of the twentieth century.

At the end of every year bound volumes of all twenty four semimonthly issues were sold, though the color lithographed covers were not included. These volumes provide a rich source also for anyone investigating the unknown Expressionist painters, for Biermann included almost every painter of any quality. He discovered such talented painters such as Reinhold Ewald, Ewald Dülberg, Wilhelm Kohlhoff, Erna Pinner, Carl Gunschmann, Hans Gerson, Walt Lauent, Wilhelm Schnarrenberger and many others.

## 269. DIE DACHSTUBE (The Attic Room)
Edited by F.G. Lehr
Art Editor: Joseph Würth
Verlag Die Dachstube
Darmstadt, 1915-1918
Raabe 24, Perkins 168
1915-1916—11 issues—2 double issues
1916-1917—8 issues
1917-1918—10 issues—1 double issue
1918—3 issues

On August 6, 1915, the fifteen-year-old schoolboy Joseph Würth, called "Pepy" by his friends, gathered his cronies into another group: "another" in this case refers to the multiplicity in German life of groups and societies for any and every purpose. Würth's group was a society for the promotion of German culture. The war was on. Their older friends were at the front. The five students from the Ludwig Georg Gymnasium in Darmstadt were sure that great social changes were taking place. They read poems to one another, showed their graphics, painted and wrote stories. This alone soon seemed sterile, so they decided to publish a periodical. Würth was an amateur printer, and had already put out a handwritten magazine, the Kunstschau, the year before. Die Dachstube was also first handwritten, then hectographed (mimeographed). Older friends at the front such as Carlo Mierendorff and Theo Haubach agreed to contribute poems and articles. At the end of the first year Joseph Würth had made a total of 67 Marks profit, which he used to buy a small case of type. The money had been contributed by well wishers, not earned by subscriptions.

Pepy learned the printer's trade by apprenticing with a local typesetter and printer, Menzlaw. Pepy's handset pages were at first printed on a copy press, but later, as his knowledge of the craft grew, he bought a small printing machine. He printed the first books with this press. He printed 65 issues of Dachstube altogether, until the fall of 1918.

Subsequently, the new periodical, Das Tribunal, the replacement and a more radical paper, was published under the editorship of Mierendorff, though Pepy kept alive the name of his publishing house, Die Dachstube. He continued to publish small volumes of poetry and novels, all illustrated.

He did not print the actual periodical, but remained on the board of directors as joint publisher. He printed his own series, Die kleine Republik.

Das Tribunal lasted another two years, then Würth changed the name of the publishing house to "Darmstädtder Verlag, the handpress of Joseph Würth." His earlier authors still sent books to him. Würth remained the cultural center for all these writers and artists, and was the central mailing address for a score whenever they wanted to find out a friend. Mierendorff used a pseudonym during the Nazi time, Dr. Karl Willmer. He was killed in an air raid during the war, and Würth had his remains brought back to Darmstadt.

Pepy Würth was an elegant man, walking with a cane, always with a cigarette dangling from his mouth. He frequented the Cafe Opera, had a kind word for everyone, but could be sarcastic when necessary. He was a citizen of the world and also of a small city. He always remained a fanatic about beautiful book design. There was no other publisher who set the type himself, printed himself, used beautiful bindings, produced fine printing and fairly perfect typesetting. He worked on multicolor illustrations by hand, and spent night after night experimenting to find the correct combinations for his books.

He had begun with shock, and recognition of the cruelty around him, of risk from the censors, of breaking the silence of the possible. "Beginning shy lips spoke wisdom and a new way of speaking. Questions were asked. Toys were put aside as the world became that of a nightmare." Würth never tired of calling for a new world.

## 270. EOS (The Greek can be translated with two meanings: EWS is an alternate for EWOS, from Aeschylus meaning: In the Morning. Or the translation can be taken from the Bacchylides Lyricus, in which the meaning is: Until, or more specifically: A Point of Time Up to Which an Action Begins. A positive translation is difficult because of the lack of accents. Eos was Aurora, the rosy fingered dawn in Greek mythology. Young and lovely, Eos was created to awaken desire)
Heft 1 and 2: Eine Dreimonatsschrift für Dichtung und Kunst. Published by Emil Pirchan
Buch 3 and 4: Ein Ausdruckwerk ringender Kunst.
Published by Emil Pirchan and Paul Baumann
Verlag die Wende, Berlin, 1918 and 1921 (Publishing dates 1918-1920)
Estimated edition: 250 examples
Raabe 46, Schlawe page 38
38 x 28.7 cm.
Graphic illustrations by E. Betzler (3), J. Eberz (6), C. Hoelloff (6), C. Rabus (3), E. Schertel (1), W. Schnarrenberger (5), W. Wanzer (2), and others.
Editions: Ausgabe A: I-XL, with a portfolio; B: 41-250
Etchings printed by Franz Hanfstaengl, Munich
Printed by Offizin der Mandruck G.m.b.H., Munich

Paul Baumann, a doctor of philosophy, was the major driving force behind Eos, and also contributed essays, criticisms and theater pieces.

The periodical was intended to show more than the extent of German Expressionism. Its editors were interested in a kind of fantastic outlook common to the post romantic German writers and thinkers. Each issue had a subtitle addressing a common but different theme, such as "Fantastic," "Symbolic," "Ecstatic," and "Mystic." It was intended to be luxurious, with special paper and small editions.

Only four volumes were published between 1918 and October, 1920. They were printed on handmade paper and the type was hand set. The printing was carefully done, page by page, by hand.

The issues vary from rather decadent art to cubistic styles. Most of the artists were minor professional illustrators, and thus followers of current trends. The prints have a precious quality also. Both writing and illustrations are heavy with Volkish traditions, the deep gloom from the Nordic traditions; and the combination is well done, well designed and printed, and is a fine expression of this period.

## 271. **FAUST** (*Faust*)
Eine Rundschau (*A Review*)
Edited by Anton Mayer (1921), Paul Landau. Second year (1922) by Ludwig Sternaux. After 1922, by Paul Landau. First year published by Julius Bard, Berlin.
After issue six, 1920, published by Erich Reiss, Berlin.
Perkins 170, Schlawe p. 71
1921-1923 12 issues, 1 double issue
1923-1924 11 issues
1924-1925 9 issues
1926-6 issues
24.5 x 17.2 cm.

Editorial intentions changed rapidly to keep the periodical alive during the difficult time of political change and inflation in Germany. The first six issues had important articles about modern art. Each later issue was built around themes such as the Theatre, Flowers, the Circus, etc.

The magazine had an aesthetic background in ancient and modern art, but not the more abstract varieties. Anton Mayer, one of the editors, was an expert on both Greek art and Dutch painting. He also was correspondent for the newspaper, National Zeitung. Thus the Faust articles tend to range throughout the history of art from Lucas van Leyden to Kandinsky.

The three issues in the collection have such theme titles as "Nature and Men," "Sturm und Drang" and "Gold." The level of intellectual content is high for such periodicals. Faust is not completely Expressionist, but surveys such movements as the modern-functional, old master engravings, gold coins, garden philosophy and such. The political stand was fairly conservative, as was expressed by the cover set in fraktur type and the interior in a roman type. Each article is a concise commentary, short but full of philosophical problems. Mayer had already written for Pan II. Paul Landau was included in the Deutscher Revolutions-Almanach of 1919, a radical work of the German revolution, but Landau's primary mission was as a skilled editor.

## 272. **FEUER** (*Fire or Bombardment*)
Illustrierte Monatsschrift für Kunst und künstlerische Kultur
Edited by Dr. G. Bagier
Year 1-3 published by Gebrüder Hofer, Saarbrücken
After Year 2, issue 2, published by Feuerverlag, Weimar
October 1919-June 1922: Two original graphics by Jaeckel.
Perkins 171, Schlawe p. 35
30.5 x 22.2 cm.
I. Jahrgang 1919-1920
Band I, Oktober 1919-März 1920, 491 pp. (1-491)
Band II, April-September 1920, 405 pp. (493-898)
II. Jahrgang 1920-1921
Band I, u.d., 380 pp. (1-380)
Band II, u.d., 343 pp. (383-726)
III. Jahrgang 1921, 330 pp. (1-330)
With articles by G.F. Hartlaub, Guido Bagier, Walther von Hollander, Emil Ludwig, A.E. Bruckmann, Karl Ernst Osthaus, Kurt Pfister, Will Grohmann, Rudolf Kayser, Ernst Weiss, James Simon, Fritz Hoeber, Willi Wolfradt, R.G. Binding, Fritz Dülberg, Friedrich M. Huebner, Adolf Behne, Udo Rukser, Rudolf Schulz-Dornburg, Paul Westheim, Alfred Flechtheim, Oskar Loerke, Walter Cohen, Alfred Kuhn, Alois Schardt, Rudolf Grossmann, Kasimir Edschmid, Wilhelm Michel, Werner Deubel, H. von Wedderkop, Wilhelm Wenke and others.

CONTENTS:
Plays by Georg Kaiser, Alfred Wolfenstein, Karl Zuckmayer, Hermann Essig, Albert Talhoff.

Poetry by Theodor Däubler, J.R. Becher, Paul Zech, Georg Trakl, Klabund, Herbert Eulenberg, Leo Sternberg, Alfred Wolfenstein.

271.

270.

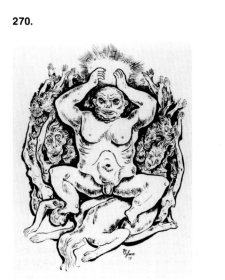

272.

Articles about: Barlach, Lasar Segall, Hans Sutter, August Babberges, Cezanne, Rodin, Campendonk, Max Thalmann, Lehmbruck, Emil Orlik, Rohlfs, Feininger, Janthur, Gleichmann, Morgner, Hodler, Eberz, Kokoschka, Heinrich Nauen, primitive Art, Jawlensky, Karl Knappe, Heinrich Heidner, and others.

This beautifully printed monthly was intended to be a critical outline of art, literature and music. It is a deluxe periodical and very rare today. The title was taken from a line of poetry by Herbert Eulenberg: "Der Sage nach Trug einst Gottersöhn. Das Feuer, die Nacht zum Tag." (After delusion one day the legend of a Son of God, the fire that illuminates after the day.)

The contents begin with a dissertation about art and artists' culture, the evolution of music, a critical article about Heinrich Nauen, relationships between the Rhineland and Berlin.

Feuer's printer, Gebrüder Hofer, was one of the oldest continuing houses in Germany, founded in 1742.

Literature is represented by criticism of Gorki and Tolstoi and the Russian novel.

There is a mixture of everything from police architecture (prisons and police stations) to lyrical poetry.

The first issues came out twice a month, but the periodical then settled to one a month. Later issues were monographs about artists, with, of course, emphasis on Rhineland painters.

FEUER
Jahrgang II, 1920-1921, page 210
Woman in a Jewelry Store
By Rudolf G. Binding

I saw a beautiful woman fishing
Happily among rings on the tables
Of a jeweler.

Young and content, she spread the slender hand
Closed, stretched, clawed, those paws
Of a beautiful animal.
And playing idly with the rings
And I watched peacefully from the darkness
Into the lovely sparkling of stones and body
Which originated there.

There: the eye flash went astray,
Suddenly with one that hummed over here,
Woven together the

Softly unsaid things
In the room, for her and the rings
And came to me,

Came close, half forwardness,
Half shy invincibilities.
And she stands in a spell.

Startled from her marvelous animality
She was extinguished in the fire of sapphires
Like dew on grass

And playing idly with the rings
As though with colorless dead things
A beautiful woman.

273. **DAS FORUM** (The Forum)
Edited by Wilhelm Herzog
21.5 x 14.7 cm.
Years 1-13 Forum Verlag, Munich, distributed by the Delphin Verlag, Munich.
Interrupted publishing—4th year, published in Potsdam by Kiepenheuer, and 5th year in Berlin by Forum Verlag.
The rest were published in Munich
1914-1929.
Raabe 19, Perkins 173, Schlawe p. 55

Wilhelm Herzog (1884-1960) was a successful editor for many years. Later he became a prominent dramatist in the 1920s. His first periodical was März, a collaboration, which began in 1907, although Herzog became the sole editor in 1913. Pan II began in 1910, with Herzog joining Paul Cassirer for the first year.

Das Forum began in April, 1914 and continued fairly uninterrupted until 1929, though there was some trouble with military censors and the publishing changed locations at least twice. It began and finished in Munich.

This was an all-around periodical with some revolutionary tendencies, presenting the best original prose and poetry, some letters and commentaries about events of the time. The writers whom Herzog promoted were international in origin. In this first issue alone, Flaubert and Romain Rolland contributed letters and political beliefs.

Herzog, who was not a bit nationalistic, criticized the emphasis on community in German life. He wrote against capitalism, militarism, the great bureaucracy of imperial life. He printed "curiosities" as Karl Kraus had in Vienna, and let the text of stupid articles tell their tales of fools and vices. The titles of his articles tell us some of his interests: "At the Grave of Liebknecht;" "Oh! This Republic;" "Anatole France;" "Relationships with the Communists;" "Workers, Civil Servants and Officers in the German Republic;" "The Modern Type of Revolutionary;" "Schiller as Bolschevist;" "The War and the Worker;" "The Crown Prince as Harem Owner, Democrat and Telegraphist." He was censored and stopped publication of Das Forum for a couple of months, and published a few books to get around the censors, as private presses were not controlled. His friend, Richard Landauer at the Delphin Verlag in Munich helped spread the issues of Das Forum through his booksellers around the nation.

This periodical had a strong effect on the intellectual thinking of the young German revolutionaries. It reinforced the movement from Berlin, begun by Paul Cassirer and his circle for an international flavor to German art and literature; this was a strong movement until the 1930s. But later Herzog lost prestige because of a later middle-of-the-road editorial policy.

DAS FORUM
1 Jahr, Heft 1, April, 1914, page 44
Feuilleton-Automaten (Feuilleton-Automat)
By Hans von Weber
Cliché phrases instead of ethics-morale, pathos instead of strength of character, we are used to it, this our official world, which has a little box for every passion, and for every explosion a paragraph or heading. For instance one says, "military budget." Everyone knows what is going to happen next: the conservatives sound hymns of jubilation, the center whines and groans and starts to act, the liberals and "sozi's" storm and one knows in advance how much each group is going to fume and for how long. Only the National Liberals always find a new gesture to embarrass. In the end the whole affair, however, is going to be approved up and down, from right to left. Then everybody pounds his chest and claims that it is all to his credit.

Then it goes on "moral protection and dual question," and— Oh, hell it all comes out of my ears, always the same comedy with the same ending, especially deals between cows and the same babbling about ideals and freedom and progress. It is a stagnating village pool, this German Reich, daily sinking more and more into reaction and submissiveness! And where once an outcry was heard or a deed lit up, or a decision startled, now all recent events are being hushed up by the officials and the press, until nothing can be seen or heard about it. One may think about the Zabern affair or the recent and famous vote of censure in the Reichstag. I think Bethmann has not even laughed about this limitless embarrassment of all Germans, so matter-of-factly did this correct philosopher find the outcome!

I once knew a village doctor, who measured diseases after the needed number of spoonfuls of medicine or compresses:

"Is my angina dangerous?" asked the patient. "Ten or twelve compresses and three bottles of gurgling fluid," he answered. Of course, in cases where he would have to answer, "One coffin," he remained silent. But in critical situations he reacted with a strong hand and healed while healing was still possible, so that the patient soon became a convalescent.

In Germany none of the state-doctors keep silent, but whatever may happen, murder and manslaughter, military rule, embarrassment of the states, treason, it is always about the number of editorials and feuilletons which are needed to calm down the excitement: Count Mielszinski 50, Redl 200, Sviha 175, Zabern 1000 and Kotan before Russia 500 feuilletons, and so on. The whole world then is tired of it and something new can arise. Nobody gets healed. One can easily see how the young Crown Prince says to himself merrily; "Let's risk a small one of one hundred feuilletons," and then telegraphs; "Go right ahead." This is a Cossack ride over newspaper columns, nothing else! Aside from these ink sprayers, nothing else has any consequence nowadays. Fists hit the beer table with indignation, and then they open again mildly and make a friendly reach for the beer stein.

This thinking in the same cliché, this general watering down of inner morale must hurt everybody, especially those with feelings. When they're open in the general fog by a quick deed which lets one see for a moment—before the feuilletons begin to run—how things really are and how humans can still feel, this must hurt.

It is the warning signal of a spiritual emptiness of scaring proportions. Cliche's from which the feuilletons draw their way of thinking, "feeling," and just judging become so much a habit for the unthinking readers. Then they, like phonograph records, begin to think "feel," and judge in the form of feuilletons, as soon as they are stimulated by an event. The feuilletons are not necessary any more as the masses think along these lines already by themselves. One needs only to wind them up. The real and deepest reason for this mechanization in the thinking apparatus of the world lies in the leading thoughts which rule them all. "We want to be left alone. Do not disturb the stock market. Quieta non movere! Down with every troublemaker!"

Like dummy books, good bourgeoisie show the title of the classics on the outside, but are hollow inside, because the candy inside is already munched away and gone for a long time . So it happens with their liberalism, their freedom, their social feeling—everything is dead and hollow. If we say "murder" to them, then the automats roll their eyes, but if you crow "duel" then he does a Kotan. And if he is scared by a crash, a bang, a scream, he calms down fast: he knows that soon the slimy hand of the feuilletonist will wipe the wrinkles of worry from the soft foreheads.

What is history? Something to read!
The heart is at the center.

DAS FORUM
I Jahr, Heft I, April, 1914, page 48
"For Frank Wedekind"
The poet Frank Wedekind will be fifty years old in July of this year.

The twenty six year old created the children's tragedy *Spring Awakening* (Frühlingserwachen). He had to wait for fifteen years until he could see it on the stage. No other among contemporary poets had to fight as he did against his fellow creatures. After decade-long misunderstanding and disrespect, which he experienced not only from the unknowing public but foremost by the great majority of those who may judge publicly, after infamous abuses and strong doubts about the honesty of his creativity, he succeeded finally within the last years to break through.

A part of the German public, though not a great part yet, has recognized his originality, his fanaticism, and his creative power. Many thousands love him for the hardness and merciless consciousness from which his passionate confessions originated.

He has never made the slightest concessions to the public as an artist. He was ridiculed, reviled and mocked; announced as a clown, at the slightest, appreciated as a joker or as a minstrel, because he knows how to play the guitar. But he remained, in our mercantile and compromise loving time, a rare case: himself!

273.

And now when we survey the work of his life, there are fifteen works before us. They are different in value and importance for their creator, but all created by an original mind, enlivened by a fanatic genius and formed with a cold sureness of an artisan.

It is now up to us to honor an artist, who never belonged to a group, who much rather went his own way as a dangerously isolated one, in a way rich in bitterness.

We want to confess that he strengthened and inflamed us by the unsparing openness of his art. We want to confess that our love belongs to the creator of the Marquis von Kieth, of Lulu and Hetmann.

We believe that this poet, who succeeded in materializing his visions, is a successor and equal of Kleist and Büchner, and he may be celebrated and named with the same right as any other dramatist of our time.

We demand from our theater managers that they, remembering this, consider it as the noblest duty to give the public a more comprehensive and encompassing showing of the overall work of Wedekind whenever possible. They should present a cycle of his works, or at least arrange especially well prepared showings of single dramas. They will honor themselves this way and be a late satisfaction for the poet from the miserable, faint-heartedness and hostile indifference from which he has had to suffer all too long.

After so many torturous years he should be pampered for once: he, sensible and odd should for once taste the joy which a misled public usually bestows lavishly on moderately endowed spirits.

He should know this joy, that his work is being heard from many German stages and that his worlds are opened to all strata of the public.

He may feel then that his creations are rooted in the best of the German people, and that they are joined by a steadily growing crowd of those who are able to experience and value his work.

| | |
|---|---|
| Lovis Corinth | Heinrich Mann |
| Maximilian Harden | Thomas Mann |
| Wilhelm Herzog | Albert Steinrück |
| Max Liebermann | Franz von Stuck |

**274. DIE FREUDE**
**BLÄTTER EINER NEUEN GESINNUNG**
*(Joy, Pages of a New Disposition)*
Edited by Wilhelm Uhde
Writing editor: Helmud Kolle
Die Freude Verlag
Burg Lauenstein (Oberfr.), 1920
Raabe 94, Perkins 174, Schlawe p. 22
Total edition: 1550
A. 1-50 signed and numbered, including Kornfeld 75: Auslöschendes Licht by Paul Klee
B. 1500, logo by Johannes Molzahn
26.2 x 19.8 cm.

Uhde was a professional writer and art historian. He was a partisan of French Moderns, with a very early interest in Braque and Picasso. He lived mostly in Paris, except for a few years in Germany.

The writing editor was a young nobleman named (Helmut) von Hügel, who took the pen name of Helmud Kolle.

Only one issue of the magazine came out. It was perhaps too grand a plan, for the intentions were to list all the new art-critical, philosophical, political and literary ideas of the new times. Of course this new time was demolished with the political repressions of the Weimar Republic.

The list of contributors is most impressive, and includes Braque, Jammes, Claudel, Buber, writing and illustrations by Klee, Picasso, Rousseau, Chagall, Eberz, Itten and others.

The only issue was published in 1550 copies, with 50 of these numbered and signed. The logo was designed by Johannes Molzahn.

The political slant was slightly left of the middle of the road. Editorials advocated opening the jails to free the proletariat, and founding a sovereign authority of the workers. The power of ideas was to motivate peaceful activity to help build the kingdom of the poor, achieve equality and brotherhood for all. They also expressed a distaste for "superficial art" which owes its appearance to "optical views and taste," but were in favor of art which grows out of love and sentiment for mankind.

"Pages for a new way of thinking" was the undertitle. "Joy" was the main title. Ecstatic Expressionism couldn't survive in the battle between socialists and communists.

DIE FREUDE
Erster Band, 1920, page 105
Der Zephir *(The Zephir)*
By Klabund

As though on wings and rings
He walks the hill
His soles lightly touch
The womanlike meadow.
Now we may sip
in the eye of evening,
And ground and herd
Drowned in dew.
I turn my hands,
The damp ones, toward the glow
Of the moon's stiletto
Already unsheathed.
Caressing winds
Embrace the ankles
Which glide happily now,
Lead softly
Into the eternal rest.

**275. GENIUS** *(Genius, An Anonymous Deity in Roman Mythology, which Protected Groups of People and the Places of their Activities)*
Zeitschrift für alte und werdende Kunst
Year 1 edited by Carl Georg Heise, Hans Mardersteig, and Kurt Pinthus
Year 2 & 3 by Carl Georg Heise and Hans Mardersteig.
Kurt Wolff Verlag
Munich, 1919-1921
Year 1: Books 1 & 2 (319 pgs)
Year 2: Books 1 & 2 (332 pgs)
Year 3: Books 1 & 2 (356 pgs)
Raabe 74, Perkins 175, Schlawe p. 47
35.5 x 27 cm.

Mardersteig, later one of the premier printers of the world as founder of Officina Bodoni and Valdenega in Verona, Italy, was responsible for the elegant taste of all Wolff's early publications. He and Carl Georg Heise, later director of the Lübeck and Hamburg museums, worked to expand the outlet of the Wolff publishing efforts. They were jointly responsible for this new art journal, which was intended to include traditional as well as modern art.

Genius became one of the most scholarly and attractive art journals of the time. The combination of Mardersteig's typographical taste and Heise's wide scholarship was impressive.

Two issues each year, a total of six, were published. Each book was divided into two parts: art and writing. There were many original graphics as well as fine color reproductions tipped in.

The writing was mostly about newer problems and new thoughts about old and modern art. Contemporary forms of philosophy and major statements about these ideas, as well as poetry were included as a cross section of the times. The contributors were highly respected art historians and museum directors for the most part. Heise worked mostly with the second section about literature and "mankind."

The political attitudes in Genius are middle-of-the-road: the ecstasy of earlier prophets is criticized and the unusual is also taken to task. Another intention was to show taste and scholarship as a way of leadership to help people find life in art itself. Art in life itself could be shown also.

Original graphics by Marc, Schmidt-Rottluff, Seewald, Heckel, Archipenko and others appeared in various issues.

Kurt Pinthus had been the head reader and literary advisor for Wolff in Leipzig, and continued after the firm moved to Munich. He had wide knowledge of the Expressonist writers, was friendly with most, and proved a champion for them. Pinthus became more than a reader, being both an editor and friend of the contributors than was the publisher, Wolff.

Original prints in GENIUS:

1919, 1st Book
275/1. Karl Schmidt-Rottluff; Kopf (Head), woodcut, 17.2 x 23.9, (1916) Schapire 189
275/2. Richard Seewald, Der Hirte (Shepherd) woodcut, 23.8 x 17.8 cm. Jensch 77 III, handcolored.
275/3. Karl Caspar; Johannes auf Patmos (St. John on Patmos) litho, 24 x 21.5 cm.

1919, 2nd Book
275/4. Franz Marc; Aus der Tierlegende (From the Legends of Beasts) woodcut, 19.7 x 17.8 cm., (1912) Lankheit 831
275/5. Heinrich Nauen; Mutter und Kind, (Mother and Child), etching, 23.8 x 18.3 cm.
275/6. Ignaz Epper; Mädchenkopf (Girl's Head), litho, 33 x 23 cm.

1920, 1st Book
275/7. Frans Masereel; Business Man, woodcut, 20.7 x 16.2 cm.
275/8. Georg Ehrlich; Tröstung (Consolation) litho, 19.8 x 23.5 cm.
275/9. Erich Heckel; Mädchenkopf (Girl's Head), woodcut, 25.8 x 17 cm., (1913) Dube 264

1920, 2nd Book
275/10. Max Kaus; Kopf (Head), woodcut, 28.6 x 20 cm.
275/11. André Rowveyre; Kopf (Head), woodcut, 24 x 17.8 cm.

1921, 1st Book
275/12. Edwin Scharff; Die Brüder (Brothers), litho, 27 x 17 cm.
275/13. Alexander Archipenko; Figürliche Komposition (Figurative Composition), litho, 31 x 22.5 cm.
275/14. Karl Hofer; Das Nest (The Nest), litho, 27.5 x 23.3 cm., Rathenau 34.

1921, 2nd Book
275/15. Karl Schmidt-Rottluff; Lesender Mann (Man Reading), woodcut, 27.9 x 19.8 cm., (1921), Schapire 274
275/16. Alexander Kanoldt; Klausen (Town in Switzerland), litho, 28.5 x 23.5 cm.

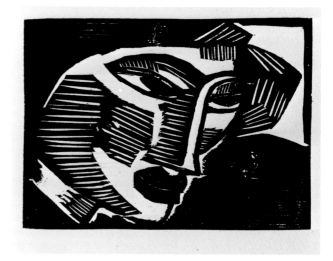

275/1.

276. **DIE INSEL** (Island)
Began 1-10-1899; ended August/September, 1902
Editors: Year 1/2 Otto Julius Bierbaum, Alfred W. Heymel, Rudolf A. Schröder. Year 3 Otto Julius Bierbaum alone
Verlag Schuster und Löffler (Verlag der Insel)
After the third year the name was changed to Insel-Verlag, Leipzig
Printed by F. Drugulin, Leipzig
Schlawe I, p 60
Editions: about 3000
Luxury edition of 400
Additional: 1-15 on Imperial japan paper
16-40 on Holland Bütten, all numbered
1-10 with signed prints
11-40 with signed prints
23.8 x 18.3 cm.

This great production of the Jugendstil era was the finest printing effort of the time in Germany. The intention of Die Insel was to print new and original drama and poetry, with some new prose. Each issue had a theme. One of the best printers was chosen and the paper and design were always first rate. Title pages of early issues were designed by Heinrich Vogeler. Even in addition to the collectors' edition of four hundred, fifteen examples were made on japan paper, and twenty five on special handmade Bütten. It was an extraordinary effort to produce an exceptional journal, with no consideration for cost. Unfortunately, the effort lasted only four years. A poster was designed by E.R. Weiss to publicize the new journal.

Contents tell of Jugendstil interest in Japanese life, prose by Franz Blei, protest against money and millionaires by Paul Scheerbart illustrated by Felix Vallotton. Meier-Graefe also wrote an important essay about the modern aesthetic.

218

## 277. **J.B. NEUMANNS BILDERHEFTE** (*J.B. Neumann's Picture Pamphlets*)

Verlag Graphisches Kabinett Israel Ber Neumann was involved with the Expressionists early in their development. He moved to Berlin and opened a print cabinet which specialized in old master and modern graphics. He was an enthusiastic gallery owner, more interested in his artists than possible profits. One reads no real criticism of Neumann in artists' correspondence, although there are frequent references to greedy art dealers.

Neumann also collected with a passion, sometimes keeping the best art for himself. He tried to promote the young painters by every means possible: evenings of readings in the gallery, special openings to present the artists to their friends, occasions for manifestos by the Dada wildmen, and the first Dada show, May 1919.

Neumann's knowledge was wide, and his sensitivity great. He could never understand why his artists did not sell more of their work. His expertise included knowledge about old master drawings, negro sculpture, and medieval art.

The print room of J.B. Neumann, the modern section, published these picture pamphlets to publicize his exhibitions. Alternating in the same series were pamphlets called "Sonderhefte," special pamphlets, which had one theme or the work of one artist.

The publicity from these books was not overwhelming, but the pamphlets remain an historical series of documents about a special man and a special time. He had been an important and early enthusiast, publishing prints by Kirchner and Kokoschka since 1913. Some of the artists he exhibited and published included Beckmann, Jaeckel, Meidner, Heckel, Janthur, Schmidt-Rottluff, Feininger, Chagall, Lehmbruck, Marc, Mueller, Nolde, Grosz, and Kubin.

Neumann was forced from Germany by the Nazis, moved to New York City and presented his beloved German Expressionists there until his death in 1961. His gallery in Germany was divided between Nierendorf and Günther Franke, both of whom collaborated with the new project in New York.

277.

# J.B.NEUMANNS BILDERHEFTE

Marc Chagall, Zeichnung

VERLAG GRAPHISCHES KABINETT
JSRAEL BER NEUMANN / BERLIN W 50

276.

**OTTO DIX**
278. J.B. Neumann
drypoint, 1922
29 x 24 cm., Karsch 49/II
Published by Karl Nierendorf,
50 examples on etching paper

278.

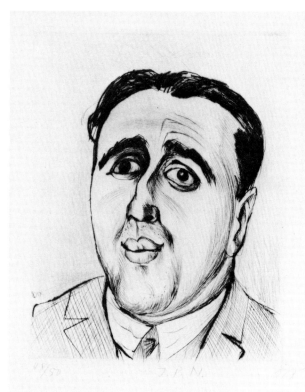

279.

**Das junge Deutschland**

Zweiter Jahrgang        Nr. 6.

Fünfter Jahrgang der Blätter des Deutschen Theaters

Tod und Reichstag

Von Walter Hasenclever

Meine Herren!

Auf die Frage, weshalb ich rede, anstatt zu handeln, will ich Antwort geben. Ich bin ein Bürger des Zukunftstaates. Was der Friede nicht vermochte, hat der Krieg erreicht. Sozialismus und Militarismus, die Erbfeinde, haben das Wunder vollbracht: sie haben, anstatt sich aufzuheben, einander ergänzt. Noch vor zwei Jahren schwebte ich zwischen Kaserne und Schutzhaft. Weil ich Sozialist war, wurde ich Soldat; aber durfte ich als Soldat noch Sozialist sein? In dieser Notlage habe ich die Kriegskredite bewilligt, denn ich glaube an den ersten Paragraphen aller Parteien: daß der Zweck die Mittel heiligt. Das ist der Grund, weshalb ich rede, anstatt zu handeln; denn wenn ich handelte, müßte ich ein Lehrbuch der Geschichte schreiben und beweisen, daß die Idee der Freiheit von Fichte bis Hindenburg sich nicht geändert hat.

Meine Herren Abgeordneten! An jeden von Ihnen ist die Frage herangetreten, sei es am Sterbebette eines Menschen oder am Tisch der Aktionäre, wie sich Recht von Unrecht unterscheidet. Gesetzt, es gäbe vor dieser Frage keine Zensur, und die Entscheidung, wie sie auch ausfalle, unterläge nicht der Zustimmung des Generalkommandos — wären Sie imstande, gegen Ihr Gewissen die Forderung Macht geht vor Recht, zu bejahen? Ich will nicht die Frage stellen, ob es erlaubt ist, einen Menschen zu töten. Politik und praktische Vernunft würden den Gegenbeweis antreten; ich hätte nichts als den kümmerlichen Appell an das Grauen der Mitwelt.

Als im Frühling des Jahres 1912 die „Titanic" im Meere versank, lag der Eisblock, an dem sie zerschellte, auf allen Herzen. Bis in die kleinsten Spelunken Australiens drang die Nachricht, daß tausend Menschen verloren waren. Die Zeitungen füllten sich mit dem Todeskampf der Unglücklichen, der zur Ewigkeit wurde. Gekrönte Häupter standen beiseite; einen Augenblick waren Ihr Empfänge vergessen; arme Kinder, im Gischt ertränkt, schrieen in den Schlaf der Bürger; Frauen hörten das Winseln der Bräute vor Lloyds, und allgemein beklagte Europa, diese Welt zusammenhangloser Völker, eine Welt, in der es geschehen konnte, daß tausend Menschen sinnlos dem Tod verfielen.

Drei Jahre später, um dieselbe Zeit, wurde die „Lusitania" torpediert. Das Schauspiel des furchtbaren Sterbens wiederholte sich; doch war an Stelle der Elemente, zu deren Bekämpfung Jahrtausende nicht genügten, die Erfindung der Menschen getreten. Mein Herz schlägt höher, und ein jähes Gefühl von Stolz und Vaterlandsliebe durchzuckt mich, wenn ich bedenke, daß jene, die damals starben, unsere

139

**279. DAS JUNGE DEUTSCHLAND** *(The New Germany)*
Monatsschrift für Theater und Literatur
Year 1, Heft 1 and 2 edited by Paul Kornfeld
Thereafter edited by Deutsches Theater zu Berlin
Editor of the first part: Arthur Kahane
Editor of the second part: ("Blätter des Deutschen Theaters): Heinz Herald
Erich Reiss Verlag
Berlin, 1918-1920
Raabe 47, Schlawe p. 102
1918 10 issues, 2 double issues (1-12)
1919 11 issues, 1 double issue (1-12)
1920 4 issues, 2 double issues (1-6)
23.5 x 18.3 cm.

The periodical was divided into two sections: one was concerned with general topics of the theater and related literature, the second part was devoted specifically to the German theater in Berlin.

The first section is an important document by the new writers. It probes the Expressionist mediums of writing, with emphasis on poetry, essays about new kinds of plays, essays about supposed spiritual situations, detailed critiques of drama as performed in many cities, descriptions of stage production and portraits of actors. Also included were stage designs and interpretations of stage action.

It is fitting that the first issue presented a criticism of the first truly Expressionist play, "Der Bettler," by Reinhardt Sorge, recently deceased. This issue also contained Paul Kornfeld's essay about the new psychological man, which was the basis of Expressionist theater—the most important statement about the new theater in Germany. Many of the later issues had more original prints related to the theater.

The first performance of the first true Expressionist play was December 23, 1917, and it is fitting that the voice of Expressionist theater, Das junge Deutschland, appeared during the next month as a first endeavor.

In retrospect, Kahane wrote about his experience as an editor of the magazine. He mentioned his desire to combine the new way of thinking in the theater with the older plateaus, but found at first nothing but laughter. Persistence finally paid off as new friends were found and strong talents as well. The new writers had found their outlet.

Later the writers appeared with their own publications and no longer needed the friend that had promoted it all, so the periodical stopped publication in 1920.

Heinz Herald, editor of the second half of the magazine, was producer for the Reinhardt theater in Berlin. It was in his theater matinees that Expressionism had impressive encounters with the public. Evenings were devoted to the conservative classics.

Zum "Bettler" *(To the Beggar)*
by Richard Sorge

Your flight digs white circles:
Through darkness, through gigantic dreams,
Through streaks of fortune, gigantic cave rooms—
Restless toward the morning, restless toward the evening...

Your wild screams spiral higher
From the father's curse and all of mother's pain;
Soon eternal creation kindles star candles—:
And a defiant salvation rises from the clay...

Then your wings touch those bolts,
In whose jaws some brains are crushed;
You love the nostalgia, which floated you here,
You catch it and tumble down into the crucible.

Two Poems by Gustav Sack

Mystika *(Mystic)*
Thousand, many times a thousand years
Rolled up like lightning,
Before I sprang up
From a loving couple, a silly joke

Of an eternally nameless one.
Poor little fool's song,
Which in wild years disappears
Roaring, before it has hardly sounded!

But still I hold within me
All the tortures of the world
And what will be, that
First must be pictured within me.

Yes, the father, who called me,
Can become existence within me,
Even without me there would be an end
To the savage dance of the earths.

How the fool's cap rings!
But without such sound
Will you and the entire world
Burst lightning fast into nothingness!

Der Tote *(The Dead)*

There, behind, where the heather, where the west wind
thrusts,
His hour has struck;
There the fool has loosened his veins
And transported himself to the grave.

Soon the ravens circled, raven-black and compact
Over the poor cadaver,
Greedy for his hungry bowels
They held their croaking palaver.

Then the fox gnawed his stiffly frozen limbs
Through the windy night,
And then the honored spring awakes,
And horse flies dance down.

But in the fall cleanly glistening
His bones were chalk and silk,
And lamenting the west wind
Pushed his rain song across the heather.

### 280. DAS JUNGE RHEINLAND *(The New or Young Rhineland)*
Overall editor: Gert Heinrich Wollheim
Introduced by Verlag Das Junge Rhineland, Düsseldorf in issue 1
Published issue 2 and after by Julius Baedeker, Düsseldorf (2-9/10)
Oktober 1921 to Juli 1922
Perkins 177
8 issues/1 double issue
22.2 x 14.1 cm.

Das Junge Rhineland began as an organ of radical groups in the Rhineland called "Das Junge Rhineland" under the inspiration and advice of Christian Rohlfs. Members included: Walter Cohen, Herbert Eulenberg, Dr. Friedrich, Franz Haniel, Karl Koetschau, Richart Reiche, Ludolf Rosenheim, A. Stein, Edwin Suermondt, Hermann von Wedderkop and Wilhelm Worringer. In support of this group were Bernhard Sopher, A. Uzarski, Arthur Kaufmann, Hedwig Petermann, J. Enseling, and Wilhelm Ernst.

It was an activist periodical; with expanding intentions for each issue. After the eighth issue, the magazine began to include most left wing political-art groups in Germany. These included Novembergruppe, Dresdner Sezession, Darmstädter Sezession, Die Schaffenden, Künstlergruppe Halle a.d. Saale, and Künstlergruppe München des Kartells.

The last issues were divided into three of the most important groups ('Novembergruppe,' 'Dresdner Sezession,' and 'Das Junge Rhineland'), each of which had a separate section for propaganda and descriptive prose.

Each issue included biographies or autobiographies of the artists. There were also some literary contributions, mostly by writers of the Rhineland circle. Later issues became more political than artistic or literary, and moved far to the left.

We have later issues, heft, or issue, 9/10, July 1922, with important statements about the Dada scene. There is also an amusing encounter between a young painter and a professor, who tells the young man: "You are a terribly naive youngster." The illustrations are Magic-Realist, Constructivist, or New Objectivist.

An artists' cartel formed to publish this group of issues held a congress in 1922. One announcement in the introductory manifesto was an attack on the director of the Düsseldorf art academy, which described him as a poor minister of art. There was an appeal against a critic who wrote that the exhibition at Galerie Wollheim was a center of anarchy in art, represented the state of art among the young as the "Cloaca" (orifice) of the time and wondered what could follow. There was also an announcement of the Congress for International Artists, which included participants from every major country in Europe, America, and the Far East.

The section representing the Dresdner Sezession is relatively moderate, and includes reasonable poetry and biographies. But the section by the Novembergruppe is wild and dogmatic. The introductory poem by Moritz Melzer asks us to join hand-to-hand and carry the banner high. "Your place, your mirror, our pledge, everyone's day." A manifesto begins: "Art is information" (propaganda).

At the end of each issue are advertisements from banks and clothing stores, which were apparently not afraid of the wild statements by these radical artist groups.
280.

221

## 281. KRIEGSZEIT. KÜNSTLERFLUGBLÄTTER
*(Wartime. Artists' Pamphlets)*
"Der Ertrag ist für gemeinnützige Zwecke bestimmt!"
Founded and edited by Paul Cassirer and Alfred Gold
65 issues plus a separate print by Max Oppenheimer
Paul Cassirer Verlag
Berlin, August 1914/March 1916
Perkins 180

During the last days of July 1914, Germany declared a state of emergency in preparation for war. There were a few dissenting voices even among the parties of social progress. Many artists, professors, and writers signed a declaration backing German Imperialism as such. Thomas Mann wrote a long essay supporting the German idea of community as opposed to the idea on internationalism. Real opposition to the war came from a small group of Expressionists, most of whom emigrated to Switzerland.

Cassirer was a great publisher, an enlightened and educated man. He supported left wing political parties, but his major interest was with the Secession artists of Berlin, through his close friendship with Max Liebermann. Cassirer and his friends supported the war as a nationalist, anticapitalistic, antiinternationalistic effort.

Alfred Gold, Cassirer's associate editor, was an art critic, trained in philosophy. He spent some time in Paris as a young man and later again in the 1920s. His art criticism was fairly conservative, including special interests among the painters and thinkers of his Austrian birthplace.

There was some strident, anti-Western propaganda in the paper. It is interesting to note the change in attitude as war losses in huge numbers became evident to the German public. The first issue shows German soldiers as noble custodians of culture, leaders in war, bastions against the British lion and the French cock. The German submarine campaign is supported. Coming victory is symbolized: soldiers balance against bags of British gold. Only Kollwitz is subdued in tone. Barlach is violently anti-Western. The sinking of the liner Lusitania is praised. Later issues carry a sadder tone. The humor becomes human. These nationalistic contributors included Barlach, Beckmann, Gaul, Grossmann, Jaeckel, Kollwitz, Liebermann, Meid, Slevogt, E.R. Weiss, and others. Käthe Kollwitz withdrew after the death of her son at the front.

Cassirer became less enthusiastic and finally disenchanted. Victories seemed too costly in human life for this humanist. He became a member of the Progressive Social Democratic Party, during the split among the radical socialists in 1916, and a more active participant in dissent. He ended Kriegszeit and began another journal, Der Bildermann, which showed the changed attitudes of the artists.

Lithographs in Kriegszeit

1. BALUSCHEK, H. #2 Sept. 7, 1914, Der Siegesbote auf der Normaluhr *(Messenger of Victory on the Public Clock)*
2. BARLACH, Ernst #12, Nov. 11, 1914, An der Ostgrenze *(On the Eastern Frontier)*, Schult 63
3. #14, Nov. 25, 1914, lügt, Stürme, lügt *(lie Storms, lie)*, Schult 64
4. #17, Dec. 16, 1914, Der heilige Krieg *(The Holy War)*, Schult 65
5. #20, Dec. 30, 1914, Erst Sieg, Dann Frieden *(First Victory, Then Peace)*, Schult 66
6. #28, Feb. 24, 1915, Strassenecke in Warschau *(Street Corner in Warsaw)*, Schult 67
7. #32, March 24, 1915, Sturmangriff *(Heavy Attack)*, Schult 68
8. #46, July 1, 1915, Und wenn die Welt voll Teufel wär *(And if the World was Full of Devils)*, Schult 69
9. #49, July 28, 1915, Die Bethlehem Steel-Company in Amerika *(The Bethlehem Steel Company in America)*, Schult 70
10. #50, August 5, 1915, Evakuierung *(Evacuation)*, Schult 71
11. #53, Sept. 15, 1915, Untitled/Der Drescher von Masuren *(The Thrashing of Masuren)*, Schult 72
12. #57, Nov. 15, 1915, Serbische Elegien *(Serbian Elegy)*, Schult 73
13. BATO, Josef #30, March 10, 1915, Vorrücken im Granat und Schrapnellfeuer *(Moving Forward in Grenade and Shrapnel Fire)*
14. BECKMANN, Max #11, Nov. 14, 1914, Untitled/Bildnis des verwundeten Schwagers Martin Tube *(Portrait of the Wounded Brother-in-Law Martin Tube)*, Gallwitz 53 c, Glaser 69

281/171.

15. BEHRENS, Peter #56, Nov. 1, 1915, Heerführer im Osten *(Army Leader in the East)*
16. BONING, W. #5, Sept. 30, 1914, Die hohe Kirche zu Reims *(The Cathedral at Reims)*
17. BÜBBNER, E. #5, Sept. 30, 1914, Ehrliches Spiel! *(Honest Play)*
18. BÜSSNER, E. #29, March 3, 1915, Generalleutnant v. Ludendorff *(Lieutenant General von Ludendorff)*
19. BÜTTNER, Erich #8, Oct. 1914, Über Paris *(Over Paris)*

## 282. KÜNDUNG
### EINE ZEITSCHRIFT FÜR KUNST (Proclamation)
Edited by Wilhelm Niemeyer and Rosa Schapire
Einmann-Werkstatt Johannes Schulz
Hamburg, 1921
Raabe 96, Perkins 181
7 issues, 1 triple issue, 3 double issues
45.5 x 34 cm.

1st Folder, 1st part, January 1921 (Heft); front and back 42 x 32 cm.
All titles by Schmidt-Rottluff. Some black and white, some with one color added as a background/green, red, brown, etc. Usually from a solid block of various woods. Title poem by Wilhelm Niemeyer, woodcut by Schmidt-Rottluff.
Text: Wilhelm Niemeyer, Karl Lorenz, Ernst Fuhrmann.
Woodcuts by: Karl Opfermann, Gerhardt von Ruckteschell, Heinrich Stegemann, Willi Fitze.

1st folder, second part, Feb. 1921, from 2 on sold by Lucas Grafe.
Title page poem by August Stramm. Woodcut by Karl Opfermann.
Text: Kurt Heynicke, Elisabeth Fuhrmann, Dr. Rosa Schapire, Ernst Fuhrmann.
Two woodcuts by Lasar Segall, printing press prints of 3 more (5)

1st folder, third part, March 1921.
Title page poem by Karl Lorenz, woodcut by Franz Radziwill
Text:Anton Schnack, Wilhelm Niemeyer, Ernst Fuhrmann
Four woodcuts by Franz Radziwill.

1st folder, 4-5-6 part combined, April, May, June 1921.
Text: Wilhelm Niemeyer, R. E. Laman, Titus Mafundu, Olse Meyer-Line; six photos of African Art.

1st folder, VII and VIII parts, July, August 1921
Title page poem and woodcut by Siegfried Schott.
Text: Siegfried Schott.
4 woodcuts by Siegfried Schott.

1st folder, IX & X, September, October 1921
Title page, poem by Wilhelm Niemeyer; woodcut by Hugo Meyers.
Text: Wilhelm Niemeyer.
14 plates, a woodcut book by Hugo Meyer.

1st folder, XI, XII, November, December 1921
Title page: poem by Wilhelm Niemeyer, woodcut by Willi Titze.
Introduction: by Wilhelm Niemeyer, woodcut by Hugo Weber.
Text: Richard Blunck, Erna Gerlach, Simon Kronberg, Wilhelm Niemeyer, Edlef Köppen, Siegfried Schott, Thomas Ring, Gertrud Ring.
Woodcuts by Emmey Hesz, Werner Lange, Thomas Crodel, Thomas Ring.
Extra insertions: Thomas Crodel, litho of Theodor Daübler.
Last issue: "with this issue the Kündung ends"

The Einmann workshop closed under the title Hamburger Handpresse and changed names to open as Handdruck Presse, December 1921.

A magazine for art was the undertitle. This luxurious periodical was always printed in appropriate typefaces to fit the subjects. Each issue always had a poem carved as a woodcut on the first page. The cover for all issues was a woodcut by Karl Schmidt-Rottluff, with a different color background for each issue. He also designed the logo for the last page, that of Johannes Schulz. Schulz was a famous teacher at the arts and crafts school in Hamburg, and used his experience and taste to lay out the pages. He was not afraid to be original.

Each issue contains late Expressionist poetry, speeches, and essays about politics and art. The unity of graphics and letters is remarkable. It shows real participation by the Expressionist artists.

Niemeyer was a long-time art historian and docent at the art and crafts school in Hamburg. He promoted young artists, wrote one of the catalogues for the famous Sonderbund exhibition, and was member of the Jury of selection. His colleague, Rosa Schapire, was an eminent art historian also, a friend of the Brücke artists from the beginning, a member of the group, cataloguer of Schmidt-Rottluff's graphic works, and frequent correspondent with Kirchner, Heckel, and the rest.

Hamburg at this time was a conservative northern city, a Hanseatic city of commerce and middle class values. It had settled ideas and centralized methods built around shipping. There were many Expressionist poets living in this pleasant city of the Elbe and the Alster, but they were little appreciated by the proper citizens.

In a role other than poet, Niemeyer used an early issue of Kündung to promote the work of Karl Lorenz, of Die Rote Erde fame, with his problematical lyrical poetry. The writers of Hamburg tended towards the long-winded, not the schematic shortness of Berlin.

Every issue is functionally designed with sans serif type used for certain modern works and traditional letters for traditional writing. The paper is of fine, handmade quality.

282.

### 283. DAS KUNSTBLATT (Art Paper)

Edited by Paul Westheim
Year 1-9 published by Kiepenheuer Verlag, Berlin-Potsdam
Year 10-11 published by Akademische Verlagsgesellschaft Athenaion, Wildpark-Potsdam.
Year 12 (Nr. 1-11) publ. by J. M. Spaeth, Berlin.
Year 12 (Nr. 12)/Year 16 publ. by Hermann Reckendorf, Berlin.
Year 17 (Nr. 1-3) publ. by Wendt & Matthes, Berlin.
1917-1933
Deluxe Edition:
110 numbered editions with one extra print
1-100 for subscribers.
1-10 museum edition.
Regular Edition Unknown. (About 1000)
Perkins 183, Schlawe 35
28 x 21.5 cm.

A lifelong dream of Paul Westheim, the first issue of this great art journal was planned while Westheim was an active soldier, during a war time when young painters were totally ignored. It was an impressive dream. It was first promoted, with the help of the art dealer J. B. Neumann, by an introduction to the great publisher Gustav Kiepenheuer. This allowed the dream to become a reality and Westheim found enthusiastic support. Kiepenheuer provided the best printers, the best designers, fine paper, and expensive means of reproducing the illustrations. Kiepenheuer also promoted another dream of Westheim's, the portfolios of original graphics called Die Schaffenden.

283/2.

Das Kunstblatt included an original print in each issue for most of the first three years, and also put out a deluxe edition with another extra print on special paper.

The beginning was difficult, because the art public did not accept Westheim's ideas. After the issue on Kokoschka in 1917, the magazine gained in popularity and continued to grow until the editorial offices were closed by the Nazis in 1933.

Kiepenheuer promoted the journal in other ways besides financial ones. He issued art monographs and art history books. He advertised and promoted, until Das Kunstblatt became the voice of the young painters all over Germany.

The art contents were expanded to include important critical articles about sculpture, film, architecture, literature, and music. There were long, complete essays about painters and writers, not tentative criticisms. The taste and scholarship improved every year. It became a true international art journal. Its essays are referred to in most art histories today; in particular those about Jawlensky, Matisse, Morgner, Pechstein, Carra, Man Ray, Mies van der Rohe, as well as many of the younger Italian and French painters.

Original Prints in DAS KUNSTBLATT
Deluxe Editions of 1917 and 1918 (The deluxe editions duplicate the original prints in the regular edition and add an extra print. The prints which appear in both editions are listed under the regular edition.) :

1. BOLLSCHWEILER, Dec. 1917, #12, Knieendes Mädchen (Kneeling Girl), etching
2. CAMPENDONK, H. August 1917, #8, Frösche und Schmetterling (Frogs and Butterfly), woodcut, Engels 24
3. April 1918, #4, Bauerngang (Peasants Walking), woodcut, Engels 33
4. FEININGER, L. March 1917, #3, Fischerboot im Regen (Fishing Boats in the Rain), Prasse, Orig. Graphik in Sammelwerken u. Büchern 17
5. FELIXMÜLLER, C. Jan. 1918, #1, Mädchenkopf (Girl's Head), lithograph, Söhn 112, titled there "Kopf Londa II"
6. GLEICHMANN, O. May 1918, #5, Vergänglichkeit (Transitoriness), lithograph
7. GRAMATTE, W. Sept. 1917, #9, Kaserne (Barracks), drypoint, Eckhardt 108
8. Nov. 1918, #11, Der Kranke mit den Blumen (The Sick Person with a Flower), lithograph Eckhardt 54
9. GUBLER Max July 1918, #7, Kommune (Town), lithograph
10. HECKEL, Erich Feb. 1917, #2, Irre beim Essen (Lunatic at the Table), drypoint, Dube 129 B, 1914
11. HÖCH, Hanna April 1917, #4, Der Prophet Matthäus (The Prophet Matthew), woodcut
12. KLEMM, Walter May 1917, #5, Kleinstadt (Small Town), etching
13. KOKOSCHKA, O. Oct. 1917, #10, Pörtrat Käthe Richter (Portrait of Käthe Richter), lithograph, Wingler/Welz 113
14. LANGE, Otto Nov. 1917, #11, Füchse (Foxes), woodcut
15. MEIDNER, Ludwig March 1918, #3, Radierte Porträt-Skizze (Etched Portrait Sketch), etching
16. NOLDE, Emil Jan. 1917, #1, Madonna (Madonna), woodcut, Schiefler-Mosel 142, titled there "Mutter mit Kind"
17. PECHSTEIN, Max June 1918, #6, Mutter (Mother), woodcut, not in Fechter
18. ROHLFS, Christian Sept. 1918, #9, Der gute Hirte (The Good Shepherd), woodcut, Vogt 36, ca. 1911
19. SCHARFF, Edwin Aug. 1918, #8, Zwei Männer im Boot (Two Men in a Boat), etching
20. SCHAEFLER, F. Dec. 1918, #12, Wanderzirkus (Traveling Circus), drypoint
21. SCHMIDT-ROTTLUFF, K. Feb. 1917, #2, Mädchen mit Zöpfen (Girl with Braids), woodcut, Schapire 200
22. SEEHAUS, Paul Oct. 1918, #10, Brücke (Bridge), etching
23. STEGER, Milly July 1917, #7, Karyatide (Caryatid), lithograph
24. WACHLMEIER, L. June 1917, #6, Vor dem Café (In Front of the Cafe), lithograph

Original Prints in DAS KUNSTBLATT
Regular Editions of 1917 to 1920

25. BAUMBERGER, Otto July 1918, #7, Kreuzabnahme (Decent from the Cross), lithograph
26. BOLLSCHWEILER, Jack Dec. 1917, #12, Gärtnerei (Nursery), lithograph
27. BURCHARTZ, Max Aug. 1919, #8, Zwei Männer (Two Men), lithograph

28. CAMPENDONK, H. Aug. 1917, #8, Mädchen mit Fröschen *(Woman with Frogs)*, woodcut, Engels 25
29. June 1919, #6, Sitzender Mann *(Sitting Man)*, woodcut, Engels 44
30. DERAIN, Andre Oct. 1919, #10, Stilleben *(Still Life)*, woodcut
31. EBERZ, Josef April 1917, #4, Flusslandschaft *(River Landscape)*, lithograph
32. FEININGER, L. Feb. 1919, #2, Schiffe am Hafenquai *(Ship at the Harbor Dock)*, woodcut, Prasse W116
33. Jan. 1920, #1, Dorf *(Village)*, woodcut, Prasse W301
34. GLEICHMANN, Otto Oct. 1918, #10, Weltentrückte *(World Wandering)*, lithograph
35. July 1919, #7, Untitled, lithograph
36. GOTHEIN Werner May 1918, #5, Kuss *(Kiss)*, lithograph
37. May 1919, #5, Raucher *(Smoker)*, woodcut
38. GRAF, Gottfried Aug. 1918, #8, Untitled, woodcut
39. HECKEL, Erich Jan. 1918, #1, Frühlingslandschaft *(Spring Landscape)*, woodcut, Dube 225
40. HELBIG, Walter Sept. 1920, #9, Vogelpredigt *(Preacher Bird)*, woodcut
41. HOFMAN, Vlastislav Feb. 1920, #2, Raskolnikow *(Raskolnikov)*, linoleumcut
42. HOHLT, Otto March 1920, #3, Untitled, lithograph
43. KERSCHBAUMER, Anton Sept. 1919, #9, Schleuse *(Sluice)*, lithograph
44. KLEMM, Walter May 1917, #5, Enten *(Ducks)*, woodcut
45. KOKOSCHKA, O. Oct. 1917, #10, Porträt Käthe Richter *(Portrait of Käthe Richter)*, lithograph, Wingler/Welz 112
46. LANGE, Otto Nov. 1917, #11, Porträt *(Portrait)*, woodcut
47. LEGER, Fernand July 1920, #7, Untitled, lithograph
48. LOMNITZ, Alfred June 1920, #6, Gespenstersonate *(Ghost Sonata)*, woodcut
49. MACKE, August April 1918, #4, Komposition (Drei Akte) *(Composition/Three Nudes)*, linoleumcut
50. MEIDNER, Ludwig June 1917, #6, Porträt *(Portrait)*, lithograph
51. Dec. 1918, #12, Gebet *(Prayer)*, lithograph
52. MUELLER, Otto Jan. 1919, #1, Strand *(Beach)*, lithograph, Karsch 76 II.
53. FELIXMULLER, C. March 1919, #3, Mutter *(Mother)*, woodcut Söhn 142
54. PECHSTEIN, Max June 1918, #6, Säugling *(Infant)*, woodcut, not in Fechter
55. Nov. 1918, #11, Badende *(Bathers)*, lithograph, not in Fechter
56. ROHLFS, Christian Sept. 1918, #9, Tod mit dem Sarg *(Death with a Coffin)*, woodcut, Vogt 104
57. Dec. 1919, #12, Elias in der Wüste *(Elias in the Wilderness)*, woodcut, Vogt 41
58. SCHLICHTER, R. April 1920, #4, Tanz *(Dance)*, lithograph
59. SCHMID, Wilhelm March 1917, #3, Sängerin *(Singer)*, lithograph
60. SCHMIDT-ROTTLUFF, K. Feb. 1918, #2, Menschenpaar *(Pair of Humans)*, woodcut, Schapire 199
61. SCHRIMPF, Georg Feb. 1917, #2, Untitled, woodcut

62. STEGER, Milly July 1917, #7, Auferstehen, *(Rising of the Dead)*, lithograph
63. STÜCKGOLD, Stanislaus Sept. 1917, #9, Erfüllung *(Fulfillment)*, lithograph
64. Aug. 1920, #8, Untitled, lithograph
65. WACH Aloys Oct. 1920, Landschaft mit Frauen *(Landscape with Women)*, woodcut
66. ZIERATH, Willy Nov. 1919, #11, Untitled, woodcut

## OTTO DIX

284. Paul Westheim
Lithograph, 1923
Karsch 63
Published by Karl Nierendorf, Berlin
Editions: a-proofs on paper 45.2 x 58.4 cm., b-edition of 55 on paper 46 x 58.5 cm.
38.5 x 47.2 cm. (Image)

284.

## OSKAR KOKOSCHKA

285. Paul Westheim (Porträt) *(Paul Westheim's Portrait)*
Lithograph, 1923
Wingler/Welz 162
Signed in pencil, on van Gelder paper
As published in Die Schaffenden, 4th year, 3rd portfolio
Berlin: Euphorion Verlag
Edition: 125 impressions
25.9 x 30.3 cm.

The patient and intelligent Paul Westheim's purpose was to make Expressionist art more widely known. He also combined an interest in Expressionist literature with the illustrations, making both available together.

This was in contrast to Herwarth Walden and his intellectual level of high purpose in Der Sturm. Walden was not a popularizer, but a dogmatic editor. He was not interested in the wide range of Expressionist art, but in the circle of young painters and writers who formed around his publication.

Westheim's interests were more general.

Westheim writes about finding mostly idealists among his publishers. He mentions also the financial success which these publishers achieved, even though they put out controversial works.

Westheim's relationship with Kokoschka was primary. The works of the still young artist were illustrated in the issue of October, 1917. The special issue was devoted to Kokoschka, bringing a survey of his entire works up to that time.

Westheim's portrait is straightforward and simple in its exploration of the facts. It shows a man who was immediately trusted by the great publisher, Kiepenheuer of Weimar, to edit the new magazine. It is the face of a man who was not afraid of decisions, of saying yes to new talent, of open-mindedness and initiative.

Of Kokoschka, Westheim wrote: "The lithographs are to be taken as first fixations in which the creator takes it upon himself to test himself about the supporting factors of his means."

Kokoschka had to find a new language for his compositions, a language which lived in rhythm. The procedure appears in the face, which shows determination and clearness.

Otto Dix, too, gave homage to this important critic and thinker.

285.

## 286. KUNST UND KÜNSTLER (Art and Artist)
Monatsschrift für bildende Kunst und Kunstgewerbe
Verlag von Bruno Cassirer
Berlin, 1902-1933
30.9 x 24.5 cm.

Karl Scheffler, the editor, was a major promoter of German Expressionism, after a period of supporting the German painters of the Secession artists' group. He also wrote for Feuer and Der Querschnitt, much about young artists, and became fairly reactionary during the decline of Expressionism.

The art magazine, Kunst und Künstler, was published for thirty-one years without interruption, until the Nazis stopped publication in 1933.

The range of material was more varied in the period between 1910 and 1914. Kunst und Künstler was intended to include original graphics used for pertinent articles, as well as illustrations for stories and artists' journals. Exceptional works were published by such artists as Liebermann, Corinth, Slevogt, Barlach and Beckmann. One also finds major essays about the dance, and critical articles about major painters, such as Rembrandt, Munch and others. During the 1913 season, however, the greatest exhibition at the Sturm gallery was not considered important enough to review.

The layout is traditional. There are a few illustrations from the modern school, mostly French, but text descriptions and illustrations described Impressionists into the middle of this time. As an art magazine which considered all eras and kinds of art, Kunst und Künstler is not a solely Expressionist journal. Only at intervals did editorial policy foster the ecstatic painters. Scheffler summed up the movement in 1919, by attempting to predict the future of German art, though without much validity. He was more interested in German culture and art than a particular group of modern painters. His expertise favored Liebermann and the Secessionists.

The periodical is very Germanic, with dull layout, and language that is diffuse, but many issues were very important because of the original material by important critics and artists.

Many issues contained original lithographs by such artists as Barlach, Liebermann, and Grossmann, and etchings such as one by Renoir.

Important Original Prints in Kunst and Künstler

Jahrgang XI, 1912, pages 3-12 (October issue Heft 1.)
Ernst Barlach; Eine Steppenfahrt, von Ernst Barlach
(A Journey to the Steppes by Ernst Barlach) thirteen lithographs, 1912
Schult: 49, 50, 51, 52, 53, 54, 55, 56, 57, 58, 59, 61, 62

Jahrgang XI, 1912, pages 131-134 (December Heft 3).
Max Liebermann; Am Strand von Scheveningen (At the Beach at Scheveningen) von Josef Israels
Three lithographs, 1912

Jahrgang XI, 1913, pages 289-296
Max Beckmann; Aus einem Totenhaus, Abschnitt "Das Bad"
(From the House of the Dead, excerpt, "The Bath")
seven lithographs, 1912
Gallwitz: 28 (1-9)

Jahrgang XI, 1913, pages 489-500
Werner Schmidt; Die Liebe des Flibustierführers,
Novelle von Paul Ernst
(The Loves of the Leader of the Flibustiers,
A Novel by Paul Ernst)
twelve lithographs

Jahrgang XII, 1913, pages 3-8
Max Slevogt; X Kapitel seiner Lebensbeschreibung (Ten Chapters of his Autobiography), von Benvenuto Cellini
eight lithographs

286.

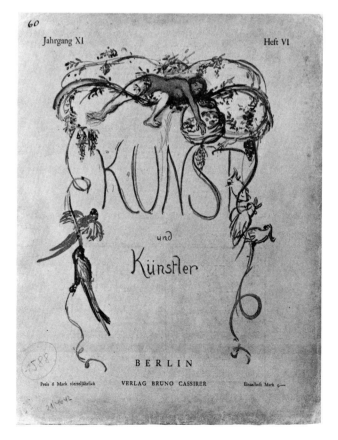

Jahrgang XII, 1914, Pages 407-414
Willi Geiger, Stierkampf, *(Bullfight)*
six etchings

Jahrgang XII, 1915, pages 563-574
Bernhard Hasler; Die Novelle von Johann Wolfgang Goethe
*(The Short Story of Johann Wolfgang Goethe)*
lithographs

Jahrgang XIV, 1915, pages 57-68
Rudolf Grossmann; Till Ulenspiegel von Charles de Koster
*(Til Ulenspiel by Charles de Coster)*
seven lithographs, including one hand colored

Jahrgang XV, 1917, pages 463-466
Max Liebermann; Bassompierre von Johann Wolfgang Goethe
*(Bassompierre by Johann Wolfgang Goethe)*
three lithographs

Jahrgang XVII, 1919, pages 341-348
Max Slevogt; Die Eroberung Mexikos durch Cortez
*(The Conquest of Mexico by Cortez)*
seven lithographs

Single Prints in Kunst und Künstler (A Selection)

Jahrgang XI, 1912-1913
Rudolf Grossmann; Berlin Bilder V, lithograph, page 80
Lovis Corinth; Frauenkopf *(Woman's Head)* etching, page 238
Rudolf Grossmann; Berlin Bilder VI, lithograph, page 340
Hans Meid, Idylle *(Idyl)* etching, page 592

287.

## 287. DER LOSE VOGEL *(The Free Bird)*

Eine Monatsschrift
Edited by Franz Blei
Leipzig, Demeter Verlag, 1912-1913
Printed by P. A. Demeter, Leipzig
23.3 x 21 cm. Raabe 8,
Jahr 1, Januar 1912 to Dezember 1912-6 Hefte
Jahr 2, Januar 1913 Heft 7
Febr/März double issue, Heft 8/9
April/Juni, double issue, Heft 10/11 (Published by Kurt Wolff Verlag, Leipzig)

Der Lose Vogel was a periodical with exemplary editing by Franz Blei, and was also carefully printed. The early Expressionists in Berlin greeted the new periodical with joy. Blei tried to both edit the contents and find contributors without topical limitations. E. R. Weiss set up the cover design and created the cover logo, a green bird perched on an open orchid.

Using the method of early eighteenth century periodicals, Blei kept the contents anonymous. We know that some of the writers were Max Brod, Franz Werfel, Robert Walser, Belloc, Robert Musil, and other friends of Franz Blei.

The interests of Blei were contained in the articles, for he maintained complete control of the material. He provided articles and commentaries about politics, ethics, philosophy, literature and art. In the later issues there were historical memoirs, stories, poems, and reviews of new books and discussions.

The purpose was stated in the announcement circulated to prospective subscribers:

"A small group of writers, who want to emphasize the reality by the anonymity of their contributions as opposed to today's emphasis on the personal, write this monthly magazine, Der Lose Vogel, in the attempt to help the so-called modern man learn to renounce his 'Epitheton' and become a human being, destined to work in his way and talent (may it be ever so small and narrow), to be of greater fullness and better fortune for him and therefore to life as a whole. Otherwise he loses himself in an always superficial versatility and false activity, which makes him a fool and helps nobody. We are revolutionary enough to think opposition against things which might damage is worth more than revolutionary conventions which bloom out of empty phrases, as long as it comes from the ardour of a small circle of good willed and therefore well-experienced unified life. Are we strong enough to swim against the current in the river bed? We want later generations to recognize from our happy effort that the period they are judging bad had some honest and proud courage, even if it was not successful. This magazine Der Lose Vogel, does not promise its subscribers to be the best of its kind. It is a collection only because writers have no other way of announcing themselves as fellow creatures, even when they want to convey something out of themselves, and because public preaching is sounding from all pulpits."

## 288. MARSYAS *(Marsyas, a Satyr from Phrygia, Who Challenged Apollo to a Musical Contest. Marsyas, a Flute Player and Representative of the River Gods)*

Eine Zweimonatsschrift *(Twice Monthly)*
Edited by Theodor Tagger
Verlag Heinrich Hochstim
Berlin, 1917-1919
Raabe 35, Perkins 185, Schlawe p. 45
Edition-235 examples
1-35 japan, signed
1-200 on handmade Bütten
1917-1919: 6 issues
39.9 x 29 cm.
#XXVII/35
Special edition on Japan. Contains 195 (of which 97 are signed) original graphics. Original graphics include: Pechstein (Fechter 97-100, 84-87, and two not in Fechter, 26 prints total), Gramatte (Eckhardt 45, 119-122, 13 prints total), Fingesten (11), Geiger (5), Genin (30), Grossmann (13), Jaeckel (3), Meid (16), Pellegrini (15), Pickardt (7), Thum (2), Wetzel (7).

Theodor Tagger (who used the name of Ferdinand Bruckner in other writing) was a late Expressionist dramatist and, later, an exponent of new Objectivity.

Tagger intended to publish a very deluxe periodical on ivory paper with original graphics. Marsyas became that in fact, with three kinds of hand-made paper used: 35 on two kinds of japan and 200 on hand-made paper. Each issue contained a commentary by Tagger about Expressionist literature. His choice of art tended towards the fantastic and impressionistic. Tagger was classically educated, inclined more to the south and a classical sun rather than northern moodiness. He grew from the liberal tradition which included Goethe.

Tagger used the greatest writers of his time, from Kafka to Thomas Mann, from Georg Kaiser to Däubler. He kept the quality high during the three years in which Marsyas was published.

For Marsyas, special typefaces were used by the great printing house of Imberg & Lefson, Berlin, printer for the Pan-Presse. All original illustrations were printed separately by professional master printers.

In the mood of the age, Tagger tried to keep an atmosphere of intense and energetic spiritual life in the magazine, with an insistence on the best prose and graphics. He tried to make each issue a minor chronicle of each phase of Expressionist literature.

Marsyas first appeared every two months. But there were interruptions as the issues were proofed, caused not by a financial problem but one of intention to make each issue as perfect as possible.

In the first issue, Tagger declared his editorial intentions: "To elevate creation into the spiritual sphere, to give these energies which are scattered now, but will some day be united."

He thought art would unify the period where politics created barriers.

The main illustrators were: Geiger, Genin, Gramatté, Grossmann, Jaeckel, Meid, Pechstein, Pelligrini, Scharff, Schinnerer, Tappert, and others.

The edition on display is the deluxe one on japan paper. It includes progressive proofs of the original etchings, sometimes having two or three changes in each plate.

Hugo von Hofmannsthal wrote an article of reflections (aphorisms). "The anthropological center of man is chauvinism. The vision (sight) of children is a refreshment that only the eyes of their mothers and fathers see. In the beginning of life man is a subjectivist, and understands little of subjectivity later. The spirit fights a great army to army war with sin."

Marsyas was a real example of a luxury periodical which maintained a high level throughout the time of the war, and this was accomplished only because of the high intellect of the editors.

288.

### 289. MENSCHEN *(Mankind)*

Year 1: Monatsschrift für neue Kunst
Jüngste Literatur, Graphik, Musik, Kritik
Year 2: Buchfolge neuer Kunst
Literatur, Graphik, Musik, Kritik, Politik
Year 3-5: Zeitschrift neuer Kunst
Edited first year by Felix Stiemer and Heinar Schilling
(48 x 32 cm.)
Edited second year by Heinar Schilling (24.2 x 32 cm.)
Edited third and fourth years by Heinar Schilling and
Walter Hasenclever
Edited fifth year by Iwan Goll.
Dresdner Verlag
Dresden, 1918-1922
Raabe 39, Perkins 186, Schlawe 17
1918-10 issues, special additional leaflet on November, 1918
(Heft 1-10)
1919-First Quarter-6 issues (Heft 1-6)
1920-4 issues (Heft 1-4)
1921-6 issues (Heft 1-12) one double issue, one issue with six issues in one
1922-3 issues (Heft 1-3)
16 issues: 1918 (Nr. 1-10), 1919 (Nr. 1-6, II, III, IV, V, VII). Original woodcut title "Menschen" by Felixmüller (Söhn 119). Original woodcuts by Felixmüller (Söhn 32, 55, 86, 88, 99, 101, 105, 109 , 114, 124, 127, 129, 130, 131, 132, 133, 136, 146, 147, 158), C. Gunschmann (1), W. Grimm (8), C. Klein (2), G. Tappert (2), and others.

Mankind is the title and gives the intention of this periodical for new art, progressive literature, graphics, music, criticism. The intentions were shortened after the second year: a magazine for the new art.

Felix Stiemer was a great progressive publisher in Dresden. He founded the Dresdner Verlag in 1917 as an outlet for original prints in portfolios and as a showcase for new writers.

The editor during the early years, Heinar Schilling, was an early Expressionist poet, who later became interested in racial theory and joined the Nazi party with some enthusiasm.

Dresden had a large circle of Expressionists during 1917 and the years following. They held evenings of lectures and readings from the new art and writing. Felix Stiemer published their ideals until 1921.

Menschen had the avowed policy of unmasking the materialism of the time in all its manifestations and variations. Idealism was still the central principle although a subtle political change was taking place. Stiemer himself was very interested in new music, professional and amateur. Menschen contains some of the first criticism of compositions by Paul Dessauer, Klemperer, Knorr, and other modernists.

Issues of the first year were published with covers of different colors with a large format, and a woodcut title by Felixmüller, who did most of the illustrations. Later Tappert, C. Klein, Walter Grimm, Schmidt-Rottluff, and minor graphic artists did more of the illustrations.

The second year saw a smaller format of rust color, with a reduced title. Editorial policy became more radical. The announcement for the second year of publication mentions that idealism now means international socialism, unchanging and radical in spirit and deed. Poetry and essays alternate with political plays.

The Dresdner Verlag also expanded into series on drama, poetry and the new prose. Its policy also took a left swing after the Spartakist rebellion and division of German socialism into many different political variations.

The publications of Menschen were quite varied. Some issues were advertising booklets. Special issues on meetings by left-wing groups and propaganda editions also appeared. It was once called "a political paper for Monday." There were special editions featuring the artists of Kiel, about Gruppe 1919 in Dresden, about power groups in Hamburg, new ceramics, bibliographies of recommended books. The last issues were edited by Iwan Goll as a brother periodical to the French magazine Clarté.

MENSCHEN

Zweiter Jahrgang, 1919,
Heft II. Nr. 33/36, p. 7.

Aufruhr *(Revolt)*
By Alfred Guenther
(Translated by the author's son, Peter Guenther)

Released out of the hand of fate,
whirling in delight and grief,
breaking out of the cage like an animal,
falling like storms over the land,

grab with unprotected hands
fire, poison, and flood and not be lost,
to roam in the happiest realms,
to see the most sorrowful death!

Throw yourself, a soul, against your enemy,
sluggish blood, break over the walls!
Cry, scream upwards! Until God's light
shines into the darkness of your home.

Now you will have to risk yourself.
Is your heart meant, is mine?
And you must tell me,
what keeps us apart, God, and what makes us one.

Heft VII, Nr. 54/61, 1919

Two poems by Kurt Schwitters
*Sublimity*

Churches tower a human
Oppress sun-high mountains
Steeply breaking through
Surrounding points glowing with speed
Hot body—soul near.
Warm ardour! Glowing!

Small I?
Big!
Poor I?
Rich!
Great mountains weigh,
Church towers weight steeply!
Glowing men weight the sun.
I?
Glowing
Steep!
!

*A Morning of the World*

A dissonance drifts through distances—
Lifts green heaven—
Work—
Worlds—
Wilting—
Flaming hot silence—
Bathes the white morning—
Bells sound death—Broken greed aged humility—
Broken humility greedy aged—Morning bells souls kneeling—
Ten millions sink in a world enflamed—
Ten billions flame steeply—
Flame gives birth cave high—
Sings—
Burns—
Ruins—
Builds up—

MENSCHEN

Zweiter Jahrgang, 1919,
Heft V. Nr. 46/49

*Schmidt-Rottluff*
By Felixmüller (excerpt)

He is no star—he does not stay. He is reality, flesh and spirit of our earth. He is towering rock in our time measure. Hard, big, and defined in its shape. Some little people have struck their eyes on him. There are ingredients of brutality, because they cannot fathom the impact of his form. Because his impact is not from this time. He is stronger. His language is opposed to form over this time. His people have a timeless and eternal view. His people are shaped for all time. They resemble the Assyrians, Indians, Negroes to whom Schmidt-Rottluff is brotherly close. Two of his naked people trample to death the miserable, ridiculous ballast of the old culture of our century: The aesthetic. With him there is nothing aesthetic, beautiful. Everything is large and wonderful, has harmony in unity. His concept is an expression of our longing for conflictless existence.

Schmidt-Rottluff has treaded down all systems which surround us, which weigh on us, which grind us, depress us, blind and kill us. He is free like a giant. Powerful and broad, Schmidt-Rottluff stands over us. He is like the sun, and like it beams his glow at noon over the earth: vertical, upright. He is opposed to the dirt of the banal, silly, indifferent earth. He is calmness and unity. From him flows the goodness and strength of our nature—and through him we become knowing about the great unity which forces us to be loving, blessing people whether to animal, tree, sun, earth, moon, stars.

289.

## 290. **MÜNCHNER BLÄTTER FÜR DICHTUNG UND GRAPHIK** *(Munich Plates for Writing and Graphics)*

Eine Monatsschrift
Overall editor: Renatus Kuno
Collaboration by René Beeh, Campendonk, Karl Caspar,
Paul Ernst, Otto Freiherr von Gemmingen, Rudolf Grossmann,
Hans Johst, Alfred Kubin, Paul Klee, Georg Müller Verlag,
Alfred Neumann, Karl Nötzel, Paul Renner, Edwin Scharff,
Adolf Schinnerer, Richard Seewald, Walter Teutsch, Otto
Zarek, Otto Zoff.
Georg Müller Verlag
Munich, 1919
Raabe 56, Perkins 188
1 issue, 11 double issues (Example of deluxe issue with all
prints)
30 x 23.5 cm.

The enthusiastic collaborators for this new journal of culture in
Munich included artists, writers, dramatists and poets. Unfor-
tunately the periodical came out in only eleven issues from
January until December, 1919. The socialist revolution in
Munich put a stop to the magazine.

The editors tried to integrate original graphics with art history
and literature. The new was emphasized, especially the new
ideas in Munich, although literary ideas from Claudel, Flaubert,
Rimbaud, and some Polish and Russian writers were included.
This effort was combined with an attempt to popularize the
younger painters in Munich, and a subscribers edition of one
hundred was also a separate issue. An original print was in-
serted, often handcolored.

Coming from an easy-going Munich, the articles seem conserv-
ative. There is some radical criticism, especially of Thomas
Mann's stand for imperialism during the war, but most issues
were current. One special is devoted to Rimbaud. Standing
beside the older artists was the younger Expressionist genera-
tion, without diluting the statements embossed on time by these
more organized individuals.

Many of the most advanced ideas are in the world of theater
and dance, with major novels and criticism by Frank Wedekind,
and a long selection from Georg Kaiser's famous Expressionist
play, *Alcibiades Saved.*

There are many interesting statements about the period of social
change and cultural idealism after the war, Munich was a Catholic
section of Germany, more conservative, with less chance for wide
acceptance of radical politics. That was the reason the short
revolution was put down with ferocity and much bloodshed.

Munich retained its reactionary background as the center for
racist ideas throughout the Weimar period. Citizens of Munich
may have been known as easy-going people, but sometimes
they were roused to a violently antidemocratic extremism.

MÜNCHNER BLÄTTER FÜR DICHTUNG UND GRAPHIK
Erstes Jahrgang/1919/Heft 1-12
Original Graphics, by issue and in order of appearance:

Issue 1:
RICHARD SEEWALD, untitled lithograph, p. 2, Jentsch L94
RENE BEEH, untitled lithograph, p. 3
KARL CASPAR, untitled lithograph, p. 7
PAUL KLEE, "Akrobaten" *(Acrobats),* lithograph, p. 10,
Kornfeld 71 IIa
ADOLF SCHINNERER, untitled lithograph, p. 11
WALTER TEUTSCH, untitled lithograph, p. 15

Issue 2:
HEINRICH CAMPENDONK, untitled lithograph, p. 18
EDWIN SCHARFF, "Umarmung" *(Embrace),* lithograph, p. 19
RENE BEEH, untitled lithograph, p. 23
MAX UNOLD, untitled lithograph, p. 30
RUDOLF GROSSMANN, "Berliner Pferdemarkt" *(Berlin Horse
Market),* lithograph, p. 31

Issue 3:
ADOLF SCHINNERER, untitled lithograph, p. 35
PAUL KLEE, "Drei Köpfe" *(Three Heads),* lithograph, p. 38,
Kornfeld 70 IIIa

MAX UNOLD, untitled lithograph, p. 39
RICHARD SEEWALD, "Geträumte Urwaldlandschaft"
*(Dreamed Primeval Jungle Landscape),* lithograph, p. 43,
Jentsch L95
EDWIN SCHARFF, "Reiter" *(Rider),* lithograph, p. 47

Issue 4:
ALFRED KUBIN, "Gespenst des geizigen Müllers" *(Ghost of the
Avaricious Miller),* lithograph, p. 51, Raabe 120
KARL CASPAR, "Der brennende Dornbusch" *(The Burning
Thornbush),* lithograph, p. 55
RENE BEEH, "Robinson", lithograph, p. 59
RUDOLF GROSSMANN, "Ochsenstall" *(Oxen Stall),*
lithograph, p. 63

Issue 5:
MAX UNOLD, utitled woodcut, p. 67
JOSEF EBERZ, "Die Nonne und der Tod" *(The Nun and Death)*
woodcut, p. 71
RICHARD SEEWALD, "Der Blinde und der Lahme" *(The Blind
and the Lame),* woodcut, p. 75, Jentsch H85
HEINRICH CAMPENDONK, "Frau mit Blume" *(Woman with
Flower),* woodcut, p. 79, Engels 32

Issue 6:
ALFRED KUBIN, "Der kleine Sparer" *(The Small Investor),*
lithograph, p. 83, Raabe 120
KARL CASPAR, untitled lithograph, p. 87
EDWIN SCHARFF, "Segelboot" *(Sailboat),* lithograph, p. 91
WALTER TEUTSCH, "Faun und Nymphe" *(Faun and Nymph),*
lithograph, p. 95

Issue 7:
ADOLF SCHINNERER, "Werbung" *(Wooing),* lithograph, p. 99
KARL CASPAR, untitled lithograph, p. 103
RUDOLF GROSSMANN, untitled lithograph, p. 107
JOSEF EBERZ, "Erlösung" *(Deliverance),* lithograph, p. 111

Issue 8:
ADOLF SCHINNERER, untitled lithograph, p. 113
RENE BEEH, untitled lithograph, p. 117
HANS GÖTT, untitled lithograph, p. 121
RUDOLF GROSSMANN, untitled lithograph, p. 125
RICHARD SEEWALD, untitled lithograph, p. 128, Jentsch L97

Issue 9:
RENE BEEH, "Einsiedler" *(Hermit),* reproduction after a
pen drawing, p. 130
ADOLF SCHINNERER, "Stelzenläufer" *(Stilt Walkers),*
lithograph p. 135
MAX UNOLD, untitled lithograph, p. 139
PAUL KLEE, "Wald" *(Woods),* lithograph, p. 142,
Kornfeld 72 IIa titled there: "Zahlenbaumlandschaft"
*(Number-Tree Landscape)*
PAUL KLEE, "Portralt" *(Portrait),* lithograph, p. 143,
Kornfeld 73 IIa titled there: "Versunkenheit" *(Reverie)*

Issue 10:
KARL CASPAR, untitled lithograph, p. 149
RUDOLF GROSSMANN, "Die Loge" *(The Box),*
lithograph, p. 153
JOSEF EBERZ, "Liebespaar" *(Pair of Lovers),*
lithograph, p.157
ALFRED KUBIN, untitled reproduction after a pen drawing,
p. 159, Raabe 120

Issue 11/12:
ALFRED KUBIN, "Hommage à Rimbaud" *(Homage to Rimbaud)*
lithograph, p. 161, Raabe 120
KARL CASPAR, "Gott Vater zeigt Adam das Paradies" *(God the
Father shows Adam Paradise),* lithograph, p. 165
MAX UNOLD, untitled lithograph, p. 169
ADOLF SCHINNERER, untitled lithograph, p. 173
WALTER TEUTSCH, untitled lithograph, p. 177
RENE BEEH, "Der Zufriedene" *(The Contented One)*
lithograph, p. 181
PAUL KLEE, "Der schreckliche Traum" *(The Horrible Dream),*
lithograph, p. 185, Kornfeld 76 IIa
RICHARD SEEWALD, "Den Wanderern" *(The Travelers),*
lithograph, p. 189, Jentsch L89
EDWIN SCHARFF, untitled lithograph, p. 192

**MÜNCHNER BLÄTTER FÜR DICHTUNG UND GRAPHIK**

Vorzugsausgabe (*100 numbered examples on Bütten*)
Original graphics appearing in the special edition, by issue:

Issue 1:
RUDOLF GROSSMANN, untitled hand-colored lithograph,
18 x 11.5 cm.

Issue 2:
HEINRICH CAMPENDONK, "Am Tisch sitzende Frau mit Katze
und Fisch" *(At a Table, Sitting Woman with Cat and Fish),*
woodcut, 17.5 x 15.2 cm., Engels 42

Issue 3:
WALTER TEUTSCH, "Zu einem Sonett von William
Shakespeare" *(To a Sonnet by William Shakespeare),*
woodcut, 14 x 12.7 cm.

Issue 4:
RICHARD SEEWALD, "Kind und Katze" *(Child and Cat),*
hand-colored lithograph, signed, 21 x 17 cm., Jentsch L96

Issue 5:
KARL CASPAR, untitled lithograph, 21 x 15 cm.

Issue 6:
RUDOLF GROSSMANN, "Zirkus" *(Circus),* lithograph,
17.8 x 20.5 cm.

Issue 7:
MAX UNOLD, untitled hand-colored lithograph, 13 x 16 cm.

Issue 8:
EDWIN SCHARFF, untitled lithograph, 21.5 x 11 cm.

Issue 9:
PAUL KLEE, "Insekten" *(Insects),* hand-colored lithograph,
20.6 x 14.7 cm., Kornfeld 74

Issue 10:
FRIEDRICH FEIGL, untitled hand-colored lithograph,
14.5 x 17.5 cm.

Issue 11/12:
HEINRICH CAMPENDONK, "Zwei Akte im Boot vor
Sternenhimmel *(Two Nudes in a Boat before a Starry Sky),*
woodcut, 12 x 23.5 cm., Engels 43

292.

291.

**RICHARD SEEWALD**

291. Münchner Blätter für Dichtung und Graphik *(Munich
Plates for Writing and Graphics)*
lithograph in red and black, on yellow paper , 1919
77 x 58.5 cm., paper size 95.5 x 68 cm.
Jentsch P 6 only state, signed by the artist in pencil

This poster was made to advertise the new periodical, which
was a joint venture by artists and writers in Munich.

Seewald was interested in the poster form. He is known to have
designed sixteen posters up to the present.

**MÜNCHNER BLÄTTER FÜR DICHTUNG UND GRAPHIK**
Erster Jahrgang, 1919, Sechstes Heft, p. 89

*The Low Door*
by Ernst Weiss

You nurses with mother-of-pearl faces, who hold the night shift,
There to remove blood from the lips of the dying,

You, good doctor Johann Müller, who cared for the plague-
ridden orderly,
The drunken one, cured him and died,

I, myself, who put God near his breath, who warmed himself in
the glow of his God-like eyes.
I who was not afraid of God, but loved Him,

Mozart, over whom there was always spring and white sounds,
The fiery thirds of clarinets, he did not know bitterness and
blood,

Man of justice,

You, who was not smothered by your love,
You, good human who discovered the paradise of animals
And slid there into the corners of dreams:
Moments of remembering are consolation, moments of
forgetting the mind which was lost as you sank down into
silence with falling arms.

My consolation is in the memory of those who
raked in the good,
My consolation is with those who heaped good into the barn
of their soul,
Open to good, ready for happiness.

Words, you unite people; a deeply glowing embrace,
The silence which wraps them in community,

But I know, moments of unity are only a pause,
But I don't know how the usurers, murderers and conquerors of
this time can be forgiven,

But the scale is still balancing. The low door is opened. The
world is undecided. The glance of love makes justice tremble
And is my consolation.

290.

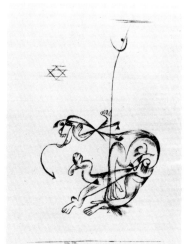

## 292. NEUE BLÄTTER FÜR KUNST UND DICHTUNG
**1918, 1919, 1920,** *(New Pages for Art and Writing)*
Writing editor: Hugo Zehder
Verlag Emil Richter
Dresden, 1918-1921
Raabe 14, Perkins 189, Schlawe p. 46
1918-1919: 11 issues (Heft 1-11)
1919-1920: 12 issues (Heft 1-12)
1920-1921: Yearbook only, December 1920
28.8 x 22.3 cm.

Hugo Zehder, the editor, was an architect and writer in Dresden. He was also very involved with the theater and art movements. He had formerly been secretary to Dr. Karl Woermann, director of the Dresden art gallery.

The stated intention of this periodical was to present itself to writing and criticism only about new Expressionist painters, architects, sculptors, the new writing, and critical articles about new literature.

Dresden was the center of fine printing in Germany, a restored medieval city, which was later destroyed by fire bombing during the last days of World War II.

The first Neue Blätter series had been published by the great printer, Jacob Hegner at Hellerau in 1912-1913. This later monthly publication began in 1918, carried the idea forward; and had some original woodcuts and reproductions of works of art.

The contents were similar to other Expressionist journals. There were articles about Art and Sentimentality, Art and Definition, poetry and essays, short stories and articles about modern architecture. The same logo was used as cover for each issue, but year dates were changed, and zodiac signs for the particular months were used. There were some socialist articles, though most related to art.

Many of the illustrators were drawn from the area around Dresden during this difficult time. Among the most notable were Dix, Heckel, von Hoffmann, Klee, Kokoschka, Lange, Meidner, Mense, Nolde, Poelzig, Scharff, Schwitters, L. Segall, and Taut. The publisher Richter did not permit the use of a large size, fine paper, nor a deliberately Expressionist format. Inside, however, we find advanced ideas, and common themes to Expressionism: suicide, the end of the world, symphonic poetry cycles and the rest. The political activism was scholarly.

Orig. woodcuts by Lasar Segall (May 1919).

1919  NEUE BLÄTTER FÜR KUNST UND DICHTUNG
Jahrgang 2, Juni Heft, p. 48
*The Child Murdress*
by Iwan Goll

She had hurriedly washed the dishes,
Dunked stolen lumps of sugar into her coffee-
Then she remembered it, like someone who looks around,
something misplaced.
A black hat cocked past the window.
She ran up to her room, where rain beat on her heart,
And when the flaming angel appeared,
tiny arms outstretched, motionless,
She was scared like a child.
Already the red bed sheet was gone.
And how did it happen, that a farmhouse dreamed in
the morning,
A white dog barked around blackberry bushes,
And the bridge moved like waves under her step!
The grey penitentiary wagon drove over the sky-
And how did it happen, that spring hung pale pink on the banks.
And she didn't know, heavy in herself,
Heavier than the splashed sheet,
She smiled at the kind water, mild and calm.

## 293. NEUE JUGEND *(New Youth)*
Monatsschrift
Edited by Heinz Barger; writing edited by Wieland Herzfelde
Year 1, until #11/12, published by Verlag Neue Jugend, Berlin
Heft 11/12 published by Malik Verlag
1916-1917, 6 issues
22.2 x 17 cm.

The first issue called itself number 6 to fool the wartime censor. It had no normal approach to the war, which was in full fury, amid some discontent among the public, especially among the intellectuals.

The intention was described in the introduction as "booklets" not only for the young, but those who are free from philistinism and narrow-mindedness. Youth should not be ashamed of these efforts, but should use them as a point of spiritual possibilities, of maturity.

Herzfelde was still a soldier, in and out of the army, planning and sometimes succeeding with publishing. He had a radical reputation already and had to disguise his efforts with complicated, sometimes funny, schemes to fool the straightlaced military censors.

The name of the new publication was a subterfuge. The censors thought it was a school magazine for children, although an old publication with the same name had gone out of business at the beginning of the war.

This periodical carried the first drawings of George Grosz. The contents expressed the poisonous hatred of the inactive intellectuals toward the war and gave them a temporary medium of expression until the government caught up. Hatred against those oppressing freedom was the continuing theme. Though described as an art journal, the editors expanded into politics as much as the censors allowed, had no basic address listed, and circulated the issues secretly.

293.

# NEUE JUGEND
MONATSSCHRIFT
HERAUSGEBER HEINZ BARGER
JULI

BERLIN, VERLAG NEUE JUGEND
I.JAHR MCMXVI/HEFT SIEBEN/FÜNFZIG PFENNIGE

Younger painters and poets were supported; indeed, the editors were willing to back any voice against the lethargy of the public. Neue Jugend announced manifestos, could not pay contributors, said it could not be influenced financially or politically, and asked for the support of all who were not old or submissive.

Five issues were allowed, then publication was closed by the censors. The last two numbers were sensational in size, like a newspaper, and used four-color printing in keeping with the change to a Dada approach. In one of these issues, Grosz wrote a satirical article about the necessity of a bicycle for a politician.

Heinz Barger edited the Neue Jugend Almanach as well as the first Grosz portfolios. The group also organized evenings at which, mainly anti-war agitation was delivered into the teeth of excited, mostly hostile audiences; and at some of these meetings women fainted and screaming, weeping mobs rioted.

NEUE JUGEND
July, 1916

*Fantasy*
by Richard Huelsenbeck

Flat heads bloom in rainbow colors
From negroes, scream furiously through the nights,
Cars there, driving as flaming sheafs.
On easy bridges, dissolve in steam.

The supreme court wildly vomits its carrion smell,
As drums sound over countryside and city.
Vile pictures cry vile pictures
Dancing with schemes, waving cute and tired.

An old chief-priest screams in his bathrobe
And shows the contours of his thighs.
Beasts cough in menageries gone wild.
A Ceylon lion lifts his paw to swear.

So we pity the dead man thrown down
On loaded tables where oil streams run.
His brain is glass, holes hiss from his legs,
A parrot pulls on beautiful pants.

He dreams of beaches, where mangroves stand,
Where the monkey trembles and sea cows bark.
A staring star lights our night
Where oceans foam like champagne.

The cord broke on bodies of equators!
Armies of professors dispersed, swaying
Like a thousand houses chasing women.
Sweat stands giggling on lifeless pores.

September, 1916

*Daisy*
by Wieland Herzfelde

Asian doll, you
Castle of poppy seed and gin,
The meaning of your language is parable.
No summer enjoys you.

From eyelashes, tongue a heavy play of
Sweet night shade, snake tongue tops,
Which get scratched by magic stones from Iris.
Your hands are empty with longing.

Soft as sleep, your skin is soft as new snow.
Who knows if a kiss penetrates your skin.
Who knows, if a kiss penetrates your sleep.
How deep your body sinks into the new snow,
The one, Daisy, who trusts your play?

Cruel, demanding, moss-tender maiden
At last with blood-face, red and white,
Ocean cool shell of mother pearl,
Loves which she does not dare to open.

## 294. DER NEUE PAN *(The New Pan)*

Eine Monatschrift für alte und werdende Kunst
Kurt Wolff Verlag
Munich, Oktober 1917
35 x 26.5 cm.

The publication of any luxurious art journal began with subscriptions and fund raising. In order to show the particular kind of essays and illustrations, mock-up models were usually made, printed in small numbers by hand, and sent to prospective backers or important critics as samples.

This is a rare example of such proof material. About ten of these special first issues were made. If the periodical had been put into production, the ten were to have been presentation copies.

1917 was a war year. Even with paper shortages and censorship the new venture was approached with enthusiasm and little shortage of funds by the publisher, Wolff. The old Pan had failed, gone through a revival and failed again, probably because of the cost of fine color illustrations and high pay for contributors. Expense proved as much an issue as Wolff's refusal to compromise with lesser quality.

The span of interest in the new Pan is shown in the table of contents: articles on Holbein with expensive color plates tipped in, Negro sculpture, Baroque painters, Meier-Graefe on Impressionism, Rodin on the Cathedral at Rheims. The art experts were the best among those who were not in the German army. Even the enemy, France, had furnished an author.

But the excellent color illustrations, the fine printing, good paper, large format were not enough. The year was one of suffering and death. There was not enough interest in a new venture of this kind and the Neue Pan never appeared in more than a pre-issue.

294.

**295. DAS NEUE PATHOS** *(The New Pathos)*
Year 1, Heft 1 & 2 edited by Hans Ehrenbaum-Degele, Robert R.
Schmidt, Ludwig Meidner, Paul Zech
After, edited by all of the above except Ludwig Meidner
1913 as a periodical
Later a yearbook edited by Paul Zech
Verlag E. W. Tieffenbach
Berlin, 1913-1920
Raabe 12
1913-4 issues, two double issues (Heft 1-6)
1914-3 issues (Heft 1-3)
1914-1915: Yearbook only, 30 pp, 39 x 28.4 cm.
1916- no publication
1917-1918: Yearbook only, 24pp. 39 x 28.4 cm. (38 x 24.8 cm.)
1919-Yearbook only, 48pp. 39 x 28.4 cm.
One of 250 examples on Bütten. Original graphics by Heckel
(Dube 109 IIB, 222 II), Schmidt-Rottluff (Schapire 85), Meseck
(2), Behmer (2), Gerstel (1), Meinke (1), Olbrich (1), Rösler (2),
Steinhardt (1), E. R. Weiss (1) and E. Smith (1)

There were two issues in 1913, with early Expressionist poetry
and art. The title was taken from the famous meetings among
intellectuals in Berlin known as the "New Club" and the
"Neopathetic Cafe."

Pathos is suffering as well as sympathy. Recognition was for
both past oppressions of artists and writers and sympathy for
their latest works. The new pathos represented itself as showing
visions of catastrophe and rebuilding. Meidner's apocalyptic
visions exemplified the new viewpoint.

After the two issues of 1913, Das neue Pathos came out in seven
additional issues as a monthly, but its form became more stri-
dent. Early issues were assembled hastily and contained print-
ing mistakes and poor quality design. But when the effort went
into a yearbook, there was time for planning and more careful
assemblage of ideas and material.

Hans Ehrenbaum-Degele, one of the editors, was an intelligent
young poet in the Expressionist circle. He published little before
he was killed early in the war. Paul Zech was an all-around writer
and bohemian poet with experience as a laborer, wanderer, and
an early socialist-idealist in the trades. His fluent French gave
him positions as a translator and critic in this tongue. He wrote
one of the first monographs on Rilke. Meidner was a friend to
all young painters and writers in Berlin. Schmidt was a writer,
and poet using traditional forms in an ecstatic, urban style with
semi religious meanings. He also wrote for Menschen.

The Journal tried to close the apparent gap between poet and
audience: the poet would be the energy of city life, and unify as
prophet of industrialization in an international state of being.

Inspiration was doubly from the cafe evenings and from Stefan
Zweig's book about Verhaeren (published 1910): "There must
be a return to close contact between the poet and the listener. A
new emotion is being developed. Today, the poet is able to tame
and stimulate the passions of our time, a rhapsodist, the kindler
of the sacred fires, the energy of today."

Erich Heckel

295.

*Rondel for Two Yoked Light—Pails*
by Oskar Loerke

The second heaven-pail shall rise now,
Blood spilling the other must sink.
Sebastian Bach, the organ became my own
For you, it sounds like bass-violas and violins.

Sebastian Bach loosens to me his own
Fountainhead of light out of silence.
The second bucket I hear rising in thunder,
The other one thunders to the depths.

Fountains of light sound like your own,
You far away ocean sing now from all tributaries
You far away ocean sing now in close roaring silence.
Queen bee stars unite in order and exhibition.

*Rondel in a Village Church at Night*
by Oskar Loerke

Notes come in skipping rows
At night from an organ music stand.
In Pentecost May a black skeleton
Is preaching with dignity on the pulpit

Perhaps around the serious black skeleton
Of the theologist in Whitsunday May
Dance notes like mice in twos
Half notes astral, quarter notes lucrative.

The question, can they escape,
The sixteen tails of death in May
And whiten their tooth brushes for bed.
Perhaps they always stood in rows
On the organ, in the book and on the desk.

## 296. DER QUERSCHNITT (The Cross Section)

Year 1, Heft 1-3: Mitteilungen der Galerie Flechtheim
Year 1, Heft 4/5 and after: Marginalien der Galerie Flechtheim
Year 1 edited by Wilhelm Graf Kielmansegg
Year 2 edited by Alfred Flechtheim, Kielmansegg, and Hermann von Wedderkop
Year 3-9 edited by von Wedderkop
Various undereditors including Dr. Alfred Semank, Wolfram von Hanstein, Edmund Franz von Gordon.
Year 1 & 2 published by Galerie Alfred Flechtheim, 4○
Year 3 published by Querschnittverlag, Frankfurt/Main
Year 4-13, Heft 4 published by Propyläen-Verlag, Berlin
Year 13 to 14/15 published by Kurt Wolff
Year 15/16 published by Heinrich Jenne
1921-1936
Perkins 194, Schlawe 59.
19.9 x 13.7 cm.

In the beginning this was a yearbook listing the catalogues of the Galerie Flechtheim in Düsseldorf and was issued in small editions to friends of the gallery. It changed later, in 1922, to a periodical.

Alfred Flechtheim was an important art dealer and publisher of prints and illustrated books. He began as a wholesaler in grain, and on the side helped organize the great Sonderbund exhibition. He opened as an art dealer in 1913. He had always collected and befriended young artists, always specializing in painters from the Rhineland area.

Der Querschnitt means Cross Section. This is what the journal became, a survey of art life in all of Germany and the north of Europe. The journal changed style after the second year. Flechtheim had lost interest, and turned it over to another publisher. But he found the periodical a necessary medium and began anew.

The early propaganda for the gallery was expanded to include curiosities of the day: manifestos by various groups, news of other exhibitions in Germany, anything that interested the various editors who came from the circles of friends and employees and the Flechtheim gallery. The later issues are cross sections of public interests, and include advertisements, news events about art personalities, the travels of these people, (who was where and why), poems (one by Vlaminck), best wishes for birthdays, biographies of collectors and artists, letters from Paris and Rome and Munich. One later editor was interested in the art of boxing, so he used many articles introducing the new fighters; the periodical Boxsport bought advertising space. Another was interested in films, especially those of Charlie Chaplin. The later issues included advertising from every major gallery in Germany. Der Querschnitt was very popular as a curious mixture of this and that about the art world.

Flechtheim grew very wealthy, expanded his operations to new galleries in Berlin, Frankfurt, and Cologne. His galleries became the center of art life in the Rhine valley. He died in 1937, no longer an important art dealer because of the radical political changes that removed Jews from business enterprises.

DER QUERSCHNITT

Issue of April 1, 1928
Printed by Otto von Holten
Special edition printed on the 50th birthday of
Alfred Flechtheim of 350 examples
Edited by Curt Valentin
With contributions honoring Flechtheim by writers and painters including: Archipenko, Beckmann, Benn, Braque, Chagall, de Chirico, Cocteau, Derain, Dufy, Paul Rosenberg, Glaser, Hausenstein, Ernest Hemingway, Hofer, Kahnweiler, Kisling, Klee, Leger, Maillol, Matisse, Mehring, Meier-Graefe, Mopp, Nauen, Pascin, Picasso, Pechstein, Pinthus, Max Schmeling, Weiss, Zweig and many others.
24.5 x 18 cm., 48 pp, special heavy cardboard, yellow covers.
350 impressions

By Ernest Hemingway:
God bless Flechtheim!
to whom I owe 100 dollars cash and much more
in many other ways.
But we'll pay the money within the year and
wish you all happiness always.

The age demanded that we sing and cut away our tongue.
The age demanded that we flow
and hammered in the bung;
The age demanded that we dance
and jammed us into pants
and in the End the age was handed
The sort of shit that it demanded
(But not by Flechtheim)

By Rena and Rudolf Rosenthal, New York:

For Alfred Flechtheim only five artists
are worth mentioning in the States-
Josefine Baker, Hemingway, Dempsey, Lindbergh, Chaplin.
And this man considers himself an art connoisseur.

Doppelheft 4/5, Ende September, 1921, page 130
Vom Film (About Film)

Dear Mr. Flechtheim;
Please, what does the film mean?—What please?—Very true! A domestic fight between a married couple of a not quite harmless kind, a couple which usually gets along well together.

But now, listen to what a "high testing authority", which prohibited the picture, sees in it and describes in its pious way of thinking: "A man in brutal and unusual excitement grasps her violently from behind, gets his hand into the neck line of the struggling girl. This an instigation of overstimulating fantasy, the direction for vile imagination, a clue for eventual imitation. The presentation is suited to overstimulate the imagination. It brings about damage to a healthy and virtuous development."

At this occasion a few words about the film. Since I know that soon Slevogt and Corinth will be invited to work in the production of big (and expensive) films, and since I assume that both artists will not be able to resist the dollar-temptation, I do not know why we should not talk about films in this little paper.

The situation of the film industry was such, as formed after the war, that the manufacturers must consider the sale of their "merchandise" in America. If one considers that the literary "niveau" of the educated American is on the level of a garden gazebo, we don't have to waste words about the literary "niveau" of our films. The word "art" can refer therefore only to: photography, architecture, direction and maybe, acting abilities. And already there are some doubts here. How come that (to put it mildly) mediocrities like Mia May, Lotte Neumann, Ossi Oswalda-to say nothing about the devine Fern-are ranked higher than artists on the level of a Höflich, Durieux, Welcker, Weisse? Simply, because the film is for the masses, and because masses and art remain oppositions as long as the world revolves.

The film from which the present picture derives—remember the name of the artistic operator, Curt Courant and the architect, Ernst Lessing (of whom nobody will believe he gave his film debut here)—is named "Blood."

The idea came from an idea by Tilla Durieux, the production is by me, and I want now, after a long study of this topic, to hand it over to America. Long live art!
Yours,
Arthur Landsberger

## 297. REVOLUTION (Revolution)

Zweiwochenschrift
Edited by Hans Leybold (except Nr. 5 which was edited by
Franz Jung )
Heinrich F. S. Bachmair
Munich, 1913
Raabe 16, Schlawe p. 15
5 issues
31 x 21 cm.

"They appeared with roaring pathos, with expressions on their faces like bible-breaking martyrs; they burst through the air like the nobleman from La Mancha and they call it Revolution."

However, the writer of the above was in a small circle, the harmless circle of writers and painters responsible for this revolutionary paper. The story has involuntary humor, though the intent was taken up later as some great expectation and prediction. "The writers cried, bravo, bravo, the entire 'Cafe des Westens' agrees with me." This was their background.

Hugo Ball, the future Dada personality, was a contributor. His contribution ended the venture, for his poem in the fourth issue was "Der Gehenkte (The Hung Person)"; and was an attack on the Virgin Mary, no small criminal act in Catholic Munich.

The model for this new and small-lived periodical was Die Aktion. Revolution did not call for political revolution but an artistic-literary one.

Though action had been taken to stop the periodical, a special fifth edition was brought out by Franz Jung, who was fighting to release a friend , Otto Gross, from prison. It was distributed in the city of Graz, where Gross was languishing. The issue did help in the release of Jung's friend.

What did this revolution begin against? "Merely the literary teachers, critics who were not writers, and the porters of art, for germinating and sprouting, against the neutral and objective."

The cover carried the famous woodcut by Richard Seewald.

## 298. DIE ROTE ERDE (The Red Earth)

Monatsschrift für Kunst und Kultur
Year 1, Heft 1-3 edited by Karl Lorenz and Paul Schwemer
Year 1, Heft 4/5 and after edited by
Karl Lorenz and Rosa Schapire
Folge 2 edited by Karl Lorenz
Year 1 published by Dorendorf & Dresel, Hamburg
Folge 2, 1st Book published by Adolf Harms, Hamburg
Folge 2, 2nd Book published by Gemeinschaftsverlag
hamburgischer Künstler
1919-1923
Raabe 80, Perkins 195, Schlawe p. 46
1919-1920: 7 issues, 2 double issues
1922-1923: Folge 2, 2 books
32.3 x 23.6 cm.
Numbers 6, 7, 8/10. Three volumes.
Original woodcuts and linocuts by Achmann (2), Feininger (Prasse W. 66), Felixmüller (Söhn 180, 191), Kaus (2), Kriete (2), O. Lange (2), W. Lange (2), Maetzel-Johannsen (1), Opfermann (2), Pechstein (Fechter 153, 152,), Schaefler (2), Schmidt-Rottluff (Schapire 46, 202, 231), Titz (2)

There were two issues of what was planned as a monthly series but which actually came out irregularly. The second edition in 1922-1923 lacked the undertitle describing it as a monthly magazine. Some of the early issues covered three months, some one month. The last two were yearbooks in an edition of 450 copies, 100 on special paper with signed prints. From June 1919 until March 1920 there were sixteen individual copies printed, representing some double issues; some months were completely missing. It was a financially troubled publication.

It was also a far-left socialist magazine, with tendencies towards one of the future communist divisionisms. It is a characteristic late-Expressionist publication with poetry and graphics. The motto was somewhat like this: "The Red Earth cultivated by young Expressionist art with all its powers. Exclusively The Red Earth has given itself the task of preparing the earth for large coming masses of mankind. All artists who are of importance for these earth-mankind tasks will work together with The Red Earth."

Included are manifestos, essays such as one about the November dead in the German revolution; most of these are written by the editors, Schapire and Lorenz. Rosa Schapire writes about art, including an important article on the religious woodcuts of Schmidt-Rottluff. There are also short plays, and notices of important deaths such as that of Richard Dehmel.

Some of the advertisements are revealing. One ad indicated that the formerly middle-of-the-road publisher, Paul Cassirer, now swings middle-of-the-road-left, and publishes a series of books called Wege zum Socialismus.

The title page is a woodcut by Karl Schmidt-Rottluff.

296.

297.

298.

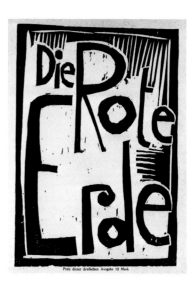

**299. DER RUF** *(The Summons)*
Ein Flugblatt an junge Menschen
edited by Akademischen Verband für Literatur
und Musik in Wien
Wien und Leipzig, Verlag Brüder Rosenbaum
1912/1913, Raabe 9
5 issues published in 1912-1913, with varying paging
Heft 1, Februar 1912, pp. 1-68
Heft 2, März 1912, pp. 1-50
Heft 3, November 1912, pp. 1-32
Heft 4, Mai 1913, pp. 1-25
Heft 5, Oktober 1913, pp. 1-60
22.3 x 14.7 cm.

The unmarked first issue had a special title, "Karneval," in February, 1912. It was edited by Paul Stefan, Ludwig Ullmann and Erhard Buschbeck. Later magazines had a theme too, such as "Frühling" *(Spring)*, "Krieg" *(War)*. Schiele did a cover for the issue of November, 1912.

It was an Austrian literary magazine representing early Expressionism. The magazine offered a forum to the generation of young Viennese writers and artists before the war. There was an academic connotation in the title, which made the contents seem more officially sponsored to the public.

Two other issues were produced, about music and a special exhibition catalogue of an international black and white show in 1912. Schiele did the poster for the Musik Festwoche (Week of Music Festival), as in our example for Friedell's lecture.

Der Akademischer Verband für Literatur und Music in Wien was a loose association of artists and writers, who produced lectures, exhibitions and music recitals. Three events were announced in this issue, a G. B. Shaw evening, an Arnold Schönberg evening, and a Nestroy-Feier (Feuer?) with readings by Karl Kraus.

The small periodical was designed in Austrian Jugendstil typography without color. The fine typeface marks it as an attempt at modernity. The artists who lent their work for reproduction included Josef von Giveky, Moritz Jung, Gustav Klimt, Oskar Kokoschka, and Schiele.

DER RUF

Heft 2 1912, Page 36
Heiterer Frühling *(Merry Spring)*
by Georg Trakl

At the brook, which runs through the fallow, yellow field,
The wilted reed still lies from last year.
Through the floating gray, a sound is wonderful,
The warm mist of past waves.

Catkins dangle softly in the wind on willows,
Its sad dreams a song of a soldier,
A meadow strip whistles, blown weakly,
A child stands in soft and gentle contours.

The birches there, the black thornbush,
Are also fleeing figures dissolved in smoke.
Things light-green bloom and others rot.
And toads sleep in the young leek.

You I love truly, you strong washerwoman.
A stream still carries the Golden Burden of Heaven.
A little fish flashes by, gets paler.
So your glances flee through the twilight.

The clouds outside, linen glows white.
A little bird chirps as though mad.
The mild grain swells, and
Enraptured bees collect in earnest diligence.

Come now dear one to the tired worker!
A lukewarm ray falls into his hut.
A tart and pale forest streams through the evening
And buds crackle gaily now and then.

How all developing things seem so sick!
A breath of fever encircles the milestone.
But a merry spirit waves out of branches
And opens the fearful soul wide.

299.

**300. SATURN** *(Saturn was an Ancient Latin and Roman God of Agricultural Divinity, a God Synonymous with Abundance)*
Eine Monatsschrift
Year 1 & 2 edited by Hermann Meister and Herbert Grossberger
Year 3 & 4 edited by Hermann Meister
Year 5 edited by Hermann Meister and Robert R. Schmidt
Saturn-Verlag Hermann Meister
Heidelberg, 1911-1920, 8°
Raabe 7, Perkins 196, Schlawe p. 27
1911- 5 issues (Heft 1-5)
1912- 12 issues (Heft 1-12)
1913- 12 issues (Heft 1-12)
1914- 5 issues (Heft 1-6) one double issue)
1919-1920: 12 issues (Heft 1-12)
20.5 x 14 cm.
Jahrgang II, 1912: Heft 4-9, 12. Jahrgang III, 1913: Heft 1-3, 5, 6.
Original graphics by Grossberger (6), Hacker (1),
Kirchner (Dube 200), Lyck (2), Dörr (3), Szafranski (1),
Benson (1), Pelzer (1), Zunk (1).

This example from a provincial Expressionist group was edited by Hermann Meister, a man of international reputation, and busy as writer and translator. He was also an enthusiastic rugby player, edited a sports paper, was friend and supporter of the Expressionist poet Albert Ehrenstein. Meister was enthusiastically supported by the German-Jewish circle around Kafka and Max Brod in Prague, most of whom wrote poetry which Meister published either in his periodical or in book form. He wrote many of the articles, many as introductions of young poets, as well as "feuilletons," short episodes about humorous or touching situations.

Grossberger, art editor, was the Jugendstil artist and poet responsible for the art contents.

Franz Blei wrote an article for the first year which called the magazine "a collection for the new generation." He joined Austrian participation in 1912, 1913 and 1914 with Ernst Weiss and Heinrich Nowak. The right of the young writers to publish was supported by Saturn. It apologized for not having room enough to publish all young thinkers in each year of publication.

As with most of the Expressionist publications, the postwar issues went left in politics, had manifestos, essays about socialism, and poems which varied in content from romantic to socialist-pacifist.

The Saturn-Verlag, founded by Meister, also published an anthology, called Flut, and a series of small Saturnbücher, containing erotic poetry, idylls, and short stories.

**301. DIE SCHÖNE RARITÄT** *(The Beautiful Rarity)*
Edited by Adolf Harms
Founded by Adolf Harms and Georg Tappert
Literary editor Gerhard Ausleger
Verlag "Die Schöne Rarität Adolf Harms
Kiel, 1917-1919
Raabe 33, Perkins 197, Schlawe p. 44
1917-1918: 8 issues (Heft 1-9) one double issue
1918-1919: 12 issues (Heft 1-12)
25.4 x 20.8 cm.
Jahrgang II, achtes Heft und neuntes Heft (Nov. and Dec. 1918).
Original woodcuts by Felixmüller (Söhn 152), Tappert (1),
B. Klein (1), Capek (2), V. Hofmann (2), Spala (2) Zrzavy (1)

The first year of the publication saw larger format, but used fewer original prints. The second year was a quarto form, with many original prints. These were also printed in special small editions of 15 to 20 and sold separately.

It was a monthly periodical containing Expressionist literature and graphic art, the true combination of German Expressionism. *The Beautiful Rarity* is not universal, for the poetry and art came mostly from the Dresdner group. There was some Rhinelander art as illustrations such as that of Morgner, now dead. Tappert and Felixmüller are the other major artists who participated.

Gerhard Ausleger wrote most of the issues himself. He made a living as a bookseller in Offenbach a./M. He also wrote reviews for Menschen. His knowledge was varied, and included drama, art, poetry; his own poetry was of lyrical, semi-religious quality.

Georg Tappert and the printer, Harms, were the responsible publishers.

Most of the issues had one or more original woodcuts. Two of the other Rhenish artists who contributed are C. Klein and Mense. Certain issues were sometimes devoted to one artist. There was a special issue for young Czech poets. Tappert designed the title used for all issues. It is a precious periodical, with small, almost square format and a heavy typeface, Germanic and bold. The printing is mediocre.

**302. DIE SICHEL** *(The Sickle)*
Monthly periodical until the third year, when it became a yearbook. 1919-1921
Edited by Georg Britting (literature) and Josef Achmann (graphics)
Verlag der Sichel, Regensburg, later Munich (Third year)
Raabe 82, Perkins 198, Schlawe p. 20
50 examples prepublication examples, handsigned prints
1919-6 issues
1920-11 issues, 1 double issue
1921-1 issue
24.8 x 14.2 cm.

By the third year our example, the monthly, had become a yearbook because of financial difficulties.

Regensburg is situated in eastern Bavaria. It was long a Roman city and the "castrum" still exists in outline. Later the city's tradition was religious, and many churches and abbeys remain.

Georg Britting, one of the editors, was born in 1901 and died in 1964. He was one of the most notable writers from this city. After the war, in which he was severely wounded, Britting started this periodical as an escape from bitter memories. The editorial work kept him in the field of literature, and he published seriously until his last book in 1960, a series of essays about the future. His variation on the Hamlet theme, published in 1932, gave him some fame. He is most notable as a lyric poet, with a vocabulary of vivid originality, and of a rapid and complex rhyme. Britting lived most of his life in Munich, where he settled permanently in 1920.

Josef Achmann, the art editor, was very active in the periodicals. He began his career with work for Die Aktion, then worked for Die Schöne Rarität, Menschen, Neue Künstler Blätter 1918, Der Weg, Die Bücherkiste, Die Rote Erde, Konstanz, Der Sturmreiter, and illustrated for Der Schwarze Turm and Die Drucke der Tafelrunde. Much was done in collaboration with his friend Karl Lorenz in Hamburg. Achmann was always the artist of that northern city.

Die Sichel was a literary-artistic periodical that attempted a relationship between literature and graphics, as a solution to world culture problems. There were few critical articles, and modern art was presented without extreme politics. Most of the early issues were built around a theme. There was also an attempt to find and publish young poets and writers of prose. The section presenting new books was always very small.

The designer found a relationship between word and picture that was harmonious for the period. The layout is modern, with roman faces and clean copy. The relationship with Hamburg is always strong, and Karl Lorenz appears in most issues.

300.

301.

302.

## 303. DER STURM (Storm, Assault, Fury)

Year 1-3: Wochenschrift für Kultur und die Künste
Year 4-7: Halbmonatsschrift für Kultur und die Künste
Year 8-21: Monatsschrift für Kultur und die Künste
Edited by Herwarth Walden
Verlag Der Sturm
Berlin, 1910-1932
Raabe 1, Perkins 201, Schlawe p. 39

1910-1911 56 issues (1-56)    2° in size (42 x 30.8 cm.)
1911-1912 48 issues (57-104)
1912-1913 31 issues (105-153) 18 double issues
1913-1914 26 issues (154-203) all double issues
1914-1915 17 issues (1-24) seven double issues
1915-1916 12 double issues (1-12)
1916-1917 12 issues (1-12)
1917-1918 12 issues (1-12)
1918-1919 12 issues (1-12)
1919-1920 12 issues (1-12) 4° after this (29.3 x 22 cm.)
1920 9 issues (1-12) three double issues
1921 12 issues (1-12)
1922 11 issues (1-12) one double issue
1923-12 issues (1-12)
1924 4 issues (March, June, September, December)
1925 10 issues (1-12) two double issues
1926-1927 12 issues (1-12)
1927-1928 10 issues (1-12) two double issues
1928-1929 10 issues (1-12) two double issues
1929-1930 7 issues (1-10) three double issues
1932 3 issues (1-3)

This major publication began as a weekly, but became twice monthly after the fourth year. After the eighth year, financial difficulties cut the production time to once-a-month.

Founded by a musician-trained writer named Georg Levine, who was renamed Herwarth Walden by his first wife, the poet Else Lasker-Schüler, Der Sturm was one of the two prime areas around which the early German Expressionist creators grouped.

Walden had organized lectures about the new writing and art while he was working as editor of other papers. Lasker-Schüler and Walden founded the new Sturm after censorship degraded his other work, and published the first issue on March 3, 1910. Walden made modern art the center of his life. He was a fanatical propagandist for the young painters and writers. Like a magnet, he drew intelligent and original minds to Berlin from all over Europe. He introduced Expressionism, Cubism, and Futurism to the German public.

Der Sturm became a publishing house, art gallery, school, theater group, book publisher, meeting place, mail drop, center for discussions, publisher of prints, and later a political headquarters. Walden analyzed art and poetry, argued about and castigated middle class values, made many enemies, and was protected by friends in high political office.

A circle of artists grew up around the periodical. It included such people as Schrimpf, Muche, Topp, and van Heemskerck. The work of others was also published, such as Kirchner, Klee, Heckel, Schmidt-Rottluff, Nolde, Pechstein, Marc, and most of the other literary or art experimenters of the era.

Walden never lost his dream of showing the most extraordinary in poetry and art, drama and literature. Against German cultural opposition, Walden pounded home this thesis, successfully expanding the Expressionist movement first in one area, and then another, into music and essays, art and theater. At one time most of the important European thinkers were united under the banner of Der Sturm.

Change came during the war. Klee wrote a letter protesting the name, "Sturm," wanting peace instead of storm. Lothar Schreyer called Walden a man of beginning and ending, a man of an apocalyptic age. Many of his artists left for other galleries, and wrote for other periodicals, leaving Walden an embittered man, and a more politicized editor.

Another major influence was made by the Sturm poets, notably August Stramm, who altered the German language, and was allowed great freedom because of Walden's policies. During the 1912-1920 period, the writers attacked all reactionary phenomena, all decaying concepts of the nineteenth century. Imperialism was savaged. "Doctor Walden" was the attending physician at the birth of a new way of seeing the world.

Walden organized the first Kokoschka exhibition, the first show by the Blaue Reiter in Berlin, held over 100 exhibitions by 1921. But he could never afford to pay advance commissions to his painters, so he lost them to more established art dealers such as Cassirer and Neumann, who paid monthly stipends.

Walden gradually moved further left, finally becoming a Communist, moving to Moscow after the fall of the German Republic. He was taken by Stalin's police during the roundup of Germans living in Russia in 1941, and disappeared forever.

### Some of the Original Prints in DER STURM

Unless noted in index, contents, or under graphic with the terms "original" or "Vom Stock gedruckt", the print cannot be confirmed as an original graphic.

| | |
|---|---|
| ARP, Hans | 1912, April, #154/155, 7, Untitled, (Head) "Original drawing". |
| BEGEER, F. A. | 1924, IV, 197, Untitled, (Abstract Form), lino cut. |
| | 1924, IV, 203, Untitled, (Geometric Composition), lino cut. |
| BENGEN, Harold | 1912, March, #103, 823, Untitled, (Landscape), w.c. |
| BOCCIONI, Umberto | 1912, April, #107, 21, La Peinture des États d'ame /I. Les Adieux (Painting of the States of the Soul, I: Farewells), "Original drawing". |
| | 1912, May, #108, 29, La Peinture des États d'ame/II: Ceux qui s'en vont (Painting of the States of the Soul, II: Those Who Go Away), "Original drawing". |
| | 1912, May, #109, 35, La Peinture des États d'ame / III: Ceux qui restent (Painting of the States of the Soul III: Those Who Remain), "Original drawing". |
| CAMPENDONK | 1916 February, #21/22, 121, Untitled, (Woman and Landscape), w.c. (Engels 10) |
| | 1916, February, #21/22, 129, Exlibris/ Herwarth Walden, (Bookplate of Walden) w.c. (Engels 5) |
| | 1916, May, #2, 13, Untitled, (Woman and Animals in Landscape), w.c. Engels 7) |
| | 1916, June, #3, 33, Untitled, (Fantastic Creature) w.c. (Engels 11) |
| DEXEL, Walter | 1918, December, #9, 119, Untitled, w.c. |
| EINGARTNER, Jacob | 1913, September, #176/177, p. 89 Untitled, w.c. |
| FILLA, Emil | 1913, October, #182/183, 117, Untitled, (Cubist Still Life), w.c. |
| | 1914, 2nd February edition, #198/199, 177, Kopf (Head), w.c. |
| FISCHER, Oskar | 1923, #4, 53, Periphere des Gleisdreiecks, (Periphery of the Triangles of Tracks), lino cut. |
| | 1923, #4, 55, Telegraph (Telegraph), lino cut. |
| | 1924 I, 31, Untitled, (Geometric Forms), lino cut. |
| | 1924 II, 107, Untitled, (Geometric Forms), lino cut. |
| FURMANN, Paul | 1923, #6, 91, Untitled, (Abstract Forms), lino cut. |
| | 1924 III, 143, Untitled, (Abstract Forms), lino cut. |
| GERLACH, Karl | 1912, May, #III, 49, Das Konzert (The Concert), w.c. |
| HAFFENRICHTER, Hans | 1923, #12, 181, Untitled, (Figure), lino cut. |

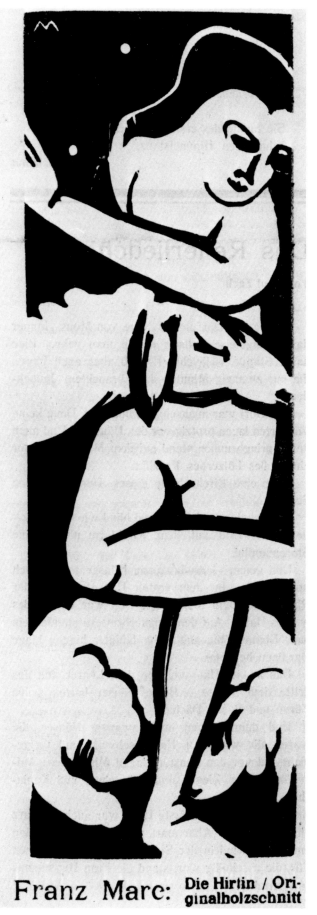

**Franz Marc:** **Die Hirtin / Originalholzschnitt**

303.

| | |
|---|---|
| **HEEMSKERCK, Jacoba van** | 1914, November, #15/16, 105, Two Untitled Woodcuts, *(Abstract Landscape Forms)* |
| | 1916, January, #19/20, 113, Untitled, *(Landscape)*, w.c. |
| | 1916, January, #19/20, 115, Untitled *(Bridge)*, w.c. |
| | 1916, February, #21/22, 123, Untitled, *(Abstract Forms)*, w.c. |
| | 1916, February, #21/22, 127, Untitled, *(Abstract Forms)*, w.c. |
| | 1916, April, #1, 5, Untitled. *(Mountain Landscape)*, w.c. |
| | 1917, June, #3, 37, Untitled *(Abstract Forms)*, w.c. |
| | 1918, May, #2, 17, Untitled, w.c. |
| **HELBIG, Walter** | 1913, April. #154/155, 1, Landschaft *(Landscape)*, w.c., initialed in block. |
| **HERZOG, Oswald** | 1919, March #12, 149, Revolution, w.c. |
| **HOFMAN, Vlatislav** | 1914, December, #17/18, 118-119, Garten-pavillon: Das Obergesims *(Garden Pavilion: The Upper Cornice)*, lino cut of the creator. |
| **HUBER, Hermann** | 1913, April, #154/155, 7, Untitled, *(Nudes)*, ''Original drawing''. |
| **KANDINSKY, W.** | 1912, October #129, 158, Ankunft der Kaufleute, 1906, *(Arrival of the Merchants)*, w.c. initialed in block. (Roethel 19 II: ''Bewegtes Leben'', 1903) |
| | 1912, October, #129, 158, Auf dem Album Xylographies 1907, *(From the Album of Xylographies)*, w.c., initialed in block. (Roethel 54: ''Schalmei'') |
| | 1912, October, #129, 160, Mitgliedskarte der Münchener Künstlervereinigung 1909 *(Membership Card of the Munich Artists' Association)*, w.c., initialed in block. (Roethel 78: ''Felsen'') |
| | 1912, October, #129, 157, Untitled, 1910 *(Forms)*, w.c., initialed in block. (Roethel 80: ''Holzschnitt für den Sturm'') |
| | 1912, October, #129, 159, Untitled, 1907 *(Women and Cat)*, w.c., initialed in block. (Roethel 69: ''Katze'') |
| | 1912, October #129, 159, Untitled, 1906, *(Women in Mythical Landscape with Castle)*, w.c. (Roethel 67: ''Sitzende Mädchen'') |
| **KASSAK, Ludwig** | 1924 II, 53, Untitled, *(Construction)*, lino cut. |
| | 1924 II, 57, Untitled, *(Geometric Forms)*, lino cut. |
| **KIRCHNER, E. L.** | 1912, March, #101, 807, Akrobaten *(Acrobats)*, w.c. (Dube 194 II) |
| | 1911, August, #75, 595, Ruhe *(Repose)*, w.c. (Dube 172 II) |
| | 1911, July, #70, 567, Sommer *(Summer)*, w.c. (Dube 185 II) |
| | 1911, September, #77, 611, Tanzerinnen *(Dancers)* w.c. (Dube 179) |
| | 1911, September, #78, 623, Untitled in Der Sturm, (in Dube 173 titled Liegendes Mädchen *(Reclining Girl)*, w.c.) (Dube 173) |
| **KLEIN, Cesar** | 1912, February, #98, 783, Untitled, *(Seated Nude)*, w.c. |
| | 1912, April, #105, 5, Untitled, *(Interior with Seated Model)*, w.c. |
| | 1912, June, #115/116, 81, Untitled, *(Seated Nude in Landscape)*, w.c. |
| **KUBIN, Otakar** | 1914, April (2), #3, 9, Untitled, *(Landscape with Sun)*, w.c. |
| | 1914, May (1), #3, 16, Untitled, *(Man)*, w.c. |

LAURENCIN, Marie 1913, April, #156/157, 9, Untitled, *(Female in Interior)*, w.c.
1913, April, #156/157, 13, Untitled, *(Woman on Horse)*, w.c.
1913, May #160/161, 27, Untitled, *(Antelope Head)*, w.c.

LUTHY, Oskar 1913, April, #154/155, 7, Untitled, *(Female Nudes)*, "Original drawing".

MARC, Franz 1913, January, #144/145, 253, Die Hirtin *(The Shepherdess)*, w.c., initialed in block. (Lankheit 828 II)
1912, October, #129, 163, Pferde *(Horses)*, w.c., initialed in block. (Lankheit 844 II)
1912, December #138/139, 229, Pferde *(Horses)*, w.c. (Lankheit 832 II)
1912, September, #127/128,145, Tierlegende *(Animal Legend)*, w.c. (Lankheit 831 II)
1912, October #132, 185, Tiger, w.c. (Lankheit 833 II)
1914, April (1), #1, 185, Tiger, w.c. (same as Lankheit 833 II but not in Lankheit)
1913, April, #156/157, 11, Untitled, *(Horse)*, w.c. (Lankheit 830 II)
1913, May, #160/161, 25, Untitled, *(Sleeping Woman)*, w.c. (Lankheit 829 II)
1912, September, #125/126, 133 Versöhnung *(Reconciliation)*, for a poem by Else Lasker-Schuler, w.c. (Lankheit 837 II)

MAXY, M. H. 1923, #10, 153, Untitled, *(Geometric Forms)*, w.c.
1923, #11, 170, 171. 2 Untitled woodcuts *(Abstract Forms)*

MELZER, Moriz 1912, February, #97, 775, Grablegung *(Burial)* signature in block.
1912, March, #102, 815, Untitled, *(Seated Nudes)*, w.c.
1912, June, #115/116, 84, Untitled, *(Horse)*, w.c.
1912, July, #177, 93, Untitled, *(Seated Woman in Landscape)*, w.c.

MENSE, Carl 1914, June (1) #5, 33, Untitled, *(Animals and Natural Forms)*, linol. cut, initialed in block.
1914, July (2), #8, 57, Untitled, *(Animal Forms)*, w.c.
1914, September (2), #12, 81, Untitled, *(Human Forms)*, linol. cut.

MOHOLY-NAGY 1923, #1, 5, Untitled, *(Abstract Construction)*, linol. cut.
1923, #10, 149, Untitled, *(Construction)*, linol. cut.
1923, I, 25, Untitled, *(Construction)*, linol. cut.
1924, II, 61, Untitled *(Construction)*, linol. cut.
1924, II, 67, Untitled, *(Construction)*, linol. cut.
1924, IV, 181, Untitled, *(Construction)*, w.c.
1924, IV, 187, Untitled, *(Construction)*, w.c.
1924, 14, 193, Untitled, *(Construction)*, w.c.

MORGNER, Wilhelm 1912, November, #136/137, 209, Acker mit Weib *(Land with Woman)*, w.c.
1912, May, #109, 37, Der Rattenfallen Händler *(The Rat Trap Dealer)*, w.c.
1912, September, #125/126, 138-139, Fressende Holzarbeiter, *(Woodworkers Eating)*, w.c.
1912, September, #127/128, 149-150, Holzarbeiterfamilie *(Woodworker's Family)*, w.c.
1912, June, #112, 61, Landschaft mit einer Strahlenden Sonne *(Landscape with a Shining Sun)*, w.c.

1912, December, #138/139, 226, 227, Tierdressur *(Animal Trainer)*, w.c.
1912, June, #113/114, 70-74, Untitled, *(Organic Forms)*, w.c.

MÜNTER, G. 1913, January, #142/143, 245, Neujahrswunsch *(New Year's Wish)*, w.c., initialed, dated and greeting cut in block.
1912, November, #136/137, 209, Untitled, *(Working in the Fields)*, w.c., initialed in the block.
1912, December, #138/139, 231, Untitled, *(Children Playing)*, w.c., initialed in block.
1913, March, #152/1533, 285, Untitled, *(Outdoor Family Scene)*, w.c.

NERLINGER, Oskar 1923, #3, 37, Untitled, *(Construction)*, w.c.
1923, #7, 103, Untitled, *(Rectangular Forms)*, w.c.
1924 I, 35, Untitled 1923 *(Construction)*, linol. cut.
1924 III, 147, Untitled, *(Geometric Form)*, linol. cut.
1924 IV, 217, Untitled 1923 *(Construction)*, linol. cut.
1924 IV, 223, Untitled 1923, *(Concentric Forms)*, linol. cut.

NOLDE, Emil 1912, October, #133, 192-193, Untitled *(2 Figures)*, "Original drawing". (Not in Schiefler-Mosel)

PECHSTEIN, Max 1912, January #94, 747, Badende *(Bathers)*, w.c. (title says 'Original Farbenholzschnitt' but appears black and white) (Fechter 108 a)
1912, January #93, 740, Erlegung des Festbratens *(Killing of the Banquet Roast)*, w.c. (not in Fechter)

PEETERS, Jozef 1923, #1, 11, Untitled, *(Abstract Forms)*, linol. cut.
1923, #3, 43, Untitled, *(Circles)*, linol. cut.
1923, #7, 105, Untitled, *(Construction)*, linol. cut.

PERI 1923, #12, 187, Untitled, *(Geometric Form)*, linol. cut.

RICHTER-BERLIN 1912, May, #III, 53, Der Torsteher *(The Goal Stayer)*, w.c., initials in block.
1912, February, #99, 791, Die Brüstung *(The Balustrade)*, w.c., initials in block.
1912, March, #104, 831, Kopf eines Zerhackten *(Cut up Head)*, w.c., initials in block.
1912, July, #119/120, 105, Landschaft mit Bachmühle, *Landscape with Millbrook,* w.c.
1912, July, #119/120, 107, Landschaft mit Holländischer Mühle *(Landscape with Dutch Mill)*, w.c.
1912, October, #130, 169, Untitled, *(Seascape)*, w.c.
1913, July, #168/169, 61, Untitled, *(Dancing Woman)*, w.c.

ROSENKRANZ, Fr. 1912, July, #119/120, 101, Untitled, *(Landscape with Sun)*, w.c.
1912, August, #121/122, 119, Untitled, *(Landscape)*, w.c.

SCHMIDT-ROTTLUFF 1914, 1st February edition, #196/197, 169, Akte *(Nudes)*, w.c., signed in the block. (Schapire 106)
1914, July (1), #7, 49, Untitled, *(Sailboats)*, w.c. signed in the block. (Schapire 103)

SCHRIMPF, Georg 1916, April, #1, 7, Untitled *(Seated Figure)*, linol. cut.
1917, June, #3, 35, Untitled, *(Horse)*, initialed in block.

SEGAL, Arthur    1912, October, #132, 181, Am Strande
*(On the Beach)*, w.c.
1912, July, #117/118, 95, Die Dame
*(The Lady)*, w.c.
1912, February, #97, 772, Lebensfreude
*(Joy of Living)*, w.c.
1912, January, #92, 731, Die Lesende
*(The Reader)*, w.c.
1911, December, #91, 723, Lotos *(Lotus)*, w.c.
1912, January, #95, 755, Sommersitz
*(Summer Residence)*, w.c.
1912, August, #121/122, 113, Untitled,
*(Cityscape)*, w.c.
1913, October, #180/181, 109, Untitled,
*(Figures on the Beach)*, w.c.
1912, September, #127/128, 153, Vom
Strande I *(From the Beach)*, w.c.

STEINHARDT,
Jacob    1912, November, #136/137, 217, Untergang
*(Destruction)*, w.c., initialed, dated and
titled in block.

STOERMER, Curt    1913, June, #166/167, 53, Untitled, *(Hooded
Creator and Two Figures)*, w.c.

STORM-
PETERSEN    1913, January, #144/145, 257, Drame
Obscure, *(Obscure Drama)*, w.c.

TAPPERT, Georg    1912, March, #100, 799, Der Clown
*(The Clown)*, w.c.
1912, April, #106, 13, Excentric,
*(Eccentric)*, w.c.
1912, June, #113/114, 70-71, Untitled,
*(Two Seated Nudes)*, w.c.

TEUTSCH,
Hans Mattis    1923, #11, 166, 167, 2 Untitled Woodcuts
*(Abstract Forms)*
1924 II, 105, Untitled, *(Organic Forms)*,
linol. cut.

TOPP, Arnold    1918, November #8, 101, Untitled, w.c.
1918, December #9, 113, Untitled, w.c.
1918, December #9, 117, Untitled, two w.c.
1919, March #12, 153, Untitled, two w.c.
1919, March #12, 155, Untitled, two w.c.

UHDEN, Maria    1918, November #8, 105, Untitled, w.c.,
initialed in block.
1918, June #3, 39, Untitled, w.c.
1918, June #3, 43, Frau am Wasser, *(Woman
in the Water)*, woodcut.

WACHTLMEIER, L.    1914, November #15/16, 107, Untitled, w.c.

## DER STURM
Neunter Jahrgang, Achtes Heft, November 1918

*Describing My Bride*

Excerpt from the essay by Mynona (Salomo Friedländer)
Mynona's satire on expressionist egotism and soaring imagin-
ation. He mocks the new introduction of science fiction into the
field.

What a life! I dressed myself in suns, clothed myself with the
Milky Way! I am an electric fluid full, the stars etherical fruit,
fruit on all my orbits, oscillation, longing, fulfilling. I ripple with
light, I am always everywhere, all in all. One night around one
o'clock; I slept in the girth of the planetary system; I heard in
the myriad of my ears (my local reflex functions are excellent)
whispered beseechingly, in a dying sigh which I considered an
impudence: "MY SOUL BRIDEGROOM!" How sick I felt! Was I
engaged by mistake to some of my party girls? In spite of the
close guardianship of my trained organs? And it again sounded
"LOVER" still that impudent call: "MY SOUL BRIDEGROOM,"
then I lost my patience. I dynamically orientated myself, and
saw on some obscure planet a chest of divided compartments
called a "house". In one of the cells of that "house" there was a
meager cot, a small object of oblong shape, just a little longer
than a meter, but only one third as wide and even less thick. On
one end of its length sat something like a ball, almost entirely
covered by a ray like, string like blond mass, Part of the ball was
free of this mass, contained a hole of reddish color......

STURM ABEND
AUSGEWÄHLTE GEDICHTE
Verlag der Sturm, Berlin, u.d. (1918)
p. 31

Expressionist-Artillerist *(Expressionist Artillery Man)*
by Franz Richard Behrens

Bah!
Over there an ice bird flies off, arrow straight
As do all birds of this earth
One and twenty
The descent is not known by nature
Two and twenty
It is an organism
Three and twenty
Don't lose the idea
Whether the dear victims have worth
Five and Twenty
Foaming, shrapnel, glue-sun longing
Six and twenty
My singing soul must break
Seven and twenty
Damned life feeling-born damned
Hot expression
Nine and twenty
The air stinks of sulfurous millions, coal
Blood-absinthe
Air is steel and pure
One and thirty
Bomb holes are not harmoniously dotted
Two and thirty
An enemy observer finds this highly fortunate
Three and thirty
Explosions scream light in thunder pounding crashing
Four and thirty
The power of the commander disciplines the will
Five and thirty
The body blood sees beautiful colors, old jacket
Are bone splinters, impressionists and naturalists
Seven and thirty
Being and super being
Eight and thirty
My weapon reciprocates to the sixth
Nine and thirty
It must stand not one meter to the right
One and forty
Cannons are worked
Grenades are thrown
Two and forty
Bombardments begin
Three-
I seem to dissolve
-and
I remove myself pronto
-forty
And
Rags grimaces explode

DER STURM

Neunter Jahrgang, Sechstes Heft, September 1918, page 82

Poems by August Stramm

*Battle Fields*

Staring horror eyes broken stirred up field
Up and down
Down up
Burning
Sun
Flinty sun
And
The burnt

*Unfaithful*

Your smile cries in my breast;
Your lips sealed with passion are iron.
In your breath is a hint of dried up leaves.
Your glance becomes a coffin
And
Hastens on it noisy words.
Forgotten
Your hands still crumble!
Free
The hem of your dress woos
Dangling
Over, above.

*Undecided*

Torture
Regret
Trembling
Defiance
Stride, stride
Wave
Want
Speaking speaks
I speak
And
You must be here

STURM ABEND
AUSGEWÄHLTE GEDICHTE , p. 49

*To the Poet August Stramm*

by Adolf Knoblauch

The creative ones must farm their acre by themselves.
Nobody can replace them and supersede them among mankind.
So God can allow no substitution on earth:
He does not recognize pastors and priests.
He wants the lone creative ones to experience God
on their own,
Although by no means be gods!
Out of creative individuals He speaks with all voices of His
Superhuman Being.

DER STURM

Vierter Jahrgang, Nummer 154-155, April, 1913, page 3

*Angelic Strophes*

by Rudolf Leonhard

You walked around and around you was a rustle,
A rustle was around you like deep ocean;
You, a drowning one would wade in it,
And were bent down silently to listen.

*The Word*

Do you feel the heavy wrestling fullness within the
limited world?
It swells of said and unsaid things.

*The Reader*

You read. Your head gets heavy. It flows out an open door.
You read. And feel confused: all words are alive.

*Looking Up From My Book*

Let the books rest; feel yourself tightly surrounded,
Shadowed and threatened, knowing: the dead are living

*Maculatae*

It was the pure spirit which seduced your body;
the spirit, which felt the same spirit in your body.

*The Inscrutable*

When a blind man tumbles into the cups of your breasts,
drawn up knees, kissed your warm body,
Have you revealed yourself to me, oh soul of my wife;
But seeking, I never solved the riddle of your body.

*Unveiling*

The structure of the world dims, your body lies made
I touch your skin. I have seen the world.

DER STURM    Jahr 10, Heft 6, page 90-92, 1919

*The Manifest of Expressionism*

By Johannes Molzahn
(excerpt)

The earth shakes, rolls-pulsates roaring in space. -mightily its
axis is thrown-since-He-the Eternal-touched its body.
Centuries-milleniums dry up before Him.-His blood had marked
us.- pulled forwards, HE, the great expressionist.-we-forged-by
Him-jubilate his orbit. How He preceded. We acclaim to you!
The work to which we are bound as painter-sculptor and poet
obliges us-is powerful energy of such events, is cosmic will-
glow of eternity. -living arrow-turned towards you. It should
bore into you-glow in the blood-that it may flow faster and
livelier-to better glow into eternity.
Suns and moons are our pictures-which we spread before you.
Star spangled banner of eternity-glowing against you. Thrown
between beginning and end, in deepness and crest thrown-
there is for us no heritage nor possession-which would be
worthwhile to accept. We carry the great promise.
Some wanted to deceive us with lassitude-but we have jumped
over this lie-the deception and mirror-that was held before
us-we have broken it-all foul glamour-it hides the disfiguring
marks badly. Grins of need everywhere.
On wreckage and debris we prepare the work-fighting to drive
our way into the stars.
There is no you and I any more-all is purpose-goal-is damming
the flow of eternity-the day past-the hour gone-nothing keeps
US there any more-centuries-milleniums-hammer-glow
forwards-bore their energies into eternity!

Each work of art is a flaming sign of the ETERNAL. No work-that
is not forged by struggle-thrown by struggle- so we want to
praise the struggle-the roaring wild music of struggle-the
screaming blood-the sword-which sings and jubilates through
space-encircling destruction........

(Punctuation from the original)

# DAS TRIBUNAL
## HESSISCHE RADIKALE BLÄTTER

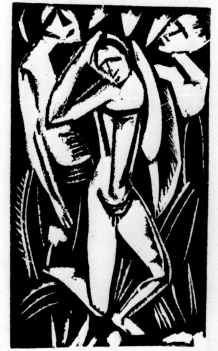

304.

### 304. DAS TRIBUNAL (The High Court)
Hessische radikale Blätter
Edited by Carlo Mierendorff
Verlag Die Dachstube
Darmstadt, 1919-1921
Raabe 59, Perkins 207
1919-10 issues (1-12) two double issues
one extra plate in April
1920-1921-4 issues (1-7) seven parts in one issue
30 x 22.5 cm.
Jahrgang 1, 1919: Heft 3-12. Eight issues.
Original woodcuts by Eberz(2), Gunschmann (1), Dülberg (1), Georgi (1), Masereel (1).

Das Tribunal (High Court) became an outgrowth of the Darmstadt group around the Dachstube publications. It first appeared as a regular monthly in January, 1919, and continued until 1920, when irregularly issued parts were published.

This literary-political periodical was similar in format and size to Die Aktion, Pfemfert's magazine in Berlin. The various published numbers had mottos: "Against Hunting. For Justice. Against Indifference. For Renewal and Renovation."

It was a publication for the younger generations, like most Expressionist efforts. "New generations" meant more than the young. It meant youth in thought and action. Graphic art, essays, and political statements followed poetry in each issue.

At the end of the first year, and amid the changing problems of blockade by the Allies, inflation for the diminishing middle class, political assassinations, and attempts to find a working way between Bolshevism and social democracy, the editorial view of this small publication in Darmstadt changed. Promotion of the new talent was not enough. Das Tribunal undertook the task of engaging in polemics and controversy. It meant to hoist the flag of political ideas, proposing to promote the positive, reply and threaten when attacked. Socialism became Das Tribunal's major statement. It dropped lyrical poetry as a major

intent. There was one inconsistent issue centered about Kokoschka. The last issue included a complete drama by René Schickele, called The New Man, which was a new form of socialist comedy.

Das Tribunal appealed to a supra-national European community. The best brains in Germany wrote or created graphics for the new purposes of the editor.

As a joke, Mierendorff also published a periodical opposing Das Tribunal. It was a "highly moral" magazine called Hessenborn. The middle class believed Mierendorff's joke against himself, which was published on April 1st. It was undertitled, A Hessian Periodical for Moral Culture. The editor received many letters praising his ideas in Hessenborn and attacking Das Tribunal.

Darmstadt was a small city. Most of the intellectuals knew each other. Mierendorff was able to publish Das Tribunal with the help of his younger friend, Joseph Würth; and use the fine talents of his other friends there, Kasimir Edschmid and Rene Schickele.

DAS TRIBUNAL
Fünftes Heft, Mai 1919. Page 63
*Spring Day*
By Rudolf Leonhard

The sun rises into the blue,
Precisely glorified houses
Stand in light,
A woman is ecstatic in the ringing.

Oh day after night!
You are awakened,
Spread everywhere.

But yesterday
Brother and sister fell
Nearby, touched by your finger,
Mocked, ridiculed
Body on body.

Think, heartbeat,
In every hour
There is the smell of death
In the mouths of the dead.

6 Heft, Juni 1919, 1 Jahrgang

*Pearls*
Taken from the Därmstadter Täglicher Anzeiger.
(*The Darmstadt Daily Announcer*) Reprinted intact

Most of the periodicals took articles from other journals, which obstructed and disliked the Expressionists, and printed them intact to show their exact stupidity.

"The toad Cezanne." With this suppressed outcry of my fearful soul, may everything be compressed that comes up in the face of this shunning light, sneaking, swallowing all values of beauty from the natural world and sucking up in merciless ambush, vomiting it again as indigestible; ugly, multicolored, mouldy remainders, nightshades, belladonna and hemlock vomits up again and again from my highly respectable insides. These raving distortions, stretchings and displacements, cripplings and disfigurations, and idiocies-arrived at from miscarried foreshortenings, refined evil, perverted lust by making ugly...this cunning and malicious innocent looking from the country.

Van Gogh...the more the rottenness in his works escalates such obvious perversity and terror, which creates hyper nervosity, then everyone feels free of doubt what a sad spirit child he was...placard like, caricature, an unhealthy craving for grossly affecting or simply repulsive colors, the torture of delusions of grandeur, pushing to be original, overwrought, jumping, these seem to be the ingredients from which the loathsome mush of van Gogh is mixed together.

## 305. DER WEG (The Way)
Edited by Walther Blume
Verlag Der Weg, München
1919, Raabe 60, Perkins 208
Jahr 1, 1919: 10 issues with varying paging

1 Januar    pp. 1-12
2 Februar    1-12
3 März    1-12
4 April    1-12 (edited by Hans Theodor Joel and
Eduard Trautner, Verlag Karl Lang Der Weg)
5-6 Mai - Juni    1-16
Juli    1-12
8-9 Aug - Sept    1-20
10 Oktober    1-12
32.2 x 24 cm.

The periodical was in quarto format, printed on rather poor quality, wood-containing paper. Numerous woodcuts were used, mostly original ones. It was a monthly periodical for Expressionist literature, art, and music.

The under editors were Eduard Trautner for literature; Fritz Schaeffer for art; the early music editor was Walther Blume, followed by Wilhelm Petersen.

Most of the contributions were poetic (lyric, prose and scenes from drama). Der Weg also included dedications, announcements and descriptions of events and personalities.

Der Weg is a typical late Expressionist periodical (the original example being Die Aktion), making an attempt to unify the community of all arts of a mutual opinion.

The artists, included Josef Achmann, Campendonk, Josef Eberz, Felixmüller, Grosz, Kaus, Klee, Nerlinger, Scharff, Schmidt-Rottluff, Schrimpf, Wach and others. Most produced woodcuts.

Writers included J. R. Becher, Kurt Bock, Oskar Maria Graf, Toller and some others, now obscure, from the Munich area.

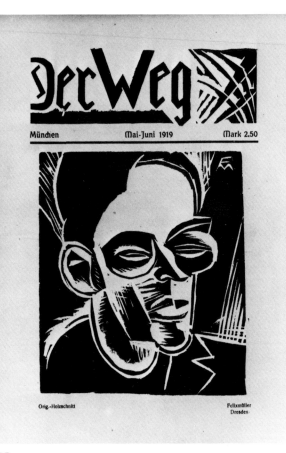

Der Weg
München    Mai-Juni 1919    Mark 2.50

Orig.-Holzschnitt    Felixmüller
Dresden

305.

DER WEG
Januar, 1919, page 4

Unser Weg (*Our Way*)
by Otto Zareck

Revolutionary pathos is contagious. We excuse ecstasy, enthusiasm, threateningly raised will-power, we excuse, as gestures from those whose life is realization. Woe to those who, as onlookers, can read the easily acquired twitching of face muscles, the flying step and the powerful voice, play tragedy in the audience. Youth, which does not need to learn from earthly time (and all earthly time is relative) walks with their own instincts, walks from the beginning of history, to its ending: the one way.

Our way is walked by everyone who believes in mankind. Maybe to believe in men, this alone is revolutionary thinking. It is essential to tear the cap off bourgeois, academics, reactionaries, but also off the radicals of cleverness, the anti-capitalistic economists.

What is "fraternization?" An aesthetic affair? I deny that, although not with indignation. If a belief in the absolute originates in the full consciousness (from which a field alone grows into art) fine, then there is no more danger to affirm art. Responsibility creates its forming. Shaping: deep wisdom is understood for this word. It is the developed Spirit and the developed work. Art made without these chaste values is hateworthy: without beauty, without the resting spirit, without silent friendship. If we eliminate them, what remains?

Talk about lasting values. Also, talk about it, that which has been burned. There is only one way, and we all walked the path: the way toward the simple, to the loving I. But there is no way (although we blinded ones spoke of it so often) from the loving I to the You and to the masses of mankind. Not that the One down from the Mount speaks to the congregated and waits for their ascendency; no, because the single ones try to ascend from many sides! To devote oneself does not mean: to give oneself up, to assimilate, or what is the same, to babble away. "Not the similar is the friend of the similar, but what belongs." (Plato)

The monumental in the experiences of the singular I, the remaining part, is; the work. Art cannot be medium. It is: expression. It presumes the substance; it is the expression of the best meaning; it says: all this is you!

What is beauty? If we knew this we would be old. We ask about life: we find the eternal. Does Hölderlin live no longer among youth? "You ask for men; nature. To rejuvenate you again and the old bond of the spirit will renew itself with you. There will be only one beauty, and mankind and nature will unite in an all embracing divinity."

Heft 2, Februar, 1919, page 6
*Paul Klee*
By Ernst Grünthal

Blooming of last visions, lost things floating in space: Towards the emptiness, the infinite, soundless, softly hovering into the distance, wrapped in a web of glassy dreams.

Substanceless soulfulness, of strong painfully hard objects, touched by utterly sensitive fingers, shortly before the irretrievable slipping away into dissolution, lost. Still visible, but hardly to be held: like soap bubbles, which burst only by sudden approach. Klee is allowed to touch them because he encircles them with love, and loves with unspeakable tenderness, with child-like shyness, almost as if in a dream.

The axis of the soul, the twitching, jumping nerve of each being, impaled on a pointed pen, with one movement, then buried as life-centered form into the visible, carefully spread on paper for safe keeping. A herbarium originates, not filled with plant bodies. Blooming wonderfully on each of its pages, are the likenesses of chaste flowers. Vegetative, dreamlike, subdued plantlike spirits are invigorated, enlivened in these images.

Childlike, shy penstrokes, starting and starting again, shape towards each other. They become entangled in algae-like, unconscious liveliness. Protozoan bodies become visible, bulge, push, melt and divide their body substances: life appears in cosmic completeness.

The unheard of, the never-seen originates, becomes real in unbroken soulfulness, as only wide open childrens' eyes can see. For them a touchable corporeality is transparent in ghostliness. For them only the most central, primeval life, the innermost mixture, is sought through the search for truth in all its essential and imaginable grimacelike and fanatical likeness.

Of course, such polarity seems banal to the conventional, to those who abstract conventionally and have the "natural" reality of the grownup. We can ghost for them, the "only-educated" ones, who are weeping and bent dolls cast aside, ever at the moon-rising hour. What an event this fairytale can be for them, this floating towards heaven. Gallows birds form raving melodies for them, terrible dissonances of a "fiery orchestra," the displacement of lines by confined circles and raylike openings.

306. **DIE WEISSEN BLÄTTER** (The White Pages)
Eine Monatsschrift
Year 1 edited by Erik Ernst Schwabach.
Year 2-7 edited by René Schickele with the exception of Year 7,
Nr. 4/5 edited by Paul Cassirer
Year 1 & 2 published by Verlag der Weissen Bücher, Leipzig
Year 3/4, 1916/17 published by Verlag Rascher, Zürich & Leipzig
Year 5, 1918 published by Verlag der Weissen Blätter, Bern-Bumplitz
Year 6, 1919 and after published by Paul Cassirer, Berlin.
1913-1921
Raabe 15, Schlawe p. 12
1913/1914 - 11 issues (1-12) one double issue
1915 - 12 issues (1-12)
1916 - 12 issues (3 I-3 IV)
1917 - 6 issues (4 I-4 III)
1918 - 6 issues (5 III-5 VI)
1919 - 12 issues (1-12)
1920 - 11 issues (1-12) one double issue
1921 - issue (1)
22.5 x 15 cm.

This periodical began as a monthly magazine which specialized in criticizing the problems of the time in terms of psychological phenomena. *The White Pages* was mostly literary at first. It grew into one the three most important vehicles for German Expressionist writers after Die Aktion and Der Sturm, which were both published in Berlin. Die Weissen Blätter was important outside the capital. It began in 1913, which was the year of expansion for Expressionism, and continued until 1921, which some critics dated as the decline of the movement, the last of the most precocious work.

Kurt Wolff backed the new enterprise, and hired the young Erik-Ernst Schwabach as editor. René Schickele took over editorship during wartime. The publication echoes the bloody years. It became pacifistic and antiwar in tone. Schickele tried to hold out a promise for a new beginning.

Every fresh and talented writer was given a voice. Many new poets appeared for the first time in Die Weissen Blätter. Most important of all were the critical and literary texts which appeared during the years when the magazine was published in Leipzig and Switzerland. These contained many of the most basic texts of German Expressionism.

Schickele was a member of the great circle of Alsatian writers, and artists which included Otto Flake, Arp, and Stadler. He almost always wore a Panama hat, "over a long stride of determination." As a bilinguist, he took all expressionism as his realm, French as well as German. As a European specialist, he maintained his cultural leadership as editor even in exile during the war. He preferred to direct his campaign over champagne at the Kronenhalle in Zürich. He wrote, tried to stay solvent, and worked on his novel, Benkal, a devastating account of a womanizer. He drew freely from the best brains in Germany and France. Kurt Wolff called him a nature-lover, not an Expressionist. His courage was constant: he kept his faith that man is good; he was never defeated either by poverty during difficult times or in his war against laissez-faire thought.

Die Weissen Blätter was always unpopular with the German public, but it kept the trust of the young. It always spoke for the coming generation. It began with a lyrical approach, then went through a violent antiwar period in exile, became the spokesman of international pacifism, and later became influenced by Dada, returned to Germany as a left middle-of-the-road literary and art journal. Schickele began to work on his own writing, and gave up the editorial control. The last issue is a mixture containing articles about class warfare, new lyrical poetry, truth in works of Shakespeare, and a story by René Schickele.

DIE WEISSEN BLÄTTER
7. Jahrgang, September, 1920

Jenseits *(Beyond)*
by Walter Hasenclever

This is typical dialogue of Expressionist playwrights. The plot is less important than the language of force and silent meaning.

306.

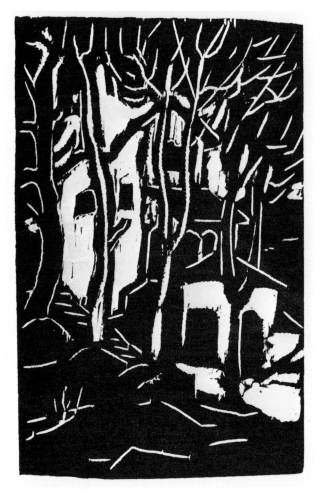

The rapid fire speech relates to the quick energy of the poets and painters. There is much mannerism, little interchange between characters living in isolation amidst multitudes. People state intense passions to silent and unhearing rooms. Hasenclever uses this device of a single dialogue with remarkable strength in later plays. Each speech was isolated on the stage by long beams of spotlights in a darkened setting.

Some scenes from the drama

Persons: Raul, Jeane. Place: The House
First Scene: Window

Jeane: This is my house. This is my window. This is the sky. The sun is shining. I know, I live, I am happy, I am loved. (She takes a few roses) It is going to be summer. Yesterday was Sunday. The star of Sirius rises when it is night. The night when I kiss. The night when I love. I am safe. I am with you. No dress hides me, no veil. I am naked before you. Only for a few hours. Time is eternal. Return again! (She opens the window.) This is my house. This is my window. These are flowers in my hand. If only they could feel as I feel. (She throws the roses through the window.)
. . . . . . .
. . . . . . .
Raul, the husband's friend enters.

Phone rings. Husband is killed in mine explosion. Wife faints.
. . . . . . .
. . . . . . .
Raul: (Lifts the unconscious one, puts her down on a sofa.) A person passes by. Someone in an uncaring room. (Picks up the phone receiver.) Where are you, human being? Where is your shadow? Are the lights veiled? Don't you float on the earth any longer? If there is a fate to fulfill, I will fulfill it. Is there action among ghosts? I go into battle with the invisible. May they come. I am ready.

Dritter Jahrgang 1916
Quartal Juli-September, page 76

*No!*

By Peter Baum

No! I swam through your fog-hours,
Heard unchained shrieking for myself-
All the infernal commotion of dark dogs
Maiming you.

But I know your rugged abysses,
Moving your stony rocks,
I shall glow at your gods of death
Incite my sunrise!

Yes, we ascend! My sun boils
Through the skies like dark slavery,
And my sun-golden crown
Is forged from squared stones.

*You!*

You! I shall yet carry you away as loot,
You shall atone for my bad hours
And with shy, sweet words
Tell me of your love.

Wait, soon I shall humiliate, then grab you-
I lie in ambush all nights.
A long sea of sorrow
Pours wildness into me.

7 Jahrgang, Juli, 1920
page 330

Excerpt from *"Dadaist Wit"*
By Bernhard Bernson
From the article and proclamation, *The Art Jerk*
by Wieland Herzfelde and George Grosz in Die Pleite.

What should the worker do with art?

When he has to work hourly for his most basic needs, where he fevers under shattering conditions, into which he constantly sees companions sink, his family and his co-fighters, thanks to the bourgeois bloodsuckers and swollen owner-toads, feeling guilty for every minute he does not spend liberating this world from the slime-tentacles of the capitalistic system.

Where he constantly has to keep his eyes wide open to forestall crimes, schemes, deceits, distortions, slander with which the bourgeios society tries to destroy his work for salvation...

What shall the worker do with art which wants to lead him in spite of all these scary facts into a world of ideas untouched by it, keeping him from revolutionary action, wanting him to forget the crimes of the proprietors, deceive him into a bourgeois imagination, of a world of peace and order which also hands him over into the claws of those who mangle him instead of lashing him into fury against the dogs!

What shall the worker do with the spirit of the poets and thinkers in the face of all that chokes the breath of life, shall he not feel responsible to take up the fight against the exploiters?

Yes, what good shall art do for the workers? Did the painters give their pictures as answers in the fight for liberation of the workers? Did it teach them to free themselves from the yoke of a thousand-year-old suppression?

Workers! By presenting in painting anything to which the bourgeois can cling, which mirrors beauty and happiness, helps them, strengthens them, sabotages your class-consciousness, your will to power.

By directing you towards art and crying: "Art for the people!" they want to seduce you into believing a possession you own in common with your tormenters, once again want to make you pliable with the "soulful," make you feel small in proportion to the wonder-works of the human spirit.

Swindle! Swindle!

Meanest deceit!

No, art fits into museums in order to be stared at by little bourgeois on a vacation trip. Art fits into the palaces of the bloodhounds, covering the safes. If Mr. Stinnes, after a completed black-market deal, puts his hands into his lap (calloused by clipping coupons from stock receipts), tired from incessant additions on how to keep you underpaid, he lifts up his near-sighted eyes onto the heights of pure humanity, refreshes his overworked mind on antique art pieces or on Kokoschka's master ham art, or the "power of music," one can hardly assume that these pictures preach the necessity of destroying the old and building a more just world!

307. **DIE WELTBÜHNE** (*The World Stage*)
Wochenschrift für Politik - Kunst - Wirtschaft
(*Weekly periodical for politics, art and economics*)

Edited by Siegfried Jacobsohn until 1926
Edited a short period by Kurt Tucholsky
Edited by Carl von Ossietzky 1926-1933
To 1913 published by E. Reiss, Berlin
After 1913 published by Verlag der Schaubühne,
Charlottenburg-Berlin
22 x 14.5 cm.

This cultural-political journal was built from the beginning around themes from the theater, literature, and politics. It had begun in 1905 as Die Schaubühne, the private operation of

Siegfried Jacobsohn. The title after 1918 was changed to "Die Weltbühne," the world as a stage.

Jacobsohn was a somewhat embittered former drama critic who started the periodical as a theater magazine. With the political changes after the war, Jacobsohn felt the work needed more political emphasis. It was a very small weekly, but full of personal opinions of the editor and publisher. It was a gigantic anti-pathetic voice, and he attracted many of the young Expressionist writers who were turning socialist and pacifist, such as Stephan Zweig, Mehring, and Toller. But the major contributor, and future editor for a short time after Jacobsohn's death in 1926, was the enigmatic writer of social comedy, Kurt Tucholsky.

Under Jacobsohn's editorship the periodical became a spokesman for the leftwing intellectuals. It was against patriotism, fought against militarism, nationalism, capitalism, and against the corruption in Germany among judges and the public communication systems.

Jacobsohn worked hard for the Expressionist theater, especially the problems revolving around Reinhard Goering's drama called Seeschlacht *(Sea Battle)* which presented the great naval battle at Jutland from the view of sailors in a gun turret, and was closed by military censors. He supported Heinrich Mann against his brother, Thomas Mann, in the famous battle between concepts of universal brotherhood and national community.

Tucholsky was an authentic genius plain and simple. He had an ear for dialect, comedy, and satire. He presented the simple and the complex among German society in a naturalistic crosssection that was devastating. After Jacobsohn's death he decided to live in Paris, so the editorial duties were turned over to the great man of peace, the Nobel prize laureate, Carl von Ossietzky. The periodical still contained many articles by Tucholsky, but the general tone changed to one of international pacifism.

307.

Von Ossietzky was a man of true spiritual courage. An early enemy of the Nazis, he was later arrested by them and made prisoner #562 at Oranienburg concentration camp. He died of the effects of this imprisonment.

Die Weltbühne never exceeded a circulation of 20,000 copies, but it was a major outlet for Expressionist thinkers, retaining its earned reputation for honest criticism of social evils, balanced with fine film and drama criticisms. Die Weltbühne kept up an unending fight against rearmament. It was the brilliant Tucholsky who diagrammed the evils in postwar Germany with humor and accuracy. He sometimes filled complete issues, writing under different names, such as Peter Panter or Caspar Hauser.

DIE WELTBÜHNE
XXVI Jahrgang, #17, 22 April 1930
Verlag der Weltbühne, Berlin-Charlottenburg

This article in Die Weltbühne concerns the great debate in Germany during 1931. The Brüning government brought the great united bloc of the Socialists into disunity, especially by its handling of the construction of Pocket Battleship B. The Socialists felt that Brüning had to be supported because of opposition by the growing Nazi menace. With the great debate over the battleship, expulsions and resignations followed. Many transferred to the Communist Party. Four different divisions in the Socialist party developed and left it with few good speakers to mobilize the masses, while the National Socialists had fiery speakers who could influence the middle class and some disenchanted workers' groups.

"B"
By Carl von Ossietzky

A new era of governmental double talk has replaced the mild civilian idocy of the Müller rule. It is similar to the time of Cuno. Only the tasks of today are not so depressing any more. The Rhineland becomes free, the Young-plan is signed. Now, undisturbed, we can turn to internal reconstruction. It is being done already.

We are being charmed by the model of the armored cruiser "B" on the house table. From this example a docent of the university could develop the entire history of political corruption, by nature, and how it was accomplished. How was it? Figaro Treviranus chartered a strawman, who proposed to put the first installment in the parliamentary budget in 1930. In committee, Mr. Groener had declared there were no foreign political problems. The chancellor will welcome the proposal. So much for Mr. Groener, who until recently had renounced the proposal with a flood of tears. There is a proposal made by the East Prussian, Mr. Jon Gayl and Mr. Moldenhauer thinks, with his Rhinelandic openness, that the government does not think to change the master plan. It asks the assembly not to be influenced by this position in any way. This is how the government looks into the risk, fearlessly so, by pushing the armored cruiser. The government seems like the curious woman, who would like to know how it feels to be raped once, who goes into the dark forest with iron resolve not to call for help until there is nothing to be done about it anymore. It is to be assumed that the government will not scream in an all too undignified manner after being well raped.

Even today there are Republican publicists, who see in Hermann Müller, by his stomach ailment, a handicapped Bismarck.

Things never went well with Germany when "Michel" heard the hissing of the ocean wind. If a few highly situated gentlemen saw the future on the water, then this future meant disaster. What does the Tirpitz-follower, Treviranus, care about such considerations? The main thing to him: the crews are busy, men have jobs, there is activity. What comes after does not matter. Just put Germany on board an armored cruiser; it will be able to drown by itself!

But also Brüning has his shy admirers, who although not agreeing with his deeds, still find aesthetic enjoyment in his way of fingering objects. I find the artistic pleasure ceases when one's throat is slowly strangled. The most skillful accomplishment of Mr. Brüning was his entrance to politics. This man, so his

friends tell, had the thought of a lion for his entrance: the destruction of Hugenberg. Mr. Brüning topples Hugenberg by making him indispensable. Agricultural politics, the armored cruiser; day after tomorrow there may be a "Volks' conservative" as Prussian Secretary of the Interior—how could a pronounced right wing government act differently? Brüning defeats Hugenberg by leaving nothing left for him to do.

Spare us the puffed-up Hugenberg image. What is one person compared with these issues? The power which we call Hugenberg today was called Stinnes seven years ago, ten years ago Ludendorff.

An admirer of the "system," Brüning found that, at least, he gets Parliament to move. Does this way, as the affair of the armored cruiser was handled, have anything to do with decent parliamentarism? How would a cabinet be treated which would try something similar in a country with old and respectable traditions such as England? And where—except in states of white dictatorship—is it a rule that the Secretary of Defense stands up, as Mr. Gröner did, and expresses proclamations about foreign politics.....

Maybe Mr. Brüning, himself, feels somewhat uneasy at the thought of the armored cruiser. But his "Treviranism" holds him in its grip, and the good man Schiele will succeed in proving that East Prussia needs strong maritime guards in order to consume its blessed subsidy in peace.

And in order to be very sure of this, the Chancellor lets it be known he does not intend to ask the question to the Cabinet. So he circumvents conflicts around election time. If in spite of this, a left corner of the government party should open his mouth, the chief of the Reich would be carried along by the grumbling masses (volk), like old Attinghausen: "Be united, united, united!" And all will be united.

Can one get excited? It was the Social Democrats themselves, who were talked into giving up resistance to the Navy program. Social Democrat influence ended the Communist plebiscite against the armored cruiser A. It was a dismal failure. That is only two years back, and does not do much to strengthen the republican spirit.

The armored cruiser problem is much more than an internal quarrel, even more than a question of budget. True, the finances of the Reich are not such that millions and billions could be put into a militarily worthless toy. Much greater is the foreign-political misfortune. This armored cruiser will be considered a gross provocation in Poland and Russia, where we are not always in agreement....

Also in Western Europe our maritime rearmament is looked upon with the utmost distrust. Gröner's navy program has been judged most unfavorably in England. While France tries to make its own rearming understandable by pointing to Germany's plans. The armored cruiser "B" will not only be unfavorable to our foreign policy, but will give new driving power to the maritime rearmament of the whole world. That is all we need after the embarrassing London conference.

XXI Jahrgang, #47, 24 November 1925
*Mauricet*
By Peter Panter (Kurt Tucholsky)

It is like this:
A good looking guy, with parted and thinning hair (too much fun) sits before the woman of the house, after mutual accomplishments (sexual), he smokes a cigarette. She seems a little fearful probably because of her husband or girl friend, and he makes a schoolboy grimace, like a boy caught smearing rotten cheese under the teacher's chair. —nothing is going to happen, Bah! It never got that far. Afterwards he squashes the cigarette carefully in the ashtray, tosses it on the floor, turns out the light. The lady is satisfied.

When he appears as himself—that is as Fursit and Mauricet—without a moustache pasted on, he sings and makes fun of it as well as jokes, sings chansons in a tuxedo. "Insolent" is not the word. It is an extract of insolence. His co-singer, the old Fursit, whose political songs are mostly at the level of a bull session at a veterans club, and who now appeals successfully to the stu-

pidest philistine instincts, should listen to how Mauricet creates a political song, sniffles and bleats—he says the most unbelievable things, but is so smooth and fast that one does not catch it. He steps in and is gone. Much of it cannot be understood, most of it. Previously I have explained why he lets Maurice Rostand say: "Mon cure les Riches." We are all dead. But he slams out the meaningful chansons, which refer to the large ads of the company which praises macaroni cut into pieces so one can eat them in comfort. Mauricet: "Les Macaronis, pour être bons, doivent-ils être courts ou doivent-ils être longs?"

The women are quick with the word: is hesitation possible? No. The wind has already blown Mr. Mauricet behind the stage wings from which he appears with a mustache and plays with Rip, the most delightful "quetch" talk that one can imagine ("Quetch" in yiddish: one who always complains).

Rip-that is one of the thousand Julius friends of Paris, he tastes of Polgar and luckily not at all like the German national poet Rebner. He sits on stage in a red house coat, diligently working on a crossword puzzle, telephones, sings folk songs with a tremolo in his voice, throws new couplets around as if they occurred to him every night, every morning, every noon, getting out of bed—that is the case, for the Paris stages are full of his songs Rip-Pip-Pip....here in small boutiques his texts are even better than in big operettas, more insolent, more pointed, frothier; and when I could listen to it like that forever, he sits at the table again in the same pose; as in the beginning he is working diligently on a crossword puzzle. If it would not be embarrassing to me, I would wait for him at the stage entrance.

A lady appears and whines an old French song, all of Biedermeier is in it.
"On dit que tu te maries..."
And Groffe is also here, like the others in the real theater, to speak unnaturally, number six—but what insolent texts and spicy jokes! If your charm nourishes your insolence, give it full measure...I always am amused, like a cannon ball in a milk wagon, and wish it would never, never end.

XXI. Jahr, Nr. 31
4 August 1925
page 177
*About a Soldier's Appearance*
by Theobald Tiger (Kurt Tucholsky)

High collar, pressed into
a monkey suit;
The civilian interior warped,
Recoils from ordinary things.
Your face is strange and empty
You don't understand a thing.

Final picture and last sound—
You have departed
And now I must worry as long as I live
about this.
Around you plows the farmer's plow
You are clay and satisfied.

Dear one, do I see you today,
ugly and disguised,
I have often greeted you dead man,
Envied you a lot.
Lice, Lieutenant, bloody grass—
Say, why did you do it?

The same moon shines on us,
the same stars see—
Germany, used to slavery
longing for barracks.
Torture, four years, stolen rations
are forgotten—are forgotten...
Shouting the marching songs:
"Again tomorrow! Again tomorrow!"
Greetings to you—!
You have shattered on it:
on the worst crap of the world.

**308. ZEIT-ECHO** *(Echo of an Era)*
Year 1914 and 1915: Ein Kriegs-Tagebuch der Künstler *(A War Daybook of Artists)*
Year 1915/16 and after: no undertitle.
Year 1 and 2: edited by Otto Haas-Heye
Year 3: edited by Ludwig Rubiner, 8°
Artistic direction by O.T.W. Stein
Year 1 and 2 published by Graphik-Verlag, Munich
Year 3 published by Zeit-Echo Verlag Benteli, Bümplitz-Bern
1914-1917
Raabe 22, Perkins 205, Schlawe p. 43
1914/1915-23 issues, one double issue (1-24)
1915-1916-15 issues (1-15)
1917-4 double issues
24.7 x 16.5 cm.

Each issue had a cover woodcut by Max Unold, showing two men blowing bugles before a city in flames, printed in black for regular issues and brown for the special edition. The covers were of gray or yellow paper and bound with colored string. During the war the editors moved to Switzerland, where they continued publication, sometimes with double issues such as the four between May and August-September 1917.

It began as a literary-artistic publication, with poems, fiction and essays. It also contained many original lithographs and sketches. Founded as a war diary, the magazine attempted to show the effect of the war on painters and writers. It intended to define the mood of those years, and originally took no political stand. Pacifists as well as war enthusiasts were welcomed. Everyone was allowed to speak "what was in his heart."

When Hans Siemsen took over as designer in the second year he saw a changed mood among intellectual Germans. "I think that the mood of war for the last year is about all we can take." The change became anti-war. It became somewhat confused, "full of grief and giddy."

When Rubiner took over the next year, after almost a complete interruption for the year, the emphasis became a moral matter, not bibliophile. Entertaining works were no longer accepted. Only anti-war or pacifist sketches, poems, novels, and essays were published. There were important Expressionist manifestos, discussions about the coming age.

Early issues illustrated war scenes of suffering, pathos, and heroism. After the seventh issue, the pictures became even sadder, more suffering was exposed, though patriotic ballads were also printed. There is a growing sense of sadness in the pages before the publishing house moved to Switzerland.

As the numbers are not dated, the exact publishing date of each is not easily traced. We know there are five issues in the first year, and seventeen issues before the move south.

Rubiner wrote the intentions of the periodical in the last year: "A publication has the right to live only when it offers a movement which gives the people a means of identification. They must want to accomplish the things of the spirit with every means of the body, and see no difference between normal speaking, acting, and writing from the expression of their human act of love."

Our copy is one of three known copies with the additional Klee lithograph of 1914 titled Schlachtfeld, Kornfeld 62 (Heft 3, 1914).

ZEIT ECHO
Ein Kriegs-Tagebuch der Künstler
Original graphics in order of appearance:
1914
Issue 1 *(First Issue Unpaginated)*
　WILLY NOWAK, untitled lithograph, p. 1
　MARIA CASPAR FILSER, untitled lithograph, p. 3
　ADOLF SCHINNERER, untitled lithograph, p. 5
　WERNER SCHMIDT, untitled lithograph, p. 7

308.

Issue 2:
MAX UNOLD, untitled woodcut, p. 9
O. TH. W. STEIN, untitled lithograph, p. 12
EDWIN SCHARFF, untitled lithograph, p. 13
RENE BEEH, untitled lithograph, p. 19
MAX UNOLD, untitled woodcut, p. 22
WILLY NOWAK, untitled lithograph, p. 23

Issue 3:
WILLY GEIGER, untitled lithograph, p. 25
WERNER SCHMIDT, untitled lithograph, p. 27
MAX UNOLD, untitled woodcut, p. 29
WALTER TEUTSCH, untitled lithograph, p. 31
PAUL KLEE, "Schlachtfeld" *(Battlefield)* lithograph, p. 32, Kornfeld 62 II
RENE BEEH, untitled lithograph, p. 33
WERNER SCHMIDT, untitled lithograph, p. 36
EDWIN SCHARFF, untitled lithograph, p. 37
RICHARD SEEWALD, untitled lithograph, p. 38, Jentsch L7
FRANZ M. JANSEN, untitled woodcut p. 39

Issue 4:
FRIEDRICH FEIGL, untitled lithograph, p. 43
RENE BEEH, untitled lithograph, p. 47
ALFRED KUBIN, "Kriegsfurie mit Brandfackel" *(War Fury with Firebrand)*, lithograph, p. 51, Raabe 73
WILLY GEIGER, untitled lithograph, p. 53
A.H. PELLEGRINI, untitled lithograph, p. 55

1915

Issue 6:
ALFRED KUBIN, "Cäsarenkopf" *(Head of Caesar)*, lithograph, p. 75, Raabe 79
EDWIN SCHARFF, untitled lithograph, p. 81
RENE BEEH, untitled lithograph, p. 87

Issue 8:
MAX FELDBAUER, untitled lithograph, p. 109
FRANZ HECKENDORF, untitled lithograph, p. 119

309. **DER ZIEGELBRENNER** (The Brick Maker)
Edited by Traven Torsvan Croves (under the alias of Ret Marut)
Also mostly written by the editor.
Verlag "Der Ziegelbrenner."
Munich, 1917-1921
1-Jahr, Heft 1, 1 September 1917, 24 pp (1-24)
1-Jahr, Heft 2, 1 Dezember 1917, 23 pp (25-38)
2-Jahr, Heft 3, 16 März 1918, 22 pp. (49-71)
2-Jahr, Heft 4, 27 Juli 1918, 31 pp (73-104)
2-Jahr, Heft 5/6/7/8, 9 November 1918, 55 pp. (105-160)
3-Jahr, Heft 9-14, 15 Januar 1919, 96 pp. (1-96)

**Der**
**Ziegelbrenner**

**Zensur**

Alle Aufsätze, Besprechungen und Komödien,
die während des Krieges dem Ziegelbrenner
von der Zensur gestrichen wurden

Preis dieses Heftes
**3.60 Mark**

Verlag: „Der Ziegelbrenner", München 23

3-Jahr, Heft 15, 30 Januar 1919, 24 pp. (1-24)  309.
3-Jahr, Heft 16/17, 24 pp. (1-24)
3-Jahr, Heft 18/19, 3 Dezember 1919, 24 pp. (1-24)
4-Jahr, Heft 20/21/22, 6 Januar 1920, 48 pp. (1-48)
4-Jahr, Heft 23/24/25, 20 März 1920, 40 pp. (1-40)
4-Jahr, Heft 25-34, 30 April 1920, 72 pp. (1-72)
5-Jahr, Heft 35-40, 21 Dezember 1921, 20 pp. (1-20)
(Includes drawings by Franz Wilhelm Seiwert in last number)
21 x 12 cm.

The obscure history of Traven Croves will some day be un-
covered. He refused recognition in later life, and wrote under
various pseudonyms such as Ret Marut, Traven Torsvan, and
Hal Croves, and Bruno Traven.

He spent his early life in Munich as a radical, actor and socialist,
engaged in leftwing politics, the publication of this antiwar
journal until 1921, and reaction against political change. He
became very radical, seems to have lived as a sailor for a few
years, and finally emigrated to Mexico, where he wrote his
novels and essays in German. He had them published in Ger-
many first and then in numerous foreign languages. His first
novel was published in 1926, sent by mail to Büchergilde
Gutenberg, unasked for but accepted. His second novel was
the famous "Treasure of the Sierra Madre," published the fol-
lowing year. Most of the novels were concerned with the prob-
lems of the peasant or poor man. Though not distinguished in
use of prose, his action was lively, and the characters were

original. All his writings were sent through the mail from a post
office box in Mexico. He may have joined the "Wobblies" (IWW)
in Mexico.

Der Ziegelbrenner began as an antiwar, pacifist journal in Sep-
tember, 1917. The early issues also had selections from Shel-
ley, theater criticisms, and the like. But it was mainly about the
"others," the opposing youth, those against "murder and
rape," those true to this opposition. There were quotations
from the supporters of war, the German newspapers, and a
comparison of a cadaver found on the street with a shelled
soldier.

Using the false name of Ret Marut, Traven tried to keep the
authorities away from his publishing efforts. He moved the
postal address each month.

Traven was not pro anything. To him the British, French, Italian,
or Bulgarian blood lust was as savage as any German ruthless-
ness. Over and over he repeats the saying: "Life over death."
The third issue becomes almost hysterical in political criticism.
Theater criticisms are dropped. With the end of the war near,
Traven writes: "I damn the day. Think only how to make men
free." Referring to an ad from Ullstein Verlag, Berlin, Traven
writes a long critical article about the book," Manfred von
Richthofen, der rote Kampfflieger," ace of German aces, which
was advertised.

Issues become fewer, are concentrated from among many
issues into one booklet as police intervention is diverted by
devious measures and constant hiding. In January, 1919, the
publisher says: "The world revolution begins." One of the con-
tributors, a Professor Dr. Karl Horn, is murdered by reactionary
troops.

The magazine also printed criticisms of itself by other periodi-
cals. British papers call it nihilistic. The Pe, journal of the Ger-
man writers, calls it "a luxurious expressionist journal."
Simplicissimus calls it a "local rag." A Dortmund paper calls it
"middle-class-democratic."

Most of the correct information about Traven is taken from his
will, which was entered into Mexican records three weeks be-
fore his death in 1969. He had listed his birthplace as Chicago,
and his birthdate as May 3, 1890. His correct name was made up
from the names of his two parents, Traven Torsvan Croves.

DER ZIEGELBRENNER
9 November 1918, Heft 5/6/7/8, page 105
*Twilight of the Day*
by Ret Marut (Traven Croves)
(Traven's idealistic vision of a new day, an early example
of his thinking)
The storm closes!
Twilight brings day,
Be ready!
Sleep out of eyes, guys!
Twilight brings day!
A new day.
A new day?
A new day??
Be ready!
Think about it!
Words, words, nothing but words storm at me.
Where is the deed?
The new day?
Smashing with a club is no deed; a murder is no deed.
Think!
But words, words, nothing but words storm at me.
Break the world into a thousand, thousand splinters!
Make it like the loose sand of the desert
So not even one single remnant of the old wall
Darkens the sunlight of the new world.
Don't hang tightly to words!
Don't stay glued to old wisdom!
Work!
Complete, full, restless work!
The heavyweight superior thinkers, the shy ones, the superior
thinkers about justice

They will stop you soon enough.
Think!
Thinking only makes you a free one,
Thinking only makes you god-like.
Think about it!
The storm closes.
Twilight brings day.
Be ready to receive it!
Sleep out of eyes, guys!
Each may stand up for his own!
The single think, only, is mankind.
The storm closes.
The day begins
Think about this!

21 December 1921, Heft 35/40, Page 1.
*Seven Faces of the Time*
by Ret Marut (Traven Croves)
(A late example of his thinking. These words were written by
the former anarchist and now commited Communist writer at
the end of his time as publisher, writer for his own magazine,
black-listed actor and rather sour philosopher. Croves soon
left Munich under an assumed name).

It is "the time." Whoever wants to may read "our" time. By no
means however must it be called "my time." For My time is not
what grins here in brutal openness at the horrid truth. My time
stands in wild opposition to the time. I have no communion
whatsoever with the time which loafs and whores. I am not a
contemporary.

The person which in that form gave face to "the time," thought
the drawings were in straight opposition to the words, which
followed the faces. I wish they stood in the fold stronger oppo-
sition to the words. But there is no "stronger opposition." There
is only opposition, and opposition as I feel it has no adjective.

If I say "wild" opposition or "flaming" opposition, this would
not be emphasis but adornment. The spirit is freezing and
wants to warm on hearts blood.

The spirit feels contrast: the first thought storms into the world.
The matter feels contrast: the first primeval cell closes: the
storm becomes an individuum. Contrasts: the silent harmony
of the universe, enlivened unity of all things.

## ALMANACS

### 310. DAS AKTIONSBUCH *(The Action Book)*
Herausgegeben von Franz Pfemfert
Verlag der Wochenschrift "Die Aktion,"
Berlin-Wilmersdorf, 1917
Printed by F. E. Haag, Melle in Hannover
cover by Felixmüller
22.3 x 15 cm.
346 +6 pgs.

The reasons for this first collected almanac by Pfemfert were
probably connected with the war, which resulted in heavy cen-
sorship against periodicals, but allowed some freedom to book
publishers. There was also the wartime paper shortage and
disappearance of many trained printers and artists into the
army ranks. Other editors also diverted to book publishing dur-
ing this difficult time.

As the Aktion periodical was outspoken against "Volk" sick
patriotism, Pfemfert's continued efforts were made possible
only because of an important sponsor in the government.

The Aktionsbuch is no commercial almanac, as the editor
comments in the closing statement. It was his hope to cry alarm
in that time of folk murder against the way of death. He pre-
sented this collection as a prediction of the new spirit.

The articles, poems and essays are all taken from excerpts and
complete writing published in Die Aktion. Even during the war,
Pfemfert published French works by Peguy, Victor Hugo, Bal-
zac, Matisse, Laurencin and others. There is no unity to this
group, but the range is very wide. Included are literary descrip-
tions of books by Voltaire and Tolstoi; Chinese translations,

war correspondence, poems by Expressionists, some poetry
from New York, drawings by Kirchner, Matisse, Schrimpf, and
others who published in the main periodical. There are
thoughts about the German soldier and his revolutionary ten-
dencies. There are dissections of contemporary morality.
There is also satire, and essays about political corruption. All in
all, the range is so wide as to give no common view, but the in-
teresting combination contains much of early ecstatic poetry
and idealistic prose.

It is a unique book, which places Pfemfert's wide interests to-
gether for this one time, for he did not publish as extensive a
collection again. During the 1920's Pfemfert became so politi-
cal that the wider stances of his earlier years were lost in shrill
rhetoric.

DAS AKTIONSBUCH
Berlin-Wilmersdorf, Verlag der Wochenschrift
"Die Aktion." 1917

Excerpts:

*In the Morning*
By Jakob von Hoddis

A strong wind sprang up.
Opening the bleeding doors of the iron heaven.
Pounding on towers
Sounding brightly supple over the iron apartments
of the city.
The morning sun is sooty. Trains thunder on dams.
Golden angels plow through clouds.
Strong winds are over the pale city.
Steamers and cranes awake on the dirty flowing stream.
Disgusted bells bang in weather beaten domes.
You see many women and girls going to work.
In the pale light, wild from the night, their skirts wave.
Limbs created for love
Bend to the machine and disgusted toil.
See into the tender night.
Into the trees tender green.
Hark! The sparrows cry.
And outside on wilder fields
Sing larks.

*The Dreamer*
by Jacob van Hoddis

Blue green night, the silent colors gleam.
Is he threatened by the spear's red ray
And raw armourers? Do Satan's armies drive here?
The yellow flickers, which swim in the shades,
Are the eyes of immaterial horses.
His body is bare and pale, without defense.
A faded rose festers in the earth.

Denk an seine Bleisoldaten *(Think of His Lead Soldiers)*
By Irwin Piscator

You must cry now, mother, cry-
He was a boy, when he was small
Played with lead soldiers,
They were all fully loaded,
All died, kerplunk and silent.

Later the boy grew up,
Later he became a soldier,
Stood then in the field.

You must cry now, mother, cry-
When you read: "Dead as a hero."
Think of his lead soldiers...
They were all fully loaded
All died, kerplunk and silent.

Botschaft *(Message)*
By Ernst Stadler

You shall feel again that all strong and young
powers sweep around you,
That nothing stands still that heaven's gold
circles and stars float around you,
That sun and evening fall low and winds go

Over the wave steps of the ocean.
You shall reach, wildly into the light starred heaven
Through tumbling and breaking.

Did you think the tender harborlights could
Hold your sails,
Which blow up like young breasts, unruly
Pushing under a thin linen cloth?
Listen, in the dark are ghostly love voices,
Which flows and speaks to your blood —
And you wished to fold your hands
In devotion?

Feel: The light and rain of your dreams
Is dissolved,
The world is torn apart, Chasms pull and
Heaven's blue flames,
A storm is loose and blows your heart in
Melting embrace,
Until it sinks limitless down into the scream
of pleasure and joy and death.

## 311. DER ALMANACH DER NEUEN JUGEND AUF DAS JAHR 1917 *(Almanac of the New Youth from 1917)*
Edited by Heinz Barger
Verlag   Neue   Jugend
Berlin (1916)
Raabe 30
18.5 x 12.5 cm.

Begun in November, 1916, in an edition of 5000 examples, this first almanac was fated to failure from the start because of censorship during the war. Parliament had not yet voted changes, not taken censorship from the immediate responsibility of the General Staff, which looked unkindly on any anti war propaganda.

The publisher, Wieland Herzfelde, was still in uniform, delegated the editing to the writer, Heinz Barger. He had taken the name Neue Jugend from a school periodical to fool the censors.

The dedication is a quote from Walt Whitman: "The significant awaits from me to you," from an address to a poet. The contents are relatively anti war. There is an essay by Mynona on the war; letters from a dead soldier; Becher on the solidarity of socialist armies; Däubler's hymn to Nietzsche; an important essay about Whitman. There is an early story by Kafka. The drawings reproduced are by Kokoschka, Grosz, and Meidner.

After this issue the firm was closed, took a new name, Malik Verlag, after the title of a novel by Else Lasker-Schüler.

At the end of the volume is a bibliography with recommendations of the writers and lists of the publishers of their works. The new publishing house lists its own newly printed works. These include important first works by George Grosz, such as the first Grosz-Mappe, and the book of portrait reproductions by Meidner, Acht Köpfe, eight heads mainly of writers.

311.

DER ALMANACH DER
NEUEN JUGEND
AUF DAS JAHR
1917

VERLAG NEUE JUGEND · BERLIN

## 312. MENSCHHEITSDÄMMERUNG *(Twilight of Mankind)*
Symphonie jüngster Dichtung
Edited by Kurt Pinthus
Ernst Rowohlt Verlag
Berlin, 1920
XVI+316+4 pgs.
Raabe 126
21.3 x 13.5 cm.

Kurt Pinthus was an important writer and critic. He had been main reader for the Kurt Wolff Verlag in Leipzig; and later for Ernst Rowohlt, who had started anew in Munich after a period as editor for another company following the breakup with his first partner, Wolff, and later in Berlin. Pinthus found, promoted, and published most of the best younger poets.

This almanac of poetry, *The Twilight of Mankind,* was the most creditable summing up of the new poetry, and the most influential on a later buildup of the poets' reputations. It was a master grouping, due to Kurt Pinthus's impeccable judgment and taste.

The introduction to the collection states: "This poetry has intensity, radical nature, an expression of the new and better human ity, attitude and form as an attack against the past ages, an appeal for the new age they desire whole-heartedly."

Pinthus calls his book a *"Symphony of Newest Poetry,"* the end of an epoch. Its themes and variations consist of "collapse and scream," "discovery of the heart," "summons and indignations." Pinthus describes the book as more than a mere collection of poems; it is the collection. He is correct. The book has been described as a skeleton holding up to view the totality of the time.
There are twenty-three authors and twenty-seven poems.

After forty years Pinthus republished Menschheitsdämmerung with up-to-date bibliographies and new biographies of all the authors. The new pocket edition of 1959 had the same publisher and was a great success in German-speaking countries.

Pinthus used some illustrations by Expressionist artists such as Meidner, Barlach, Kokoschka, Lasker-Schüler, Lehmbruck, and Schiele for the fourteen illustrations.

*A Walk Through the Cancer Ward by a Man and His Wife*
By Gottfried Benn

The Man:
Here, this row has disintegrated abdomens
And this row has disintegrated breasts.
Bed stinks next to bed. Nurses change hourly.

Come, lift this blanket without minding.
See, this lump of fat and foul juices?
That was once a big man
And was called ecstacy and home. –

Come, look at this scar on a breast.
Feel the rosary of soft knots?
Feel without thought. The flesh is soft and insensitive. –

Here this one is bleeding as from thirty bodies.
No one has so much blood. –
Here a man has cut a child
Out of a cancerous womb. –

One lets them sleep. Day and night. – New ones
Are being told: Here one sleeps for health. – Only on Sunday
One allows wakefulness a little because of the visitors. –

Not much food is consumed any more. Their backs
Are chafed. You see the flies. Sometimes they
Are washed by nurses. As one washes a bench.
Here the ground reaches each bed.
Flesh flattens into land. Hearts give way.
Juices are ready to escape. Earth calls.

*Sommerfrishe (Health Resort)*
by Alfred Lichtenstein

Heaven is only a blue jellyfish.
And circled are fields, green hill tops jutting –
Peaceful world, you great mousetrap,

I escape you endlessly...Oh had I wings!–

One gambles. Drunken! One chatters about future states.
Over each hangs his shout.
The earth is a plump Sunday sausage,
Charmingly soaked in sweet sun sauce.

Yours the wind however...tattered with icy claws
The soft world. That was my finding.
Yours the storm however...There the beautiful blue
Eternal heaven is shredded a thousand times.

313.

### 313. DER MORGEN (The Morning)
Ein Almanach des Verlages Carl Reissner in Dresden
Carl Reissner Verlag
Dresden, 1926
157+5+19 pgs advertisements and biographies
23 x 15 cm.

A publisher's yearbook is an interesting selection of the peculiarities and varieties of public tastes of the time.

This publisher's almanac or yearbook celebrates the firm's approaching fiftieth birthday. The original publisher, Carl Reissner, began the firm in 1878. He died in 1906, and was succeeded by his son-in-law. The house published drawings and woodcuts by George Grosz, Käthe Kollwitz, Alfred Kubin, Heinrich Zille, among others. Its list of authors included Maurice Maeterlinck, Pierre Loti, Jacob Wassermann, Friedrich Ebert, and Lou Andreas-Salome, friend of Rilke and Nietzsche.

The publisher's preface of Der Morgen calls this yearbook a work for the "creation of a new land," work for the "morning of the future." It describes its own history as revolutionary. When he first began in 1878, Carl Reissner published poetry, novels of the school of Naturalism. The naturalistic drama of Gerhart Hauptmann followed, with these remaining the backbone of the firm.

Yet the collection is conservative, though tasteful, a typical effort of a major German publishing house. It contains much nationalistic mysticism of the twenties. Traditional works form many of the articles in the almanac: Hauptmann, Brandes writing about Shakespeare, Emil Coué on autosuggestion, an excerpt from Eulenberg's "Mensch und Meteor." But an occasional Expressionist variation appears with George Grosz, Kubin, and a late play by Franz Werfel.

314.

### 314. DIE NEUE DICHTUNG (The New Writing)
Ein Almanach
Kurt Wolff
Leipzig 1918
Raabe 45
18.5 x 12.7 cm.
Bibliography

Begun as a separate unit after the division of the earlier venture with Rowohlt in 1913, the Kurt Wolff Verlag became a less revolutionary center for the new young writers. The main reader for the firm was Kurt Pinthus, who befriended visiting writers, for Leipzig was a kind of pilgrimage center for German authors. Franz Werfel worked as reader also for some time, though mainly to benefit his stomach during trying years.

The gay and merry young people met in cafes and wine parlors, bringing friends and inviting those whom they admired. Max Brod introduced a group of German-writing authors from Prague, such as Kafka, Baum, Pick, Hasenclever.

This almanac of 1918 features the Prague Germans. The type of writing is both fantastic and Expressionistic. It ranges from the wild lines of Becher to aphorisms by Leonhard. There are selections from plays and an important discussion about drawings by Meidner. The elder statesman of Expressionism, Henrich Mann, writes about the young species of the time.

Wolff had already begun different publishing enterprises, and lists them in the back of the green-covered volume. Weisse Bücher, grown out of the periodical Die Weissen Blätter, had mostly native German writers. Wolff's Verlag published international authors such as Gorki, Anatole France, and others.

315.

The novel (Roman) is featured in a series. These were novels of individual development, influenced by Goethe's Wilhelm Meister.

In keeping with the ideas of the firm's designers, the illustrators are drawn from traditional backgrounds, not new intentions. Meidner is the sole "modern" artist. Wolff himself does not seem to have opinions about the art.

This green colored almanac was the fourth from the Wolff firm. The first, Das bunte Buch, was followed by a collection in the Der Jüngste Tag series, a 1917 collection called Der Neue Roman.

Die neue Dichtung (New Writing) is a cross section of Expressionist literature. The contents are not activist but emotional, inner creations. There is an important essay at the end of the book by Kurt Pinthus, head reader for Wolff, and collaborator more than employee. This essay analyzes the new "speech method" style of the new poets.

The lists of new publications following the main contents has two publishing houses: Kurt Wolff Verlag and Hyperion Verlag in Munich. Rowohlt, Wolff's original partner, worked for the Hyperion firm until later in the year when he started a new venture on his own. The list is a fine selection, showing the kinds of books these enthusiastic German publishing houses issued: collections of letters, erotic novels, new drama, Roman (inner development of a hero), love lyrics, illustrated books, journey and travel books, luxurious editions of the classics. Wolff had also backed the publishers of Die Weissen Blätter.

Wolff later emigrated to New York City, where he founded the great publishing house called Pantheon Books.

## 315. ALMANACH AUF DAS JAHR FRITZ GURLITT
(Almanach for the Year Fritz Gurlitt) Berlin: Fritz Gurlitt Verlag.
Almanach auf das Jahr 1919, 21.5 x 16 cm.
Almanach auf das Jahr 1920, 22.2 x 16.5 cm.
Das Graphische Jahr Fritz Gurlitt, 2 volumes, 1921 & 1923.
27.2 x 19.5 cm. and 26.8 x 19 cm.

These yearly almanacs were published from 1919, first in paper-bound pamphlets. The Fritz Gurlitt Verlag was founded by the art dealer as an outlet for the original art gallery. After 1920 the Almanach changed into a twice-a-year yearbook until 1923.

All the issues had original graphics. Later the publications had special editions on fine paper with extra prints, plus the regular edition for the public of about 1000 books.

Early almanacs were real ones with calendars. Articles described the activities of the gallery and its circle of artists. There were a few poems and critical articles to fill the space. The major intention was at the rear of the publication where new publications and new issues of prints and illustrated books were listed. The gallery also produced reproductions, some signed. Gurlitt listed the portfolios under the title "Die Neuen Bilderbücher" or as "Mappenwerke." Kokoschka and Pechstein had new portfolios.

Most of the artists were less important, such as Geiger, Janthur, Scheurich, Klein, Krauskopf. Most were in the figurative tradition, for Gurlitt was never known for any interest in abstraction. The gallery also published single prints by these artists, plus Corinth, Grossmann, Hettner, and Hodler. Most of these artists were associated with the Berlin Secession movement.

Fritz Gurlitt Verlag was also interested in Jewish themes, and started a publishing house devoted to them. It was called Verlag für Jüdische Kunst und Kultur, edited by E. Alexander and Karl Schwarz. They promoted the works of Perez and Gorelik, which were illustrated by Meidner, Steinhardt, Struck and Lesser Ury.

The volume for 1921-1922 was an analysis of graphic techniques in some detail. All the major mediums are outlined and explained. The volume for 1922-1923 is made up of autobiographical information about the gallery artists. It contains some of the major information about obscure as well as famous artists from Klee to Wimmer. The introduction is an outline of "The

Way of Graphics" by Edwin Redslob, an intricate criticism of developments from the time of Menzel until the new age.

**Original Prints in Fritz Gurlitt Almanacs**
**1919 Almanach**
1. Lovis Corinth; Selbstbildnis, (Self-portrait) 16 x 10.8 cm; not in Schwarz, lithograph
2. Richard Janthur; Ikarus, (Icarus) Lithograph, 15.1 x 8.3 cm.
3. Max Pechstein; Untitled, woodcut, 12 x 10.6 cm. not in Fechter

**1920 Almanach**
1. Max Pechstein; Umschlag, (Cover) woodcut, Fechter 159, 18 x 13 cm.
2. Lovis Corinth; Untitled, (Woman), 20 x 15 cm., not in Schwarz, lithograph
3. Lovis Corinth; Untitled, not in Schwarz, 5.8 x 5.3 cm. etching (Self portrait)
4. Max Pechstein; Kopf, (Head) Fechter 149 8x 10 cm.

**1921 Das Graphische Jahr, Pre-Publication edition, signed**
1. Lovis Corinth; Männliches Bildnis, (Man's Picture) drypoint, 13.5 x 11 cm.
2. George Grosz; Arbeitslose, (Out of Work) lithograph, 22 x 17.5 cm.
3. Felix Meseck; Mann und Frau, (Man and Wife) etching, 17 x 12 cm.
4. Max Pechstein; Weiblicher Kopf, (Female Head) woodcut, 10 x 8 cm.
5. Lovis Corinth; Lesender Mönch (Reading Monk) etching, 18.6 x 4.8 cm.
6. Richard Janthur; Frau mit Schakal, (Woman with Jackal) lithograph, 12.4 x 14.3 cm.
7. Paul Scheurich; Jüngling mit Turban, (Boy with Turban) lithograph, 19.4 x 15.8 cm.
8. Otto Schoff; Zwei Mädchen, (Two Girls) etching, 8.7 x 12 cm.
9. Wilhelm Wagner; Frau mit Pelz, (Woman with Fur) etching 6.9 x 9.8 cm.

## YEARBOOKS

**316. DIE ERHEBUNG** (Elevation)
Jahrbuch für neue Dichtung und Wertung
Edited by Alfred Wolfenstein
S. Fischer Verlag
Berlin
2 Volumes: 1919 (422 pgs., 22.2 x 14.5 cm.) and 1920 (385 pgs, 21.5 x 13.8 cm.)
Raabe 107

This brown paper-bound yearbook attempted a cross section of the new Expressionist literature in four parts: lyrical poetry, drama, epic poetry, and appreciations.

The second volume is a representation of new spiritual trends, a beginning study. The new peace was announced as a time of change, perhaps a real peace instead of an interval between wars. Spiritual power was declared to be a source of power for this turning point. New art was now beginning with a fertile task towards the future. The yearbook was announced as a comprehensive force showing the determined and truthful work of the young. "They will proclaim, announce, and show different methods of renovating the age. The attitude of the yearbooks will face wrongness with the truth of its words. It feels united with the peace movement which moves over the earth against the threatening numbness. It speaks to the new class of workers, the humane ones."

Alfred Wolfenstein was turning into an activist during this time. This meant personal activity, not just revolutionary literature. He had been a successful lyrical poet in the Aktion circle. Later he wrote about the comradeship of all men. He tried a cabaret, "Warring Brothers," failed, and remained a melancholy leader and propagandist for the new man.

Some of the titles in Die Erhebung tell the intent: "Each Man's Right to Happiness"; "Subjectivity," etc.

316/2.

Wolfenstein writes in the preface about the old being a tyranny, triumphant in all its forms during the miserable war time. But creative writing is a gift from the earth of the new, the beautiful peace time. The new is a fire of changing contour, not rigid oldness.

Samuel Fischer, the publisher, was a beloved man and the most important publisher in Berlin.

DIE ERHEBUNG
Zweites Buch, page 1
*The Boy*
By Kurt Heynicke

I am a torch lighted by the sun!
A brown boy am I.
Playing a green flute by day in the meadow.

Rising forth out of the dawn
With heavy fist on horse and plow,
I float ahead smiling over the waiting sod.
Oh, how the rye will blossom
But also blue weeds dream shyly
Around the borders of the field.

And the scythe shall sing,
Like my flute,
Which sounds then from the edge of the forest.

I am the spring, the summer, and the blessed fall.
My hips are heavy from the sun,
But my mouth dances
With my flute like a lark over the field.

Oh, let me be a smile
With the smile of an embrace
Because of humility,
As long as the soul has not given birth
To heaven, one bends down kissing the earth.

Erstes Buch, page 22
*To the Murdered Brother*
By Albert Ehrenstein

Oh child, never been, saw nothing!
The front was remote
The doctor only too near.

From repeated oddities by teachers
In mostly narrow houses,
You dreamed yourself into heroic patrols,
A caged butterfly in the web of war!
Drinking from the stars on the grey morning,
Hungry and coughing you did duty,
Running in dust out the end of streets,

Where soldiers receive moldy cornbread
Under a sad sky in the evening.

Then the pains came.
Proudly, you did not complain,
Not wanting to report sick in front of comrades.
Too many donors offered
Healthy appendix to the knife-arm.
You unconscious one, sick one,
Were called a fake by the army doctors.

And, pus filled days too late, the murderous
Job cursed by butcher doctors.
You endured the terrible torture tearlessly.
You, who had to see, while bleeding to death
In the Viennese hospital, dying men
punished in the dying room.

You faded listening to the good
Nurse Andersen's fairy tales,
The others live. For the heirs of the
Reigning Princes of your age,
Larks still sound noisily,
They play tennis, play behind the front .
War? Fame? Feudal make believe!
You got digitalis, injections,
Camphor, Saline solution, caffein.

Step into the primeval pain, the fever curve swells.
You were longing for home.
The last door opened.
In vain you resolved to
Drink a lot of milk and recover.
But you must sink down into the dead crowds.

317/1-5. **GANYMED** *(An Ancient Greek Deity, a God Not of Divine Birth. He was Noted for Extraordinary Beauty. He Became the Cup-Bearer of the Gods on Mt. Olympus)*
Blätter der Marees-Gesellschaft, edited by Julius Meier-Graefe, (year 1-2) R. Piper, Munich
Jahrbuch für die Kunst, edited by Julius Meier-Graefe with the assistance of Wilhelm Hausenstein, (year 3-5)
R. Piper and Verlag der Marees-Gesellschaft, Munich
1919-1925, Perkins 144
Year 1-2: 21.5 x 15.5 cm. Year 3-5: 28.3 X 21 cm.

This was a yearbook issued by the great art scholar, Julius Meier-Graefe. The dedication by name, Marees-Gesellschaft, refers to the German expatriate painter of earlier, Hans von Marees, who was seen by some as a direct ancestor of Expressionism.

Inspiration from Hans von Marees was an elevating influence as beginning and ending. The publisher stated his intention to focus mostly on his own time period, not that of Marees, nor Delacroix, nor Mozart. The past would be related to present thinking.

The editor Meier-Graefe had taught in Paris and Berlin, had an international taste, and wide acquaintanceship among scholars throughout Europe. He promoted modern art and had an early influence as propagandist for French Impressionism.

The society published in three categories: books, portfolios with original prints, and facsimiles.

These were fine years for the society. It had five years of publications. Editions were for bibliophiles. There were regular editions of 200 to 300 books (1000 later) and also special editions of 50 numbered copies, sometimes on japan paper with an extra print. After the third year, portfolios were issued to accompany the yearbook, usually given to pre-subscribers.

The Marees-Gesellschaft society had previously issued a great portfolio, the Shakespeare Visionen, in 1917, and illustrated books by Grossmann, Unold, and Beckmann.

Meier-Graefe's troubles with the publishing business are documented by the irregular issues of books and prints. The first issue of 1919 came with a separate print and included four original prints. Again four prints were included in the 1920, 1921

and 1922 issues, and the 1922 yearbook had an accompanying portfolio of prints. The publisher could not finance an issue for 1923, but a portfolio of contemporary prints was sold. There was no yearbook in 1924. The last Ganymed appeared in 1925, with a portfolio of fourteen signed prints.

Meier-Graefe tried to hire great designers for the yearbooks. E.R. Weiss did most of the designing. The yearbook's page size varied as income diminished with inflation, but was increased in later years.

List of Original Prints in Ganymed

Erster Band, 1919
28 illustrations
Logo by E. R. Weiss; editions: 50 numbered, 300 for subscribers; 158 pp, 21.5 x 16 cm.

Original lithographs by Rudolf Grossmann:
1. Der Kunstfreund *(Lover of Art)*, 15 x 10.5 cm.
2. Freude am Schönen *(Delight for Beauty)*, 14.2 x 10.3 cm.
3. Der Kunst Händler *(Art Dealer)*, 14 x 11 cm.
4. Der Unverstandene *(The Misunderstood)*, 14 x 11 cm.
5. Der Kritiker *(The Critic)*, 14 x 11 cm.

Zweiter Band, 1920
39 illustrations
Editions: pre-publication of 100 examples on japan paper, 1300 examples; 244 pp, 21.5 x 16.7 cm.

Original etchings by Otto Schubert:
6. Frühling *(Spring)*, 11.7 x 9.2 cm.
7. Sommer *(Summer)*, 12.2 x 9.2 cm.
8. Herbst *(Autumn)*, 11.8 x 9 cm.
9. Winter *(Winter)*, 12.2 x 8.8 cm.

Dritter Band, 1921
59 illustrations
Editions: patron edition of 200 examples with portfolio, 1150 examples without portfolio, 214 pp, 28.5 x 21 cm.
10. Max Beckmann, Bildnis Dostojewski (titled Dostojewski II) *(Portrait of Dostoyevsky)*, drypoint, Gallwitz 160b, 16.8 x 11.8 cm.
11. Karl Hofer, Tanzerin *(Dancer)*, lithograph, Rathenau 169, 21.5 x 14.2 cm.
12. Adolf Schinnerer, Der Kinderhirte *(The Children's Shepherd)*, etching, 15 x 15 cm.
13. René Beeh, Bettler *(Beggar)*, lithograph, 24.3 x 13.5 cm.
14. Rudolf Grossmann, Der alte Gartner *(Old Gardener)*, etching, 20 x 14.5 cm.
15. Alfred Kubin, Jeremias *(Jeremiah)*, lithograph, Raabe 142, 12.5 x 9 cm.

For pre subscribers, the following separate portfolio was included with the yearbook. The portfolio has signed examples of the above prints in addition to the following:
16. Lovis Corinth, Tiergarten *(Animal Preserve)*, to the etching, Schwarz 471, 13 x 18.2 cm.

317/36.

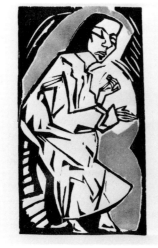

17. Rudolf Grossmann, Die Grossmutter *(The Grandmother)*, hand-colored lithograph, 31 x 27.5 cm.
18. Bernhard Kretzschmar, Der Fleischerladen *(The Butcher Shop)*, etching, 26.3 x 29.5 cm.
19. Alfred Kubin, Tier auf der Alm *(Bull in the Alpine Pasture)*, lithograph, Raabe 144, 24.8 x 21.5 cm.
20. Richard Seewald, Stadt *(City or Ascona, 1921)*, woodcut, Jentsch H 108
21. Max Slevogt, Phantasie nach der Dante Barke *(Fantasy After the Dante Barque)*, etching, 23.3 x 29.5 cm.
22. Max Unold, Kinder auf der Strasse *(Children in the street)*, lithograph, 30 x 22 cm.

Vierter Band, 1922
77 illustrations
Editions: 300 for patron edition with extra portfolio in addition to the yearbook, 2370 examples without the portfolio, 314 pp. 28 x 21 cm.
23. Franz Hecht, Aus der Legende des Heil. Franz, nach Taddeo Gaddi *(From the Legend of St. Francis after Taddeo Gaddi)*, woodcut, 17.4 x 13.9 cm.
24. Max Beckmann, Tanzende, *(Dancers)*, woodcut, Gallwitz 197, 18 x 10.5 cm.
25. Heinrich Campendonk; Die Bettler, nach Brueghel, *(Beggar after Brueghel)*, woodcut, 14.2 x 17.3 cm., Engels 62
26. Richard Seewald; Aus dem Camposanto, *(On the Camposanto)*, woodcut, 14 x 17.7 cm. Jentsch H. 116
27. Felix Meseck; Landschaft mit Ziegen, *(Landscape with Goats)*, etching, 19.5 x 14 cm.
28. Max Unold; In Memoriam René Beeh, woodcut, 18 x 13.8 cm.

For Pre-subscribers a separate portfolio of signed prints including the six above plus the following:
29. Paul Kleinschmidt; Bei der Kartenschlagerin, *(Near the Fortuneteller)*, etching 33 x 22.7
30. Karl Hofer; Novize, *(Novice)*, lithograph, 21.5 x 14.2 cm. Rathenau 169
31. Franz Hecht; Die Stadt, *(City)*, woodcut, 24.5 x 19.5 cm.
32. Karl Rössing; Der Eingebildete Kranke, *(The Imaginative Sick One)* woodcut, 19 x 13 cm.
33. Peter Trumm; Coriolan und seine Mutter, *(Coriolanus and his Mother)*, woodcut 24.5 x 31.7 cm.
34. Rudolf Grossmann; Zigeunerwagen, *(Gypsy Wagon)* etching 16.7 x 12.7 cm.

Fünfter Band, 1925
68 illustrations
28.3 x 21.5 cm., 248 pp.
editions: 100 examples with extra portfolio plus book
1000 examples without portfolio
35. Hugo Troendle; Brücke, *(Bridge)*, lithograph 14.5 x 19 cm.
36. Erich Heckel; Frau, *(Woman)*, color woodcut, 18 x 10.5 cm., Dube 259 ii
37. Hans Gött, Schlafendes Mädchen, *(Sleeping Girl)* etching, 13.2 x 21 cm.
38. Adolf Schinnerer; Überfahrt, *(Passage)* etching, 12 x 18.5 cm.
39. Rudolf Grossmann; Jahrmarkt, *(Fair)* etching, 15 x 19.5 cm.
40. Otto Nückel, Regenwetter, *(Rainy Weather)* metal print, 18 x 13.5 cm.

For pre-subscribers a separate portfolio was included in addition to the six above prints and contained:
41. Lovis Corinth; Frauenbildnis, *(Head of Woman)* lithograph, not in Schwarz.
42. Karl Caspar; Kluge Jungfrau, *(Wise Virgin)* color lithograph
43. Franz Hecht; Holzschnitt nach einem altitalienisches Meister, *(Woodcut taken from an old master from Italy)*
44. Wassily Kandinsky; Unbenannter Holzschnitt, *(Untitled)* woodcut, Roethel 181
45. Felix Meseck; Jagd, *(Hunt)* etching
46. Max Beckmann; Zaratelli, etching, Gallwitz 247
47. Reproduction: Renoir
48. Reproduction: Picasso

**318. DAS GRAPHISCHE JAHRBUCH** (*The Graphics Yearbook*)
Edited by Hans Theodor Joel
Karl Lang Verlag, Darmstadt, 1920
55 pgs + 2. 12 text pictures and 32 full-page plates
1 original woodcut by Schmidt-Rottluff, 1 original woodcut by Gottfried Graf, and 1 original lithograph by Walther Ruttmann.
22 x 17 cm.

Hans Theodor Joel was a writer and publisher mostly in the Munich area. He also edited the periodicals Der Weg and Die Neue Bücherschau, introducing new writers and poets. Joel was hired by the Karl Lang publishing company, which issued some prints and promoted Expressionism at this time.

As Joel mentions in his preface, this was to be a kind of day-book of the period, with emphasis on black and white graphics. Art was to him not singular, but of a thousand varieties. He chose examples from major galleries in Germany: Goltz, Flechtheim, Richter, and the Munich publishing center, Marées-Gesellschaft.

Essays are also included and range from short articles about form, the beginnings of a new German graphic art, Beckmann, Meier-Graefe, to autobiographies by individual artists. Joel had a chance to pick from his favorites and these were men such as Meidner, Beckmann, Kokoschka, Gleichmann, Gramatte, Kaus, and late Expressionists.

The Lang publishers were also responsible for Die Fibel portfolio, collections, which included Feininger and Gramatté. Most of the prints reproduced in Das Graphische Jahrbuch were for sale at the Lang book store.

Original prints in Das Graphische Jahrbuch, 1919
1. Karl Schmidt-Rottluff; Kopf, (*Head*) woodcut, 18 x 12
Schapire 253 (Kleine Prophetin) (*Small Prophet*)
2. Gottfried Graf; Untitled, woodcut, 15.6 x 9.7 cm.
3. Walther Ruttmann; Untitled, lithograph, 16 x 10 cm.

318.

DAS GRAPHISCHE
JAHRBUCH

Herausgegeben von
HANS THEODOR JOEL

KARL LANG VERLAG / DARMSTADT

**319. DAS HOLZSCHNITTBUCH** (*The Woodcut Book*)
Paul Westheim
Gustav Kiepenheuer, Potsdam, 1921
editions: 100 examples, each print signed, bound in half parchment, with 5 hand colored old master woodblocks
regular edition unknown
25.6 x 20 cm., 192 pp, 4 original woodcuts by Heckel, Feininger, Campendonk and Schmidt-Rottluff.

During the nineteenth century there was a renewed interest in printmaking by finer artists. Academies taught the techniques. Certain skilled technicians opened studios to print for artists. Many publications appeared, which explained the techniques in detail. Other publications explained the results to a rising middle class public ready for education in the field. Paul Westheim, editor of Das Kunstblatt, followed these other specialists with this book about the woodcut which differs because of his emphasis on modern art.

Westheim begins by asking the artist of the 20th century to look at his aesthetic background. He then describes the time of Gutenberg and the beginning of printing, the early block book and the religious print of the fifteenth century. Some of the early techniques are described.

Throughout most of the book, Westheim lectures to the modern artist in pedantic terms. His final chapters try to take us out of the "upper air atmosphere" of the ignorant-but-highly-motivated. Westheim is direct with descriptions about technical solutions by Munch and Kirchner. He had placed the elements of woodcut in the direct line from the primitive woodcuts of the late fourteenth century to modern conventions. He asks the artist to come out of the exalted atmosphere of the atelier and enter the history of woodcut with uncut energy.

Original Prints in Das Holzschnittbuch, 1921, each signed

1. Heinrich Campendonk; Frau mit Blume, (*Woman with Flower*), woodcut, Engels 32, 18 x 12.1 cm.
2. Lyonel Feininger; Segelboote (Mit Mond) (*Sailboats with Moon*), woodcut, Prasse W 183 iii
14.8 x 17 cm.
3. Erich Heckel; Zwei am Meer (*Two by the Sea*), woodcut, Dube 326B, 17.8 x 13.6 cm.
4. Karl Schmidt-Rottluff; Gespräch vom Tod, (*Speaking about Death*), woodcut, Schapire 267   17.8 x 13.3 cm.

**320. JAHRBUCH DER JUNGEN KUNST** (*Yearbook of New Art*)
Edited by Professor Dr. G. Biermann
Klinkhardt & Biermann
Leipzig, 1920-1924
Perkins 150
1919-20: 27.3 x 21 cm.
1921-24: 29 x 21 cm.

Dr. Georg Biermann was a very successful publisher in Leipzig. He was also the general director of all art and crafts for the city of Cologne, and an important art historian as well. His further credits include Der Cicerone and Monatsschrift für Kunstwissenschaft (*Art History and Culture*). His magnificent series of small books about the young European painters, Junge Kunst, remains a landmark of the kind.

The first volume of this yearbook was in 1920. We have the next three. There were also subscribers' copies in an edition of one hundred with an extra signed print. Unsigned and original graphics fill all the volumes of this series. Biermann used his own extensive scholarship and also hired the most important critics to write about the most important artists of the time. Some of the major articles were about Heckel, Munch, Picasso, Matisse, Laurencin, and Barlach. Other critical essays outlined various movements such as Expressionism, Impressionism, Dada, art as a psychological-sociological problem, profiles of some American painters, and the usual antinaturalism.

There are original works by Felixmüller, Campendonk, Grosz, Beckmann, Coubine, Archipenko, Dix, Masereel, and others of the German and French.

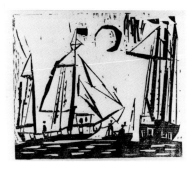

319/2.

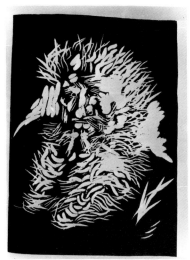

320/7.1920

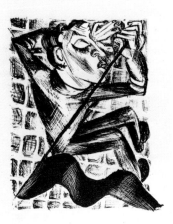

321/6.

In later issues are important monographs about Hodler, Feininger, Klee, Moholy-Nagy, Munch, Kandinsky, Foujita, Dix, Joseph Stella, and Karl Hofer, and Matisse.

Biermann also published a yearbook about Asiatic art. His periodical, Der Cicerone, was the first great international art magazine with regular articles from America and Europe.

Original Prints in Jahrbuch der Jungen Kunst
1920
1. Max Pechstein; Fisherhafen *(Fishing Port)* lithograph, 24.8 x 16.5 cm.
2. Franz Nietzsche; Leid *(Grief)* woodcut, 19.7 x 15.9 cm.
3. F. Adam Weber; Am Brunnen *(At the Fountain)* woodcut, 20.7 x 15.9 cm.
4. Lyonel Feininger; Buttelstedt *(City of Buttelstedt)* woodcut, Prasse W 208, 20.3 x 15.5 cm.
5. Erich Waske; Sonnenaufgang *(Sunrise)* lithograph, 19.5 x 14.6 cm.
6. Max Burchartz; Frau vor dem Fenster *(Woman By a Window)* lithograph, 17.8 x 14.6 cm.
7. Wilhelm Morgner; Bärtiger Mann *(Bearded Man)* linocut, 22.9 x 17.2 cm.
8. Josef Eberz; Versöhnung *(Reconciliation)* lithograph, 18.4 x 14.7 cm.

1921
1. Heinrich Campendonk; Landschaft mit Ziegen und Wildkatzen *(Landscape with Goats and Wildcats)* woodcut, Engels 48, 15.2 x 17.8 cm.
2. Franz Heckendorf; Landschaft *(Landscape)* lithograph, 18 x 24 cm.
3. Ewald Mataré; Landschaft, woodcut, 14.5 x 22 cm.
4. George Grosz; Thomas Rowlandson zum Andenken *(With Thanks to Thomas Rowlandson)* lithograph, 26.5 x 20 cm.
5. Joseph Achmann; Familie *(Family)* woodcut, 16.2 x 14 cm.
6. Eberhard Viegener; Samson, woodcut, 12.6 x 10.4 cm.

1922
1. Max Beckmann; Liebespaar *(Lovers)* lithograph, Gallwitz 267, 20 x 14 cm.
2. Robert Kohl; Untitled *(Family)* lithograph, 19.5 x 28.3 cm.
3. Wilhelm Kohlhoff; Der Reiter *(Rider)* lithograph 22 x 18 cm.
4. Bernhard Kretzschmar; Der Schöne Sonntag *(Beautiful Sunday)* lithograph, 26 x 19 cm.
5. Walter Teutsch; Schaferszene *(Willow Scene)* woodcut, 20 x 15.2 cm.
6. F. M. Jansen; Zeitgenossen *(Contemporaries)* woodcut, 20 x 15.5 cm.

1923
1. Othon Coubine; Mädchenkopf *(Girl's Head)* lithograph, 22 x 15 cm.
2. Georg Schrimpf; Zwei Frauen mit Kind *(Two Women with Children)* lithograph, 19 x 16 cm.

3. Carlo Mense: Arkadische Landschaft *(Arcadian Landscape)* lithograph, 14 x 20 cm.
4. Conrad Felixmüller; Liebespaar *(Lovers)* woodcut, 22.5 x 16.8 cm., Söhn 314
5. Alexander Archipenko; Doppelakt *(Double Models)* lithograph, 28 x 19 cm.
6. Karl Friedrich Gotsch; Knabe im Mondschein *(Boy in Moonlight)* woodcut, 19 x 19 cm.

1924
1. Otto Dix; Kinderbildnis *(Child's Head)* lithograph, 27 x 20 cm. Karsch 126 ii
2. F. Marchand, Strassenansicht *(Street View)* lithograph, 15.8 x 21 cm.
3. Franz Masereel, Untitled *(Kneeling Man)* woodcut, 11.2 x 8.8 cm.
4. Charles Crodel, Untitled *(Landscape)* color lithograph, 16.4 x 22 cm.
5. J. E. Laboureur; Untitled *(Man and Woman in Landscape)* lithograph, 21.5 x 15 cm.

321. **DAS KESTNERBUCH** *(The Kestner Book)*
Edited by Dr. Paul Erich Küppers
Heinrich Böhme Verlag
Hannover, 1919
158 + 2 pgs. 12 illustrations
Raabe 139, Perkins 134
29 x 23 cm.

Printed in the winter of 1919 by Edler and Krische in Hannover, this yearbook used a half-linen binding, and included the leading artists who joined Kestner Gesellschaft in Hannover. The Kestner Museum had promoted young artists for over fifty years and still continues to do so. In conjunction with exhibitions, portfolios and single prints and posters were published for subscribers and also continue to this day.

Paul Erich Küppers organized the first group effort and put together this yearbook, the first published after the war. He was a tragic figure, an intelligent pupil of Wilhelm Worringer, but suffering from tuberculosis since 1912. His later book about Cubism (1920) was a major work. Küppers had been the head art advisor to the Kestner Gesellschaft since 1916. He succumbed to disease five years later.

Küppers's taste was apparently unchecked and he chose his favorite writers and artists. These included a wide range among men such as Thomas Mann, Alfred Döblin, Mombert, Worringer, and Walt Whitman (Spelled Whitmann). Original prints included woodcuts by Heckel, Unold, Seewald, Felixmüller, Barlach, Klee, Feininger, and the one painter from Hannover, Kurt Schwitters.

**Original prints in Das Kestnerbuch**

1. Erich Heckel; Männer am Strand *(Men at the Beach)* woodcut, 1919, Dube 319 iiB, 17.5 x 13.4 cm.
2. Wilhelm Plünnecke; Untitled *(Man and Woman before a City)* woodcut, 17 x 13.1 cm.
3. Max Unold; Untitled *(At the Table)* lithograph, 17 x 13.2 cm.
4. Richard Seewald; Wäscherinnen am Lago Maggiore, *(Washerwomen at Lake Maggiore)* lithograph, 1919, Jentsch L. 91, 13.5 x 18.2 cm.
5. Eberhard Viegener; Untitled *(Discussion)* woodcut, 16.8 x 12.8 cm.
6. Felixmüller; Toter Genosse *(Dead Comrade)* lithograph, 1919 Söhn 76B, 17.2 x 14.2 cm.
7. Otto Gleichmann; Untitled *(Two Men)*, lithograph, 7.5 x 14.3 cm.
8. Ernst Barlach; Barmherziger Samariter, *(The Good Samaritan)* woodcut, Schult 163, 17.6 x 12.9 cm.
9. Paul Klee; Auslöschendes Licht *(Extinguishing Light)* lithograph, 1919, Kornfeld 75B, 16 x 13 cm.
10. Max Burchartz; Untitled *(Man with Fish)*, lithograph 17.3 x 13.2 cm.
11. Lyonel Feininger; Rue St. Jacques, Paris, woodcut, 1918 Prasse W 46 ii, 13.6 x 11.5 cm.
12. Kurt Schwitters; Untitled, woodcut, 1919, 18.8 x 12.2 cm.

322.

**322. DAS NEUE HAMBURG** *(The New Hamburg)*
Edited by Karl Lorenz
Printed by Hartung, Hamburg
31.5 x 24 cm., 189 pp
450 examples: 50 on Bütten, 100 on Hadern Bütten
Gemeinschaftsverlag Hamburgerischer Künstler
Hamburg, 1923, cover woodcut by Karl Opfermann
With woodcuts by Paul Schwemer (3), Adolf Bauer-Saar (3), Claus Wrage (3), Otto Niebuhr (3), Heinrich Stegemann (4), Karl Opfermann (3) plus cover, Gerhard von Ruckteschell (3), Emil Maetzel (3), Robert Köpke (3), Kurt Lowengard (3)

Already in this early period of the 1920s, the emphasis in this conservative city of the north is on less political matters. Instead becomes a real cross section of poetry and graphic art in the Hanseatic city. The poetry is also conservative, as though the experimentation of the Sturm writers had not existed. Art in Das Neue Hamburg is most influenced by Marc and Feininger, also from the early Brücke cameo prints and the ever present influence of Schmidt-Rottluff in this city. The prose is romantic and elevated. There are impressions in prose of seascapes, towns, and episodes during the day. The long influence of von Hofmannsthal is evident and continuing in the heightened emotion, the clear yet precious language. After the revolutionary speech of the earlier periodicals edited by Karl Lorenz, this yearbook, the only one published in this series, seems tame.

**323/1. UNSER WEG 1919** *(Our Way)*
Ein Jahrbuch des Verlags Paul Cassirer
Paul Cassirer Verlag
Berlin, 1918
With an original lithograph by Max Liebermann
*(Man Reading)*
117 + 1 pgs
24 x 18.7 cm.

**323/2. UNSER WEG 1920**
Ein Jahrbuch des Verlags Paul Cassirer
Paul Cassirer Verlag
Berlin, 1919
With an original woodcut by Ernst Barlach, Gruppe in Sturm *(Group in a Storm)*, Schult 162
136 pgs.
Raabe 182, Perkins 153
24.3 x 18.5 cm.

Unser Weg, 1919 and 1920 were two yearbooks issued by the Paul Cassirer publishing house and art gallery to promote its artists and authors. Each issue of *Our Way* contains an original print. Selections of new and recent work by the gallery's graphic artists were listed. It mounted Impressionist more than Expressionist exhibitions, for Cassirer had promoted Expressionism only lately, while Impressionism had interested him since the late nineteenth century. Lovis Corinth and Liebermann were close friends of the publisher.

The listed authors are political, anarchistic, lyrical, post-romantic, middle-of-the-road Expressionist. There are selections from books by Kropotkin, Franz Marc's letters from the Front, letters of Rosa Luxemburg, a play by Kokoschka called *Orpheus,* an Expressionist play by Hasenclever called *Antigone,* a critical essay by Max Deri about Cezanne. At the end of the volume were lists of new prints by gallery artists. These include Barlach, Beckmann, Grossmann, Heckel, Kokoschka, Liebermann, Meid, Munch, Purrmann, Slevogt—an imposing group.

The 1920 issue also presents an important group of writers with more selections from politics, drama, criticism, novels, some aphorisms by Franz Marc. There is no separation of socialism into Bolshevist or social democratic parties. Most socialist ideas were still humanitarian, not doctrinaire. The German communist party had not yet been formed out of the split in the large following of socialists.

Cassirer later became anticommunist, or as he called it, anti-Bolshevist; but retained strong collaborations with the German socialists. Cassirer sets down his views at the end of the second volume. He is for freedom of expression for both the left and right. He wants a path separating his ventures from the tragedy of the fallen soldiers of all countries. He wants a day of new politics. He wants to continue the tradition of publishing great literature, which would include messages from the young, ethical socialists. The graphics are supposed to be representative of the Berlin Secession group.

At the end of each volume, Cassirer lists the fine illustrated books of the Pan Presse, founded long before to publish the Pan magazine, and kept as part of the Cassirer firm for its best efforts in publishing.

# BOOK SERIES

### 324. DIE AKTIONS-LYRIK *(Lyrical Poetry from Die Aktion)*
Volumes 1-7
Edited by Franz Pfemfert
Verlag der Wochenschrift Die Aktion
Berlin-Wilmersdorf, 1916-1922
21.2 x 13.8 cm. (Vol. 5) Raabe 149

Seven different collections of lyrical poetry were selected and published by Die Aktion. Volume 1 and 2 were anthologies, the first of German and the second of Czech poets. The lyrical style changed with Gottfried Benn's morbid works as the third. Drawings were added with the fourth. The emphasis then became activist, with anti-war poetry for the last volume as Pfemfert changed his politics.

Pfemfert was a collector of poetry and poets. He published those works out of the periodical which were to his liking. In this way he tried to develop a new age of lyrical poetry in Germany. The poet was told to be proud of his profession. "Thousands of hands move, it is a joy to create poems." In the introduction, Peter Scher wrote: "Consumers try to escape from the unjust things. People on their way to the stock market eat up the optimistic lyrical poems. Bakers push their bread into the ovens with a new pathos. Conductors of trains step on the bell of warning with the free lyrics hidden in their clothing."

Pfemfert was a great instigator and developer of new things. He depended on will power and great discretion. He aroused feelings of friendship and friendliness among the young writers and artists, a wish to belong together, which had not existed before. During the war years, Pfemfert kept the hope of lyrical poetry alive, made room so poets could be heard, sounded the music of hope through the moral collapse in Germany. "Poetry, which before was a symbol of Cain, has become a symbol of new time, whose toast is confronted by 'good dinner' from the poet."*

* Die Aktion. Jahrgang 3 (1913, Nummer 27 vom 27 Juni: Lyrische Anthologie. Peter Scher's foreword. All quotes in this essay are from this foreword.)

### 325. DER JÜNGSTE TAG *(Judgment Day)*
Kurt Wolff Verlag
Books 1-75 published in Leipzig; Books 76-86 published in Munich
Books 1-86 (Some double numbers)
Raabe 145
20.7/21.7 x 12.7/13 cm.

In the spring of 1913, Wolff, Hasenclever the dramatist, and Kurt Pinthus, head reader for the Wolff firm, were sitting in a bar. Inspiration for the series came from the Insel volumes of slim books by famous authors at a reasonable price, though this new series by the Wolff establishment was to present young or still unknown authors. The title of Der Jüngste Tag *(The Last Judgement)* was chosen after a random selection by pencil in a book of poems by Franz Werfel struck the poem *We Are*. There were thirteen double volumes, so the actual number of individual volumes was 73, not as numbered to 86.

Many advisors made selections, and the editorial board of Wolff, Pinthus and Werfel kept the quality of the contents very high.

As in many cities, the meeting places in Leipzig seem to have been wine cellars such as "Wilhelm's" and an ancient restaurant called "Kaffeeborem."

Early issues included some of the most talented writers in the German-speaking countries: Kafka, Hasenclever, Trakl, Ehrenstein, and some of the Czech poets introduced by Hasenclever, who was from Prague.

This became an inspiration for the younger generation of German readers. The slim and inexpensive volumes (80 pfennings) presented the most divergent trends of Expressionism.

Wolff eventually expanded into art books and became the leading exponent of German Expressionist writing and art books, though he later refused this description and thought himself more an internationalist. Wolff's prospectus describes the new series in these terms: "The new poet shall be absolute. He shall start from the beginning ....That poet who hour after hour tries to find that realization is turbidity and delusion." Franz Werfel.

Some of the covers have reproductions of important drawings by Meidner, Kokoschka, Starke, Feininger, and others. The first covers were printed in different colors, but after volume 34, uniform covers were used. The series was a major influence on other series of Expressionist art and poetry books. Wolff had asked the young poet to arise, to know that his poems were more than a small drop in interlocking life, but that writing was a duty, a prophesy of coexistence and death.

Der Jüngste Tag was used again and again in Germany. Its first use was in an anonymous High German poem of c. 1270, as a use of the day of judgement in conjunction with a message of sympathy toward the poor and oppressed.

324.

325.

323/2.

DIE AKTIONS-LYRIK
HERAUSGEGEBEN VON FRANZ PFEMFERT
DÄUBLER / DER HAHN

VERLAG DIE AKTION / BERLIN-WILMERSDORF

MAX BROD
DIE ERSTE STUNDE
NACH DEM TODE

DER JÜNGSTE TAG · 52
KURT WOLFF VERLAG · LEIPZIG
1917

## 326. STURM-BÜCHER (Books From Der Sturm)

Verlag Der Sturm
Berlin, 1914-1919
16 volumes (1-14, [15], [16])
Raabe 147
20 x 13 cm. (Vol. 6)

Walden had a belief in his writers beyond the monthly deadline of Der Sturm. He tried to create a huge publishing series of books by these men and women of the Sturm circle. The writers were his friends, devoted friends in this early time. Authors were published in a shortened series because of paper shortages during the war. They included August Stramm, Mynona (S. Friedlaender), Aage von Kohl, Adolf Behne, Peter Baum, and Lothar Schreyer. Behne and Schreyer wrote about art. Kohl was a translator, working from Nell Walden's Danish texts.

August Stramm was the most creative thinker of the entire group. He had begun as a traditional poet, seen the effect of Futurism and Cubism on language, used this inspiration with German prose, drama, and poetry, and rearranged grammar. He made new word combinations, also, under the influence of the French symbolists, placed his lines of verse in picturesque positions sometimes, while supporting himself as a high official for the German post office department. Stramm bloomed just before the war, produced a large amount of original works in drama and poetry within a two-year period, left behind only this work as he had destroyed earlier efforts. Stramm was killed on September 1, 1915, during an attack on the Russian front.

The other major poet, Peter Baum, was introduced to Walden by Else Lasker-Schüler. Kokoschka had painted him. Baum was also killed in the war in June, 1916.

Mynona was a doctor of medicine, born in German Posen. His real name was Salomo Friedlaender. He was an all around writer, poet, essayist, critic. He wrote about Kant, Goethe, Schopenhauer, Nietzsche. Under the name of Mynona, a reversed anagram for anonym (anonymous), he worked in various styles, Expressionist, grotesque, lyrical. He worked for Der Sturm, Die Aktion, and other periodicals as a free-lance writer. He emigrated after 1933 to Paris.

After 1919, Walden turned to politics more and more, perhaps because some of his major artists had left for other art galleries, and many of his poet friends had been killed in the war. The series Sturm-Bücher ended with a volume on theater as art work, published about the time Walden and Schreyer started the Sturm theater project.

## 327. DER ROTE HAHN (The Red Rooster)

Edited by Franz Pfemfert
Verlag der Wochenschrift Die Aktion
1917-1925
21.7 x 13.5 cm.
Band 1-59/60 (42 different booklets, 25 single issues and 17 double issues).

The title of this series was taken from the play by Gerhart Hauptmann, which was published in 1901. It was performed at the Workers' theater in Berlin. The symbolism contains both a message of dawn and left wing activity.

Franz Pfemfert published many series from different standpoint. His series of small books called Aktions-Bücher der Aeternisten, was originated for Ferdinand Hardenkof's proclamation about the Eternity Group.

Die Aktions-Lyrik was intended to present lyric poets of the new generation. A Politische Aktions-Bibliothek was created to provide an outlet for essential but radical political tracts.

The Rote Hahn was a series of small pamphlets which was created to provide a more permanent method of printing articles and essays from the periodical Die Aktion. It also was necessary to use this medium because of military censorship of the mother periodical during the war.

Pfemfert, himself, selected the articles, edited them and sent the manuscripts out for bids at journeyman printers. He did not oversee the final design.

The series began as mainly literary, with some foreign writers being introduced to the German public. There was a tendency to keep the books in a modern and radical idiom, but after 1918, Pfemfert's revolutionary growth intruded and cast aside the earlier intentions, as they had done with all his other publications. From the creative prose of Iwan Goll in 1918, the tendency moved into the radical essays of Bogdanov, Lenin, Lunatscharski and Karl Marx. It finally became a vehicle for socialist propaganda.

## LIST OF EXPRESSIONIST ILLUSTRATORS AND DRAFTSMEN

Rene Beeh 1886-1922
Josef Eberz 1880-1943
Willy Geiger 1878-1970
Walter Gramatte 1897-1929
Rudolf Grossmann 1882-1941
John Heartfield 1891-1968
Ludwig von Hofmann 1861-1945
Franz Jansen 1885-1953
Rudolf Koch 1876-1934
Alfred Kubin 1877-1959
Rudolf Levy 1875-1944
Frans Masereel 1889-1972
Ewald Matare 1887-
Georg Mathey 1884-1968
Hans Meid 1883-1957
Felix Meseck 1883-1955
Emil Orlik 1870-1932
Karl Rössing 1897
Josef Sattler 1861-1931
Paul Scheurich 1883-1945
Otto Schoff 1888
Richard Seewald 1889
Arthur Segal 1875-1944
Ottomar Starke 1886
Adolf Uzarski 1885
Wilhelm Wagner 1887
Karl Walser 1877-1943
Emil Rudolf Weiss 1875-1942

## PUBLISHING AND ILLUSTRATION

Modern German book illustration is based on the usual opposing influences which set the trends for all modern printing. The private press movement depended on traditional design, which was an extension of French and Italian classical layout and relationship between text and picture. Much of the other side came out of the aesthetics of Art Nouveau, with non-historical newness. In Germany much of the design solution remained that of the mid-nineteenth century, taken from the books illustrated by Rethel, Chodowiecki and Menzel.

There were certain built-in problems with the production of books which kept development from reaching wide horizons. The presses, typefaces, paper, and workers were frozen by tradition. The publishers sought no new solutions. The text seemed the most important part of the book. It took the transitional period, after photographs became the major means of reproduction in the late nineteenth century, to focus attention on new methods. There was a reaction against the mechanical means which formed some of the background of the crafts movement in England, leading to Art Nouveau. This response took two paths: The first was a tightening of traditional methods of design and production through refining the work; the second was a jump into new production methods by development of technologies which could solve the old problems

in new ways. Large lithographic presses were introduced. Color printing was perfected. The crafts movement, to some extent, brought fresh talent into the tight and confining unions, though many of the best private printers remained outside the organizations. They were artists.

The modern movement began with a literary idea, Symbolism. This worked perfectly with the book. It also reinforced the ideas of new design, for every symbol could be interpreted as having an inner and non-particular meaning. Format no longer meant traditional unity. The book now had a particular relationship between text and picture, based more on space and symbolic meaning. The illustrations were no longer meant to be natural ornaments to the text. In some cases the artist wrote out the text in longhand and related the line to his illustrations, much as the calligraphers had done before the invention of movable type.

During this period, the mid-nineteenth century idea of education was major among the middle to upper-lower elements in society. Unions and related organizations held lectures and classes. It was the century of Socialism. It was the century of rising wealth outside the nobility. It was the century of belief in the perfectibility of man through scientific achievement. It was most of all the century when the artist became an important symbol as a cultural leader, though in practice such leadership seldom resulted in economic success for him.

Prints became an important means for the new advertising. The poster developed. The calling card became more widely used. Stationery became common. Signboards became an eyesore.

It was said of German Christianity that the Germans took from it a feeling of being better through being chosen, but forgot the lesson of humility. German publishing had this same sense of superiority without self-criticism.

Publishers tend to be conservative people in respect to art illustrations. Tradition through guilds, unions and set methods tended to narrow the methods used in the production of books. Unless a publisher was also an art dealer or collector, the artists hired to do the important, deluxe editions were either artists associated with the particular publisher or printer or traditional professions. Dealers used their own artists.

Publishing as an industry sees relationships as economic opportunities. There is a relationship between a man who buys and a man who sells, and the concrete differences of personality are eliminated. In practice this combination fosters a conservative production, negating the most valuable achievements of human culture, respect for and cultivation of the uniqueness in creative art. It looks for likenesses, not differences, traditional success, not untried visions.

In some cases, as with Piper in Munich, the most creative books, such as the Blaue Reiter Almanach, were made in spite of this feeling. Piper would not support the earliest publications of Kandinsky or the Blaue Reiter, but charged one-half the costs against expenses plus a total commitment for the final costs if the book failed. Bernard Koehler paid for the Blaue Reiter Almanach. Though Piper now takes much credit for these early editions of works by great artists, most of his publications were from the classics, not the contemporary art of the time. Piper had done a series on modern illustration, including the work of Toulouse-Lautrec and Munch, but his major efforts were in literature with the collected works of Dostoyevsky and philosophical books about art, such as Worringer's *Abstraction and Empathy* in 1908. One looks in vain for major illustrated material with original prints by German Expressionists before 1912, when Kandinsky's *Über das Geistige in der Kunst* was published. Klänge followed. There are no other major illustrated books until Piper undertook the editions of the Marées-Gesellschaft in 1917. These were carried through with fine illustrated books each year until 1926.

Paul Cassirer in Berlin became involved with illustration early as copublisher of Pan magazine. He continued the early love for illustrated material with many fine editions. Cassirer was also an art dealer.

Rowohlt started as a printer with the Drugulin house in Leipzig. Then he began a publishing house from a front office in the printing works. His illustrated books are very traditional, which can be expected from his background. His silent partner, Kurt Wolff, was well off financially, took over the Rowohlt publishing house in 1912 and changed the style into a more modern concept of good taste combined with modern illustrators. Kurt Wolff produced mostly average things, though some of the more original poets and writers among his friends recommended artists such as Kirchner. The problems of material shortages account for some of the loss of quality from the end of the war until the middle twenties.

Ernst Rowohlt and Kurt Wolff were extremely fortunate to employ Hans Mardersteig, one of the greatest typographers and designers of the twentieth century, during the early days of their press in Leipzig and Munich.

Most of the great typographers came out of Jugendstil. Emil Preetorius worked first with the Insel Verlag. The others, too, worked with small commercial presses. Walter Tiemann, F. H. Ehmcke, E. R. Weiss, Rudolf Koch, Marcus Behmer, Henry van de Velde are names well known to historians of fine book design. Their influence on book production and design is still felt today. New typefaces and new methods for production layout were used in the wide expansion of German book production. Ehmcke worked for Diederichs; E. R. Weiss was long associated with the sensitive S. Fischer Verlag. These and other talented men gathered together the elements of the illustrated book, creating a unity of design and clarity that was unsurpassed. Though all these designs tended to be conservative, rational thinking was necessary as a steadying influence on Expressionist illustrators who tended to be irrational.

The publishers of the most beautiful editions worked in the traditional areas, influenced by Florentine and early German book design, much as publishing remained traditional all over the civilized world. It was humanistic design, not avant-garde. The artist, too, who did the illustrated editions, was traditionally minded and grounded in the use of space against type similar to Renaissance ideals.

Some of these publishers were very concerned with Expressionism. Kurt Wolff published the most Expressionist titles of any of these men, with Erich Reiss coming second to Wolff. The Sturm house was third most important by number. Fourth was Piper, although he specialized in art books of all kinds. Klinkhardt & Biermann involved itself in a major effort to publicize the younger artists and came fifth in quantity. Sixth was the Delphin Verlag. Seventh was Die Aktion, with many political tracts written or illustrated by Expressionists. Periodicals were part of the publishing tradition, as were the private print galleries associated with publishing companies. None of the publishers above were exclusively Expressionistic in intent, with the exception of Walden.

The smaller publishers were more concentrated. Alfred Richard Meyer, while he was active as a publisher, worked with vision and imagination. Felix Stiemer and the Dresdner Verlag were impressive. Heinrich Bachmair, while he was active, edited and published another important list. But these young men had little financial backing and most ended their efforts when inflation became rampant. Walden stayed in publishing through periods of trouble with censors and rightists because of powerful friends in government circles and also his own fanaticism.

One other note about the German reading public should be mentioned. Inexpensive books, such as those by the Insel press, the "Insel-Bücherei" founded in 1912, sold over twenty-five million copies by 1937. Rilke's Cornet alone sold over 900,000 copies. Of larger formats, Oswald Spengler's Untergang des Abendlandes *(Decline of the West)* sold hundreds of thousands of copies in the 1920's. A factor in this success was the efficiency and comprehensiveness of the book organization, 'Börsenverein des deutschen Buchhandels,' founded in 1825, which supported any efforts against piracy and price wars. This was important in the control of the business climate. The German public bought books.

All the elements are complicated in Germany. Among European nations, Germany had always been last in the establishment of public libraries in towns and cities outside the confines of universities and government establishments. General readers had to borrow from lending libraries intended for children and women, who were the great new reading public early in the twentieth century. Serious readers had to buy books.

Many small publishers had book shops in which the sale of prints and books was an easy combination. The idea of special editions, museum editions, and special numbers of periodicals grew in popularity during the first years of the century. In most cases, art was only one element in the output from a publisher, but it was a major one. Entire series were built around major books and schools of art.

The portfolio, also, was not a new idea in Germany. Cycles had been prominent since the early Block Books of the fifteenth and sixteenth centuries, made for uneducated priests. Albrecht Dürer made the cycle form an artistic unity with his Large and Small Passion and other religious series. Much of this tradition was lost in the eighteenth century when the majority of prints were no longer made for books, but merely reproduced paintings. Hogarth seems to have been chiefly responsible for this trend.

The "livre de peintre" was a product of the Romantic age. Original prints in series appeared again with William Blake's The Illustrations for the Book of Job, which appeared in 1825. Travel books became popular with the new process of lithography, but the process did not come into its own until after 1851. Lithography was developed first by the artist. Goya worked in aquatint, in Los Caprichos of 1799, and later in lithography. None of these examples had developed texts, and must be thought of as series. Delacroix made his dramatic illustrations for Goethe's Faust in 1828. Because of the freedom and spontaneity of the lithographic process, the Romantics took it up.

Lithography was used in fine book illustration, but the introduction of photolithography in 1863 killed most of the original efforts. The new process of wood engraving took over the popular field of illustration. The painter-lithographer was left in charge of the field. Books began to have snob value among a rising bourgeoisie, and the text became less important to these collectors. Individual prints and portfolios of prints also became popular, though most were travel collections and exotica. Manet took up the new method of transfer paper for lithography and opened the medium for new contributions by the Impressionists. The Japanese color print, made usually without a long text, and sometimes as a series, brought a message of pure color to the French Impressionists in the 1860's. Celtic patterns, too, became the rage. The woodcut probably became the fashion after the magazine L'Imagier was founded by Remy de Gourmont and Alfred Jarry, and Gauguin's use of the medium was very influential.

In Germany the series tradition had been kept alive as early as 1808, when Strixner's reprinting of Dürer's Prayer Book of Maximilian was supervised by Senefelder himself. Menzel had finished many books and portfolios, including the three volume Uniforms of the Army of Frederick the Great of 1857. Busch did his free and imaginative books, with doggerel that was not needed to understand the illustrations. German comic papers appeared, such as Fliegende Blätter. Max Klinger began his series, Amor and Psyche, in 1880.

Rebirth came from France. The prints and portfolios of the "Edition de la Revue Blanche" impressed Cassirer and Count Harry Kessler during a visit to Paris. They brought French printers to Berlin and started the great era of the Pan-Presse. It was the premier printing house in Germany, beginning Liebermann, Corinth, and Slevogt in this fine medium. All these artists had been associated with the Paul Cassirer gallery.

It became the domain of the private art gallery and associated publishers to print portfolios. Gurlitt, Steegemann, Diederichs, Der Sturm, Dresdner Verlag, Flechtheim, Cassirer, Neumann, Piper, Goltz, and the Roland Verlag all published portfolios. Various groups such as the Wiener Werkstätte, and bibliophile societies, such as the Maximilian Gesellschaft, also issued portfolios. The Marées-Gesellschaft in Munich was responsible for many fine editions. The Kestner-Gesellschaft still continues.

We have chosen a representative group showing various trends from the mysticism of Diederichs's house to collected prints in one portfolio by the Marées-Gesellschaft.

Since lithography's beginning in Germany, all early printing for the new medium was done in workshops. With the rise of commercial lithography and various other rapid means of printing, the workshop idea was lost until the end of the nineteenth century. Artists doing etching had coordinated their efforts in societies, but technical facility was lacking. The woodcut had degenerated into commercial wood engraving in the nineteenth century, and until commercial transfer of the image by photography, the original woodcut was put aside. It was only in France that a high level of technique was facilitated by small workshops which were usually promoted by art dealers.

With the spread of graphic art after the French Impressionists approached the new outlet with some attention, a more rapid need for skilled printers arose with Symbolism and Jugendstil, which were more intellectual and, perhaps, more literary than the fresh look at nature of Impressionism. France had kept the tradition of fine printing of lithography alive since the 1820s when Goya worked in southern France.

In Germany the great workshop under the direction of Reinhold Hoberg was formed to print for the Pan periodical, and, after the demise of that magazine it became independent. It was the cornerstone of very fine printing in Germany. Later many other centers were begun. Most specialized in outside work such as posters and advertising brochures.

For fine etching and aquatint and drypoint printing, artists could use the facilities at:
Berlin: Felsing, Sabo, Voigt, Ruckenbrodt, van Hoboken
Munich: Wetteroth
For lithography, a more common medium:
Berlin: Pan-Presse, Lassally, Birkholz
Hamburg: Gente
Flensberg: Westphalen
Jena: Schröder
Munich: Wolff & Sohn, Bruckmann, Wetteroth
Hannover: Leunis & Chapmann
Dresden: Hoffmann
Oldenburg: Lambrecht & Sohn
For the woodcut or not:
Berlin: Pan-Presse, Imberg & Lefson, Voigt, Lassally
Munich: Bruckmann

There were many other centers and some artists, such as Campendonk, printed for their friends.

The concept of the workshop had spread into the crafts and art academies with a return to the idea of craftsmanship as a renewal. Lange and his students at the Breslau academy printed very fine works for Otto Mueller and others. Many of the small work centers were closed during the difficult twenties or the Great Depression, but the academies have continued to produce fine printers and technicians, who advise and collaborate with modern artists in Germany.

What these centers gave to artists in France and Germany was a technical education for the means of realizing the artist's intentions. The printing of graphic art is not easy. Copper plates and most metals, rapidly lose the printing surface if printing pressure is not closely regulated. The surface of a limestone or zinc plate as used in lithography must undergo a chemical transformation before it will absorb ink. Too little control can cause rapid loss of image. The woodcut, more a medium for home printing by spoon or barin, needs no large press or technical attention. Yet the impression can be printed too black or too white, and a sure bite into the paper from the hard wood surface also takes some skill, especially for a large edition of like impressions.

There is the fine art of matching technique to printing paper. Color mixing is difficult, for some colors are opaque and others are transparent, and the amount of neutral extender to be

added is critical. Even the care and storage of printing surfaces takes special care and, frequently, a large area for large litho stones. There are many other considerations, such as the storage of impressions, trimming facilities, collation and the scores of other details which a specialized workshop provides.

But the technical inspiration is paramount. For example, Felsing developed certain methods of soft ground etching which completed the intentions of artists such as Käthe Kollwitz and inspired Munch. It was only with this help that a complete edition of exactly alike impressions could be made for a rapidly growing market of collectors, each of whom wanted the most perfect impression for his money.

Artists who print their own woodcuts or etchings usually do not have the patience to make large editions. This was the case with Nolde, Kirchner, and Rohlfs. Various impressions differ considerably. We might define these different images as mono-prints. Some artists, such as Rohlfs, desired this. Otto Mueller was never able to print well: the late color lithographs made under the supervision of Lange at the Breslau academy, attest to the difference between an amateur printer of lithography and a superb technician. There may be something personal about the hand printed impression made by the creator. But much of this is sentimentality unless the intention is to make a monotype, or if the print is of utmost rarity, as is the case with many by Kirchner or Nolde. Then, skill may not be a consideration. Most of the professionally printed impressions bring higher prices unless the single impression has some profound meaning in the history of art.

The Leipzig printer Carl Ernst Poeschel takes his place among the greatest printers of all ages. The Officina Bodoni in Verona, operated by the German emigrant Giovanni (Hans) Mardersteig, ranks among the greatest private presses in the world. But both printers, plus all their talented contemporaries, are disciples and heirs to the British pioneers who, at the turn of the century, rediscovered and reestablished the art of printing.

It was at the Chiswick Press that William Morris had the first books printed which inaugurated the revival of good printing. The actual impetus came from Emery Walker. Two basic conceptions underlay Morris's work and remain the basis of present day good printing: the unity of ink, type, and paper; the use of two opposite pages, rather than the individual page, as the major unit from which the design of the book was conceived. With the fifty-three books (18,000 copies) issued by Morris from 1890-1898, the impact on every press in the world cannot be overlooked. Morris broke the crude sway of commercialism. Though Morris had tried to provide choice specimens of what a great book should be, even if for the few, his methods were adapted by other presses to the needs and possibilities of ordinary printers, publishers and book lovers.

The ascendancy of the typecutter over the calligrapher started with Gutenberg. In Germany Gothic typefaces remained equally popular until the Nazi era, when Hitler declared that Gothic type was a "Jewish invention." The expansion of the roman type was then complete in middle Europe. This took most of the heaviness, which we usually associate with Gothic faces, out of German design, though the change had begun before World War I. Many of the Expressionist types were a combination of heavy body letters with sans serif extensions. The greatest use of the Gothic was during the nationalistic fervor of the first World War, when propaganda was put mainly in heavy Gothic typefaces.

Expressionist groupings, nationalistic-volkish, ecstatic-idealist, figurative-Expressionist, geometric-Expressionist, and other tangents all attacked the page with different visions.

From the first, Nolde and Barlach saw medieval tradition as an extension into the German present. It made a historical tradition out of early legends and sagas. It gave the new German nation a great sense of continuous being. Barlach used the chisel as a tool of web making, following the lessons of Dürer and the illustrators of the sixteenth century. Nolde began with this intention, but his northern irrationalism came through more prominently than his volkism. The results were less traditional, as his hand seemed to make its own way in spite of reactionary

groundings, and this, perhaps, saved his innate greatness.

The figurative Expressionists broke with objective reality in order to strengthen imagination, add spiritual meaning, give an inner expression rather than an impression. They used distortion and elongation of the human figure and natural landscape, pulling and pushing forms, twisting poses and muscle planes, using the attitudes of the actor or marionette, creating a mood of excitement within outline and shaded form.

Abstract Expressionists, such as Kandinsky, broke with optical reality as one pole of a double intention. They were not against the real and saw unity of both as a possible image of the psychic mind. In order to strengthen this idea of inner content, the abstract Expressionists gradually moved into a search for basic elements such as pure color to find the groundwork of eternal symbolism which "might echo in every observing soul." These enigmatic words are common, but the search for a psychological basis of aesthetic enjoyment, power or strength was a thoroughly modern message of integration.

Only the abstract, figurative Expressionists, such as the men of the Brücke, attacked the page with a new vision. They saw words as tools. Words can be weapons, too; woodcuts can be weapons and tools.

Not all books are designed for continuous reading. Not all illustrations are made to fit the text, as strong imaginations and inner invention may create a barrier. The will of the artist may be imposed over the literary message. The quality of spirit can be complementary, too, though the traditional art of the illustrator tends to be self effacing.

The Brücke illustrator was less considerate of the author. He was not afraid to offend; in fact, he frequently shocked by sharpness and angular originality. Taste, as we think of it in traditional terms, was opposed. The lack of taste in the nineteenth century German home had been exactly paralleled in the ugly book design of that era. Horrible, complicated, badly printed designs were common. Decorative typefaces were used on a cheap paper. It was against this area that the Brücke illustrators joined the Jugendstil revolt, but their contribution was less communal than powerful.

Sans serif typefaces were probably commonly used first about 1816. The letter body was shorn of serifs to make it a better and bolder tool in advertising, and the lack of cheap smooth printing paper made the new design functional, for it printed well on coarse paper. It was used in posters and many advertisements. One of the first names for sans serif faces was "Grotesque," and unless it is used skillfully the effect can be that.

In the minds of the Brücke artists to some extent, and later more frequently in the Bauhaus, serifs, though helpful to legibility, came to represent an ended and offensive tradition. The serif-less types were rather ugly and disproportionate until Paul Renner designed the typeface, "Futura" in 1924.

But these block letters had a power which combined well with woodcuts. They could be stretched horizontally more than traditional letters. Clear outlined inner spaces gave a large white illusion. It could exactly echo the width of a woodcut line, be it wide or narrow. It had the heaviness which the medieval fraktur also possessed, and thus could be thought of in a semivolkish manner. But it had none of the nationalistic and reactionary history; it could be called international, yet had none of the elegance or "frivolity" of the French type.

The architectural background of most of the Brücke artists was probably the basis of their choice of typeface. It had been used for display and signatures on their plans. The idea of integration between line and letter also came from this use with drawings and layouts. Jugendstil architects and designers had already created a fine, new tradition of original lettering. Kirchner used certain Jugenstil mannerisms, such as putting umlauts within letters instead of above them. He also combined other letters within the type block of an L, which could not have been accomplished with old style letters. Most of these designers did not like an open area between design and letter, and used small insertions which could tie the areas together, making a surface web of integrity, and also creating an extra sense of excitement as the surface vibrated with small spots.

From the Brücke, too, came the idea of black as a color, having a positive plastic value. Black had been a traditional symbol of death in the western world, though in the east it was not. It has a frightening context in itself because of this symbolism. Alone it is very potent. The young painters realized this European meaning was part of an outworn tradition. They began to use black as a common and neutral denominator, separating the Impressionist from the Expressionist world. They saw black in elementary shapes, on plane surfaces, and used in pure lines of varying width and texture as the essential. It was a primitive move onto the threshold of a new vocabulary. An essential psychological elaboration no longer stood in the path of new rhythmic relationships.

Kandinsky, too, looked at black as a symbol. He analyzed colors for their psychological effect, as thinkers had always done. White was discordant, but "had possibilities for rebirth, black was traditional, devoid of possibilities." White was more universal for it could be mixed with any color, while black can be mixed with only certain deeper hues. Kandinsky's spiritualism carried into his general symbolism. His illustrations tend also to be spiritual companions rather than exact comments from the text.

At the Bauhaus, the designers of social synthesis formed around architecture found the sans serif typeface related directly to architecture. Tradition was traced from a rounded form with open letters to a closed and blocked letter. This was the end of a development which began in the early nineteenth century with the elegant sans serif letters of Julian Hibbert, which had grown from Greek uncial carving.

Most of the independent Expressionists worked for publishers who hired designers. Typography became important again in the 1920s with the development of De Stijl in Holland, of Dada in Berlin and Hannover, and of the various Constructivists in Germany, after the movement was forbidden in the Soviet Union. In these cases, the search for purified abstract form, and the mathematical aspects of space, were the unities which brought out a new typography. It was no longer the expression of a painter within the figurative, Expressionist tradition of the Brücke.

109.

**SCHMIDT-ROTTLUFF**
109. Manus Offizin Fritz Voigt
*(Office Card for the Printer Fritz Voigt)*
Etching, 1922; Schapire Gebrauchsblätter 76.

## Paul Cassirer

Ernst Barlach writes of first being reserved with Paul Cassirer. He compared his own high class savagery with Cassirer's aloof personality. But both men soon met in trust, and that was the central attraction which held them together throughout Cassirer's activity.

Paul Cassirer was born February 21, 1871 in Gürlitz. He was known as a charming man, although his famous temper made him a formidable opponent. This untamed temper was combined with an extraordinary aggressiveness.

He was the major sponsor for the new Secession painters at the beginning of their separation from the older art groups at the academy. Paul Cassirer and his cousin Bruno opened a publishing house in 1898, the date of the first Berlin Secession exhibition. The two split up in 1901, when Paul opened his art gallery on Victoriastrasse, near his home in the Tiergarten.

Cassirer's home was a famous gathering place for artists, politicians and intellectuals. It was distinguished also for its beauty, for the small garden room built under a skylight. His furniture was Jugendstil and very modern for the time. Even his dinner service was designed by fine artists.

Paul Cassirer's first show exhibited Paul Cezanne, then unknown in Germany. The show was not a success. Wilhelm II suggested that the art dealer was "bringing garbage from Paris." Cassirer's gallery showed mostly Secession artists until the various separations around 1901. He later exhibited some of the Brücke men, and the French Impressionists. He opened a small printing house in conjunction with the Pan magazine, and later continued this fine center for fine lithography until his death. His taste was French influenced: the books of the late 1890's were given German seriousness and a clearer, more open typography. He sponsored various periodicals, such as Der Bildermann, and Kriegszeit, but was patient with neither and soon moved on into other ventures. Pan II did not exist long.

Paul Cassirer's long career as a publisher and art dealer took many political twists and turns. He began as an internationalist; became nationalistic during the war; soon saw the results of German war aims; changed into an international socialist. After the war, Paul joined the Social Democrat party, the Independent section, and wined and dined a sucession of activists such as Breitscheid, Kautsky, Schickele and Kestnerberg.

He was always a prominent figure at the theater because of the activities of his wife, the famous actress Tilla Durieux. He was the first champion of Barlach and Kokoschka.

Paul Cassirer used most of his gallery artists as illustrators. These included Slevogt, Walser, Liebermann, Kubin, Corinth, Grossmann, Orlik, Barlach, Oppenheimer, and Pechstein. He was later responsible for part of the publishing effort for Die Weissen Blätter. He championed Edvard Munch, was the earliest person in Germany to spread his reputation and that of Vincent van Gogh, through his closeness with Meier-Graefe and Dr. Julius Elias, the critics.

Paul Cassirer was not always a loved figure in the various activities at which he participated. But his electric energy, his trust towards his beloved artists, his liberal humanitarianism in Berlin made him an important figure in the development of German Expressionism.

**LUDWIG MEIDNER**
328. Septemberschrei *(Cry in September)*
Hymnen/Gebete/Lästerungen
Berlin: Paul Cassirer. 1920
Printed by Dietsch & Brückner, Weimar
Edition: Prepublication edition of 100 books, with signed, hand printed lithographs, on van Geldern paper, in half leather binding. Regular edition unknown.
8 + 76 + 4 pages, 30 x 22.4 cm.
14 lithographs by Meidner inserted between paging and not page numbered.

Ludwig Meidner has been called the complete Expressionist. He wrote poetry, essays, biographies, music, criticism, painted, printed, designed books, and knew most of the important writers and poets, appeared in the following periodicals with illustrations and poetry: Die Weissen Blätter, Neue Blätter für Kunst, Der Sturm, Das Neue Pathos, Die Bücherei Maiandros, Die Aktion, Der Anbruch, Saturn, Die Erde, Agathon Feuerreiter, Die Erhebung, Das Tribunal, Der Silberne, Spiegel, Das Junge Deutschland.

His style developed early into a visionary explosion of cataclysm and apocalyptic distortion. His style continued in this way of thinking into the 1920s. His book Septemberschrei combines these energies, themes, and verve with the same anguish and pathos.

He had experienced the downfall of the idealistic revolution of the socialist artists. When the obsessions of a sensitive man are completely frustrated by a blood bath, the reaction is bound to be severe. A heaviness appears in Meidner's later drawing that was not evident before in the sensitive prewar draftsmanship. He seems world weary.

The prose of Septemberschrei was written in 1917, as a small declaration on the front page tells us. Although there is some division between later and earlier concepts, the writing maintains passion and idealism. It was finished while a frustrated painter was in the army. The lithographs were made in the upstairs studio in Berlin of which George Grosz writes in his autobiography.*

Meidner had been influenced earlier by the fine reed pen drawings of van Gogh, but here he uses a thick and somewhat awkward brush line. Details are crude and designs are not worked out. He gets into the domain of caricature in many of these hurriedly made sketches. There is also a sense of bewilderment to most of the subjects, rather than the earlier heroism. The ecstatic pain of the sensitive painter resulted in a weaker draftsmanship.

*Grosz, George, A Little Yes and a Big No, N. Y., 1946, p. 212

## Bruno Cassirer

Bruno Cassirer, Paul Cassirer's cousin, was born on December 12, 1872. Bruno studied for his doctoral thesis in Munich; his subject was Dürer's landscapes. He was described as a quiet and studious man, an opposite to his art dealer cousin.

The Bruno and Paul Cassirer publishing house was opened in 1898 on the most elegant side of the Tiergarten in three small rooms, as Rilke mentions while he was an art critic. Small exhibitions were held in conjunction with the book publishing venture. Bruno married Paul's sister, Else. Their famous cousin, Ernst, was a widely known philosopher of humanism. Bruno was black eyed, with a very straight carriage and clean features.

In 1901 the cousin-partners parted with some enmity, and each signed an agreement not to interfere in the business of the other. Bruno continued the publishing house under his own name, and moved to Derfflingerstrasse. His educational background was in art history, and the publishing effort began as that of an amateur; and he always kept this somewhat fresh look at the page and makeup of the book.

In October 1902, Bruno founded Kunst und Künstler, a realization of his plans to present new writers, get the feel of current thought and, primarily, influence the public. One of his first authors was the important writer, Wilhelm von Bode. Friedländer soon wrote for Bruno, followed by Curt Glaser, Max Deri, Adolf Goldschmidt, Alfred Lichtwark, Gustav Pauli, Eckart von Sydow, Hugo von Tschudi, and, Karl Scheffler. Through these most important art writers, the publishing house soon expanded with many other famous authors, such as Kristeller, Dodgson, Lehrs, Springer.

Many of these early books are important today; such as Kristeller's "Copper Engraving and Woodcut of Four Centuries" (1905) and Schiefler's catalogue of Munch (first published in 1907). Bruno's library of art writers had started in 1903. These included Gauguin's "Noa Noa" and the letters of van Gogh.

Bruno Cassirer's Kunst und Künstler retained its interest in Impressionism too long, and other organs, such as Der Sturm began to present the newer art. By 1901, Bruno began to publish Russian authors in translations by August Scholz. Philosophy was represented by the Neo-Kantian, Hermann Cohen, and his student, Ernst Cassirer.

Cassirer's first reader (Lector) was Christian Morgenstern. Morgenstern remained a friend and helper until his death in 1914. Morgenstern helped Cassirer take over all the contracted authors of Albert Langen.

The illustrated books first appeared to be failures, but Slevogt had brought a wealth of material to Berlin, and these new techniques were applied to the efforts of other illustrators. The firm was able to open up traditional design, especially through the fairy tale illustrated book, and upset some established practices. Slevogt placed his drawings outside the text, rather randomly.

Because of his approach as amateur, Bruno Cassirer tried to disregard the British traditions, also: early freshness from Britain had become sterility in Germany. Cassirer placed the artist first, above the text.

The Bruno Cassirer Verlag also printed small editions of from three to five hundred copies. Luxury editions on finer paper were also issued.

Barlach was approached, but he was under contract to Paul Cassirer, and could not get approval; although Scheffler succeeded in using Barlach in Kunst und Künstler.

After the war, the devaluation of money caused issuance of many cheaply made illustrated books. Bruno Cassirer's publishing house got into financial trouble, and he stopped production for some time. He did one more hand-illustrated book in 1930, a book by George Grosz: Über alles die Liebe.

328.

Bruno Cassirer was a publisher who did not turn over the jobs to underlings. He sometimes spent months to get all particulars correct. He made all final decisions. He adjusted paper and tones to arrive at what he had projected in his mind. The books of the press are clean, with elegant typography, though still Germanic in look by a certain stiffness and darkness of type strike, but readable and with overall quality much above average for any time.

## RUDOLF GROSSMANN
329. Til Ulenspiegel (Til Ulenspiel) by Charles de Koster
Mit 7 Original-Lithographien von Rudolf Grossmann, including one handcolored
Printed in: 1915, Page 57-68
Kunst und Künstler; Jahrgang XIV, 1915
Page size: 30 x 24 cm.
Unknown edition.

329.

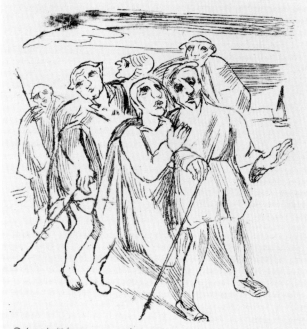

„Doch zu geben?" fragte er.
„Ja," sagten sie, „Schläge für die Allzubreisten. Und wenn du deren bedarfst, werden wir dich
wie einen Haufen Korn schlagen."
„Ich verzichte darauf."
„Komm essen," sagten sie.
Er folgte ihnen in den Hof der Herberge, gar froh, diese frischen Gesichter um sich zu sehen. Plötz-
lich sah er mit großem Gepränge, mit Fahne, Trompete, Flöte und Tambourin, die Brüder vom
guten Vollmondgesicht in den Hof einziehen, welche dem lustigen Namen ihrer Bruderschaft alle

## Ernst Rowohlt

In the back room of a wine parlour in Dresden, the firm of Ernst Rowohlt, publisher, was discussed by the young enthusiast and his friends. He was a huge man, with ginger colored hair and a short nose.

His venture was an early fantasy, adding his title to books published: "printed for Ernst Rowohlt." His taste ran to the late romantic poets such as Stefan George and Hugo von Hofmannsthal. He first apprenticed at the Insel Verlag, later with the great printing house of W. Drugulin. His first book was printed in 1908. In 1909 he discovered a dramatist, Herbert Eulenberg and printed his books. The next year eighteen titles were issued, some under the imprint of Drugulin-Druck (seven titles). Some of the authors included Goethe, Verlaine, Brentano, nine by Eulenberg, Shakespeare and Paul Scheerbart. Thirty-three titles were issued in 1911, and included Georg Heym, Dauthendey and Baudelaire. Until February, 1913, when Rowohlt's new partner, Kurt Wolff, bought him out, the titles were impressive, with Carl Hauptmann, (Rowohlt's discovery), Georg Heym's Umbra Vitae, Rodin, Arnold Zweig, and Kafka

among his authors. The circle of his friends met at the "Kaffeeban" restaurant to hear music and discuss literature and art. Werfel and Hasenclever, Max Brod and Kafka called and became friends.

After the sale of his part of the business, Rowohlt left Leipzig for Berlin and headed the Hyperion Verlag until he was drafted into the artillery during the war. He left the army in 1918, and began to plan a second publishing house. It was actually begun on January 7, 1919. His new reader was Dr. Paul Mayer, who became a close friend and stayed with him for 20 years. Rowohlt lived the first months of 1919 in Dresden in the "Weisse Hersch," a small hotel, and his associates there included Kokoschka and Hasenclever. Among the titles of 1919 were books by Büchner, Rudolph Leonhard, Karl Marx, Swinburne and Hasenclever. His first illustrated book as a new publisher came out in 1920, by Dietz Edzard. Among the books of 1920 was Menschheitsdämmerung, the greatest anthology of Expresionist poetry. He later employed Rudolf Grossmann, Georg Mathey, Max Liebermann, Felix Meseck, Renée Sintenis, although the illustrated book was not his major interest.

During this time he introduced to German readers such authors as Kafka, Brod, Tucholsky, Musil, Bronnen, H.R. Knickerbocker, Sinclair Lewis, Ernest Hemingway, Joseph Hergesheimer, Thomas Wolfe, Hans Fallada, Jules Romains, Ernst von Salomon, Clarence Day, William Faulkner, and others.

The publishing house closed in 1943. It had been taken over by the Nazis in 1940, under an SA-Führer. Rowohlt's friend, Kurt Pinthus had left for New York, and later Washington, where he was a consultant at the Library of Congress.

Rowohlt spent the war in Berlin and later Hamburg, where he married his beautiful companion, the actress, Maria Plirenkämper.

The third Rowohlt Verlag was begun in Stuttgart in November, 1945, with branches later in Hamburg and East Berlin (1949). After 1950 and the isolation of West Germany, the permanent center was Hamburg. Some of the Rowohlt's later authors included Gide, Silone, Lorca, Saint-Exupéry, Anna Seghers, Steinbeck, Thurber, Grahame Greene, Isherwood, Jack London, Sartre, Paul Bowles, Henry Miller, Genet, Grosz, John Cheever, Durrell, Arthur Miller, with emphasis on translations from English, American and Japanese literature.

The firm is still carried on by his son in Reinliek bei Hamburg. Rowohlt died in 1960. His interpretations of modern literature had been the primary influence among book publishers in Germany.

330. Das grosse Bestiarium der modernen Literatur
(The Great Bestiary of Modern Literature)
Franz Blei
Berlin: Ernst Rowohlt Verlag, 1922
Edition: 430 numbered copies, hand-colored: A: 30 copies on van Gelder paper handcolored, signed by the artists and author. B: 400 copies on Hadern paper (all rag), signed by artists and author, handcolored. C: on wood-free paper without the lithographs.
Printed by Buchdruckerei Poeschel & Trepte in Leipzig. Lithos printed by Dr. C. Wolf & Sohn, Munich
21.5 x 13.5 cm., 6 + 253 (7 pp advertising)
With 18 original hand-colored lithographs by Th. Th. Heine, Olaf Gulbransson, and Rudolf Grossmann (six each)

This modern bestiary was based on the long tradition in medieval literature using allegorical references to men with the appearance and habits of beasts.

It is a witty book which sometime should be translated into English. Blei uses alphabetical order for satire about poets and writers. He tells of invented excursions. He defines figmental problems. He lists imaginary books as authors might have written them. Most of the jokes are very humorous. For example, among the imaginary books he lists: Strauss, Richard, The Art of Hofmannsthal's Music as Noise; or Grafin Hen-Hen, The

*Rilke and his Salon: The Women.* Or Conrad von Hot City, *The Meyrink,* or a *Stain on the K.u.K. Armee* (reference to the Imperial Austrian Kaiser's Army, ka ka also meaning defecation in children's talk).

The illustrations are very close personifications of the authors as their nearest animal relatives. Hermann Bahr is a gentle lion; Bjornson is a spouting whale; Edschmid is a cloud of chickens; Stefan George is a pink flamingo; Hermann Hesse is a bespectacled dove; Lasker-Schüler is an overturned beetle; the two Mann brothers are insects on opposite sides of a tree trunk; Meyrink is a showman with a pig; Wedekind is a kneeling sphinx before a giant phallus.

Translations:

### DAS BROD *(Max Brod)*, page 23

A domestic animal is also called Max Brod. It is recently kept frequently in Jewish synagogues. It is harmless and takes food from the hand even when aggravated, from which one can conclude its suitability as a religious animal. Some people seem to predict that the Max Brod will someday enjoy wide recognition like the Buber [Martin Buber], the well known holy animal of the Jews. But the small, not at all impressive Max Brod lacks the basis, in spite of the great pains it takes with it. The format of the Gartenlaube [harmless magazine without tendencies] does not get larger by cutting the string which binds it, unfolding the pages. Comparatively speaking!

### DIE DÄUBLER *(Theodor Däubler)*, page 26

She is a mighty jellyfish, which lives in the Mediterranean and is mostly silver-grey. But she may bring forth other colors. The system of her intestinal threads is extraordinarily entangled. Often she gets confused herself, and gets entangled even more, trying to untangle herself. Then she loses the ability to play with color.

### DIE FACKELKRAUS *(Karl Kraus)*, page 30

The Fackelkraus has an antinature, because she was born out of the excrements of what she wants to destroy. She is always swollen with rage because of the unclean birth. She is remarkable through her ability to imitate the voices of the people. She does this in different ways. She imitates the voices of prophets and poets in order to be like them, to be mistaken for them. Other voices are imitated so she can mock and destroy them. Before the Wedekind [Frank Wedekind] was extinct, the Fackelkraus was its girl friend, and posted herself on the raised platform when the Wedekind copulated or otherwise secreted. The Fackelkraus always expressed a loud acclaim there in order to be heard. She gets into great anger and always gets malicious to the point of being poisonous when she thinks she hears others. In order to prevent the others from being heard, she uses two means. One is that the Fackelkraus praises; the other is that she mocks. Both she does with an overstraining falsetto voice, in order to be heard.

The Fackelkraus, namely, has no nature, but is nothing but voice and, therefore, lives only so long as she can be heard. Since she knows this, and is afraid of death like every living being, she has her voice carefully trained to be heard. In rage the Fackelkraus has a voice which becomes especially artful, because she cries with always new voices in case people cannot hear her. When she sees that people have heard her, she becomes very proud and repeats everything people have said about her over and over. She forgets her fear then, and one can hear a voice that is not ordinary.

The Fackelkraus is a useful animal, therefore, although one can only allow her to be close if one is born without a sense of smell.

Here one can admire God's wisdom, who gave one voice to most animals, because they only have one nature. The Fackelkraus, however, has no nature, but only an antinature; instead she has numberless different voices. Because of the voices, some listen to her, and for this circumstance she thanks her life and can consume large quantities of the excrement from which she was born.

DIE DÄUBLER

330. DIE DÄUBLER

MENCKEN (H. L. Mencken), page 49

That is the name of the most important American zoologist, and that means (since Lowell was American but not important) this Mencken is not only the most important, but the first. His sharp wit makes it regrettable that we do not see this Mencken opposite a better fauna than the mostly ridiculous North American. It is being led to barren pasture by Presbyterian pastors' wives —and these are ninety percent of the inhabitants of the U.S.

## Jakob Hegner and the Avalun Verlag, Hellerau

It was customary for German publishers to influence the art of the book. After all, they promoted the book, paid for the printing and sold it. It is unique, though, when an important publisher also becomes a printer of books. Jakob Hegner was such a man. He published and printed certain fine books for the attitudes of special audiences.

An unrecognized poet and novelist, Hegner settled in Hellerau, near Dresden, in 1912. The German workshops had been founded here in 1909 as direct result of the foundation of the Deutscher Werkbund in 1907. A return to fine craftsmanship was the idea behind the colony at Hellerau: Tessenow, the architect, worked here, as well as the great bookbinder Peter A. Demeter, and the creative school of Jacques Delcroze taught rhythmic gymnastics. In 1913 Hegner founded the Hellerauer Verlag there. He founded his own printing factory in 1918, Avalun Verlag, with the help of his master printer, Malte Mueller. They did work for their own publishing house as well as for Cassirer, Schneider, Schocken, and for the great bibliographic societies.

Jakob Hegner gathered the kind of literature which complemented his gifts for the extraordinary. Jammes and Claudel, Bernaros and Marshall were brought into the circle of the German language. Hegner was the agitator. He published the great critical edition of Kierkegaard. Hegner was a connoisseur, behind author and editors, and the third silent voice behind the books.

As a publisher, former writer, master printer, Hegner was able to see sentence, print, and binding as one unit. A sense of recklessness has no part of this unity. He rejected strong accents. His books had little extra jewelry or ornament.

## 330. DER THOMASMANN UND DER HEINRICHMANN

### DER THOMASMANN UND DER HEINRICHMANN
(Thomas and Heinrich Mann), page 47

Both of these animals belong to the family of medium sized wood beetles. They are of different colors, otherwise they are the same in living habits and nature. One finds them always living on the same tree, but on its opposite sides, since the two wood beetles cannot stand each other at all. If the Thomasmann bores into a tree below, so sits the Heinrichmann on the same tree higher. If one finds the bore into a linden tree juicy, the other finds it rotten, and vice versa. The strange thing is that the two always make mistakes with the trees. They think they are beetling on an oak tree, when they are sitting on a door of pine, or a fir when it is a chest of lindenwood. But each is always in anger about the presence of the other. What one finds juicy, the other always finds rotten. Only when one places both beetles on a writing pen do they devote themselves to their activity, busily running up and down on it. As far as color is concerned, the Thomasmann shows black and white striped wing-spans, while those of the Heinrichmann are blue-white with, sometimes, red dots (which fast disappear at the approach of humans). These small red dots can easily be removed by slight rubbing.

## LOVIS CORINTH

331. Die Räuber (The Robbers)
Illustrated by Lovis Corinth
Friedrich von Schiller
Hellerau: Avalun Verlag, 1923
31. Avalun Druck
Edition: 280 examples: Nr. 1-50 with extra portfolio of lithographs. Nr. 1-150 with all lithographs signed by the artist, bound in parchment. Nr. 151-280 with signature only on the justification page, in false parchment binding.
Text printed in the workshop of Jakob Hegner; lithographs printed on the hand press of A. Rogall, Berlin; bindings by the workshop of E. A. Enders, Leipzig. All hand bound. With 12 original lithographs (7 full-page) by Lovis Corinth (Müller #797-808). 35 x 25.5 cm.

Hegner's style is related to earlier British designing. His logo is printed high on the page. The text columns are closed, not broken. The typeface, called "petit Neuland," had been designed by Rudolf Koch. It is used here in two colors, red oxide and black. The chapter (act) headings are spread the width of the two column text. Corinth's illustrations are placed carefully next to horizontal borders, which also carry the balance across the two pages. This is the late Corinth, suggestive rather than Impressionist. Corinth is skillful with his headings over constant half-page length. Simplicity and careful planning achieve balanced design in this easily read, well executed, well illustrated book.

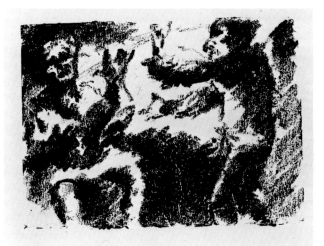

FÜNFTER AKT / ERSTE SZENE

331.

### Eugen Diederichs

This important publisher was outside actual Expressionism. He was one of the founders of the Werkbund, the society based on the British Arts and Crafts Society, combining industry and art together by raising the aesthetic standards of modern life. What made him one of the most important influences in German cultural life, and this included the arts, was his interest in mystical culture.

There is a consistent development among German thinkers in search of myth. It became a kind of mythomania with the National Socialists and their followers, such as Gottfried Benn and Hans Johst. Diederichs followed a less racial variety, one founded on the criticisms of Schopenhauer and Nietzsche, but which turned into the racism and nationalism these philosophers would have abhorred. Myth-seeking is antirational. It was part of the late nineteenth century opposition to scientific materialism.

Diederichs's term, "New Romanticism", is important to Expressionism. He promoted the idea through his authors and as editor of the very important periodical Die Tat, for which he assumed responsibility after 1912. Diederichs was a man who loved controversy, though rarely from the left wing intellectual. The framework of New Romanticism was familiar to the Germans, though this publisher attached a transcendent reality to the emphasis on inner and spiritual vitality. Diederichs thought that creative aspirations would come from the Volk, through concrete environments conducive to idealism. He opposed ideology to organization. As part of this cultural revival, Diederichs published monographs about German culture (at least twelve titles), thirty-eight volumes of fairy tales from all lands, the classics, a remarkable edition of Goethe's Faust (1909), and the early work of the Chassidim inspired writer, Martin Buber. The mysticism of Buber parallels that of Diederichs.

There was a deep elitism in Diederichs and his circle, which was far different from the Volk ideas of the Nazis. The anti-intellectualism of the group did inspire some of the painters, by producing an atmosphere in which primitive art could be rediscovered. The New Romantic's call for an end to empiricism and a rejection of science fell on eager ears among the young poets and painters of Berlin and Dresden. Diederichs's attitude towards Christianity also influenced the painters after World War I, for the ethical potential would be brought forth by religious art, not by a return to the rules of orthodoxy.

### GUSTAV WOLF

332.  Am Anfang/Genesis *(In The Beginning/Genesis)*
7 lithographs by Gustav Wolf
Jena: Eugen Diederichs, 1913
Edition: 250 hand printed, signed and numbered examples; 50 examples hand colored.
Portfolio: 51 x 40.5 cm.; sheet: 50 x 38.7 cm.
Title page, 7 pages text (Biblical text of the seven days of creation, one day to a page), 7 lithographs (tusche drawings) by Gustav Wolf of the Biblical account of creation

Gustav Wolf was born in 1887. He worked most of his life with publishers as designer, graphic artist, and later as a printer-publisher himself. He had wide interests in various media. He did fine small sculpture, though his central work was accomplished for the various publishers, such as Diederichs and the Heidelberg printers.

Wolf was a product of the great German Werkbund, begun by Friedrich Naumann, Avenarius, Hermann Muthesius, and Diederichs in 1907. In order to raise the standards of modern life, a society of artists, industrialists, designers, and technicians was organized and remained in existence for many years. The major purpose was also to bring some measure of joy and pride in work back to the stagnating worker under the growing Industrial Revolution in Germany. The Werkbund, unlike the British movement, was not socialist but antisocialist.

Eugen Diederichs was the first German publisher to attempt to unify the whole book. From the Werkbund philosophy, Diederichs went back to basic construction out of the best materials, questioned every traditional method, was an audacious entrepreneur of his own ideas, and supported the greatest designers of book layout and type design in all the European countries. Diederichs's books were built around the title page, not the cover. He felt that the title page should show its structure and be effective by its beauty. He promoted new typefaces by Ehmcke, Tiemann, Koch, and Behrens.

332.

Bl. 7

Der siebente Tag

275

This Genesis is an example of the firm's fine editions, made on handmade paper, printed by hand and with a justification page showing the Lion designed as a logo for Diederichs by Wolf. Diederichs took part in every stage of the development of every book until Max Thalmann took over this job in 1921 (Diederichs had by this time become involved in a complicated philosophy of culture-politics which falls outside our expertise).

The little-known sculpture of Wolf is designed along the general style of Expressionism. It shows an African influence, as do his woodcuts and etchings. With the lithographs of Genesis, Wolf begins in a granite-like cube which he opens up in succeeding illustrations as the world is delivered from darkness. Plate One is the first daylight as God said: "Let there be light. And God called the light Day, and the darkness he called Night." The progressive development of the Creation is slowly formed around the separation of Heaven and the Firmament. At this time Wolf stays within traditional concepts of book design. He builds in an explosive centering of diagonals until the creation of the fifth day, when he introduces grotesque animals and fish. The later plates retain the intensity, grotesque symbolism, and opening of the spatial areas. The last plate has a word in Hebrew: Jehovah (Lord). In traditional Hebrew, this word would be pronounced "Adonai", which means God.

From Gustav Wolf's early training under Trübner to his late Expressionist period is a great jump in conception, probably quite difficult for a designer in the book trade, for publishers and printers tended to be technically traditional. The craft of printing restricted the introduction of new ideas which could be printed with existing techniques.

In 1933 Gustav Wolf and Richard Benz began a workshop, which started as a new beginning for the journal Die Pforte. This periodical had begun as an anthology under the auspices of Saturn Verlag Hermann Meister in Heidelberg in 1913. They had a small group of books published by Dreiländerverlag in Munich in 1919. Wolf attempted to bring the Werkbund ideas together under his art direction. The workshop became a great center for book design, and the printing of single prints, posters, and typography.

## MAX BECKMANN

Two Portraits of Reinhard Piper

333. Porträt R. Piper *(Portrait of Reinhard Piper)*
Lithograph, 1921
65.8 x 47 cm., Gallwitz 156, Glaser 160.
Dedicated to Piper by Max Beckmann and dated 8.4.21.
Given to Lotta Tieffenbach by Piper. She was a close friend of Piper's mother and was her teacher at the art school in Königsberg.

334. Porträt R. Piper *(Portrait of Reinhard Piper)*
Woodcut, 1922
21. 6 x 10.3 cm., Gallwitz 210 b, Glaser 214.
On orangish japan paper, signed, from the edition of ten (VII/X).

## Reinhard Piper

The Piper publishing house was opened in 1904. Three names were the most important in the first days: Dostoyevsky, Marées, and Schopenhauer. Piper's interest was with the great poets, the great artists, the great philosophers of the late nineteenth century. Among the important names are Daumier, Delacroix, Hodler, Manet, Renoir, Cezanne, van Gogh, Liebermann; among the older names are Poussin, Cranach, Dürer, Brueghel, Rembrandt, Goya, Hogarth; writers such as France, Morgenstern, Queri; critics such as Meier-Graefe, Scheffler, Worringer, Hausenstein, Deri; the music of Mahler, Schoenberg, Reger.

Other themes which were published by the Piper firm were Buddhism, mysticism, the Aphorists, Gothic, Impressionist, and modern illustration, and the beginning of Expressionism.

The publishing house is still doing business under the direction of Klaus Piper, the original founder's son.

333.

Reinhard Piper eventually headed the greatest art publishing house in Germany. His personal recollections about the start of his great venture provide examples of luck and skill. Piper worked first with another publisher, a colleague and travel companion, Georg Mueller. Meanwhile he worked quietly on his own plans. He had only eighteen thousand Marks to begin. Private contracts for a series of art monographs called Moderne Illustratoren, and a pocket library were secured. He approached his employer, Mueller, who agreed to become his partner in a second publishing house. It was called R. Piper & Company.

At first Piper was his own editor and secretary. He owned no typewriter, but wrote everything by hand. Mueller had to sign everything as half-owner. This was in May, 1904. The first book appeared and sold out, as did the second. The total turn-over of books during the first year was greater than Mueller's other company. Piper was accepted into the glamorous list of important German publishers.

During the first year and thereafter Piper concentrated part of his new issues in art books. In 1904 he published books about Toulouse-Lautrec, T. H. Heine and a portfolio of prints by artists in Munich. The next year, 1905, he extended into a fine series of poetry, including works by Walt Whitman, Stifter, Jakob Böhme and others. He began the great translations of Dostoyevsky's entire oeuvre edited by Moeller van den Bruck. Most years saw one or two portfolios with original prints.

Julius Meier-Graefe's monographs, Impressionisten and Illustratoren were started. Wilhelm Worringer's impressive and influential book, Abstraktion und Einfühlung, appeared in 1908. There were books about Buddha, Hans von Marées, van Gogh, Cezanne, and the important reply to the Secessionist rebellion against French art, Ein Protest deutscher Künstler, called Im Kampf um die Kunst. In 1912 Piper published Kandinsky's Über das Geistige in der Kunst and Der Blaue Reiter Almanach.

This was the beginning of an impressive book list each year. Piper introduced many books by Kubin, many important critical essays about Expressionism, and became the publisher for the very expensive and well designed group of publications for the Marées-Gesellschaft, which are the finest series of portfolios and reprinted classics of the German Expressionist period. Included in the Marées list were Shakespeare Visionen and Ganymed for the Marées-Gesellschaft, with works illustrated by Beckmann, Grossmann, Unold, Teutsch, Corinth, Meseck, Sintenis, Hofer, Klee, Kubin, and others.

The Piper firm published through the Nazi years, but had an encounter with Josef Goebbels when the Reichsminister stopped publication of Barlach's *Drawings* in 1936 (and the artist sent his famous letter explaining that he was a good German, neither Jewish nor degenerate). The war years cut production somewhat and the authors Piper published were mainly classical. There was one anthology of poetry from the German battle lines in 1943, but most of the books were inexpensive editions in the Piper-Bücherei group of small pocket books. One title was published in 1945. Munich had been heavily bombed and the house on Karlsplatz had been destroyed. But in 1946 the firm put out eighteen new titles and has continued up to the present day.

334.

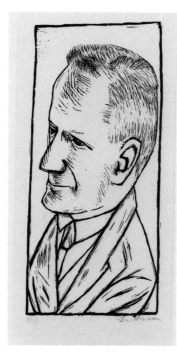

### RUDOLF GROSSMANN

335. Eine dumme Geschichte *(A Stupid Life or A Story of Misery)*
**Dostojewsky**
Munich: R. Piper & Co. Verlag, 1918
V. Werk der Marées-Gesellschaft
Edition: 200 examples: 50 on japan paper with an extra suite of the lithographs, all signed; 150 on holland thick paper, with one original drawing.
Lithos printed by Franz Hanfstaengl, Munich; text printed by Breitkopf und Härtel, Leipzig, under the supervision of E. R. Weiss. Japan edition hand bound at Spamersche Buchbinderei, Leipzig. Each numbered edition is printed with the owner's name (in this case #3 had Dr. Wilhelm von Kaufmann).
Book: 23 x 16.5 cm., 10 + 103 + 3 pp. Portfolio: 34.4 x 26.5 cm., title page + 21 prints (26.7 x 22 cm.) + 1 orig. drawing.
Twenty-two original lithographs by Rudolf Grossmann

*A Stupid Life.* A life of frivolity, dancing and gambling, of material loss through these abuses, of final reckoning, make up Dostoyevsky's account of reverse "Roman", of no growth through developed spiritual progress, but only downfall.

This book is a collaboration between artist, publisher Julius Meier-Graefe of the Marées-Gesellschaft, and E. R. Weiss, one of the best book designers in Germany. It was meant to be a fine volume for collectors. Our copy is part of a special edition finer than the regular one, for there are proofs and one drawing included in the extra suite of lithographs. The lithographs, which seem carelessly drawn and quickly executed are really carefully studied works. Reality is transferred further into fantasy and simplicity in some of the rejected or changed drawings. There is an attempt by both the artist and book designer to balance the weight of the page block with the brilliance of the opposite, illustrated page. The headings are kept light.

Rudolf Grossmann, the artist, was born in 1882 in Freiburg, from a family of painters on the maternal side. Grossmann "flunked" the entrance examinations at two official art academies. He went to Paris for five years, spent much of this time at the Cafe du Dome. He found life and art together in Paris, never forgot the lesson of unity there, found a reflection of art on the surface of life. Grossmann later traveled all over Europe seeking a new world. He settled in Berlin for many years, experiencing the healthy energies there with moodiness and humor. Grossmann became interested in the tragic pathos of life, in which the hero becomes a skeptical and non-interested spectator.

This is a fairly early work by Grossmann. His line is heavy, the mood is gloomy and does not reflect the wild humor of the author's descriptions. The famous incisive laughter of the later Grossmann illustrations is developing, but is not yet consistent with the text.

335.

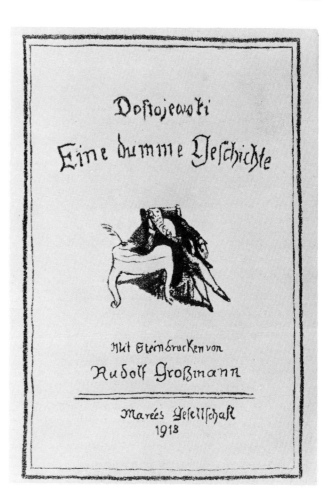

## PORTFOLIOS AND INDEPENDENT ILLUSTRATORS

336. Shakespeare Visionen *(Visions of Shakespeare)*
Eine Huldigung deutscher Künstler *(A Tribute of German Artists)*
Marées-Gesellschaft, III. Drucke, 1917 (dated 1918)
R. Piper & Co., München
Text by Gerhart Hauptmann
Printed by Otto von Holten
Designed by E. R. Weiss
Editions:
Edition A—with 37 prints, all signed; with text on japan paper; 50 examples
Edition B—with 32 prints, on Bütten paper, 150 examples
Text by Hauptmann is 50 x 29 cm. (8 f)
59 x 49 cm.
Bound in blue cardboard

Prints in Edition B:
1. KARL HOFER, Masken, *(Masks)* lithograph; Rathenau L. 6; 43.5 x 32.2 cm.
2. MAX UNOLD, Das Volk, *(The People)* woodcut; 17.9 x 13.8 cm.
3. ERICH KLOSSOWSKI, Sommernachtstraum, *(Midsummers Night Dream)* lithograph; 25.6 x 22.8 cm.
4. ADOLF SCHINNERER, Visionen, *(Visions)* etching; 28 x 22.5 cm.
5. F. AHLERS-HESTERMANN, Imogen Schlafend, *(Sleeping Imogen)* lithograph printed on blue-grey paper; 28 x 41 cm.
6. LEO VON KÖNIG, Falstaff, lithograph; 36 x 29.5 cm.
7. KARL CASPAR, Sommernachtstraum, *(Midsummers Night Dream)* lithograph printed on orange paper; 38 x 26 cm.
8. RUDOLF GROSSMANN, Caliban I, lithograph hand colored in brown ink; 37.5 x 28 cm.
9. RUDOLF GROSSMANN, Caliban II, lithograph printed in brown ink; 38.5 x 33.7 cm.
10. WERNER SCHMIDT, Richard III, lithograph; 34 x 29 cm.
11. LOVIS CORINTH, Falstaff, etching; Schwarz 389; 26.8 x 20 cm.
12. WILHELM NOWAK, Sommernachtstraum, *(Midsummers Night Dream)* handcolored lithograph; 24 x 30.5 cm.
13. MAX NEUMANN, Edgar & Gloucester, lithograph; 37 x 29 cm.

14. WALTHER TEUTSCH, Imogen, woodcut; 14 x 16.8 cm.
15. RICHARD JANTHUR, Wintermärchen, *(Winter Tales)* lithograph; 30 x 20 cm.
16. FRANZ JANSEN, Die beiden Veroneser, *(Two Gentlemen from Verona)* handcolored woodcut; 22 x 25.5 cm.
17. WILHELM KOHLHOFF, Das Drama, *(The Play)* lithograph; 27.2 x 24 cm.
18. OTTO HETTNER, Die Komödie, *(The Comedy)* lithograph on tan japan paper; 21 x 31 cm.
19. E. R. WEISS, Vision, *(Vision)* drypoint; 31 x 26.5 cm.
20. OSKAR KOKOSCHKA, Sturm, *(Storm)* lithograph; Wingler/Welz 86; 26.5 x 24 cm.
21. FRANZ JANSEN, Wintermärchen, *(Winter Tales)* handcolored woodcut; 28.3 x 21 cm.
22. HANS FREESE, Ophelia, lithograph; 25.5 x 24.8 cm.
23. WILHELM (WILLI) JAECKEL, Hamlet, lithograph; 26 x 21 cm.
24. OLAF GULBRANSSON, Othello, lithograph printed on orange paper; 27 x 27 cm.
25. FELIX MESECK, Lear, etching; 30.8 x 28.7 cm.
26. ALFRED KUBIN, Caliban, lithograph; Raabe 95; 32 x 26 cm.
27. TH. TH. HEINE, Lady Macbeth, etching; 36 x 18.5 cm.
28. BERNHARD HASLER, Sturm, *(Storm)* lithograph printed on grey paper; 38 x 25.5 cm.
29. WILHELM NOWAK, Imogen, lithograph; 38.5 x 25 cm.
30. LOVIS CORINTH, Krönung Heinrichs V, *(King Henry V Crowned)* etching; Schwarz 390; 15 x 26.2 cm.
31. MAX BECKMANN, Mord, *(Murder)* etching; Gallwitz 54 b; 22.5 x 27 cm.
32. OTTO SCHUBERT, Finale, *(Ending)* lithograph; 41.5 x 23.5 cm.

The above plus the following prints are in Edition A (on japan):
33. WALTHER TEUTSCH, Othello, woodcut; 17.2 x 12.5 cm.
34. WILHELM NOWAK, Sommernachtstraum, *(Midsummers Night Dream)* lithograph (not handcolored); 24.3 x 30.2 cm.
35. FRANZ JANSEN, Die beiden Veroneser, *(Two Gentlemen from Verona)* woodcut (not handcolored); 22 x 26 cm.
36. FRANZ JANSEN, Wintermärchen, *(Winter Tales)* woodcut (not handcolored); 28 x 22 cm.
37. RUDOLF GROSSMANN, Caliban (I); handcolored lithograph printed in brown ink; 37.5 x 28 cm.

336/1.

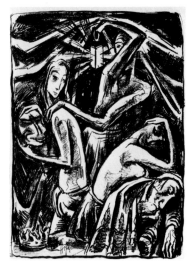

336/31.

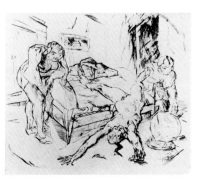

336/8.

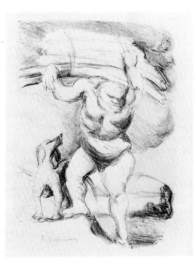

## WALTER GRAMATTÉ

**337.** Der Mantel *(The Overcoat)*
Nikolai Gogol
Translated by Felix Gaber
Berlin-Potsdam: Gustav Kiepenheuer Verlag, 1919
Der Graphischen Bücher Band 3
Edition: 1100 examples:
100 numbered examples on handmade Zanders-Bütten,
signed by artist, bound by hand.
Printed by Offizin W. Drugulin, Leipzig
Lithos printed by the Panpresse, Berlin
25.5 x 18.5 cm.
6 + 39 + 1 pgs
With 12 original lithographs by Walter Gramatté
(Eckhardt 55-66)

Gogol's searching humor reached universal sources in this famous story about pride, acquisition, and loss: the poor government clerk who saves for many years, penny by penny, until he can afford a simple overcoat, is robbed of this mighty possession and suffers complete breakdown from shame.

Gramatté rejected the dull-ecstatic primitivism of many Expressionists. He tried for spiritual fullness through objective forms. The humans are tragic, with burning eyes, slumped shoulders, the weight of human similarity in pain, a procession of repeating lives. Gramatté does not work in the clarity of sunlight, but under the moving shadow covering the sun; his characters are people of the shade. Hands, the possessors, are overlarge. Unseen spirits haunt the dark shadows surrounding the inward sufferer.

Gramatté's illustrations further the mood of Gogol's short novel. Personal though the interpretation is, the artist's view is a logical one for a young German moving in a time of dissatisfaction with possessions, among a group searching for higher values than the material.

337.

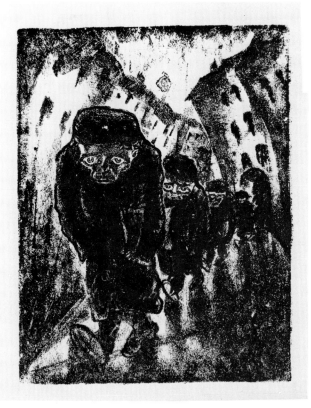

**338.** Die Fibel *(The Primer)*                    338/1.
Edited by Hans Theodor Joel
Introduction by Georg Kaiser
Karl Lang Verlag, Darmstadt
(Put together in Munich-Pasing), 1919
Unknown edition
43.9 x 33 cm.
Prints on Zanders-Bütten paper:
GEORG BIRNBACHER. Liebende *(Lovers)*, woodcut,
17 x 14.7 cm.
LYONEL FEININGER. Segler *(Sailing-Vessel)*, woodcut, 1918,
Prasse 99: "Barke und Brigge auf See," 17.7 x 18 cm.
WALTER RUTTMANN. Spaziergang *(The Stroll)*, lithograph,
1919, 26 x 17 cm.
WALTER GRAMATTÉ. Das Kreisen *(The Circling)* lithograph,
1918, Eckhardt 51, 26.3 x 20 cm.
FRITZ SCHAEFLER. Bildnis Butting *(Portrait of Butting)*,
woodcut, 1919, 32.2 x 23.2 cm. (338/1)

The Karl Lang Verlag of Darmstadt had formerly been the Albert Karl Lang Verlag of Munich-Pasing. Two portfolios were announced; and this one was described "as quickly selling out the edition" (Das Graphische Jahrbuch, Karl Lang Verlag, 1919).

Hans Theodor Joel had been Lang's editor for the two periodicals of this publishing house: Der Weg and the early issues of Die Neue Bücherschau, which was taken over later by others after Lang moved. Joel and Lang were not the persons around whom the Expressionists gathered in Darmstadt: instead the better writers formed around the circle of Carlo Mierendorff and the Dachstube group. Darmstadt had a long tradition as a center of radical ideas. Georg Büchner had published his Hesse Courier there, and this youthful endeavor became the underground soul of the city.

The Lang bookstore and publishers tried to carry on some of this tradition. Georg Kaiser, great Expressionist stage writer, introduces the portfolio with a message of rebirth through the vision of the draftsman-artist. The Volk are the direction of these artists. Creation is made real by work.

Lang had promoted Expressionist poets and painters in Munich, mostly those around Die Aktion circle. Birnbacher and Schaefler had been represented in each, and Ruttmann in one of Lang's periodicals. Birnbacher also appeared in Der Sturm. Schaefler later was represented in Die Rote Erde. As authors and artists they were represented by the Lang Bookstore-Art Gallery.

Walter Ruttmann: North and South German art is divided at the Mainz river. This is the division between northern craftsmanship and southern form-seeking. Both these elements appear in the work of the Frankfurter artist, Walter Ruttmann. In his case it was will-to-form through his pencil and prints, by his craftsmanship in months of careful thought about technique, until the whole conception was understood. Ruttmann was a musician, a cellist before he became a painter and graphic artist. Music lives in all his works. His line is abstracted like the page of musical symbols, curving and diminishing. He tried to capture the other world of mysticism, of swinging rhythms and the music in line.

Fritz Schaefler: The Munich-born painter, etcher, and woodcutter struggled long and hard for his mastery of mediums. He was close to the Aktion style early: forceful contrasts of simple vertical planes. His etchings are more linear, with few curves in shading, mostly parallel lines in a modified Cubism formed around crossed masses. His personality was expounded in quick and vigorous cuts into wood, straight pushes of the chisel, and in straight sweeps of the etching point for broad effects. He was not a man for small details. Ecstatic effects from Die Aktion are achieved by the great contrasts, not expression of features.

Georg Birnbacher: Very little is known about this artist. He died in 1919 at a very young age. He had worked on Der Sturm in Berlin and Der Weg. His woodcut was printed and signed by Fritz Schaefler. Birnbacher produced few prints and has little documentation in the histories of art.

Walter Gramatté: Like the young soldiers in All Quiet on the Western Front, the 17-year-old Gramatté entered the war with enthusiasm, but naive experience. He was wounded badly almost at once, wounded again, had a physical breakdown, studied art in between these breaks in his life, was finally discharged from the army in 1918. As a student he made some important friends in Berlin, and with some help from these, Gramatté was given the Gogol book, Der Mantel, to illustrate for the very important publisher, Gustav Kiepenheuer. He married, found the relationship unhappy and was divorced. He was friendly with the Der Weg group in Munich through his relationship with Marsyas, Die Neue Bücherschau, and the circle around Karl Lang. Das Kreisen, the mixed-up man going around in a circle, is the introverted theme of this postwar work by Gramatté. His inner but sober self-consciousness took the form of many self-portraits, a dreamlike man in exile from the real, the isolated man in darkness, in solitary and oppressive sadness. His friend Hermann Kasak, reader for the publisher Kiepenheuer, had recommended Gramatté for the first book, and probably influenced his interest in the poetry of Hölderlin, that wild rebel who showed life as containing obstacles against insurmountable and unknowable cruelties from fate. Gramatté shows man, too, as a wild-eyed somnambulist, the dreamwalker.

Lyonel Feininger: The year 1918 was an especially difficult one for this artist. He was an enemy alien, placed in one location and not given permission to move around the country. His family had barely enough food. Feininger found himself in a middle place between abstraction and reality in his work. The year 1918 was the great time of woodcut production. The cuts of late 1918 have real compressed energy, complexity, and complicated planes of thrusting line and triangle.

There are two states of this print. In the first, the geometric is emphasized. To bring more complexity to the design, Feininger sanded or filed the surface down, lowering the printing plane and allowing some of the undersurfaces to be picked up in printing. This accounts for the spotted effects between lines, which are traces of chisel cuts between the main forms of the design. This combined the intentional with the accidental.

339. **Deutsche Graphiker der Gegenwart** (*German Graphic Artists of Our Time*)
Kurt Pfister, editor
Klinkhardt und Biermann, Leigzig, 1920
Printed by Julius Klinkhardt Buchdruckerei
33 x 25 cm., 42 pp. plus 31 (f.) illustrations,
23 original graphics and 8 reproductions
Editions: 1-100 on handmade paper, with an original etching by Max Beckmann: Selbstbildnis (*Self-Portrait*), 1920,
19.5 x 14.5 cm., Gallwitz 144
101-600 on thick paper, with a paper cover

Original prints in Deutsche Graphiker der Gegenwart,
in order of appearance in the book:
LOVIS CORINTH; Selbstbildnis (*Self-Portrait*), lithograph, 1920, Schw. L.409, 31.5 x 23.7 cm.
MAX LIEBERMANN; Selbstbildnis (*Self-Portrait*), lithograph, 21.3 x 16 cm.
KÄTHE KOLLWITZ; Selbstbildnis (*Self-Portrait*), lithograph, 1920, Klipstein 145 ib, 23.2 x 20 cm.
AUGUST GAUL; Ziegen (*Goats*), lithograph, 24.5 x 22 cm.
RUDOLF GROSSMANN; Die Boxer (*The Boxers*), lithograph, 21.5 x 18.5 cm.
ALFRED KUBIN; Auf der Flucht (*On the Flight*), lithograph, Raabe 126, 18.8 x 16.2 cm.
PAUL KLEE; Riesenblattlaus, (*Giant Aphid*), lithograph, 1920, Kornfeld 77 iib, 14 x 6 cm.
GEORGE GROSZ; Er hat Hindenberg verspottet (*He Had Jeered at Hindenberg*), lithograph, 23.5 x 17.5 cm.
ERNST BARLACH; Gruppe im Sturm (*Group in a Storm*), woodcut, 1919, Schulte 162, 17 x 12.2 cm.
RICHARD SEEWALD; Die Ziege (*The Nanny Goat*), woodcut, Jentsch H. 81., 15.7 x 21 cm.
HEINRICH CAMPENDONK; Tiere (*Animals*), woodcut, Engels 33 titled as Bauerngang, (*Peasants' Stroll*), 7.9 x 13.5 cm.

339. Beckmann, Pierrot und Maske

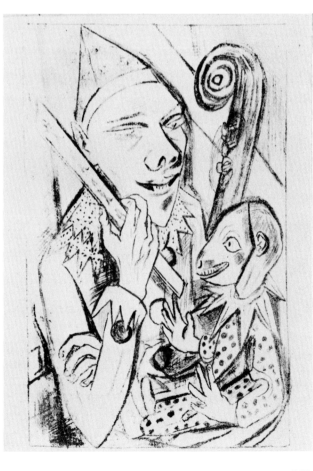

339. Mueller, Badende

ERICH HECKEL; Jüngling *(Youth)*, woodcut, c.1913, Dube 266B, 19 x 14 cm.
OTTO MUELLER; Badende *(Bathers)*, lithograph, 1920, Karsch 110c 17.5 x 23.7 cm.
MAX PECHSTEIN; Weib vom Manne begehrt *(Woman Coveted by a Man)*, woodcut, Fechter 157, 25.2 x 16 cm.
KARL SCHMIDT-ROTTLUFF; Frauenkopf *(Woman's Head)*, woodcut, Schapire 191, 1916, 25.7 x 18 cm.
LYONEL FEININGER; Hansaflötte *(Hansa Fleet)*, woodcut, 1918, Prasse W. 115, 16.5 x 21.9 cm.
CONRAD FELIXMÜLLER; Selbstbildnis *(Self-Portrait)*, 1919, woodcut, Söhn 189b, 24 x 17 cm.
MAX UNOLD; Die Strasse *(The Street)*, lithograph, 27.7 x 18 cm.
KARL CASPAR; Heimsuchung *(Visitation)*, lithograph, 25.5 x 18 cm.
RENE BEEH; Löwe *(Lion)*, lithograph, 18 x 18 cm.
ADOLF SCHINNERER; Das Gastmahl *(The Dinner Party)*, lithograph, 22.7 x 18 cm.
LUDWIG MEIDNER; Bildnis *(Portrait)*, lithograph, 25 x 19.5 cm.
MAX BECKMANN; Pierrot und Maske *(Pierrot with a Mask)*, lithograph, 1920, Gallwitz 146, 31.5 x 20.3 cm.
Cover design: Original lithograph by Richard Seewald, printed in blue ink, Jentsch L. 110, 33 x 24 cm.

Klinkhardt and Biermann was the name of a major publishing firm in Leipzig. The actual firm was managed by Dr. Werner Klinkhardt, while Dr. Georg Biermann travelled, edited and wrote for his own and many other publishing companies. Biermann held a final approval over any publication as he was the scholar and Klinkhardt was the business man. I have described the activities of Dr. Georg Biermann elsewhere in this catalogue.

The printing house of Julius Biermann was founded in 1834. The two brothers who inherited the business, Werner and Viktor, were fourth generation in the field. Viktor managed the fine printing establishment, and was noted for excellent typography, which he prepared for his own publications and those of other fine printers, such as Tieffenbach's Officina Serpentis.

Kurt Pfister held a Ph.D. in art history. His range of expertize was extensive, and he wrote about the Renaissance, Dutch art and Modern art. His major contributions were about Rembrandt and Brueghel for the Marées Gesellschaft. He lived most of his life in Munich. Pfister's scholarly articles appeared in such periodicals as Feuer, Das Kunstblatt, Kunst und Künstler; and he wrote for the Junge Kunst series, also published by Klinkhardt und Biermann.

This survey of the modern art of Pfister's time has selections from the work of the better artists. It exhibits fine taste. The thirty-nine page essay begins by asking about the intentions of graphic art. He describes the harmonious mixture of picturing and spirit, idea and method, world and form. There is a comparison between his beloved Dutch etchers and the Expressionists. He brings the ideas up to the present by describing the intentions of the nineteenth century graphic artists and their different approach to modern graphic art. Most of the background of Expressionism is reviewed, such as the use of the primitive woodcut, exotic views, Japanese and Indian art, Negro art, peasant methodology, and the influence of Cezanne and Munch.

Each of the artists whose work is exhibited in this book is given a short and descriptive paragraph about his methods and spiritual intentions. The writing is concise and a model of short, descriptive prose.

339. Campendonk, Bauerngang

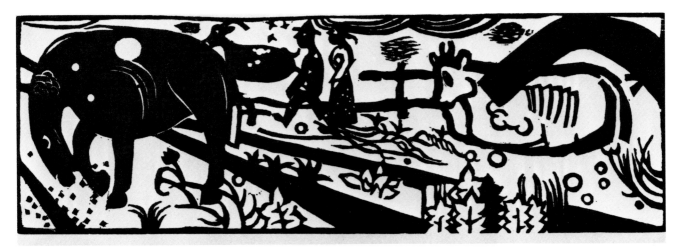

**LOVIS CORINTH**

340. Biblische Szenen (Portfolio title is Biblische Motive) (*Biblical Scenes*)
5 woodcuts by Lovis Corinth, Schwarz 370-374.
Berlin: Verlag Fritz Gurlitt. 1919
92. Werk der Gurlittpresse
Edition: 75 examples:
25 examples on japan, first 15 of which are numbered and given in Portfolio. 50 examples on Bütten, first 30 of which are numbered and given in Portfolio. The other prints on japan and Bütten appeared as single prints and were sold singly through the Gurlitt Gallery.
Two handcolored proofs of Schwarz 374, "Christus am Kreuz," red color added, were printed.
Woodblocks: 32 x 40 cm.

The total edition of Biblische Szenen seems to have been seventy-five plus the two proofs. Karl Schwarz lists a separate printing of twenty on japan and fifty on Bütten, but our verification is on the printers page in the portfolio ("Die ersten 15 Exemplare der Japan-und 30 Exemplare der Büttenausgabe wurden numeriert und als Mappen herausgegeben.") The rest were issued as single prints ("Die übrigen erscheinen als Einzeldrucke").

Corinth chooses the Protestant tradition of sin and redemption in his five woodcuts. As is typically Germanic, the sinful section is dominant. Four woodcuts show man's base nature: rejection of God's commands, expulsion and sense of nakedness, the life of hard work as eternal payment for pride, brother kills brother, and Christ's assumption of man's sins. Corinth obviously designed these prints with the late war in mind. 1919 was the time of hope, of belief in future brotherhood among mankind, of Christian revival and escape from reality.

Each plate has a different concept design. Light radiates upward from the tree of knowledge. The expulsion has broad horizontals around a broken pattern of confused light areas in the center, giving a sense of confusion to the theme. Toil after expulsion is set in horizontal shapes, pressing the weary figure downwards and reemphasized by the symbol of the devil, a black dog. Cain kills Abel in silhouette which curves into the heavy weapon and carries through the diagonal clouds down on the vulnerable head, made non-material by deep gouging. The crucifixion is designed around three sets of crossed rays, with the vertical figure worried by surface bruises in a cruel and emotional frontal contrast.

Corinth's use of emotional force is astonishing. It resembles none of his other work. It seems a true art of unreality. One sees exceptional power of insight after his partial paralysis from the stroke. He fought against this deficiency by will power, apparent in the strong statement of these woodcuts. It may be a broader concept than his former love of sheer paint, smell of varnish and movement of trained muscles; and the force of will combines with Corinth's bravura, something he never lost.

The early Corinth called himself an Impressionist. But from the beginning there was an inner conflict between his upbringing and the strict schools of East Prussia, from which he gained a rigidity and conservatism that even the understanding and guidance of his father, through journeys to outside countries, could not diminish. Understanding by a family aids, but does not counteract the effect of early peer-militarism, which in Corinth's case took the style of heroic draftsmanship. He was a painter of conventional influences: Courbet, Frans Hals, Rubens. His graphic art was another matter: he recast the naturalist tradition into a personal language of form and symbolism, contained in a web of deeply felt emotions. He kept the earthy personality of the barracks; his inner personality and sensitivity combined to keep him from following the Jugendstil style of flatness, that of his friends Obrist, Behrens, Eckmann in Munich. But he ingested the demonic and mystical elements from Jugendstil, and took hedonistic delight in the act of creating in different mediums, including painting and graphic art. The earthly and sensitive united in a psychological interest for macabre drama. Corinth is always the painter happiest in the act of painting. Every turn of the brush, swift slash of the drypoint, quick cut of the knife attests to this pleasure in the act.

The severe stroke Corinth experienced in 1911 at the age of fifty-three, was a crisis which provided a transformation, a welding of previous tendencies towards nervous frenzy, deeper emotional intensity in his graphic art. It pulled him closer to the Expressionists, though his solitary battles were never a fantasy from the primitive. He needed a poetic liberation, not a sensual revolution, for the sensual already was there. His later techniques were freed as an extension of older cultural craft, not in an entirely new fashion.

We must also remember Corinth's background in drama, since he was a stage designer for Max Reinhardt around the turn of the century. He spent most leisure hours reading the classics. Max Halbe, the dramatist, was a close friend, as was Gerhart Hauptmann.

Corinth reversed himself in his later years, rejecting French-Slavic influences on German art, and became reactionary in his personal writings. The Prussian education broke through his whole development and negated an earlier intellectual liberalism from the circle around Cassirer and Liebermann.

340.

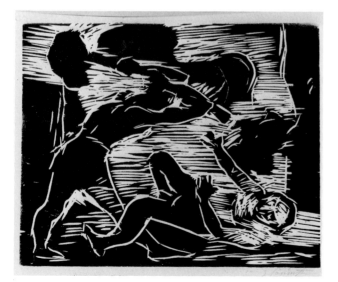

**HUGO STEINER-PRAG**

341. Der Golem (*The Golem*)
Roman
Gustav Meyrink
Leipzig, Kurt Wolff Verlag, 1915
Printed by G. Krensing, Leipzig
Lithographs printed by Meiszner & Buch, Leipzig
344 pages
25.4 x 19 cm. (with 8 original lithographs by Hugo Steiner-Prag)

341.

Kurt Wolff, the publisher, prided himself on his knowledge of literature and taste. However, he had never heard of Meyrink, who had already written nine works of drama and poetry and was a prolific contributor to humor magazines such as Simplicissimus. Meyrink walked into the office of Wolff's publishing house one day and proposed that his novel be published. He had completed it, but only in the form of dictaphone rolls, a novel method then. Wolff paid for advance rights and published the book by the relatively unknown writer from Starnberger See near Munich. The first title of *Eternal Jew* was changed to The Golem. Hans Mardersteig designed the book. Hugo Steiner-Prag was hired to illustrate it. The book was Wolff's first great financial success.

Hugo Steiner-Prag was born in 1880. During most of his life he was a teacher, responsible for the taste and creativity in the book illustration section of the Staatliche Akademie für Graphische Künste in Leipzig. Earlier he had been Kirchner's teacher at the Crafts School in Munich. He worked with printers, designed typefaces, kept an alert and skillful talent busy in the field of book illustrations, book cover art and fields related to book production, and sent out into the art and commercial worlds many trained designers and artists.

The Golem theme was a popular one in Germany; this clay monster given life by the Rabbi Löw, brought to breath by the shimmering reflection from a shem (charm). The great film producer, Paul Wegener, had hired an Expressionist writer, Hendrik Galeen, to write a film called Der Golem, released in 1915, at the same time as the book. Wegener, strangely enough, had a Mongolian cast to his face and resembled the illustrations by Steiner-Prag. The theme had many variations, and Wegener made a new film version of the story in 1919/1920.

## ALFRED KUBIN

Alfred Kubin was born in Bohemia, part of the Austro-Hungarian Empire, in 1877. His father was first an army officer, then a surveyor in the civil service of the Emperor. His mother had been a pianist before her marriage. His first meeting with death occurred at ten, when he was impressed by the sight of his father carrying the dead body of his wife, crying out his grief. Terrible unhappiness for the young dreamer, expulsion from two schools and merciless punishment by his father, gave the inner imagination of the young Kubin a full development. He apprenticed with his uncle, a photographer, for four years, but lost his attention to books ("Uncle" was his father's brother-in-law). He rode on a bicycle, kept snakes and animals, drank and caroused. He tried suicide, but the gun didn't fire and he lacked strength to try again.

In the spring of 1898, the twenty-one year old Kubin began studying art in Munich. He discovered Schopenhauer and Nietzsche, the prints of Max Klinger. He met Klee and Munch, who became his friends. Paul Cassirer gave him a one-man show in 1902, and also helped him financially.

He fell in love with a young Austrian girl, Emma Bayer, but she died soon after. He married a young widow, Hedwig Gründler, in 1904, and found some security. He bought a small castle in Zwickledt, and lived there until his death in 1959.

Kubin went through various crises in these years, had his inspiration dry up, went back to the books of the mystics, worked in anguish, travelled, finally finished his novel, *The Other Side,* which was published by Georg Müller in 1909. This was the turning point in his recognition.

He joined the Blaue Reiter in 1911. He exhibited with Walden's Sturm gallery in 1913. After this period Kubin retired from physical participation in society and became an observer of his own inner life. He worked mostly in illustration. Much of the material he illustrated was literature he liked, a most fortunate way of life for this subjective man.

Experience with techniques of reproduction gave Kubin the chance to experiment with different methods of drawing for exact reproduction, as techniques for transferring images to plates by cameras were not yet perfected. Kubin's illustrated books were rarely made from original lithographs, so this was a real problem for the artist. He had made single drawings as well as other sketches for texts. After *The Other Side* and the Edgar Allen Poe illustrations in 1909, Kubin began his use of line and careful cross hatching, which would relate more to the typeface than wash drawings. The pen drawing became an important medium for Kubin.

We know that Kubin used his sketchbooks for inspiration more than direct observation of nature. The world of his inner vision never became a desert.

A severe mental illness during Army service frightened Kubin into a profession, one in which he had shown abilities earlier, that of painting and drawing. He translated his dream life into supernatural visions on paper and canvas. This kind of art needed a firm viewpoint, for it was not instinctive, but was formed of things seen inwardly. Kubin found two components: one, the rhythm of the hand; two, the clearly thought-out form, the construction as abstract negotiation between the viewer and the dreamer.

**342. Pferde (Verwilderte Pferde)** *(Wild Horses)*
Ink over pencil drawing, c. 1918-1919, 29 x 44 cm.

This animated drawing of wild horses was probably a study for the reproduced drawing in the portfolio Wilde Tiere (Munich: Hyperion Verlag, 1920. 33 illustrations. Raabe #125). The quick calligraphy, the nervous overlap of line after line is typical of Kubin's method. Contour is separated from background by sky, not by outline. The ground is a thicket of lines acting as a beginning for the thrusting motions of the wild horses, perhaps leaping in joyous freedom, with a touch of the demonic in the violent act.

**343. Caliban** *(Caliban)*
Crayon lithograph
Signed in pencil
32.3 x 27 cm.
From Shakespeare Visionen, Munich: R. Piper & Co. 1918
3. Druck der Marées-Gesellschaft, printed by O. Comsee, Munich
Edition: 150 on Bütten, 50 on japan paper
Raabe #95

In the over one hundred fifty illustrated books Kubin did during his creative lifetime, British literature was not a common source. He did this study of Caliban and a Hamlet, plus *The Waiting Book* by Thomas Hardy.

The grotesque side of Romanticism appealed to Kubin. The erotic is not covered up but mixed in a vat of dream and horror. Perhaps this is why he did not find Shakespeare an inspiration, for the great Britisher was a man of action and thought, more than a tormented neurotic. Strindberg was the perfect human symbol for Kubin.

Shakespeare had been an important inspiration for German writers and literary public after the fine translations begun by A.W. von Schlegel in 1797 and completed in 1853 by Ludwig Tieck and others. These works were redone frequently and finally for the German public of our time by Hans Rothe.

Caliban the savage, the deformed slave in *The Tempest,* is drawn with that faint shuddering sensation which Kubin uses to give body to idea. Kubin uses his fund of memory for the setting, a reservoir of torment and grotesqueries. Perhaps he took an idea from a prehistoric model in some museum, combining this with traditions of German supernatural demons. Kubin shows the world between dream and reality, enjoying his demonic dreams and transforming them into visual images. For Shakespeare, Kubin shows the image in clear light without half-darkness, the penetration of mysterious shadow through the subject. The great reservoir of the subconscious is embodied in this squat and crude human. Unreleased savagery and uncontrolled brutality seem near the surface.

**344. Jeremias** *(Jeremiah)*
Ink lithograph, 1921
Signed in pencil, 12.2 x 9 cm.
From Ganymed-Mappe I
Munich: Verlag der Marées-Gesellschaft/R. Piper & Co.
Portfolio of 13 signed prints accompanying the Ganymed Jahrbuch für die Kunst, Bd. 3, 1921, special edition Nr. I-CC. Also appears unsigned in the Ganymed Jahrbuch, Bd. 3. Plate #12. Raabe #142

In the Hebrew canon Jeremiah is known as a latter prophet, and in the English Bible, as one of the major prophets. In the Bible, Jeremiah is shown as shy, reticent, and introspective, and these characteristics probably appealed to Kubin. The outstanding characteristic of the prophet was courage, but we see no trace here, only a singing old man. Luther has written of Jeremiah as the messenger of God's message directly to the heart without a mediator. Perhaps Kubin sees the prophet as the seer of doom, of the destruction of Jerusalem (civilization) and future restoration. Kubin presents the introspective man singing his inner visions, not the vigorous speaker against injustice.

Kubin had also illustrated part of the Bible in 1918, in Der Prophet Daniel (Munich: Georg Müller Verlag. 12 reproduced drawings).

342.    344.

343.

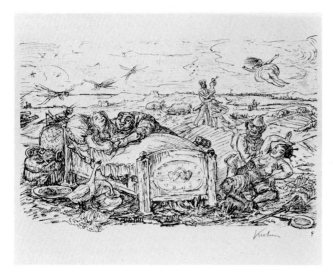

345.

## FELIX MESECK

346. Das Märchen von Gockel und Hinkel *(The Fairy Tale of the Rooster and Cripples)*
By Clemens Brentano
With original etchings by Felix Meseck
Munich: Drei Masken Verlag, 1922, 6. Obelisk-Druck
Edition: 340 examples: Nr. I-LXX; Nr. 1-250 with colophon signed by the artist.
Printed by Offizin der Mandruck, Munich. Etchings printed by Künstlerpresse der Mandruck, appeared in Spring 1922
27.4 x 19.2 cm., 106 + 2 pgs

Felix Meseck was a professional illustrator, one of the most successful, doing work for the best designers, printers and publishers. He had worked for Officina Serpentis and Jakob Hegner at Avalundruck, Fritz Gurlitt and Rowohlt, Piper and Prometheus Verlag.

Meseck was born in Danzig in 1883. He described his childhood as being without goals, always "on a straight line which was pulled from the unknown." He studied at the academy in Berlin, later in Königsberg. He describes his early commercial life in Berlin as dreadful.

Meseck's traditionalism is a complicated thing. He sees old heritage as "only dead in the person who does not recognize the sprouts of the new in himself." He feels the long rows of ancestors, but also sees a road-sign to something new. He sees humanity in the old and eternal. He sees humanity trying to change a boring routine; but he makes a point that is the essence of his art: unhappy is the person who wishes to change his nature.

A professionally trained illustrator has a different method of working with pages. With such a humorous book as Brentano's *The Fairy Tale of Rooster and Cripples,* Meseck can move into Expressionistic exaggeration. He has many styles, each functional to the material. Meseck had no inner urge for spiritual development through art. He had training in naturalistic as well as imaginative relationships with the text. Meseck tended towards the sad and morbid in these illustrations.

He had found the field of illustration very difficult after the war, wrote of his hopes and depressions. His relationship was with Goya or Brueghel rather than with Heckel and Kirchner. His view of life here is grotesque, an intermix of animal and human reality peculiar to the fairy tale.

The author, Clemens Bretano, part of the Heidelberg group of Romantics, collected folk songs and fairy tales with his friend, Achim von Arnim. Gockel und Hinkel appeared late in Brentano's life, in 1838. He was a man of prodigious poetic fantasy, and prefigured some of the ecstatic feeling of Expressionists, combined with Volk tradition in German popular poetry.

345. Rauhnacht *(Cold Night)*
Richard Billingis, with a foreward by Otto Stoessel
13 lithographs by Alfred Kubin, Raabe 281
Berlin: Volksverband der Bücherfreunde/Wegweiser Verlag, 1925. Edition unknown. Printed by O. Birkholz, Berlin
Portfolio without text: 1 pp. preface, 13 prints, each signed, in paper covers, 36.2 x 46.8 cm.

Kubin had a distinctive art-handwriting. His vision has demonic force, captivating the viewer, sometimes frightening by its rude power of suggestion. Horror and happiness stand side by side. Early hallucinations are turned into obligatory draftsmanship. His primitive horror became phantomistic poetry dipped into "the shadow of fright." Kubin says: "Life is a dream." His illustrations for Rauhnacht are beyond the power of gravity, full of floating specters, naked maidens with bells around their waists. He sees masses of ghosts, rising dead, umbrella-carrying flyers, floating lovers, toads and snakes and giant grasshoppers flying through a landscape filled with running horses, shrouded ghouls and beds in an open field. Kubin imagined space as a thing confined by magic magnetism. He finds pure, unbroken symbolic power in the secret halls and rooms of dreams.

346.

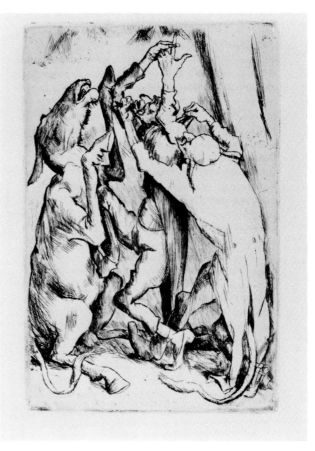

## JOSEF EBERZ

347. Unnennbar Brudertum *(Inexpressible Brotherhood)*
Verse 1904-1917
By Kurt Hiller
With original lithograph illustrations by Josef Eberz
Wolgast: "Der Kentauer" Verlag/Hermann Kruse. 1918
1. Kentauer-Druck
Edition: 350 examples: Nr.1-100 on Van Gelder Bütten, signed by poet, with 6 original lithographs. Nr.101-350 on Strathmore-Alexandra-Bütten, with 2 original lithographs
Printed by Radelli & Hille, Leipzig
23.5 x 16 cm., 36 + 4 pgs

This small and well-designed book contains the collected poetry of Kurt Hiller from 1904 to 1917. Hiller was a former lawyer, who turned to the new expressions, as a means of impressing on the world of Berlin his view of heart and mind, his vision of a new world. He had contributed to Die Aktion early, writing critical articles. He became a very important man of letters. By 1918 Hiller was a political activist. His friends from Der Neue Club, which he had founded, also moved to the left. Hiller was a melancholic, a true stylist and lucid thinker.

The artist, Josef Eberz, was born in 1880 in the small German town of Limburg (Lahn), which was the center of religion for this region. Eberz always carried a mythical, religious feeling in his art. He is objectively religious. His subject matter is visionary, depending on exotic details, such as tropical plants and leaves. He works from within, as instinct tells, rather than from the techniques of the old masters.

He began a lyrical period in 1918, attempting to show growth through pulsating shape. The two lithographs are opposites: the first is a study of desolation and sorrow. The second is a rising man, newly born and gesturing in a tropical landscape, an illustration for the poem called Archipelagos: "Your raised arms carry the surface skin of yellow and pale Chalcedone."

347.

348.

## KARL RÖSSING

348. Taras Bulba *(Taras Bulba)*
By Nikolai Gogol
With 50 woodcuts by Karl Rössing
Vienna, Leipzig, & Munich: Rikola Verlag, 1922
Edition unknown, including 150 numbered examples, signed by the artist, on better paper, bound in half-parchment by Buchbinderei F.J. Bösenberg, Leipzig
149 + 3 pgs., 24 x 18.5 cm.

Karl Rössing, born in 1897, was among the younger professional illustrators.

One of the best traditional book designers in Germany, F.H. Ehmcke, arranged the Gogol book with introductory wood engravings before each chapter beginning, balancing a capital letter. The inner forms are scratched into modelling and match the visual weight of the type blocks which make up a complete page. Paragraphs are also separated by wood engravings, which alternate eye directions back and forth.

Rössing's style is created from the white-on-black technique. The background is retained, while lines are cut into this with a fine burin. The illustrator uses his technique to find form, arranges shape into cubistic masses, and keeps the design functional to the straight cut of the burin.

The great revolt of Bulba and his people, which Gogol has presented with simplicity and feeling, is illustrated by Rössing with emotional expression. A primitive landscape is preserved, cruelty is shown, rigidity of purpose is acknowledged. Gogol's view of history is brought to the German reader as a sense of lost nationalism, an echo of defeat by treachery, which the German middle class thought brought the German armies down to defeat in World War I. The hero, with Greek definition of "hubris," is tumbled down from glory but dies undefeated in spirit.

Rössing was also a sculptor, and his wood engravings have much of the stone-like depth and objectivity of sculpture. There are picture puzzles in the shading. Composition is the most important element. His use of relief is also important in how the page relates to horizontality and mass.

Rössing takes the seventeenth century setting, the savage war between Poles and Cossacks, the inner struggles between Taras and his sons, as a descriptive language for the illustrations, breaking plane and verticality into complexity, which reflects the social mixtures rather than the Ukrainian countryside of far-reaching vistas.

## RICHARD SEEWALD

349. 10 Holzschnitte zur Bibel *(10 Woodcuts of the Bible)*
11 handcolored woodcuts by Richard Seewald
Vienna, Zurich, and Munich: Dreiländerverlag. 1914-1916
Edition: 250 examples
1-25 printed and handcolored by the artist, signed
25-100 handcolored and signed by the artist
101-200 handcolored with justification page signed by the artist
Jentsch: H48-58; each 17.9 x 13.9 cm.

Richard Seewald was born in 1889 in Arnswalde (Neumark). As a graduate of the classical gymnasium and a student at the University in Munich, Seewald built a fine knowledge of classical history, language and literacy, which became the trademark of his later art. He was a man of ideas. None of the recognized art schools seemed satisfactory, so the young Seewald taught himself from magazines and postcards. He naturally moved toward caricature and sketching from the local humor magazines, eventually supported himself and began a long career as illustrator, painter and writer.

Seewald was well-travelled, a frequenter of European museums and churches. He knew Corsica, the Mediterranean coastline, and was influenced by this sun-drenched area so loved by German romantics. His early youth in the wild woods gave him a love of animals, the stimulations and confirmations of mountain air, forest and stream.

His early style, shown in these woodcuts for the Bible, is rooted in German peasant art. The testament of Jesus does not interest Seewald, but he prefers the passions, myths and eternal flow of archetypes in the Old Testament. Man is hero and man is victim there. To Seewald, the Bible is a great landscape of happenings; people are small in God's landscape, usually grouped, creatures of both paradise and murder, usually unclothed, relating to beast and land, but victimized by war and the supernatural.

The compositions are balanced between black and white masses. Line is carefully designed for inner movement around the picture plane. Voluptuous and spiritual nature-mixture is combined with easy intimacy of humans and animals. Adam and Eve take the apple from a female, many-breasted snake. The flood has vertical rain. The trumpets around Jericho tumble down cubistic walls. A horned Moses calls down the wrath of wind and water. The Land of Canaan and Paradise brings fruit and rest; one with a centered sun, the other as a treed God. Balaam's ass sees the angel, and a nude David smites the giant. The cycle ends with the only night scene, with the Fall of Jerusalem in rape and burning.

Seewald's style as illustrator is primitive in method and sophisticated in concept. He retained this literary-graphics' interest all his life. His earliest work was for Francis Jammes', Der Hasenroman. Seewald illustrated this same book again in 1952.

349.

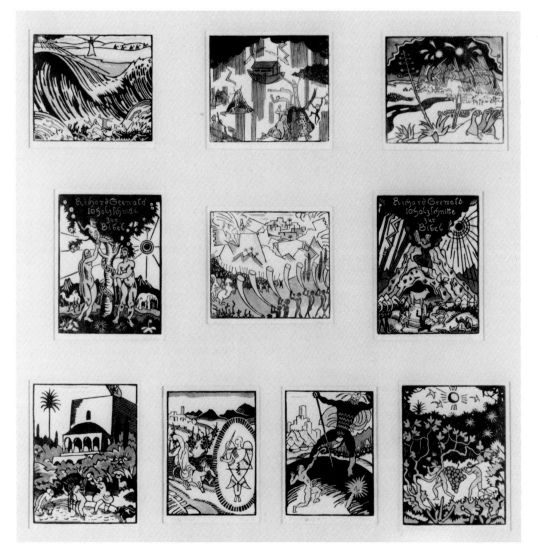

## ADOLF UZARSKI

350. Tuti-Nameh *(Tales of the Parrot)*
13 original lithographs by Adolf Uzarski
Düsseldorf: A. Bagel Verlag. 1919
Edition: 85 examples
Nr. I-V on Imperial japan paper
Nr. 1-80 on Van Gelder Bütten paper, signed, dated, and numbered. Portfolio: 66.2 x 51 cm., Sheet: 55.5 x 51 cm.
Lithographed title page, 12 prints in portfolio

Adolf Uzarski was born in Duisburg-Meiderrich in 1885. His early work is typical Jugendstil, with flat patterning and line outline. The drawings and prints develop into a kind of romantic lyricism in the war period. Later he worked for the Flechtheim gallery as edtor of their publications, a member of their stable of artists. He left Flechtheim in 1920 for the gallery run by A. Bagel in Düsseldorf. This was probably a mistake, for Flechtheim had handled painters such as Braque, Klee, Rohlfs and Picasso, while the Bagel gallery handled painters such as Schwarzkopf, Umbach, Zahn, who are now obscure.

During this period Uzarski allied himself with western German artists, and was publicized in von Wedderkop's fine outline of these Rhenish artists, Deutsche Graphik des Westens, Weimar, 1922.

After the lyric period, Uzarski became more abstract in his approach to form, though his literary background was always apparent. He had already made a reputation with his illustrations for Petronius in 1913, Das Gastmahl des Trimalchio, (printed by Poeschel und Trepte, in Leipzig).

Tuti-Nameh (Nama) was in Indo-European series of fables in an Islamic environment. Tuti-Nama, *(Tales of the Parrot)*, is built around the theme of the bird which sees more than the other characters, uncovers the infidelity of a woman, and squawks and complains. Some scholars place these tales close to the Sindibad *(Sindbad)*, collection. It is later than Arab sources, probably of Persian-Moghul origin, and belongs with the Marzban-Nama, another collection of animal stories and allegorical-mystical poems.

Uzarski illustrates the strictly human portions of the collection. Probably, he discovered the stories in the translations of Friedrich Rückert and Paul Lagarde. Lagarde worked in the Indo-Persian field (1884) and was a strong exponent of the Volk theories, which developed into antichristian and antijewish propaganda. Rückert had worked in the Persian field as early as 1837.

Uzarski uses the oriental settings of the stories in the Rhenish tradition of Lehmbruck and Nauen, a writing composition with extended proportions and semiabstracted details. Exaggerated gestures are promoted by the breakup of light into crossing diagonals. Form is broken by knife scratches away from the center. Magic horses, gigantic serpents, impossible plunges into bottomless chasms, ecstatic dances and wild storms form the center of attraction for the artist in the Expressionist tradition. The major theme of the original Nama is ignored, i.e., the relationship between animal and man, woman as deceiver, and animal as the loyal though sly companion of man.

350.

## RICHARD SEEWALD

351. Penthesilea. Ein Trauerspiel *(Penthesilea. A Tragedy)*
By Heinrich von Kleist
Munich: Goltz Verlag, 1917
Edition: 200 examples of which 140 on holland Hadern-Bütten, numbered, signed by artist on colophon.
Printed by K. Hof-und Universitätsbuchdruckerei und Lithographischen Kunstanstalt, Dr. C. Wolf & Sohn, Munich.
Covers by A. Köllner, Leipzig. 30.7 x 23 cm., 8 + 129 + 2 pgs
With 21 lithographs by Richard Seewald, a unique copy with all lithographs signed by the artist.

Heinrich von Kleist was a solitary man, who lived in an inner wilderness, and wrote about individual man fighting fate (he was not a gregarious person like Goethe). Kleist's world was floating on the edge of incomprehensibility.

Penthesilea was queen of Scythia, and leader of the Amazon armies. She joined forces with the Trojans in front of Troy and confronted the Greeks with eastern fury and irrational hatred. In this version, based on certain Latin variations, Penthesilea kills Achilles. In Virgil, the major source, Achilles is killed by Paris, who wounds him in an unprotected heel.

Kleist employs the legend for metaphysical drama. Achilles is confronted with a situation which shatters his belief in world order. This world of imagination for Kleist was used as symbolism of the cleavage in the universe between nature and man. This was the direct appeal for the Expressionist generation. Penthesilea was published in 1808, but never performed in Kleist's lifetime. Kleist suffered from erotic instability, a symptom of his general disorientation. This is the theme of Penthesilea. The heroine has this mixture of love-hatred, pronouncing a curse on life itself, setting her dogs on Achilles, and finally killing herself.

Seewald uses an emotional approach to Penthesilea in his work, showing action and confusion of battle. Characters are small, victims inside a large nature. He brings out the emotional dialogues by dark shapes and sweeping color lines. Women are heavy and strong. Achilles resembles St. Paul under a sun-ray. There is use of a circular motif, which animates the page. The Amazon armies are wild forces with elephants, chariots and spotted horses. Seewald uses a varying tone, sometimes gray, sometimes black, to balance the text. There is little consideration for the inner motivations of Kleist. All is external battle and flesh. Seewald's characters are lost in the larger world, unlike the tormenting explanations of the author with his human anguish as a basis for drama.

351.

**FELIX MESECK**                                                    352.

352. 15 Kaltnadelarbeiten zu H. von Kleists Penthesilea
*(15 Drypoints to H. von Kleist's Penthesilea)*
Felix Meseck
Berlin-Potsdam: Ferdinand Möller Verlag, c. 1920
Edition: 55 examples:
Ausgabe A: 5 examples on japan, numbered I-P. Ausgabe B: 15 examples on Zanders-Bütten, numbered 1-15. Ausgabe C: 35 examples on Bütten, numbered 1-35
All signed and numbered by Meseck
Printed by Hübel & Denck, Leipzig
Title page, colophon sheet and 15 prints
Portfolio: 38.5 x 29 cm., sheet: 36.7 x 28 cm.

In the Rifkind Collection there are two versions of Penthesilea: illustrated by Richard Seewald in 1917 and by Felix Meseck in 1920. Meseck, the professional illustrator, tries a different approach.

Meseck shows us a pensive Amazon, a tortured woman. The scenes showing Amazons are cleansed of detail, without special costumes, but with simple and universal robes. Action moves from close up to distant battles in an overpowering mountainous landscape. Meseck emphasizes grace and easy motion, not the violent conflict of Seewald. Achilles is not the god-like man, but a long-nosed wrestler in tights. Classical poses in the later scenes of conflict come from Meseck's interest in Renaissance art. There is contrast between Rosenfest, the sexual feast associated with men, and the madness of unrestricted hand-to-hand-combat. Idyllic and quiet love gardens contrast with death in stillness. The crude Achilles dies from Penthesilea's arrow in his throat, her dogs ready to tear him apart.

Meseck loses the message of the story with his last illustrations of the Amazon's grief. He presents it as a sentimental sadness, not the irrational fury in Kleist's play, one of the major symbols of Kleist's intentions.

Neither set of illustrations is able to present a truly emotional cross section of Kleist's play. Both concentrate on the superficial, exterior realities in a drama of psychological imagination.

# FRANZ JANSEN

353. Rechtsbesitz *(Certificate)*
Woodcut, 1921
on Bütten, 33.2 x 26 cm.

353.

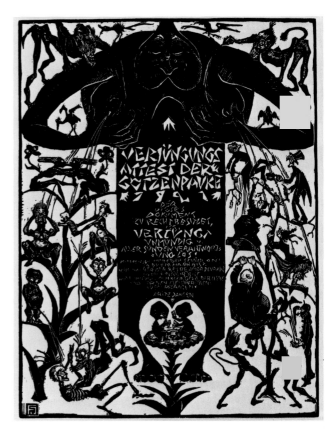

This handprinted certificate was issued for semicomical and semiserious purposes: "The Thundering Gods Attest to a Rebirth." Its text addresses "all sinful youngsters:" "One is always alone in mankind. Thus you are a man. Woman is a bestial and plural lover." Jansen asks us to pay with a little gold for love and supper.

There is an Oriental character to the script, a grotesque animation to the small figures, based in style from the frontispieces of late medieval books. God is female, with squirting milk from full breasts. She is helped by two devilish monsters, one adding milk from a bottle. Woman-God smiles. Twin trees of life hold nude lovers and happier creatures to the left, clothed citizens in a kind of Last Judgement on the right, with the two devils shaking the trunk. Centered are two moronic infants playing cards.

The woodcut is a statement of hope and cynicism, the two major attributions of the postwar generation of German artists.

Franz Jansen passed through every phase of Expressionism, although he did not come to graphic art until 1912. Jansen was born in 1885 in Cologne, a large city. Just as most of the Expressionists were trained in architecture or at crafts schools, Jansen studied architecture, worked for Otto Wagner for three years. It was in Vienna that the young man became a painter, with J.B. Neumann providing inspiration for beginning talents. He drew at night, was a soldier during the day in World War I. His pent-up emotion, the feeling of bursting inside brought Jansen to serious art.

He sent prints to Zeit-Echo during the war. His political turn towards activism in art brought him later in contact with Die Aktion groups, and he made many prints for that periodical, mostly grim cartoons after political events. He bitterly attacked the Social-Democrat-Party, which had begun its oppression of leftwing workers.

Jansen's woodcut style is simplified in these cartoons, along the lines of Masereel's woodcuts. Earlier etchings were sketchy and impressionistic. As an architect he had sketched in fields and woods. By 1918, he began the series of *Plates of Time,* which encompass German life in instinctive and truthful parody. The drawing is flat and shaded by simple straight lines.

Jansen helped make the woodcut a voluptuous medium for an intoxicated explosion of power. He was always linked to content. He cried in horror against pain and death through these illustrations. He showed the fatigue of postwar Germany.

Jansen was a prolific artist. We can list over twenty-six portfolios: a prophet; Rhineland landscapes; *The Cry; Passion; The War; The Rhine,* etc. Though Jansen later lived in a small town on the Rhine, Feldhoferbrücke, he retained his contacts in Berlin until his death in 1953. Throughout his later life he retained two outlooks: the first was a savage commentary on German society and its citizens: the second was a lyrical exposition of the Rhenish landscape.

## RUDOLF KOCH

354. Kriegserinnerung *(War Memory)*
Woodcut, 1919
Offenbach a.M.: Verlag Wilhelm Gerstung
13. Rudolfinischer Druck
Signed
200 examples hand printed
33.5 x 22.5 cm.

Rudolf Koch represented one of the finest from the Offenbach school of all-around artists. He was a masterful designer of new typefaces: his "Petit Neuland" is still famous. He was called the God of handwork.

Koch was born in Nürnberg in 1876, somewhat before most of the Expressionists. He apprenticed with Gebrüder Klingspor, the great type house, in 1906. He had already put in eight intense years of study at the Crafts and Art school in Offenbach. He designed his first new typeface in 1910. His virtuosity soon brought him fame, and he painted, made prints and designed for the better printers and publishers. In the year 1911, Koch combined with the great printer Rudolf Gerstung, and produced a private series of works called Rudolfinische Drucke. Our example is one of these. The series lasted from 1911 to 1924.

Koch reintroduced the "Einblattholzschnitt": the woodcut with type and illustration cut on one block of wood, similar to late medieval blockbooks of the same region.

After the Great War, Koch returned to Offenbach and continued the series. He produced a family book first, then a series of initials for a book by Friedrich Schiller. This woodcut was next, the third single-page work. Koch also returned to fraktur typefaces with these prints. He had already developed various roman faces for the industry, but his most personal attempts for himself were rougher, less elegant.

Koch died in 1934, and left a following which practiced his creative freedom within the traditions of the printing trade.

Koch's greatest books were for the Insel Verlag: especially the Das ABC-Büchlein of 1934. Other fine examples of his design talents were for Dostoyevsky's Ein russisches Evangelium of 1922, Das Blumenbuch of 1929-1930 and the great Johannes Evangelium of 1921. His most famous and expressionistic blockbook is the Elia, with five double pages of cut blocks, done for Gerstung in an edition of 200 examples, number 10 in the Rudolfinische Drucke series.

Translation of the Rudolf Koch woodcut, Kriegserinnerung: "These are my boots. I wore them at my fortieth year as a grenadier in the sands of the Mark, on the roads of Serbia, over the heights of the "Dead Man" near Verdun, in the field hospital and at home. And then again in the Champagne and near Reims on the heavy days of fighting before the Brimont. There they perished on May 2nd, 1917, by a French grenade."

354.

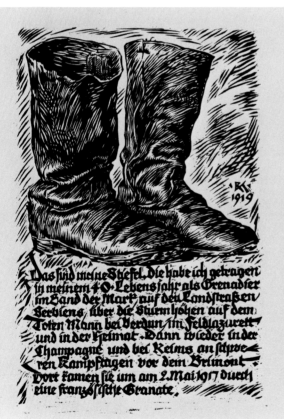

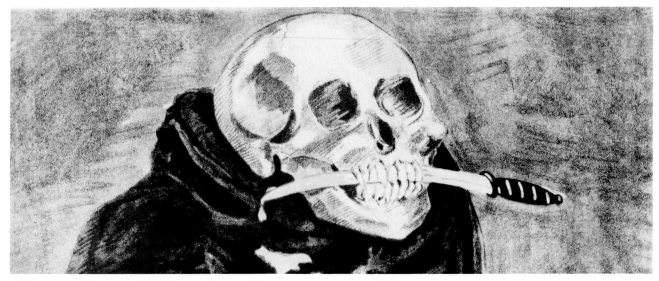

## LIST OF REVOLUTIONARY–ERA ARTISTS
### NOVEMBERGRUPPE MEMBERSHIP
### LISTED AT "ERSTE SITZUNG DER NOVGRUPPE."

Max Pechstein
César Klein
Georg Tappert
Moriz Melzer
Heinrich Richter-Berlin
Oskar Kokoschka
Rudolf Belling
Georg Leschnitzer
Otto Mueller
Oskar Moll
M. Frey
Rudolf Steiner
Karl Jakob Hirsch
Frl. Irma Stern
Bruno Krauskopf
Rudolf Bauer
Wilhelm Schmid
Bernhard Hasler
Erich Mendelsohn
Richard Janthur
Otto Freundlich

and mentioned as Zustimmungserklärungen liegen von folgenden Kollegen vor:

Otto Mueller
Karl Jakob Hirsch
Heinrich Campendonk
Otto Hettner
Hans Purrmann
Schlicht, München
Heinrich F. Bachmair, München
Rüdiger Berlit, Leipzig
Fritz Schaefler, München
H. Mauermayer, München
A. Wachlmayer, München
Max Schwimmer, Leipzig Lindenau
Fredwaak, Leipzig
J. Nitsche, München
E. Timm-Bergedorf, Hamburg
Curt Störmer, Worpswede

### SEZESSION GRUPPE 1919, DRESDEN

Peter August Boeckstiegel
Otto Dix
Gela Forster
Will Heckrott
Otto Lange
Constantin von Mitschke-Collande

Conrad Felixmüller
Otto Schubert
Lasar Segall
Hugo Zehder, Architekt
Associate: Oskar Kokoschka

### UECHT GRUPPE, STUTTGART, 1920

Gottfried Graf
Edmund Daniel Kinzinger
Albert Mueller
Hans Spiegel
Walt Laurent
Heinrich Eberhard
Ida Kerkovius

### JA! STIMMEN DES ARBEITSTRATES FÜR KUNST IN BERLIN. NOV. 1919

Presidents:

Walter Gropius
César Klein
Adolf Behne

Committee Members included:

Max Pechstein
Karl Schmidt-Rottluff
Erich Heckel
Ludwig Meidner
Lyonel Feininger
Bruno Taut
Max Taut
Otto Bartning

among contributors:

Karl Schmidt-Rottluff
Moriz Melzer
Georg Tappert
Hermann Obrist
Gropius
Bruno Taut
Max Taut
Adolf Behne
Karl Ernst Osthaus
Wilhelm R. Valentiner

signatures, more than 100 included:

Paul Cassirer
Alfred Flechtheim
L. Feininger
E. Heckel
L. Meidner
Otto Mueller
Heinrich Nauen
E. Nolde
M. Pechstein

## EXPRESSIONISM AND REVOLUTION 1918 TO 1922
By Ida Katherine Rigby

In the years immediately following the First World War some German Expressionist artists allied themselves with left wing forces for social change. Most limited their efforts to effect utopia to paper projects and protests; some, however, engaged in activist politics.

Before the war the desire for social change was expressed in abstract, metaphysical terms. Herwarth Walden's Der Sturm (Berlin) represented the typical aesthetic, cultural, and by implication, political critique. In 1918, in the aftermath of the Russian Revolution and following the fall of the Kaiser, the mode was activist. The left wing intellectuals welcomed the tabula rasa on which to write the prescriptions for the new order.

César Klein's *The New Bird Phoenix* printed in An alle Künstler *(To All Artists)*, 1919 symbolized the artists' faith in the magical ability of a new Germany to rise from the ashes of defeat. An anonymous poet in the Expressionist journal, Kraefte *(Power)* published in Hamburg, expressed this same popular illusion:
The War
The end of the atrocious, lying, material era.
Decay of the perishable body.
Ascent of the Soul. (Kraefte, 1:1, 1919, p. 5)

Karl Schmidt-Rottluff's monumental 1918 Christus captures the other, tormented, brooding visage of a beleaguered time bereft of consolation whose suffering is given a bitter poignancy by the inscription, *"Has Christ appeared to you?"*

The end of Expressionism as a dynamic force came between 1920 and 1922. Paul Raabe attributes its denouement to the artists' "painful realization of the incompatibility of artistic wishes and political reality,"[1] and their subsequent disenchantment with political activism. Expressionism was dead long before the Nazis subjected the Expressionist artists to the cultural version of the final solution, and perhaps the disillusionments of the immediate postwar years quickened its wane. On the other hand, the 1914 war was a dislocation from which the movement could not recover. The exaltation of the years 1918 and 1919 was only a brief blaze kindled of embers from a fire already extinguished. By implication Expressionism had always advocated social change, but in the final analysis its concerns were aesthetic and cultural, not political. Dedication to political activism could not sustain and revitalize it.

The years immediately preceding the end of Expressionism were years of euphoria induced by the illusion that artists could in fact contribute to the shaping of a new society. Will Grohmann described the atmosphere which nurtured these illusions: "There occurred a miracle, with few exceptions everyone felt himself part of a community, morally obliged to believe in the good in humanity and to create the best possible world...So many dreams appeared to be realized, and even for the artist there was a place in the new state, in the new society."[2]

The short period between the revolution of November 6, 1918 and the establishment of the Weimar Republic witnessed an unprecedented activism among the German intelligentsia which habitually had shunned politics.

On the eve of the war much Expressionist imagery and rhetoric was infused with a sense of moral mission and apocalyptic urgency, but the artists were apolitical. Wassily Kandinsky called on the artist to lead society from its materialistic foundations to a new spiritual base, while his friend Franz Marc painted "altarpieces" to the new religion. Marc wrote from the trenches: "Today the ground is being prepared for the grandest movement of the fourth estate, but these occurrences do not actively inspire me. Art draws another road to eternal life."[3] For them, a spiritual revolution was the precondition for social reform. Walter Hasenclever's comments on the purpose of his 1914 play, *The Son,* also expressed the widespread conviction that art could effect social change. "This play," he contended, "had the purpose of changing the world."[4]

Franz Marc and Ludwig Meidner best expressed the attitude which welcomed the war as a cathartic cataclysm. Meidner painted apocalyptic landscapes and Marc wrote of the regeneration of Europe "In War's Purifying Fire." Many enlightened circles welcomed the war. In reality, it was a hiatus in the careers of these prophets, many of whom lost their lives. Most of those who survived were temporarily politicized. Whereas their prewar motivation for espousing social change had been romantic, their post war rationale was Marxist.

Marc had dreamed of the birth of a new Socialist Europe, but he confided, "I am a Socialist in my deepest soul, with my entire being, – but not a practical Socialist."[5] Herein lay the difference between pre- and postwar involvements. In place of books, easel paintings, and metaphysics, there appeared broadsheets, posters, and polemics. Content superseded form. This development led Expressionist critic Willi Wolfradt to assert in 1919 that "totally modern painting is poster and caricature." [6]

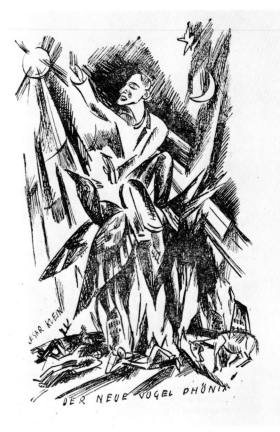

Fig. 1. Klein, The New Bird Phoenix, from An alle Künstler, 1919.

355.

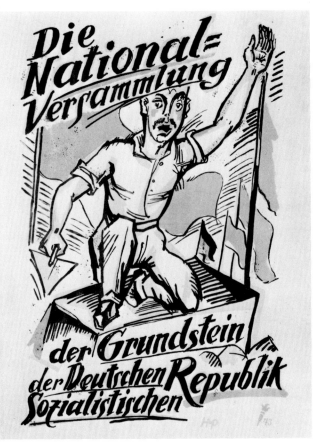

356.

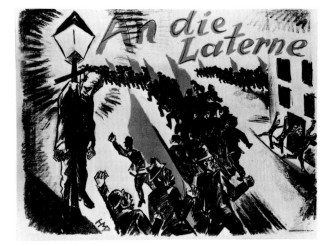

## MAX PECHSTEIN

355. Die Nationalversammlung/der Grundstein der Deutschen Sozialistischen Republik *(National Assembly, the Cornerstone of the German Socialist Republic),* lithograph, Chipp 74, Rademacher 94, c. 1919, 67.8 x 50.2 cm.

356. An die Laterne *(To the Street Light)* lithograph, c. 1919 71.1 x 91.4 cm.

357. Erwürgt nicht die junge Freiheit *(Don't Strangle the New Freedom/Through Disorder and Civil Strife, – or Your Children Will Starve),* lithograph, Internationale Plakate 302, 99.1 x 60.6 cm.

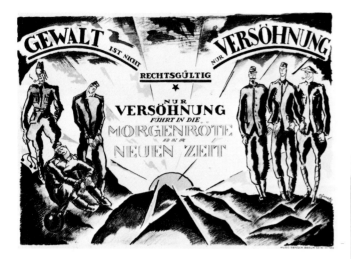

**PLUENNECKE**
**358. Gewalt ist nicht rechtsgültig** *(Power is not Legal/Only Reconciliation Leads to the New Day)*, **lithograph, 1919, 66 x 90.8 cm.**

**WILLI JAECKEL**
**359. Bauer hilf, die Städte hungern!** *(Peasant Help, the Cities are Starving!)*, **lithograph, c. 1919/1920, Internationale Plakate 327, 72.5 x 95 cm.**

357.

**CÉSAR KLEIN**
**360. Nationalversammlung** *(Workers, City People, Farmers, Soldiers of All Races in Germany/Unite in the National Assembly)*, **lithograph, Rademacher 95, 67.5 x 86 cm.**

295

361. Berliner Secession, *(For the Play, The Last King of Orplid)*, lithograph, c. 1919, 71.1 x 47 cm.

362. Das Gesetz *(The Law)*, poster for a play by that title, ud., lithograph, 71.6 x 96.5 cm.

363. Die Gefahr des Bolschewismus *(The Danger of Bolshevism)*, lithograph, 94 x 69.3 cm., ud.

364. So führt euch Spartakus! *(Thus Spartakus Leads You/ Brothers,/save our Revolution)*, lithograph, c. 1919, 91.4 x 67.4 cm.

365. Ohne Kohle keine Lebensmittel zufuhr *(Workers! Will You be Satisfied? Without Coal, No Provisions/Work Brings Bread/ Miners and Farmers Call You)* lithograph, ud, 64.2 x 84.5 cm.

366. Konsumenten, vereinigt euch in der Konsum-genossenschaft *(Consumers, Unite in the Cooperative!/ Forward Bremen!/Co-operatives Are an Important Step on the Road to Socialism)*, lithograph, c. 1920, 79.7 x 57.8 cm.

Expressionist journals with names like Menschen *(Mankind)*, Die Rote Erde *(The Red Earth)*, Der Anbruch *(The Beginning)*, and Das Junge Deutschland *(The New Germany)* celebrated the coming social order.

During the war the Dadaists had attempted to unite art and politics. Dada pamphleteering and polemics expressed the artists' disaffection with established interests and modes of thought. Richard Huelsenbeck's Dada Almanach and Hugo Ball's Almanach der Freien Zeitung give an overview of the ephemeral documents of Dada and evoke the frenetic, irreverent style of the Dada critique. Although the Expressionist style was ecstatic, these artists put forward more systematic appeals and programmatic manifestoes than the Dadaists, formed unions, and designed posters for the myriad socialist, communist, anarchist, and pacifist causes advanced in post-war Germany.

Kurt Hiller, publisher of Das Ziel *(The Goal)*, a yearbook in service of a "world league of the intellect", coined the term Aktivismus in 1915. His activism, however, was still that of the theorist and the intellectual, not the politician. The most tireless publicist was Franz Pfemfert, editor of Berlin's Die Aktion. Unlike most German left wing intellectuals in 1918, Pfemfert was no stranger to activism. In 1915 he had founded the Anti-nationalist Socialist Party Group of Germany. The 1917 Aktionsbuch, an anthology of essays and prints culled from previous issues of his Aktion, indicates the revolutionary tenor of the pre-war numbers. They had included articles on Bakunin, Peguy, Proudhon, and Juarés, by Franz Mehring, Alexander Herzen, and Karl Liebknecht. Ludwig Rubiner *(The Collective: Documents for the Intellectual Altering of the World)* was another influential proponent of Aktivismus. His tone recalled prewar idealism, but his political alliance was specific: the Communist Party.

Although their elected means differed, the post war leftist intellectuals generally believed that the opportunity for nurturing a New Man through an essentially socialist system was at hand. Their efforts to effect the new order, however, were dissipated in the dissensions and divisions born of ideological intricacies and organizational feuds which precluded the formation of a united front among the variously pacifist, socialist, communist, and liberal leftist factions.

In a 1917 issue of Die Aktion, Ivan Goll called upon the artist to be prophet and leader, priest and politician. Such admonitions fell on eager ears. Karl Jacob Hirsch recalled, "It started. We were ready to throw everything away…Rubiner's call for a political art had long stirred us…Content was what counted, and that was Freedom, Equality, Brotherhood."[7] Expressionist activism was frenzied, embattled, missionary, rebellious in spirit and style, Expressionist Rausch. The ecstatic visionary Meidner was the most extreme example of this spirit. He was for Renewal! Brotherhood! The Deed! The World! The salvation of mankind was his obsession (To varying degrees this had always been the Expressionists' goal. The Brücke's was an anti-bourgeois, antimaterialist critique as was that of the Blaue Reiter).

361.

362.

363.

364.

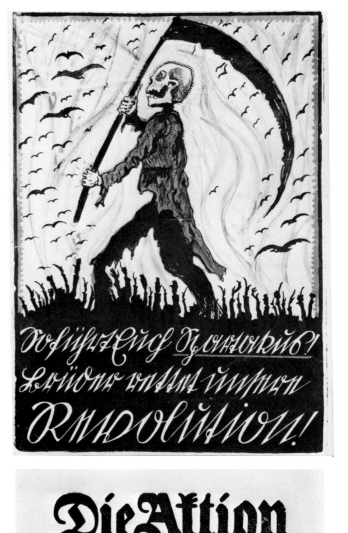

365.

366.

**Fig. 2.  Hirsch, Die Freiheit, from Die Aktion, Heft 8 Nr. 9/10.**

For those who became activists, it was the war experience which transformed their rhetoric from prophetic, apocalyptic, and utopian to political and activist. The prewar writings of the Expressionists portray the artist as a spiritual seismograph sensitive to the tensions of the times. In 1914 Paul Klee wrote: "I have had this war within me for a long time."[8] In 1915, on receiving a post card of his 1913 *Fate of the Animals*, Marc wrote of the forebodings uttered in that portentous, cataclysmic work. "It is a premonition of this war, spectator-like and stirring. I can hardly imagine that I painted it!...It springs from an artistic logic, to paint such pictures before the war, not as dumb reminiscences after the war."[9]

The Sturm *(Storm)* circle of which Marc was a member had always eschewed participation in politics, and continued this stance after the war. The title of Oswald Herzog's woodcut, Revolution, in a 1919 number of Der Sturm alluded to political upheaval, but the idiom was abstract and its appeal was to an elitist, aesthetic sensibility. Some important Expressionists, notably Ernst Barlach and Alfred Kubin, remained pessimistic about the proposed alliance with the masses and refused all invitations to participate in the artists' unions.

Although Barlach conceded that it was the artist's duty to raise the level of consciousness of the masses, he considered it his more important task to raise the intellectual and spiritual level of his own work "undisturbed" by the pressure to organize and propagate."[10] He did, however, contribute patriotic lithographs to wartime publications i.e., the Kriegszeit *(Wartime)* and the Bildermann *(Picture Man)*. Kubin, in responding to an invitation from the Berlin Novembergruppe *(Novembergroup)* expressed the same disaffection from politics. "We [artists] effected our revolution long ago, do it over and over, and are actually winning it. Mixing the common people and art would hardly be possible for us in the near future."[11]

Fig. 4. Barlach, Der heilige Krieg, from Kriegszeit, #17, 16 December 1914.

Fig. 3. Herzog, Revolution, from Der Sturm, #12, March 1919.

The general postwar mood, however, was activist. The quintessential postwar activist Expressionist periodical, Menschen *(Mankind)* published in Dresden, editorialized, "Expressionism...is no purely technical or formal problem, but primarily an intellectual (epistemological, metaphysical, ethical) attitude... In politics this idealism is called anti-national socialism; we need it, radically and absolutely, not in the mind alone, but in action." (Menschen, II:3)

Some, like the Dadaist Hugo Ball, who were early aware of this distinction between intention and action, became completely disillusioned with art and embraced politics. On August 7, 1914, Ball wrote, "Art? That is all finished and ridiculous; dispersed to the winds. It has no more meaning."[12] The wartime journal, Zeit-Echo *(Echo of the Times)* stated, "Until now painters have not occupied themselves with real life because they invested it with no importance." It concluded that since "art is the only human accomplishment which consciously demands from men the realization of a moral earthly existence," the artist was indispensable in bringing about the new order and should commit himself to its realization. (Zeit-Echo, 3:1/2 (1917), p. 19).

In this spirit, on December 13, 1918, a month after the November Revolution, the Novembergruppe issued a call to fellow artists: "The future of art and the gravity of recent days compels us revolutionaries of the spirit (Expressionists, Cubists, and Futurists) to union..."[13] The Novembergruppe's program called for the reintegration of the artist into society, reconciliation among nations, the reorganization of institutions (schools, museums, galleries) affecting artists, and the elimination of capitalist influence from all spheres of cultural life, i.e., awarding of commissions for buildings. Among those signing the original call were Max Pechstein, César Klein, Georg Tappert, Richter-Berlin, and Rudolf Belling.

Under the influence of the Novembergruppe and the Soviet experience, similar groups sprang up throughout Germany. The Sezession Gruppe 1919 in Dresden (including Conrad Felixmüller, Otto Dix, and Hugo Zehder) demanded that the new society be established through the "free expression of personality."

367. Sezession Gruppe 1919
Dresden: Verlag E. Richter, March 1919
Voice of the Dresden Secession
Founded by Will Heckrott, Lasar Segall, Otto Dix, Otto Schubert, Constantin von Mitschke-Collande, Hugo Zehder
3 original woodcuts, 26 illustrations, 35 pp, 28.6 x 22.5 cm.

Members of the Sezession Gruppe 1919, Dresden:

Peter August Boeckstiegel
Otto Dix
Gela Forster
Will Heckrott
Otto Lange
Constantin von Mitschke-Collande
Conrad Felixmüller
Otto Schubert
Lasar Segall
Hugo Zehder, Architect
Outside follower: Oskar Kokoschka

Fig. 5. Barlach, Dona Nobis Pacem, from Der Bildermann, #18, 20 December 1916.

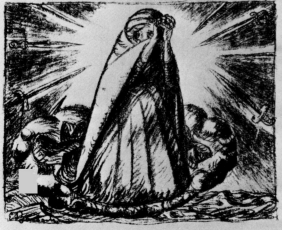

367.

SEZESSION GRUPPE 1919
Introduction
*The New World*
By Walter Rheiner

Young painters appear, prophets of the new world. They are chased, tortured, made happy, hymnical prophets of the wonder of wonders: of this frothing world, of these heaven thrown men, of the twinkling clouds, screaming suns, fluttering moons, dusky animal world, of chaotic commotion, which storms and has no end. And they call to you or they sign and cry—: full of the cosmos, which forms within them, new with every day, with every hour. They cannot keep silent, the excited ones, witness to the eternal event. They speak to you about the magic which lives in everything.—About new men in the midst of the world and centered in themselves, of the inner night, of the inner day, which breaks about them of the inter human of the I and you and of the struggle against the outside, which crowds and shakes them. Their pictures are the new being, which originates within them.—Look at these pictures which are living here on the walls: drops of water, drops of light, crumbs of the sun, dust of the moon,—seen and shared from beyond the human eye. But created by people like you, who speak to you of things which concern you in the deepest way. —Open your eyes! We talk about you! You should be given something, something should be done to you. —Now take your places, move, recognize your way and the way that is in you somewhere lost, covered up, perhaps, made numb by non-intrinsic, non-real—but somehow, somewhere, still in you!

Don't look for that which your eye, the all too tired eye, is used to. You should not be entertained or bored, —you should not see once more what you always saw. Don't look for description, beautiful reproductions, mild repetitions, sole poetry of the eye! These young painters deeply understand that which originated within you, became what it is, worth destroying. And they push what falls, they bring down what falls! Your great world breaks! Don't you notice it yet? It lies in ruins. It has fallen apart and is dead, as all mechanics are dead and must be dead. But life in you! Becoming in you! Being lives! Out of shapes torn to shreds, out of liberated colors, out of wincing planes, and space, and the roaring mathematics of chaos balls together into a new cosmos, the spirit; out of the ashes the phoenix soars, which with flapping wings enlivens and moves your emptied firmament. Do not look for the well-known figures, the beautiful women, the well-behaved houses, the familiar trees and paths, the well-known faces. Color, line, surface, space are elementary triumphs, in battle, in a dark struggle ascending from the deeper grounds of eternal laws. Nothing greets you as familiar. —Unless you began from the beginning, from the bottom, with a first glance into the world of which you had been blind and see now. That is it! Don't only look—See! And you will feel what the painters know. Out of the crooked or straight lines, of the dream constructed planes and spaces, out of stumbling or sleeping colors, there sounds a magic symphony. Flame! It roars, it storms. The ball of the sun is now being born; the moon crystallizes; a house grows, a tree; a path moves forward, an enthusiastic path; again Zeus comes down, the origin of being, towards Leda, towards earth, conception.— The face of it takes shape, a flowing landscape; eye drips with ether; a tree is now really a tree, nothing else. It sways, it derives from man, who appears suddenly. Adam towards Eve (God stands somewhere in the far distance). A child blooms, becomes family, procreated out of the laws of growing and procreation. —The year rises from the orbit of the earth around a star. Spring breaks in. May sounds. The queen of May gives a thousand miracles, a thousand attachments of a great miracle.—Life begins and with it death.

Look there! Close your eyes and look there! The world is becoming! (The world starts within a human being) Painters stammer from such a beginning. Architects arch you anew, create the new body for you, the statistical star; they build you a new house, —a ship that lands in the skies—: Frozen prayer, restful song from the last home from which you originated: Ecstatic ether!

Open your eyes! Painters surround you! Figures surround you! Up from your sleep! Up from blindness! Learn to see! Learn the spirit!

You are men, and we address you!

The artists group in Halle demanded the installation of artists and workshops in the elementary schools so that the students' full practical and artistic potentials would be awakened early. The Magdeburg artists' union grandly asserted that "Art will become religion…What politics has spoiled, art will put to right. Through her man finds man…enemies [will become] brothers…We believe in a grand, free art and the redemption of mankind through it…"[14]

Max Pechstein expressed the egalitarianism inherent in the artists' proposals—no longer, he stated, should art be the province of the songs of the idle rich, but a metier accessible to the sons of common folk. Bruno Taut's demand that exhibitions be moved from stuffy museums to more popular surroundings reflected the same democratic sentiment. It was this popular belief in the humanization of man through art which inspired the architects Walter Gropius, Bruno Taut, and Hermann Finsterlin.

Whereas Gropius' and Taut's ideas were romantic and expressive, even expressionist, Finsterlin's studies were completely unfeasible visions of Expressionist "architecture of the soul." His manifesto in Frühlicht *(Early Light,* a Magdeburg publication dedicated to avant-garde and visionary architecture) was a characteristic Expressionist document. It infused architecture with profound metaphysical meaning and described a new world born of man's free creative fantasy. For this new world, Expressionist architects would design fantastic structures whose forms suggested function, but function defined more in terms of the structure's relationship to the individual's inner, spiritual and aesthetic life than utilitarian purpose.

The belief that architecture could mold men's lives shaped the founding principles of Gropius' Bauhaus. Lyonel Feininger's *Cathedral of Socialism* for the Bauhaus Manifesto symbolized the proposed realignment of society. The artist, craftsman, and architect as members of an organic state (ostensibly lost since the Middle Ages and symbolized by the cooperative effort and communal values incorporated in the Gothic cathedral) would again build communal structures geographically and spiritually central to the life of the German Volk, unified under socialism rather than Christianity.

This new preoccupation with politics did not go unnoticed among the critics. Individuals as diverse as Willi Wolfradt, Wilhelm Hausenstein, and Julius Meier-Graefe discussed the phenomenon at length. In 1919 Alfred Flechtheim reopened his gallery in Düsseldorf with a catalogue dedicated to "Revolution in Art." The most widespread manifestation of this new involvement was of course the sudden efflorescence of radical literary periodicals illustrated with prints and drawings by Expressionist artists. The artists' contributions to the periodicals indicated varying degrees of sympathy with the leftist politics of the publishers. Most of the prints had little thematic connection with the political poems and radical tracts alongside which they were printed.

During the war only a few periodicals continued publishing prints by Expressionists. The majority of Expressionists were pro-war, either out of patriotic sentiment (Barlach) or the feeling so well expressed by Marc that Europe needed a fiery purge. The short-lived Berlin Bildermann *(Picture Man)* published during 1916 attempted to give artists a continuing proscenium. It began patriotic and partly pro-war, softened its tone, and ended the year mildly anti-war. The Berlin-based Kriegszeit *(Wartime)* began by publishing nationalistic, anti-Western lithographs by Barlach, and others, alongside a few humanitarian images by Käthe Kollwitz. It remained nationalistic in tone. Kollwitz's revulsion for war intensified with the loss of her son and culminated in the stark, rending images cut for the 1924 portfolio, Der Krieg *(War).*

The Munich-based Zeit-Echo *(Echo of the Times)* styled itself a war diary for artists and attempted to document the years 1914-1917 in pictorial and poetic form. During 1917, when Lud-

wig Rubiner assumed control it became increasingly anti-war in tone. The Alsatian René Schickele took over the Leipzig-based Die Weissen Blätter (White Pages) in 1914 and turned it into an anti-bourgeois, internationalist, pacifist publication when he moved its headquarters to Switzerland during the war. There he published tracts by anti-war exiles denouncing militarism, nationalism, and all forms of exploitation.

Artists' unions issued manifestoes, and proclamations by individual artists appeared in booklets like An alle Künstler! (To All Artists!), 1919 and Ja! Stimmen des Arbeitsrates für Kunst in Berlin (Yes! Voices of the Work Council for Art in Berlin). The Arbeitsrat publication set out to "clarify the artists' relationship to the times" by publishing responses to a thirteen point questionnaire. It defined the artist (including the architect) as the consciousness in touch with the spiritual life of the German Volk and declared that the role of the artist was therefore to design and decorate communal structures which would give cohesion to the national community by providing the Volk with concrete symbols of cultural unity.

Max Pechstein designed the aggressive cover for An alle Künstler! The poems, essays, and proclamations in the pamphlet expressed the contributing artists' faith in the power of a socialist Ministry of Culture to re-establish the artist in a pro-

ductive relationship to society. Ludwig Meidner's call "To All Artists, Poets, and Musicians" (previously published in the magazine Das Kunstblatt) posited a "sacred solidarity" between the artist and the proletariat because "as artists...we have experienced their plight and are [also] dependent on the collecting bourgeoisie." He admonished artists to join the worker's party, the "decisive non-ambiguous party."

Pechstein's contribution, "What We Want," expressed the then common faith that the Socialist Republic would democratize art. "Art to the People!" was his slogan. Kurt Eisner's "The Socialist State and the Artist" offered practical solutions to the reintegration of the artist into society – principles which were applied in his short-lived Bavarian Socialist Republic. Art, Eisner contended, would no longer be a refuge, but life itself would become a work of art and the state the greatest artistic creation. He proposed fixed salaries for artists so they would not be under duress to create.

The painter Kurt Erich Meurer's contribution best expressed the activist artists' ecstatic faith in the redemptive power of socialism. "Socialism is nothing but an upward trend, a joyful direction, a categorical imperative: Be Human! Only Human!...Then art will take over he task of religion."

Fig. 6. Liebermann, Untitled, from Kriegszeit, #38, 5 May 1915.

Fig. 7. Kubin, Japanischer Feldherr, from Zeit-Echo, Heft 4, 1915/16.

**368 A. An alle Künstler!** *(To All Artists!)*
Berlin, (Willi Simon), 1919
Raabe 125, Perkins 137
20 x 14 cm., 48 pp. 4 illustr. + cover dwg by Pechstein
Cover on heavy, yellowish stock

*Appeal to Socialism*, p. 1.

The unpolitical poet does not criticize, he warns. There were too few flames in the street, so how could the phoenix be born? What we have experienced since November is at most a cliché of a revolution. Sterile blood has made total kitsch of it. Chaos does not endure. The grumbling tremor has hardly shaken Michel's peaked nightcap [A figure similar to Uncle Sam]. Why did not wine flow instead of blood? Why did not a wave of boundless sensuality roll toward us, after which the ark of peace and unashamed loathing of free trust could have floated far away? For once, why did not naked and menacing oppose naked and conciliatory men before true horizons? Why didn't heaven close its sun-eye, open it again to a new and jubilant, hymnlike development? One can build either a passageway in a house or a temple with the same stones, but one has to shake them in mixture first. The bourgeoisie loathed chaos. We loath order, which is not ordained to define the battles of excited blood, and as a real justice to nail the ninety theses of brotherhood on doors of houses and churches, bazaars, factories and bordellos, which are now filled with the spirit of paragraphs, of animal trainer's cleverness and the medieval idiocy of justice. A terminology of happiness is assembled by the demagogues of accident, which culminate in a parcel of land and full pot on the stove. They tickle material greed with one word, but never touch the ideal longing, make the inquisitive a satisfaction. We long to return to the idea. We cannot stand the godlessness of the world and the materialism blindly cast about. We are not against precision or formalizing, but we desire the honorable and standardized dancelike in Nietzsche not the scorn of compassion. I always think if one substracts a certain dowry of the pathological, Bethlehem is not far away from Weimar and the world catastrophe has not directed Zarathustra so much much "Ad Absurdum" that no mistral wind flew in on the wings of the Holy Ghost and blew a "Paian" in front of eternal justification of lust.

But you, Mr. Secretary of Education, are worshiped by the public, re-examine the seminars! Is it so non-crucial to shape anew the educational materials or to make the outgoing of the Holy Ghost a daily miracle, to bring up new generations from the deeply buried structure which is ripe for the holy anarchy of the idea. Roll the stone of rejuvenation away from the source of rejuvenation. I dream of a blooming "illiteraturdom" of the mind, a paradise of simplicity. Prevent mankind from perishing in the ice of the intellect, and scatter music into the streets, propagandize the dance, the forest school, the flower festival!

**368 B. Ja! Stimmen des Arbeitsrates für Kunst in Berlin** *(Yes! Voices of the Work Council in Berlin)*
Photographische Gesellschaft, Berlin, 1919
Perkins 132,
editions: large regular edition, 55 examples on
Bütten paper with woodcut by Feininger as title page.
24.5 x 19 cm., 116 pp, 32 f illustrations.

Intentions as expressed by questions in Ja! Stimmen des Arbeitsrates für Kunst in Berlin, page 7-8

*Workers' Council for Art: Questions Which Need Explanations*

I
Curriculum
Which measures can be considered suitable to achieve a thorough reform of education for all kinds of art?

II
State Subsidy
From what point of view does a Socialist state dispose of questions about art and support for artists? (purchases, national art commissions, museums, schools, exhibitions, etc.)

## III

**Settlement**
What requests are to be directed towards central government which will guarantee that new agreements within future years will be selected according to broad cultural view points?

## IV

**Transfer of Artists into Crafts**
How can the great mass of art-proletariat be won over to the crafts and escape destruction in the face of threatening economic catastrophe?

What demands must be made on the state so the rising generation can be educated on a purely crafts-orientated base to begin with?

Between 1918 and 1925, 122 different literary journals of varying longevity were published throughout Germany;[15] most of these were liberal to radical in bias. Of those 122, fifty-three were founded after 1918 and folded before 1925. The mortality rate was high. No medium was better suited to inform, persuade, and recruit than the inexpensive, flexible format of the quickly published journal or broadsheet. These publications carried advertisements, announcements of meetings, manifestoes, essays, poems, and prints. Johannes Becher, Romain Rolland, Gustav Landauer, and Bruno Taut shared the same pages with prints by Pechstein, Felixmüller, Meidner, Frans Masereel, Erich Heckel, Schmidt-Rottluff, and George Grosz.

The frequently issued periodicals could respond instantaneously with special numbers to the events of the day. Pfemfert, for example, dedicated the February 1, 1919 number of Die Aktion to his slain friends the Spartacists Rosa Luxembourg and Karl Liebknecht. Karl Jacob Hirsch contributed a line portrait of Liebknecht for the title page. Felixmüller remarked of his frequent contributions to Die Aktion, "I always did my woodcuts without time for proofs because Pfemfert was always in a hurry."[16]

Expressionism had always prided itself on its youthful vigor, and the frenetic dedication to radical causes continued this tradition. As had the first manifesto of Expressionism, the Brücke Manifesto, these periodicals addressed themselves to youth, biological and spiritual, and often chose titles i.e., Neue Jugend (*New Youth*), Das Junge Rheinland (*Young Rhineland*) and Neue Deutschland (*New Germany*) which emphasized their tie to the future through their appeal to youth.

The periodicals forged a community of readers, and their publishers often sponsored art exhibitions and literary evenings which became gathering points for the local intellectuals. This association promoted active exchange of ideas in the pages of the journals as well as at the Soirées. In 1920 the critic Ludwig Redslob, writing for Feuer (*Fire*) in Saarbrücken suggested that "in our times magazines are more important than books."[17]

Although they addressed momentous issues which affected everyone, the periodicals were short-lived because their leftist solutions were attractive to only a few. Class warfare, anti-bourgeois satire, and permanent revolution were no staple for sustaining a broad readership. Inflationary costs hastened the end of many journals, but more important, by 1922, Expressionism was dead and revolution was no longer a live issue. The journals founded in the spirit of Expressionism and with the purpose of promoting left wing politics lost their raison d'être.

Pfemfert's Die Aktion was the most consistently political of the longer-lived periodicals and the model for many. A list of the artists who contributed to it includes the most political of the Expressionists, i.e., Josef Achmann, Felixmüller, Otto Freundlich, Grosz, Raoul Hausmann, Karl Jakob Hirsch, César Klein, Meidner, and Georg Tappert. Die Aktion was founded in 1911 to further leftist ideas and the "organization of intelligence" in the service of society. During the war, it became increasingly combative and partisan and with the May 4, 1918 issue carrying as title page Felixmüller's woodcut entitled "Long Live World Revolution," Die Aktion committed itself to communism and the proletarian revolution.

Fig. 8. Hirsch, Cover illustration for Die Aktion, IX. Jahr, Nr. 20.

Fig. 9. Felixmüller, Liebknecht, from Menschen, 15 January 1919.

Felixmüller believed that the language of art was universal, and therefore frequently contributed to the most radical periodicals in the hope of furthering universal brotherhood through art. The title of the Dresden periodical Menschen, for which Felixmüller designed the title plate, evokes this popular concept of the New Man. He would be neither German nor Frenchman nor Englishman, but an abstraction, uncorrupted, Rousseauean man, quintessential man whom the intellectuals sought to liberate from the chains of capitalism, militarism, and nationalism.

The internationalist emphasis of the radicals was epitomized by Romain Rolland whose pleas for international reconciliation appeared frequently in the radical journals and by Frans Masereel, a Belgian exiled in Switzerland during the war. Masereel's quest for salvation took him through the factories and slums of the Grossstadt (metropolis) as well as to Alpine retreats. His visionary, philosophical novels in woodcut, Mon Livre d'Heures (My Book of Hours) and Les 25 Images de la Passion d'un Homme (Twenty-five Images of the Passion of a Man) record the spiritual odyssey of the engaged artist whose moral outrage leads him to taunt the capitalist bosses and harrangue the workers as he wanders the wretched slums of the workers' quarters. His proletariat was international.

The periodicals included in this exhibition indicate the wide geographical distribution and philosophical diversity of the avant-garde journals. (Each periodical is described in detail in Section IV.) Among the prewar and wartime journals only a few,

i.e., Die Aktion and Munich's Revolution (emulating the spirit and format of Die Aktion) promoted activist politics. The cover of the October 15, 1913 number of Revolution carried a woodcut entitled "Revolution" by Richard Seewald. The issue was confiscated because a poem, "The Hanged Man" by Hugo Ball was considered inflammatory. During the war only a few radical journals, mostly Dadaist, were able to dodge the censors. Among them were the anti-establishment Neue Jugend, published sporadically in Berlin by Wieland Herzfelde's radical Malik Verlag. It published ascerbic subversive drawings by George Grosz.

Berlin was the vortex of prewar radical activity and remained so after the war. Among the radical journals in this exhibition which originated in postwar Berlin were Die Aktion, Das Junge Deutschland (The New Germany) and Der Anbruch (The Beginning), the first issues of which were published in Vienna. Der Anbruch was printed in a folding, broadsheet-poster format. Its tone was often strident. In January, 1919 it published Meidner's inflammatory call "To All Artists, Poets, and Musicians" which called artists to commit themselves to socialism: "No longer can the vast majority be compelled to subsist in the most wretched... conditions, while a tiny minority gluts itself at an overloaded table. We must choose socialism...it provides every human being with work, leisure, bread, a home, a higher goal. Socialism must be our new creed!" (Der Anbruch, January 1919).

Fig. 10. Masereel, Plate from Die Passion eines Menschen, Kurt Wolff, Munich, 1921.

Fig. 11. Masereel, Plate from Mein Stundenbuch , Kurt Wolff, Munich, 1926.

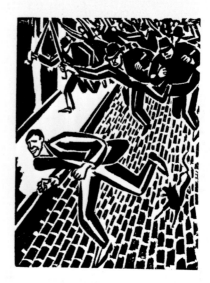

GEORGE GROSZ / ZEICHNUNG

**Fig. 12. Grosz, Drawing from Neue Jugend, Feb./März, 1917.**

**Fig. 13. Seiwert, Drawing from Der Ziegelbrenner, 21 December 1921.**

**Fig. 14. Schmidt-Rottluff, Der Heilige, from Die rote Erde, I. Jahrgang, Heft 6, 1919.**

Schmidt-Rottluff: Der Heilige

Beckmann, Heinrich Campendonk, Feininger, Heckel, Oskar Kokoschka, Kubin, Masereel, Meidner, Mueller, Pechstein, and Schmidt-Rottluff were among the artists who contributed prints to Der Anbruch. Das Kunstblatt *(The Art Pages)* promoted Expressionism and occasionally carried radical manifestoes, i.e., Meidner's above "Call."

In Munich the pro-Russian Die Bücherkiste *(The Book Chest)* with prints by Achmann, Campendonk, Grosz, Masereel, Georg Schrimpf, and Maria Uhden, and Die Münchner Blätter für Kunst und Graphik *(The Munich Pages for Art and Graphics)* with prints by Campendonk, Rudolf Grossmann, Klee, Kubin, and Seewald promoted radical causes. Bruno Traven's pacifist Der Ziegelbrenner *(The Brickmaker)* printed drawings by Franz Seiwert and Grosz's caricatures of the German bourgeoisie.

In Düsseldorf Das Junge Rheinland *(The Young Rhineland)* sought to cultivate a radical Rhenish consciousness, but its editors were in close communication with radicals throughout Germany and its pages publicized the activities of radical groups in every German city.

Menschen *(Mankind)* and Hugo Zehder's Neue Blätter für Kunst und Graphik *(New Pages for Art and Graphics)* were published in Dresden. Menschen printed works by Dix, Felixmüller, Oswald Herzog, Hirsch, C. Klein, Kokoschka, Oskar Nerlinger, H. Richter, Schmidt-Rottluff, and Tappert. Special numbers were dedicated to the Kraefte-Gruppe Hamburg, the Gruppe 1919 Dresden, and the Novembergruppe Berlin. Menschen offered itself as "a broadsheet, an organ for poets, writers, painters, and musicians for whom art is a way of changing humanity and of calling for unity and collectivism."

305

In Hamburg Rosa Schapire and Paul Schwemer's *Die Rote Erde (The Red Earth)* dedicated itself to effecting the coming socialist millenium, and grandly stated that "Die Rote Erde" is the only periodical in the world which sets for itself the task: "To prepare the earth for the grand coming of humanity. All artists...who are meaningful [for this preparation] are working with the Rote Erde."[18]Achmann, Felixmüller, Heckel, Mueller, Pechstein, and Schmidt-Rottluff were among those who contributed prints.

In Heidelberg the prewar Expressionist Saturn turned political and issued proclamations and manifestoes. Josef Achmann's Regensburg *Die Sichel (The Sickle)* promulgated radical viewpoints. Campendonk, Felixmüller, Richter-Berlin, Schrimpf, and Tappert contributed prints. In Kiel *Die Schöne Rarität (Beautiful Rarity)* fostered radicalism and dedicated special issues to Felixmüller and Tappert. Heckel, Hirsch, both B. Klein and Cesar Klein, Wilhelm Morgner, Pechstein, and Schrimpf also contributed.

The Hannover Zweemann published Expressionist critics and poets and included contributions from the Dadaist Kurt Schwitters. It favored a Soviet solution to Germany's problems and promoted cultural understanding in articles like Melchoir Hala's "Dostoevsky and the New World." Many of the radical publishers were enamored of the USSR. Franz Pfemfert in a special issue of Die Aktion dedicated to revolution eulogized the Russian experiment: "The 7th of November began a new, bright epoch for mankind. On the 7th of November what for thousands of years were only the hollow dreams of the enslaved became reality...Russia's workers and peasants laid the groundstone of the communist world structure; two years ago Russia's proletariat brought the kingdom of heaven to earth...The 7th of November means the creative beginning of a new world...in which work is free and revered." (Die Aktion, 15 November, 1919, p. 734).

Carl Mierendorff's Das Tribunal *(The High Court)* subtitled the "Hessian Radical Pages," grew out of Darmstadt's radical, anti-war Dachstube *(Garret)*. It called on intellectuals to abandon their earlier "clean hands" approach and pleaded for involvement in politics rather than metaphysics. Masereel, Meidner, and Kokoschka were among the artists to contribute prints.

For all its vigor, dedication, and grandiose projections, Expressionist activism had minimal impact. The Expressionists' alliance with socialist and communist causes isolated them from the mainstream development of Weimar politics. It was perhaps too a contradiction inherent in the concept "Expressionist Activism" which, along with the realities of German politics, guaranteed the failures of the Expressionists' utopian dreams.

The essence of Expressionism—albeit rebellious, anti-bourgeois, anti-technology, anti-urban—was subjective and introspective. The Expressionists were bent more on redeeming man's spirit than ameliorating his material condition. The expressionist stance was ecstatic, apocalyptic, visionary, and filled with yearning for immortality. Critic Wolfgang Paulsen commented that the Expressionist took part in daily life not to serve it, but to redeem mankind from it.[19] This approach naturally prevented any sustained dedication to politics. They were poets, not pragmatists.

When the Expressionists wrote of the new man, they meant the man described by Georg Kaiser, "It is not so important that man should be able to do something as that he should be recognized. Man that is recognized becomes a reality...I believe in this man to come, and belief is enough."[20] In the final analysis the activist Expressionists remained visionaries not politicians, and their activity, however energetic, remained peripheral to German postwar politics.

In style and interests the artists who designed posters, leafleted the factories, and joined the soviets were alien to and misunderstood by the workers whose cause they romantically espoused. As in the USSR, the concerns, tastes, aspirations, style, and interests of the aesthetic and political avant-garde were not coincident.

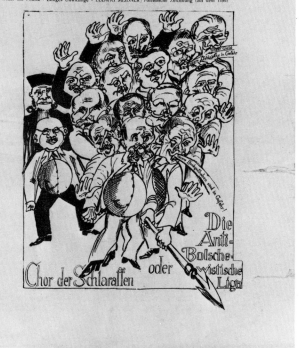

Fig. 15. Meidner, Cover illustration for Das Tribunal, April 1919.

Die Aktion
IX Jahrgang, Nr. 37/38, September 1919, p. 643-644
*A Day in Munich*
by Alfred Vagts

Today they have loudly stamped on human rights,
Which they usually kill "in secret"; murder orders
given in secret,
Black marketeers, provocators, marching orders:
counter revolutionaries.
District attorney and general are only made different
by their uniforms.
An excellency was made fearful one November day
When in Flanders the tattooed arm of a marine grabbed
for his epaulettes,
Painted a cross of ashes on his forehead, and "Carry On"
on his belly.
The holy signs stand bent like justice today, like a
swastika on a steel helmet.
Revenge for the first revolution never ends.
A sausage-like finger denounces the poet
and his girl as Spartakists,
So they can be escorted through the town with raised hands.
Rifle muzzles are pressed to their shoulders
like branding irons.
The escort threatens: "Lower your arms and you will be shot!"
Unchecked tears run down the face of the woman:
Like some Sebastian figure tied to the stake of
an advertising kiosk.
The town is beneath her feet, over which she rises like
a savior over Jerusalem.
Like some frightened Veronika, the poor girl sighs
on her asphalt journey.

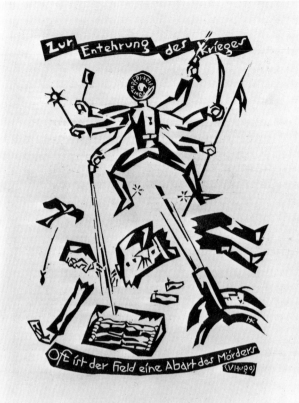

**Fig. 16. Kiel, Graphisches Manifest, from Das Tribunal, Heft 3, 1919.**

Hold the red torn cloth patiently in your small hand
around your heart!
Soon it will blossom out like poppies: Oh our sunniest day!
You could have joined your simple minded sisters:
In their heavenly day off from work, the girls stand guarded
By a soldier's tin plated star!
They walk together under the trees.
Tell these women how it shames them,
when murderous tanks carry their names,
When night after night they have to walk the fat dogs
owned by lazy ladies through the streets.
When their arms are held by fists which grab them
like hand grenades.
You shyly pricked the wanted-posters of flown leaders,
I stand before you, unnoticed, like a nightingale which sings
unseen in the night.
A screaming truck full of soldiers disturbs your houses, guard
lanes, men mobilized try to stand erect before him, wobbling.
The court of justice of the glowing sky opposes,
The sentence is not going to be carried out:
If one experienced Manet's painting: *The Execution of Maximilian*
felt the bullets ricocheting from the sunny eternity of
the rampart,
Humans would never shoot humans against the wall.

368C.  Kunst der Zeit *(Art of the Time)*
Organ der Künstler-Selbsthilfe
Sonderheft: Zehn Jahre Novembergruppe
Heft 1-3, III Jahrgang, 1928
Editor: J.J. Ottens, Berlin-Frohnau
Geschäftsstelle des Komitees der Künstler-Selbsthilfe
Berlin-Frohnau
printed by P. Schmid and Co., Berlin
31.5 x 24 cm., 102 pp (2)

We stand on the fruitful ground of the revolution.
Our slogan is:
Freedom, Equality, Brotherliness!
Our association was derived from the equality of
human and artistic opinion.
We consider it to be our noblest duty to donate our best
efforts to the ethical reconstruction
of the free young Germany.
We plead for efficiency in every manner and support this
conviction with all means at our disposal.
We demand an unrestricted expression of opinions and
free public attitude towards it.
We consider it our special duty to gather all valuable talents
in the field of art and to direct it towards public benefit.
We are neither a party nor a class by itself, but human beings,
people who indefatigably perform hard work in the place
assigned to us by nature. This work, as any work, should benefit
the public, must meet general public interest, and needs the
recognition and honoring of the entire public.
We have respect for the accomplishments, which we honor in
every field and in every form, and we are of the opinion that
the most efficient ones should be given the most difficult
tasks, when the performance has to be undertaken for the
benefit of the entire population.
In common, everyone at his place working at hard and never
tiring labor to build up our goal.
Our fight is against all destructiveness – our love is for all
constructive powers.
We feel young and free and pure.
Our spotless love belongs to the free, young Germany from
which we want to fight reaction courageously and without
restraint, with all powers at our disposal.
We direct all our brotherly greetings to all responsible and
called Cubist, Futurist, Expressionist artists
who wish to join us.

*To the Novembergroup, Berlin, . 30*

Expressionists, Cubists, Futurists.
You have the glory to have prepared the revolution to a great ex-
tent. Later generations will recognize this. Because you
screamed while the others still whimpered. No one is about to
water this down, your revolution.

Don't make a policy of conjunction, don't make an art of con-
junction. Expressionists, don't let yourselves be led by intelle-
ctuals who try to save the pseudo-cultural goods of capitalism
within the new freedom. You are leaderless. Place yourselves
on the absolute ground of Socialism, destroy the old, in order
to build up the unhampered new. Don't be only Expressionists
in art, but Expressionists of humaneness. Cubists, down with
the capitalist form of art. Forward into the waves of mankind,
splinter yourself, give yourself.

We ask you to join the "Association for Social Peace," let us
know your interest at least for the time being, so we can mail
you our leaflets. We shall also join your group.

With greetings,

Painter Curt Stoermer, secretary and member of the Workers'
and Soldiers' Council.

Kreis Osterholz

*Translation of Novembergruppe Letters and Manifestoes,*
p. 10-11

*Circular Letter of Dec. 13, 1918*
Potsdamer Strasse 113, Villa II

Dear Sir;
The future of art and the seriousness of the present hour forces
us revolutionaries of the spirit (Expressionists, Cubists,
Futurists) into unity and close community.

The promulgation and realization of a comprehensive program, which is to be carried through with deputies in different art centers, should bring us a close amalgamation of people and art. Our duty is to get in touch with like-minded people of all countries. The creative instinct united us as brothers years ago...As a sign that we have found ourselves united, a common initial exhibition is in the planning stage. It should be shown in the large cities of Germany, and later in Europe.

The Work Council
M. Pechstein, C. Klein, G. Tappert, Richter-Berlin, M. Melzer, B. Krauskopf, R. Bauer, R. Belling, H. Steiner, W. Schmidt

*Guidelines of the Novembergruppe,* (Jan., 1919)
I. The "Novembergruppe" is a German association of radical artists.
II. The "Novembergruppe" is not an agency for economic protection.
III. The "Novembergruppe" wants to achieve a decisive influence in settling all artistic questions by extensive association with like minded, creative powers.
IV. We demand influence and cooperation:

1. At all tasks in architecture as a public affair: city-building, settling, public administration construction, of industrial and welfare public construction, – care of monuments – removal of artistically worthless, pomp-buildings.
2. The reorganization of art schools and the instruction. suspension of government supervision, – choice of teachers by artists' associations and the students, – suspension of stipends, – standardization of schools for architecture, sculpture, painting and ornamental art, – installation of work and testing stations.
3. With the reorganization of the art museums, suspension of activities by one sided collectors, – removal of over-crowding because of scientific purposes, – turning art places into peoples' places, – into unprejudiced mediators of timeless laws.
4. Assign exhibition halls.
5. Remove capitalistic prerogatives and influences during the making of art laws. Social equality for the artists as neutral workers, – protection of art property, – Exemption from duty for artworks (free import and export)
V. The "Novembergruppe" will prove its unity and achievements by continuous publications and one yearly exhibition taking place in November. The organization of the current publications and exhibitions is done by the central working council. Members of the association are entitled to equal space and the exhibitions will be jury free. All special exhibitions will be decided by the council in the same manner.

## NOTES

1. Paul Raabe, Der Ausgang des Expressionismus Biderach an der Riss: Biderach Verlagsdruckerei, 1966, p. 7.

2. Will Grohmann, in Kunst der Zeit, Zehn Jahre Novembergruppe, 1928.

3. Diether Schmidt. Manifeste, Manifeste, 1905-1933 Dresden: VEB Verlag der Kunst, 1964, p. 104.

4. Helmut Gruber, "The Political-Ethical Mission of German Expressionism," The German Quarterly (January, 1967): 1-87.

5. Die Kunst im Dritten Reich (July, 1937): 61ff.

6. Victor Miesel, ed., Voices of German Expressionism (Englewood Cliffs, 1970), p. 190.

7. Jacques Barzun; "On Nazi Art," Magazine of Art, Oct. 1945, p. 211.

8. Schmidt., op. cit., 90.

9. Ibid., p. 96.

10. Altmeier, op. cit., 185.

11. Ibid., p. 187.

12. Raabe, op. cit., p. 10.

13. Schmidt., op. cit., p. 158.

14. Ibid., p. 180,

15. Susi Stappenbach, Die deutschen literarischen Zeitschriften in den Jahren 1918-1925 als Ausdruck geistiger Strömungen der Zeit, Inaugural Dissertation, Friedrich-Alexander-Universität, Erlangen Nürnberg, 1961, p. 158.

16. Lothar Lang, Expressionist Book Illustration in Germany, 1907-1927, Janet Seligman, transl, Boston: New York Graphic Society, 1976, P. 81.

17. Stappenbach, op. cit., p. 162.

18. Paul Raabe, Die Zeitschriften und Sammlungen des Literarischen Expressionismus, Repertorium der Zeitschriften, Jahrbucher, Antologien, Sammelwerke, Schriftenreihen und Almanache 1910-1921, Stuttgart: J. B. Metzlersche Verlagsbuchhandlung, 1964, p. 106.

19. Wolfgang Paulsen, Expressionismus und Aktivismus: Eine Typologische Untersuchung, Bern und Leipzig: Gotthelf Verlag, 1935, pp. 4-5.

20. Gruber, op. cit., p. 195.

Note:
Translations appearing with numbered items and of poetry are by O. P. Reed, Jr.

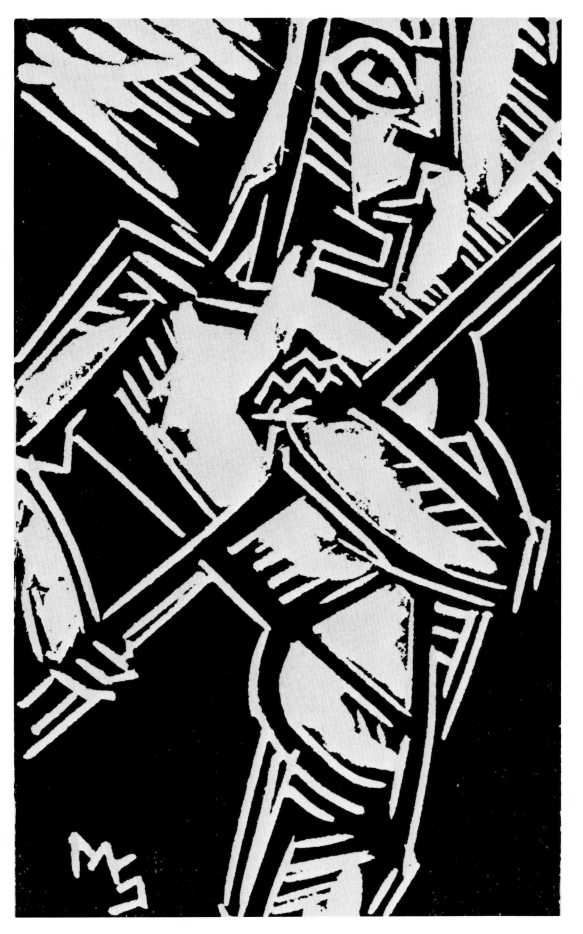

## NEW OBJECTIVITY

### MAJOR ARTISTS

Max Beckmann 1884-1950
Heinrich Maria Davringhausen 1894-1970
Otto Dix 1891-1969
Conrad Felixmüller 1897-
George Grosz 1893-1959
John Heartfield (Helmut Herzfelde) 1891-1968
Karl Hubbuch 1891-
Alexander Kanoldt 1881-1939
Franz Lenk 1898-1968
Ludwig Meidner 1884-1966
Carlo Mense 1886-1965
Franz Radziwill 1895-
Christian Schad 1894-
Georg Schrimpf 1889-1969
Richard Seewald 1889-

### REALISTS

Herbert Böttger 1898-1954
Leo Breuer 1893-
Carl Grossberg 1894-1940
Ernst Hassebrauk 1905-
Albert Heinrich 1899-
Käte Hoch 1873-1933
Franz Lenk 1898-1968
Kurt Querner 1904-
Georg Scholz 1890-1945

### OTHERS OF THE NEW OBJECTIVITY

Jankel Adler 1895-1949
Hans Bluschkek 1870-1935
Hans Bellmer 1902-1975
Werner Berg 1904-
Rudolf Bergander 1909-
Fritz Burger-Mühlfeld 1882
Friedrich Busack 1899-1933
Bernhard Dorries 1898-1970
August Dressler 1886-1970
Heinrich Ehmsen 1886-1964
Adolf Erbslöh 1881-1947
Peter Foerster 1887-1948
Bruno Goller 1901-
Otto Griebel 1895-
Hans Grundig 1901-1958
Wilhelm Heise 1892-1965
August Heitmüller 1873-1935
Werner Heldt 1904-1954
Hannah Höch 1889-
Heinrich Hoerle 1895-1936
Eugen Hofmann 1892-1955
Werner Hofmann 1897-
Willy Jaeckel 1888-1944

Franz Maria Jansen 1885-1958
Joachim Karsch 1897-1945
Arthur Kaufmann 1888-
César Klein 1876-1954
Bernhard Kretzschmar 1889-
Walter Spiess 1896-1947
Heinrich Stegemann 1888-1945
Niklaus Stöklin 1896-
Ernst Thoms 1896-
Max Unold 1885-1964
Eberhard Viegener 1890-1967
Karl Völker 1889-1962
Rudolf Wacker 1893-1939
Josef Wedewer 1896-
Wilhelm Lachnit 1899-1962
Richard Lindner 1901-
Kurt Lohse 1892-1958
Josef Mangold 1884-1937
Otto Möller 1883-1964
Willi Müller-Hufschmid 1890-1966
Reinhold Nägele 1884-1972
Otto Nagel 1894-1967
Heinrich Nauen 1880-1941
Kay Heinrich Nebel 1894-1967
Oskar Nerlinger 1893-1969
Ernst Neuschul 1895-1968
Richard Oelze 1900-
Wilhelm Ohm 1905-1965
Erich Ockert 1889-1953
Otto Pankok 1893-1966
Max Peiffer-Watenphul 1896-1976
Herbert Ploberger 1902-
Kurt Querner 1904-
Anton Räderscheidt 1891-1960
Ludwig Ronig 1885-1959
Karl Rössing 1897-
Wilhelm Rudolph 1889-
Karl Rüter 1902-
Wilhelm Schmid 1892-
Wilhelm Schnarrenberger 1892-1966
Franz Sedlacek 1891-
Franz W. Seiwert 1894-1933
Herbert Spangenberg 1907-
Erich Wegner 1899-
Gert Hein Wollheim 1894-
Gustav Wunderwald 1882-1945
Wladimir Zabotin 1884-
Rudolf Jacob Zeller 1880-1948
Magnus Zeller 1888-

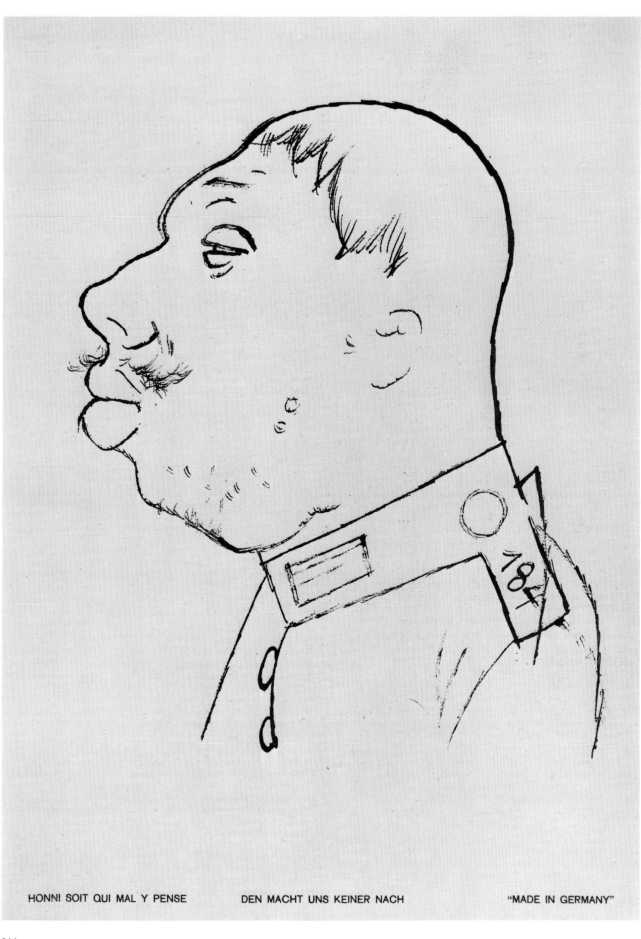

HONNI SOIT QUI MAL Y PENSE       DEN MACHT UNS KEINER NACH       "MADE IN GERMANY"

# LATER INDEPENDENTS

## NEW OBJECTIVITY
### Neue Sachlichkeit and later German Tradition

The time honored tradition of opposed spirit and flesh in German art and literature is rarely empirical or pragmatic. It has dealt with a universe in which the only escape is into nothingness, transcendental absolution or personal ambivalence. It rarely presents an exact situation or mood. It tries for a world view.

The early Expressionists attempted three variations of a long tradition, but took it to extremes. They were mainly nonpolitical and involved with these personal solutions outside traditional politics, although most were politically conscious.

After the resignation of the Kaiser and the control of government by the Social Democrats, most politically conscious people believed the intention was to introduce socialism. But Germany wanted to continue as it was, not change. When this refusal to change became apparent, a transformation took place, especially among writers and artists. First came an almost hysterical abandonment to wild hope, followed by full despair. The split brought both politicalization and escapism. But the attempt to be free of political thought focused on a new element in German thought: the daily, the empirical, the pragmatic, the momentary scene.

A need for serenity and a need for a brutal reality arose. The monumental picture, the dramatic change, the close look at nature in classic configuration were all combined in many of these outlooks. Yet a stern and very bitter view of outside life was also compelling. Because of the blockade, starvation was everywhere, money was valueless, jobs were scarce. The parasites of despair, the pimps and profiteers and the grotesque wounded and wretched of the earth became the principle subjects of the empirical approach. There was also the childlike approach, but instead of inner attitude, external primitivism was attempted: not that of the ancient savage, but the untrained.

In the search for classic configuration, Futurism and Cubism both congealed in a semipolitical aspect. The Bauhaus and certain left wing movements became extremely abstract in conception. The "hard edge" became a political weapon, because it was truly functional for mass publication.

Art as idea was also left out entirely by the painters of magic, the Dadaists and Surrealists. Commonplace things became the subject, not a world view.

Behind the real Neue Sachlichkeit of the middle 1920s was a European tendency not alone German. Picasso, Derain, De Chirico and others were also conceiving in classic-realistic art style. In Germany the approach was more bitter.

In the Bauhaus, concrete reality in abstraction became a major theme. Feininger began to clarify his Cubism. Schlemmer humanized the rational and humanistic. Kandinsky forgot most of his mysticism in favor of pure, formal organizations. Klee sought the universal symbol, a formal analogy of abstract picture surface, with orientation in the real world.

The new realism, Neue Sachlichkeit, stood between Expressionism and complete abstraction. It ranged from the horrible to the commonplace.

What changed most in the Expressionists remaining was angularity based on primitive sources. Kokoschka became more romantic. Many of the other Expressionists undertook the path of flat tone and outline, with intersecting form and rather pleasing but "pretty" color effects.

Emphasis also changed from inner to outer life. The bicycle race, the boxing match, the music of jazz, the cinema, the cult of everything American took over these functions. Non-utopian ideals also were present. Accuracy, simplification of means, perhaps, evolved from the idea of mass production. The spirit in which Expressionism had been applied to the inner life was now changed, but its formal innovations were used.

The grouping of artists continued in the 1920s. Almost every large city had some organization inspired with revolutionary thought. Manifestos were frequent. Many were for or against Expressionism. There was a growing feeling of impotence and shrieks came loud and violent. There was little empathy, but divided interests by ego, mockery, sentimentality and political formalism.

In an age of dissolution, dissonant color and magic symbolism shared kinship with the reality of chaos.

There was a somnambulistic feeling to some of the art. Allegory was used. The great darkness of fear was caught in a nightmare of hallucination. The mask became a symbol of non-individualism. Montage was used to rearrange photographic realism. Juxtaposition of simultaneous events brought life and death face to face. Some new forms, some new grammar of painting, a search for a still unknown language continued as it always had. Neue Sachlichkeit did hold up the mirror of the age to itself. The self sufficient German painter of the 19th century had become expended into infinity because of a changed vision of eternity.

There was a straining of early Expressionism to filter out ecstatic turnings, but a love of nature remained. These were the real qualities of the period: nature worship, cynicism, hardship, traditionalism, disillusionment, factualness. But being German, the painters of the New Objectivity gave each work a heightening, an emotion-filled report of the satire or common event. Realism could be shocking as well as clinical. In most cases the fact remained clearly observed.

There was one other major influence. Communist policy after 1920 tended towards criticism, not revolution. Bolshevists were advised to work within parliamentary action. By 1925 the party was in the hands of Ernst Thälmann, who ruthlessly carried out Soviet policy, and this included the social realism which was promoted by Stalin.

The effect of Willy Münzenberg on the art of this period has never been outlined. He was one of Lenin's earliest non-Russian followers. His campaign for famine relief started a fifteen year period of activity as chief propagandist for the Comintern. First through the Malik publishing house and later through his own concerns, Münzenberg used most of the left wing intellectuals, as well as artists such as Grosz, Kollwitz, Dix, and many others. The Münzenberg empire, with Communist money, finally included theaters, film production, publishing houses and newspapers. His promotions helped sponsor the social realism of official party memos. His philosophy of socialism became much of the backbone of art for many of the better artists. In June, 1924, he helped form the Red Group, the Union of Communist Artists of Germany. A pamphlet by George Grosz, with the help of Wieland Herzfelde, outlined the place of the artist in society (Die Kunst ist in Gefahr, Berlin: Der Malik Verlag, 1925).

Elsewhere, Felixmüller wrote that aesthetics were dead and art must be a historical thing of the present. Karl Hofer wrote about the new naturalism. Otto Dix wrote that the object was primary. Rudolf Schlichter wrote that anguish about suffering society must come before temperament. Franz Roh, in his important book, Nach-Expressionismus (Leipzig: Klinkhardt & Biermann, 1925) wrote that man could express warmth and sympathy even through photographic trueness. Empathy would win over abstraction.

Ernst Troeltsch, world famed scholar, had warned that cooperation by German intellectuals with Bolshevism would lead to cultural catastrophe. But he was ignored by all sides. Instead of Troeltsch's call for integration of Germany into western civilization, complexity remained, and the intellectuals became more splintered in nationalism, and non-compromise. The extreme radicalism of both right and left put the artist in a position of no direction.

The complete politicalization of the artist made him vulnerable. For many of the older artists, inspiration was diminished. Kirchner looked for optical inspiration; Heckel found an ornamental method far short of his earlier efforts. Only the inner inspired artists kept some high level. Barlach and Nolde worked in more and more isolation.

## MAX BECKMANN

The Expressionist Max Beckmann follows the Impressionist Max Beckmann. His trend was different from such groups as Die Brücke. He had little interest in primitive art, or in extremely bright color. He sought a new vitality which would combine his own subjectivity, emotionalism and an intuitive approach with the traditional use of space and form. He was not interested in wild brushstrokes or decorative quality within shapes.

The beginning of the war brought Beckmann's painting to a stop. He began to do more print making. In 1914 he became a hospital orderly, experienced the horrible carnage and suffering of the wounded. He saw the tragedy of life, and then somehow he began to see the grotesque humor. The traumatic effect of his war experiences caused an apparent nervous breakdown and after hospitalization, left him with two years of convalescence. During this time he did more than twenty-four etchings, for plates were easily carried and did not require the equipment necessary to print lithographs. Out of his inner torture and reaction to inhumanity, Beckmann made a pronounced step into a preoccupation with violence and pathos, part of the late manifestation of earlier German poets and painters. He retained the influence from the indigenous art of Germany, the Northern Gothic and the Italian Renaissance. He began to move closer to the subject, with less action from a camera's view. By 1917 his new style was becoming definitive.

369. Die Fürstin *(The Princess)*
by Kasimir Edschmid
With six etchings by Max Beckmann, Gallwitz 89
Weimar: Gustav Kiepenheuer, 1918.
Printed by Offizin W. Drugulin, Leipzig
Etchings printed by Carl Sabo, Berlin
Edition: 500 Examples: Nr. 1-30 signed etchings on Zandersbütten paper, Nr. 1-35 bound in pigskin at the Weimar Arts and Crafts School under the direction of Otto Dorfner
Nr. 36-130 handbound in morocco by E.A. Enders, Leipzig.
Nr. 131-500 on Holland paper and bound in cloth
Cover design by Else von Guaita
82 + 1 pgs.
30 x 23.5 cm.

Kasimir Edschmid was a propagandist for the Expressionist movement. His various manifestoes were important documents for the movement. His important book about Expressionism in literature and the new poetry, published in 1919, was a landmark for the young creators. It came out as the first of twenty-nine booklets Edschmid edited for the Erich Reiss Verlag, a series called *Tribune of Art and Time* (Tribüne der Kunst und Zeit), 1919-1922.

Edschmid's poetic novel Die Fürstin is a series of sensations, impressions, and visual notations during a sailboat ride. It describes spiritual desire, sorrow, the sense of death and desolation amid scenes of beauty and comradeship. The novel is divided into five parts, each one part dream and part development of the hero: he meets Jael; he experiences graduation night; he writes and receives a love letter; he has a concluding dream which sums up his development in symbolism, and subsequently he wakes up not knowing where he is: "the summer landscape shimmers in silver, he feels a sadness in his breast." It is a poetic vision in rich language.

Beckmann ignores the poetic feeling of the text and illustrates according to his frame of mind, violently and grotesquely. The painter had capsulized his feelings about art in 1917 in a catalogue: "An artist must be a child of his age; he must be naturalistic toward himself; he must be objective toward his inner vision." In Die Fürstin he brings us face-to-face with real objects, intensified and perplexing. All the scenes are close-ups, cutting off extremities, making symbolism out of pieces of the material world. Here Beckmann's later symbolism appears: the bell and the skull, the moon and angled arches, but used in a traditional sense, given the normality of religious tradition and Baroque satire.

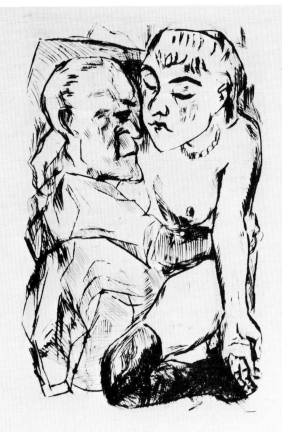

369.

370. Stadtnacht *(City Night)*
Seven lithographs by Max Beckmann to
Poetry by Lili von Braunbehrens, Gallwitz 135-141
Munich: R. Piper & Co., 1921
Edition: 600 examples in two editions, Nr. I-C with extra
portfolio on japan paper, with each lithograph signed by
the artist. Nr. 1-500 signed on the printer's page by the artist.
Printed by Knorr & Hirth
Lithographs printed by Dr. C. Wolf & Sohn, Munich
47 + 3 pgs
27.8 x 23.2 cm.

Lili von Braunbehrens's lyrical poetry is written in series like a
song cycle, beginning in sunshine and ending in pain. It is
mainly unrhymed with tightly controlled meter. The tone is one
of sadness, but not of violence.

Beckmann is changing in 1920. His approach is more abstract,
yet personal abstraction, with loaded shapes, articulated with
long shading and bending of perspective back and forth. The
square format is used as a vehicle in which to swing his unre-
ligious characters. The style is hard, aggressive and dogmatic,
reflecting the artist's personal and perhaps dormant self-
consistency. Every shape is fractured against another. Propor-
tions are deformed to fit the shape. In most of the compositions
a central circle is the core of the swinging movement. (Defor-
mations are common to German Expressionism.) Spatial depth
is obtained by overlap, change of level, swing off the vertical
plane.

The symbolism represents human weaknesses. It relates to
solitude, unhappiness, murder, violence, and sexual satire. A
trumpet juts out of a phonograph over the back of a reclining
woman. A hooded ghost-figure strangles a staring man, while
another screams into the night. Half-nude women sit beside a
table with drunken men, one of whom is collapsed. All these are
Expressionist themes of the time. Beckmann retains his fond-
ness for the properties of such things as windows, cats, um-
brellas, etc.

In Stadtnacht Beckmann shows us the peculiar tension of the
large city, with interactions of the inhabitants through violence
and frustration. His drawing has changed towards the childlike.
Beckmann looks at his creatures with a new blunt attitude. His
war experiences are not yet shaken off and the subjective in-
spiration of the later works is only beginning.

371. Jahrmarkt *(Fair)*
Ten original drypoints by Max Beckmann, Gallwitz 163-172
Munich: Verlag der Marées-Gesellschaft/R. Piper & Co., 1922
36th Edition of the Marées-Gesellschaft
Edition: 200 examples: 75 examples on japan paper, each
signed by the artist, in portfolio with parchment cover,
125 examples on Bütten paper, signed by the artist, in
portfolio with linen cover.
Text printed by Otto von Holten, Berlin
Etchings printed by Franz Hanfstangel, Munich
Title design and typography by E.R. Weiss
Type: Altdeutsch
6 loose leaf pages + title page + 10 prints
Portfolio: 56 x 41.5 cm.

The bibliophile society and publishing house under the direc-
tion of Julius Meier-Graefe published deluxe editions contain-
ing many original graphics. In addition to the yearbook
Ganymed, Meier-Graefe produced books about Manet,
Brueghel the Elder, facsimiles of antique frescoes, and von
Hofmannsthal's drama Ariadne auf Naxos with illustrations by
Willi Nowak. These continued until 1928.

Beckmann had become vitally interested in the drama of life,
writing four plays between 1921 and 1922. None was produced,
but they show his mixture of fantasy, realism and moralistic in-
tent. His style was still developing toward the later comment on
the brutality and chaos he saw around him.

There were some related works such as this Jahrmarkt, scenes
from the great New Year's Day fair put on in most German cities
and towns. Beckmann had begun to free himself from
academic drawing, using quick modelling in bright light.

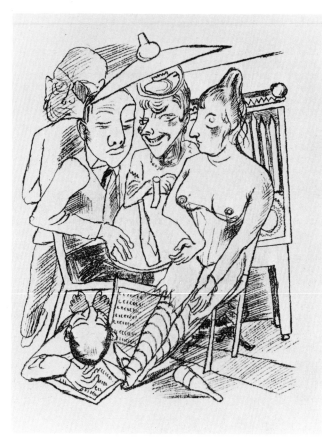

370.

371.

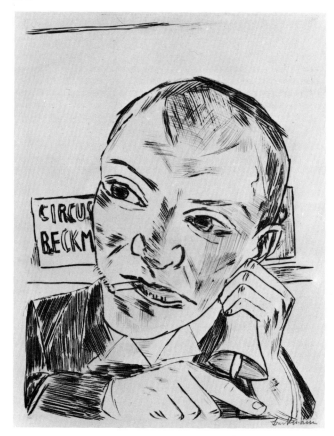

In Jahrmarkt Beckmann presents his private theater. In *Circus* Beckmann begins with the artist calling the audience to attention by ringing a bell. The *"Self Portrait with Cigarette"* covers the sensitivity with a veneer of a circus barker reminiscent of Wedekind's introduction to the Lulu cycle of plays or Goethe's introduction to Faust. But the characters are driven into a confined space, edges are pushing inward. The cast is made of human puppets, forced into violent positions, but frozen in place.

Earlier works had placed light figures against black backgrounds, but this Beckmann of beginning New Objectivity casts no shadows from his creatures or covers them in gloom. Following his interest in the Italians, Francesco Traini and Paolo Uccello, he adopts mannerisms of these masters by bringing the observers into such a position that many perspectives are apparent and space seems a jungle of jagged objects as though in a horizonless junkyard. Compression takes the place of physical limitations by depth. Performers are shown behind the scenes, a giant is exposed to the comments of the public; a passive negro is described by an excited barker; the public becomes performer on the merry-go-round. The circus is not a place of noise and smells of candy and exotic things for this artist. It is a scene of stillness, with episodes of estrangement between person and person, and isolation of intentions between performers and public. There are touches of intimacy later, when people talk at a table, musicians practice, performers make up their faces for the acts to come.

The schematic construction is based on linear, not spatial composition. Areas are darkened for emphasis, not reality. Formats change from long to horizontal to square, from full up-to-the-edges to simple and clean inner images. It is all, perhaps, a comment on the disintegration in civil life which Beckmann's clairvoyance projects into graphic symbolism.

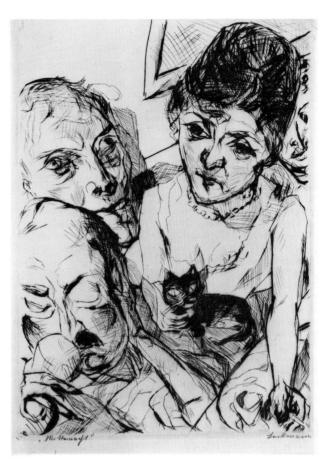

372.

371.

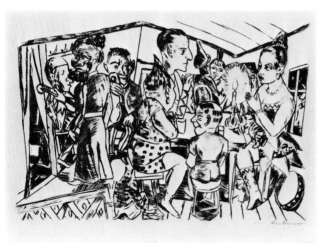

372. Der Abend (Selbstbildnis mit Battenbergs) *(The Evening or Self-Portrait With the Battenbergs)*
Drypoint etching, 1916
Plate 10 of the portfolio: Gesichter (19 Etchings)
Portfolio with text by Meier-Graefe, designed by E. R. Weiss
100 numbered examples: I-XL on japan paper,
1-60 on thick paper
Printed in 1919-1920 for the Marées-Gesellschaft
(XIII. publication)
R. Piper Verlag, Munich
23 x 17.5 cm.
Gallwitz 67 (Edition of 60 on Bütten)

373. Mainlandschaft *(River Main View)*
Etching, 1918
Plate 6 from above portfolio
25 x 29.8 cm.
Japan paper edition of 40
Gallwitz 99 b

Max Beckmann received a medical discharge from the German army in 1915. He was placed in a hospital for two years for medical treatment and convalescence. This was a time of great difficulties for the artist, for he had lost confidence in the painting which had brought him early fame. He tried to begin all over again through the investigation of drawing and graphic art. He painted only two paintings during the two years of recovery, but made many experiments with etching and lithography. At the end of 1915 Beckmann met the family of the Battenbergs in Frankfurt am Main, scene of his hospitalization. Ugi Battenberg was a painter and let Beckmann work in his studio, provided intellectual companionship and understanding for the suffering exsoldier.

The early anxiety of the work around 1914 is emphasized and clarified in the etching of the Battenberg family ("Der Abend"). The planes of the picture now burst with energy. Space is arbitrary, has no existence outside the placement of the figures. There is no center of interest, but as with medieval pictures, the eye is allowed to float from interesting area to interesting area, from the sleeping Ugi, to the dreaming wife Fridel and her staring cat, to the child cut off by the right side of the frame, to the unfocused-appearing Beckmann staring past the woman into space. The entire series of Gesichter is a panorama of experiences from that short past.

*River Main View* from the same portfolio is the least emotional in the series. Perhaps it is the major contrast, a stopping place after and before violence. There is no madness nor cruelty. He presents the scene with sensitivity, not light and dark. His Secessionist naturalistic manner is gone. The great S-curve through the composition is the binding. The foreground and background are woven together with this linear perhaps medieval concept. The river Main in Frankfurt is idyllic and peaceful. Human contact with nature is close and intimate in this drypoint. For a time space is friendly to man.

374. Selbstbildnis *(Self-Portrait)*
Woodcut, 1922
Published by R. Piper Verlag, Munich
Edition of 80 examples: I-XX on tinted japan paper.
1-60 on Bütten paper.
22.2 x 15.4 cm.
Gallwitz 195 c

373.

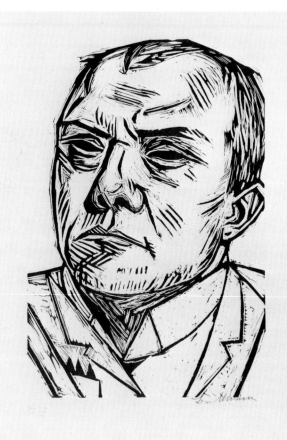

374.

375. Bildnis Frau H. M. (Naila) *(Portrait of Frau H.M.)*
Woodcut, 1923
Plate 2 from the portfolio Mappe der Gegenwart, published by Marées-Gesellschaft with text by Meier-Graefe. 42 facsimiles of drawings and watercolors, 6 signed plates by Corinth, Grossmann, Beckmann, Klee, Meseck, and Heckel.
57 x 32.5 cm. The English and French editions had a reproduction after Matisse substituted for the six original prints, edition unknown.
Regular edition of Marées-Gesellschaft publications was:
I-XL on japan paper, 1-60 on Bütten paper.
Gallwitz 252

In Selbstbildnis of 1922, Beckmann is the observer, the stiff moralist. He is a witness of the contemporary scene. He is physically impressive, with a round, self-sufficient appearing head. He shows the immense vitality of his physical condition through the careful modelling of the wood around each turn of form and change of plane. He presents himself almost as a rock-like idol. He is not a man of vanity in this portrait. He is "objective" in the sense of Neue Sachlichkeit; is objective to his inner vision. The cutting is strong, almost coarse, the bluntness of the symbolic force is vivid.

The portrait of Frau H.M. is a late work in a period of harmony and self belief. His search for form had been successful. The modelling is unemphasized and assured. He gives a brilliant simplicity to the hair and gown. The subject is relaxed. Yet there is an enigma to the expression of the Rumanian girl, a mystery and hidden objectivity. This portrait, with its emphasis on the character of the sitter not the composition of the picture, begins a long series of portraits which study human character, and its attitudes and features. Beckmann studied this model carefully; and made a profile sketch in etching before the woodcut.

# RUDOLF GROSSMANN

Under the movement called "Neue Sachlichkeit," we find the name of Rudolf Grossmann. His artistic life was a definition of this term, for Grossmann saw reality in a cold and logical manner. His was the eye of the physician seeking clues to diseases of the soul. His cure was put in graphic form, creating his game plan in accentuated time-psychology.

Rudolf Grossmann was born in Freiburg on January 25, 1882. His mother was a painter. He sketched and wandered, studying medicine and philosophy until 1904. In 1905 Grossmann moved to Paris for five years. This was the great time of learning, absorbing the art atmosphere, making friends, smoking and drinking at the Cafe du Dome, being a free soul in the center of the art world. He became close friends with Feininger, Matisse, Pascin, and Hans Purrmann, but seems to have moved with the circle of German and Scandinavian painters.

**376. Bauerntanz Brügge** *(Peasants' Dance in Brugge)*
Etching, no date (ca. 1906)
13 x 18.1 cm.

This early etching shows Grossmann's developing technique. He emphasizes the strange isolation of the dancing figures. His drawing is primitive. The composition is awkward. The feeling of sadness is apparent. The keen eye of the observer sees quick reality with stronger analysis than the hand can accomplish.

**377. Mädchen mit grossem Hut** *(Girl in Large Hat)*
Etching, no date (ca. 1907)
21.7 x 13.8 cm.

A later etching made during the years in Paris. There is a free use of the needle, in the manner of the young Segonzac. The mood is serious, still and fixed in compositional tension. Drawing has improved with the training of the eye. Form is investigated without knowledge, however, and the slightness of the achievement is apparent.

376.

377.

375.

**378. Zwei Pariserinnen im Cafe** *(Two Parisians in a Cafe)*
Etching, no date (ca. 1908)
10.8 x 7.8 cm.

The discussions with Pascin and the electric atmosphere in Paris have provided the young artist with growth and direction. His eye begins to see clearly. He places the subjects more carefully. He begins the exaggeration that becomes typical later: large heads, a better idea of turning forms; the bending of perspective for psychological emphasis, less over-drawing. Simplicity is what he learned from Matisse, but simplifying for tension. Grossmann begins his panorama of humanity. He is interested in the varieties of human experience, less in personal development and inner emotional expression. His is a dialogue with his characters, finishing their conversations with speech through his art.

378.

**379. Jüdisches Theater: Der Zauberer** *(Jewish Theater: The Magician)*
Etching, no date (c. 1905), 19.2 x 11.3 cm.

Grossmann and his friends were no different from the French and expatriot painters of Paris during this time. Picasso and Braque, too, visited the theaters, cabarets and circuses for amusement and inspiration. Industry and middle-class society was not interesting nor were the social problems of the Industrial Revolution. This came after the war. For a special period, about six months, Grossmann wandered in Paris, drew the streets, squares and entertainments.

The Jewish Theater was a center of fine acting, vaudeville acts in Yiddish, and an outlet for young writers in that language. It did not appear exotic to the painters. Kokoschka has written of his delight in the Jewish Theater in Vienna, which was a regular visiting place for the circle around Adolf Loos.

In this etching, the drawing is still primitive, as though the artist worked directly on the plate from the actual scene. The balance of the design is careful. There is a sense of reality to the scene: the pause of the magician, the silence of the audience.

379.

**380. Kubin nach Tisch** *(Kubin After Supper)*
Pencil drawing on paper, 1912
18 x 31 cm.

Grossmann draws his friend Alfred Kubin resting after supper. The artist had returned to Berlin in 1910, begun a series of portraits of the great and the less great that continued for the rest of his life.

He has developed his hand and eye. The long sweeping pencil lines are sure and accurate. Kubin dreams his visions of gnomes and unspeakable grotesqueries before our eyes. The arms are overlarge and balance the bald head.

Grossmann now works for Paul Cassirer and Alfred Flechtheim, especially the former with a series of landscapes in Berlin. He begins to lose the elongated extensions of the Paris period and compacts his forms.

380.

**381. Max Liebermann**
Drawing in carbon pencil, no date (ca. 1924)
47.7 x 32.2 cm.

After journeys to Italy, and residence in Tegernsee and Munich, Grossmann returned to Berlin. He had married in 1919, and spent one year in Italy with his friend Hans Purrmann. Then he settled in Berlin in time to join the Berlin Secession, the Free Secession and Deutscher Künstlerbund. The witty Liebermann was now an old man, though still a prominent figure in the art center of Germany. Grossmann draws a disillusioned painter, a side seeking, inward turning man. This is foreign to what we know of Liebermann's extrovert temperament. Paul Cassirer, Liebermann's major promoter, had asked Grossmann to move nearer the publishing center, for in the early 1920s, Grossmann's illustrations were in great demand.

He joined the circle around the intellectual Cassirer. He took no part in manifestos or protests. He worked, studied the reality in Germany, commented in original fashion. He expressed the new reality through his art not his throat. He retained his wit and patience among the wild men of the left.

Because he took little interest in formal developments, was visual primarily, Grossmann may be considered a minor artist on the fringes of Expressionism. Human beings are what interest him, not formal originality.

## WILLY JAECKEL

382. Das Buch Hiob *(The Book of Job)*
With original lithographs by Willy Jaeckel
Berlin: Erich Reiss, 1917
Erster Prospero-Druck
Printed by the Buchdruckerei Oscar Brandstetter, Leipzig
Lithographs printed by Hermann Birkholz, Berlin
Edition: 200 numbered examples (Nr. 1-60 on van Gelder Bütten, each lithograph signed by the artist, bound in parchment. Nr. 61-200 on Bütten)
Unpaginated
38.5 x 35.5 cm.
Text from the original translation by Martin Luther, reedited by Walter Unus.

Willy Jaeckel was born in Breslau and was trained there at the Academy of Art. His early interest was in anatomy and muscle structure for monumental systems of composition. His first painting in 1912 expressed this interest in the use of muscle-men posed in tormented positions. There is an apparent influence from Michelangelo in the twisted torsos and shortening of perspective giving thrust to the violent action. Backgrounds are designed to fold and twist as counters to the fierce diagonals. His portfolio, Memento of 1915-1916, was an antiwar statement influenced by the concepts of Goya's Los Desastres de la guerra.

Although the subjects in his *Job* portray Russian cruelty to Germanic peoples, the universal cruelty of war is readily apparent in Jaeckel's skillful use of explosive design, a concentration of forces in a hammer-like use of contrasting geometry.

Since Das Buch Hiob was published before the actual rise of the New Objectivity movement, Jaeckel had been a subscriber to many of the principles which formed the grouping in the 1920s. In his illustrations Jaeckel combines some patriotism with antiwar propaganda. Job's redemption was part of the Expressionist view of the future.

*The Book of Job* is the first of the wisdom books in the Old Testament. The great biblical references to God, man, Satan, righteousness and redemption date from an early time. Job was a perfect and upright man, one who feared God and shunned evil. The subject is the age-old one of the sufferings of a righteous man. There are six parts which divide the section into monologues, dialogues, God's words, Job's confession. In the minds of the religious revivalists during the Great War, dogma seemed unfitting.The message of God's corrective purposes, the testing of Job was more than a return for Job's goodness. The major theme of God's ultimate triumph over evil, Satan, was part and parcel of the idealism, the hope for a new world which motivated most of the Expressionists and turned their thoughts towards religious symbolism.

**382.**

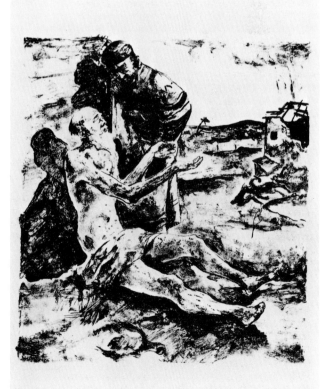

# FRANZ RADZIWILL

Four hand printed woodcuts, 1921:
As issued in Kündung. Eine Zeitschrift für Kunst. Edited by Wilhelm Niemeyer and Rosa Schapire. Erste Folge, drittes Heft, March 1921.

383/1. Abkehr *(Alienation)*
28 x 19.7 cm.

383/2. Liebesgram *(Lovegram)*
22 x 31.3 cm.

383/3. Landschaft *(Landscape)*
19.7 x 28 cm.

383/4. Der Prophet *(The Prophet)*

Franz Radziwill was born on February 5, 1895 in the northern marshlands of Germany, in Strohausen. He was associated most of his life with the area in and around Hamburg, that city of shipping and commerce. He was first apprenticed to a bricklayer, then studied architecture for three years. Later he attended the Arts and Crafts school in Bremen. He met the group in Worpswede, Modersohn, Vogeler, Hoetger and Clara Westhoff-Rilke about this time and their influences were strong. He served in the German army from 1915 until his capture by the British in 1918. Released in 1919, Radziwill returned to Bremen, joined the Freie Sezession as the last and youngest member. He lived for a short time in Berlin where he was close to Grosz, Schmidt-Rottluff and Otto Dix, and joined the Novembergruppe.

The year 1921 was the beginning of a difficult time for this painter. He had lost faith in his art and was turning more and more to poetry and prose. By 1923 he had completely stopped painting, but somehow in 1924 he found new faith through his friends and through the political efforts of the organizations to which he belonged; and began painting again. This was the end of his Expressionism, for he became a Realist, following the example of his friend Otto Dix.

Radziwill's woodcuts for Kündung are his only illustrations for a periodical. They show how he had developed his style in motion, primitive drawing and strong contrasts of white and dark. He attempted monumentality through the manifestations of ornamental as opposed to objective narrative. Each form is made simple and stark, in flat planes without spatial depth. It has some of the interest of the fairytale and naive decoration.

After the period of Realism, Radziwill turned to fantasy, a kind of personal Germanic surrealism from inner visions, not associated with a movement, as this artist for some years became a recluse, a sailor on tramp steamers and sailboats.

Radziwill succeeded Klee at the Düsseldorf Academy in 1933, but he was expelled as well by the Nazis in 1935.

383/1.

384.

## RUDOLF SCHLICHTER

**384.** Auszug aus Lucians Nachrichten vom
Tode des Peregrinus
*(Departure of Lucian, Epilogue from the Death of Peregrinus)*
by C.M. Wieland
Mit 10 Lithographien von Rudolf Schlichter
Verlag von Richard Weissbach
Heidelberg, 1920
21 + 1 pgs.
pg. size: 33.5 x 25.3 cm.
Third book of the Argonautenkreis
150 examples
Text printed by Offizin W. Drugulin, Leipzig
Lithographs printed by Friedrich Hornung, Leipzig
Type: Französische Antiqua
Signed by Schlichter on the colophon

Richard Weissbach, the publisher, was an enthusiastic idealist who had wide circles of friends among the academic community in Heidelberg. He had published and promoted the early Expressionists such as Kurt Hiller, and backed the journal called "Argonauten." The Argonautenkreis was founded in 1920 as a remaining idea for the earlier group of writers who had worked for the periodical. There were only five publications in the series, three illustrated.

Christoph Martin Wieland had translated Lucian in six volumes, published in 1788-1789. He had founded two early periodicals: "Der Teutsche Merkur" and "Attisches Museum." His vast writings include much comment on classical philosophy and his translations of twenty-two of Shakespeare's plays were their first major introduction in German.

Wieland took Lucian's commentary on Peregrinus Proteus as the basis for his essay. Peregrinus had been a Cynic, and an exponent of various doctrines including Christianity. He had been a teacher in Athens, and after dismissal and loss of students, he sought one great sensation. He created this sensation by immolating himself on a funeral pyre during the celebration of the Olympic Games in 165 A.D. Lucian, supposedly, was present.

What appealed to the later German reading public was Wieland's style. He was fluent, had a light touch; his temperament was not heavy but more French, like Voltaire's. This selection is from an essay published in 1791.

Schlichter, the illustrator, was a product of both the Arts and Crafts school in Stuttgart and the Karlsruhe Academy, under Trübner and Thoma. Thus his background was realism, fine drawing, and none of the psychological tendencies of other young painters. His war service radicalized him violently. He showed with the Novembergruppe and later the Dada group in Berlin. Later he mainly worked as an illustrator for the Kiepenheuer Verlag. Schlichter, like most of the New Objectivity men, was a very left wing radical in the 1920s. He belonged to the Red Group in Berlin, The Association of Revolutionary German Painters, and did many illustrations for radical journals. Schlichter's illustrations for Lucian were made early in his development. He shows influence from Dada painters such as Grosz and Dix, with pseudo Cubism and massing of form into one dominant shape. Lucian's fluent style and humor (he was called the Aristophanes of Greek prose) is not apparent, for Schlichter at this time was ill-educated in the classics, though he later studied culture and philosophy. The various elements of Peregrinus's confusions are outlined by figure symbolism: the orator speaks; he dances with a nude woman who is riding on a carrot; he speaks and speaks to unknowing audiences; he finally burns himself on the pyre.

This is Schlichter without irony and cruel comment, the young artist of wit and thought. His bitter feelings came later, and with them a sense of tragedy and cold form.

**385.** Tanz *(Dance)*
Lithograph, 1920
28.8 x 21.4 cm.
In Das Kunstblatt, April 1920, Heft 4 , pg. 96

Each painter writes in graphic form against the problems of his time. In Germany original sin was always a major force through the political and social diversions common to that land. German artists used foreign forms, from France and the Orient, but rarely overemphasized construction as did the French, and kept some of the middle-European sentimentality under their commentary on cruelty.

Schlichter is a reporter. The platform of his world is located in calligraphy, semiabstraction and social comment. His abstraction is taken from cubistic relocation of perspective. His calligraphy is careful and uninterrupted line, forming form without much shading, swelling into a round shape and pulling taut into a hard outline.

His social commentary is comical and grotesque, at the limits of humor. His people are semi-mechanical dolls, armless, sad, or idiots, in a fantasy of social symbolism. One moves from the real back through the unreal, with some of the subject matter also beyond the limit of taste, but located enough in the fantastic to dull the horror.

His line is always beautiful; too beautiful in many cases to be uninvolved. This is his major weakness: versatility. It is a kind of artistic sentimentality, this ability to be always aesthetically appealing through line.

His early sense of the ridiculous turns after 1922 into a kind of neo-realism. His great portrait of Bert Brecht had dryness, no sentimentality, but psychological observation.

During the 1920s before the rise of the Nazis, Schlichter lost himself in studies of cultural philosophy, moved again into fantasy after World War II, and became a semi-Surrealist.

385.

RUDOLPH SCHLICHTER: TANZ      ORIGINAL LITHOGRAPH

# GEORGE GROSZ

**386. Kleine Grosz-Mappe** *(Small Grosz Portfolio)*
20 lithographs in portfolio, Lewis p. 272; Dückers 19-38
Berlin-Halensee: Malik Verlag. Fall 1917
Edition: 120 numbered examples: Nr. 1-5 on Imperial japan,
signed, Nr. 6-20 on same paper, signed,
Nr. 21-120 on handmade paper
20 lithographs, unsigned, each sheet measuring 29 x 21.5 cm.
in portfolio with paper covers measuring 30 x 23 cm.
title page and three pages text.
Lithographs in order of appearance:

1. Fräulein und Liebhaber *(Young Woman and Sweetheart)*
2. Strasse *(Street)*
3. Strassenbild *(Street Picture)*
4. Kaffeehaus *(Coffee House)*
5. Goldgräberbar *(Golddigger Bar)*
6. Krawall des Irren *(Riot of the Insane)*
7. Strasse des Vergnügens *(Street of Entertainment)*
8. Werbung *(Courtship)*
9. Gesellschaft *(Society)*
10. Cafe *(Cafe)*
11. Spaziergang *(Stroll)*
12. Häuser am Kanal *(Houses at the Canal)*
13. Vorstadthäuser *(Suburban Houses)*
14. Die Fabriken *(The Factory)*
15. Die Kirche *(The Church)*
16. Das einzelne Haus *(The Detached House)*
17. Der Dorfschullehrer *(The Village Schoolteacher)*
18. Jägerlatein *(Huntsman's Tall Stories)*
19. Mörd *(Murder)*
20. Hinrichtung *(Execution)*
Missing title page and three pages text

Wieland Herzfelde, the publisher of this second portfolio, had
been a champion and friend of the artist since Theodor Däubler
had introduced the two radical thinkers. John Heartfield, Wie-
land's brother, had also been a close companion during 1915
and 1916.

Herzfelde had been active as an antiwar activist. He had been
censored frequently and been put on the blacklist of German
authorities. Antiwar periodicals were planned and some were
actually begun.

During all this time, Herzfelde had to move his living quarters,
the center of his publishing activities. Grosz had also moved
and hidden, been insolent toward authorities and written par-
odies of sentimental German war hymns. Grosz and Herzfelde
collaborated in another scheme in one of the hiding places, an
attic studio on the Kurfürstendamm. Both the Erste George
Grosz Mappe and the Kleine Grosz Mappe were prepared in this
isolated room.

The Kleine Grosz Mappe included some of the artist's poetry,
which he had read to audiences in some of the mediocre cafes
and cabarets in Berlin.

George Grosz shows some humor, but his attitude toward
mankind was so cynical that he has little social understanding
of the kind which makes up great humor. Anyone familiar with
certain kinds of professions in which real danger is a daily ex-
perience, police or fighter pilots, knows how the strain pro-
duces comical commentary in original forms, cynical juxtapos-
itions with grotesque descriptions; and all very humorous, but
jest is not raised into art by danger alone. It takes another
mixture of other psychological dimensions and inhibitions.
Grosz changes jest into more than entertainment. His deep
feeling is the catalyst.

The characters in the drama of George Grosz are bestial pup-
pets, a dehumanized mankind. Life and death are the pathway
filled with murderers, whores, insane gangs of night wander-
ers, drunken and staggering morbidities. Grosz found the
world sick and evil.

The layout and typography of this portfolio was by John
Heartfield. He used a kaleidoscope of images, which reflect the
tumultuous feeling of the artist, George Grosz.

The poem which introduces the drawings carries the same
symbolism:
Ha! In Copenhagen the stock exchange has fallen!!
Ha! In New York the stock exchange has fallen!!
Bethlehem Steel shares…Who can know?
Men push, sick,
Confused, old putrid men roar peace rumors
From still fresh, printer's-black-shining articles.
Further:
Streets are sodden
Rain is in hair strands
Auto buses stagger
Black legs pushing umbrellas into each other,
Only illuminated advertisements bloom:
Rheingold, Manoli, Steiner's Paradise Bed,
The Anti-Christ soon will come, We sell Ready-Made Clothing.
Crows and street trucks
Corrode the asphalt…It is odd!!
Adventurers pull past, rigid hats,
Black on polished hair, set to the rear.
The syphilitic's mottled profile shimmers
Through the dark…no nose can stand this life..!!

The schnapps tavern seems by this time…a fairy grotto,
By this time cocktails, gin, grog, backsides.
Heidi, music…a correct negro music!
Can someone ragtime?
Dance…please!
Rio dips down…harbor streets
and matches, hello! Your warm cakes baking!
Oh, Argentinians, desirable land!
I drink chocolate,
On a bamboo veranda,
And black cigars,
Great straw hat on the head…
And hippopotamus whip…
Mulatto, proud and cowherds in Fray-Bentos…
I fire the revolver away
later, when I walk to the broad log hut,
With red blouse and brown…
The dog barks in anger…
And the parrot sings in English.
Ha! I love it! Early! Dew is on the grass,
And on my revolver, the great shooting knife,
My black shaggy dog…Oh! Colorado!
Freedom!

387. Gott mit Uns. Politische Mappe *(God for Us. Political Portfolio)*
9 lithographs in portfolio, Lewis p. 273; Duckers 46-50, 52, 53
Berlin: Malik Verlag. June 1920
Edition: 125 numbered examples
A: Nrs. 1-20, 9 prints with
title page, printed in Strathmore Japan, in half-vellum
portfolio, each signed
B: Nrs. 21-60, 9 prints printed on heavy handmade paper,
in half-silk portfolio, each signed
C: Nrs. 61-125, 9 prints printed on light handmade paper,
in half-linen portfolio, unsigned.
#119/125, with title page and paper covers, 50.3 x 34.3 cm.
Prints in order of appearance: (Titles are by George Grosz,
not literal translations)
1. Dieu Pour Nous; Gott mit Uns; *God for Us* , 29.5 x 43.5 cm.
2. Les Boches Sont Vaincus – Le Bochism Est Vainqueur; Für
deutsches Recht und deutsche Sitte; *The Germans to the
Front* , 38.3 x 31.5 cm.
3. L'Angélus a Munich; Feierabend; "Ich dien",
39.4 x 30 cm.
4. Liberté, Egalité, Fraternité; Licht und Luft dem
Proletariat; *The Workman's Holiday* , 35.2 x 29.8 cm.
5. Le Triomphe des Sciences Exactes; Die Gesundbeter;
*German Doctors Fighting the Blockade* , 32.3 x 29.8 cm.
6. Les Maqueraux de la Mort; Zuhälter des Todes; *The Pimps
of Death* , (size unavailable)
7. L'État, C'est Moi; Die vollendete Demokratie; *The World
Made Safe for Democracy* , 44.4 x 30.2 cm.
8. Écrasez la Famine; Die Kommunisten fallen – und die
Devisen steigen; *Blood is the Best Sauce* , 30.5 x 46 cm.
9. Honni Soit Qui Mal Y Pense; Den Macht uns Keiner nach;
*Made in Germany* , 28.5 x 25 cm.
Eight of nine prints (missing plate 6)

388.

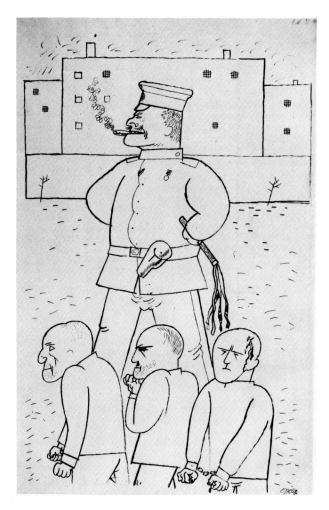

388. Preliminary Drawing for Plate 7, L Etat, C'est Moi; Die
vollendete Demokratie; *The World Made Safe for Democracy*
Pen and Ink Drawing, ca. 1920
Signed in pencil
49.5 x 33.2 cm.
This original drawing for the lithograph in the portfolio Gott mit
Uns proves that the "lithographs" are reproductions.
It is not on transfer paper or drawn on limestone.

387/5.

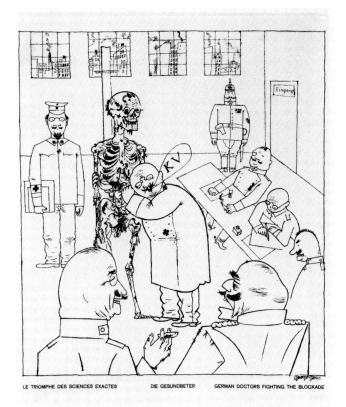

LE TRIOMPHE DES SCIENCES EXACTES     DIE GESUNDBETER     GERMAN DOCTORS FIGHTING THE BLOCKADE

**389. The Boss**
lithograph, 1922
58.5 x 43.2 cm.
signed, not dated
On laid paper
Ex collection: Hanna Bekker vom Rath, Frankfurt a M.

Plate 1 for the Portfolio, Die Räuber *(The Robbers)*
Berlin, Malik Verlag, 1922
Portfolio 70 x 50.5 cm.

Edition: 100 numbered and signed copies: A. Nrs. 1-5 on handmade japan in vellum portfolio. B: Nrs. 6-10 on handmade japan in half-vellum portfolio. C: Nrs. 11-45 on handmade Bütten in half-silk portfolio. D: Nrs. 46-100 on handmade Bütten in half-linen portfolio.

E: unknown edition, 1923, unsigned in cardboard portfolio (known as People's edition).

With Die Räuber, Grosz was not concerned with ideas about originality or hand made images. He wanted the rhetorical message to be paramount. Drawings were reproduced.

Friedrich Schiller's play about a heroic nobleman from Franconia spells out Schiller's feeling about justice and surrender. The prose is tense and, sometimes, violent. It was a late manifestation of the Sturm und Drang period in Schiller's life. Erwin Piscator produced the play in 1926, and received an immense success with the creative production.

Grosz takes lines from the play to use as a basis for the criticisms of German society. To him, the Robbers are the men of business, army and judicial system. The quotation from the play says, "I will uproot from my route whatever obstructs and blocks my progress toward becoming the master." Grosz makes the romantic message into a revolutionary one with his image of stupid power.

389.

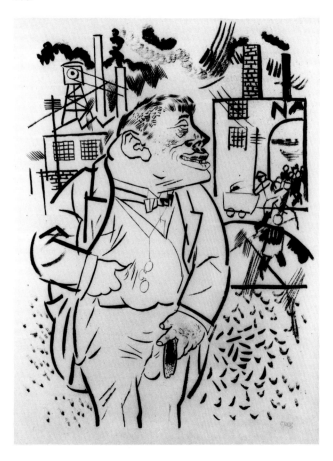

**390. Lady Hamilton oder Die Posen-Emma oder vom Dienstmädchen zum Beefsteak a la Nelson. Eine ebenso romanhafte wie auch novellenschaukelnde durchwashsene Travestie** *(Lady Hamilton, or the posing Emma or from Servant to Beefsteak a la Nelson: A so precise fantasy as likewise a short story, streaky travesty. Industriously and fleshly drawn)*
by Alfred Richard Meyer
With 8 hand colored lithographs by George Grosz
Lewis, pg. 291 checklist
Berlin: Fritz Gurlitt Verlag, 1923
Edition: 300 examples. The first 100 examples were hand colored and signed by the artist on each print.
Colophon signed by the author
Type set and printed by Otto von Holten
Lithographs printed by Hermann Birkholz, text by Paul Eipper
Die neuen Bilderbücher, 5. Reihe, Nr. 2 (Fritz Gurlitt)
53 + 3 pgs
30.3 x 25 cm.

Grosz always added dimensions to the books he illustrated. In these illustrations he portrays the members of the upper middle class as money-grabbing, profiteering pleasure lovers in all their nudity, wrinkles, and leers. Grosz uses strong acid to facet the scenes of lust and abandon. What Grosz is showing is the moral decay in scenes of postwar Germany clothed as eighteenth century Britain.

It is peculiar that this book was made for profiteers and it was marketed for a German public suspicious of money, who were investing in books. Grosz gave them the anatomy of lust and they loved him for it. The books were not cheap in price. This edition sold originally for 1000 Marks.

Gurlitt's Die neuen Bilderbücher was started in 1916 to promote fine illustrated books. It included artists such as Corinth, Kokoschka, Pechstein, Janthur, Zille, Seewald, Meid, Grosz, Jaeckel, Kubin and others. The authors were international and included Arnim, Bach, Merimee, Goethe, Novalis, Swift, Heine, Kipling, Gautier, Louys, Balzac, and Brentano.

There is some question of the originality of these prints. They may have been transferred by photographic means or have been drawn on transfer paper. The line of the lithographs does not have the preciseness of a tusche drawing. As the lithographs were hand-printed by a professional printer for the artist, the process was probably not straight reproduction, but some half-way measure.

Grosz was very interested in period costumes. He had designed for Max Reinhardt's production of *Caesar and Cleopatra;* he had worked on Shaw's *Androcles and the Lion.* He had returned to a simpler means of drawing after the short period of Dada-Cubism. But Grosz used this incisive and clean method of drawing in a nonsentimental way. Grosz did not appeal to the idealism and generous instincts of the bourgeoisie. Grosz was a complete but sensitive pessimist. His hatred is always apparent with its gallows humor. His intention is not to draw an artistic line. Lady Hamilton's plump, mincing poses are not abstract conceptions but unities of character, motives and appearance.

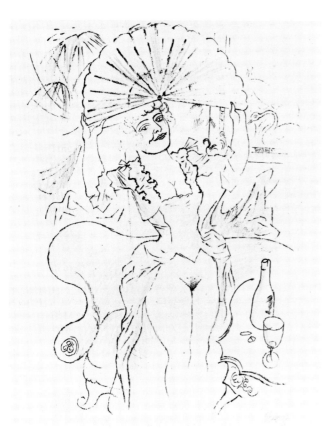

390.

391.

### 391. Kobes *(Kobes)*
by Heinrich Mann
with 10 lithographs by George Grosz
Lewis, pg. 291 checklist
Berlin: Propyläen Verlag, 1925
28 x 23 cm.
2 + 72 pgs.

Kobes sleeps not. Kobes dances not. Kobes works twenty hours a day. Kobes the profiteer, is based on the legendary career of Hugo Stinnes.

Stinnes represented one of the figures who took advantage of the inflation period in postwar Germany to build an enormous fortune. He had been influential before the war, but his vertical trust was amazing later. He started with iron and steel, then acquired companies in shipping, transportation, lumber, hotels and real estate, bought newspapers and bought politicians. Stinnes and other industrial leaders wielded great political power. They were able to stop a socialist movement supporting direct taxation to pay for government expenses. This increased inflation until the middle class was financially wiped out, social ties were cut, and Germany sustained strikes and massive unemployment.

It is this image of the self industrialist that Mann uses as the central figure in his novel. Heinrich Mann belonged to a school of literature which was oriented towards European liberalism. He was influenced by the social radicalism of Marx and the psychology of Freud. For large masses of the German people these ideas were alien. They took their image of Germany from pre-industrial society. Mann was, in his way, a cultural historian of this time, as he became later for the time of Henry IV of France.

The prose of Heinrich Mann stripped off the mask of the age, just as George Grosz's illustrations cut away the flesh itself along with the clothing. Mann was also a politically committed writer, a pacifist during the first World War, and an opponent of oppression from either the right or left. He was essentially a humanitarian in the liberal tradition of the old German intellectual before nationalism.

Grosz is more realistic in his hatred of Stinnes-Kobes. He sees him as a spider casting a web over society. Stinnes plays with the human population as he plays with his toy trains. Kobes is against complaints. Kobes works twenty hours a day.

In this book Grosz shows some sympathy for the victims, but for only a few. Kobe's colleagues are cruel looking, stupid, animal-like, fat-headed or pathetic. Kobes is shown as a devil with horns, a medieval throwback with one horned foot. Describing a radio speech, Kobes says, "On the radio I speak only for me." Kobes refuses a woman: "With my attention to family and morals, no." Kobes works twenty hours a day.

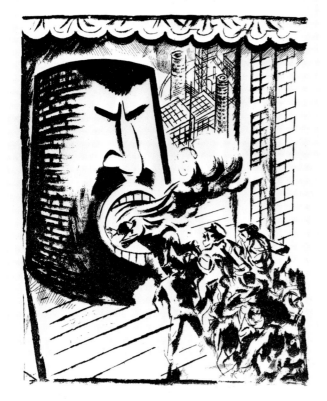

392. Port D'Eaux-Mortes *(Port of Dead Water)*
Pierre MacOrlan
Au Sans Pareil, Paris, 1926
Text printed by R. Coulouma
Lithographs printed by Duchatel
Edition: 1260: 20 examples on vellum paper, with extra suite
on china or japan, 40 examples on japan Shidzuoka, extra
suite on holland or china, 60 examples on van Gelder, extra
suite on china, 100 examples on van Gelder, 1000 examples on
vellum Lafuma, 40 examples hors commerce
Lewis page 292, check list
21.5 x 16.3 cm.

Grosz travelled to Paris with his old friend, the writer Pierre
MacOrlan in April, 1924. He was commissioned to put these ex-
periences into illustrations for MacOrlan's novel.

The book is built around the Cafe de Beau Patron. Grosz intro-
duces some exact, representative illustration in the beginning
lithographs, but falls back on German types later. Early we see
the misfits of Paris, the hurdy gurdy player, motionless whores,
card players; and here Grosz introduces a murder in the
background.

The author calls the cabaret Beau Patron the debris of his his-
tory. Grosz sees the people of the lithographs as debris for
Death, for this flat faced monster appears in the later pictures
as a kind of *Dance of Death*. Judat, the murderer, is condemned
to death. In the last illustration, Grosz shows some pity: as
death has entered the prison in reality for Judat; and people
kneel in compassion, a concept not common to the artist.

These are probably transfer lithographs. Grosz saw no value in
originality. He preferred to work energetically directly on
paper, which was sometimes transfer paper, sometimes not.

392.

**DIE ROTE FAHN** *(The Red Flag)*
Heft 57, 1924
*Manifest of the Communist Artists' Group*

In the Communist party painters and draftsmen have organized
and activated into a "Communist Artists Group." The members
of this group call themselves "Red Group." The association of
Communist artists is convinced that a good Communist is a
Communist in the first place, and only afterwards a professional
artist, that all knowledge and abilities are only tools in the
service of the class struggle. They give themselves the task to
contribute for the realization of the following program for the
effective reinforcement of Communist propaganda by typo-
graphy-picture or means of the theater in close collaboration
with the central organs of the Communist party.

In place of the so-far too anarchistic method of production of the
Communist artist, there must now be organized cooperation:
1. Organizing of unified ideological propaganda evenings.
2. Practical cooperation between all revolutionary planning.
3. Action against leftover, free German ideologies at proleta-
rian meetings (romantics and home singers).
4. Educational work about art in districts, sample designs for
posters, (wall newspapers??), instruction for designing in-
struction posters and placards etc. Help with the still dilettante
attempts of party members to announce the revolutionary will
by word and picture.
5. Organization of traveling exhibitions.
6. Ideological and practical educational work among the rev-
olutionary artists themselves.
7. Action and attitude against counterrevolutionary manifes-
tations of culture.
8. Decomposition-respectful neutralization work among
civilian artists.
9. Exploitation of civilian (noncommunist) art exhibitions for
our propaganda purposes.
10. Getting in touch with students at all art schools in order to
revolutionize them.

We consider the "Red Group" as the core of a constantly
enlarging organization of all proletarian and revolutionary
artists of Germany.

So far several writers, of theater people, Comrade Piscator,
have joined the communistic artists' group. We invite other
painters and writers to work with us on the basis of our working
program, work practically and to join us. Correspondence
should be sent to the secretary Rudolf Schlichter, Berlin, Neue
Winterfeldstrasee 17.

Berlin June 13 1924 "Red Group"
Association of Communist Artists
President: George Grosz
Substitute president: Karl Witte, writer
Secretary: John Heartfield

**OTTO DIX**

393. Radierwerk IV. Zirkus *(4th Etching Work, Circus)*
10 Radierungen *(10 etchings)*, 1922, Karsch 32-41
Im Selbstverlag (?) in 50 Exemplaren erscheinen
1. Die Verächter des Todes *(The Disdainers of Death)*
Drypoint, 1922, Karsch 32, 34.7 x 27.7 cm.
2. Illusionsakt *(Illusion Act)*
Drypoint, 1922, Karsch 33 II, 30 x 25.7 cm.
3. Sketch *(Sketch)*
Drypoint, 1922, Karsch 34 II, 39.4 x 29.7 cm.
4. Balanceakt *(Balance Act)*
Drypoint, 1922, Karsch 35 II, 29.9 x 19.7 cm.
5. Maud Arizona (Suleika, das tätowierte Wunder)
*(The Tattooed Wonder)*
Drypoint, 1922, Karsch 36 II, 29.9 x 19.8 cm.

6. Internationaler Reitakt *(International Riding Act)*
Drypoint, 1922, Karsch 37 II, 39.9 x 29.8 cm.
7. Amerikanischer Reitakt *(American Riding Act)*
Drypoint, 1922, Karsch 38 II, 34.7 x 30.9 cm.
8. Technisches Personal *(Technical Personnel)*
Drypoint, 1922, Karsch 39 II, 30 x 19.8 cm.
9. Lili, die Königin der Luft *(Lili, Queen of the Air)*
Drypoint, 1922, Karsch 40 II, 29.9 x 19.8 cm.
10. Dompteuse *(Animal Trainer)*
Drypoint, 1922, Karsch 41 II, 39.9 x 29.7 cm.
Each print signed, dated, titled and numbered in pencil. #9/50

Otto Dix was born in 1891 in Gera, Thüringen. At eighteen he studied with a decorative painter, and later had a stipend to attend the Kunstgewerbeschule in Dresden. After the war, Dix returned as a master student under Otto Gussmann.

Dix was sharpened by war suffering. He changed from a decoratively trained painter into a bitter and cynical sightseer in the land of horror and misery. He delved into the irrational, the uncreated art, the dada.

His memory was etched with barbaric trench warfare, gas attacks, broken bodies; and warped mentalities made unfeeling toward human life, pushed over the edge of control into a dream world, super-real too, in a lunar landscape. In the meeting of this sensitive man with events overpowering his sensibilities, accusation became reality and the ghastly naturalism at first took a trend toward ecstatic symbols. But the effects of peace — starvation, blockade, and frustrated social goals — turned Dix into an objective realist.

He moved to Düsseldorf and joined Das junge Rheinland group of artists, who were inspired by revolutionary fervor. For Dix, George Grosz's saying, "Man is a beast" held true. Dix found the idealism of the German soldier and the millions of deaths a great deception.

Before the war, in 1912, Dix had begun a kind of realist painting, but later also passed through Expressionist and Dada periods. His sense of disillusion and despair focused his conceptions, and allied them with an early interest in medievalism. He had a slight sense of being a self-conscious and oversensitive participant, which made him over compensate, searching for the most unappetizing and deliberately shocking symbolic psychology. At the same time Dix arrived at clarity of form, a three-dimensional quality that revealed the materiality of both substances and emotions. This was fulfilled in his famous *War* series.

On the opposite side of this look at life was Dix's nuance of social and political comment through graphics. The war experiences still influence  when we examine other symbolic meanings. Dix had learned the etching technique under the inspiration and direction of Conrad Felixmüller in Dresden. He began in 1920. Many of the early works were interpretations of his paintings, such as the street beggar after the painting in the Stuttgart gallery. He created a long series of studies of whores and caricatures of common life.

The culmination of this symbolism is reached with the publication of the Zirkus-Mappe in 1922. Here  in this amusement, we see, behind dark and unrevealing shadows lit by bright spots, things exposed in another kind of illumination. The *Acrobats* stand before the Death that is always with them. The *Illusionist* brings forth a woman spider dancing with a skeleton. *"Sketch"* is a comedy routine become grotesque, with puppet and monster balanced equally.

The *Balancing Act*  is scratched into fantasy, with painful line and balanced dachshund. *The Tattooed Lady, Maud Arizona,* stands bored, exposing her ships and nudes, angels and stars, over a stiffened posture. The *International Riding Act,* a woman of flags and delicate feet, rides her dappled pony holding flags of victors. The *American Riding Act,* wild Indians seen through German eyes, was a basic act in most circuses. The United States had become the hope of Germany with Wilson's peace definitions. *Lili, Queen of the Air* is a child, moronic looking, with wise eyes and dainty hands. *The Lion Tamer* is a muscled type of German woman, with skull face, broad shoulders and squat proportions. An impersonal determination, German dis-

cipline, and a touch of sadism are in the expression of the staring strong woman. The *Technical Personnel* are tough sailors, tattooed and coarse, the reality behind the scenes of the circus. These are the types of Germans one sees in bars, beer halls, singing and sweating. Though the subject matter depicts entertainment, Dix uncovers a violently bitter attitude in these people working close to death.

Dix always described his major interest as the object. He thought expansion into new areas was through the object; that form was developed from the "what", and "how" was the method he used which could come closest to the things he saw.

393/2.

393/10.

**394. Leuchtkugel erhellt die Monacu-ferme** *(Very Light Illuminating the Monacu-Farmstead)*
etching, 1924
14.8 x 19.8 cm.
Printed by Otto Felsing
Published by Karl Nierendorf, Berlin
Karsch 86
From the series: Der Krieg *(The War)*
Editions: a. A few proofs b. Edition of 70 examples

Taking an example from the relief etchings of William Blake, Otto Dix etches the plate for a reversed kind of placement of ink, not in the lines but on the surface of the plate. The ink was applied with a roller and carefully wiped so the lines remained clean and printed white.

The scene is one of desolation, illuminated by the stark light of an exploding Very light, which swayed and rocked in the wind on the cloth lines of a small parachute.

The effect of the black and white, which is used as outline not form turning, is similar to the method of drawing by artists in the late medieval period, and Cranach in particular. Half tones are merely suggested in the mind of the viewer, and only two tonal values are selected to create depth and precision.

This moment of ruin and tragedy is forever cast into the eery light of a hellish vision.

Berliner Nachtausgabe, December 3, 1927
*The Object is Primary*
By Otto Dix

A slogan has moved through the last years of the creative generation of artists: Create new forms of expression! Whether this is at all possible seems very doubtful to me. If one stands before paintings by the old masters, or concentrates on a study of these creations, most people are sure to agree with me.

Anyway, the new in painting for me lies in the expansion of the object, an enhancement of the forms of expression which is already present at the core of the existing forms of expression of the old masters. For me, in any case, the object remains primary and form is shaped only through the object. Therefore the question which has always been of the greatest importance is whether I can come close as possible to the thing that I see; because the what is more important than the how to me. Only from the what develops the how.

394.

Das Junge Rheinland
Heft 9-10, Juli 1922, page 23
*The Dadaist (Otto Dix)*
By Ilse Fischer

Of course at the time of the Dadaistic climax he produced confusing, simultaneous paintings, symbolistic color chaos and grotesquely conscious kitsch creations. He sent giant sizes to exhibitions, which caused talk. They were pictures aggressively profaning the bourgeois life, and show all the shades from loathing-ridiculous to painful-repulsive. He pasted in real Dadaistic parts of fabric, photos, chopping of letters, streetcar tickets, stamps and printed mottos. He tore holes in the canvas, used colors in the rawest, most impudent way.

For the sake of these pictures, we count him among the Dadaists. He is a Dada painter even without them—although he had to paint them of course—because Dada is no form of art, has nothing to do with art than with all other forms of life. Dada is a slogan for an all destroying, negatively oriented, creative power. Dada is active expression of self destroying chaos. Decisive for Dada is not its product, but its personality.

Dix is thirty years old. His sharply chiseled face is devastated and grey. He has the mouth of the reckless, driven man, with the prominent lower lip of the brutal and deep lines at the edges, grey eyes of the sober analyst, the finely modelled nose of the emotionally clear person, the wide and bulging forehead of the desperate thinker, the smoothly brushed blonde hair of the American.

During his days of affirmation of life, the muscles of his face were taut, his eyes of naive liveliness. His skin has a warm blood tone and the mouth a grossly merry laughter. When one sees the man like that one believes in his carefree readiness for enjoyment, is so under the spell of his flying spirit that one forgets to trace the dangerous lines on this hard head.

He also has the American way—when his income permits it—which is as irregular as himself—in the cut of his suit, with exaggerated, wide, short pants, padded shoulders, unreasonably high waist line. In general, his wardrobe is a conglomerate of cast-off clothes from the art conscious bourgeoisie, and show a desire for extravagant elegance. In this mixture he moves with a healthy matter of fact. His gait is American, short and conscious. Even during periods of melancholic depression he walks like that.

His muscular hands are uncared for, because he is a proletarian by birth, by instinct and for rebellion. He hates the bourgeois, into whose intellectual, art loving, art paying circles his profession and his striving for exhalted knowledge has driven him. He hates their social conventions and social forms as lies-hates, finds the bourgeois need static and the desire for owned property as egotism. He never trusts the bourgeois, senses in their utterances signs of arrogant egotism, feels they are always antagonistic toward himself. That their antagonism is only a more or less instinctive defense—they never attack—does not penetrate his proletarian feelings.

He expresses himself insultingly and aggressively among like-minded ones. "Puke, kitsch, junk, shit" is all that he likes. But his feelings of belonging to the working classes are contradicted by his refined demands on life and his enormous sensibility. He can't stand the awkwardness of proletarian manners, their narrow horizon, the dependent instinct of the masses. He will be felt as estranged by the proletarians, in spite of his visible sympathy.

So he moves uprooted between the classes. His behavior in bourgeois circles is simple and modest. He is not pushy, behaves at first always reserved as an observer. Only at the occasion of some arrogant utterance of the bourgeois does he jump up violently and spout in refined factory worker's dialect a few revolutionary sentences.

In art oriented, unconventional houses, people like to invite him for dinner and supper parties. Then he does not restrain himself, and gives himself to the enjoyment of the hour as soon as the general atmosphere goes beyond formal social limits.

Sleeping over the festivity, one can comment on his uninhibited behavior, but without holding it against him, because first of all it is a free spirit, and second one does not feel so perfect oneself. Maybe aristocrats may express their disapproval, but this man is tolerated in good society. They do not win against the general judgement: "a good natured, brutal guy." One overlooks his lack of social graces because of his natural openness and his artistic importance.

He is aware of this judgement, and laughs about it contemptibly. But he is still (though he wouldn't admit it and nobody would notice it) hurt in his vanity. He feels with instinctive sureness immediately whether someone really wants the best for him or not. His sensitivity is especially strong toward women. It is difficult for him to be alone outside the studio.

He follows conversations closely, often without participating, until he does at a certain point with passionate decisiveness. His philosophical education is not thorough. He negates ideas such as soul, spirit, law as being beyond human spheres of understanding. He recognizes nothing but the space within which the movement of life exists, which is all the same in its primeval substance.

He digs cruelly, cuts everything with the ecstasy of the lustful murderer. But he is like the one who, after the deed, is terribly sobered and goes away empty; and so he stands in the end before things and people, before himself, sobered and hopeless.

Do you understand now the gruesome truthfulness of his lustful murderer pictures, you who are thinking a little contemptibly about the choice of such a motif, which appears to you as dishonest because you know very well that this good humored guy will never murder a woman?

Chaos moves in his brain to the utmost elements of being, and chases him for hours in conditions of agonizing fear, which comes close to being persecutional delusions.

## BAUHAUS

This short essay will not be a complete outline of the Bauhaus. This later movement was a divergent theme from the main body of German art history. It held important philosophies of life, which still influence thinkers of our time.

Much of the background for the Bauhaus came from the Dutchman, Henry van de Velde. He had prepared the way with his philosophy of the Werkbund movement. His arts and crafts seminars in Weimar were important educational beginnings for the young Walter Gropius. Van de Velde's idea of an architecture which encompasses all life provided a sense of unity between monumental and decorative art.

Early ecstatic and idealistic Expressionism was beaten down by the events of the Great War. Afterwards, men desired action that "meant rolling up one's sleeves and getting one's hands dirty." The articles for everyday use were important, as a new world was to be built out of the norm, not from the untypical artists. Man would have to be "normalized" if he was to have a viable purpose. The mass produced object would not be used and designed in a new "apotheosis of rationalism," but freedom would be indispensable. The machine was considered a projection of the hand.

Especially in the design of books, free expression was disregarded. Moholy-Nagy saw a form of construction which had little regard for the practical, while Gropius advocated the practical and functional. Moholy-Nagy desired a universal typeface, without small or large capitals. The elementary idea was to realize a basic form in as pure a means as possible. He worked with squares, triangles, circles and oblong rectangles. The book form was square and thick.

The emotional and irrational was still taught by teachers such as Klee and Kandinsky, but the Bauhaus books were made to be rhetorical, static, accelerating into photomontage and photography. Type designs became impersonal by choice. Futura type was used in preference to more dynamic faces. Spacing was given importance in the dynamics by diagonal setting, curved lines, changes of type sizes, disregard of classical spacing, and asymmetry. This was carried throughout advertising, books and printed matter. From basic Bauhaus design of a circle with triangle and rectangle inserted, came all the later variations.

Moholy-Nagy was not entirely a radical. He used logical structure as the Futurists had not. He gave order to the text sections, and his books are readable. "Practicality alone is of no value. Decisive, however, is the creative order of the elements." The Bauhaus used a limited form after all. This was the basis of good design. Limitations must produce some rational solutions. Complete freedom in typography usually brought chaos.

The Bauhaus artists did not work in the accoustical emotional sign language of van Doesburg and Werkman. Because of their background in architecture, the designers of the Bauhaus remained essentially practical.

## LIST OF BAUHAUS ARTISTS AND ASSOCIATES

Dates indicate years at the Bauhaus
Anni Albers (Student) 1930-1933
Josef Albers (Student) 1923-1933
Alfred Arndt (Student) 1929-1932
Herbert Bayer (Student) 1925-1928
Anton Brenner 1929-1930
Marcel Breuer (Student) 1925-1928
Friedrich Engemann 1928-1933
Lyonel Feininger 1919-1932
Walter Gropius (Director) 1919-1928
Karla Grosch 1928-1930
Gertrud Grunow 1921-1924
Edvard Heiberg 1930
Ludwig Hilberseimer 1928-1933
Johannes Itten 1919-1923
Ernst Kallai 1928-1929
Wassily Kandinsky 1922-1933
Paul Klee 1920-1931
Gerhard Marcks 1919-1925
Alfred Meyer 1919-1924
Hannes Meyer (Director) 1927-1930
Ludwig Mies van der Rohe (Director) 1930-1933
Lazlo Moholy-Nagy 1923-1928
Georg Muche 1921-1927
Walter Peterhans 1928-1933
Lilly Reich 1932-1933
Alcar Rudelt 1928-1933
Hinnerk Scheper (Student) 1925-1929/1931-1933
Oskar Schlemmer 1920-1929
Joost Schmidt (Student) 1925-1932
Lothar Schreyer 1921-1923
Xanti Schawinsky 1927-1929
Mart Stam (Guest) 1928-1929
Gunta Stölzl (Student) 1925-1930
Hans Wittmer 1927-1929

## LYONEL FEININGER

395. Kathedrale (Cathedral)
Woodcut, 1919
Prasse W 144; F. 1923. State 1-B
Large edition on poor wove colored papers (Gray, green, yellow, red-orange)
Title page for Programm des Staatlichen Bauhauses in Weimar (Program of the State Bauhaus in Weimar)
30.4 x 18.9 cm.

Feininger had begun his production of woodcuts during the year of 1918. He produced about one hundred seventeen examples during this time.

The Academy at Weimar had lost its director at the beginning of 1915, for Henry van de Velde was an enemy alien and was forced from his position by persecutions, anonymous letters threatening death to his wife and children. Van de Velde wrote to Gropius on April 11, 1915 and asked if he would be interested in the post as director. Van de Velde had also recommended Obrist and Endell.

The long negotiations with Walter Gropius began. He insisted from the first on the absence of restrictions. Gropius's first ideas were for an educational institution which would be a counselling service for industry. Later during early 1919, the architect, who was practicing in Berlin, had participated in the Working Council for Art after the revolution. There he had laid down the ideas which were to be manifested in the Bauhaus.

This program sought unity in the arts. "Salon Art" was disowned. The new structure of the future would unite painting and sculpture and architecture in one whole, and rise towards heaven like the crystal symbol of a new faith. This inspired the subtitle for the Feininger woodcut, The Cathedral of Socialism.

Feininger took this task seriously. He made a smaller study which went through many changes. It was even proofed with the type, but ultimately rejected for a larger size.

Feininger had already used another woodcut as title page for Ja! Stimmen des Arbeitsrates für Kunst in Berlin, 1919, the manifesto of the German artists of the Novembergruppe. Gropius added his name. Feininger used Rathaus von Zottelstedt 2, woodcut of 1918, as a reproduction, not printed from the original block.

Feininger thought of this image, The Cathedral, as a summation of socialist art through architectural unity. He was anxious to express unity, move to Weimar and the Bauhaus, which he had visited in 1906 and 1911, and had thought of living there after a summer spent in the city in 1914. The war had caught the Feiningers in Weimar and they remembered the city with affection after their brief exile during the war. Feininger had signed the Novembergruppe manifesto and joined that affirmation of the future after the revolution of November 9, 1918. This woodcut vision represents the mastery of space through spirit and work.

## Program of the Staatliche Bauhaus in Weimar

(The Staatliche Bauhaus resulted from the merger of the former Grand-Ducal Saxon Academy of Art with the former Grand-Ducal Saxon School of Arts and Crafts in conjunction with a newly affiliated department of architecture.)

AIMS OF THE BAUHAUS

The Bauhaus strives to bring together all creative effort into one whole, to reunify all the disciplines of practical art—sculpture, painting, handicrafts, and the crafts—as inseparable components of a new architecture. The ultimate, if distant, aim of the Bauhaus is the unified work of art—the great structure—in which there is no distinction between monumental and decorative art.

The Bauhaus wants to educate architects, painters, and sculptors of all levels, according to their capabilities, to become competent craftsmen or independent creative artists and to form a working community of leading and future artist-craftsmen. These men, of kindred spirit, will know how to design buildings harmoniously in their entirety—structure, finishing, ornamentation, and furnishing.

PRINCIPLES OF THE BAUHAUS

Art rises above all methods; in itself it cannot be taught, but the crafts certainly can be. Architects, painters, and sculptors are craftsmen in the true sense of the word; hence, a thorough training in the crafts, acquired in workshops and in experimental and practical sites, is required of all students as the indispensable basis for all artistic production. Our own workshops are to be gradually built up, and apprenticeship agreements with outside workshops will be concluded.

The school is the servant of the workshop, and will one day be absorbed in it. Therefore there will be no teachers or pupils in the Bauhaus but masters, journeymen, and apprentices.

The manner of teaching arises from the character of the workshop: organic forms developed from manual skills.
Avoidance of all rigidity; priority of creativity; freedom of individuality, but strict study discipline.

Master and journeyman examinations, according to the Guild Statutes, will be held before the Council of Masters of the Bauhaus or before outside masters.
Collaboration by the students in the work of the masters.
Securing of commissions, also for students.
Mutual planning of extensive, utopian structural designs—public buildings and buildings for worship—aimed at the future. Collaboration of all masters and students—architects, painters, sculptors—on these designs with the object of gradually achieving a harmony of all the component elements and parts that make up architecture.

395.

Constant contact with the leaders of the crafts and industries of the country. Contact with public life, with the people, through exhibitions and other activities.

New research into the nature of the exhibitions, to solve the problem of displaying visual work and sculpture within the framework of architecture.

Encouragement of friendly relations between masters and students outside of work; therefore, plays, lectures, poetry, music, costume parties. Establishment of a cheerful ceremonial at these gatherings.

The ultimate aim of all visual arts is the complete building! To embellish buildings was once the noblest function of the fine arts; they were the indispensable components of great architecture. Today the arts exist in isolation, from which they can be rescued only through the conscious, cooperative effort of all craftsmen. Architects, painters, and sculptors must recognize anew and learn to grasp the composite character of a building both as an entity and in its separate parts. Only then will their work be imbued with the architectonic spirit which it had lost as "salon art."

The old schools of art were unable to produce this unity; how could they, since art cannot be taught. They must be merged once more with the workshop. The mere drawing and painting world of the pattern designer and the applied artist must become a world that builds again. When young people who take a joy in artistic creation once more begin their life's work by learning a trade, then the unproductive "artist" will no longer be condemned to deficient artistry, for their skill will now be preserved for the crafts, in which they will be able to achieve excellence.

Architects, sculptors, painters, we all must return to the crafts! For art is not a "profession." There is no essential difference between the artist and the craftsman. The artist is an exalted craftsman. In rare moments of inspiration, transcending the consciousness of his will, the grace of heaven may cause his work to blossom into art. But proficiency in a craft is essential to every artist. Therein lies the prime source of creative imagination. Let us then create a new guild of craftsmen without the class distinctions that raise an arrogant barrier between craftsman and artist! Together let us desire, conceive, and create the new structure of the future, which will embrace architecture and sculpture and painting in one unity and which will one day rise toward heaven from the hands of a million workers like the crystal symbol of a new faith.

Walter Gropius

RANGE OF INSTRUCTION

Instruction at the Bauhaus includes all practical and scientific areas of creative work.
A. Architecture
B. Painting
C. Sculpture
including all branches of the crafts.

Students are trained in a craft (1) as well as in drawing and painting (2) and science and theory (3).

1. Craft training—either in our own, gradually enlarging workshops or in outside workshops to which the student is bound by apprenticeship agreement—includes:
a) sculptors, stonemasons, stucco workers, woodcarvers, ceramic workers, plaster casters
b) blacksmiths, locksmiths, founders, metal turners
c) cabinetmakers
d) painter-and-decorators, glass painters, mosaic workers, enamelers
e) etchers, wood engravers, lithographers, art printers, enchasers
f) weavers
Craft training forms the basis of all teaching at the Bauhaus. Every student must learn a craft.

2. Training in drawing and painting includes:
a) freehand sketching from memory and imagination
b) drawing and painting of heads, live models and animals
c) drawing and painting of landscapes, figures, plants and still life
d) composition
e) execution of murals, panel pictures and religious shrines
f) design of ornaments
g) lettering
h) construction and projection drawing
i) design of exteriors, gardens and interiors
j) design of furniture and practical articles

3. Training in science and theory includes:
a) art history—not presented in the sense of a history of styles, but rather to further active understanding of historical working methods and techniques
b) science of materials
c) anatomy—from the living model
d) physical and chemical theory of color
e) rational painting methods
f) basic concepts of bookkeeping, contract negotiations, personnel
g) individual lectures on subjects of general interest in all areas of art and science

DIVISIONS OF INSTRUCTION

The training is divided into three courses of instruction:
I. Course for apprentices
II. Course for journeymen
III. Courses for junior masters

The instruction of the individual is left to the discretion of each master within the framework of the general program and the work schedule, which is revised every semester. In order to give the students as versatile and comprehensive a technical and artistic training as possible, the work schedule will be so arranged that every architect, painter, and sculptor-to-be is able to participate in part of the other courses.

ADMISSION

Any person of good repute, without regard to age or sex, whose previous education is deemed adequate by the Council of Masters, will be admitted, as far as space permits. The tuition fee is 180 Marks per year (it will gradually disappear entirely with increasing earnings of the Bauhaus). A nonrecurring admission fee of 20 Marks is also to be paid. Foreign students pay double fees. Address inquiries to the Secretariat of the Staatliche Bauhaus in Weimar.
April 1919.

The Administration of the
Staatliche Bauhaus in Weimar:
Walter Gropius

396. Die erste Bauhaus-Ausstellung in Weimar
*(The First Bauhaus Exhibition in Weimar)*
Juni bis September 1923
Written and designed by Oskar Schlemmer
Printed by Gustav Christmann Inh. Eberhard Eigel, Stuttgart
Unknown edition
Size folded: 20 x 20 cm. Opened: 20 x 60 cm.

This rare publicity sheet was not circulated because of possible political implications in the use of one phrase: "The Cathedral of Socialism." It shows the background of architecture as the focus of all art. Architecture is the total work of art.
(Translation follows from Wingler, The Bauhaus, Cambridge: M.I.T. Press, 1969).

Die erste Bauhaus-Ausstellung in Weimar
*(The First Bauhaus Exhibition in Weimar)*
Translation:

The Staatliche Bauhaus in Weimar is the first and so far the only government school in the Reich—if not in the world—which calls upon the creative forces of the fine arts to become influential while they are vital. At the same time it endeavors, through the establishment of workshops founded upon the crafts, to unite and productively stimulate the arts with the aim of combining them in architecture. The concept of building will restore the unity that perished in debased academicism and in finicky handicraft. It shall reinstate the broad relationship with the 'whole' and, in the deepest sense, make possible the total work of art. The idea is old, but its rendering always new: the fulfillment is the style, and never was the 'will-to-style' more powerful than today. But confusion about concepts and attitudes caused the conflict and dispute over the nature of this style which will emerge as the 'new beauty' from the clash of ideas. Such a school, animating and animated itself, unintentionally becomes the gauge for the convulsions of the political and intellectual life of the time, and the history of the Bauhaus becomes the history of contemporary art.

The Staatliche Bauhaus, founded after the catastrophe of the war, in the chaos of the revolution and in the era of the flowering of an emotion-laden, explosive art, becomes the rallying point of all those who, with belief in the future and with sky-storming enthusiasm, wish to build the 'Cathedral of Socialism.' The triumphs of industry and technology before the war and the orgies in the name of destruction during it, called to life that impassioned romanticism that was a flaming protest against materialism and the mechanization of art and life. The misery of the time was also a spiritual anguish. A cult of the unconscious and of the unexplainable, a propensity for mysticism and sectarianism originated in the quest for those highest things which are in danger of being deprived of their meaning in a world full of doubt and disruption. Breaking the limitations of classical esthetics reinforced boundlessness of feeling, which found nourishment and verification in the discovery of the East and the art of the Negro, farmers, children, and the insane. The origin of artistic creation was as much sought as its limits were courageously extended. Passionate use of the means of expression developed in altar paintings. But it is in pictures, and always in pictures, where the decisive values take refuge. As the highest achievement of individual exaggeration, free from bonds and unredeemed, they must all, apart from the unity of the picture itself, remain in debt to the proclaimed synthesis. The honest crafts wallowed in the exotic joy of materials, and architecture piled utopian schemes on paper.

Reversal of values, changes in point of view, name, and concept result in the other view, the next faze. Dada, court jester in this kingdom, plays ball with paradoxes and makes the atmosphere free and easy. Americanisms transferred to Europe, the new wedged into the old world, death to the past, to moonlight, and to the soul, thus the present time strides along with the gestures of a conqueror. Reason and science, 'man's greatest powers,' are the regents, and the engineer is the sedate executor of unlimited possibilities. Mathematics, structure, and mechanization are the elements, and power and money are the dictators of these modern phenomena of steel, concrete, glass, and electricity. Velocity, rigid matter, dematerialization of matter, organization of inorganic matter, all these reduce the miracle of abstraction. Based on the laws of nature, these are the achievements of mind in the conquest of nature, based on the power of capital, the work of man against man. The speed and supertension of commercialism make expediency and utility the measure of all effectiveness, and calculation seizes the transcendent world: art becomes a logarithm. It, long bereft of its name, lives a life after death, in the monument of the cube and in the colored square. Religion is the precise process of thinking, and God is dead. Man, self-conscious and perfect being, surpassed in accuracy by every puppet, awaits results from the chemist's retort until the formula for 'spirit' is found well…Goethe: 'If the hopes materialize that men, with all their strength, with heart and mind, with understanding and love will join together and become conscious of each other, then what no man can yet imagine will occur—Allah will no longer need to create, we will create his world.' This is the synthesis, the concentration, intensification, and compression of all that is positive to form the powerful mean. The idea of the mean, far from mediocrity and weakness, taken as scale and balance, becomes the idea of German art. Germany, country of the middle, and Weimar, the heart of it, is not for the first time the adopted place of intellectual decision. What matters is the recognition of what is pertinent to us, so that we will not aimlessly wander astray. In balancing the polar contrasts; loving the remotest past as well as the remotest future; averting reaction as much as anarchism; advancing from the end-in-itself and from self-directedness to the typical, from the problematical to the valid and secure—thus we become the bearers of responsibility and the conscience of the world. An idealism of activity that embraces, penetrates and unites art, science, and technology and that influences research, study, and work, will construct the "art-edifice" of man, which is but an allegory of the cosmic system. Today we can do no more than to ponder the total plan, lay the foundations, and prepare the building stones.

But

We exist! We have the will! We are producing!

396.

# JOHANNES ITTEN

397. Utopia I/II
Dokumente der Wirklichkeit *(Documents of Reality)*
Ein Sammelwerk in 7 Lieferungen
Edited by Bruno Adler
With five three-page spread original lithographs
by Itten , one hand-colored, all signed
Weimar: Utopia Verlag, 1921
Editions: Regular edition unknown; Nrs. 1-75 printed on good
paper; Museumsausgabe: 7 examples (not 10), paperbound
with an original drawing by Schlemmer on the cover, #1/7.
86 pp (4 pp), 33.2 x 24.8 cm.

Utopia was a project planned to be published in seven parts,
but only these two were published. Its editorial head was Bruno
Adler, a translator and professional writer in Weimar. Utopia's
subtitle "Wirklichkeit" refers to reality. In Bruno Adler's case it
meant religious reality, not political utopia. Utopia is an attempt
to put religious ideas in form for modern thought. To this end
Adler includes Indian, Greek, biblical, medieval translations,
and quotations from the romantic painter, Philipp Otto Runge.

The major importance of this book is in its center pages de-
signed by Johannes Itten and set in type by Friedl Dicker. Here
Itten puts down his philosophy for teaching art, the method he
used in the first courses at the Bauhaus, which was located at
this time in Weimar.

His motto might be quoted from preliminary statements: "All
life is transformed by form. Space is used as a quality as is time.
Perception is by observation alone." In Utopia Itten's writing is
set in two-color type in the form of free association designed to
lead the eye from idea to idea in elegant changes of type sizes.
After this introduction Itten analyzes five religious paintings,
including one by the Zen painter Mu-chi. He uses line, tone and
basic symbolism as a background for analysis. In one painting
he presents an overlay of the geometrical balance of the design
and attempts a mathematical analysis of its proportions. He
also defines inner rhythms thoroughly. The analysis is all done
as original, signed lithographs, printed from eighteen plates.

Our copy of Utopia has a special hand-painted cover by Oskar
Schlemmer. Schlemmer's cover uses Bauhaus methods of
typography: T-square lettering, india ink and colored tones with-
in free spaces.

As these are the only basic documents of Itten's philosophy of
teaching, and as his courses were the most valuable in the en-
tire early Bauhaus, forming the future of much of later Ameri-
can teaching through his pupil Josef Albers, and through the
great typographer Joost Schmidt, we should spend some extra
time on an analysis of Itten's ideas. After Moholy-Nagy took
over the preliminary design classes, the concepts changed
into Constructionism and visual perception.

Johannes Itten, the neglected thinker and painter, was Swiss
like Klee, born in the Berner Oberland. His first ten years were
spent as a free child of the Alps, which developed his love for
the outdoors and his spiritual loneness. He studied mathema-
tics and nature-biology first, though he drew and painted in his
spare time. He visited special locations to examine the new art:
Munich for the Blue Rider, Paris for Cubism.

397.

In 1913 he began full time art studies under Hölzel in Stuttgart, where he met Schlemmer and Baumeister. He did his first oil painting in 1915. Then Itten moved to Vienna, where he directed a private school. Adolf Loos became interested in his abstract paintings and organized an exhibition in 1919. Probably through Alma Mahler, Itten met Walter Gropius, who was very impressed by his formal ideas about education.

Itten's ideas became the backbone of the new Bauhaus courses for beginning students. Itten thought of art as a psychic method of creating form, a higher ethical and self-developing system. He taught this through free analysis of old master paintings which allowed the students to discover the governing principles basic to art and introduced the idea of formal structure. He attempted to move the student by exciting perception; to Itten perception was the path to form. This idea was opposed to Gropius's pragmatistic theory of unity among craftsmen.

Itten attempted to combine his search for form with new ideas about the unity of space and time. He was against the teaching of form as such through life drawing or drawing from casts, for he felt that neither drawing nor concepts of space and time could be taught; perception has first to be awakened and cultivated in the beginner. This meant a free search among materials and forms. Itten also intended a separation from utilitarianism, from social grouping of artists in work. He thought individual development could produce self-conscious artists who could face any task because of this higher development in the personal self.

To Gropius the crafts movement was an aesthetics-hampered group of individualists. The engineer seemed to him the only untarnished designer. The early Bauhaus had no school of architecture for this reason. This ideological split between Itten and Gropius led to Itten's resignation in 1923.

What Itten brought to the Bauhaus was his idea of inventiveness in art. The student was asked to invent in color contrast, texture, form. Itten was the intellectual stimulus who brought his friends Kandinsky, Klee, Muche, and Schlemmer to the attention of Gropius. Another of Itten's friends, Gertrud Grunow, an exceptional human being who taught only part-time at the Weimar Bauhaus, was a wise psychologist in helping the young students develop their inner directions.

The beginning students were given studies of nature. Much also came from structural analysis of old master paintings; the student was asked to find basic rhythms. Observation was developed as well as accurate renderings of materials, by studying the basic characteristics of each. As the students developed their observation, Itten promoted free association from the subjects observed. This led naturally to abstraction. There were no fixed conditions except the basic set of materials; in most cases the students chose these. Collages were used as supplements to graphic methods. Two and three-dimensional directions were investigated. Complementary effects were emphasized in color and spatial design. Static/dynamic relationships were also thoroughly investigated.

Many of Itten's ideas about art education were personal thoughts. He was an artist with wide interests, and would visit far-off exhibitions for ideas and study. Some of the studies of materials came from the philosophy of the Werkbund, but Itten thought about artistic development as a spiritual thing, not a development for industry or industrial manufacture. He retained the Expressionist thinking, and tried to influence the other masters against the ideas of Gropius, who would have none of these nonmanual labor orientations. It was not strange that the best artists were developed during the period of Itten's tenure at the Bauhaus.

Gropius promoted the idea of collaboration; Itten that of individual development. To some extent Itten shared the idea of a working community of artists and craftsmen, but had none of Gropius's background under Behrens and Bruno Paul, both all-around men in architecture, industrial design, book production and the social philosophy rising out of the Jugendstil.

398. Staatliches Bauhaus in Weimar 1919-1923
*(State Bauhaus in Weimar 1919-1923)*
Edited by the Bauhaus Staff
Typography designed by Moholy-Nagy
Cover designed by H. Bayer
Das Staatliche Bauhaus in Weimar and Karl Nierendorf in Cologne,
Weimar-Munich: Bauhausverlag. No date.
Edition: 2600 examples. 2000 in German, 300 in English, 300 in Russian; text and plates printed by
F. Bruckmann A.G., Munich; color plates printed by Löbbecke, Erfurt; color printing of lithographs by Dietsch & Brückner, Weimar
225 plates, 28 pp (1pp.); 24.6 x 25.5 cm.

The exhibition of 1923 marked the end of the first phase of the Bauhaus. After 1923 the Bauhaus changed considerably. Both Schreyer and Itten had departed after basic disagreements with Gropius. Though their names are still listed as masters of the school in this catalogue, both had gone elsewhere by the time this first book from the Bauhaus was issued.

It is interesting that Gropius selected mostly painters as master teachers in all the crafts. Schreyer and Marcks were the only exceptions, and Lothar Schreyer painted as well as wrote and sculpted. Schlemmer never did teach painting.

398.

The book sums up the early Bauhaus tradition, set into form by Gropius in 1919. Itten had promoted some of his friends from around the Sturm circles as masters of the Bauhaus.

The breakup of 1923 was caused by many situations of the time. There was a student revolt. There was also a philosophical-religious revival with non-German customs, such as the study of consciousness, Oriental thought, dietary restrictions, Oriental folk songs, and folk poetry. None of these interests by some of the masters and many of the students were along the lines of Gropius' intentions to unite technology and architecture, mother of it all.

Postwar students were not easily dominated by authority. Itten's attempts toward instinctive inner development may have been more exciting than Gropius' cold logic. But Itten departed for Berlin, where he set up his own school, focused on his particular methods of education.

Itten's beginning article about the VORKURS, the preliminary course in design, was not printed. His ideas are given through the examples of his students. Students had six months with Itten before they were allowed to continue in the master classes; some would not adapt to the free study Itten promoted. In his classes, students were not told to do special tasks, but to study materials and analyze their special properties. Creative expression was the goal.

This was the first important exhibition by the four year old school in 1923. The exhibition was intended to show the public what had been accomplished by the faculty and students. Everyone participated, and the students put on musical events, plays and lectures. Thousands attended and the events were publicized in the European press.

Many of the masters designed postcards for the exhibition. An example is Wassily Kandinsky's *Exhibition Card #3,* printed in black, blue, and red. (Color lithograph, 1923, Roethel 179, 15 x 10 cm.). Twenty cards in all were produced for publicity purposes. These were lithographed.

This book was a compilation of all the endeavors, intended as a permanent outline of the Bauhaus. The design makeup was functional to the ideas of the designers. As typography and photos were printed by different commercial firms, each was made on a different paper. There is a mixture of typefaces, serif and sans serif, as well as a mixture of sizes. The last section, with illustrations, is consistently set in a heavy sans serif typeface. The three divisions of the book are carried through the table of contents as margin numbers across the page to solve any problem of identification. It is all very logical. The three sections are: The School; The Work; Free Painting and Sculpture by Apprentices and Masters.

There are two articles by Kandinsky, one each by Gertrud Grünow and Paul Klee in Part One. In Part Two, there is an article about the new typography by Moholy-Nagy. Kandinsky writes about a synthesis in the theater; and Schlemmer describes his theories of ballet.

The book has been used as a basic philosophy of art by many later students, but it is the preliminary synthesis at the Bauhaus before the changes towards Constructivism and Functionalism. The spirit of architecture hung over following years at the Bauhaus in more evident fashion. In a review of the 1923 exhibition in Das Kunstblatt, (Vol. VII, 1923), Walter Passarge understood the works as an attempt to break with the past, though this was not so. The works were seen as incom-plete, unfinished. The earnestness of the students and masters was complimented. Passarge singled out Feininger among the painters. Kandinsky he called a Constructivist. Klee is noticed as having produced no new concept. In the same magazine, Paul Westheim, the editor, called the ultimate Bauhaus ideal the square.

Complaints about the radical ideas of the Bauhaus brought a police search in November, 1923. It is apparent that traditionalists saw the simplified approach to architectural unity as a danger.

## WASSILY KANDINSKY
400. Kleine Welten *(Small Worlds)*
Zwölf Blatt Originalgraphik *(Twelve Sheets of Original Graphics)*
4 lithographs, 4 woodcuts, and 4 etchings, each signed.
Roethel 164-175
With a vignette on the title page (Roethel 176).
In portfolio with cover design by Kandinsky, each print in original mat
Berlin: Propyläen Verlag. 1922
Edition: 230 numbered examples: Nrs. 1-30 on japan, page size: 35.5 x 28 cm.; Nrs. 31-230 on Bütten, page size: 34 x 29 cm.
#78/230, Title page, 1 f text, 12 prints, portfolio: 46 x 35.2 cm.
KLEINE WELTEN PRINTS
1. Kleine Welten I, 1922
color lithograph, four stones: yellow, red, blue and black
24.7 x 21.8 cm., Roethel 164
2. Kleine Welten II, 1922
color lithograph, four stones: yellow, red, blue and black
25.4 x 21.1 cm., Roethel 165
3. Kleine Welten III, 1922
color lithograph, four stones: yellow, red, blue and black
27.8 x 23 cm., Roethel 166
4. Kleine Welten IV, 1922
color lithograph, four colors: yellow, green, violet and black
26.7 x 25.6 cm., Roethel 167

Kleine Welten I       Kleine Welten V       Kleine Welten X

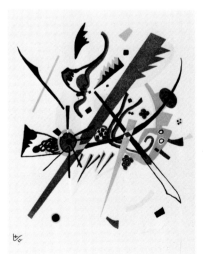

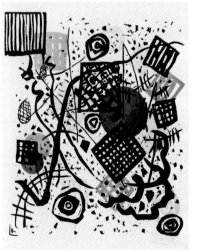

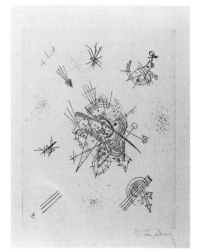

5. Kleine Welten V, 1922
color woodcut, four colors: yellow, red, blue and black
(probably a color lithograph as printed in the portfolio—
see text), 27.5 x 23.5 cm., Roethel 168

6. Kleine Welten VI, 1922
woodcut, 27.2 x 23.3 cm., Roethel 169

7. Kleine Welten VII, 1922
color woodcut, three colors: yellow, blue and black
(Probably a color lithograph as printed in the portfolio—see
text), 27.1 x 23.3 cm., Roethel 170

8. Kleine Welten VIII, 1922
woodcut, 27.3 x 23.3 cm., Roethel 171

9. Kleine Welten IX, 1922
drypoint etching, 23.7 x 20 cm., Roethel 172

10. Kleine Welten X, 1922
drypoint etching, 23.9 x 20 cm., Roethel 173

11. Kleine Welten XI, 1922
drypoint etching, 23.8 x 19.9 cm., Roethel 174

12. Kleine Welten XII, 1922
drypoint etching, 23.7 x 19.7 cm., Roethel 175

When Kandinsky returned to Germany in the winter of 1921, the situation was difficult for the artist. He had a new wife to support. His sales at the Sturm gallery would have provided considerable income, but inflation had reduced the total to very little actual cash value. Food was very expensive. He was a stateless person: important Russian artists had opposed him. Kandinsky was happy to join the faculty at the Bauhaus in June, 1922.

Before his move to Weimar, Kandinsky had agreed to supply a portfolio to the Propyläen Verlag in Berlin. The etchings, lithographs and black master blocks for the woodcuts were finished before Kandinsky and his wife left Berlin.

In Weimar, Kandinsky became acquainted through Feininger, the Form Master of the printing workshop, with Carl Laubitzer, Master lithographer, and the journeyman Ludwig-Hurchfeld-Mack. They set up the plates and printed the black blocks and etchings in the Bauhaus workshop. According to Roethel (p. 452) the colors were printed at a commercial shop in the city of Weimar. The color plates for the woodcuts were drawn on stone by Kandinsky and overprinted on the black impressions from the wood.

It is my belief that the two color woodcuts were done entirely on the stone. The registration marks show black lithography, which would not transfer as fine lines from a wood block registration mark; they seem to have been printed at the same time as the black blocks. The black color is the last printed, over the colors. There is no texture nor depth to the ink. Either a black master block was put on the stone by photographic means or by direct transfer (printed in tusche). The stones had large margins; some of the edges over print far to the outside; and the black registration is consistent to the size of the stone. On all the color lithographs the registration marks are the same as the woodcuts, and are positioned the same.

Why these were printed outside the facilities of the school is not known. We have only Kandinsky's testimony to Galka Scheyer, mentioned by Roethel. The Bauhaus printing workshop had made fine woodcuts as early as 1920. By 1923 there were presses for lithography, etching, and letter press. Kandinsky's lithograph in color for the Bauhaus-Mappe of 1922 was superbly printed in the workshop. But only single folio sheets could be produced there, not books.

The set of Kleine Welten is a statement from the Russian time. It sums up his attitudes towards a personal message and contrasts with the nonpsychological attitudes of the major Russian painters of the immediate post revolution. He saw mechanics as a new naturalism. He retained his mysticism.

The set is divided into three sets of four prints each. The first four color lithographs are close in style to the motifs of the mural decorations Kandinsky painted for the jury-free exhibition in Berlin in 1922, prior to the Bauhaus appointment.

401.

The first plate is designed around centered diagonals, which balance the horizontal and vertical impressions for the eye. There are no real planes relating to the sides, a difficult design problem, but Kandinsky balances by centering a great blue plane, which recedes and anchors the composition. Plate two has a raised center and central weight from a large blue form, but this is used as a vibration for color forms. Plate three seems an abstraction from an early landscape. Everything is acentric. There is more repetition through smaller lines. There are many points of "sound." Plate four is a recapitulation of one and two, with greater turning of plane, opened circles, and optical illusion of space. The floating effect is anchored by centered interest in squares, as opposed to the striped diagonal at left. The four woodcuts are studies in shape overlay, white on black line opposing black on white line, shape as holes in space and shape made from complicated spiral lines. Plate six is partially engraved, with the imposed texture used to mold roundness in circle and triangle. Some other texturing is also introduced.

The four etchings are less successful; and some aquatint would have provided better mass. Kandinsky's crosshatching seems less motivated, more instinctive or play-like. Plate ten, the most successful of these four, seems the most simplified in line.

It is obvious that Kandinsky was studying the possibilities of all aspects of these different mediums against the principles of the point, square and circle. His dictionary of art composition is also a study of tensions. Tensions can be acentric or eccentric. The colors are more arbitrary than those Kandinsky used later, for he had not made into a law for himself the relationship between shape and color. The first four color lithographs have subtle variations in color due both to transparency and color change from, say, a slight pink to a fuller red. Greens are cold and warm; yellows also vary in this way. It is apparent that the colors were mixed under the supervision of the artist.

These prints were beyond the abstract Expressionism of the prewar years in Munich, his most revolutionary period. In this Bauhaus period, Kandinsky was attempting to avoid the decorative tendencies which he found among his modern Russian peers.

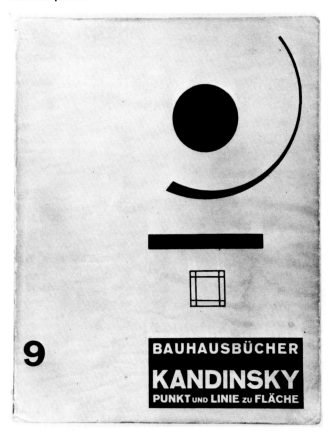

401. Punkt und Linie zu Fläche *(Point and Line to Plane)*
Beitrag zur Analyse der malerischen Elemente *(A Contribution to the Analysis of the Painterly Elements)*
Wassily Kandinsky
Bauhaus Bücher 9; Typography by Herbert Bayer;
with 1 color print, 102 vignettes, and 25 illustrations.
Munich: Verlag Albert Langen. 1926; Printed by
Hesse u. Becker, Leipzig; Photos by Sickert u. Reiche,
Dessau; 191 pp (7 pp), 23 x 18 cm.

During most of the development of printing, the type had been predominant. Everything was designed around the flow of line and the movement of the eye horizontally. The Futurists destroyed this concept, although the influence of their anarchy was not prolonged until the time of the Bauhaus.

The Bauhaus published a series of books to disseminate the ideas of the young school. With a strong background in design through architecture, the teachers of the Bauhaus liberated the illustration, which had been pressed into spaces left over by the text. Photographic techniques also influenced this concept, for type could be reduced in size, moved around in experimentation and placed in any direction or angle. The Germans called this a "Schaubuch," a modern illustrated book. In Bauhaus books the illustration becomes at least the equal of the text. Type does not have an independent existence, as it did before. In the placement of type, white or blank areas are no longer mere margins or ornaments, but part of the visual concept. They tend to be wide and important as optical contrasts. In the Bauhaus conception of design, the large white space is indispensable. Tension is created as an emotional impact. Each page is designed as an element in itself as well as a relationship within the general rhythm in the succeeding pages. Refinement was not desired, although the effect was one of great strength and some elegance.

The fine typography of Paul Renner, who lived in Pasing near Munich, also affected the thinking of the Bauhaus teachers. Renner had not exploded into new forms with his "Futura" typeface, but refined it from roman majuscule to clean, simple forms. His essential humanism was in opposition to the wild destruction of the Futurists.

The taste of the young Herbert Bayer was also humanistic not extremist, in contrast to that of the other teacher, Moholy-Nagy. We can compare some covers of the Hungarian with the text by Bayer. Moholy-Nagy keeps to vertical contrast and abstract formalism. Equal spacing is provided between the vertical shapes, and this mathematical spacing has little sympathy for the thinking of Kandinsky. Bayer builds around set margins but uses a bold typeface to give line content. He also uses a rather heavy roman face in the text. His modern feelings are expressed by his method of double spacing between lines rather than indenting for paragraphs. All illustrations are placed within these margins, but varied in size and weight to provide interest as visual effects. The horizontal balance of the paragraphs is also carried throughout the text.

In *Point and Line to Plane*, Kandinsky discusses the basic properties of the picture plane. He had always believed that a painter could provide insights through prose writing. He wrote an article in the first Bauhaus magazine about this "Value of Theoretical Teaching in Painting." He never lost sight of his ideas of synthesis.

Kandinsky defends theory in the beginning of this book. He investigates form in isolation and combination; although his final premises seem insufficient for formal conclusions, he shows the basic forms of graphic art. He begins with the zero point and makes it live. He shows us harmony and dissonance. He shows us surface changes and asks our collaboration in this vision and in being educated by his ideas. He looks forward to a grammar of all the arts. He sees analogies in nature and music. He seeks the naturalness of line, as it appears "in nature." He develops laws of tension and relaxation.

The book was an excerpt from his course at the school. It was never completed, but was published in various essays and symposia. These spoken ideas were his textbooks, for there were no printed ones at the Bauhaus. Klee also wrote some of his material for the Bauhausbücher.

## LOTHAR SCHREYER

402. Kreuzigung *(Crucifixion)*
Spielgang Werk VII *(Libretto VII)*
77 woodcuts, printed from the blocks in black
and hand-colored with stencils
Hamburg: Werkstatt der Kampfbühne. 1920
Editions: 25 on japan paper, hand printed; 500 on good German
paper, printed by Gustav Petermann, Hamburg
Ausgabe II Fünfhundert Werke
78 f (unpaginated), book: 32 x 43.5 cm., page: 31.3 x 43 cm.

Lothar Schreyer left the German army late in 1916 and joined Walden on the editorial board of Der Sturm periodical. In 1918 they formed the Sturm-Bühne, an organization to publish and perform the new Expressionist works for the theater. As an associated organization, the Kampfbühne was directed by Schreyer for a few years.

This play, Kreuzigung, was performed in Hamburg in April, 1920. Schreyer had designed the portfolio and had it printed in the theater graphics workshop on April 12, 1920, but the publishing date was put off until May 1921. Perhaps the reason for this delay was the first edition, which was printed in an edition of twenty-five and had a price of 5000 Marks. The cheaper second edition at 150 Marks had a larger edition of five hundred and was printed at a professional printing shop, handcolored by stencil.

The text for the play was published in Der Sturm #11, 1920, pp. 66-68. The Sturm-Bühne organization lasted from 1918 until 1921. Schreyer's writings about the theater appeared in Der Sturm from 1917 well into the 1920s, though by then his major works had been done for the Bauhaus. Schreyer became involved in the dispute with Gropius over Expressionist versus Constructivist theory, actually against the path of development within the Bauhaus, and left for Berlin and Dresden. He finally moved permanently to Hamburg, where he lived and wrote about art and the stage until his death in 1970.

Kreuzigung is Schreyer's total theater, based on a complete mixture of art and performance. He thought the Expressionist theater should be more than a performance of sounds and words, but a combination of artistic unity. He searched for synthesis in the costumes and stage design which combined with words and action to form a unified rhythm on the stage. Color and form appear as rhythm and stillness. Sounds should appear as word sounds and noise sounds. Such a complete theater would turn away from traditional forms of the theater, which Schreyer thought were mere means for enjoyment, products from a corrupted society. It was intended as a break from traditional theater, just as the new painting was broken from Realism and Impressionism. The play was no longer played but announced, made into a course of action without hero actors, without outside lighting men, without a dictator-director, without propmaster. It was a theater of effects without using dramatic effects as such.

402.

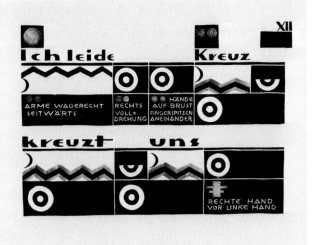

This folio of the play is called the "score". By this word Lothar Schreyer meant a totality of gesture, movement, tone, rhythm and symbolism. "Score" is not only musical but universal. The "score" is divided into measures and volume. Every action, turning or kneeling, is orchestrated in the directions. Color is used to begin and end a sequence. The symbolic content was paramount in this theater, developed out of the Sturm time. The intellectual content was not important: the symbolic-color-tonality was important. Instead of logic in the plot, there is logic in the plan.

The performances must have been wild events, with whispering and shouting, pantomime and grouped designs of actors. Schreyer tried to develop empathy by releasing the formal, traditional continuity of historical theater into this psychological-religious framework of basic emotion. Every aspect was non-naturalistic. The drama became a fragmented element of some deep mystery.

Schreyer taught in the drama workshop at the Bauhaus in 1921, although he had been appointed as an arts and crafts teacher. His Expressionist interpretation of the theater dissolved the logic of drama, and made the logical relationship of the theater to architecture a minor consideration. To Schreyer, feelings were more important than logic. He left the Bauhaus faculty in 1923. What he left for Oskar Schlemmer to inherit was the planning of action, the free use of light and color, the study of directed motion and dance-like activity. His use of pantomimic gesticulations was adapted into a free communication.

403.

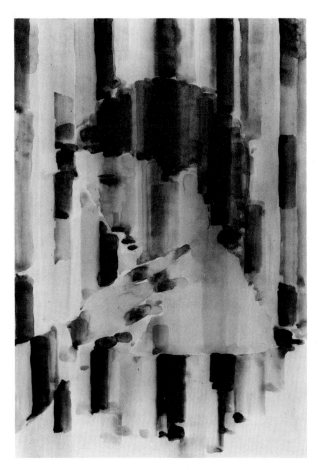

## OSKAR SCHLEMMER

403. Untitled *(Profile)*
Watercolor, c. 1932 (dated by Karin von Maur, Oskar Schlemmer Arkiv, Stuttgart)
53.3 x 38.1 cm.
Ex collections: Dr. F.C. Valentin, Stuttgart; Schlesisches Museum der bildenden Kunst, Breslau.
Signed verso by Tut Schlemmer, the artist's wife.

Oskar Schlemmer is an interesting example of an artist whose influences came from other sources than that of most Expressionists. He was concerned with the formal problems of the modern ballet. His was more than a singular interest, for he concentrated on this dance medium as a total expression of modern idioms: lighting, costume, rhythm and originality. It was his attempt to integrate form into the modern movement as a message of the new time. Synthesis was his intent, not ecstatic action. Though the abstract was the basic symbolism of this effort, man was always the center.

The graphic mediums were not Schlemmer's major thrust, so we use this fully mature watercolor as our basis for explanations.

Schlemmer was a maker of theories, probably begun under his study with the theorist, Adolf Hoelzel. But his theories, when mature, place him closer to the Cubists than the revolutionary Expressionists. He was not a nationalist but a European. He tried to bring together both the organic world of flesh and feeling with the geometrical world of analyzed concave and convex roundings. He wished to present the emotional in action, not sentimentality, as a synthesis of all elements. His formal vocabulary developed in the 1920s until a fairly established and unemotional use of form and color grew out of the early concern for the theater and architecture. His early *Triadic Ballet* was the ground form from which later manifestations grew. Relief sculptures shown in the Uecht exhibitions during November 1919 were fixations of his functional approach, his spiritual skeletons, his problem solving with the human form.

Schlemmer was called to the Bauhaus in late autumn, 1920. He took over the workshops devoted to murals, and, a year later, those devoted to wood and stone sculpture. Here he developed his work, using the elementary colors of the chromatic scale, and also the most elementary forms of geometry: rectangle, circle, ellipse, "golden triangle." Most of his printed explanations negate the entire idea of symbolic meaning.

The watercolor is made from two colors: brown and blue, with shades added by black from the central scheme. It shows a woman: "The idea of high style in art will always be man, man as a beautiful object." It has the combinations that Schlemmer desired: a balance of abstraction, pre-thought out laws, and a sense of nature, emotion by totality and a complete idea.

Schlemmer had left the Bauhaus in 1929 after Gropius had resigned and the dictatorial Hannes Meyer had taken his place for a short time. The Breslau Academy became Schlemmer's teaching assignment, with the colleagues Oskar Moll (Director), Kanoldt, Mense, Molzahn and Otto Mueller.

In 1930, he discovered that his murals at the Bauhaus had been destroyed. His salary was cut and the family moved into a small house in the Werkbund colony, where this watercolor was probably made. He worked on a large number of these watercolor profiles, but most have been destroyed, either by the Nazis or bombing and the Russian invasion of the area around Breslau.

The happy time in Breslau lasted until March, 1932, when the academy was closed because of right wing pressures. This watercolor sums up the times of happiness, of cultural freedom for the artist. He could still work for centered space by stretching vertical lines, create tensions by moving and interrupting the verticals, make new configurations of space by slanting the head against the intruding arm, and by the penetration of color through forms to disturb the basic static tableaux.

## DADA

Although Dada had the most important influence on American abstract art of our time, it relates to German Expressionism as a diversion. Dada was Expressionism turned inside out. Skin was made out of its guts. What the Expressionists and Fauvists realized with color, the Cubists with volume and structure, the Dada painters found in the future, a time free from material and formal inhibition.

It began with nihilism and participated in the chaotic political evolutions of that troubled time. Objectivity of chance was the real weapon in this trend away from romantic thoughts in Expressionism. Dada brought complete freedom for the artist either for or against moralistic constrictions. The object remained or was discarded within the values of immediacy.

The early destructive elements in Dada extinguished themselves in great sparks of personal confrontation between its leaders and followers. These men moved into religion or Communism or other doctrines. Some of the painters remained nonconformists, kept away from schools of art. They accepted permanent revolt within the functioning oppositions of the time. Most became optimistic, not nihilistic, and became life-enhancers, opposed to death-wish militarism and nationalism. Some sought the magic of Surrealism. Others kept outside the "European Swindle." With these, Dada became a permanent state of mind, which made new nonbelievers out of believers.

Kurt Schwitters described two kinds of Dada: the kernel and the husk (husk after the Huel, translating Huelsenbeck). He thought kernel-Dada kept to the modern tradition of abstract art, while husk-Dada became entirely wordy and politicalized.

The image of Dada becomes full of contradictions as each participant writes his own and different versions. This is logical, for Dada was not a movement but an artistic ethic. Each artist and writer approached the limits of his vision. The new approach to art was practiced in many countries and many cities, and it was colored by the flavor of each place.

## KURT SCHWITTERS

404. Anna Blume, Dichtungen (Dada Dichtungen)*(Dada Poetry)*
Paul Steegemann Verlag, Hannover, 1919, first edition
(revised 1922); Die Silbergäule, Band 39/40
22 x 14.6 cm., (1) 37pp (4), light green paper covers

Anna Blume is a conventional woman, an image for Schwitters himself. It is through her mouth that the artist speaks nostalgic and bourgeois thoughts. But the format is pure collage of this and that. It is about an artist and his strange thoughts: the sun is black; about Anna Blume, Merzgedicht 1 ; Johannes Molzahn; a green child; various prose poems of Merz types; a portrait of Rudolf Blümner; the world as a stage; an explanation of the artist, with the last lines sending a greeting to Herwarth Walden.

Schwitters translated Anna Blume himself; one version is printed in Schwitters in England by Stefan Themerson (Gaberboccus, 1958). Anna Blume has a red dress, wanders on her hands and wears her hat on her feet. Her yellow hair is colored blue. She is a small green animal. He calls her Eve: he reads her through her back, etc. The poem is written in common words, not the lofty language of the Expressionists. Exact meaning is not attempted. Trivia is language. There is some irony, some mockery of the girl, some gentle sentimentality, some mixture of words through supposed intoxication. Though the language is banality itself, it has an easy originality of special talent for the tangled vocabulary.

In other poems, Schwitters uses sound words without meaning. These partly phonetic poems were what he called "elementarizing" language. He combines these with comedy made from unconscious humor, the "golden sayings" of the bourgeoisie. He had much fun, a gentle mocking. He mixed up these banalities into a strange group of associations that were removed from the original intent.

Schwitters designed the cover in his early Merz style, which combined Futurist lack of parallelism with Expressionist form. The world of Schwitters has no up or down, but a roundabout mixture of shadow and substance, of exciting calligraphy and prosaic, old style script.

## LIST OF DADA ARTISTS
### ZURICH

Hans Arp 1887-1966
Fritz Cäsar Baumann 1886-1942
Viking Eggling 1880-1925
Walter Helbig 1878-1968
Marcel Janco 1895-
Paul Klee 1879-1940
Oscar Wilhelm Lüthy 1882-1945
Otto van Rees 1884-
Hans Richter 1888-1976
Christian Schad 1894-
Arthur Segal 1875-1944
Marcel Slodki 1892-1943 (?)
Sophie Täuber-Arp 1889-1943

### BERLIN

Otto Dix 1891-1969
George Grosz 1893-1959
Raoul Hausmann 1886-1971
John Heartfield (Helmut Herzfelde) 1891-1968
Hannah Höch 1889-

### COLOGNE

Johannes Theodor Baargeld (Alfred Grünwald) 1891-1927
Max Ernst 1891-1976
Heinrich Hoerle 1895-1936
Franz Wilhelm Seiwert 1894-1933

### HANNOVER

Kurt Schwitters 1887-1948

404.

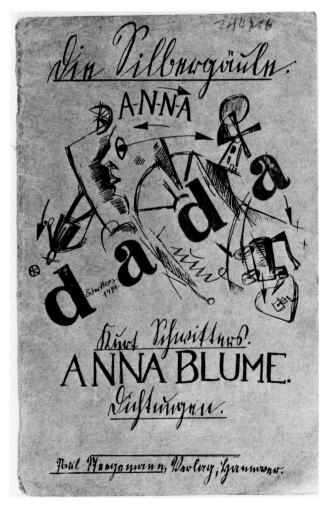

## KURT SCHWITTERS

**405. Merzverlag Kurt Schwitters O.J., Hannover, 1923/1932**

1. Merz 1
Holland Dada, January 1923, 16 pp, 22.2 x 14.3 cm.

2. Merz 2
nummer i *(number i)*, April 1923, 15 pp, 22.2 x 14.3 cm.

3. [Merzmappe, 1923: Merz 3
Kurt Schwitters, 6 Lithos auf den Stein gemerzt]
50 numbered examples, 57.2 x 45.1 cm.

4. Merz 4
Banalitäten *(Banalities)*, July 1923, 15 pp, 22.9 x 14.6 cm.

5. Merz 5
7 Arpaden *(7 Arp Things)*, 7 Lithos by Hans Arp, 1923,
50 numbered examples in portfolio, 45.4 x 34.9 cm.

6. Merz 6
Imitatoren watch step! *(Imitators watch step!)*, October
1923, 16 pp, 22.6 x 14.6 cm.

7. Merz 7
Tapsheft *(Fumble Issue)*, January 1924, 8 pp,
31.4 x 23.5 cm.

8. Merz 8/9
Nasci *(Sweets)*, April/July 1924, 22 pp,
31.1 x 23.5 cm.

9. [Merz 10
Announced but never published. Bauhaus-Buch]

10. Merz 11
Typoreklame *(Typography Propaganda)*, Pelikan-Nummer,
undated [1924], 8 pp, 29.3 x 22.3 cm.

11. Merz 12
Der Hahnepeter *(The Roosterpeter)*, [1924], 16f

12. Merz 13
Lautsonate *(Noisy Sonata)*, phonograph record

13. Merz 14/15
Die Scheuche *(The Scarecrow)*, 1925, 12 pp, 20.3 x 23.9 cm.

14. Merz 16/17
Die Märchen vom Paradies *(Fairy Tales from Paradise)*,
1925, 32 pp, 27.3 x 21 cm.

15. Merz 18/19
Ludwig Hilberseimer, Grossstadtbauten *(Metropolitan-Made)* [1925], 30 pp, 24.2 x 15.3 cm.

16. Merz 20
Kurt Schwitters Katalog *(Kurt Schwitters Catalogue)*,
[1927], 8 pp, 23.9 x 15.9 cm.

17. Merz 21
Erstes Veilchenheft *(First Violet Issue)*, 1931, 12 pp,
20.6 x 31.1 cm.

18. [Merz 22 and 23 announced but never published]

19. Merz 24
Kurt Schwitters: Ursonate *(Ursonata)*, 1932, 42 pp,
21 x 14.9 cm.

Kurt Schwitters was habitually bourgeois by dress, appearance and quiet voice. His Dada clothed in middle-class tone was not always appreciated by the less moderate members of the movement.

Schwitters was basically a warm, spontaneous human being with humor in his criticism, instead of using the killer instinct of political Dada. He developed a wide range of interests in typography, oil painting in his spare time, architecture, drama, language reform and a development of optophonetic German. Some of these, such as his studies in language, were utopian, and were later dropped. His commercial typography, with a special interest in the colophon as a design, was part of the radical reform of printing styles and new typefaces then current. Photography and photomontage played an important part in his development.

Hannover, Schwitters' birthplace, was not totally Expressionist in the early 1920s. Most of its young artists were more interested in geometrizing Constructivism, the opposing function to

emotional outpouring. El Lissitzky worked for the Pelikan factory there.

From an early interest in Dada, Schwitters moved into a personal kind of Functionalism, though never as an end in itself. Schwitters was closer to the group in Zurich. He hated the political agitation of the Berlin Dadaists, such as that of Grosz. Huelsenbeck also disliked Schwitters. Thus, Schwitters was not invited to exhibit with the First Art Dada Fair artists in the exhibition during 1920 in Berlin. Schwitters proclaimed himself a nonpolitical pacifist. In the 1920s Schwitters joined Walden in a battle of criticism against Paul Westheim, publisher of Das Kunstblatt, who attacked Der Sturm writers and artists with demeaning articles. In Tran Nummer 16, Schwitters addresses Westheim: "Herwarth Walden fights for art, your war is against art, you write like a peat salesman." Though Schwitters was non-political, he was quick to take action against critics who suggested any lack of seriousness in his attitudes.

Schwitters' poetry grew out of the Sturm group, especially influenced by August Stramm. In the Merz idea, words were vehicles for content, not members of self-contained sentences set in lines like columns of soldiers. Schwitters was attracted to the early poetry of Hans Arp, who was closer in temperament to Schwitters than other Dada writers. Phonetic poetry began early, appearing in Merz as ready-mades. Schwitters' humor is his own and not Expressionistic. The collage of his language exercises was taken from bits of colloquial speech he overheard. Merz 4 contains these banalities mixed to make both delight in language and fun. It was reality cut up with a scissors of unconscious comedy.

405.

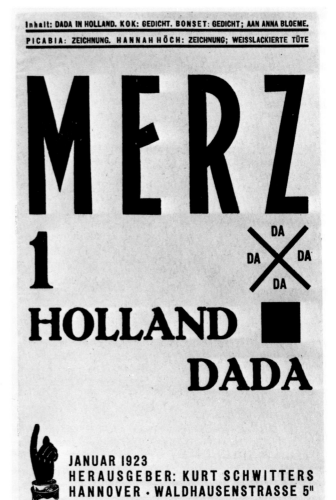

Merzverlag Publications
Merz 1

This periodical was published in the fall of 1922-spring of 1923 during a lecture tour of Holland with his friends the van Doesburgs and Vilmos Huszar, an original but little-known puppet master who had a mechanical dancing doll. Theo van Doesburg probably provided the idea of the Merz magazine with his periodical Mecano (which was issued in four numbers in 1922-1923).

Van Doesburg translated Schwitters' most famous poem, "Anna Blume" into Dutch. The Merz 1 booklet attempts to outline Dada in Holland, though it describes only pseudo Dadaists, except for I.K. Bonset (one of van Doesburg's Dada personalities) and Petro van Doesburg (Nelli) as a Dada female. BUT HOLLAND IS DADA.

Merz 4

Merz 4 begins Schwitters' disassociation from Dada. It shows more of an alliance with de Stijl (with Mondrian, though the issue is still illustrated with photographs of works by Arp, and Arthur Segal). The motto is: "This Summer the Elephants Will Wear Whiskers."

Merz 4 is a study in banalities; to Schwitters this meant a collage of the usual and common. He cut public and private utterances and written words into parts and reassembled them into stranger combinations. Some of his quotations:
Jean Cocteau: "Cubism is a procession."
Anonymous: "Guard against the ideal."
Patch: "A painting is a postcard."
Meidner: "Mr., Mr., give me your conflict."
Peters: "Try not to be so stupid."
BRILLIANTINE FOR THE HAIR.

Merz 14/15

Later issues are studies in humor and typography. In Merz 14/15 Theo van Doesburg carried out the original typography in the typesetter's shop, choosing and rearranging type ornament and various-sized typefaces. None of the pages are drawings; instead they are assembled from the boxes of type (ie., ready-made or found).

Merz 16/17

Merz 16/17 is another book for children, with a fairy tale by Käte Steinitz and Kurt Schwitters. Käte Steinitz was the wife of Schwitters' personal physician, and was collaborator and inspiration for the young painter. She had a wonderful delight in the ridiculous, the laughter of children, a deep commitment of talent. The typography of this issue is less exciting than that of the previous double number. The pages are constructed as collages: drawings cut up into outlines, pasted together, and photographed for the plates.

Merz 20

This issue is in the form of a Kurt Schwitters catalogue. It is printed on poor quality paper in a large edition to accompany his 1927 travelling exhibition (Grosse Merz Ausstellung), which went to Wiesbaden, Frankfurt, Bochum, Barmen, Cologne, and Braunschweig.

What Schwitters brought into art was a potential for amusement which was formed out of an immense container of particles from his broad imagination. His humor was a pure thing, not tinged with the sad or cruel, critical suffering of the rejected, though he was that. Untutored audiences, somehow, drew his sounds and images inward through eye and ear and found the mental mixture a delight, no, even a great joy. He was able to touch some universal level, opening barriers to fountainhead levels of pleasure.

# HUGO BALL

406.  Almanach der Freien Zeitung
*(Almanac of the Free Newspaper)*
Edited by Hugo Ball
Berlin: Der Freie Verlag, 1918
20.3 x 13.4 cm., XIV + 305 + 1 pgs

Hugo Ball's background was in the theater. He wrote two plays and was both critic and playwright for the Munich Kammerspiele in 1912. One might find the outgoing exhibitionism of Ball and his circle growing out of the early training. Ball had tried to be an actor, studying at Max Reinhardt's school for some time; but he failed.

The truthful documentation for Ball's Dada existence can not come out of his memoirs, for Ball converted to Catholicism in 1920 and reedited his notes, expurgating much material, made the facts conform to his new standards. It is from his writings of the time that we can document his interests and actions. Ball had already helped edit the periodical Revolution in 1913-1914 (five issues). He had tried for a job as director of the Dresden Theater in 1913. He had studied political philosophy in 1914-1915. Now an antiwar protestor, he was joined by Emmy Hennings, recently released from prison for forging passports used by young antiwar objectors. By May, 1915, Ball and Hennings left for Zurich, both carrying forged papers under the name of "Willibald."

Both Zurich and Bern were full of refugees from the war. It was in Bern that Heinrich Schlieben founded Die Freie Zeitung. Hans Richter designed the logo and Hugo Ball was hired as a political journalist. By the time this anthology was published Ball had retired partially from the Dada group having read his manifesto against "organizations" on July 14, 1916.

Ball took some interest in later Dada activities, but soon became political, joined the staff of the Freie Zeitung in September, 1917. He founded the Freie Verlag in 1918 to publish his and other writings from the journal. He undertook a study of German myth, becoming anti-Prussian, anti-Jewish and anti-Protestant. In 1919 Die Freie Zeitung ceased publication. In July of that year Ball returned to Catholicism, and began to reeducate himself in his rediscovered religion.

406.

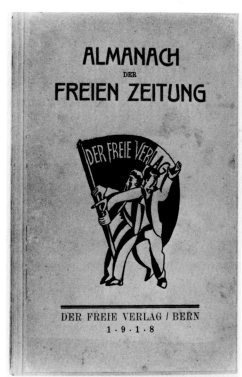

## RICHARD HUELSENBECK

**407. Dadaistisches Manifest** *(Dada-like Manifesto)*
by Richard Huelsenbeck
Berlin, April, 1918 (Manifesto read by Huelsenbeck on
12 April, 1918 at the first meeting of Club Dada, Berlin)
Separate printing
Edition: 25 examples printed
Unpaginated (4 pages), 28.2 x 21.8 cm.
Manifesto undersigned by: Tzara, Jung, Grosz, Janco,
Huelsenbeck, Preiss, Hausmann, Lüthy, Glauser, Ball,
Birot, Cantarelli, Prampolini, R. van Rees, Mme van Rees,
Arp, Täuber, Morosini, Mombello-Pasquati.
On our copy: pg. 3, in his handwriting, "Text written by
Richard Huelsenbeck."

In Berlin, Huelsenbeck delivered his "First Dada Speech in
Germany" in February, 1918 at the "Saal der neuen Sezession"
sponsored by the enthusiastic art lover J.B. Neumann.
Huelsenbeck's speech was a summing up of the Dada ap-
proach as activated through the group in Zurich with its begin-
nings in the Cabaret Voltaire.

A month later Huelsenbeck's Dadaistisches Manifest attacked
Expressionism and Futurism (He calls Futurism a "new view of
Impressionist realization as seen by pudding-heads"). In addi-
tion he stated that "to be against this manifesto is to be a
Dadaist". The manifesto addresses itself to an antiaesthetic at-
titude towards life; it tears up all slogans. At the Dada Club
every man is President.

This manifesto introduced Dada to Berlin. There is some prob-
lem dating the Dadaistisches Manifest because Huelsenbeck
used the pages in a later Dada Almanach (in 1920). The first
printing occurred while Tzara was still in Zurich, before he
joined Picabia in Paris. By 1918 the Zurich Dada movement had
been exploded like a bomb by Picabia's strong actions against
the idea of art. In Berlin, these nihilistic developments were not
as apparent. There was bitterness, but not hatred for life.

Before Huelsenbeck came to Berlin in 1918 there had been
anarchistic tendencies by Raoul Hausmann, Baader, Franz
Jung, the Herzfelde brothers and George Grosz. The credo
from Zurich was needed to unite these varying tendencies into
the short-lived Dada movement. Richard Huelsenbeck, M.D.,
brought antiart, which combined with the existing hellraising.
In the revolution Dada took every side, from Spartakus through
Communism, to Bolshevism and on to Anarchism. But the
trumpet of doom had sounded. Dada was antiauthoritarian, and
the authorities were repressive.

407.

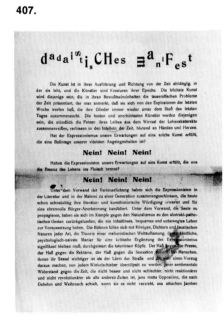

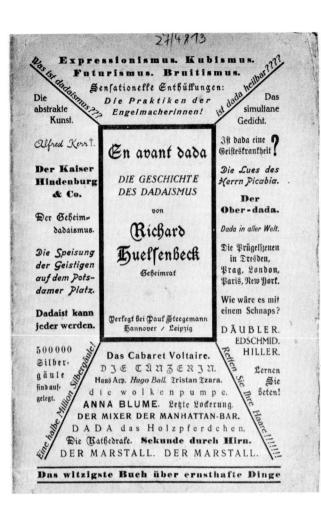

408.

**408. En avant dada. Die Geschichte des dadaismus**
*(Before dada, The History of dadaism)*
Paul Steegemann Verlag, Hannover, 1920
Die Silbergäule, Band 50/51, tan paper covers
23.5 x 15.4 cm., (1) 44 pp (5)

Both Huelsenbeck and Schwitters were published by Paul
Steegemann, although Huelsenbeck always had a dislike for
the young Hannoverian painter. The two diversions of Dada
had created some chaos as early as 1920. Huelsenbeck wrote
this history of the beginnings of the idea as a counter. But
contradictions have remained to this day. Even the origin of the
word has been in dispute. Huelsenbeck writes about his acci-
dental discovery of the name with Hugo Ball, in a German-
French dictionary.

Huelsenbeck arrives at the date of spring, 1916 in Zurich as the
beginning of his message. It was then that the Cabaret Voltaire
was founded. The author says that he writes with a revolver. He
condemns all art including his own pamphlet. It was a state-
ment of unity between Huelsenbeck, Hausmann and Baader.
He ends the writing with a dialogue between three men; Dr.
Smartney, a Hearst reporter from Illinois; Peupilos, an Egyptian
priest, later a porter at the Hotel Exzelsior; a Dadaist. The con-
versations revolve around money, how Dada is an eminent
metaphysical time of angels, how Dada is not a Singer sewing
machine, Dada is the American side of Buddhism.

Only the cover has some creativity, with use of different type
sizes and faces. The cheaply produced booklet contains an im-
portant message of argument and varying truth according to
whom one reads about the time.

## MAJOR INDEPENDENTS, SECOND GENERATION EXPRESSIONISTS AND FOLLOWERS

Rudolf Bauer 1889-1953
Willi Baumeister 1889-1955
Walter Dexel 1890-
Conrad Felixmüller 1897-
Werner Gilles 1894-1961
Friedrich Gotsch 1900-
John Heartfield 1891-1968
Franz Heckendorf 1888-1962
Josef Hegenbarth 1884-1962
Karl Jakob Hirsch 1892-1952
G.B.R. van Hoboken 1892-1971
Max Kaus 1891-
Ida Kerkovius 1879-1970
Cesar Klein 1876-1954
Karl Kluth 1898-
Johannes Molzahn 1862-
Rolf Nesch 1893-1975
Hans Purrmann 1880-1966
Werner Scholz 1898-
Paul Seehaus 1891-1919
Renée Sintenis 1888-1965
Max Unold 1885-1964
Fritz Winter 1905-1976

Berlin was the great city of theaters for every class of German citizen. Other major and minor cities in Germany had state and city-backed theaters, and most had important playwrights as resident writers.

In Germany, the theater had been the major means of expression for mass audiences from the times of Goethe and Schiller. It was taken seriously. Comedy had never been successfully produced until the times of the later Weimar culture, when a direct attack on the political scene made use of humor, although this was more in the realm of satire than comedy. The new realism was so strong that it demanded some laughing relief against the terrible facts.

It is no coincidence that many Expressionist artists were closely associated with the stage. Kokoschka, Grosz, Felixmüller, Hirsch, Heartfield, Grossmann, Dexel, Klein, Molzahn, Gilles and many others designed, wrote or produced for the stage. The art of Oskar Schlemmer is so closely associated with ballet and acting as to be inseparable. The marionette show, the motion picture, ballet, pageant, medieval Passion play, all influenced the painters and writers. But in this later day of Expressionism, a close association with the stage usually meant the Socialist stage, and sometimes, because it used the most imaginative means, the Communist stage.

The wildest days of ecstatic speech and abstract dialogue were over. The new look at contemporary life was through the near-sighted eyes of a new realism. The historical present, the document rather than the look backward into a recently united German past, was the intent. The subjects were behaviorism, American efficiency, American jazz, American technology, Lindbergh, machinery and American pragmatism. America was on the lips of the future-seeking youth. The other side of the influence came from old relationships with Russia, early Soviet Russia, land of new opportunity and freedom before the rise of Stalin. Although some writers and artists visited the new Communist state and reported adverse reactions, outside Russia the appeal was carried worldwide by propagandists and fellow travelers. Perhaps the later doctrines had not been jelled into the bureaucracy and close supervision of world opinion in the various changes of Soviet official policy.

The realistic drama took the form of the timely, with class justice, abortion, capital punishment and the morality of the middle classes as major themes.

The impact of the Russian stage had been paramount since the period of 1905 to 1910. With the rise of Russian Bolshevism, the Moscow Art Theater and its methods, the disuse of "individual characterizations" and "klass-kernel," spread to German Communist groups. Alexander Tairov created his Constructivism, with use of geometry, levels, inclines. Vsevolod Meyerhold brought a complete break with the tradition of Stanislavski. Working class acting groups were formed. The audience was supposed to be an uneducated lower class, which, however, neither appreciated nor understood the special designing and special writing for them. The "living newspaper", based on a town crier tradition, was more successful and had movable props. The tradition of the town pageants produced a form of drama called "mock trials" which put the middle class before working class audiences who were their judges. Art became a skillful means of improvisation, sometimes with a clever use of everyday materials. Art as art was banned from the living theater. Drama became an incitement, and acting became a political act.

The greatest genius among German stage producers, Erwin Piscator, was a dedicated Communist. He employed George Grosz in many productions. Abstract design and imaginative dialogue were allowed by Soviet censors from the Russian Embassy, who controlled Communist literature, art and drama after the Central Committee became subservient to the commands of Stalin.

It is important to realize that German radicalism in the 1920s was not a new form of action. The German Communist party was not even formed until December 30, 1918. It was not a party of isolated or individual political ideals, but was the offspring of the old Social Democrat party, which split three ways at the time. Socialist parties had always been closely restricted in Germany, and this gave the organizations a "German" character. Authoritarianism was the result. The Communist party itself was divided between those who wanted instant revolution and those who placed their trust in the inevitability of "historical materialism." This was one reason art was never fully controlled in an official policy of social realism. Communist and every other left wing group could be abstract or realistic, be propagandist or purist. As the Walden group radicalized in the 1920s, the art in Der Sturm became more abstract.

The groups around Herzfelde and Heartfield were formed out of the Dada reaction against the failure of the Novembergruppe to carry out its plans. Herzfelde, as a party member, was accountable to the Comintern, as were the members of the Rote Gruppe (Red Group of Communist Artists).

Specialized newspapers had been common since the eighteenth century. Communist newspapers and periodicals were founded. Die Rote Fahne used Grosz often. Willi Münzenberg, Communist deputy at the Reichstag (mentioned elsewhere), published the Arbeiter Illustrierte Zeitung, one of the first to use photo-journalism. Periodicals used montage and satirical drawings in an imaginative composition and extraordinary design to get and keep attention.

With Grosz, as with so many of the other left wing artists, the Fifth Congress of the Comintern in June 1924 ended a close personal effort to realize a party line. After that time party decisions were forced on the artists. Bolshevization was carried into art, and the artist was no longer free, but a disciplined artist and controlled party member.

Most of the artists never developed into controlled Bolsheviks. The early revolutionaries believed in a revolutionary art, created out of the relationship between the artist and the people, not out of official doctrines and outside standards.

## DER QUERSCHNITT DURCH 1922
1922, page 172
Jazz by George Antheil (excerpts)

For the immediate future there will be only two kinds of music, the Banal, and the Mechanistic.

Ragtime embraces the first and is the nucleus of the second.

The first will derive its energy from the pulse of the new people, and the second from the direct environment of these masses; the towers, new architectures, bridges, steel machinery, automobiles, and other things which have a direct functioning, and are aesthetically placed directly apart from the organization of the sentimental which the first includes.

The first will be both sentimental and banal, and will be the artistic reorganization of the new people by a solitary genius. Here organization has the uppermost hand. It will find its energy in the most powerful musical fragments of these people—the most obstinately banal ones.

The second will be purely abstract and will derive its energy from the rhythmic genius of a solitary innovator whose sense of time spaces comes from the present moment of intricate machines which are new arms and legs of steel and reach out and change the entire epoch. This man must invent new machineries for the locomotion of time, or the musical canvas, in such a way that we have a new musical dimension.

To anyone who has lived every day of his life in America and heard the cheap and almost primitive cafe orchestras, especially of the smaller cities, and has heard the infinite variety of headlong rhythms produced by a single clarinet upon a single tone with the strongest and most fascinating relationships between the entire time spaces—to claim monotony because of the lack of vertical interest—i.e. the nuance, or the change of tonalities, or other musical machineries and paraphernalia that belongs to the immediate past is to declare one's pedantry, and if one is a composer it is to declare one's unnecessity.

For American jazz is the product and folk song of an enterprising and daring blood that has left other lands in the spirit of materialism and dissatisfaction. Jazz is not a craze—it has existed in America for the last hundred years and continues to exist each year more potently than the last.

And as for its artistic significance, the organization of its line and color, its new dimensions, its new dynamics and mechanics its significance is that it is one of the greatest landmarks of modern art.

409.

410.

**MAX UNOLD**
409. Kinder auf der Strasse *(Children on the Street)*
Lithograph, 1921
signed and dated in pencil on Bütten
29.9 x 22 cm.
From Ganymed-Mappe I, 1921
Munich: R. Piper/Verlag der Marees-Gesellschaft

410. In Memoriam Rene Beeh *(In Memoriam Rene Beeh)*
Woodcut, 1922
Signed and dated in pencil on vellum
13.9 x 18 cm.
From Ganymed-Mappe II, 1922
Munich: R. Piper/Verlag der Marees-Gesellschaft

Max Unold was Swabian born, raised and educated. He had the humor and crudity of the Bavarian. He studied art privately, also at the Munich Academy under Habermann. Most of his travels to France were short ones and show little influence from the new trends there. Unold was an early member of the Münchner Secession, and also joined the Neue Secession in 1911. He worked in graphic art from 1911. During the war he expressed his unhappiness in graphic art, and like most of the other German painters, carried this feeling into the later years. His books and graphic art were published by the Gurlitt Press.

Max Unold's earliest illustrations were traditional woodcuts, although done with vigor and movement. His shading style was based on late medieval illustrations. He was an accomplished historicist with woodcut techniques. The small Florentine pocket books had a major influence. This was a fine tradition of balanced illustration and legible type makeup. Unold used the Expressionist manner, but his lack of internal direction made the character of his expression more a caricature of the styles. Perhaps he was too rational.

Rene Beeh, the Alsatian, had died in 1922. The memorial woodcut by Unold was probably requested by Meier-Graefe, publisher of the Ganymed portfolio in which it appeared. Beeh had provided inspiration for other painters by his wild nature. He had experimented with drugs, made exotic journeys, designed squat figures, negroid and happy. He saw the irrational and horrible in a landscape of oleander and tamarind trees.

Unold presents his friend in discussion with two others. The style is based on "Brücke" conceptions, though without the inner tension. It is a bourgeois version of an exotic and complicated artist-friend.

The first print, also from Ganymed, a lithograph, has the sentimentality of the Bavarian: The exaggerated drawing too is from Pechstein and other "Brücke" painters. Again there is little of the linear design, creative use of tone, or deep study of character. Unold almost always seemed to work better with printing type opposed to his illustrations, for his major talents were somehow connected with literary relationships.

**RENEE SINTENIS AND E. R. WEISS**
411. Sappho
Twenty-two poems by Sappho (Greek text)
Written on etched plates by E. R. Weiss
Etched illustrations by Renée Sintenis
Munich: R. Piper Verlag, 1921
31. Druck der Marees-Gesellschaft, edited by Julius Meier-Graefe
Editions: 250 examples: Nrs. I-LXV on Japan paper, with the colophon signed by Weiss and Sintenis, accompanied by an extra suite of 12 prints and one extra discarded proof in a portfolio (36 x 25.7 cm.): Prints on Japan, each signed by Sintenis with the Marees-Gesellschaft blindstamp (sheet: 25.4 x 20 cm.). This example #XIX. Nrs. 1-185 on Bütten, with the colophon signed by Weiss and Sintenis
Printed by Alfred Ruckenbrod, Berlin

411.

#171/185
Unpaginated
Book: 27 x 20.5 cm.
Page: 26 x 20 cm.

This small volume of remnants from the poetry of Sappho is considered one of the finest balances between typography and illustration in all modern book design. The relationship is perfect in weight and proportion. As is fitting for a Greek text, the ornamentation is simple, yet it is not neoclassical but contains the experience of one of Germany's finest designers in the modern idiom.

E. R. Weiss was born in 1875. He was trained as a painter, wrote poetry, and did commercial art. His first boundaries within youthful originality were found in the framework of Eugen Diederichs's publishing venture in 1895. The first major works were done for the Insel series in 1900. Weiss worked with the thoughts of great authors from the beginning. Rilke, von Hofmannsthal, Gerhart Hauptmann, and Martin Buber were among these inspirations for the young designer. Weiss was adaptive in these early works rather than original. He designed for the texts more than for his creative originality. His taste was always supreme even in these derivative tasks. His drawing gave way to a deep interest in typography; and Weiss created new typefaces for the great foundries of Germany. These faces were known for grace, lightness, openness and rhythm. Weiss also changed the old concept of the page into an open space, as opposed to a closed rectangle which had been handed down since late medieval traditions. His twenty years as chief designer for the Fischer Verlag gave him the opportunity to design many typefaces as well as to modernize production methods. Weiss was said to have designed with a feather rather than a fist.

Renée Sintenis, Weiss's wife, was a frequent collaborator in creative ideas, as she contributed her skills as a sculptor to the linear thoughts of the typographer. Space was important to the new design. She did illustrations for only six different books, but all are tasteful and balanced productions. She was born in 1888, studied at the Berlin School of Arts and Crafts. Her major fame was as a skillful sculptor of exquisite modelling. Her animals and children were shown in Germany at the Flechtheim and Gurlitt galleries. Sintenis was also a popular sculptor of portraits and bronze medals.

René Crevel writes about Sintenis in Junge Kunst, Band 57: "Her pompadour has bewitched Europe. Her animal park is a delicate growing cover over life. A big and always young woman has bent down in order to hear the subterranean heart. Her new Adam will be worthy of the new epoch... The beautiful mixture of people and animals will be a symbol of youth in Berlin for a long time."

## CONRAD FELIXMÜLLER

This second generation artist among the Expressionists encountered the problems of the person who catches up a flaming torch that is already bright.

Felixmüller was born in Dresden in 1897. As with Klee and Kandinsky, Felixmüller centered his life around music. He was a student of piano and violin. He began his art training in 1911 at the Arts and Crafts school, later entered the Art Academy and became a master student until the age of seventeen. Considered a superior student, he was given a portfolio to illustrate after the song cycle by Arnold Schoenberg, Lieder des Pierrot Lunaire. The student also illustrated a portfolio for the Else Lasker-Schüler Hebräische Balladen. This accomplishment led to an exhibition at the gallery of J.B. Neumann in Berlin. Felixmüller, an outgoing person, made many friends among the intelligentsia in Berlin, such as Franz Pfemfert, Hausmann, Däubler, Sternheim, the Herzfelde brothers, Becher, Walden and Franz Mehring. He began sending prints for sale to the Richter gallery in Dresden.

Later Felixmüller was very active in the political movements of Berlin. He illustrated for Der Sturm, many works for Die Aktion, Die schöne Rarität, Der Weg, Menschen, Die Sichel, Die Rote Erde, Der Cicerone. He joined the Dresden Secession and the Novembergruppe. After 1918, Felixmüller did considerable work for the theater, in both costumes and stage design.

Felixmüller thought of art as an historical expression of human society. He thought human beings had been placed at the center of art, placed by social responsibility, not romantic fanaticism. Art should replace the solitary and obscure styles with subject matter drawn from daily life. Art would look for the unity of the human race, the single person in the masses, "to know and want the same."

His graphic art grew from the Dresden Brücke style, though it appeared seven years later. There are mixtures of other styles from Munch and Meidner. Around 1915 Felixmüller's style becomes more complex, with a cubistic turn of form. This develops into a complicated and activist Cubism for the Aktion woodcuts. His later styles alternate a distorted realism with non-linear woodcut techniques. He begins to focus more on the emotional content of the subject rather than a play of technical virtuosity. After 1921 this artist works in the "Neue Sachlichkeit" tradition of cabaret scenes, people in landscapes, penetrating portraits and grasp of halftone in woodcuts, which was his original contribution.

Felixmüller illustrated thirteen portfolios up to 1958. His early reputation, even as a young man, led to appearance of his work in such fine books, yearbooks and periodicals as Das Kunstblatt (9), Neue Blätter für Kunst und Dichtung (8), and Die Schaffenden (3).

It is difficult to sustain the impulses which begin a strong movement. Though the official schools in Dresden, birthplace of "Die Brücke," were not especially friendly to the work of the young painters, students were moved by these nonacademic trends, and also moved by the great presentations at the Dresden opera, the theater and cafe discussions. Felixmüller discarded most of the academic backbone of his early training for a cloak of "Brücke"-like mannerism. It was a fair fit, though by no means tailor-made.

**412. Mother and Child**
Ink drawing, 1914, 21.5 x 13 cm.

This wash drawing by the 17-year-old student at the Dresden Academy is a study in black shape against a pyramid. It represents his early, formal style.

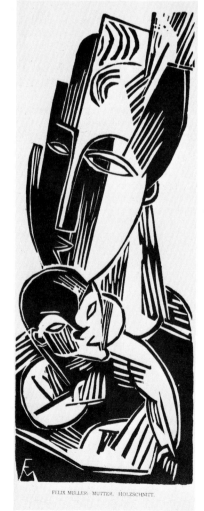

FELIX MÜLLER: MUTTER. HOLZSCHNITT.

**413.**

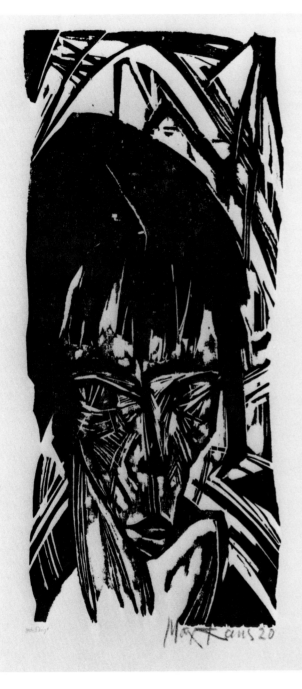

**413. Mutter mit Kind***(Mother with Child)*
Woodcut, 1918, Söhn 157 b
22.5 x 9 cm.
From Das Kunstblatt, March 1919 (also printed in
Die Rote Erde, August 1919, Söhn 157 c).

The mature Felixmüller is more of a complicated artist. He mixes Cubism and Expressionism in the manner of the Dada painters in Berlin, much as Dix used this means in his early woodcuts. He combines the turned planes with an ornamental shading and the beginning of a simplified system of circles and squares (which he does not investigate further). It approaches some of the concepts of the later Constructivists. It may be a satirical comment on religious madonnas.

The vertical shading along the form is original with this artist. Reality is forced into confinements of geometry as an expression of the new age. The human is an element in a mechanical age, and this "means of production can be a religious hope for mankind."

## MAX KAUS

**414. Mädchenkopf***(Head of a Girl)*
Woodcut, 1920
Signed by artist and printer
Editions: 125 examples total
Printed by F. Voigt
As printed in Die Schaffenden/Eine Zeitschrift in Mappenform
Edited by Paul Westheim.
Weimar: Gustav Kiepenheuer
Year II, 1921. Mappe I, #5, "Mädchenkopf"
28.4 x 12.5 cm. (Image)

Max Kaus was a city man, born in Berlin on March 11, 1891. He was somewhat younger than the other Expressionists. Kaus was trained in the Arts and Crafts school in Berlin-Charlottenburg, as a wall decoration painter until 1913. A journey to Paris in 1914 opened his eyes to the new painting. He exhibited with many galleries through the years, and had a fine reputation until the Nazi time. About two-hundred paintings and most of his graphics were lost to bombing during World War II, so today his early work is rarely seen.

Most of Kaus's development came from his meeting with Heckel, Helbig, and others, while he was serving as a hospital orderly in Flanders during the first World War. Kaus's first exhibition began in 1919. Later he developed an association with the Paul Cassirer gallery.

Kaus began his mature graphic work as an illustrator in 1916 for Klabund poems, Dumpfe Trommel und berauschtes Gong. Kaus was not connected with the Novembergruppe. He neither signed nor followed any political manifesto. Perhaps his inclination was melancholy, not social comradeship. Kaus was fascinated, like Kirchner and Heckel, with circus and variety shows, though he rarely painted them except early in his career. He was also very interested in outdoor life, especially sailing off the Havel River into the North Sea.

Much of his early work can be seen only through his illustrations because single prints were mostly destroyed. Kaus illustrated for Der Querschnitt and Das Kunstblatt and many gallery catalogues.

The characteristics of Kaus's subjects are Slavic, moody, with Russian slanted eyes, pointed chins, and thin or pointed noses. Intense stares predominate and hands gesture in eastern fashion. There is some influence from the Brücke style of Heckel, but with more animation to the atmosphere in backgrounds and planar areas. Many of the subjects in the twenties are people in profile, nude or at rest. Perhaps his most original contribution is in the woodcut medium. Between 1917 and 1920 Kaus did a series of studies in different techniques, from diagonal patterning to vertical planes, thin shading lines to massive calligraphic patterning, contrasting simplicity with clashing mood-violence, moving through distended realism to overall oval repetition.

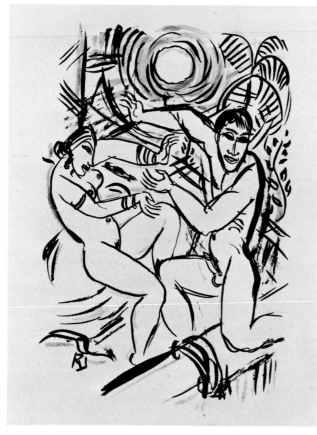

415/3..

415. Der Venuswagen. Eine Sammlung erotischer Privat-drucke mit Original-Graphik *(The Chariot of Venus/A Collection of Erotic Private Publications with Original Graphics)*
Herausgeber Alfred Richard Meyer
Erste Folge/Band I-IX
Nine volumes
Berlin: Fritz Gurlitt Verlag. 1919
Privatdrucke der Gurlitt-Presse
Editions: Each volume printed in 700 examples, of which 40 (with the exception of Band IX, which has 35) printed on Bütten and bound in leather or parchment.
Book: 30.5 x 24/26 cm.
Page: 26.5 x 23.5/25.5 cm.

Alfred Richard Meyer wrote an introduction to this series. In it he describes the erotic as the basis of all art and much of religion until the near centuries. Eroticism is closely related to the idea of original sin. The erotic and pornographic are different: pornography he calls unartistic; the erotic wears the mask of art.

"The erotic can be ironic, satirical, burlesque, and sometimes grotesque, as seen through the eyes of the Expressionists. All centuries view the erotic through the eyes of their cultural visions. Each people has its own idea of erotic natures. Each had an erotomania which was the country of fantasy. There were echos such as these: 'Woman is a devil. Two stars triumph in art. Woman is an angel.' For the holy Cyprians woman was a demon, through whose gate we enter Hell. The holy Chrysostomos and Hieronymus thought all women were nasty and filled with the devil."

It is interesting that the confiscation of Der Venuswagen was made under the Weimar Republic, which had a guaranteed freedom of expression under the constitution. Yet the public prosecutor, Ortmann, used a paragraph from the German Criminal Code of 1871 (Paragraph 184-184a), which allowed prosecution for obscene or "indecent" books or drawings.

Willi Geiger's illustrations for Huysmans and the Corinth drawings for the Schiller were confiscated outright. Zille's drawings were also taken and never used.

Against these backgrounds, Meyer presents his Venuswagen. He begins with the turning rhythms of the young Schiller. The wagon flies into spheres of heaven and earth. Poets sing on the highroad. The colored Indians and Chinese flame magnificently. A king cries the last bacchanal. Goethe tries a bed in heaven. A chorus sings for tomorrow.

Through the eyes of the artists is seen the personality of art: Lovis Corinth, Willi Geiger, Max Pechstein, Richard Janthur, Willy Jaeckel, Marcus Behmer, Paul Scheurich, Bruno Krauskopf, Otto Schoff, Heinrich Zille, George Grosz, Max Kaus, Klaus Richter, Franz Christophe, Rudolf Grossmann, and Georg Rössner were commissioned. Pechstein, Behmer, Grossmann, Krauskopf, Zille, Grosz, Kaus, and Richter were not published as the series was closed by court order after the trial for obscenity. Wilhelm Wagner was added to the original list and he designed one extra set of illustrations. There were nine in all, and only these, for legal troubles took time and the publisher rushed through as many volumes as he could before the judgment was enacted.

Band I

415/1. Der Venuswagen/Ein Gedicht von
Friedrich Schiller/1781
*(The Chariot of Venus/A Poem by Friedrich Schiller/1781)*
Lithographien von Lovis Corinth *(Lithographs by Lovis Corinth)*
8 color lithographs
Lithographs printed in 1919 on the Gurlitt-Presse.
Text printed by Otto von Holten, Berlin
#35. Colophon signed by the artist
(2f) 33pp (5pp)

This was the volume which caused the first court action. Schiller, the national poet of Germany, was given laudatory notice as a romantic writer, not an erotic commentator. In many ways these were hidden documents, considered not for public gaze. Corinth's free illustrations had too much intimacy for the government censor, though the pictures are neither pornographic nor antinationalistic. The work of the schoolboy Schiller—he was at the Stuttgart military academy during this time of 1781—is a mere curiosity.

Band II

415/2. Sappho oder die Lesbierinnen/von E. Jouy
*(Sappho or the Lesbians By E. Jouy (Victor Joseph Etienne)*
Mit Radierungen von Otto Schoff *(With Etchings by Otto Schoff)*
7 etchings
Translated by Balduin A. Möllhausen
Etchings printed on the Gurlitt-Presse in 1920.
Text printed by Otto von Holten, Berlin
#35. Colophon signed by the artist, (1f) 25pp (6 pp)

This selection from Jouy's "Galerie des Femmes" presents the woman as lover of woman. The elegant Jouy, poet for opera, lyricist for Rossini's "Wilhelm Tell," was a high Romantic writer. The witty dialogue is illustrated by Schoff with mock innocence. The women walking into a woods before the eyes of interested boys move into a perfumed grotto, make love in front of a crucifix, weave and stretch in womanly delight under tree and sun. There is an innocence to the drawing that covers the slight shock of the action. There is also a stiffness to the posed figures which, perhaps, a German illustrator found tenable to his understanding of woman as a secondary factor in society.

## Band III

**415/3. Pantschatantra/Fabeln aus dem indischen Liebesleben**
*(Pantschatantra/Fables out of the Indian Life of Love)*
Lithographien von R. Janthur *(Lithographs by R. Janthur)*
10 full page color lithographs by Richard Janthur
Title page drawn by Janthur, 22 vignettes and initials
Colored lithographs printed on the Gurlitt-Presse in 1919
Text printed by Spamersche Buchdruckerei, Leipzig
#35. Colophon signed by the artist. (2f) 47pp (5pp)

The book contains eleven fables of humor and deceit. Contents resemble the Decameron, with wives fooling their husbands, young wives taking strange lovers, men with huge egos being taken down to normalcy, and a wonderful story of a princess with three breasts. Janthur's animation fits perfectly with these Indian fables. The Slavic faces become Hindu. Primitivistic concepts become rational in the stories. Janthur's humor becomes a violent commentary. His linear style seems well related to the type size.

## Band IV

**415/4. Das Aldegrever-Mädchen/Eine Novelle von Alfred Richard Meyer** *(The Aldegrever-Maiden/A Short Novel by Alfred Richard Meyer)*
Mit handkolorierten Original-Lithographien von Georg Walter Rössner *(With Hand-Colored Original Lithographs by Rössner)* 8 full page handcolored lithographs
Lithographs printed in 1919 on the Gurlitt-Presse
Text printed by Otto von Holten, Berlin
#35. Colophon signed by the author. (1f) 40pp (2f)

Meyer's novel had been written in 1911 and was published in the Venuswagen for the first time. The novel begins with a statement that life was a day of wonder on the morning that begins the narrative. Artists discuss the Nürnberg Little Master: "Do you not know Aldegrever? Here you can see the flesh of the German sixteenth-century." There are adventures built around Aldegrever-like pictures. The narrative also uses symbolism such as flowers entwined and woods filled with nudes. It is a summer of happiness for the artists, followed by only remembrance of the Aldegrever women. Rössner's illustrations are pretty, unoriginal, and add little to Meyer's clever prose.

## Band V

**415/5. Der Mord im Kastanienwäldchen/oder/Die ereignislose Hochzeitsnacht** *(The Murder in the Chestnut Woods/or/the Uneventful Honeymoon Night)*, Henry de Koch
Original-Lithographien von Franz Christophe
*(Original Lithographs by Franz Christophe)*
Translated by Balduin A. Möllhausen
Lithographs printed on the Gurlitt-Presse in 1919
Text printed by Otto von Holten, Berlin
#35. Colophon signed by the artist. 52pp (1f)

The grotesque romantic story of revenge and retribution belongs more to the early romantic tradition of the French, though the Germans left records of intense interest in these morbid stories among the rental lending libraries of their large cities. The illustrations are traditional to the field, not Expressionistic. Christophe uses the eighteenth-century French tradition too, of rustling cloth, lovers on knees, languid nudity and tears.

## Band VI

**415/6. Erotische Votivtafeln** *(Erotic Votive Tablets)*
Heinrich Lautensack
Lithographien von Willy Jaeckel
*(Lithographs by Willy Jaeckel)*
7 lithographs
Lithographs printed in 1919 on the Gurlitt-Presse
Text printed by the Buchdruckerei Gustav Ascher G.m.b.H., Berlin, #35. Colophon signed by the artist. 32pp (2f).

The book begins with Lautensack's praise of man and woman. *The Mourning Ugly Woman, Self-Love, Pan, The Blind Harpist and his Woman, Young Jews, The Corset* are some of the titles and show the range of contents from satire to erotic intention. Jaeckel continues his interest in the monumental nude. The illustrations are vignettes on fairly empty margins. The influence from Kokoschka is evident. Expressionism is internalized into movement of shading and symbolism, not design. There is little inner emotion as in Kokoschka, but instead a static monumentality that is Jaeckel.

## Band VII

**415/7. Die königliche Orgie/oder/Die Österreicherin bei Laune/Eine Oper/Von einem Leibgardisten veröffentlicht am Tage der Pressefreiheit/In Musik gesetzt von der Königin/1789** *(The Royal Orgie/or/The Austrian in Humor/An Opera/Published by a Bodyguard in the Days of the Free Press/Set to Music by the Queen)*
Original lithographs and vignettes by Paul Scheurich
Lithographs printed in 1919 on the Gurlitt-Presse
Text printed by Otto von Holten, Berlin
#35. Colophon signed by the artist, (1f) 38pp (2f)

Neither in concept nor art is this an expressionist volume.

## Band VIII

**415/8. Die Kirschen** *(The Cherries)*
Wilhelm Heinse
Lithographien von Wilhelm Wagner
*(Lithographs by Wilhelm Wagner)*
8 full page lithographs
Lithographs printed in 1920 on the Gurlitt-Presse
Text printed by Otto von Holten, Berlin
#35. Colophon signed by the artist (1f) 45pp (5pp)

John Jakob Wilhelm Heinse combined the frank voluptuousness of Wieland with Sturm und Drang energy. He had a passion for art, and using his principal novels as framework introduced his views of life and art through the characters, as Wieland had begun earlier. Heinse had a great influence on the romantic school through his development of the "Bildungsroman," a novel of spiritual and inner development. Heinse was the great eroticist of the generation before Heine, in the early 1800s.

For the Expressionist, Heinse appealed more in his justification of sexual freedom than for his exoticism, through his method of projecting himself into classical and other early cultures, combining erotic and exotic desires in a created country of the imagination, where such appetites could be indulged. Wieland is the opposite of the religious: "Mysticism negates expression and art." He wrote with a light touch and some frivolity, which balances the seriousness of the German literature of his time. His writing was more related to Voltaire and Ariosto.

Wagner's figure studies add little to the genial poetry of Heinse. The lithographs have some sense of sadness, tension and shame, but none of abandonment or freedom. That they are transfer lithographs is apparent by the paper texture in the master block.

**Band IX**

415/9. Gilles de Rais/von J. K. Huysmans
*(Gilles de Rais by J. K. Huysmans)*
Originallithographien von Willi Geiger
*(Original Lithographs by Willi Geiger)*
15 full page lithographs and one vignette
Translated by August Döppner
Lithographs first printed in 1914, printed in 1919 on the Gurlitt-Presse for this edition
Text printed by Otto von Holten, Berlin
#35. Colophon and the first illustration signed by the artist. 40pp (2f).

This prose is a condensation of parts of Lá-Bas (1891), Joris Karl Huysmans' symbolic novel of old and modern satanism and black masses. Gilles de Rais was Joan of Arc's satanic contemporary. He was also an exoticist as tradition has him deriving sensual divergences from Suetonius's *Lives of the Emperors*. To Huysmans, sadism and satanism are the opposite poses of Catholicism, for de Rais also had a passion for liturgical, ceremonial and sacred music. The angular Expressionism of Geiger's illustrations shows how this movement cannot express true horror, but must combine abstraction and dramatic lighting to focus on the nervous and mysterious. Gilles de Rais was a realist, not a fantasizing neurotic. He performed terrible deeds, not symbolic thoughts. There is a short step from sadism to cults of national subliminal energy. When the inner energy of the Expressionist meets the reality of terrible evil, there is no contest, for evil always conquers.

## DER QUERSCHNITT
1921, Dezember, Heft 6, page 226

Der Venuswagen
Wolfgang Gurlitt was fined a 1000 Marks penalty for publishing Der Venuswagen, with the illustrations of Lovis Corinth, the "Carriage of Venus," and for other art books.

### 1. The Battle Against Art

The newly inflamed battle against "filth in word and picture," organized by special departments of the police and the district attorney, has lately led well-known artists in front of a judge. Men like Corinth, Zille, Scheurich, Geiger, Jaeckel, Klemm are exposed to the damaging reproach that their works are smutty, which means, according to the judgement of the courts: 'suited to insult and shame the virtue of normal people concerning sex.' The question is: what is the criterion for 'lewdness' in a work of art? Kohler describes this in his paper, 'The Sensual and Lewd in Art.' In the forefront of his discussion about the fundamental phases:

'Of all human feelings, none is more important that the feeling of love, meaning sexual love, because it is connected with the species, and through the species to all the creation. Therefore, the description of love has always been the richest and most fruitful field of art. The artist must have the right to lift the veil with which the sober but unavoidable conventionalisms covers us. For art, there are no wraps and girdles, for it there is no shy blushing. It draws the human with a strong hand, and through the human draws manifested strength of infinite nature.'

These, Kohler's thoughtful phrases, form an essential part of the jurisdiction of the courts of law. The courts also have the point of view that the artist has the power to present the objectivity of his work so there remains a pure joy in the beautiful.

Works of art which are activated by sex life and love have been shown to the widest audiences in museums and art galleries always, without a normal district court taking a successful offense. Works by Moderno, van Eyck, Menzel, Rubens, Sinding, Correggio, Michelangelo, etc.

'Art is able'—so says the court—'to spiritualize objects of the mind also, which push back the sensual emotion by the natural aesthetic feelings. Decisive therefore is the degree of artistic achievement that the picturesque presentation has reached.'

The question of lewdness in a work of art is also essentially a question for art, which can only be decided by its representatives and not by police organs. There should never be sequestration or an investigation ordered before famous artists or organs of art like the Berlin Artists Association, both Secessions, etc. They had the chance to take a stand on the question of whether the respective work is a work of art in the true sense of the word, or only produced by artistic means. For this there is no necessity for a change of law. A ministerial order to the court of law is sufficient. Works of art cannot be looked upon only according to what they show, without considering the how.

Not every work is destined for the wide public. Valuable portfolios are not made for the general public, but are meant for a small circle of connoisseurs and collectors. It would be senseless to answer the question of whether such a work injures shame—and morality, to judge it by the average feeling of the public if the work is not even distributed to the public. But even with this, there is a truism expressed, which has been recognized by the courts for a long time.

'Basic decisions,' so says the court (Volume 29 of decision of punishable crimes, page 123) come from: the average feeling of the general public, however the circle of imposters, onlookers or readers, is to be considered. The court has found in actual and thorough decisions that the paper (periodical or portfolio) would be read by only mature, educated people, except for accidental exceptions. It was therefore not a mistake for the courts to use the average comprehension for consideration. In the law, the measure for definition and judgment of the character of the paper is defined according to its lewdness. And even more epigrammatical is the same law principle expressed (Volume 32, page 418) as follows: 'The judge examines the question of lewdness of the paper exclusively by the way that he discusses the tendency towards questionable phrases in the paper. He should have been considering, however, for what kind of reading audience the paper was meant.'

Certainly artists and art lovers would be less harrassed if the phrases of law would be considered in the preliminary steps, and if the courts would hear artists and art organizations before each intervention.

The path followed presently leads to a hostile conventionalism.

Fritz Grünspach

## KARL JAKOB HIRSCH
416/1. Verzweiflung *(Despair)*
Drypoint, 1915, signed, dated and titled
19.8 x 14.9 cm., on brownish, handmade paper

416/2. Zu Gustav Mahlers Lieder Reveille
*(From Mahler's Lieder / Reveille)*
Drypoint, 1915.
signed, dated and titled: Für Gustav Mahler (Portfolio)
20 x 14.7 cm., on brownish, handmade paper

416/3. Revolution III
Drypoint, 1915, signed, dated and titled
19.6 x 14.7 cm., on brownish, handmade paper

416/4. Du Führer *(Your Leader)*
Drypoint, 1915, signed, dated and titled
24.8 x 19.6 cm., on stiff white paper

416/5. Wahnsinniger *(Insane One)*
Drypoint, 1922, signed, dated and titled
20 x 16.5 cm., on heavy, brownish paper

Most of this information came from an introduction to exhibitions at the Akademie der Künste, Berlin; at the Stadtbücherei, Hannover; at the Theatermuseum, Clara Ziegler Stiftung, Munich, 1967. Hans Heinz Stuckenschmidt and Walther Huder wrote the introduction.

Karl Jakob Hirsch was a close friend of Franz Pfemfert and the Aktion circle. He contributed to that periodical from 1915 until 1919. He shared the utopian ideals and political leanings.

Self-portraits of the time show us a high intelligent looking forehead framed by horn rimmed glasses. Hirsch was a short man, a reserved person, an examiner. He was excitable about music. This was his major concern and influence. When subjects interested him, he was ecstatic. Gustav Mahler's and Arnold Schoenberg's scores provided the central core; and he illustrated his conception of Mahler's symphonies for the Harms Verlag, Hamburg in 1920; and the Lieder of Mahler for Dresdner Verlag in 1921.

Hirsch was born in Hannover, a place of flat land and wide horizons. His search for such a northern landscape later led him to Worpswede, where he inhabited a fine brick house with his first wife, a doctor of medicine. Spring in Worpswede was a time of miraculous light; and this was what centered the artist there. Most of his middle time work was done for the theater in Berlin, a place of restless activity and noise. At home he could play his music, talk to farmers, shed tears over a limping horse, for Hirsch was a sentimentalist. Worpswede was no longer the artists' colony of Mackensen and Hans am Ende, for modern people had moved there.

Hirsch was an important scenic designer for the Volksbühne. *(the People's Theater).* He did designs for Georg Kaiser's Die Bürger von Calais, Gas I, for Gogol's Heirat, for Strindberg's first Expressionist play Nach Damascus. His sketches appeared in Die Neue Schaubühne in 1919 and 1920. Hirsch also made a few illustrations for Die Schöne Rarität.

416/5.

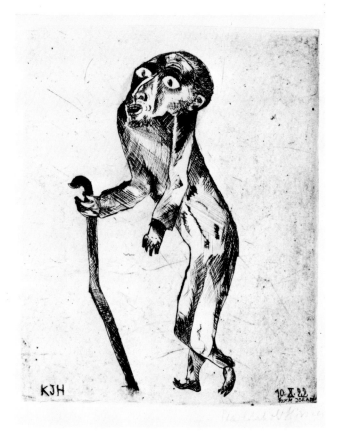

Hirsch left Worpswede in 1919, remarried in Berlin, joined the "Novembergruppe," engaged in its performances of modern literature and music, which were surrounded by the paintings and sculpture of the members. Hirsch became a "Utopist," a member of the united front of artists, who were closely grouped to support modern trends in society and aesthetics. He had been proud of his Jewish heritage, using a pen name of Jakauw Arie Ben Schlaumo. His great grandfather had been the Rabbi Samson Raphael Hirsch.

Using revolutionary material similar in theme to that of Kollwitz, these 1915 works made in Worpswede are subjects such as a *Guillotine* (Revolution III), Reveille from a Mahler orchestrated poem for Des Knaben Wunderhorn and *Despairing Men* (Verzweiflung). He uses a sketchy technique, a free drawing with deep planes and a theatrical placement of figures. Modern touches come from abstract design applied to forms, not by form itself. His primitivistic exaggerations are used for distorted heads and combined, multiple bodies. Individual pieces show an influence from Kirchner; especially in Du Führer, with angular drawings using upward, directed triangles. Facial expressions did not interest Hirsch; and he keeps them static.

His etchings of an *Insane Man* (Wahnsinniger) is probably taken from the style of his friend, Max Kaus. The inspiration was from the Torah. Form is flat and articulated by cross hatching to locate areas behind one another not around them. The cut-out flatness is made into a gesturing figure of angularity and tight rigidity. Hirsch is more interested in the psychological effect of insanity on muscles and motion.

Hirsch had been a total artist in many mediums. From the beginning, he had written poems for Die Aktion, written some critical articles, done portrait sketches and political cartoons, worked in the theater, written political tracts and moved among his wide circle of musical and literary friends.

After a trip to southern Europe in 1929, Hirsch found himself unable to paint or design for the theater. Turning to writing, he found a great theme, the bourgeois Germany of the Kaiser, which he described in his now famous book Kaiserwetter *(Kaiser Weather).* It was followed by the novella Felix und Felicia. Success in literature came too late, for Hitler was making his move towards power. Jewish authors had to hide under pseudonyms or not publish. Hirsch had no illusions about his future. He became a melancholic.

As a homeless man, Hirsch lived in New York during the war, remained in the shadows, and never adapted to American life. In his autobiography of 1946, Hirsch tells how he rejected his Jewish heritage, became a Protestant. (Heimkehr zu Gott). He returned to Germany as a member of the American occupation forces, settled in Munich, and married again, but found the bitterness did not fade from his central thinking. His later, tragic life ended in a clinic in Munich during 1952.

Like his friend, Alfred Wolfenstein, Karl Jakob Hirsch helped transform the shape of German culture during the Weimar era, but both paid for their innocent intentions, when they were caught between the left and right forces which ground them into despair.

## JOHN HEARTFIELD

**417.** Deutschland, Deutschland, über alles
*(Germany, Germany, Above All Others)*
Ein Bilderbuch von Kurt Tucholsky
Und vielen Fotografen montiert von John Heartfield
Berlin: Neuer Deutscher Verlag AG. 1929
Printed by Pass und Garleb, Berlin
Edition: 21-30 thousand
23.6 x 19 cm. 231 + 5 pgs.

John Heartfield was born in 1891 (as Helmut Herzfelde), and educated at the Kunstgewerbeschule in Munich under Dasio, Diez and Engels, and later at the arts and crafts school in Berlin-Charlottenburg under Ernst Neumann. He began showing in Die Aktion and Der Sturm. In 1914 he won first prize at the Werkbund exhibition in Cologne. In 1915 he met Grosz. Both were discharged from the army with nervous diseases.

With his brother, Wieland, Heartfield began the periodical Neue Jugend; in 1917 they established the Malik Verlag. In 1918 Heartfield joined the Communist Party. In 1919 he began Die Pleite, the Dada Gruppe, and with Grosz and Hausmann edited Der Dada. He showed in the first Dada-Messe.

From 1921-1923 Heartfield was the resident artist for the Reinhardt theater in Berlin. He also designed for Piscator's "Agitprop" theater; In 1925, "Trotz Alledem"; in 1927 Toller's "Hoppla, wir leben!"; in 1931 Wolf's "Tai Yang erwacht." From 1929-1933 he designed covers and montages for the worker's periodical, AIZ. He also did many book jackets and book designs. He fled Germany in 1933, to Prague where AIZ continued publication. He fled Prague for London in 1938, where he designed for Lindsay Drummond and Penguin Books. He returned to Germany in 1950 to live in East Berlin. He died in Berlin in 1968.

The use of montage as a political weapon was the major contribution of John Heartfield. He perfected the medium in posters, book design and periodicals. It allowed a juxtaposition of uncommon symbolism with changes in real scale. He could change faces over strange bodies. His humor remained original and strong. Most of his work was anti-fascist and satirical, not sympathetic or sentimental. He always startles and strikes with the viciousness of a sensitive man.

In some opposition to the blunt instruments of Heartfield, Tucholsky could mimic and copy dialogue and gesture. His was more a satire by exposition and editing of reality, which could be funny in itself if seen through Tucholsky's wise eyes. He was never a communist, but remained a writer of chants for the cabaret, a great satirist, a great critic of Weimar culture. He was the most outstanding of the independent left wing intellectuals. He had more brilliance, energy and insight into the particular challenges of his time. He worked with the Communists; this book was published by a Communist press. But he rejected dogmatic doctrinarism.

Deutschland, Deutschland über alles is Tucholsky's collected works from all his bitter attacks on the things he disliked in Germany. Some articles were written to accompany the Heartfield photographs. He attacked everything from the ugliness of mailboxes to stupid sports fanatics. He attacked the racist parties. He thought the parliament was a sleeping place. His negativism was put into humor, not impartially. Heartfield applied his radical vision to Tucholsky's attacks. The effective characterizations of the writer are made into superior satire by sensational juxtapositions of the artist.

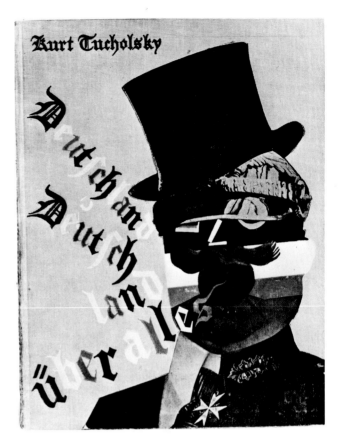

Deutschland, Deutschland über alles
text by Kurt Tucholsky
*The Parliament*
(page 138)

Whether the socialists move into the Reich's assembly—
It's all the same!
Whether Father Wirth will escape to the left,
Or whether he shuts up because of discipline—
It's all the same!
Whether the Volks Party, with their squinty eyes,
Craps in the midst of the suburbs
And the Democrats upon the bunions of the poor . . .
It's all the same!
It's all the same!
It's all the same!
With cheap talk for the city folks and farmers:
"Twelfth Hour"—Should the shame continue?
It's all the same!
Do you know who sits behind this,
Pulls the wires at each election?
Whether in the bock beer halls, the propaganda guys
Scream themselves half hoarse, sweating streams—:
It's all the same!
It's all the same!
It's all the same!
Whether executives rust completely—
It's all the same!
Whether handsome Rudi gets the secretarial post—
(It won't be cheap)
It's all the same!
Your fate, Germany, is made by industry,
Banks and shipping companies—
What a bum farce is the election!
Alert yourself, and excite to fury!
Vote, Vote! But the people's voice
It's all the same!
It's all the same!
It's all the same!

## G.B.R. VAN HOBOKEN

418/1. Tänzerin*(Dancer)*
woodcut, 1919, 10 x 8 cm., signed and dated

418/2. Liebespaar*(Pair of Lovers)*
woodcut, 1919, 9.5 x 6.5 cm., Estate stamp verso

418/3. Die Bedienerin*(The Maid Servant)*
woodcut, 1919, 6.3 x 7 cm.

418/4. Liebespaare*(Pairs of Lovers)*
woodcut, 1919, 13 x 10 cm., estate stamp verso

Loss of hearing may not affect a mature man severely if his sound memories are fixed, can be used and drawn upon after the silent world is dominant. Van Hoboken suffered partial loss of hearing as a young child, because of a severe case of scarlet fever. This lack interfered with his ambitions for various careers: that of chemist, merchant, doctor. He fell back on his early interest in drawing.

His family had emigrated from Holland to Germany in the late nineteenth century. He was born in 1893 to a family of middle class merchants. Van Hoboken retained some of the coarse honesty of the Dutch burgher.

Deafness is not only a physical but sometimes a psychological deficiency. Instinctive awarenesses of danger, flashes of color, sudden blurr of motion make seeing the focus of communication. Van Hoboken learned to study light and color, shape; and coordinate his eye with his hand. He read about the technical processes of art. He learned to see closely, interpret as well.

The young man was allowed to study art at the Knirr Academy in Munich. Out of a family of normal people, living a set pattern, the deaf boy found himself in the center of Schwabing, in a bohemian life of freedom. He became friendly with the film maker, Walter Ruttman, who later made the great film, Berlin, Symphony of a Metropolis in 1927. The two began to explore the underside of night life in Munich, the whorehouses, bars and seamy side of the southern capital.

Van Hoboken was not inducted into the army because of his hearing deficiency. He became a student revolutionary, although more an observer from street corners, a silent witness. Ruttman and Van Hoboken formed a wide circle of friends among writers and painters in Schwabing.

During this time of inner and outer exploration, Van Hoboken made these woodcuts. His women are not objects of fear to him, as with Kokoschka. They are earthy, animalistic, feminine, who perform sexual excitation, grotesqueries and pensive posing. The artist does not give any negative comment. He was no prude. Female flesh is heavy, boned, not inflated over an airy balloon, as with so many Expressionists. His technique is careful, a close survey of form and movement. He retained a humor, a sense of the ridiculous, a sympathy without mockery.

Van Hoboken composes almost as a silent film maker. He is daring with open eroticism. He fills the format with squatting female forms. He distorts to create compositional angles, but always with a sense of the real, not in a primitivistic pose. He simplifies light and dark in graphic patterning. He uses a black background as psychological phenomenon. Van Hoboken and Ruttman made an abstract film together in 1920, a forgotten work of moving planes and colors. The silent film, as it did with so many of the Expressionists, fits his interest in the play of light and concentrated, stylized movement.

He continued to "listen with his eyes." In late 1919 Van Hoboken moved to Berlin. Using his interest in chemistry to solve the technical problems of art, he opened a small private press, Hoboken-Presse. He described it as an "artists' press." Orlik and Slevogt used his services, spread his reputation among their friends in the Secession. They also renewed his interest in drawing. He became a skilled printer for Kiepenheuer, Wasmuth, Dehne, Euphorion and Sanssouci-Bücher. He was commissioned to print the etchings for Ernst Weiss's Feuerprobe, with etchings by Meidner.

Van Hoboken's friendships in Berlin grew into the left wing circles during the 1920s. He befriended Herzfelde, Heartfield, Heckendorf, Meidner, Schlichter, Oppenheimer and Steinhardt. After World War II, he emigrated to Sweden for a few years, married late in life there, and then returned to Berlin. He was now completely deaf. He became a recluse, gave up his friendships, lost interest in art. Van Hoboken died, a forgotten man on May 20, 1971.

His output was small because he spent his life devoted to printing for other artists. He made a few landscapes, with clean white lines vibrating in outline, Matisse-influenced lithographs of nudes, these erotic woodcuts and a few scenes of cabarets.

418/2.

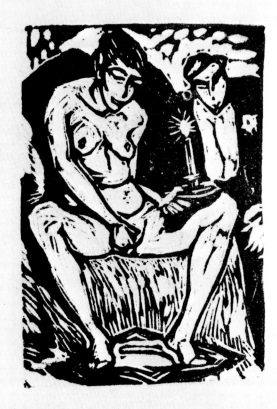

# THIRD REICH

## OFFICIAL ARTISTS

Oskar Martin Amorbach
Arno Breker
Elk Eber
Fritz Erler
Constantin Gerhardinger
Sepp Hilz
Fritz Klimsch
Georg Kolbe
Paul Mathias Padua
Josef Thorak
Adolf Wissel
Adolf Ziegler

## ENTARTETE ARTISTS
(Artists Condemned by the National Socialists)

Alexander Archipenko
Ernst Barlach
Willi Baumeister
Max Beckmann
Rudolf Belling
Georges Braque
Heinrich Campendonk
Karl Caspar
Marc Chagall
Giorgio de Chirico
Lovis Corinth
Andre Derain
Otto Dix
James Ensor
Lyonel Feininger
Conrad Felixmüller
Paul Gauguin
Ludwig Gies
Vincent van Gogh

George Grosz
Erich Heckel
Karl Hofer
Alexej von Jawlensky
Wassily Kandinsky
E. L. Kirchner
Paul Klee
Oskar Kokoschka
Käthe Kollwitz
Alfred Kubin
Marie Laurencin
Wilhelm Lehmbruck
Max Liebermann
El Lissitzky & Kabinett Abstrakten Hannover
August Macke
Franz Marc
Frans Masereel
Ewald Mataré
Ludwig Meidner
Paula Modersohn-Becker
Otto Mueller
Edvard Munch
Heinrich Nauen
E. W. Nay
Rolf Nesch
Emil Nolde
Jules Pascin
Max Pechstein
Pablo Picasso
Christian Rohlfs
Edwin Scharff
Oskar Schlemmer
Karl Schmidt-Rottluff
Georg Schrimpf

# THE THIRD REICH
### Essay by Ida Katherine Rigby

Wilhelm Hausenstein, 1920: "Expressionism, artistically has long since danced itself out...Expressionism has its Glaspalast. It has its Salon."

Ivan Goll, 1921: "Expressionism is dying."

Paul Hatvani (Vienna), 1921: "Expressionism is dead—long live Expressionism."

In 1925 Gustav Hartlaub mounted an exhibition of contemporary German art under the title Neue Sachlichkeit. Franz Roh dubbed this new style Nachexpressionismus (Post-Expressionism). By 1933 Expressionism had long since lost its elan, yet Adolf Hitler and his Propaganda Minister, Dr. Josef Goebbels, felt compelled to expunge its memory from the museums, galleries, journals, and academies. To this end they immediately mounted a vicious campaign of vilification and intimidation against modern artists, critics, museum directors, and dealers

The Nazis converged on the arts with the same all-engulfing fanaticism with which they co-opted and ordered all aspects of German life. The Nazis simultaneously lavished critical acclaim and patronage on favored mediocrities and tried ruthlessly to annihilate independent expression. Hitler recognized the utility of art in forging his community: "I am convinced," he stated, "that art, since it forms the most uncorrupted, the most immediate reflection of the life of the people's soul, exercises unconsciously the greatest direct influence upon the masses."[1]

Hitler fancied himself an artist and frequently and vehemently addressed aesthetic questions. In 1908, Hitler was rejected by the Vienna Academy in both painting and architecture. He persisted in his desire to become a painter and during the war executed small topographic sketches and designed a barracks hall mural. In retrospect he stated, "If Germany had not lost the war, I would not have become a politician, but a great architect, like Michelangelo."[2] In prison after the abortive 1923 putsch, Hitler designed party banners, emblems, and architecture. Goebbels cultivated the mystique of Hitler, "the first artist of the Reich."

On September 1, 1933 Hitler issued his first official pronouncements on art. October, 1933 saw the first "Day of German Culture" with speeches on the racial basis of the arts. At the 1935 Nuremberg Party Day Hitler gave his "Address on Art and Politics" which delineated the limits of acceptability.

So important was the cultural revolution that Hitler's earliest acts included closing the Bauhaus, launching a series of "abominations exhibitions," and urging the dismissal of independent-minded professors and museum directors. On October 1, 1932, in Dessau, the Nazi city government succeeded in dissolving the Bauhaus. The school moved to Berlin where in April it was raided by the Gestapo. There, Bauhaus students were arrested for possessing "illegal communist propaganda." On April 12 the school was provisionally closed and on the tenth of August the Bauhaus voted to disband itself.

1938

GROSSE
DEUTSCHE
KUNSTAUSSTELLUNG
1938
IM HAUS DER DEUTSCHEN
KUNST ZU MÜNCHEN
10. JULI – 16. OKTOBER 1938

OFFIZIELLER AUSSTELLUNGSKATALOG

The Schandausstellungen *(shame exhibitions)* commenced in 1933 with a large exhibition in Dresden. Lovis Corinth, Max Liebermann, and Max Slevogt were dispatched. Regierungskunst, 1918-1933 *(Government Art, 1918-1933)*, a show ridiculing Weimar Republican art policy and museum directors was launched in April, 1933 by Hans Adolf Buehler, the new director of the Badische Kunsthalle. The Brücke and Blaue Reiter in particular were the butts of attack. As new directors were appointed, Nazi policy was implemented. The Nuremberg Museum established a "Chamber of Horrors" for modern art. In 1936 the Berlin National Gallery closed its modern section.

In 1933 many faculty members were summarily dismissed from German art schools. Heinrich Campendonk and Paul Klee were fired from the Düsseldorf Academy. Max Beckmann was dismissed from the Frankfurt School of Art. Karl Hofer was expelled from the Berlin Fine Arts School over an open letter defending artistic freedom. Otto Dix was dismissed in Dresden and fled to the Black Forest. Käthe Kollwitz resigned from the Prussian Academy in protest; Max Pechstein was dismissed from the Prussian Academy. In 1933 George Grosz emigrated to America, Kandinsky fled to France, and Klee returned to his native Switzerland. In 1934 Oskar Kokoschka fled to Vienna and later to London.

Nazi party functionaries had for some time been involved in cultural affairs. In August, 1927 Alfred Rosenberg, Heinrich Himmler, and Georg Strasser founded the Kampfbund *(Battle League)* for German Culture. In March 1929 it became a mass movement and later specifically allied itself with the National Socialist Party. In 1930 Nazi minister Wilhelm Frick in Thuringia called a national meeting of the group in Weimar, and on the thirtieth of April Frick gave Germany a foretaste of Nazi policy. He banned all modern films, books, and plays, and with the aid of Paul Schultze-Naumberg, had all modern art removed from the Weimar Schlossmuseum.

With Hitler's accession to the chancellorship barely a month behind, on March 13, 1933 Hitler established Goebbels' Propaganda Ministry and Alfred Rosenberg's Ministry for the Enlightenment of the Volk and Propaganda, both charged with overseeing German cultural life. In the ensuing battle over what was to be the official "German style," classicism or expressionism, Kampfbund leader Rosenberg advocated a classical revival. Goebbels, who had written a third rate, expressionist style novel, Michael:Ein deutsches Schicksal in Tagebuchblättern *(Michael: A German Fate in Diary Form)* was pro-Expressionist and especially partial to the works of Emil Nolde and Ernst Barlach. Propaganda expediency, however, soon dictated that he promote classicism and pedestrian realism as the official German styles.

As part of the ongoing debate over the definition of German art, a group of embattled Nazi students mounted an exhibition of "Expressionist German Art" in July, 1933, which defended Barlach, Nolde and Karl Schmidt-Rottluff among others, as truly Nordic. In his September address delineating art policy Hitler carefully avoided taking sides. The Nazi Der Angriff *(The Assault)* defended Christian Rohlfs and Nolde. Even the official magazine, Die Kunstkammer *(The Art Chamber)* published articles on blacklisted artists until it was superseded in 1936 by Rosenberg's Die Kunst im Dritten Reich *(Art in the Third Reich)*.

The need to define "Nordic" art obsessed Nazi ideologues who produced volumes like Kurt Karl Eberlein's 1933 Was ist deutsch in der deutschen Kunst? *(What Is German in German Art?)*, Paul Schultze-Naumberg's seminal 1934, Kunst aus Blut und Boden *(Art Out of Blood and Soil)*, and later Wolfgang Willrich's 1937 Säuberung des Kunsttempels *(Cleansing of the Art Temple)* an unseemly assault on modernism and a celebration of the victory of a "healthy German art." "The highest idea is blood, is race, is art!" he proclaimed. He pilloried specific deviant museum directors, heretical critics and degenerate artists.

419.

419. Säuberung des Kunsttempels. Ein kunstpolitische Kampfschrift zur Gefundung deutscher Kunst im Geiste nordischer Art *(Cleansing of the Art Temple. A Battle Document of Art Politics for Healthy German Art in the Spirit of Northern Art)*
Wolfgang Willrich. 22.5 x 15.5 cm, 178 pp. (6p.)
München/Berlin: J. F. Lehmanns Verlag, 1937
Printed by E. H. Beck'schen Buchdruckerei, Nördlingen

In the battles of Kunstpolitik, Rosenberg's views prevailed because they coincided with Hitler's tastes, but Goebbels emerged all-powerful. On September 22, 1933 the Nazis consolidated state control over German cultural life by establishing the Reichkulturkammer, the RKK *(Reich Culture Chamber)* as a function of Goebbels' Propaganda Ministry. The Chamber was composed of seven sections (drama, fine arts, radio, press, literature, film, and music) and had thirty-one regional directors. The decree of November 9, 1933 which institutionalized the RKK stated that every individual who by virtue of the creation, reproduction, or execution of intellectual works, or their propagation, conservation, or sale participated in the cultural life of Germany had to register with the RKK.

Eugen Hoenig was the first president of the fine arts section and was replaced in 1936 by Hitler's favorite painter, Adolf Ziegler. By 1936 the RKK boasted 42,000 members, 14,000 of whom were artists and 15,000 architects. The fine arts section itself was divided into nine specialized groups, i.e., painting, architecture, industrial design, sculpture, etc. Membership was mandatory for all who wanted to procure the rationed materials i.e., brushes, clay, paint, etc. Before admission artists were subjected to racial, political, moral, and technical examinations, and they could be summarily dismissed for transgressions in any of these areas. In order to exhibit, an artist, dealer, or museum director had to submit an application to the RKK describing the event and presenting the racial and political pedigrees of exhibitors.

Dissidents were immediately harassed. On April 1, 1933 large placards in the Prussian Academy denouncing Karl Hofer as a "destructive, Marxist-Jewish element" exhorted students to "boycott this teacher." (In a laconic published reply, Hofer expressed his regret at being neither Jewish nor a Marxist.) The rolls of those dismissed and who resigned grew as did the ranks of emigrants. During the 1930s Kandinsky, Rudolf Belling, and Naum Gabo went to Paris; Laszlo Moholy-Nagy, Kokoschka, and Ludwig Meidner sought refuge in London; Beckmann escaped to Amsterdam. Grosz and Walter Gropius sought asylum in the United States. Campendonk fled to Belgium; Klee returned to Switzerland, and Kurt Schwitters moved to Norway to construct around himself a new Merzbau.

Oskar Schlemmer, Christian Rohlfs, Hofer, Schmidt-Rottluff, Nolde, Barlach, and Kollwitz remained and were forbidden to exhibit. Some artists were forbidden to paint. Ernst Ludwig Kirchner, Schmidt-Rottluff, Nolde and Hofer were expelled from the Prussian Academy in 1937. Events in Germany certainly contributed to Kirchner's suicide. Barlach was forced to resign from the Prussian Academy and died a broken man in 1938.

Progressive museum directors were replaced by men like the SS officer Count Baudessin whose credentials for assuming the directorship of the Essen Folkwang in 1936 included the pronouncement that: "the consumate form, the most beautiful creation...did not come from an artist's studio— it was the steel helmet worn by our marching grey columns."[3]

On March 6, 1935 the action against modern art was sharply accelerated. The Nazis announced that prior to an auction at the firm of Max Perls, the secret police had confiscated sixty-three works of "a pornographic character" by artists of the former regime. They breathlessly claimed that the quick action of the state police and the initiative shown by the Nazi cultural organizations had prevented the "shameful event" and "misuse of the word art" from taking place. The desecration of modern art was accomplished by exhibitions of official art in an effort to re-educate the public as to what was truly Germanic expression. In 1935, for example, Munich mounted an exhibition entitled Kunst aus Blut und Boden *(Art Out of Blood and Soil).*

On November 27, 1936, Goebbels issued his decree forbidding art criticism: "I forbid once and for all the continuance [of art criticism]...in its past form...a complete perversion...The reporting of art should not be concerned with values, but should confine itself to description."[4] In February, 1937 he added that critics (except for party members) had to be at least thirty years old.

By the time of this decree, the last of the independent journals had folded. Having outlived the Kunstchronik und Kunst Literatur (closed March, 1932), Der Cicerone (December, 1930), Das Kunstwanderer (December, 1932), Das Kunstblatt (March, 1933) and Kunst und Künstler (June, 1933), Kunst der Nation which had continued publishing articles on Barlach, Klee, Hofer, Kollwitz, Schlemmer, and Beckmann, among others, folded in mid-1935.

The harassment and humiliation of independent-minded artists, gallery owners, and museum directors climaxed in July, 1937 with the orgiastic "cleansing" in which over 12,000 drawings and 5,000 paintings were confisticated for the Munich Entartete Kunst *(Degenerate Art)* exhibition. It was the largest of the "degenerate art" shows calculated to incite the public against modern art. Attendance reached 20,000 on an average day and 42,000 on August 15; over two million visited the show during its four month run. The public came, not to mock the disgraced artists, but to view works which were disappearing from sight. Music received a similar treatment with modern music from jazz to Schönberg branded "decadent," and vilified in the same intemperate terms to which modern art was subjected.

420. Entartete Musik *(Degenerate Music)*
Eine Abrechnung von Staatsrat Dr. H. S. Ziegler
*(A Deduction by the Government Official Dr. H. S. Ziegler)*
Cover drawing by Ludwig Tersch (Lucky)
21.3 x 15.2 cm., 32 pp., undated (1938), published and printed by Völkischer Verlag G.m.b.H., Düsseldorf

The Entartete Kunst exhibition featured the works of leading Expressionists, Cubists, Symbolists, and Fauves crudely hung, cramped and overcrowded amidst derisive scribblings and scrawled indignant quotations of prices paid in inflated Weimar Marks by named museum directors. Scurrilous comments in the accompanying official catalogue equated modern art with the work of the deranged, inept, diseased, racially inferior, and politically subversive. Nazi critics suggested that they should "tie the artist next to his works so that every German could spit in his face."

420.

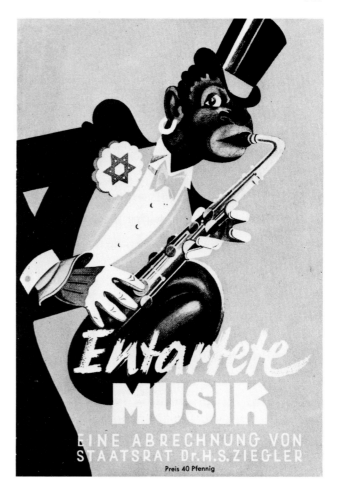

**422. Entartete Kunst** *(Degenerate Art)*
Color lithograph poster by Rudolf Hermann, 1938
117 x 82.3 cm.
Sculpture represents: "Die neue Menschen"
by Otto Freundlich
dated and titled
Printed by Mühlmeister und Johler, Hamburg

Branded as Entartete Kunst was any art which the Nazis felt fell into the following categories: Jewish (i.e., Liebermann), pacifist—unheroic—defeatist (Dix), Marxist (Novembergruppe, Bauhaus), inferior racial types (Nolde), Expressionist (Brücke), and abstract expressionist (Baumeister). The exhibition set out to explore the "degeneration of German art" by considering "infection" from foreign sources and the following categories of degeneration: "disintegration of form and color feeling," "absolute stupidity in choice of materials;" "shameless derision of every religious representation;" "the moral side of degeneration: bordellos, prostitutes;" "murdering the remnants of racial consciousness;" "idiots, cretins, and paralytics;" "Jews;" and "complete idiocy."

Alfred Rosenberg expressed the racist motivation behind these outbursts with all its malignant force: "What van Gogh, Gauguin...and Picasso had created emerged boldly...mestizoism, and mongrelization...bastardized abortions created by the syphilis of intellectual and painted infantilism...in a Berlin gone Syrian."

On July 18, 1937, in his address inaugurating Paul L. Troost's Haus der deutschen Kunst *(House of German Art),* Hitler inveighed against modern art and called for an "unremitting purification" of German cultural life. Over the door of the Haus der deutschen Kunst, Hitler had inscribed the dictum: *Art is a Mission Demanding Fanticism.* Adolf Ziegler, president of the fine arts division of the Reichskulturkammer, the next day opened the Entartete Kunst exhibition with equally fanatical fulminations against avant-garde insolence, chicanery, disease, and international cultural bolshevism.

421.

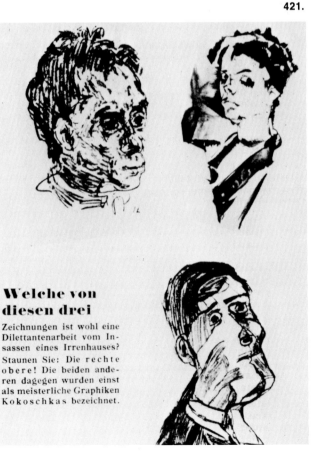

421.

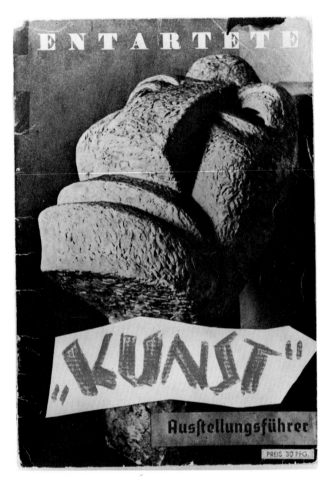

**421. Entartete "Kunst" Ausstellungsführer**
*(Degenerate Art Exhibition Guide)*
Offset lithography, 1937/1938
21 x 15 cm. 32 pp., (Responsibility for contents:
Fritz Kaiser, Munich)
Verlag für Kultur und Wirtschaftswerbung, Berlin

**Welche von diesen drei**

Zeichnungen ist wohl eine Dilettantenarbeit vom Insassen eines Irrenhauses?
Staunen Sie: Die rechte obere! Die beiden anderen dagegen wurden einst als meisterliche Graphiken Kokoschkas bezeichnet.

358

be seen by Heckel, Nolde, Kirchner, Marc (Tower of Blue Horses), Pechstein, Beckmann, Kokoschka, Kandinsky, Rohlfs, Schmidt-Rottluff, Adler, Chagall, Katz, Feininger, Otto Mueller, Hofer, George Grosz, Campendonk (spelled Kampendonck), Paula Modersohn, Klee, Otto Dix and Molzahn.

In his address, Hitler announced his victory over modernism and admonished the still obdurate that: From now on...all those mutually supporting...cliques of chatterers, dilettantes, and art forgers will be picked up and liquidated...Those prehistoric, stone age culture bearers...can return to the caves...and there apply their primitive, international scratchings...If it be a defect of vision, it is a matter for the doctor, a defect of character, a matter for the psychiatrist, if a fraud, a matter for the law, if a disease, a matter for the eugenicists.[5]

Artists too were vulnerable to the "final solution." A year later, in July, 1938, the New Burlington Galleries, London, held a protest exhibition featuring the "degenerates." Kokoschka contributed his 1937 Portrait of a Degenerate Artist; Beckmann lectured on "My Theory of Painting."

The "purification" reached a frenzied peak in March, 1939 when some 1,004 oils and sculptures and 3,835 water colors, drawings, and prints were ritualistically burned in the courtyard of the main Berlin fire station. Works which would command good international prices were saved for the summer auction in Lucerne. In 1938 the Nazis had established the Kommission Zur Verwertung der beschlagnahmten Werke Entartete Kunst *(Commission on the Value of Confiscated Works of Degenerate Art),* staffed by Nazi functionaries like Ziegler and some cooperative dealers, to determine which works could be sold abroad.

423.

422.

423. Berliner Tageblatt und Handels-Zeitung
*(Berlin Day Paper and Handels–Newspaper)*
Nr. 336-337, 66. Jahrgang, Dienstag, 20 Juli, 1937
46.7 x 53 cm., 2 f. (8 pp) Articles by Dr. Karl Korn

Translation of "Die Schau entarteter Kunst"
*(The Exhibition of Degenerate Art)*

By Dr. Karl Korn:

A walk through the special exhibition in Munich (A wire report from our special Munich correspondent), July 19, Munich.

In the arcades of the Hofgarten near the recently opened House of German Art, the exhibition of "Degenerate Art" was opened this afternoon by Professor Ziegler, the president of the Reich Chamber of the Fine Arts.

On Sunday the Führer gave his great speech on art (text published on page 5) about this new exhibition. He characterized it as a kind of anti-exhibition which should show Germans what in the new Reich under no circumstances can be called art and which will not be tolerated. The first floor of the show is over-stuffed with material. It contains a complete exhibition of paintings between 1918 and 1933. The arrangement is by themes according to the following viewpoints: Exposing the Jewish Race-Soul, Deployment Plan of Bolshevist Art, Mockery of German Women, Themes Insulting to Heroes, The Farmers Seen Through Jewish Eyes, Lunacy Become Method. So this is how sick minds saw nature. In an adjacent room large parts of Corinth's works are exhibited under the motto: "They had Four Years (to become good Nazis)." Here other painters were added.

Each picture has exact information about the former purchase price, place, and time of acquisition. Also, each picture has an added placard with the message: "Paid for by the tax money of the German working people." Single works are to

**424. Deutsche Kunst und Entartete Kunst** *(German Art and Degenerate Art)*
By Dr. Adolf Dresler
Offset lithographed catalogue, 1938
21.2 x 15.1 cm., 29 pp., Deutscher Volksverlag G.m.b.H. München, (also under name of Erika Schmauss) printed by Fritz Otto Münchmeyer, München

The despoiling of museums and galleries netted thousands of works of art. For example, the National Socialists confiscated one-hundred sculptures by Wilhelm Lehmbruck, two-hundred to three-hundred works each by Dix, Grosz, and Corinth; three-hundred – four-hundred each by Hofer, Pechstein, Barlach, Lyonel Feininger, and Otto Mueller; four-hundred by Kokoschka; five-hundred by Beckmann; nearly six-hundred and fifty each by Schmidt-Rottluff and Kirchner; seven-hundred by Erich Heckel and one-thousand by Nolde, in addition to works by the School of Paris. The Essen Folkwang and the Düsseldorf and Hamburg Museums each were robbed of over nine-hundred works and Breslau and Frankfurt lost over six-hundred each. All totalled, the Nazis destroyed 16,000 works by 1,400 artists, a far more successful pillage than any foreign conquering army could have effected.

Why these orgies of destruction, the furious outbursts and virulent denunciations, in Gottfried Benn's words, "Caesar's yap and a troglodyte's brain"?[6] They were unbridled expressions of hatred and resentment, but equally important, as calculated propaganda, they served to appease the "little man" of Hans Fallada's popular novels. From the vantage point of 1945, Jacques Barzun offered this explanation: "The condemnation of modern art…was clearly a popular policy. The lower-middle class mind was jubilant, vindicated at last in its hitherto insecure aesthetic instincts. The crazy, morbid… charlatans who had monopolized the attention of art critics… were now getting their due."[7]

Hitler's need for self-justification in face of rejection by the Vienna Academy quite unfortuitously coincided with Germany's need for national self-justification in face of humiliations by the international community. Inextricably enmeshed with Hitler's pretensions as man and dictator were the psychic needs of the defeated, dispossessed, and historically divided nation. This legacy lurked behind the bombastic, blustering, Nazi neoclassicism, a vainglorious attempt to assert the strength of the regime, a stance at once assertive and defensive.

The neoclassical style conferred legitimacy on the upstart regime and gave its citizens an image of strength and historically sanctioned respectability by clothing its heroes in the style of antiquity. The official exhibitions were dominated by this heroic neoclassicism. The Nazis also cultivated a pedestrian realism depicting simple, didactic scenes calculated to reassure and instruct during the Gleichschaltung *(the integration of German society).* A limited repertory of themes drawn from the mythology of a racist, Volk community recurred with soporific frequency in the dreary world of Nazi iconography.

Expressionism was anathema to the Nazis because it represented an attitude and advocated causes whose existence threatened the totalitarian, racist community they sought to establish. Expressionism extolled subjectivity, celebrated the individual will, was defiant and rebellious in face of authority (be it familial, institutional or ideological) and was associated with leftist political causes. The Expressionists sought to liberate the instinctual; the Nazis sought to manipulate it. The Expressionist community was cosmopolitan, the Nazis sought retrenchment into a racist, nationalist community based on the mystical ties of blood and soil.

The Expressionists deplored many of the same aspects of modern industrialized and urbanized society against which the Nazis inveighed, but as discussed previously, the Expressionists' utopia rested on the free expression of individual creativity, whereas the Nazis promoted a regimented, hierarchical, authoritarian solution which preached conformity and subordination as the bases of "real" freedom. The Expressionists conveyed their alienation from modern society in anxious, tension-ridden forms. They explored neurosis and insanity, poverty, sickness, and degradation in an intense effort to embrace the diversity of life. The Nazis used art to put forth the image of a conformist, harmonious, productive society. The Nazi facade was transparent to the Expressionists whose sense for the spurious was unerring. The Expressionists' ruthlessly probing disposition and unremitting defense of the individual's uniqueness were intolerable in the Nazi scheme of things.

In the Third Reich, in its subordination to the demands of politics and its amalgamation into the Nazi totality, art was emasculated. The powerful statements of the Brücke, the humanitarian works of Käthe Kollwitz, the probing analysis of Otto Dix, the scathing caricature of George Grosz, and the formal innovations of the Bauhaus gave way to alternately insipid or brutal, conformist works as the fine arts lent their emblem-forming power to unifying Germany in a nihilistic cause.

Dr. ADOLF
DRESLER

Foto
H. Hoffmann

**DEUTSCHE KUNST**
*und Entartete Kunst*

DEUTSCHER VOLKSVERLAG G.M.B.H.MÜNCHEN

**425.** Exhibition catalogues of the Nazi era:

**1934**

Grosse Münchener Kunstausstellung in der neuen Pinakothek Glaspalast *(Grand Munich Art Exhibition in the New Pinakothek Glasspalace) (June until October)* 18 x 12 cm., (2) 94 pp, (9) 56f illustr., Verlag Knorr und Hirth, Munich. Includes work by Karl Caspar, Julius Diez, Ludwig Dill, Josef Eberz, Fritz Erler, Will Geiger, Alfred Kubin, Richard Seewald, Toni Stadler, Max Unold, Karl Zerbe.

**1936**

Grosse Münchener Kunstausstellung, Neue Pinakothek, 27 Mai bis Oktober 18 x 12 cm., (7) 98pp., (12), 58f illustr., Verlag Knorr und Hirth Includes work by: Julius Diez, Otto Dill, Josef Eberz, Willi Geiger.

**1938**

Grosse Deutsche Kunstausstellung in Haus der deutschen Kunst zu München, 10 Juli-16 Oktober, 1938
Verlag F. Bruckmann KG, Munich
21 x 15 cm, 98 pp (1) 79f illustr. (36)
Introduction by Dr. Hans Reiner
Includes works by: Ludwig Dill, Gulbransson, Klemm, Georg Kolbe, Thöny.

**1939**

Grosse Deutsche Kunstausstellung im Haus der deutschen Kunst zu München, vom 16 Juli-15 Oktober 1939, Verlag Knorr und Hirth
21 x 15 cm. ,95 pp(1) 78f illustr. (34)
Includes above artists

After the Beginning of the War:

**1940**

Grosse Deutsche Kunstausstellung im Haus der deutschen Kunst zu München
21 x 15 cm., 109 pp (1f), 68f illustr. (42).
Some war art plus the above.

**1941**

Grosse Deutsche Kunstausstellung im Haus der deutschen Kunst zu München
Verlag F. Bruckmann, 21 x 15 cm., 91 pp, (2f) 65f illustr. (60).

**1942**

Grosse Deutsche Kunstausstellung im Haus der deutschen Kunst zu München
Verlag F. Bruckmann, 21 x 15 cm., 81 pp, (4) 65f illustr. (32).

**1943**

Grosse Deutsche Kunstausstellung im Haus der deutschen Kunst zu München
21 x 15 cm., 81 pp, (3f) 64f illustr. (44).
Includes the usual artists plus a new addition of German war artists, later publisher Lothar Günther Buchheim.

**NOTES**

1. Norman H. Baynes, ed., The Speeches of Adolf Hitler: April 1922–August 1939, Vol. I (New York, 1969), p. 574.

2. Hellmut Lehmann-Haupt, Art under a Dictatorship (New York, 1954), p. 47.

3. Entartete Kunst, offprint of original guide book (München, Verlag Y. Fongi, 1969), on jacket.

4. Franz Roh, German Art in the Twentieth Century (Greenwich, Connecticut, 1968) p. 152.

5. Die Kunst im Dritten Reich (July, 1937): 61ff.

6. Victor Miesel, ed., Voices of German Expressionism (Englewood Cliffs, 1970), p. 190.

7. Jacques Barzun; "On Nazi Art," Magazine of Art, Oct. 1945, page 211.

Note:

Translations appearing with numbered items are by Orrel P. Reed, Jr.

# BIBLIOGRAPHY

Titles, except for artists' names, are divided by subject matter. Books are listed under the category which proved most important in my research.

This bibliography lists only those books which are in the library of the Robert Gore Rifkind Collection, except some references from the two chapters by Ida Rigby.

## CULTURAL BACKGROUND

Bigelow, Poultney. Prussian Memories. New York: Putnams, 1915.

Döblin, Alfred. Berlin-Alexanderplatz. Olten: Walther, 1961.

Edman, Erwin. The Contemporary and his Soul. New York: Cape and Smith, 1931.

Friedrich Otto. Before the Deluge. New York: Harper and Row, 1972.

Garland, Henry & Mary. The Oxford Companion to German Literature. Clarendon: Oxford, 1976.

Gay, Peter. Weimar Culture. New York: Harper and Row, 1968.

Goldwater, Robert. Primitivism and Modern Art. New York: Random House, 1967.

Jackson, Holbrook. The Eighteen Nineties. Hammondsworth: Penguin Books, 1950.

Janik, Allan & Toumlin, Stephen. Wittgenstein's Vienna. New York: Simon and Schuster, 1973.

Kessler, Count Harry. In the Twenties. The Diaries of Harry Kessler. New York: Holt, Rinehart and Winston, 1971.

Kosch, Adolf. Körperbildung-Nackt Kultur. Leipzig: Oldenburg, 1924.

Koestler, Arthur. Arrow in the Blue. London: Macmillan, 1969.

Kohn, Hans. The Mind of Germany. New York: Harper and Row, 1960.

Lacqueur, Walter. Weimar. A Cultural History. New York: Putnam, 1974.

Masur, Gerhard. Prophets of Yesterday. New York: Macmillan, 1961.

——. Imperial Berlin. New York: Basic Books, 1971.

Nietzsche, Friedrich. The Use and Abuse of History. Translated by Adrian Collins. Indianapolis- New York: Bobbs-Merrill, 1957.

Pehnt, Wolfgang. Die Architecktur des Expressionismus. Teufen: Niggli, 1973.

Pinson, Koppel S. Modern Germany. New York and London: Macmillian, 1966.

Raabe, Paul. The Era of German Expressionism. Woodstock: Overlook, 1974.

Schoenberner, Franz. The Inside Story of an Outsider. New York: Macmillan, 1949.

——. Confessions of a European Intellectual. New York, London: Macmillan, 1965.

Szatmarie, Eugen. Das Buch von Berlin. München: R. Piper, 1927.

Tuchman, Barbara. The Proud Tower. New York: Macmillan, 1966.

Wichmann, Siegfried & others. Weltkulturen und moderne Kunst. München: F. Bruckmann, 1972.

Willett, John. Expressionism. New York, Toronto: Macmillan, 1970.

## EARLY BACKGROUND

Bott, Gerhard. Dokumentation-Pan. Berlin: Gebrüder Mann, 1970. 2 vols.

Cassou, Jean, Jangui, Emil & Pevsner, Nikolaus. Gateway to the Twentieth Century. New York, Toronto, London: McGraw Hill, 1962.

Der Verkehr. Jahrbuch des deutschen Werkbundes. Jena: Diederichs, 1914.

Die Durchgeistigung des deutschen Arbeit. Jahrbuch des deutschen Werkbundes. Jena: Diederichs, 1912.

Die Kunst in Industrie und Handel. Jahrbuch des deutschen Werkbundes. Jena: Diederichs, 1913.

Hamann, Richard. Stilkunst um 1900. Berlin: Akademie der Künste, 1967.

Hermand, Jost. Jugendstil, ein Forschungsbericht. 1918-1964. Stuttgart: Metzler, 1965.

Hofmann, Werner. Grundlagen der Modernen Kunst. Stuttgart: Kröner, 1966.

Hofstätter, Hans H. Jugendstil Druckkunst. Baden-Baden: Holle, 1968.

Madsen, Stephan Tsudi. Sources of Art Nouveau. New York: Wittenborn, 1956.

Nebehay, Christian M. Ver Sacrum. 1898-1903. Wien: Tusch, 1975.

Pevsner, Nikolaus. Pioneers of Modern Design from William Morris to Walter Gropius. Hammondsworth: Penguin, 1949.

——. The Sources of Modern Architecture and Design. New York: Praeger, 1968.

Powell, Nicolas. The Sacred Spring. London: Studio Vista, 1974.

Reisner, Karl August. Graphik des deutschen Jugendstils. Düsseldorf: Rheinland, 1972.

Schmutzler, Robert. Art Nouveau. New York: Abrams, 1964.

Selz, Peter. Art Nouveau. Art and Design at the Turn of the Century. New York: Museum of Modern Art, 1959.

Sterner, Gabriele. Jugendstil. Köln: M. DuMont Schauberg, 1975.

Vergo, Peter. Art in Vienna. London: Phaidon, 1975.

Waissenberger, Robert. Wien und die Kunst in unserem Jahrhundert. Wien-München: Verlag Für Jugend und Volk, 1965.

Wick, Peter & Garvey, Eleanor M. The Turn of the Century. Cambridge: Harvard University, 1970.

Exhibition. Wien um 1900. Wien: Der Stadt, 1964.

Exhibition. Wiener Secession Druckgraphik 1897-1972. Wien: Wiener Secession, 1972.

## POSTERS

Barnicoat, John. A Concise History of Posters. 1870-1970. New York: Harry N. Abrams, 1972.

Chipp, Herschel B. Jugendstil and Expressionism in German Posters. Exhibition. Berkeley, University of California, 1966.

Darracott, Joseph. The First World War in Posters. New York: Dover, 1974.

Gagel, Hanna. Studien zur Motivgeschichte des deutschen Plakats. 1900-1914. Dissertation. Berlin: Freie Universität, 1971.

Gallo, Max. The Poster in History. New York: American Heritage, 1974.

Hillier, Bevis. Posters. New York: Stein and Day, 1969.

Koschatzky, Walter & Kossatz, Horst-Herbert. Ornamental Posters of the Vienna Secession. New York: St. Martin's, 1974.

Misch, Katherine C. Die Brücke. Posters. Unpublished Dissertation. Berkeley: University of California, 1969.

Das politische Plakat der Welt. Ausstellung. Essen: Deutsches Plakat-Museum, 1973.

Rademacher, Helmut. Masters of German Poster Art. New York: Citadel, 1966.

Spielmann, Heinz. Internationale Plakate. 1871-1971. Ausstellung. München: Haus der Kunst, 1971-1972.

Wember, Paul. Die Jugend der Plakate. 1887-1917. Krefeld: Scherpe, 1966.

## EXPRESSIONISM

Bahr, Hermann. Expressionismus. München: Delphin, 1920.

Behne, Adolf. Die Wiederkehr der Kunst. Leipzig: Kurt Wolff, 1919.

Bethge, Hans. Worpswede. Berlin: Bard. Marquardt, u.d. [1901].

Buchheim, Lothar Günther. The Graphic Art of German Expressionism. New York: Universe, 1960.

Cheney, Sheldon. Expressionism in Art. New York: Liveright, 1958.

Chipp, Herschel B. & others. Theories of Modern Art. Berkeley, Los Angeles: University of California, 1973.

Coellen, Ludwig. Die Neue Maler. München: E.W. Bonsels, 1912.

Däubler, Theodor. Der neue Standpunkt. Leipzig: Insel, 1919.

Deckelmann, Heinrich. Die neue Zeit. Berlin: Weidemannsche, 1930.

Deri, Max. Die neue Malerei. Leipzig: Seemann, 1921.

——& others. Einführung in die Kunst der Gegenwart. Leipzig: Seemann, 1922.

Dube, Wolf-Dieter. Expressionismus. New York, Washington: Praeger, 1973.

Einstein, Carl. Die Kunst des 20. Jahrhunderts. Propyläen-Kunstgeschichte XVI. Berlin: Propyläen, 1926.

Evers, Hans-Gerhard, ed. Zeugnisse der Angst in der modernen Kunst. Ausstellung. Darmstadt: Mathildenhöhe, 1963.

Fechter, Paul. Der Expressionismus. München: R. Piper, 1919.

Feist, Günter & Ursula. Kunst und Künstler. Mainz: Florian Kupferberg, 1971.

Fincke, Ulrich. German Painting. London: Thames and Hudson, 1974.

Fischer, Otto. Das neue Bild. München: Delphin, 1912.

Gallwitz, S.D. Dreissig Jahr Worpswede. Bremen: Angelsachsen, 1922.

Gerold, Karl Gustav. Deutsche Malerei unserer Zeit. Wien-München-Basel: Kurt Desch, 1956.

Grautoff, Otto. Formzertrümmerung und Formaufbau in der bildenden Kunst. Berlin: Wasmuth, 1919.

Gutbrod, Karl. Künstler schrieben an Will Grohmann. Köln: M. DuMont Schauberg, 1968.

Hamann, Richard. Kunst und Kultur der Gegenwart. Marburg: Kunst-geschichtl. Seminar, 1922.

Hartlaub, G. F. Die neue deutsche Graphik. Tribune der Kunst und Zeit XIV. Berlin: Erich Reiss, 1920.

——. Der Genius im Kinde. Breslau: Ferdinand Hirt, 1922.

——. Kunst und Religion. Leipzig: Kurt Wolff, 1919.

Hausenstein, Wilhelm. Über Expressionismus in der Malerei. Tribune der Kunst und Zeit II. Berlin: Erich Reiss, 1919.

——. Zeiten und Bilder. München: "Der neue Merkur," 1919.

Herbert, Robert L., ed. Modern Artists on Art. Englewood Cliffs: Prentice-Hall, 1964.

Hildebrandt, Hans. Der Expressionismus in der Malerei. Stuttgart & Berlin, Deutsche, 1919.

Hoog, Michel & Reidemeister, Leopold. Der französische Fauvismus und der deutsche Frühexpressionismus. Ausstellung. Paris: Musee National d'Art Moderne & München: Haus der Kunst, 1966.

Huebner, F.M. Europas neue Kunst und Dichtung. Berlin: Rowohlt, 1920.

Justi, Ludwig. Neue Kunst. Berlin: Julius Bard, 1921.

Knauf, Erich. Empörung und Gestaltung. Berlin: Gutenberg, 1929.

Knevels, Wilhelm. Expressionismus und Religion. Tübingen: J.C.B. Mohr (Paul Siebeck), 1927.

Kuhn, Charles L. German Expressionism and Abstract Art. Cambridge: Harvard University, 1957.

Lamm, Albert. Ultra-Malerei. München: Georg Callwey, 1912.

Landau, Rom. Der unbestechliche Minos. Hamburg: Harder, 1925.

Landsberger, Franz. Impressionismus und Expressionismus. Leipzig: Klinkhardt & Biermann, 1920.

Lauterbach, Heinrich. Poelzig, Endell, Moll und die Breslauer Kunstakademie 1911-1932. Ausstellung. Berlin: Akademie der Künste, 1965.

Märker, Friedrich. Lebensgefühl und Weltgefühl. München: Delphin, 1920.

Martin, Kurt. München 1869-1958. Aufbruch zur modernen Kunst. Ausstellung. München: Haus der Kunst, 1958.

Marzynski, Georg. Die Methode des Expressionismus. Leipzig: Klinkhardt & Biermann, 1920.

Miesel, Victor ed. Voices of German Expressionism. Englewood Cliffs: Prentice-Hall, 1970.

Myers, Bernard S. The German Expressionists. New York: Praeger, 1957.

Otten, Karl. Expressionismus-grotesk. Ausstellung. Zürich: Verlag die Arche, 1962.

Pfister, O. Der psychologische und biologische Untergrund des Expressionismus. Bern-Leipzig: Ernst Bircher, 1920.

Picard, Max. Expressionistische Bauernmalerei. München: Delphin, 1922.

Raabe, Paul. Der Ausgang des Expressionismus. Biderach an der Riss: Biderach, 1966.

Reidemeister, Leopold. Der Sturm. Herwarth Walden und die Europäische Avantgarde. Berlin: Nationalgalerie in der Orangerie des Schlosses. Charlottenburg, 1961.

Rilke, Rainer Maria. Worpswede. Bielefeld und Leipzig: Belhagen & Klasing, 1910.

Roessler, Arthur. Zur Kunst und Kulturkrise der Gegenwart. Wien: Rudolf M. Rohrer, 1947.

Roh, Franz. German Art in the 20th Century. Greenwich: New York Graphic Society, 1968.

Sakheim, Arthur. Expressionismus-Futurismus-Aktivismus. Hamburg: Bimini, 1919.

Sauerlandt, Max. Die Kunst der letzten 30 Jahre. Berlin: Rembrandt, 1935.

Scheffler, Karl. Sittliche Diktatur. Berlin: Deutsche, 1920.

Schiefler, Gustav. Meine Graphiksammlung. Hamburg: Christians, 1974.

Selz, Peter. German Expressionist Painting. Berkeley, Los Angeles: University of California, 1957.

Sotriffer, Kristian. Expressionism and Fauvism. New York, Toronto: McGraw-Hill, 1972.

Stappenbach, Susi. Die deutschen literarischen Zeitschriften in den Jahren 1918-1925 als Ausdruck geistiger Strömungen der Zeit. Innaugural dissertation. Erlagen-Nürnberg: Friedrich-Alexander-Universität, 1961.

Sydow, Eckart von. Die deutsche expressionistische Kultur und Malerei. Berlin: Furche, 1920.

Tietze, Hans. Lebendige Kunstwissenschaft. Zur Krise der Kunst und der Kunstgeschichte. Wien: Krystall, 1925.

Tuchman, Maurice. Van Gogh and Expressionism. New York: Solomon R. Guggenheim Museum, 1964.

Vogt, Paul. Geschichte der deutschen Malerei im 20. Jahrhundert. Köln: M. DuMont Schauberg, 1972.

Walden, Nell. Herwarth Walden. Ein Lebensbild. Berlin und Mainz: Florian Kupferberg, 1963.

———& Schreyer, Lothar, ed. Der Sturm. Baden-Baden: Woldemar Klein, 1954.

Walden, Herwarth. Gesammelte Schriften. Erster Band. Kunstkritiker und Kunstmaler. Berlin: Der Sturm, 1916.

———. Einblick in Kunst. Berlin: Der Sturm, 1917 & 1924.

Wedderkop, H. von. Deutsche Graphik des Westens. Weimar: Feuer, 1922.

Westheim, Paul, ed. Künstlerbekenntnisse. Berlin: Propyläen, u.d. [1926].

———. Die Welt als Vorstellung. Potsdam-Berlin: Gustav Kiepenheuer, 1923.

———. Für und Wider. Potsdam: Gustav Kiepenheuer, 1919.

———. Helden und Abenteurer. Berlin: Hermann Reckendorf, 1931.

Wietek, Gerhard & others. Künstlerkolonien und Künstlerorte. München: Karl Thiemig, 1976.

Yamada, Chisaburoh and Keller, Horst. Der deutsche Expressionismus. Ausstellung. Tokyo: National-museum für Westliche Kunst, 1971.

## DIE BRÜCKE

Arntz, Wilhelm Friedrich & Rüdlinger, Arnold. Ausstellung. Bern: Kunsthalle, 1948.

Bolliger, Hans und Kornfeld, Eberhard. Ausstellung Künstlergruppe Brücke. Jahresmappen 1906-1912. Berne: Klipstein und Kornfeld. 1958.

Brücke-Archiv. Berlin: Brücke-Museum, u.d. [1967] Heft 1. Wentzel, Hans. "Zu den Frühen Werken der 'Brücke'-Künstler." Krüger, Günter. "Glasmalereien der 'Brücke'-Künstler." Reidemeister, Leopold. "Die 'Brücke' im Spiegel der Zeitschriftenkritik."

Brücke-Archiv. Berlin: Brücke-Museum, 1968/69. Heft 2/3. Wietek, Gerhard. "Der finnische Maler Axel Gallén-Kallela als Mitglied der 'Brücke'."

Krüger, Günter. "Fritz Bleyl. Beiträge zum Werden und Zusammenschluss der Künstlergruppe 'Brücke'. Eckhardt, Ferdinand. "Walter Gramatté und die Maler der 'Brücke'."

Brücke-Archiv. Berlin: Brücke-Museum, 1970. Heft 4.Kaus, Max. "Mit Erich Heckel im Ersten Weltkrieg." Morwitz, Ernst. "Auf die Madonna von Ostende." Kerschbaumer, Anton. "Beziehungen zu Heckel." Herbig, Otto. "Erinnerungen an Erich Heckel."

Brücke-Archiv. Berlin: Brücke-Museum, 1971. Heft 5. Reidemeister, Leopold. "Erich Heckel. Aquarelle als Vorstudien zu Bildern."

Brücke-Archiv. Berlin: Brücke-Museum, 1972/73. Heft 6. Dürrson, Werner. "Begegnung mit Erich Heckel." Heise, Carl Georg. "Kirchner-Anekdoten." Huth, W.R. "Erinnerungen an Max Pechstein." Heise, Carl Georg. "Begegnungen mit Emil Nolde." Camaro, Alexander. "Erinnerungen an Otto Mueller. Aus meinem Tagebuch Breslau." Knoch, Eberhard. "Erinnerungen an Otto Mueller."

Buchheim, Lothar Günther. Die Künstlergemeinschaft Brücke. Feldafing: Buchheim, 1956.

Dube, Wolf-Dieter & Pee, Herbert. Die Künstlergruppe "Brücke" und der deutsche Expressionismus. Sammlung Buchheim. Katalog 1. Feldafing: Buchheim, 1973.

Larson, Philip. "Brücke Primitivism: The Early Figurative Woodcuts." Print Collectors Newsletter. Jan-Feb., 1976

Pee, Herbert & Laske, Katja. Die Künstler-gruppe "Brücke" und der deutsche Expressionismus. Sammlung Buchheim. Katalog II. Feldafing: Buchheim, 1973.

Peters, Hans Albert. Maler suchen Freunde. Köln: Wallraf-Richartz Museum, 1971.

Rathke, Ewald. Graphik der Brücke. Köln: Dom Galerie, 1965.

Reidemeister, Leopold. Künstler der Brücke an der Moritzburger Seen. 1909-1911. Ausstellung. Berlin: Brücke-Museum, 1970.

———. Künstler der 'Brücke.' Ausstellung. Schaffhausen: Museum zu Allerheiligen, 1972.

Reinhardt, Georg. "Die Brücke in Bonn. Friedrich Cohen." In: Das Rheinische Landesmuseum, Bonn, Nr. 50, 1975.

Urban, Martin. Brücke. 1905-1913. Ausstellung. Essen: Museum Folkwang, 1958.

Wingler, Hans Maria. Die Brücke. Kunst im Aufbruch. Feldafing: Buchheim, 1954.

## DER BLAUE REITER

Buchheim, Lothar Günther. Der Blaue Reiter. Feldafing: Buchheim, 1959.

Gollek, Rosel. Der Blaue Reiter im Lenbachhaus. München: Prestel, 1974.

Hanfstaengl, Erika. Der Blaue Reiter. Ausstellung. München: Städische Galerie, 1971.

Lankheit, Klaus. The Blaue Reiter Almanac. New York & München: Viking & R. Piper, 1974.

———. Der Blaue Reiter und sein Kreis. Ausstellung. Villingen,-Schwenningen: Beethovenhaus, 1975.

Orlandini, Marisa Volpi. Kandinsky und der Blaue Reiter. München: Schuler, 1973.

Roethel, Hans Konrad. The Blue Rider Group. Exhibition. London: The Tate Gallery, 1960.

———. The Blue Rider. New York, Washington: Praeger, 1971.

## NEUE SACHLICHKEIT & REALITY.

Lauenroth, Heinz R. Neue Sachlichkeit in Hannover. Austellung. Hannover: Kunstverein, 1974.

Roh, Franz. Nach-Expressionismus. Leipzig: Klinkhardt & Biermann, 1925.

Schmalenbach, Fritz. Die Malerei der "Neuen Sachlichkeit." Berlin: Gebr. Mann, 1973.

Schmied, Wieland. Neue Sachlichkeit und Magischer Realismus in Deutschland. 1918-1933. Hannover: Fackelträger-Verlag Schmidt-Küster, 1969.

Schneede, Uwe & others. Realismus 1919-1933. Stuttgart: Württemberger Kunstverein, 1971.

Weiermair, Peter. Aspekte der neuen Sachlichkeit. Innsbruck: Galerie in Taxispalais, 1972.

## BAUHAUS

Bauhaus 1919-1928. Boston: Charles T. Branford, c. 1938.

———. 50 Jahre Bauhaus. Stuttgart: Württemberger Kunstverein, 1968.

———. Concepts of the Bauhaus. Cambridge: Harvard University, 1971.

Emge, August. Die Idee des Bauhauses. Leipzig: Pan, 1924.

Grohmann, Will. "Das Bauhaus." In: Das Kunstblatt. Jahrgang 11, 1928.

Kröll, Friedhelm. Bauhaus 1919-1933. Düsseldorf: Bertelsmann Universität, 1974.

Lang, Lothar. Das Bauhaus, 1919-1933, Idee und Wirklichkeit. Berlin: Zentralistitut für Formgestaltung, 1965.

Moholy-Nagy, Laszlo. Vision in Motion. Chicago: Paul Theobald, 1965.

Muche, Georg. Blickpunkt/Sturm, Dada, Bauhaus. Gegenwart. München: Langen-Müller, 1961.

Poling, Clark V. Bauhaus Color. Atlanta: High Museum of Art, 1976.

Roters, Eberhard. "Maler am Bauhaus." In: Die Kunst Unser Zeit. Band 18, 1965.

Thwaites, John A. "Bauhaus Painters and the New Style Epoch."In: Art Quarterly, 1951, pages 19-32.

Wingler, Hans The Bauhaus. Weimer. Dessau. Chicago. Cambridge: M.I.T., 1969.

## DADA

Artaud, Antonin. L'Art et la Mort. Paris: Denoël, 1929.

Ball, Hugo. Flight Out of Time. New York: Viking, 1974.

Bolliger, Hans, Janco, Marcel & Verkauf, Willy. Dada. Teufen AR: Arthur Niggli, 1965.

Dada: Dokumente einer Bewegung. Düsseldorf: Kunsthalle, 1958.

Dada 1916-1966. Köln: Vogel and Besemer, 1966.

Dada in Italy. Milano: Galleria Schwarz, 1966.

Dada. Paris & Zurich: Kunsthaus & Musée National d'Art Moderne, 1966-1967.

Huelsenbeck, Richard. En avant dada: Die Geschichte des Dadaismus. Hannover: Steegemann, 1920.

———"Dada Lives." In: Transition. Fall, 1936. Motherwell, Robert. ed. The Dada Painters and Poets. An Anthology. New York: Wittenborn, Schultz, 1951.

Richter, Hans. Dada. Art and Anti-Art. London: Thames and Hudson, 1965.

Rubin, William S. Dada and Surrealist Art. New York: Abrams, 1968.

Schifferli, Peter, ed. Die Geburt des Dada: Dichtung und Chronik der Gründer. Zurich: Der Arche, 1957.

Verkauf, Willy. ed. Dada: Monograph of a Movement. New York: George Wittenborn, 1957.

## PRINTING, ILLUSTRATION & BIBLIOGRAPHY

Barge, Hermann. Geschichte der Buchdruckerkunst. Leipzig: Philipp Reclam jun., 1940.

Bland, David. A History of Book Illustration. Cleveland, New York: World, 1958.

Die. Bücherkiste, Blätter für Freunde des Buches und der zeichnenden Künste. München: Horst Stobbe, 1920, 1923, 1924, 1925, 1926/27. 5 vols.

Cohen, Arthur. The Book Stripped Bare. Exhibition. Hempstead: Hofstra University Library, 1973.

Deutsche Bibliophilie in drei Jahrzehnten. Leipzig: Gesellschaft der Freunde der deutschen Bücherei, 1931.

Ehmcke, F.H. Drei Jahrzehnte Deutscher Buchkunst. 1890-1920. Berlin: Euphorion, 1922.

Hofer, Philip & Garvey, Eleanor M. The Artist and the Book. 1860-1960. Boston: Museum of Fine Arts & Harvard College Library, 1972.

Imprimatur. Hamburg: Gesellschaft der Bücherfreunde, 1934.

Imprimatur. Hamburg: Gesellschaft der Bücherfreunde, 1935.

Imprimatur. Weimar: Gesellschaft der Bibliophilen, 1938.

Imprimatur. Hamburg: Gesellschaft der Bibliophilen, 1950-1951.

Imprimatur. Frankfurt a./M.: Gesellschaft der Bibliophilen, 1961-62.

Lang, Lothar. Expressionist Book Illustration in Germany. 1907-1927. Greenwich: New York Graphic Society, 1976.

Lewis, John. The Twentieth Century Book. London: Studio Vista, 1967.

Perkins, G. C. Expressionismus. Eine Bibliographie zeitgenössischer Dokumente. 1910-1925. Zürich: Verlag für Bibliographie, 1971.

Pommeranz-Liedtke, Gerhard. Der graphische Zyklus. Berlin: Deutsche Akademie der Künste. 1956.

Raabe, Paul (& Greve, H.L.). Expressionismus. Literatur und Kunst. 1910-1923. Ausstellung. Marbach a. N.: Schiller-Nationalmuseum, 1960.

———.Die Zeitschriften und Sammlungen des literarischen Expressionismus. 1910-1921. Stuttgart: J.B. Metzlersche, 1964.

———. Index Expressionismus. Nendeln: Kraus-Thompson, 1972. 8 Volumes.

Rodenberg, Julius. Deutsche Pressen. Zürich-Wien-Leipzig: Amalthea, 1925.

Schauer, Georg Kurt. Deutsche Buchkunst 1890 bis 1960. 2 volumes. Hamburg: Maximillian-Gesellschaft, 1963.

———. Internationale Buchkunst in 19. und 20. Jahrhundert. Ravensberg: Otto Maier, 1965.

Schlawe, Fritz. Literarische Zeitschriften. 2 volumes. Teil 1: 1885-1910; Teil 2: 1910-1933. Stuttgart: J.B. Metzlersche, 1965.

Steinberg, S.H. Five Hundred Years of Printing. Middlesex, Baltimore: Penguin, 1961.

Wheeler, Monroe. Modern Painters and Sculptors as Illustrators. New York: Museum of Modern Art, 1936.

Williamson, Hugh. Methods of Book Design. London, New York, Toronto: Oxford, 1956.

Wilpert, Gero & von Gühring, Adolf. Erstausgaben deutscher Dichtung. 1600-1960. Stuttgart: Alfred Kröner, 1967.

## PUBLISHERS

Becher, Johannes R. "Bericht des ersten Verlagers." In: Sinn und Form. Berlin, 1960.

Bücher des Verlages F. Bruckmann. München: F. Bruckmann, 1928.

Der Almanach der Neuen Jugend auf das Jahr 1917. Berlin: Verlag Neue Jugend, 1917.

Herzfelde, Wieland. Der Malik-Verlag. 1916-1947. Ausstellungs-katalog. Berlin: Deutsche Akademie der Künste zu Berlin, 1966.

Hintermeier, Mara & Raddatz, Fritz J., ed. Rowohlt Almanach. 1908-1962. Reinbek bei Hamburg: Rowohlt, 1962.

Jung, Franz. Der Weg nach Unten. Neuweid: Luchterhard, 1961.

Meyer, Jochen. Der Paul Steegemann Verlag.
Stuttgart: Fritz Eggert, 1975.

Mierendorff, Carlo. Literarische Schriften.
Darmstadt: Darmstädter, 1947.

Oschilewski, Walther Georg. Eugen Diederichs und
sein Werk. Jena: Diederichs, 1936.

Piper, Klaus, ed. Stationen. Piper Almanach 1904-1964
München: R. Piper, & Co., 1964.

Schauer, Georg Kurt. Die Buchgestaltung des
S. Fischer Verlags. 75. Jahr Almanach. Frankfurt a/M.:
S. Fischer, 1961.

60. Jahr Eugen Diederichs.
Düsseldorf/Köln: Diederichs, 1956.

Szittya, Emil. Das Kuriositäten Kabinett.
Constance: See, 1923.

Verzeichnis aller Veröffentlichungen des
Insel-Verlags. 1899-1924. Leipzig: Insel, 1924.

Wolff, Kurt. Autoren. Bücher. Abenteuer.
Berlin: Waggenbach, 1965.

## LITERARY BACKGROUND

Abrahamsen, David. The Mind and Death of a Genius
(Otto Weininger). New York: Columbia, 1946.

Eckhardt, Wolf Von & Gilman, Sander L. Bertolt
Brecht's Berlin. Garden City: Doubleday, 1974.

Eisner, Lotte H. The Haunted Screen. Berkeley and
Los Angeles: University of California, 1969.

Gray, Ronald. The German Tradition in Literature.
Cambridge: Cambridge University, 1965.

Hamburger, Michael. Reason and Energy. Studies in
German Literature. New York: Grove, 1957.

Hill, Claude & Ley, Ralph. The Drama of German
Expressionism. A Bibliography. New York: AMS, 1966.

Hofmannsthal, Hugo von. Selected Prose.
New York: Pantheon, 1952.

Iggers, Wilma A. Karl Krauss.
The Hague: Matinus Nijhoff, 1967.

Innes, C.D. Erwin Piscator's Political Theater.
London: Cambridge University, 1972.

Kerr, Alfred. Die Welt im Drama.
Köln: Kiepenheuer und Witsch, 1964.

Krakauer, Siegfried. From Caligari to Hitler.
Princeton: Princeton University, 1947.

Krell, Max. Die Entfaltung, Novellen an die Zeit.
Berlin: Ernst Rowohlt, 1921.

Krojanker, Gustav, Juden in der deutschen Literatur.
Berlin: Welt, 1922.

Kurtz, Rudolf. Expressionismus und Film.
Berlin: Lichtbühne, 1926.

Meyer, Alfred Richard. Die Maler von der Musa
Expressionistica. Düsseldorf und Kaiserswerth, 1948.

Pauley, Ernst. 20 Jahr Cafe des Westens. Berlin:
Labisch, 1913-1914.

Pfemfert, Franz. Das Aktionsbuch.
Berlin: Wochenschrift die Aktion, 1917.

Pinthus, Kurt. Menschheitsdämmerung.
Berlin: Ernst Rowohlt, 1920.

———. Die neue Dichtung. Ein Almanach.
Leipzig: Kurt Wolff, 1918.

Piscator, Erwin. Das Politische Theater.
Berlin: Adelbert Schultz, 1929.

Poor, Harold. Kurt Tucholsky and the Ordeal of
Germany. 1914-1935. New York: Scribners, 1968.

Rühl, Jürgen. Literature and Revolution.
New York: Praeger, 1967.

Samuel, Richard and Thomas R. Hinton.
Expressionism in German Life, Literature and
the Theater. Philadelphia: Albert Saifer, 1971.

Shaw, Leroy R. The Playwright and Historical Change.
Madison: University of Wisconsin, 1970.

Soergel, Albert and Hohoff, Curt. Dichtung und
Dichter der Zeit. Düsseldorf: August Bagel, 1964.

Sokel, Walter H., ed. An Anthology of German
Expressionist Drama. New York: Doubleday, 1964.

———. The Writer in Extremis. Stanford: Stanford
University, 1968.

Wellwarth, George E., ed. German Drama Between the
Wars. New York: E.P. Dutton, 1974.

Wolfenstein, Alfred., ed. Die Erhebung.
Berlin: S. Fischer, 1919 & 1920, 2 vols.

## POLITICS & CULTURE

Altmeier, Werner. Die Bildende Kunst des deutschen
Expressionismus im Spiegel der Buch und Zeits-
chriften Publikationen zwischen 1910 und 1925. Zur
Debatte um ihre Ziele, Theorien und Utopien.
Inaugural dissertation. Saarbrücken: Universität des
Saarlandes, 1972.

Angress, Werner T. Stillborn Revolution.
Princeton: Princeton University, 1963.

Barzun, Jacques. "On Nazi Art." In: Magazine of Art.
October, 1945, pg. 211.

Baynes, Norman H., ed. The Speeches of
Adolf Hitler. April 1922 – August 1939.
New York: 1969.

Bishoff, William L. Artists, Intellectuals and Revolu-
tion. Munich, 1918-1919. Unpublished Doctoral Disser-
tation. Harvard, 1970.

Brenner, Hildegard. Die Kunstpolitik des National-
Sozialismus. München: Rowohlt Taschenbuch, 1963.

Dahrendorf, Rolf. Society and Democracy in Germany.
Garden City: Doubleday, 1969.

Fishman, Sterling. Prophets, Poets and Priests. A
Study of the Men and Ideas that Made the Munich Rev-
olution of 1918/1919. Doctoral Dissertation. University
of Wisconsin, 1960.

Grohmann, Will. "Zehn Jahre Novembergruppe."
In: Kunst der Zeit. Nummer 1-3, Jahrgang II, 1928.

Gruber, Helmut. "The Political-Ethical Mission of
German Expressionism." In: The German Quarterly.
January, 1967.

Halperin, S. William. Germany Tried Democracy.
New York: Norton, 1974.

Hunt, Richard. German Social Democracy.
Chicago: Quadrangle, 1970.

Kinser, Bill & Kleinmann, Neil. The Dream That Was No
More than a Dream: A Search for Aesthetic Reality in
Germany. New York: Harper and Row, 1973.

Kristl, Wilhelm Lukas. "Ernst Toller in der Revolution
1918/1919." In: Gewerkschaftliche Monatshefte. Köln.
Jg. 20, Heft 4, Januar 1969, p. 205-215.

Lacquer, Walter & Mosse, George, ed. The Left Wing
Intellectuals Between the Wars. 1919-1939. New York:
Harper & Row, 1966.

Lacquer, Walter and Mosse, George ed. The Coming of
the First World War. New York: Harper and Row, 1966.

Lane, Barbara Miller. Architecture and Politics in
Germany 1918-1945. Cambridge: Harvard University,
1966.

Lehmann-Haupt, Helmut. Art Under Dictatorship.
New York: Oxford University, 1954.

Lilge, Frederic. The Abuse of Learning. The Failure of
the German Universities. New York: Farrar, Straus and
Giroux, 1975.

Mosse, George. The Crisis of German Ideology.
New York: Grosset and Dunlap, 1964.

———. Nazi Culture: Intellectual, Cultural and Social
Life in the Third Reich. Munich: Rowohlt Tachenbuch,
1963.

Münzenberg, Willi. Solidarität: Zehn Jahre Inter-
nationale Arbeiter hilfe. Berlin: Neue Deutscher, 1931.

Neukarntz, Klaus. Barrikaden am Wedding.
Berlin: Internationaler Arbeiter, 1931.

Niemann, Alfred. Kaiser und Revolution:
Die entscheiden Ereignisse im grossen Haupt-
quartier im Herbst 1918. Berlin: Kulturpolitik, 1928.

Ostwald, Hans. Sittengeschichte der Inflation.
Berlin: Neufeld und Hennis, 1931.

Pallat, Ludwig & Lebede, Hans. Jugend und Bühne.
Breslau: Hirt, 1924.

Paulesen, Wolfgang. Expressionismus und
Aktivismus: Eine Typologische Untersuchung.
Bern und Leipzig: Gotthelf, 1935.

Roh, Franz. Entartete Kunst: Kunstarbeit im Dritten
Reich. Hannover: Fackelträger, 1962.

Schaffner, Bertram. Fatherland: A Study of
Authoritarianism in the German Family. New York:
Columbia University, 1948.

Schmidt, Diether. Manifeste, Manifeste. 1905-1933.
Dresden: VEB Verlag der Kunst, 1964.

Schockel, Erwin. Das Politische Plakat: Eine
Psychologische Betrachtung. München: Franz Eher
Nachf., 1939.

Stern, Fritz & others. The Path to Dictatorship
1918-1933. New York: Praeger, 1967.

Wernert, E. L'Art dans la IIIe Reich: Une Tentative
d'Esthetique Dirigée. Paris; 1939.

Willrich, Wolfgang. Säuberung des Kunsttempels.
München-Berlin: J.F. Lehmanns, 1937.

Wolfradt, Willi. "Revolution und Kunst." In: Die neue
Rundschau I, 1919. pp. 745-755.

Wulf, Josef. Die Bildenden Kunst im Dritten Reich:
Eine Dokumentation. Gütersloh: Sigbert Mohn, 1963.

## ARTISTS

### AMIET, CUNO

Amiet, Cuno /Giacometti, Giovanni.
Jubiläumsausstellung. Bern: Kunstmuseum, 1968.

Graber, Hans. "Cuno Amiet." In: Das Kunstblatt. 1918,
Heft 7, page 212.

Mandach, C. von. Cuno Amiet. Bern: Schweizerische
Graphische Gesellschaft, 1939.

### BARLACH, ERNST

Barlach, Ernst. Ein Selbsterzähltes Leben.
Berlin: Paul Cassirer, 1928.

———. Fragmente an sehr früher Zeit.
Berlin: Ulrich Riemerschmidt, 1939.

———. Das dichterische Werk.München: R. Piper.
3 volumes. Vol. 1: Das Dramen, 1956. Vol. 2: Die Prosa,
1958. Vol. 3: Die Prosa II, 1959.

———. Spiegel des Unendlichen.
München: R. Piper, 1960.

———. Stiftung Hermann F. Reemtsma.
Hamburg: Barlach Haus, 1966.

———. Das druckgraphische Werk. Dore und Kurt
Reutti-Stiftung. Bremen: Kunsthalle, 1968.

———. Die Briefe, I, II. 2 volumes. Forward by
Friedrich Dross. München: R. Piper, 1968 & 1969.

———. Das Wirkliche und Wahrhaftige. Forward by
Franz Fühmann. Wiesbaden: R. Löwit, 1970.

———. Plastik. Zeichnungen. Druckgraphik.
Köln: Kunsthalle, 1974-1975.

Carls, Carl Dietrich. Ernst Barlach.
New York: Praeger, 1969.

Flemming, Willi. Ernst Barlach. Wesen und Werk.
Bern: Francke, 1958.

Fühmann, Franz. Ernst Barlach. Das schlimme Jahr.
Wiesbaden: R. Löwit, 1968.

Groves, Naomi Jackson. Ernst Barlach. The Develop-
ment of a Versatile Genius. Doctoral Dissertation.
2 volumes. Cambridge: Harvard University, 1950.

———. Fulfilled Moments on a Higher Plane. From the
German of Ernst Barlach. Hamburg:
Ernst Barlach Haus, Hermann F. Reemtsma
Foundation, 1971.

———. Ernst Barlach. Leben im Werk.
Hamburg: Die Blauen Bücher, 1972.

Heise, Carl Georg. Ernst Barlach. Zwischen Erde und
Himmel. München: R. Piper, 1953.

———. Barlach. Der Figurenschmuck von St.
Katharinen zu Lübeck. Stuttgart:
Philipp Reclam, 1964.

Lautz-Oppermann, Gesela. Ernst Barlach. Der
Illustrator. Wolfshagen-Scharbeuts:
Franz Westphal (Lübecker Buch), 1952.

Schult, Friedrich. Ernst Barlach. Das Graphische
Werk. Hamburg: Dr. Ernst Hauswedell & Co., 1972.

———. Ernst Barlach. Das Plastische Werk. Hamburg:
Dr. Ernst Hauswedell & Co., 1960.

———. Ernst Barlach. Werkkatalog der Zeich-
nungen. Hamburg: Dr. Ernst Hauswedell & Co., 1971.

Werner, Alfred. Barlach. New York, London, Toronto,
Sydney: McGraw Hill, 1966.

Wietek, Gerhard. "Der junge Barlach in Hamburg und
Altona." In: Zeitschrift des deutschen Vereins
für Kunstwissenschaft, Band XXI, Heft 1-2, 1967.

Wolfradt, Willi. "Ernst Barlach." In: Das Kunstblatt.
1918, Heft 1, page 1.

### BAUMEISTER, WILLI.

Grohmann, Will. Willi Baumeister.
Stuttgart: W. Kohlmann, 1952.

Schmidt, Paul. "Willi Baumeister." In:
Das Kunstblatt. 1921, Heft 9, page 276.

Spielmann, Heinz. Willi Baumeister. Das Graphische
Werk. Hamburg: Spielmann, 1972.

### BECKMANN, MAX

Beckmann, Max. Max Beckmann. 1948. City Art
Museum of St. Louis, 1948.

———. Sichtbares und Unsichtbares.
Stuttgart: Chr. Belser, 1965.

———. Aus dem graphische Werk. 1901-1946.
München: Galerie Günther Franke, 1972.

Max Beckmann Gesellschaft. Blick auf Beckmann.
Dokumente und Vorträge. Schriften der Max
Beckmann Gesellschaft II. München: R.Piper, 1962.

Buchheim, Lothar Günther. Max Beckmann.
Feldafing: Buchheim, 1959.

Busch, Günter. Max Beckmann. Eine
Einführung. München: R. Piper, 1960.

Fischer, Friedelm W. Max Beckmann. Transl. by P.S.
Falla. London: Phaidon, 1973.

———. Max Beckmann. Symbol und Weltbild.
München: Wilhelm Fink, 1972.

Gallwitz, Klaus. Max Beckmann. Das Druckgraphik. Karlsruhe: Badischer Kunstverein, 1962.

Glaser, Kurt, & others. Max Beckmann. München: R. Piper, 1924.

Göpel, Erhard & Barbara. Max Beckmann. Katalog der Gemälde. 2 volumes. Bern: Kornfeld & Cie., 1976.

Jannasch, Adolf. Max Beckmann als Illustrator. Neu-Isenburg: Wolfgang Tiessen, 1969.

Kessler, Charles S. Max Beckmann's Triptychs. Cambridge: Harvard University, 1970.

Lackner, Stephan. Max Beckmann. Memories of a Friendship. Coral Gables: University of Miami, 1969.

Meier-Graefe, Julius. Max Beckmann. In: Das graphische Jahrbuch. Darmstadt: Lang, 1919, p. 22.

J.B. Neumanns Bilderhefte. Max Beckmann. Berlin: Graphisches Kabinett J.B. Neumann, 1921.

———. Max Beckmann. Berlin: Graphisches Kabinett J.B. Neumann, 1922.

Selz, Peter. Max Beckmann. New York: Museum of Modern Art, 1964.

Schmidt, Paul F. Max Beckmann. In: Jahrbuch der jungen Kunst. Leipzig: Klinkhardt & Biermann, 1920, p. 117.

Simon, Heinrich. "Max Beckmann." In: Das Kunstblatt. 1919, Heft 9, p. 257.

## BURCHARTZ, MAX

Beil, Ludwig. Max Burchartz. In: Jahrbuch der jungen Kunst. Leipzig: Klinkhardt & Biermann, 1920.

Burchartz, Max. "Selbstbiographie" (1921). In: Deutsche Graphik des Westens. Weimar: Feuer, 1922.

———. Gesaltungslehre für Gestaltende und Alle, die den Sinn bilden Gestaltens zu verstehen sich bemühen. München: Prestel, 1953.

Küppers, Paul Erich. "Max Burchartz." In: Das Kunstblatt. 1919, Heft 8, page 240.

## CAMPENDONK, HEINRICH

Biermann, Georg. "Heinrich Campendonk." In: Der Cicerone. XII Jahrgang, 1920, p.663

———. Heinrich Campendonk. Junge Kunst, Band 17. Leipzig: Klinkhardt & Biermann, 1921.

Engels, Mathias T. Campendonk. Holzschnitte. Stuttgart: W. Kohlhammer, 1959.

———. Campendonk als Glasmaler. Krefeld: Scherpe, 1966.

Mayer, Wilhelm "Heinrich Campendonk." In: Deutsche Graphik des Westens. Weimar: Feuer, 1922, p. 28.

Schürmeyer, Walter. "Heinrich Campendonk." In: Das Kunstblatt. 1918, Heft 4, p. 107.

———. Heinrich Campendonk. Frankfurt A.M.: Zinglers Kabinett, 1920.

Wember, Paul. Heinrich Campendonk. Krefeld: Scherpe, 1960.

## CORINTH, LOVIS

Berend-Corinth, Charlotte. Die Gemälde von Lovis Corinth. Werkkatalog. Intoduction by Hans Konrad Röthel. München: F. Bruckmann, 1958.

Biermann, Dr. Georg. Lovis Corinth. Bielefeld & Leipzig: Belhagen und Klasing, 1913.

Corinth, Lovis. Legenden aus dem Künstlerleben. Berlin: Bruno Cassirer, 1909.

Kramer, Hilton. Lovis Corinth. A Retrospective Exhibition. New York: Gallery of Modern Art, 1964.

Müller, Heinrich. Die Späte Graphik von Lovis Corinth. Hamburg: Lichtwarkstiftung, 1960.

Netzer, Remiqius. Lovis Corinth. Graphik. München: R. Piper, 1958.

Schwarz, Karl. Das graphische Werk von Lovis Corinth. Berlin: Fritz Gurlitt, 1917. First Edition.

———. Das graphische Werk von Lovis Corinth. Berlin: Fritz Gurlitt, 1922. Second Edition.

Schneider, Bruno F. Lovis Corinth. Berlin: Safari, 1959.

## CZESCHKA, CARL OTTO

Hofstätter, Hans H. Jugendstil Druckkunst. Baden-Baden: Holle, 1968.

Nebehay, Ingo. "Gerlach's Jugendbucherei." In: Das Antiquariat. Heft 11-12, 1966.

## DAVRINGHAUSEN, HEINRICH MARIA

Graf, Oskar. Heinrich Maria Davringhausen. In: Jahrbuch der jungen Kunst. Leipzig: Klinkhardt und Biermann, 1924.

Zahn, Leopold. "H.M. Davringhausen." In: Deutsche Graphik des Westens. Weimar: Feuer, 1922.

## DEXEL, WALTER

Dexel, Walter. Ausstellung. Hannover: Kestner-Gesellschaft, 1974.

Hofmann, Werner. Der Maler Walter Dexel. Starnberg: Josef Keller, 1972.

Kühn, Herbert. "Walter Dexel." In: Das Kunstblatt. Heft 2, page 58, 1919.

Vitt, Walter. Walter Dexel. Werkverzeichnis der Druckgrafik von 1915-1971. Köln: Walther König, 1971.

## DIX, OTTO

Conzelmann, Otto. Otto Dix. Hannover: Fakelträger-Verlag Schmidt-Küster, 1959.

Daübler, Theodor. "Otto Dix." In: Das Kunstblatt. 1920, Heft 4, page 118.

Dix, Otto. Exhibition. Paris: Musée d'Art Moderne de la Ville de Paris, 1972.

———. Zum 80 Geburtstag. St. Gallen: Erker, 1972, Galerie der Stadt Stuttgart.

Karsch, Florian. Otto Dix. Das graphische Werk. Hannover: Fackelträger Verlag Schmidt-Küster, 1970.

Kinkel, Hans. Otto Dix. Protokolle der Hölle. Frankfurt a/M. & Hamburg: Fischer, 1968.

Löffler, Fritz. Otto Dix. Leben und Werk. Wien & München: Anton Schroll, 1967.

Wolfradt, Willi. Otto Dix. Junge Kunst, Band 41. Leipzig: Klinkhardt & Biermann, 1924.

## DRESSLER, AUGUST WILHELM

Kinkel, Hans. August Wilhelm Dressler. München: Delph'sche, 1970.

## EBERZ, JOSEF

Zahn, Leopold. Josef Eberz. Junge Kunst, Band 14. Leipzig: Klinkhardt & Biermann, 1920.

———. "Die graphischen Arbeiten des Josef Eberz." In: Deutsche Graphik des Westens. Weimar: Feuer, 1922.

———. "Der Maler Josef Eberz." In: Cicerone, XII.Jahrgang, 1920, p. 595.

## ERNST, MAX

Brusberg Dokumente. Max Ernst. Jenseits der Malerei- Das Graphische Oeuvre. Ausstellung. Hannover: Kestner Museum, 1972.

Liebermann, William S. Max Ernst. New York: Museum of Modern Art, 1961.

Russell, John. Max Ernst. Life and Work. New York: Abrams, 1967.

Spies, Werner. Max Ernst. Das graphische Werk. Houston & Köln: Mevril Foundation & M. DuMont Schauberg, 1975.

## FEININGER, LYONEL

Coellen, Ludwig. "Lyonel Feininger." In: Das Kunstblatt. 1919, Heft 5.

Feininger, Lux. Lyonel Feininger. City at the Edge of the World. New York, Washington, London: Praeger, 1965.

Feininger, Lyonel (& Hartley, Marsden). Exhibition. New York: Museum of Modern Art, 1944.

———. Aus der Werkstatt Lyoneis. Berlin: Deitscher Arkiv, 1958.

———. Exhibition. München: Haus der Kunst & Zurich: Kunsthaus, 1973.

Prasse, Leona E. Lyonel Feininger. A Definitive Catalogue of His Graphic Work. Cleveland and Berlin: Cleveland Museum of Art and Gebrüder Mann, 1972.

Ruhmer, Berhard. Lyonel Feininger. München: F. Bruckmann, 1961.

Scheyer, Ernst. Lyonel Feininger. Caricature and Fantasy. Detroit: Wayne State University, 1964.

Schreyer, Lothar. Lyonel Feininger. Dokumente und Visionen. München: Langen-Müller, 1957.

Westheim, Paul. "Lyonel Feininger." In: Das Kunstblatt. 1917, Heft 5.

Wolfradt, Willi. Lyonel Feininger. Junge Kunst, Band 47. Leipzig: Klinkhardt & Biermann, 1924.

## FELIXMÜLLER, CONRAD

Söhn, Gerhart. Conrad Felixmüller. Das Graphische Werk. 1912-1974. Düsseldorf: Gerhart Söhn, 1975.

Sternheim, Carl. Felixmüller. In: Jahrbuch der jungen Kunst, Leipzig: Klinkhardt & Biermann, 1923.

## FREUNDLICH, OTTO

Aust, Günter. Otto Freundlich. 1878-1943. Köln: M. DuMont Schauberg, 1960.

## GEIGER, WILLI

Burschell, Friedrich. Willi Geiger. In: Fritz Gurlitt Almanach. Berlin: Fritz Gurlitt, 1920.

Geiger, Willi. Autobiography. In: Das Graphische Jahr. Berlin: Fritz Gurlitt, 1921.

Petzet, Wolfgang. Willi Geiger. Der Maler und Graphischer. München: F. Bruckmann, 1960.

## GENIN, ROBERT

Genin, Robert. Autobiography. In: Das Graphische Jahr. Berlin: Fritz Gurlitt, 1921.

———. Ausstellung. Esslingen: Kunstgalerie Esslingen, 1974.

## GLEICHMANN, OTTO

Beil, Ludwig. Otto Gleichmann. In: Jahrbuch der jungen Kunst. Leipzig: Klinkhardt & Biermann, 1921.

Däubler, Theodor. Otto Gleichmann. In: Das Graphische Jahrbuch. Darmstadt: Lang, 1919.

———. "Otto Gleichmann." In: Feuer, 1. Jahrgang, 1919-1920.

———. "Otto Gleichmann." In: Deutsche Graphik des Westens. Weimar: Feuer, 1922.

## GOTSCH, FRIEDRICH KARL

Grohmann, Will. Friedrich Karl Gotsch. Junge Kunst, Band 45. Leipzig: Klinkhardt & Biermann, 1924.

## GRAMATTÉ, WALTER

Eckhardt, Ferdinand. Das graphische Werk von Walter Gramatté. Zurich-Leipzig-Wien: Amalthea, 1932.

Emmil, Felix. Walter Gramatté. In: Das graphische Jahrbuch. Darmstadt: Lang, 1919, p. 51.

Gramatté, Walter. Exhibition. Ottowa: National Gallery of Canada, 1966.

———. Aquarelle. Handzeichnungen. Druckgraphik. Bremen: Kunsthalle, 1970.

## GROSSMANN, RUDOLF

Grossmann, Rudolf. Autobiography. In: Das Garphische Jahr. Berlin: Fritz Gurlitt, 1921.

———. Ausstellung. Esslingen: Kunstgalerie Esslingen, 1974.

———. Lager Katalog #53. München: Galerie Wolfgang Ketterer, u.d.

Kolle, Helmud. "Rudolf Grossmann." In: Das Kunstblatt, 1922, Heft 11.

Wedderkop, H. von. Rudolf Grossmann. In: Deutsche Graphik des Westens. Weimar: Feuer, 1922.

## GROSZ, GEORGE

Baur, John I. George Grosz. New York: Macmillan, 1951.

Bittner, Herbert. George Grosz. New York: Art Inc., 1959.

Däubler, Theodor. "George Grosz." In: Das Kunstblatt. 1917, Heft 3.

Grosz, George. Autobiography. In: Das graphische Jahr. Berlin: Fritz Gurlitt, 1921.

———. "Zu meinen neuen Bildern." In: Das Kunstblatt. 1921, Heft 1.

———. und Herzfelde, Wieland. Die Kunst ist in Gefahr. Berlin: Der Malik, 1925.

———. A Little Yes and a Big No. New York: Dial, 1946.

———. /Heartfield, John. Exhibition. Stuttgart & Berlin: Württemburgischen Kunstverein und Deutsche Akademie der Künste, 1969.

———. Ohne Hemmung. Gesicht und Kehrseite der Jahre 1914-1924. Berlin-Tempelhof: Galerie Meta Nierendorf, 1963.

Hess, Hans. George Grosz. London: Studio Vista, 1974.

Knust, Dr. Hubert. Theatrical Drawings and Watercolors by George Grosz. Exhibition. Cambridge: Harvard University, 1973.

Lewis, Beth Irwin. George Grosz. Art and Politics in the Weimar Republic. Madison, Milwaukee and London: University of Wisconsin, 1971.

Miller, Henry. "Man in a Zoo. George Grosz's Ecce Homo." In: Evergreen Review, Volume 10, number 40, April, 1966.

Salmony, Alfred. "George Grosz." In: Das Kunstblatt. Heft 4, 1920.

Wolfradt, Willi. George Grosz. Junge Kunst, Band 21. Leipzig: Klinkhardt & Biermann, 1921.

## HEARTFIELD, JOHN

Herzfelde, Wieland. John Heartfield. Leben und Werk. Dresden: V.E.B Verlag der Kunst, 1962.

## HECKEL, ERICH

Buchheim, Lothar-Günther. Erich Heckel. Feldafing: Buchheim, 1957.

Dube, Annemarie & Wolf-Dieter. Erich Heckel. Das graphische Werk. New York & Berlin: Ernst Rathenau & Euphorion Verlag. 3 volumes, 1964. 1965. 1974.

Heckel, Erich. Werk der Brückezeit. 1907-1917. Stuttgart: Württemburgerischer Kunstverein, 1957.

———. Ausstellung. München: Prestel, 1963.

Heckel, Erich. Zur Vollendung des achten Lebensjahrzehntes. Essen: Museum Folkwang, 1964.

Kohn, Hans. Erich Heckel. Aquarelle und Zeichnungen. München: F. Bruckmann, 1959.

Rare, Paul Ortwin. Erich Heckel. Leipzig: Volk und Buch Verlag, 1948.

Rathenau, Ernest. Erich Heckel. Handzeichnungen. New York & Berlin: Ernest Rathenau & Euphorion Verlag, 1973.

Schiefler, Gustav. "Erich Heckels graphisches Werk." in: Das Kunstblatt. 1918, Heft 9, page 283.

Sydow, Eckart von. Erich Heckel als Graphiker. In: Jahrbuch der jungen Kunst. Leipzig: Klinkhardt & Biermann, 1921.

Thormahlin, Ludwig. Erich Heckel. Junge Kunst, Band 58. Leipzig: Klinkhardt & Biermann, 1931.

Vogt, Paul. Erich Heckel. Recklinghausen: Aurel Bongers, 1965.

Westheim, Paul. "Erich Heckel." In: Das Kunstblatt. 1917, Heft 6, page 161.

Wietek, Gerhard. Erich Heckel. Arbeiten aus dem Besitz des Museums. Hamburg: Altonaer Museum & Norddeutsches Landes Museum, 1973.

Wilde, Oscar. The Ballad of Reading Goal mit zwölf Holzschnitten von Erich Heckel. New York & Berlin: Ernest Rathenau & Euphorion Verlag, 1963.

**HECKENDORF, FRANZ**

Kirchner, Joachim. Franz Heckendorf. Junge Kunst, Band 6. Leipzig: Klinkhardt & Biermann, 1919.

————. Neue Bilder von Franz Heckendorf. In: Jahrbuch der jungen Kunst, Leipzig: Klinkhardt & Biermann, 1924.

**HEGENBARTH, JOSEF**

Grohmann, Will. Hegenbarth. Zeichnungen. Berlin: Mann, 1959.

Hegenbarth, Josef. Autobiography. In: Das graphische Jahr. Berlin: Fritz Gurlitt, 1921, p. 56.

————. Böhmisch-Kamnitz. München: Thomabund, 1934.

Löffler, Fritz. Josef Hegenbarth. Dresden: Der Kunst, 1959.

**HIRSCH, KARL JAKOB**

Stuckenschmidt, Hans Heinz. Karl Jakob Hirsch. 1892-1952. Berlin: Akademie der Künste, 1967.

**HOBOKEN, G.B.R. VAN**

Hoboken, G.B.R. Van. Ausstellung. Esslingen: Kunstgalerie Esslingen, 1972.

**HÖCH, HANNAH**

Höch, Hannah. Ausstellung. Berlin: Akademie der Künste, 1971.

**HODLER, FERDINAND**

Bender, E. & Müller, W.Y. Die Kunst Ferdinand Hodler. Zurich: Rascher, 1923-1941. 2 vols.

Graber, Hans. Ferdinand Hodler. In: Jahrbuch der jungen Kunst. Leipzig: Klinkhardt & Biermann, 1924.

Hodler, Ferdinand. Ausstellung. Bern: Kunstmuseum, 1968.

Loosli, C.A. Ferdinand Hodler. Leben, Werk und Nachlass. Bern: Sutter, 1921-1924.

Mühlestein, Hans. Ferdinand Hodler. Ein Deutungsversuch. Weimar: Kiepenheuer, 1924. 2 vols.

————. "Hodler und die neue Kunst." In: Das Kunstblatt. 1918, Heft 7.

Selz, Peter. Ferdinand Hodler. Exhibition. Berkeley: University Art Museum, 1972.

**HOETGER, BERNHARD**

Däubler, Theodor. "Bernhard Hoetger." In: Der Cicerone. XIII. Jahrgang, 1921, Heft 22, p. 643.

Roselius, Dr. Ludwig. Bernhard Hoetger. 1874-1949. Bremen: H.M. Hanschild, 1974.

Uphoff, Carl Emil. Bernhard Hoetger. Junge Kunst, Band 3. Leipzig: Klinkhardt & Biermann, 1919.

————. "Bernhard Hoetger." In: Deutsche Graphik des Westens. Weimar: Feuer, 1922, p. 32.

**HOFER, KARL**

Hofer, Karl. Karl Hofer. Das gesammelte Werk. Mannheim: Staedtische Kunsthalle, 1928.

————. Aus Leben und Kunst. Berlin: Rembrandt Verlag, 1952.

————. Erinnerungen eines Malers. Berlin- Grunewald: F.A. Herbig, 1953.

————. Über das Gesetzliche in der bildenden Kunst. Kurt Martin, ed. Berlin: Akademie der Künste, 1956.

————. Karl Hofer. 1878-1955. Berlin: Akademie der Künste, 1966.

Kuhn, Alfred. "Über Bilder Karl Hofers." In: Das Kunstblatt. 1922, Heft 7, p. 289.

Martin, Kurt. Karl Hofer. Karlsruhe: Die Akademie der Bildenden Künst Karlsruhe, 1957.

Meier-Graefe, Julius. Karl Hofer. In: Ganymed. Jahrbuch für die Kunst. München: R. Piper, 1922, p. 92.

Rathenau, Ernest, ed. Karl Hofer. Das graphische Werk. Intro. by Kurt Martin. New York & Berlin: Ernest Rathenau & Euphorion Verlag, 1969.

Reifenberg, Benno. Karl Hofer. Junge Kunst, Band 48. Leipzig: Klinkhardt & Biermann, 1924.

Rigby, Ida K. Karl Hofer. New York: Garland Publishers, 1976.

Roeingh, Rolf, ed. Karl Hofer. Begegnungen. Fünfzehn Zeichnungen. Berlin: Deutsche Archiv-Bibliothek, 1950.

Strauss, Gerhard, ed. Festgabe an Carl Hofer zum siebzigsten Geburtstag. Potsdam: Eduard Stichnote, 1948.

Westheim, Paul. "Karl Hofer." In: Das Kunstblatt. 1919, Heft 12, p. 365.

**HOLLENBERG, FELIX**

Hollenberg, Felix. Gemälde. Graphik. Esslingen: Kunstgalerie Esslingen, 1975.

**HÖLZEL, ADOLF**

Hölzel, Adolf. Ölbilder/Pastelle. Kunsthalle am Steubenplatz. Darmstadt: Kunstverein, 1970.

**HUBBUCH, KARL**

Hubbuch, Karl. Der frühe Hubbuch 1911 bis 1925. Bremen, Berlin, München, Saarbrücken, Freiburg, 1973-1974.

————. In Frankreich und anderswo Zeichnungen. München: Galerie Wolfgang Ketterer, 1972.

**ITTEN, JOHANNES**

Itten, Johannes. Johannes Itten. Amsterdam: Stedelijk Museum, 1957.

————. Johannes Itten. Zürich: Kunsthalle, 1964.

————. Design and Form. The Basic Course at the Bauhaus. Translated by John Maas. New York: Reinhold, 1964.

————. Aquarelle und Zeichnungen. Darmstadt: Bauhaus Archiv, 1967.

————. Johannes Itten. Bern: Kunsthalle, 1971.

————. Die Jahreszeiten. Nürnberg: Kunsthalle, 1972.

————. Der Unterricht. Berlin-Charlottenburg: Bauhaus Arkiv, 1974.

Rotzler, Willy, ed. Johannes Itten. Werke und Schriften. Work catalogue by Anneliese Itten. Zürich: Orell Füssli, 1972.

**JAECKEL, WILLY**

Cohn-Wiener, Ernst. "Willy Jaeckel." In: Der Cicerone. XII. Jahrgang, 1920, p. 561.

————. Willy Jaeckel. Junge Kunst, Band 9. Leipzig: Klinkhardt & Biermann, 1920.

Jaeckel, Willy. Autobiography. In: Das graphische Jahr. Berlin: Fritz Gurlitt, 1921, p. 63.

**JANSEN, FRANZ M.**

Jansen, F.M. Autobiography. In: Das graphische Jahr. Berlin: Fritz Gurlitt, 1921, p. 67.

Winckler, Joseph. Der Rheinische Graphiker F. M. Jansen. In: Jahrbuch der jungen Kunst. Leipzig: Klinkhardt & Biermann, 1922, p. 315.

**JANTHUR, RICHARD**

Beyer, Oskar. "Der Maler Janthur." In: Feuer. I. Jahrgang, 1919-1920.

Janthur, Richard. Biography. In: Das graphische Jahr. Berlin: Fritz Gurlitt, 1921.

Rukser, Udo. "Janthurs Graphik." In: Almanach. Berlin: Fritz Gurlitt, 1920.

**JAWLENSKY, ALEXEJ VON**

Demetrion, James T. Alexei Jawlensky. A Centennial Exhibition. Pasadena: Pasadena Museum of Art, 1964.

Scheyer, E.E. "Alexej von Jawlensky." In: Das Kunstblatt. 1920, Heft 6.

Schultze, Jürgen. Alexej Jawlensky. Köln: M. DuMont Schauberg 1970

Weiler, Clemens. Alexej Jawlensky. Köln: M. DuMont Schauberg, 1959.

————. Jawlensky. Heads. Faces. Meditations. New York, Washington, London: Praeger, 1971.

**KANDINSKY, WASSILY**

Bill, Max. Wassily Kandinsky. Paris: Maeght Editeur, 1951.

Grohmann, Will. Kandinsky. Paris: Editions d'Art, 1930.

————. Wassily Kandinsky. Junge Kunst, Band 42. Leipzig: Klinkhardt & Biermann, 1924.

————. Wassily Kandinsky. Life and Work. New York: Abrams, 1958.

Hanfstaengl, Erika. Wassily Kandinsky. Zeichnungen und Aquarelle. München: Prestel, 1974.

Kandinsky, Wassily. Über das Geistige in der Kunst. München; Piper, 1912.

————. 1901-1913. Berlin: Der Sturm, 1913.

————. The Art of Spiritual Harmony. London: Constable, 1914.

————. Punkt und Linie zu Fläche. Bauhausbücher 9. München: Albert Langen, 1926.

————. In Memory of Wassily Kandinsky. Exhibition. New York: Solomon R. Guggenheim Museum of Non-Objective Art, 1945.

————. On the Spiritual in Art. New York: Solomon R. Guggenheim Museum of Non-Objective Art, 1946.

————. Regards sur le Passé et Autres Textes. 1912-1922. Paris: Collection Savoir Hermann, 1974.

Maeght Editeur. "Kandinsky. Période Dramatique. 1910-1920. In: Derriere Le Miroir. 77-88: July & August, 1955. 60-61: October & November 1953. 42: November & December 1951. 101-103: September & November 1957.

Overy, Paul. Kandinsky. The Language of the Eye. New York: Praeger, 1969.

Roethel, Hans Konrad. Wassily Kandinsky. Paintings on Glass. New York: Solomon R. Guggenheim Museum, 1966.

————. Kandinsky. Das graphische Kunst. Köln: R. DuMont Schauberg, 1970. 2 vols.

————. The Graphic Work of Kandinsky. A Loan Exhibition. New York: International Loan Foundation, 1973.

Volboudt, Pierre. Die Zeichnungen Wassily Kandinskys. Köln: M. DuMont Schauberg, 1974.

Weiss, Peg. "Kandinsky and the Jugendstil Arts and Crafts Movement." In: The Burlington Magazine. Volume C. VXII, 866, May, 1975.

**KAUS, MAX**

Buchheim, Lothar Günther. Max Kaus. Frühe Lithographien. Feldafing: Buchheim, 1964.

Kaus, Max. Graphik. Sammlung Buchheim. Hamburg: Altonaer Museum, 1973.

————. Das graphische Frühwerk Sammlung Buchheim. Berlin: Brücke Museum, 1974.

Reidemeister, Leopold. Max Kaus. Gemälde von 1917 bis 1970. Berlin: Brücke Museum, 1971.

**KIRCHNER, E.L.**

Chamisso, Adelbert von. Peter Schlemihls wundersame Geschichte. Leipzig: Philipp Reclam, 1974.

Dube, Annemarie und Wolf-Dieter. E.L. Kirchner. Das graphische Werk. München, Prestel, 1967. 2 vols.

Dube-Heynig, Annemarie. Kirchner. His Graphic Work. München: Prestel, 1961.

Durst, F. und Kornfeld, E.H., Lise Gujer. Wirkereien nach Entwürfen von E.L. Kirchner. Bern: Kornfeld, 1975.

Göpel, Erhard. Ernst Ludwig Kirchner. Farbige Graphik. München, R. Piper, 1959.

Gordon, Donald E. Ernst Ludwig Kirchner. Cambridge: Harvard University, 1969.

————. Ernst Ludwig Kirchner. A Retrospective Exhibition. Boston: Museum of Fine Arts, 1968.

Grisebach, Lothar. E.L. Kirchners Davoser Tagebuch. Köln & Campione bei Italia: M. DuMont Schauberg & Roman Norbert Ketterer, 1968.

Grohmann, Will. Kirchner-Zeichnungen. Dresden: Ernst Arnold, 1925.

————. Das Werk Ernst Ludwig Kirchners. München: Kurt Wolff, 1926.

————. E.L. Kirchner. New York: Arts Inc., 1961.

Ketterer, Roman Norbert. E.L. Kirchner. Campione bei Lugano: Ketterer, 1963, 1964, 1971. 3 vols.

Kirchner, E.L. (L. de Marsalle, pseudo) Zeichnungen von E.L. Kirchner. In: Genius, Zweites Buch, 1920.

————. (L. de Marsalle. pseudo.) Über Kirchners Graphik. In: Genius, Zweites Buch, 1921.

————. Ausstellung. Bern: Kunsthalle, 1933.

————. Ausstellung. Düsseldorf: Kunstverein für die Rheinlande und Westphalen, Düsseldorfer Kunsthalle, 1960.

————. Ausstellung. Bielefeld: Kunsthalle, 1969.

————. Ausstellung. Privatsammlung. München: Galerie Günther Franke, 1970.

————. Aquarelle und Handzeichnungen. Ausstellung. Bremen: Kunsthalle, 1972.

Schiefler, Gustav. Das graphische Werk von Ernst Ludwig Kirchner. Berlin-Charlottenburg: Euphorion, 1924-1926. 1927-1931. 2 vols.

Valentiner, Wilhelm R. E.L. Kirchner. German Expressionists. Raleigh: The North Carolina Museum of Art, 1958.

**KLEE, PAUL**

Crevel, René. Paul Klee. Paris: Librairie Gallimard, 1930.

Geelhaer, Christian. Paul Klee and the Bauhaus. Greenwich: New York Graphic Society. 1973.

Glaesemer, Jürgen. Paul Klee. Handzeichnungen I. Bern: Kunst Museum, 1973.

Grohmann, Will. Paul Klee. Paris: Editions Cahiers D'Art, 1929.

————. Paul Klee. New York: Abrams, 1967.

Klee, Felix. Tagebücher von Paul Klee. Köln: M. DuMont Schauberg, 1957.

————. Paul Klee. New York: Braziller, 1962.
————. The Diaries of Paul Klee. 1898-1918.
London: Peter Owen, 1965.
Klee, Paul. Über die moderne Kunst.
Bern-Bümpliz: Bentili, 1945.
————. Gedichte. Zurich: Die Arche, 1960.
————. Notebooks. Vol. I, The Thinking Eye. Vol. II,
The Nature of Nature. New York: Wittenborn, 1963.
————. Watercolors. Drawings. Writings.
New York: Abrams, 1969.
————. Und seine Malerfreunde. Ausstellung.
Winterthur: Kunst Museum, 1971.
Kornfeld, Eberhard. Verzeichnis des graphischen
Werkes von Paul Klee. Bern: Kornfeld und Klipstein,
1963.
Lazzaro, Gualtieri d San. Klee.
New York, Washington: Praeger, 1965.
Masson, Andre. Eulogy of Paul Klee.
New York: Curt Valentin, 1950.
Read, Herbert. Paul Klee on Modern Art.
London: Faber, 1964.
Roethel, Hans D. & Kornfeld, Eberhard. Paul Klee in
München: Paul Klee in Bern. Bern: Stämpfli, 1971,
1973. 2 vols.
Soby, James Thrall. The Prints of Paul Klee.
New York: Curt Valentin, 1945.
Wedderkop, H. von. Paul Klee. Junge Kunst, Band 13.
Leipzig: Klinkhardt & Biermann, 1920.

KLEIN, CÉSAR
Westheim, Paul. "César Klein." In: Das Kunstblatt,
1919, Heft 8, p. 244.

KLIMT, GUSTAV
Bahr, Hermann. Gegen Klimt.
Wien: J. Einsenstein, 1903.
Eisler, Max. Gustav Klimt. Eine Nachlese.
Wien: Österreiches Staatsdruckerei, 1931.
Hofmann, Werner. Gustav Klimt.
Greenwich: New York Graphic Society, 1971.
Klimt, Gustav. Das Werk Gustav Klimt.
Wien: H.O. Miethke, 1914.
Novotny, Fritz & Dobai, Johannes. Gustav Klimt.
New York and Washington: Praeger, 1968.
Werner, Alfred. Gustav Klimt. 100 Drawings.
New York: Dover, 1972.

KOCH, RUDOLF
Beyer, Oskar. Rudolf Koch. Mensch. Schriftsgesalter
& Erneuerer des Handwerks.
Berlin: Verlaganst, 1949.
Koch, Rudolf. Ein Schöpferisches Leben.
Kassel-Basel: Bärenreiter, 1953.
————. Briefe. München, Herbert Post, 1956.
Lange, Wilhelm Hermann. Rudolf Koch. Ein
deutsches Schreibmeister. Berlin: Heintze &
Blanckertz, 1938.

KOKOSCHKA, OSKAR
Beckker, Paul. "Zu Kokoschkas Bach Mappe."
In: Das Kunstblatt. 1917, Heft 10.
Biermann, Georg. Oskar Kokoschka. Junge Kunst,
Band 52. Leipzig: Klinkhardt & Biermann, 1929.
Ehrenstein, Albert. "Oskar Kokoscnka."
In: Das Kunstblatt. 1917, Heft 10.
Hodin, J.P. Oskar Kokoschka. The Artist and His Time.
Greenwich: New York Graphic Society, 1966.
Hoffmann, Edith. Kokoschka. Life and Works.
London: Faber & Faber, 1947.
Kokoschka, Oskar. Dramen und Bilder.
Leipzig: Kurt Wolff, 1913.
————. "Forsetzung der träumender Knaben."
In: Das Kunstblatt. 1918, Heft 12.
————. Vier Dramen. Berlin: Paul Cassirer, 1919.
————. Vom Bewusstsein der Geschichte.
In: Genius, Erstes Buch, 1919.
————. Ausstellung (With early graphics catalogue by
Wilhelm Arntz). München: Prestel, 1950.
————. Schriften. 1907-1955.
München: Albert Längen, 1956.
————. Exhibition. Hamburg: Museum für Kunst &
Gewerke, Kunstgewerbeverein, 1965.
————. Mein Leben. München: F. Bruckmann, 1971.
————. Handzeichnungen. 1906-1969. New York &
Berlin: Ernst Rathenau & Euphorion, 1971.
————. Erzählungen. Das schriftliche Werk. Band I, II.
Hamburg: Hans Christians, 1973-1974.
————. My Life. London: Thames and Hudson, 1974.
Lischka, Gerhard Johann. Oskar Kokoschka. Maler
& Dichter. Bern & Frankfurt a/M.: Herbert Lang
& Peter Lang, 1972.
Michaelis, Karin. "Der tolle Kokoschka."
In: Das Kunstblatt. 1918, Heft 12.

Plaut, James S. Oskar Kokoschka. A Retrospective
Exhibition. New York: Chanticleer, ud. (1948).
Rathenau, Ernest. Oskar Kokoschka. Drawings.
1906-1965. Coral Gables: University of Miami, 1970.
Schmalenbach, Fritz. Oskar Kokoschka.
Greenwich: New York Graphic Society, 1968.
Westheim, Paul. "Kokoschka. Der Zeichner."
In: Das Kunstblatt. 1921, Heft 11.
————. "Oskar Kokoschka."
In: Das Kunstblatt. 1917, Heft 10.
Wingler, Hans Maria. Oskar Kokoschka. The Work of
the Painter. Salzburg: Galerie Welz, 1958.
———— & Welz, Friedrich. O. Kokoschka. Das
druckgraphische Werk. Salzburg: Galerie Welz, 1975.

KOLLWITZ, KÄTHE
Bittner, Herbert. Käthe Kollwitz. Drawings.
London: Thomas Yoseloff, 1959.
Bovus, Arthur. Das Käthe Kollwitz Werk.
Dresden: Carl Reissner, 1930.
Deri, Max. Sonder-Ausstellung Käthe Kollwitz zu ihren
50. Geburtstag. Dresden: Richter, 1917.
Becke, A. von der. Die graphische Kunst von
Käthe Kollwitz. Berlin-Charlottenburg: Graphischen
Schaffens von Käthe Kollwitz, 1932.
Diel, Louise. Käthe Kollwitz. Mutter und Kind.
Berlin: Furche, ud.
Isenstein, Harold. Käthe Kollwitz und Ernst Barlach
(An Unpublished Paper) Kopenhagen: 1967 (Original
Manuscript in the Akademie der Künste, Berlin).
Kaemmerer, Ludwig. Käthe Kollwitz. Griffelkunst &
Weltanschauung. Dresden: Emil Richter, 1923.
Klein, Minna C. & Arthur. Käthe Kollwitz. Life in Art.
New York, Chicago & San Francisco: Holt, Rinehart
& Winston, 1972.
Klipstein, August. Käthe Kollwitz. Verzeichnis des
graphischen Werkes. Bern: Klipstein & Cie., 1955.
Kollwitz, Käthe. Mappe.
München: Georg Callwey, 1931.
————. Einundzwanzig Zeichnungen der späten Jahr.
Berlin: Gebruder Mann, 1948.
————. In ihrer Zeit. 1945-1967.
Hamburg: Ernst Barlach Haus, 1967.
————. 1945-1967.
Berlin: Akademie der Künste, 1967-1968.
————. Exhibition. Tel Aviv: Tel Aviv & Israel
Museums, 1971-1972.
Kuhn, Alfred. Käthe Kollwitz. Berlin: Neue
Kunsthandlung, Graphiker der Gegenwart.
Band 6, 1921.
Nagel, Otto. Käthe Kollwitz.
Greenwich: New York Graphic Society, 1971.
————. The Drawings of Käthe Kollwitz. New York:
Crown Publishers & Galerie St. Etienne, 1972.
Sievers, Johannes. Die Radierungen und Steindrucke
von Käthe Kollwitz. Dresden: Emil Richter, 1913.
Singer, Hans. Käthe Kollwitz. Esslingen: Paul Neff,
Führer zur Kunst. Band 15, 1908.

KUBIN, ALFRED
Bredt, E.W. Alfred Kubin.
München: Hugo Schmidt, 1922.
Hausenstein, Wilhelm. "Kubin."
In: Das Kunstblatt. 1921, Heft 7, p. 1933.
Kubin, Alfred. Aus meinem Leben. Spangenberg
Edition. München: Ellermann, 1974.
————. Aus mein Werkstatt.
München: Nymphenburger Verlags Handlung, 1973.
————. Alfred Kubin's Autobiography. Special edition
of 1000 copies. New York: Galerie St. Etienne, ud.
Mitsch, Erwin. Alfred Kubin. Zeichnungen.
Salzburg: Galerie Welz, 1967.
Raabe, Paul. Alfred Kubin. Leben. Werk. Wirkung.
Hamburg: Rowohlt, 1957.
Schmidt, Paul Ferdinand. Alfred Kubin. Junge Kunst,
Band 44. Leipzig: Klinkhardt & Biermann, 1924.
Schmied, Wieland. Alfred Kubin.
New York & Washington, D.C.: Praeger, 1969.

LECHTER, MELCHIOR
Raub, Wolfhard. Melchior Lechter. Als Buchkünstler.
Darstellung. Werkverzeichnis. Bibliographie. Köln:
Greven, 1969.

LEHMBRUCK, WILHELM
Heller, Reinhold. The Art of Wilhelm Lehmbruck.
Exhibition. Washington, D.C.: National Gallery
of Art, 1972.
Hoff, August. Wilhelm Lehmbruck. Junge Kunst,
Band 61/62. Leipzig: Klinkhardt & Biermann, 1933.
Petermann, Erwin. Die Druckgraphik von Wilhelm
Lehmbruck. Stuttgart: Gerd Hotje, 1964.
Westheim, Paul. Wilhelm Lehmbruck. In: Deutsche
Graphik des Westens. Weimar: Feuer, 1922.

————. Wilhelm Lehmbruck.
Potsdam-Berlin: Gustav Kiepenheuer, ud. [1919].

LEVY, RUDOLF
Mende, Dietrich. Rudolf Levy. In: Jahrbuch der jungen
Kunst. Leipzig: Klinkhardt & Biermann, 1923.

LIEBERMANN, MAX
Hancke, Erich. Max Liebermann. Sein Leben & seine
Werke. Berlin: Bruno Cassirer, 1914.
Liebermann, Max. Ausstellung in Zürcher Kunsthaus.
Juni/Juli 1923. Zürich: Zürcher Kunstgesellschaft,
1923.
————. Die Phantasie in der Malerei.
Berlin: Bruno Cassirer, 1916.
Pauli, Gustav. Liebermann. Eine Auswahl aus den
Lebenswerk des Meisters. Stuttgart & Berlin:
Deutsche, 1922.
————. Das graphische Werk von Max Liebermann.
Berlin: Bruno Cassirer, 1907.

MACKE, AUGUST
Bänfer, Carl. August Macke. 44 Zeichnungen auf den
Skizzenbüchern. München: R. Piper, 1959.
Bombe, Walter. "August Macke."
In: Das Kunstblatt. 1918, Heft 4.
Busch, Günter. August Macke. Handzeichnungen.
Mainz & Berlin: Florian Kufferberg, 1966.
————. August Macke. Das russische Ballett.
Stuttgart: Philipp Reclam, 1966.
Cohen, Walter. August Macke. In: Deutsche Graphik
des Westens. Weimar: Feuer, 1922.
————. August Macke. Junge Kunst, Band 32.
Leipzig: Klinkhardt & Biermann, 1922.
Engels, Mathias T. August Macke.
Recklinghausen: Aurel Bongers, 1958.
Lübbecke, Friedrich. "August Macke."
In: Das Kunstblatt. 1920, Heft 10.
Macke, August. Die Tunisreise. Aquarelle &
Zeichnungen. Köln: M. DuMont Schauberg, 1958.
————. Handzeichnungen und Aquarelle.
Ausstellung.
Bremen: Kunsthalle, 1965.
————. Tunisian Watercolors and Drawings.
New York: Abrams, 1969.
Martin, Kurt. August Macke und die rheinischen
Expressionisten. Ausstellung. Bonn: Stadisches
Kunstmuseum, 1973.
Vriesen, Gustav. August Macke.
Stuttgart: W. Kohlhammer, 1957.

MARC, FRANZ
Bombe, Walter. "Franz Marc & der Expression-
ismus. In: Das Kunstblatt. 1917, Heft 3.
Bünemann, Hermann. Franz Marc. Zeichnungen &
Aquarelle. München: F. Bruckmann, 1960.
Covre, Jolanda Nigro. Franz Marc. Dal pensiero all
forma. Torino: Martano, 1971.
Eberlein, Kurt Karl. Franz Marc und der Kunst unserer
Zeit. In: Genius, Zweites Buch, 1921.
Lankheit, Klaus. Franz Marc. Skizzenbuch aus dem
Felde. Berlin: Gebrüder Mann, 1956.
————. Franz Marc. Watercolors. Drawings. Writings.
New York: Abrams, 1960.
————. Ausstellung. Hamburg: Kunstverein, 1964.
————. Franz Marc. Katalog der Werk.
Köln: M. DuMont Schauberg, 1970.
Marc, Franz. Briefe. Aufzeichnungen &
Aphorismen. Berlin: Paul Cassirer, 1920. Vol. I-II.
Probst, Rudolf. Franz Marc. Ausstellung. München:
Städische Galerie im Lenbachhaus, 1963.
Schardt, Alois J. Franz Marc. Berlin: Rembrandt, 1936.
Schmidt, Georg. Franz Marc. Botschaften an die
Prinzen Jussuff. München: R. Piper, 1954.

MARCKS, GERHARD
Marcks, Gerhard. Exhibition.
Paris: Musée Rodin, 1971-1972.
————. Exhibition.
Los Angeles: University of California, 1969.
————. zum fünfundachtigsten Geburtstag.
Berlin: Galerie Nierendorf, 1974.

MATARÉ, EWALD
Peters, Heinz. Ewald Mataré. Das graphische Werk.
2 volumes. Köln: Christoph Czwiklitzer, 1957-1958.

MATHEY, GEORG
Bethge, Hans. Georg Alexander Mathey. Buchkunst.
Graphik. Malerei. Wiesbaden: Harrassowitz, 1957.
Osborn, Max. Georg A. Mathey. Junge Kunst,
Band 54. Leipzig: Klinkhardt & Biermann, 1929.

MEID, HANS
Jannasch, Adolf. Hans Meid.
Berlin-Wien: Paul Neff, 1943.
Leitmeier, Hans. Hans Meid als Buchillustrator.
In: Gutenberg Jahrbuch. #33, 1958.

## MEIDNER, LUDWIG

Brieger, Lothar. Ludwig Meidner. Junge Kunst, Band 4. Leipzig: Klinkhardt & Biermann, 1919.

Däubler, Theodor. "Ludwig Meidner." In: Das Kunstblatt. 1918, Heft 10.

Fichter, Paul. Zu den neuen Arbeiten Ludwig Meidners. In: Jahrbuch der jungen Kunst. Leipzig: Klinkhardt & Biermann, 1923.

Grochowiak, Thomas. Ludwig Meidner. Recklinghausen: Aurel Bongers, 1966.

Hodin, Paul. Ludwig Meidner. Seine Kunst, seine Persönlichkeit, seine Zeit. Darmstadt: Justus von Liebig, 1973.

Kunz, Ludwig, ed. Ludwig Meidner. Dichter, Maler & Cafes Erinnerungen. Zurich: Arche, 1973.

Meidner, Ludwig. Im Nacken das Sternemeer. Leipzig: Kurt Wolff, ud. (1918).

———. Autobiography. In: Das graphische Jahr. Berlin. Fritz Gurlitt, 1921.

———. Ausstellung. Recklinghausen, Berlin & Darmstadt: Recklinghausen: Aurel Bongers, 1963-1964.

———. Zeichnungen von 1902-1927. Frankfurt a/M: Frankfurter Kunstkabinett Hanna Bekker vom Rath, 1970.

## MENSE, CARL

Graf, Oskar Maria. Der Maler Carl Mense. In: Jahrbuch der jungen Kunst. Leipzig: Klinkhardt & Biermann, 1923.

Schürmeyer W. "Carl Mense." In: Das Kunstblatt. 1919, Heft 2.

Zehder, Hugo. Carl Mense. In: Deutsche Graphik des Westens. Weimar: Feuer, 1922.

## MESECK, FELIX

Holtze, Otto. Das graphische Werk von Felix Meseck. In: Jahrbuch der jungen Kunst. Leipzig: Klinkhardt & Biermann, 1922.

Meseck, Felix. Autobiography. In: Das graphische Jahr. Berlin: Fritz Gurlitt, 1921.

## MEYER-AMDEN, OTTO

Huber, Carlo. Otto Meyer-Amden. Wabern: Büchler, 1968.

Meyer-Amden, Otto. Ausstellung. Zürich: Kunsthaus, 1953.

Schlemmer, Oskar. Otto Meyer Amden. Aus Leben, Werk und Briefen. Zürich: Johannespresse, 1934.

## MODERSOHN-BECKER, PAULA

Busch, Günter. Paula Modersohn-Becker. Aus dem Skizzenbuch. München: R. Piper, 1960.

Gallwitz, Sophie Dorothee, ed. Paula Modersohn. Briefe und Tagebuchblätter. Berlin: Der Neue Geist, 1949.

Hetsch, Rolf. Paula Modersohn-Becker. Ein Buch der Freundschaft. Berlin: Rembrandt, 1932.

Küppers, P.E. "Paula Modersohn." In: Das Kunstblatt. 1918, Heft 3, p. 65.

Modersohn-Becker, Paula. Paula Modersohn-Becker und die Brücke. Bern: Kunsthalle, 1948.

Pauli, Gustav. Paula Modersohn-Becker. Berlin, Leipzig: Kurt Wolff, 1919.

Stelzer, Otto. Paula Modersohn-Becker. Berlin: Rembrandt, 1958.

Werner, Wolfgang. Paula Modersohn-Becker. Oeuvre Verzeichnis der Graphik. Bremen: Graphisches Kabinett Wolfgang Werner, 1972.

## MOHOLY-NAGY, LASLO

Kállai, Ernst. Ladislaus Moholy-Nagy. In: Jahrbuch der jungen Kunst. Leipzig: Klinkhardt & Biermann, 1924, p. 181.

Moholy-Nagy, Laslo. Malerei. Fotographie. Film. Bauhausbücher 8. München: Albert Langen, 1927.

Moholy-Nagy, Sibyl. Moholy-Nagy. Experiment in Totality. Cambridge & London: Massachusetts Institute of Technology, 1969.

## MOLL, OSKAR

Braune-Krickau, Heinz. Oskar Moll. Junge Kunst, Band 19. Leipzig: Klinkhardt & Biermann, 1921.

## MORGNER, WILHELM

Däubler, Theodor. "Wilhelm Morgner." In: Feuer. I. Jahrgang, 1919-1920, Band II (Ap.-Sept. 1920), p. 571.

———. Wilhelm Morgner. In: Deutsche Graphik des Westens. Weimar: Feuer, 1922, p. 59.

Frieg, Will. "Wilhelm Morgner." In: Der Cicerone. XII. Jahrgang, 1920, p. 489.

———. Wilhelm Morgner. Junge Kunst, Band 12. Leipzig: Klinkhardt & Biermann, 1920.

Morgner, Wilhelm. "Briefe an und von Morgner." In: Das Kunstblatt. 1921, Heft 6, p. 170.

Seiler, Harold. Wilhelm Morgner. Recklinghausen: Aurel Bongers, 1958.

## MUCHE, GEORG

Schiller, Peter H. Georg Muche. Das druckgraphische Werk. Berlin & Darmstadt: Bauhaus-Archiv, 1971.

## MUELLER, OTTO

Buchheim, Lothar Günther. Otto Mueller. Leben & Werk. Feldafing: Buchheim, 1963.

———. Otto Mueller. Feldafing: Buchheim, 1968.

Flemming, Hanns Theodor. Otto Mueller. Feldafing: Buchheim, 1957.

Karsch, Florian. Otto Mueller. Zum hundertsten Geburtstag. Das graphische Gesamtwerk. Berlin: Galerie Nierendorf, 1974.

Schmalenbach, Werner. Otto Mueller. Hannover: Kestner-Gesellschaft, 1956-1957.

Westheim, Paul. "Otto Mueller." In: Das Kunstblatt. 1918, Heft 5, p. 129.

Wolfradt, Willi. "Otto Mueller." In: Das Kunstblatt. 1922, Heft 4, p. 142.

## MÜNTER, GABRIELE

Helms, Sabine. Gabriele Münter. Das Druckgraphische Werk. München: Städtische Galerie in Lenbachhaus, 1967.

Lahnstein, Peter. Münter. Ettal: Buch-Kunst, 1971.

Münter, Gabriele. Exhibition. Los Angeles: Dalzell Hatfield Galleries, 1960 & 1963.

Münter, Gabriele. Fifty Years of Her Art. New York: Leonard Hutton Galleries, 1966.

———Ausstellung. Hannover: Kestner-Gesellschaft, 1971.

Röthel, Hans Konrad. Gabriele Münter. München: F. Bruckmann, 1957.

## NAUEN, HEINRICH

Cohen, Walter. Heinrich Nauen. In: Deutsche Graphik des Westens. Weimar: Feuer, 1922, p. 54.

Flechtheim, Alfred. "Mein Freund Nauen." In: Feuer. Band I, 1919-1920, p. 28.

Lüthgen, E. "Heinrich Nauen." In: Das Kunstblatt. 1917, Heft 12, p. 363.

Marx, Eberhard. Heinrich Nauen. Recklinghausen: Aurel Bongers, 1966.

Suermondt, Edwin. Heinrich Nauen. Junge Kunst, Band 20. Leipzig: Klinkhardt & Biermann, 1922.

## NAY, WILHELM

Usinger, Fritz. Wilhelm Nay. Recklinghausen: Aurel Bongers, 1961.

## NEBEL, OTTO

Liebmann, Kurt. Der Malerdichter Otto Nebel. Zurich-Leipzig: Orell Füssli, 1935.

## NOLDE, EMIL

Gosebruch, Martin. Nolde. Watercolors and Drawings. New York, Washington & London: Praeger, 1973.

Haftmann, Werner. Radierungen von Emil Nolde. Düsseldorf: Kunstverein für die Rheinlande und Westfalen, 1948.

———. Emil Nolde. New York: Harry Abrams, 1959.

———. Emil Nolde. Unpainted Pictures. New York & Washington: Praeger, 1965.

Heise, Carl Georg. Emil Nolde. Wesen und Weg seiner religiösen Malerei. In: Genius. Erstes Buch, 1919, p. 18.

Küppers, Paul Erich. "Emil Nolde." In: Das Kunstblatt. 1918, Heft 11, p. 329.

Nolde, Emil. Briefe. Aus den Jahren 1894-1926. Berlin: Furche, u.d. [1927].

———. Das eigene Leben. Berlin: Julius Bard, 1931.

———. Jahr der Kämpfe. Berlin: Rembrandt, 1934.

———. Welt und Heimat. Die Sudseereise 1913-1918. Geschrieben 1936. Köln: M. DuMont Schauberg, 1965.

———. Reisen. Ächtung. Befreiung. Köln: M. DuMont Schauberg, 1967.

———. Aquarelle und Handzeichnungen. Seebüll: Stiftung Ada und Emil Nolde, 1971.

———. Gemälde, Aquarelle, Zeichnungen und Druckgraphik. Köln: Kunsthalle, 1973.

———. Graphik. Seebüll: Stiftung Ada und Emil Nolde, 1975.

Sauerlandt, Max. Emil Nolde. München: Kurt Wolff, 1921.

———. Emil Nolde. Seebüll III. Flensburg: Christian Wolff, 1961.

Schiefler, Gustav. Das graphische Werk von Emil Nolde bis 1910. Berlin: Julius Bard, 1911.

———. Das graphische Werk von Emil Nolde. 1910-1925. Berlin: Euphorion, 1926-1927.

Schiefler, Gustav & Mosel, Christel. Emil Nolde. Das graphische Werk. 2 vol. Koln: M. DuMont Schauberg, 1966-1967.

Schmidt, Paul Ferdinand. Emil Nolde. Junge Kunst, Band 53. Leipzig: Klinkhardt & Biermann, 1929.

Selz, Peter. Emil Nolde. Exhibition at the Museum of Modern Art; San Francisco Museum of Modern Art; Pasadena Art Museum; New York: Doubleday, 1963.

Urban, Martin. Emil Nolde. Flowers and Animals. New York & Washington, D.C.; Praeger, 1966.

———. Emil Nolde. Landscapes. New York & Washington, D.C. & London: Praeger, 1970.

## OPPENHEIMER, MAX

Michel, Wilhelm. Max Oppenheimer. München/Leipzig: Georg Müller, 1911.

Oppenheimer, Max. Autobiography. In: Das graphische Jahr. Berlin: Fritz Gurlitt, 1921, p. 98.

## ORLIK, EMIL

Osborn, Max. Emil Orlik. In: Graphiker der Gegenwart, Band 2. Berlin: Neue Kunsthandlung, 1920.

## PANKOK, OTTO

Zimmermann, Rainer. Otto Pankok. Das Werk der Malers, Holzschneiders und Bildhauers. Berlin: Rembrandt, 1972.

## PECHSTEIN, MAX

Biermann, Georg. Max Pechstein. Junge Kunst, Band 1. Leipzig: Klinkhardt & Biermann, 1919.

Fechter, Paul. Max Pechstein. Das graphische Werk. Berlin: Fritz Gurlitt, 1921.

———. Das graphische Werk Max Pechsteins. In: Jahrbuch der jungen Kunst. Leipzig: Klinkhardt & Biermann, 1920, p. 319.

Heymann, Walther. Max Pechstein. München: R. Piper, 1916.

Lemmer, Konrad. Max Pechstein und der Beginn des Expressionismus. Leipzig: Volk und Buch, 1949.

Osborn, Max. Max Pechstein. Berlin: Propyläen, 1922.

Pechstein, Max. Graphik. Ausstellung. Hamburg: Altonaer Museum, 1972.

Raphael, Max. "Max Pechstein." In: Das Kunstblatt. 1918, Heft 6, p. 161.

Reidemeister, Leopold. Max Pechstein. Erinnerungen. Wiesbaden: Limes, 1960.

———. Max Pechstein. Erinnerungen. München: List, 1963.

## PREETORIUS, EMIL

Rüdiger, Wilhelm. Emil Preetorius. Ausstellung. München: Stuckvilla, 1973.

## PURRMANN, HANS

Glaser, Kurt. Hans Purrmann. In: Deutsche Graphik des Westens. Weimar: Feuer, 1922, p. 53.

Purrmann, Hans. Ausstellung. München: Haus der Kunst, 1962.

Weber, Wilhelm. Hans Purrmann. Das graphische Werk. Exhibitions at: Kaiserlauten, Hagen, Ludwigshafen, Baden-Baden, Freiburg, 1963/1964.

Wolfradt, Willi. "Hans Purrmann." In: Das Kunstblatt. 1918, Heft 8, p. 264.

## RADZIWILL, FRANZ

Radziwill, Franz. Aquarelle und Zeichnungen. Ausstellung. Hamburg: Altonaer Museum, 1975.

Schacht, Roland. Franz Radziwill. In: Jahrbuch der jungen Kunst. Leipzig: Klinkhardt & Biermann, 1922, p. 171.

Schapire, Rosa. "Franz Radziwill." In: Das Kunstblatt. 1921, Heft 1, p. 17.

## RENNER, PAUL

Renner, Paul. Typographie als Kunst. München: Georg Müller, 1922.

———. Mechanisiert. Graphik. Schrift. Typo. Foto. Film. Berlin: Reckindorf, 1931.

———. Die Kunst der Typographie. Berlin: Bruckhaus Tempelhof, 1948.

## ROHLFS, CHRISTIAN

Rohlfs, Christian. 1849-1938. Ausstellung. Wien: Akademie der bildenden Künste, 1961.

———. Ausstellung. Berlin: Galerie Nierendorf, 1963.

———. Aquarelle und Zeichnungen. Ausstellung. Munster: Landesmuseum, 1974-1975.

Salmony, Alfred. "Rohlfs." In: Das Kunstblatt. 1922, Heft 6, p. 243.

Scheidig, Walther. Christian Rohlfs. Dresden: Der Kunst, 1965.

Uphoff, Carl Emil. Christian Rohlfs. Junge Kunst, Band 34. Leipzig: Klinkhardt & Biermann, 1923.

Vogt, Paul. Christian Rohlfs. Aquarelle und Zeichnungen. Recklinghausen: Aurel Bongers, 1958.

———. Christian Rohlfs. Das graphische Werk. Recklinghausen: Aurel Bongers, 1960.

———. The Best of Christian Rohlfs. New York: Atlantis Books, ud. [1965]

———. Christian Rohlfs. Ausstellung. Essen: Museum Folkwang, 1968-1969.

Westheim, Paul. "Christian Rohlfs."
In: Das Kunstblatt. 1918, Heft 9, p. 265.

## RÖSSING, KARL

Ehmcke, Fritz H. Karl Rössing. Das Illustrationswerk.
München & Berlin: C.H. Beck'sche, 1963.

Rössing, Karl. "Über den Holzstich."
In: Graphis 6. 1950, No. 30, p. 183-189.

Sperber, Mannes. Mein Vorurteil gegen diese Zeit.
100 Holzschnitte von Karl Rössing. Hamburg:
Hoffmann und Campe, 1974 (reprint of 1932 edition).

## SCHARFF, EDWIN

Mayer, August L. "Edwin Scharff."
In: Das Kunstblatt. 1918, Heft 8, p. 260.

Pfister, Kurt. Edwin Scharff. Junge Kunst, Band 10.
Leipzig: Klinkhardt & Biermann, 1920.

## SCHIELE, EGON

Comini, Alessandra. Schiele in Prison.
Greenwich: New York Graphic Society, 1973.

——. Egon Schiele's Portraits. Berkeley, Los
Angeles, London: University of California, 1974.

Demetrion, James T.
Egon Schiele and the Human Form. Exhibition. Des
Moines Art Center, Columbus Gallery of Fine Arts, Art
Institute of Chicago, 1971-72.

Kallir, Otto. A Sketchbook by Egon Schiele.
New York: Johannes, 1962. 2 vols.

——. Egon Schiele. Oeuvre Catalogue of the
Paintings. New York: Crown, 1966.

——. Egon Schiele. The Graphic Work.
New York: Crown, 1970.

Karpfen, Fritz. Das Egon Schiele Buch.
Wien: Wiener Graphischen Werkstätte, 1921.

Leopold, Rudolf.
Egon Schiele. Paintings, Watercolors. and Drawings.
London: Phaidon, 1973.

Roessler, Arthur. Erinnerungen an Egon Schiele.
Wien: Wiener Volksbuch, 1948.

Schiele, Egon. Ausstellung. München: Haus der
Kunst, 1975.

## SCHEURICH, PAUL

Hölscher, Eberhard. "Prof. Paul Scheurich."
In: Gebrauchsgraphik #13. 1936, Nr. 2, pp. 14-29.

Scheurich, Paul. Autobiography. In: Das graphische
Jahr. Berlin: Fritz Gurlitt, 1921.

## SCHLEMMER, OSKAR

Grohmann, Will. Oskar Schlemmer. Zeichnungen
und Graphik. Oeuvrekatalog. Stuttgart: Gert Hatje,
1965.

Herzogenrath, Wolf. Oskar Schlemmer. Die Wand-
gestaltung der neuen Architektur. München: Prestel,
1973.

Hildebrandt, Hans. Oskar Schlemmer.
München: Prestel, 1952.

Maur, Karin von. Oskar Schlemmer und die Stuttgarter
Avantgarde. Stuttgart: Staatlichen Akademie der
bildenden Künste, 1975.

——. Oskar Schlemmer. Sculpture.
New York: Harry Abrams, 1972.

Schlemmer, Oskar. Oskar Schelmmer und die
Abstrakte Bühne. Zurich: Kunstgewerbemuseum,
1961.

——. In: Suites. No. 6, Avril-Mai, 1964.

Schlemmer, Tut. The Letters and Diaries of Oskar
Schlemmer. Middletown: Wesleyan University, 1972.

Schmidt, Paul F. Oskar Schlemmer. In: Jahrbuch
der jungen Kunst. Leipzig: Klinkhardt & Biermann,
1921, p. 269.

## SCHLICHTER, RUDOLF

Einstein, Carl. "Rudolf Schlichter."
In: Das Kunstblatt. 1920, Heft 4, p. 105.

Schlichter, Rudolf. Exhibition.
Milano-München: Galleria Levante, 1971.

## SCHMIDT-ROTTLUFF

Coellen, Ludwig. "Schmidt-Rottluff."
In: Das Kunstblatt. 1917, Heft 11, p. 321.

Grohmann, Will. Karl Schmidt-Rottluff.
Stuttgart: W. Kohlhammer, 1956.

Rathenau, Ernest. Karl Schmidt-Rottluff. Das
graphische Werkseit 1923. Berlin & New York:
Euphorion & Rathenau, 1964.

Reidemeister, Leopoold. Karl Schmidt-Rottluff.
Das graphische Werk zum 90. Geburtstag. Berlin:
Brücke-Museum, 1974.

Schapire, Rosa. Karl Schmidt-Rottluffs graphische
Werk bis 1923. Berlin: Euphorion, 1924.

Schmidt-Rottluff, Karl. Verzeichnis der Graphik von
Karl Schmidt-Rottluff. Berlin: Galerie Ferdinand
Möller, 1922.

——. Kunstblätter. Berlin: Galerie Nierendorf, 1975.

Thiem, Gunther. Karl Schmidt-Rottluff.
Berlin: Akademie der Künste, 1964.

Valentiner, Wilhelm. Karl Schmidt-Rottluff. Junge
Kunst, Band 16. Leipzig: Klinkhardt & Biermann, 1920.

——. "Karl Schmidt-Rottluff."
In: Der Cicerone. XII. Jahrgang, 1920, p. 455.

Wietek, Gerhard. Karl Schmidt-Rottluff. Graphik aus
Norddeutschland. Hamburg: Altonaer Museum, 1970.

——. Schmidt-Rottluff Graphik.
München: Karl Thiemig, 1971.

——. Karl Schmidt-Rottluff. Graphik der Jahre
1906-1921. Ausstellung zum 90. Geburtstag.
Reutlingen: Spendhaus, 1974.

——. Schmidt-Rottluff. Hamburg: Gemälde at
Altonaer Museum, Aquarelle at B.A.T.
Cigaretten-Fabriken GmbH, 1974.

## SCHRIMPF, GEORG

Graf, Oskar Maria. "Georg Schrimpf."
In: Der Cicerone. XIII. Jahrgang, p. 573.

——. Georg Schrimpf. Junge Kunst, Band 37.
Leipzig: Klinkhardt & Biermann, 1923.

Pförtner, Matthias. Georg Schrimpf.
Berlin: Rembrandt, 1940.

## SCHWITTERS, KURT

Hausmann, Raoul & Schwitters, Kurt. PIN.
London: Gaberbocchus, 1962.

Schmalenbach, Werner. Kurt Schwitters.
New York: Abrams, 1967.

Schwitters, Kurt. Schwitters.
London: Marlborough Fine Art, 1963.

Spengemann, Christof. Die Wahrheit über Anna
Blume; Kritik der Kunst, Kritik der Kritik,
Kritik der Zeit. Hannover: Zweeman, 1920.

Steinitz, Kate Trauman. Kurt Schwitters. A Portrait
from Life. Berkeley & Los Angeles, University of
California, 1968.

Themerson, Stefan. Kurt Schwitters in England.
London: Gaberbocchus, 1958.

Von den Osten, Gert. Kurt Schwitters.
Cologne: Wallraf-Richarts Museum, 1963.

Zahn, Leopold. "Ausstellung Schwitters in der Galerie
Hans Goltz." In "Cicerone, Jahrgang XIII, 1921."

## SEEHAUS, PAUL

Cohen, Walter. Erinnerung an Seehaus. In: Deutsche
Graphik des Westens. Weimar: Feuer, 1922, p. 62.

Westheim, Paul. "Paul Seehaus."
In: Das Kunstblatt. 1919, Heft 3, p. 75.

Wolfradt, Willi. Paul Seehaus. In: Jahrbuch der jungen
Kunst. Leipzig: Klinkhardt & Biermann, 1922, p. 37.

## SEEWALD, RICHARD

Grünthal, Ernst. "Richard Seewald."
In: Das Kunstblatt. 1920, Heft 10, p. 301.

Hausenstein, Wilhelm. Richard Seewald. In: Jahrbuch
der jungen Kunst. Leipzig: Klinkhardt & Biermann,
1922, p. 133.

Jentsch, Ralph. Richard Seewald. Das graphische
Werk. Esslingen: Kunstgalerie Esslingen, 1973.

Saedler, Heinrich. Richard Seewald.
München-Gladbach: Führer, 1924.

Seewald, Richard. Das graphische Werk 1912-1918.
München: Neue Kunst Hans Goltz, 1919.

——. Autobiography. In: Das Graphische Jahr.
Berlin: Fritz Gurlitt, 1921.

——. Glanz des Mittelmeers. Text and illustrations
by Seewald. Forward by Peter Meyer. Feldafing:
Buchheim, 1956.

## SEGAL, ARTHUR

Nathanson, Richard. Arthur Segal.
London: Nathanson & Segal, 1972.

Segal, Arthur. Kollektiv-Ausstellung.
Zürich: Kunstsalon Wolfsberg, 1919.

## STARKE, OTTOMAR

Sternheim, Carl. Ottomar Starke. In: Deutsche Graphik
des Westens. Weimar: Feuer, 1922, p. 47.

## SINTENIS, RENEE

Crevel, René. Renee Sintenis. Junge Kunst, Band 57.
Leipzig: Klinkhardt & Biermann, 1930.

Kiel, Hanna. Renée Sintenis. Berlin: Rembrandt, 1956.

Siemsen, Hans. Die unbekannte Renée Sintenis.
In: Jahrbuch der jungen Kunst. Leipzig: Klinkhardt &
Biermann, 1924, p. 268.

Sintenis, Renée. Autobiography. In: Das graphische
Jahr. Berlin: Fritz Gurlitt, 1921.

——. Radierte Impressionen.
Berlin: Deutscher Arkiv, 1956.

## STEINHARDT, JAKOB

Kolb, Leon. The Woodcuts of Jakob Steinhardt.
San Francisco: Genart, 1959.

Nadel, Arno. Jakob Steinhardt. In: Graphiker der
Gegenwart, Band 4. Berlin: Neue Kunsthandlung, ud.

Pfefferkorn, Rudolf. Jakob Steinhardt.
Berlin: Stapp, 1967.

Steinhardt, Jakob. Autobiography. In: Das graph-
ische Jahr. Berlin: Fritz Gurlitt, 1921, p. 129.

——. Ausstellung. Berlin: Haus am Lützoplatz, 1966.

## STERN, ERNST

Goetz, Wolfgang. Ernst Stern. In: Graphik der Gegen-
wart, Band 3. Berlin: Neue Kunsthandlung, 1920.

Stern, Ernst. Autobiography. In: Das graphische Jahr.
Berlin: Fritz Gurlitt, 1921.

## TAPPERT, GEORG

Tappert, Georg. Kunstausstellung.
Reutlingen: Hans Thoma-Gesellschaft, 1971.

Wietek, Gerhard. Graphik Georg Tappert. 1880-1957.
Hamburg: Altonaer Museum, 1971.

## THORN-PRIKKER, JOHANN

Hoff, August. Johann Thorn-Prikker.
Recklinghausen: Aurel Bongers, 1958.

Wember, Paul. Johann Thorn-Prikker.
Krefeld: Scherpe, 1966.

## UNOLD, MAX

Hausenstein, Wilhelm. "Max Unold."
In: Der Cicerone. XII. Jahrgang, 1920, p. 631.

——. Max Unold. Junge Kunst, Band 23.
Leipzig: Klinkhardt & Biermann, 1921.

Unold, Max Autobiography. In: Das graphische Jahr.
Berlin: Fritz Gurlitt, 1921.

## VAN DE VELDE, HENRY

Scheffler, Karl. Henry van de Velde. Vier Essays.
Leipzig: Insel, 1913.

Van de Velde, Henry. Une Prédiction d'Art.
Bruxelles: La Societe Nouvelle, 1895-1896.

——. Die Renaissance im modernen Kunstgewerbe.
Berlin: Bruno und Paul Cassirer, 1901.

——. Essays. Leipzig: Insel, 1910.

——. Die drei Sünden wider die Schönheit.
Zurich: Europäische Bilbliothek, 1918.

——. Geschichte meines Lebens.
München: R. Piper, 1962.

## VIEGENER, EBERHARD

Frieg, Will. "Eberhard Viegener."
In: Das Kunstblatt. 1919, Heft 3, p. 65.

——. Eberhard Viegener. In: Jahrbuch der jungen
Kunst. Leipzig: Klinkhardt & Biermann, 1921, p. 321.

## VOGELER, HEINRICH

Rief, Hans-Hermann. Heinrich Vogeler 1872-1942.
Gedenkausstellung. Worpswede: Worpsweder
Kunsthalle und Haus im Schluh, 1972.

## WASKE, ERICH

Kirchner, Joachim. Erich Waske. In: Jahrbuch der
jungen Kunst. Leipzig: Klinkhardt & Biermann, 1921,
p. 26.

——. Erich Waske. Junge Kunst, Band 24. Leipzig:
Klinkhardt & Biermann, 1921.

## WEISS, EMIL RUDOLF

Hölscher, Eberhard. Der Schrift und Buchkünstler
Emil Rudolf Weiss. Berlin-Leipzig: Heintze und
Blankertz, 1941.

Weiss, E.R. Autobiography. In: Das graphische Jahr.
Berlin: Fritz Gurlitt, 1921, p. 142.

Zerbe, Walter. E.R. Weiss. Der Schrift und
Buchkünstler, der auch Maler und Dichter war.
Bern: Schweizerisches Gutenbergmuseum, 1947.

## WOLF, GUSTAV

Benz, Richard. Die Zeichen-Sprache der Kunst.
Betrachtungen zum Werk Gustav Wolfs. In: Jahrbuch
der jungen Kunst. Leipzig: Klinkhardt & Biermann,
1921, p. 47.

Raphael, Max. Über Gustav Wolf. In: Jahrbuch der
jungen Kunst. Leipzig: Klinkhardt & Biermann, 1923,
p. 190.

# INDEX

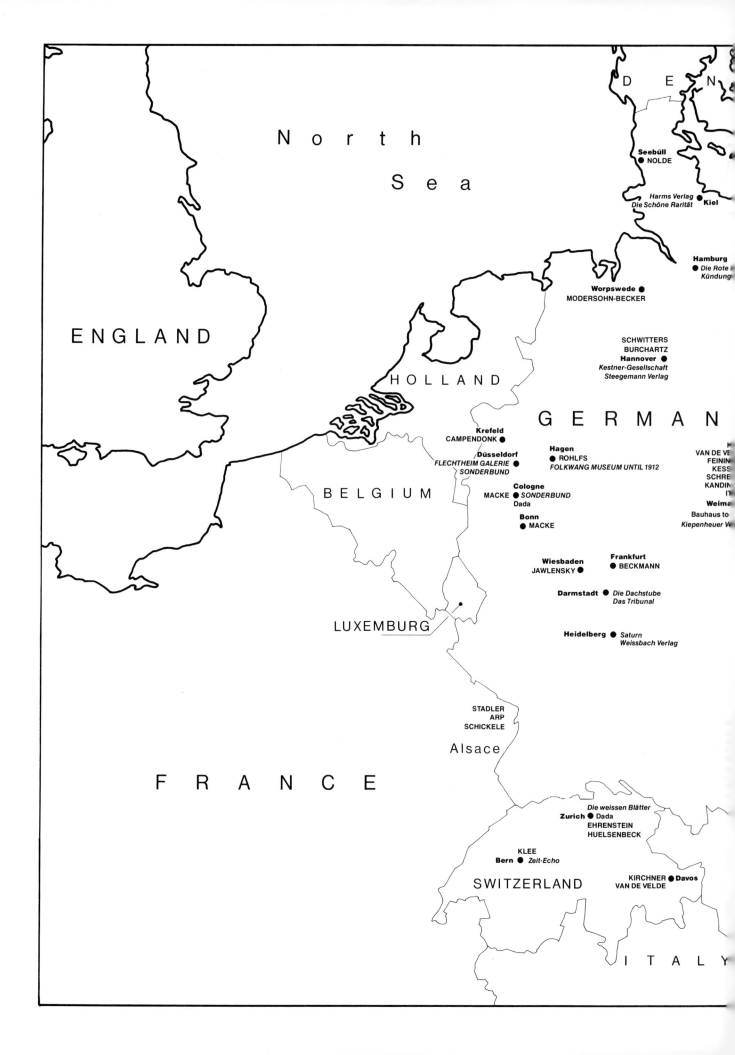

North Sea

D E N

Seebüll
● NOLDE

Harms Verlag
Die Schöne Rarität ● Kiel

Hamburg
● Die Rote
Kündung

Worpswede ●
MODERSOHN-BECKER

SCHWITTERS
BURCHARTZ
Hannover ●
Kestner-Gesellschaft
Steegemann Verlag

ENGLAND

HOLLAND

G E R M A N

Krefeld
CAMPENDONK ●

Hagen
● ROHLFS
FOLKWANG MUSEUM UNTIL 1912

VAN DE VE
FEININ
KESS
SCHRE
KANDIN

Düsseldorf
FLECHTHEIM GALERIE
SONDERBUND

Weima
Bauhaus to
Kiepenheuer V

BELGIUM

Cologne
MACKE ● SONDERBUND
Dada

Bonn
● MACKE

Wiesbaden
JAWLENSKY ●

Frankfurt
● BECKMANN

LUXEMBURG

Darmstadt ● Die Dachstube
Das Tribunal

Heidelberg ● Saturn
Weissbach Verlag

STADLER
ARP
SCHICKELE

Alsace

F R A N C E

Die weissen Blätter
Zurich ● Dada
EHRENSTEIN
HUELSENBECK

KLEE
Bern ● Zeit-Echo

KIRCHNER ● Davos
VAN DE VELDE

SWITZERLAND

I T A L Y

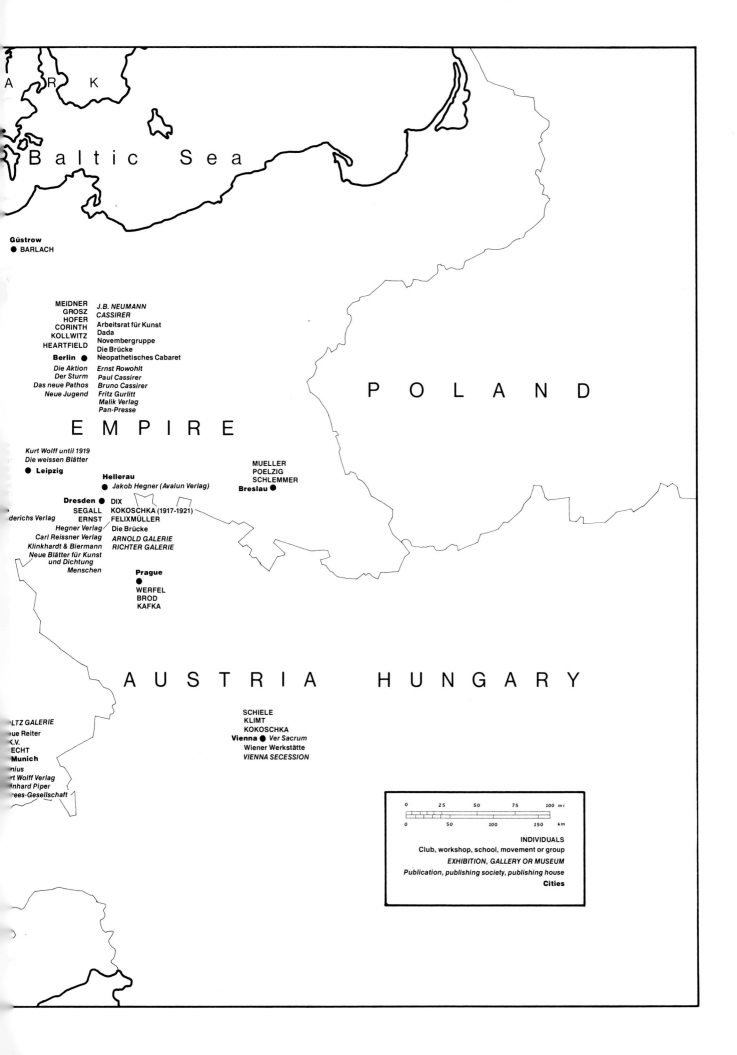

A R K

Baltic Sea

**Güstrow**
● BARLACH

MEIDNER         *J.B. NEUMANN*
GROSZ           *CASSIRER*
HOFER           *Arbeitsrat für Kunst*
CORINTH         *Dada*
KOLLWITZ        *Novembergruppe*
HEARTFIELD      *Die Brücke*
                *Neopathetisches Cabaret*
**Berlin** ●
*Die Aktion*     *Ernst Rowohlt*
*Der Sturm*      *Paul Cassirer*
*Das neue Pathos* *Bruno Cassirer*
*Neue Jugend*    *Fritz Gurlitt*
                 *Malik Verlag*
                 *Pan-Presse*

E  M  P  I  R  E

P O L A N D

*Kurt Wolff until 1919*
*Die weissen Blätter*                MUELLER
● **Leipzig**                        POELZIG
                                     SCHLEMMER
            **Hellerau**            **Breslau** ●
            ● *Jakob Hegner (Avalun Verlag)*

**Dresden** ●  DIX
SEGALL      KOKOSCHKA (1917-1921)
ERNST       FELIXMÜLLER
*Hegner Verlag* / *Die Brücke*
*Carl Reissner Verlag*   *ARNOLD GALERIE*
*Klinkhardt & Biermann*  *RICHTER GALERIE*
*Neue Blätter für Kunst*
*und Dichtung*
*Menschen*              **Prague**
                        ●
*derichs Verlag*         WERFEL
                         BROD
                         KAFKA

A U S T R I A       H U N G A R Y

                    SCHIELE
*LTZ GALERIE*       KLIMT
*ue Reiter*         KOKOSCHKA
*K.V.*          **Vienna** ● *Ver Sacrum*
*ECHT*              Wiener Werkstätte
**Munich**          *VIENNA SECESSION*
*nius*
*rt Wolff Verlag*
*nhard Piper*
*rees-Gesellschaft*

```
0       25      50      75      100 mi
|---|---|---|---|---|---|---|---|
0        50      100     150 km
```

● **INDIVIDUALS**
Club, workshop, school, movement or group
*EXHIBITION, GALLERY OR MUSEUM*
Publication, publishing society, publishing house
**Cities**

*Designed by Jack Carter*

*All text set in Helvetica Photo-Composition
at ACC Typographers, Inc., Los Angeles by
Robert Ballard, Donald Barrett, I Li Chiang,
Charles Jacobson, Joan Schmidt*

*Catalog printed on Paloma Text
by George Rice & Sons, Lithographers, Los Angeles*

*Photographs by John Thomson*

*Production
by Roberta Roberts*

*Map of the German Empire
by Ruhl A. Lophist*